For

Doris,

my friend and teacher

with abiding
gratitude for
setting me off
in the right direction.

Love,

David

October 1998

ALSO BY DAVID MICHAELIS

Boy, Girl, Boy, Girl

The Best of Friends

Mushroom (co-author)

N. C. Wyeth

N. C. WYETH

A BIOGRAPHY

by

DAVID MICHAELIS

Alfred A. Knopf

NEW YORK

1998

THIS IS A BORZOI BOOK
PUBLISHED BY ALFRED A. KNOPF, INC.

www.randomhouse.com

Library of Congress Cataloging-in-Publication Data
Michaelis, David
N. C. Wyeth : a biography / by David Michaelis. — 1st ed.
p. cm.
Includes bibliographical references and index.
ISBN 0-679-42626-4
1. Wyeth, N. C. (Newell Convers), 1882–1945. 2. Painters—United
States—Biography. I. Wyeth, N. C. (Newell Convers), 1882–1945.
II. Title
ND237.W94M53 1998
759.13—dc21 98-6143
CIP

Manufactured in the United States of America

First Edition

To Clara

Can't repeat the past?

—*F. Scott Fitzgerald,*
THE GREAT GATSBY

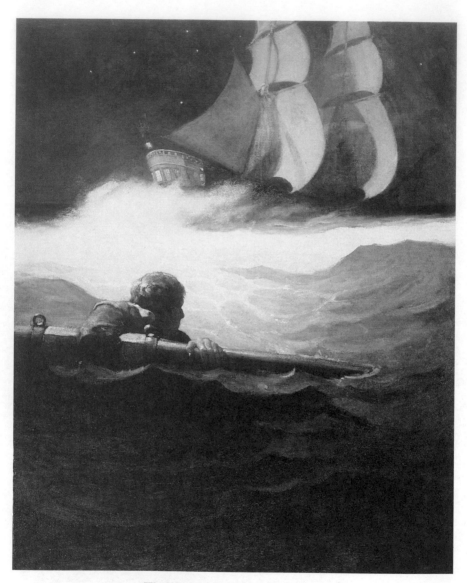

The Wreck of the "Covenant," 1913.

CONTENTS

PART ONE

Needham, 1866–1903

Black and White

IN August 1866 a grave was dug in the village cemetery for the body of an infant boy. His name was Rudolph Zirngiebel. He would have been N. C. Wyeth's uncle. Born November 28, 1865, Rudolph had lived eight months, twenty-eight days.

When N. C. Wyeth's mother's family, Swiss immigrants, buried their infant son in Needham's wooded cemetery, the Zirngiebels also buried the true cause of Rudolph's death, which was withheld from town records for four months and then officially misrepresented. No one outside the family was ever to know the truth, that Rudolph had fallen into the Charles River and drowned.

Rudolph's sister—N. C. Wyeth's mother—omitted any direct mention of her third brother from the intimate, sometimes hourly record of her thoughts, which she left to posterity in the form of thousands of letters written to her sons. The true facts of Rudolph's death never came to light during her lifetime, and the aftereffects of her concealment would supervene at the time of N. C. Wyeth's birth in 1882 and, ultimately, all through his life. The story that ends with the death of a child begins with the death of a child.

Needham was an upriver village. Bostonians in 1866 knew it as "some sleepy country town in Norfolk County." But to N. C. Wyeth's Swiss grandparents, a hilly farming community twelve miles up the Charles River offered bright prospects. Needham looked like an ideal place for Jean Denys Zirngiebel to grow and sell flowers.

Zirngiebel had come to America in search of soil. Born in the French-speaking Swiss canton of Neuchâtel, he had graduated with highest honors from the University of Neuchâtel in 1848. He served a seven-year apprenticeship in French and Swiss botanic gardens, then cultivated grapes on his own land in the canton of Bern. In 1852 he married Henriette Zeller, the

daughter of a well-to-do German-Swiss family in Thun. Henriette gave birth to their first child, Denys Jr., in 1854.

A year later, at the age of twenty-six, Zirngiebel lost his land to the Swiss Federal Railways. He gave up hope of making his start in Switzerland, left behind his wife and infant son, and sailed for America.

Zirngiebel arrived in New Orleans. At a Louisiana plantation, he presented letters of introduction testifying to his intelligence. For a few months he tended plantation gardens and learned some English. Then, with new letters of recommendation, he moved north.

In Cambridge, Massachusetts, the botanist Asa Gray hired Zirngiebel as a gardener at Harvard University's Botanic Garden, the only institution of its kind in the United States. Zirngiebel most likely moved into the gardener's quarters in Gray's stately house on Raymond Street. Then, without knowing what an ordeal he was about to put his family through, or how long-lasting its consequences, Zirngiebel sent for his wife and two-year-old son.

HENRIETTE ZELLER ZIRNGIEBEL'S family had lived in Bern since the seventeenth century. Situated by Lake Thun, their village was known to travelers as the gateway to the Bernese Oberland. Thun was a typical Swiss-German community, steeped in tradition. Women rarely traveled more than a few miles from home. To a Bernese woman in the middle of the nineteenth century, the idea of home meant uninterrupted attachment to an extended family living an orderly life in a well-run house centered on the village. Women like Henriette's aunt Rosetti, who married an Englishman and moved to England, were "never heard from." Home was the place you left when you died.

All that changed on May 10, 1856. Henriette set sail from Le Havre on the *Hamilton*. She was twenty-five years old and stood five feet, one and three quarters inches. Her hair was black, her eyes brown, her color "healthy." That, too, changed. No sooner was she reunited with her husband in America than time and distance caught up with her. The shock of leaving Thun altered Henriette Zeller Zirngiebel forever.

Arriving in Massachusetts, she felt as if she were no longer herself. America seemed strange, artificial, accelerated. She experienced a sharp sense of dislocation. In Thun, time was not much noticed, except as a melodious repetition of church bells. Americans rushed ahead, marked time by punching a clock, that "key-machine of the modern industrial age." In a few years Henry Ford would speak for the whole country when he declaimed, "We don't want tradition. We want to live in the present."

Henriette ached for home. The Needham *Chronicle* would later remark on her quiet ways, her "retiring disposition." The truth was, she remained tongue-tied by the past. Afraid to lose Switzerland, Henriette spoke only Swiss-German or French. "The mind in Nostalgia has attention only for a return to the Fatherland," stated the then-current medical dissertation on the "Swiss malady," homesickness. A Swiss physician, Johannes Hofer, who coined the term *nostalgia* from the Greek *nostos* (a return) and *algos* (pain), had observed that the illness was aggravated by "frequent contemplations of the Fatherland, and from an image of it," and that by far the greatest number of those afflicted were natives of Bern, Henriette's home canton. Images of Thun haunted her: the black lake, the distant, snow-white peaks, the timeless town—the same black-and-white images N. C. Wyeth would later hang beside his studio door.

Denys Zirngiebel, meanwhile, had grown to like America. He got on well in the New England of Emerson, Hawthorne, and Holmes. He made

Henriette Zeller Zirngiebel (1830–1903) and Jean Denys Zirngiebel (1829–1905). Switzerland remained always more real for NCW's maternal grandmother. Enfeebled by homesickness and depression, "Grandmama Z" died at age seventy-two.

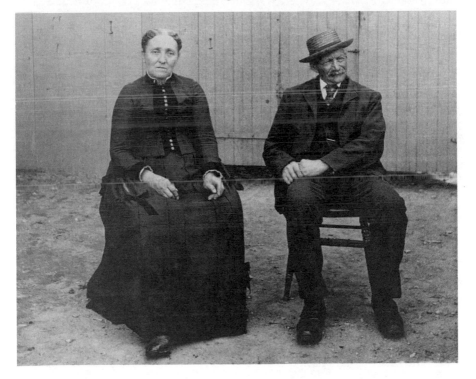

new friends easily. One of them was Andrew Newell Wyeth, the baggage master of the Fitchburg Railroad.

The Wyeths had been landowners in Cambridge for over two hundred years. Their fields and farms dominate the city maps of 1776, 1830, and 1854. Nicholas, a mason, the first Wyeth to come from England, bought a house in Cambridge on May 20, 1645. In the third generation, Jonas Wyeth destroyed tea as an "Indian" at the Boston Tea Party; Noah and four other Wyeths took up arms against His Majesty's troops on April 19, 1775; Ebenezer fought the redcoats at Bunker Hill. Ebenezer's son, John, worked his way up from printer's apprentice to become owner of the *Harrisburg Advertiser;* a booster of George Washington, John Wyeth was rewarded with the postmastership of Harrisburg, Pennsylvania. The fifth-generation Nathaniel Jarvis Wyeth patented ice-harvesting tools for the export of American ice, then went west on the Oregon Trail.

By 1856, the year of Denys Zirngiebel's arrival in Cambridge, families of Wyeths still lived side by side in clapboard farmhouses on Brattle Street. Nathaniel, the resourceful inventor and soon to be famous pioneer, inhabited Wyeth Lane. The Wyeth Ice House stood by Fresh Pond. On Garden Street, N. C. Wyeth's great-grandfather Job Wyeth occupied the first Wyeth homestead. The Andrew Newell Wyeths had just moved from Garden Street to Raymond, where the Zirngiebels had been living for a year.

Raymond Street climbed the crest of Avon Hill, crossing paths with the Fitchburg Railroad on the downslope. Joined as neighbors, the Zirngiebels and the Wyeths had sons a year apart. Andrew Newell Wyeth, Jr., known as Newell, and Denys Zirngiebel, Jr., played together, sledding in winter and skating on Fresh Pond. The Zirngiebels' connection to the Wyeths was a first step in their assimilation into American life.

Henriette, however, could not re-create herself on Raymond Street. Her center of gravity was fixed in Switzerland. Thinking always of what she had lost, Henriette had another child.

ON CHRISTMAS DAY, 1858, a girl was born on Raymond Street. The Zirngiebels named her Henriette. Hoping to Americanize the child, her father called her Hattie, as he himself was now called Dennis. But her mother made a point of pronouncing the name *on-ri-ETTE,* "as that is the French and German version of it." In any case, the baby lifted Henriette's spirits and was a turning point in her melancholy life.

Meanwhile, at the Botanic Garden, Denys Zirngiebel had not advanced. He scarcely seems to have been noticed. In a community where practically everyone was writing about everyone else in diaries, letters, scientific papers,

and sermons, Zirngiebel is nowhere to be found. His name does not appear among those of the six young men Asa Gray recruited to succeed himself as director of the Botanic Garden. Scant evidence of a gardener known as Zirngerbeit is all that survives among the Botanic Garden records.

It was the same with Longfellow. In N. C. Wyeth's version of his mother's early life in Cambridge, Denys Zirngiebel and the American poet Henry Wadsworth Longfellow were "old cronies." The poet's merry, precocious daughters, Edith and Allegra, had been friends with the Zirngiebels "for years." Hattie, N. C. Wyeth's mother, played among Brattle Street's "garden of girls," the children of *The Children's Hour.* Longfellow dandled Hattie on his knee "many, many times."

A more accurate portrait can be found in Longfellow's archives. The fact was, Longfellow had befriended numerous Swiss immigrants; Switzerland was close to his heart. In 1836 the poet had met his second wife, Fanny Appleton, while on holiday in, of all places, Thun, Henriette Zirngiebel's longed-for village. But if the Longfellows knew the Zirngiebels in Cambridge, the acquaintance was casual. In the detailed record of the Longfellows' life at 105 Brattle Street, Denys and Henriette Zirngiebel make no appearance.

In later years, N. C. Wyeth would also say that his grandfather had been the director of Harvard's Botanic Garden. In fact, when it came time to name Asa Gray's successor, the next director of the impecunious garden was chosen not for merit but for money. The job went to a rich student of botany named Charles Sprague Sargent. Yet to the end of his life, Wyeth would proudly claim the directorship for his grandfather, insisting that Denys Zirngiebel had been a "prominent Swiss Horticulturist," who had come "to this country with Louis Agassiz and worked with him for years at Harvard."

According to Zirngiebel family papers, Denys had landed in Cambridge on his own initiative, not, as N. C. Wyeth would later tell it, at his former professor Louis Agassiz' personal suggestion. Zirngiebel, it is true, had first fallen under Agassiz' spell as a seventeen-year-old at the University of Neuchâtel. Thorough and careful as a student, Zirngiebel idolized the brash, daring professor who had awed the world by announcing his discovery that glaciers had once covered Europe and North America. As it happened, however, student and professor crossed paths for a matter of months only; Zirngiebel barely glimpsed the tail end of Agassiz' cometlike career at Neuchâtel. In 1846, when Agassiz departed for the United States, Zirngiebel, like many others, may have wanted to follow. But he had first to graduate.

By the time Zirngiebel caught up to his idol, Agassiz had been enchanting Cambridge for ten years. In America, the famed Swiss naturalist had

become a household god. N. C. Wyeth's mother and uncles grew up calling him "our great hero of nature." Denys Zirngiebel's association with the great man would become an article of family creed, passed on to the next four generations. For N. C. Wyeth, the family's Agassiz connection persisted to 1919: while writing an article for *Scribner's Magazine,* Wyeth related the secret of Agassiz' teaching as if it were a family heirloom handed down by his grandfather. In N.C.'s studio in the 1920s, Agassiz' observation of the form and substance of an object for its own sake became gospel in the training of subsequent generations of Wyeth painters. But as was often the case when the Wyeths idealized a showman and merged their fate with his, historical truth proved less glorious than family legend.

Harvard has no record of Denys Zirngiebel assisting Agassiz. N. C. Wyeth's grandfather was an independent seedsman, more interested in growing and selling familiar flowers than in classifying new strains of North American flora for scientific purposes. In his own field, in his own day, Denys Zirngiebel identified himself as a "florist."

By 1864 he had decided to make the jump from botanic gardening to what was then called floriculture. Looking for a promising piece of land, Zirngiebel learned of property farther up the Charles River, in an old wayside town called Needham.

SET UPON the highest hills of eastern Massachusetts, Needham was tableland. Elevated 180 feet above sea level—higher than the top of Bunker Hill monument in Charlestown—the town boasted hills that reached 300 feet. In June the Needham air blew light and dry, unusually pure. The spruces massed along the Charles River stood thick as an Alpine fir forest.

Needham worked like Switzerland as well. Its all-powerful town meeting echoed the sovereignty of the village commune, the *Gemeinde.* The townspeople, a homogenous population of farmers and woodcutters, took a Swiss view of themselves. Industrious, thrifty, they exercised self-restraint, preferring outsiders to see them as "staid and sober," above all as "homeloving people." They marketed dairy products, bottled Needham spring water, and never tired of promoting it, as if it were an elixir. But Needham in 1864 was struggling. Ribboned by the Charles, the town had been choked by it. Too shallow for seafaring, too sluggish for rapid industrialization, the river that flowed through Needham was a canoe stream. After a pair of eighteenth-century sawmills had petered out, every attempt to make the town a manufacturing center had failed.

The powerless Charles provided Needham but one local asset. Two miles below the village, a single, narrow belt of rich bottomland ran between

the riverbank and a dirt road called South Street. The property Zirngiebel had come to see measured six and three-quarters acres along South Street. The house was a clapboard dwelling built before the Revolutionary War. Zirngiebel began renting in 1864.

The terrain was suited to growing. Across South Street, a thickly wooded knoll rose in a natural windscreen. Behind the house, an open meadow sloped 350 feet down to the river, angled toward the morning sun. Zirngiebel built three long greenhouses parallel to the road—forty thousand feet of "clayish" soil under clean, sparkling glass. Along South Street, he planted fortlike ramparts of arborvitae to redouble his protection from north winds. For irrigation, a windmill and water tower drew fresh water from the river.

By now the Zirngiebels had a third child, Augustus, known as Gig, born in Cambridge in 1861. In the spring of 1865, Henriette was pregnant a fourth time. The farmhouse was big enough for the expanding family, but the oldest son, Denys Jr., age eleven, had balked at the change; he was homesick for Cambridge. He missed Raymond Street and the Wyeths. A letter from twelve-year-old Newell Wyeth had arrived during the Zirngiebels' first winter in Needham. Denys Jr. had taken it, he told Newell, "as a signe as you hafe not forget your old friend.

"Every time I habe chance to skate or slide I wish to have you with me," Denys Jr. went on. "I will never forget all them nice times with you in Cambridge."

Denys Jr. next wrote to Newell after Christmas 1865. He cataloged his presents: "a paint box and a drum half as big as yours and a nice winter coat [and] a box of UNITED STATS PUZZLE." His brother Gig had received a box of blocks and an illustrated book, *The Little Old Woman Who Lived in a Shoe.* His sister had been given her heart's desire: "Hattie has a big Doll."

Hattie Zirngiebel longed for a sister. Nothing mattered so much as the connection she wanted with "a womankind of my own flesh and blood." Later, she remembered feeling crushed when the fourth baby appeared. "A girl would have pleased me," she wrote. But on November 28, 1865, in the birthing room at 286 South Street, a boy was born.

Denys Jr. broke the news to Newell Wyeth in Cambridge. "We have got a baby named Rudolf."

Rudolph

S OLOMON FLAGG was a one-man town hall. In addition to duties as schoolmaster, chorister, town treasurer, assessor, representative to the general court, and school committeeman, he was town clerk. Flagg recorded deaths. When a six-year-old Needham boy, Silas Williams, died of dysentery on August 23, 1866, Flagg promptly recorded the facts in his official register. He did the same for a woman named Sally Sylvester, who died of typhoid fever that day. Dysentery and typhus were routine. So were infant deaths. Of the fifty-six people who died in Needham in 1866, the largest number—eleven—were babies under the age of twelve months. On August 25, however, when the Zirngiebels' infant son, Rudolph, drowned in the river below the family homestead on South Street, Flagg made no record.

Needham's undertaker, George G. Eaton, prepared the body for burial. Rudolph was the first Zirngiebel to die in the new country. His small coffin, embossed with an engraved, oval-shaped plaque, was taken to the new family plot in Needham's rural cemetery. A Mr. Moody composed an elegy:

> *Two more little eyes*
> *Are closed to ope no more;*
> *Two more little feet*
> *Have reached the shining shore.*
>
> *Two more little ears*
> *Are deaf to sounds of mirth;*
> *Two more little lips*
> *Will lisp no more on earth.*
>
> *Two more little hands*
> *Close folded on the breast;*
> *One more little form*
> *Is gently laid to rest.*

The autumn of 1866 passed without final documentation on Rudolph's death. In December, Solomon Flagg abruptly opened Register No. 4 and turned to page 33. Burying the matter among the December dead, he entered the official cause of "Rodolf" Zirngiebel's death: "Dropsy in the brain."

Known as water on the brain, dropsy has a history as a concealing disease. It often appeared in nineteenth-century coroners' reports to divert the attention of authorities from more serious matters. By the end of 1866, after some fifty thousand Americans had died of cholera believed to have spread from Europe on arriving passenger ships, the diagnosis of dropsy began to appear on the docks in New York. In order to avoid quarantining sailors and impatient first-class passengers at the pier, a ship's medical report might list dropsy as the cause of any unnatural deaths in steerage.

If Solomon Flagg had wanted to keep a strange or accidental death quiet, if he took it as his duty to protect the temperate, home-loving village of Needham from scandal, he could have chosen no better story to give out than "dropsy in the brain."

THE ZIRNGIEBELS had no more children. It is not clear what immediate effect the death of her baby brother had on Hattie's growing up. A photograph taken a year after Rudolph's death shows nine-year-old Hattie with her finger in a book. Her eyes, averted, are shaded with black semicircles. She holds her mouth in a tight, mournful grimace.

Hattie was often depressed, "nervous," agitated for no discernible reason, and subject to what she called outbursts. "Sickness," Hattie wrote in later life, "has a terror for me." She felt crushed by the smallest change in her routine. When she looked back on herself in childhood, she seemed "so carefree. That was my nature, but a rub the wrong way generally affected me deeper than others, as I have since many times discovered."

As an adult, Hattie wrote regularly to family members. Her unpunctuated prose spiraled through time, associations falling one upon another as she visited and revisited old names and faces. She spoke often and critically of her two living brothers, Denys and Gig, but never in all her letters did she mention the third brother by name. One time, pitying herself for having had *three* brothers and no sisters, she started to reveal herself. But as for the true cause of Rudolph's death, she never came straight out with that either.

At twenty, unmarried, she was sure that the best part of her life was already behind her. Photographs taken in Boston portray a plump young woman with almond-shaped eyes made pouchy by sleeplessness. Hattie has her mother's sorrowful gaze and wavy dark hair and the kind of smile that shows pain.

She had an aptitude for languages. French and German had been the tongues of her upbringing. She thought she would become a teacher of French. "I was so intent on teaching either languages or something useful, I worked for that," she later wrote. A good education, she believed, would improve her prospects. But with limited opportunities and a profound sense of disappointment, she put aside her teaching aspirations in the fall of 1881. At the age of twenty-two, she was engaged to her old Raymond Street neighbor Newell Wyeth.

Andrew Newell Wyeth, Jr., was slightly shorter than Hattie. He had wide-set, watery blue eyes, a soft face with flat cheeks, and two ready expressions for the camera: pinched discomfort or kindly detachment. He revealed as little of himself as possible. He labored over letters, wrote ponderously, and was wry, moralizing—a born minister, his parents thought. Newell's father, Andrew Newell Wyeth, Sr., had also been expected to join the clergy. But in the 1830s, when the first American railroads had begun to carry passengers behind steam locomotives, Newell's father had left school to join the Fitchburg "road." He married Amelia H. Stimson in 1843 and became a stationmaster and inspector of cattle trains.

Newell was the only son. He served in a peaceful Cambridge militia and remained close to his three sisters, Annie, Susan, and Harriet. He had no interest in fulfilling his parents' hopes for the ministry. Newell wanted to be a farmer. On Raymond Street, he kept cows and chickens, taking orders for fresh eggs, milk, and poultry at the back door. But when he turned twenty-two, Newell gave up poultry and followed his father across the river to Charlestown. He established himself in business—A. N. WYETH, JR., HAY, GRAIN, & STRAW—alongside his father's domain in the Fitchburg freight yard. In sheds on Union Street, Newell employed nine men and made a comfortable living. In 1881, when his father retired from the freight yard at Prison Point, Newell took over as inspector of hay.

In Needham, meanwhile, the newly established Zirngiebel greenhouses had prospered. Denys Zirngiebel specialized in pansies, developing a hardy, brilliantly colored bloom that spread four inches across, "as large as the top of a common tumbler." Zirngiebel's pansies were not only well bred—in 1888 he won the first silver medal bestowed by the Boston Horticultural Society—but they were cheap, affordable to a wide public. He called them "a plant for the million[s]." With customers in every state and territory of the Union, Zirngiebel earned a national reputation as the "Pansy King." Needham claimed him as one of its most prominent citizens.

No matter what laurels fell to Denys, Henriette refused to regenerate herself in the new land. In every photograph taken of "Grandmama Z," she appears, increasingly, to wither. A small, jaded figure, draped in black skirts,

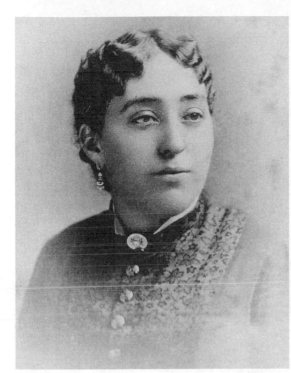

When Hattie Zirngiebel married Newell Wyeth at age twenty-two, she gave up her dream of being an educated woman. "Home duties and then marrying made me the plain ordinary [housewife] that I am."

NCW's father, Andrew Newell Wyeth II, at the time of his marriage, 1881.

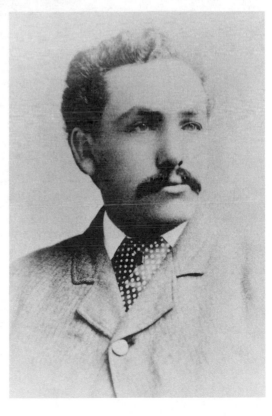

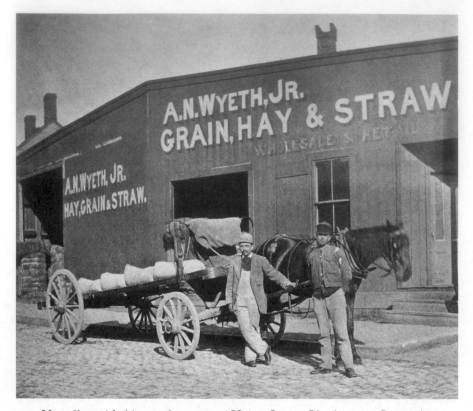

Newell outside his warehouse at 26 Union Street, Charlestown. In 1881 he
became one of five hay inspectors in the city of Boston.

with a large head and pale, thin lips, she looks as if she really had left parts of
herself somewhere else. Her grandchildren and great-grandchildren would
remember her as "a permanently sad woman."

On December 21, 1881, Newell Wyeth and Hattie Zirngiebel exchanged
vows, joining the Old World with the New. As with many events that
lay ahead, they divided the wedding. The marriage ceremony took place in
the Zirngiebels' front parlor on South Street. Two weeks later they held
the wedding reception at the Wyeth hay barns at 26 Union Street in
Charlestown. Around the corner, on Austin Street, the couple moved into a
two-story red-brick house, No. 30. For Newell, whose turned-out hips gave
him a flat-footed duck walk, it would take less than a minute to amble to
work. For Hattie, tucked away in Charlestown, marriage would mean
"doing what was expected and right for me to do." She added, with regret,
"I know it made a different woman in me."

· · ·

A CRISIS DEVELOPED during the couple's first two months in Charlestown. Hattie fell ill. She would later remember it as "homesickness at the thought of leaving my mother." She would identify the trouble as "a feeling which I no doubt inherited and have never yet been able to overcome." Whatever it was, she could bear the separation from her family no longer. She needed to go home—home to Needham. She was convinced that, with the loss of her old home, she had lost everything.

In the shadow of Bunker Hill, Hattie had tried to join Newell in his patriotism. But the Spirit of '76 would never mean as much to her as the "home-spirit." Newell, meanwhile, could no more turn Hattie into a practical-thinking Wyeth than she could get him to "feel" as a Zirngiebel. They had opposite temperaments: he, restrained, methodical, self-effacing, present minded; she, expressive, willful, demanding, drawn to the past. Hattie was continuously sick; Newell never took a sick day. On the occasion Newell Wyeth ran a fever, he pulled on his street suit, wound his watch, went to work. Hattie could try playing one Yankee trait against another, coaxing Newell home from Prison Point with the suggestion that "it will be cheaper in the end to keep quiet." It never worked.

By February 1882, Hattie was pregnant with their first child. The baby was due in October. All the more reason to go home to Needham.

For Newell the timing was bad. With his father's retirement the previous year, Newell's duties at the railroad hay depot had doubled. He needed to spend more time in Charlestown, not less. A move to Needham would require thirty miles of train travel each day. But Newell Wyeth prided himself on being a sensible man, and he could see that there would be no peace until Hattie was returned home. He was beginning to learn "how hard it is to make her look at things any differently than she wants to."

They would remain in Charlestown through May, then move out to Needham for the summer months. Meantime, the railroad made it possible for Newell to indulge Hattie's homesickness. The trip took thirty-nine minutes each way, not counting walking time. Newell would buy commutation tickets and become something new in the language: a "commuter."

Hattie admitted, "He sacrificed much time and hardship to travel the distance to have me feel contented." Newell's "sacrifice" set a pattern that would last well beyond a single summer. For all his common sense, Newell would again and again be forced to give way to the more powerful force of Hattie's irrational feelings. "She had her way pretty much the whole of her married life," N.C.'s brother Nat said later. "She liked to be babied, although she would not admit it."

Newell babied her with a house. He planned to build Hattie a "little home to live in summers."

Two Bloods

T HE NEW HOUSE stood on South Street, facing Blind Lane. It had dark shutters, gingerbread molding, and a distinctive half-hipped roof, typical of peasant cottages in Switzerland. The gable over the front porch was capped by a hip (*Zirngiebel* means "ornamental gable"), as were the dormers on the roof. When a barn was added at the rear, it too would have the half-hip roofline common to the farm buildings of Bern and Neuchâtel. Builders in America called the style Germanic Cottage. There was not another house like it in Needham.

Built on three acres of Denys Zirngiebel's pastureland, the "little home to live in summers" became known as 284 South Street. Hattie could not wait until summer, and in April 1882 the Wyeths settled in. Next door, at 286 South Street, lived Hattie's mother and father, along with her two brothers. The houses stood 150 feet apart.

For a moment that spring, it must have seemed to the Zirngiebels that their lost village had been recovered. Tidy footpaths ran among the evergreens between the cottages and barns. Cattle grazed on common unfenced pastures. A safe domestic center had at last been located and the family identity once again ensured. With Hattie next door, her first baby on the way, and cousins like the Zollingers and Zellers visiting regularly, the Swiss settlers relished the ideal of "having four generations under one roof." Only Newell Wyeth took exception. "That's a little too much of a crowd," the Cambridge Yankee wrote. "But give a fellow any chance to make a home of his own." Between the two houses, Newell planted a symmetrical orchard of apple trees.

NEWELL did not return from Prison Point until after eight every evening. In bed by nine, he rose before dawn to milk the cow and feed the hens, all the while keeping "an eagle eye on his watch for car time." He was "prompt-to-the-second," leaving the house at the same moment each morning. Six

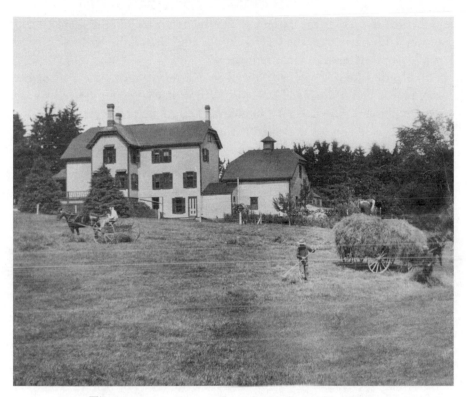

The "Germanic Cottage," 284 South Street, Needham.

days a week he took the jolting, stuffy cars of the Spring Street trolley to catch the ten-to-six train to Boston, and he also worked Sunday afternoons.

As Hattie awaited the arrival of their first baby, Newell's daily routine disturbed her. If she could not depend on her husband for companionship, to whom could she turn in a crisis? Even though her parents lived next door, she felt helpless without Newell. "What would I do if I were left *entirely* alone?" she begged him. "I'm so used to relying on you that I've no ideas of my own."

Hattie and Newell each complained that the other had the upper hand. Actually, their excesses dominated: Hattie was an insomniac; Newell's bedtime was 9:00 p.m. He was taciturn, she was garrulous. She talked for both of them, and wrote two or three letters a night. He was frugal, "hardheaded," said one of his sons. She was frugal in everything but sentiment.

Hattie lavished pity and sympathy without discretion. She had difficulty separating herself or her feelings from people and things she cared about. She saw everything as an extension of herself and attributed emotional awareness even to inanimate objects. She felt sorry for burnt cookies,

and favored them over the better ones in the batch. When the family deco-
rated its Christmas tree, she "felt sorry for the *back* of the tree and always
hung lots of ornaments on rear branches."

She pitted herself against Newell in a kind of Victorian duel of the
sexes. Hattie was a "formidable George Eliot of a woman"; Newell was "a
meek, mild man." She had a commanding, masculine presence; a ghost of a
mustache bristled on her upper lip. ("You could feel it when she kissed you,"
recalled a granddaughter.) She wore airtight blouses over her shelflike
bosom and a white linen apron over voluminous purple and gray skirts,
which brushed the floor as she walked.

She approached childbirth as if doing penance. She had a sense that,
with infants, accidents could happen; considering the death of her brother
Rudolph, this was understandable. "No doubt my family would have been
larger," she later decided, "had not accident and a certain weakness over-
come me."

HATTIE GAVE BIRTH at home on October 22, 1882. The baby was a big,
sturdy boy, his health excellent, but that did not stop Hattie's worrying. She
permitted Dr. Mansfield to handle the infant, discouraging others from
approaching the cradle. She explained that she did "not believe in letting
folks kiss the baby."

Divided over a name, Hattie and Newell called him "the baby" or, in
Newell's phrase, "the little feller." Hattie wanted to name the boy for her
father and offered to compromise and allow the American spelling: Dennis.
But according to her, Newell and his family in Cambridge talked continu-
ally of Dennis not being to their taste.

Newell preferred to combine family names. Andrew Newell (1751–1798)
of Charlestown had fought in the Battle of Concord, April 19, 1775, and at
Bunker Hill on June 17, 1775; Lydia Convers Francis (1778–1850) of Medford
had married Job Wyeth of Cambridge. "It was plain to see," Hattie later
said, "that Papa's way and word held sway."

On October 3, 1887, Newell Convers Wyeth was baptized a Unitarian.
There would be no doubt, however, whose son Convers first thought him-
self to be. Mama's crisp, white apron flew as the one flag over the divided
world of his childhood. He admired "her virile way" and was pleased
throughout his life to find that he resembled her physically. He had Hattie's
round face, high-arched nose, curly hair, big bones. He had her gaze: bright
but sorrowful, with drooping, heavy lids.

Overfed and praised for overeating, he grew up chubby. His knicker-
bockers filled out like sausages. He loved to eat. For a while he entertained

the fantasy of becoming an iceman; he loved the idea of delivering blocks of ice door to door and feasting his eyes on the neighbors' iceboxes. According to his adult recollections, he was conscious in childhood of having a "fat body and round face."

Growing into boyhood, he pictured himself and the world in factual terms. "It's a strange thing," he later said, "but I seemed to lack all that imaginative stuff that most kids have. I was quiet and my mother said I was very observant, but I saw things as they were, and not as the fairy tales paint them."

He had a temper. At school he was given to outbursts. His mother commanded him to "try and control himself and not give in so easily." She worried that "people will think that he is a worse boy than he is." At home, when he grew "tired and vexed to the point of hot tears," he would shoot off into a tantrum, losing all control of himself. At the height of the tempest, he would, he wrote later, "seek the haven of my mother's lap and she with all her healing sympathies and patience would stroke my head and so win back my composure."

He could lose himself in his mother as in no other. With her there seemed to be no restraints, nothing to keep them apart. Writing to a friend later in life, N.C. remembered the perfect tranquillity he felt in his mother's arms when she calmed his temper.

Hattie saw herself reflected in Convers. She remembered similar episodes of anger from her own childhood. But it was typical of her that, although she perceived this likeness, she could more "easily see why I inherited *my* outburst of feeling." *Her* mother had been "very, very homesick," and Hattie had been "born under those conditions." The Zirngiebels' loss of identity in the new country, she maintained, had shaped her own fragile sense of self, but Convers had been born under better circumstances.

Exonerating herself as a link in the hereditary chain of "homesickness," Hattie contended, "[I] never could account for it in my own children, as there was no feeling of distress on my part during [Convers's childhood]."

Distress was the least of it. N. C. Wyeth grew up in a world of emotional absolutes. Sudden mood swings produced cycles of ecstasy and anguish. One minute Mama was excessively sympathetic, treating her son as if he were the most important person in the world—more important even than her own husband. Then, growing strangely distant and punitive, she would turn cold, criticize the smallest imperfection, or, still worse, behave with implacable indifference. In yet another phase, pining for her family's lost home in Switzerland, her mood would plunge.

Immobilized by "homesickness" (though she rarely left home and lived beside her parents' homestead all her life), Hattie suffered prolonged phases

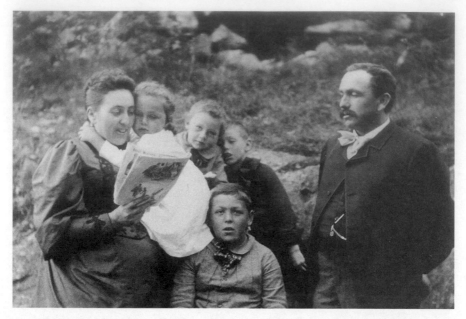

William James warily called the ten-cent magazines of NCW's childhood "a new educational power." Hattie, holding Stimson, reads aloud to Convers (front), Nat and Edwin (behind), and Newell.

of withdrawal. During one such episode, she wrote, "I hope this will end soon, or I do not know what I will come to."

She gave birth four times, and each delivery produced feelings of "great hope and satisfaction." But each new pregnancy stole her confidence. "I used to be just so anxious," she later confided to a daughter-in-law. Then, "when folks tried to reason me out of it and all went well, I found myself doing the same thing again."

After each birth—Convers in 1882, Edwin in 1886, Nathaniel in 1888, and Stimson in 1891—Newell told her, "Well, I'm satisfied. I'm only sorry for your sake."

She regretted having only sons. For the rest of her life, Hattie longed for a girl, just as she had once wished for a sister. "I always felt and missed a daughter," she wrote when she was nearly fifty. She treated her fourth son as if he were the long-lost female child. In the fashion of the period, Stimson Wyeth wore skirts in the early family portraits. Yet long after his brothers were in knickers and cravats, Stimson's "girlhood" was prolonged with lacy collars, white dresses, and long curls.

When Stimson was fifteen, Hattie still believed that a female Wyeth was the answer to her sense of isolation in the family. "What wouldn't I give

The Ore Wagon, 1907

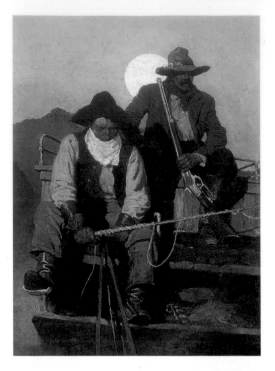

The Pay Stage, 1909

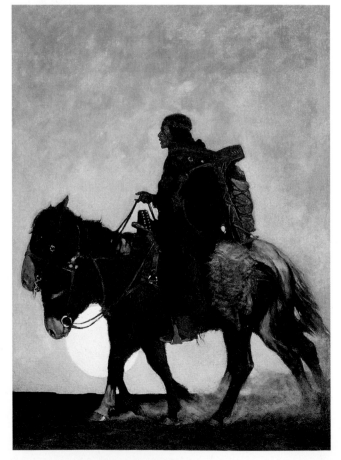

On the October Trail,
1908

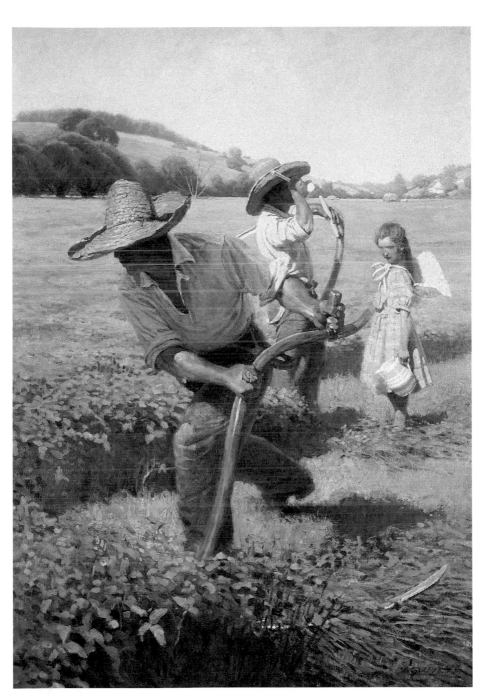

The Scythers, 1908

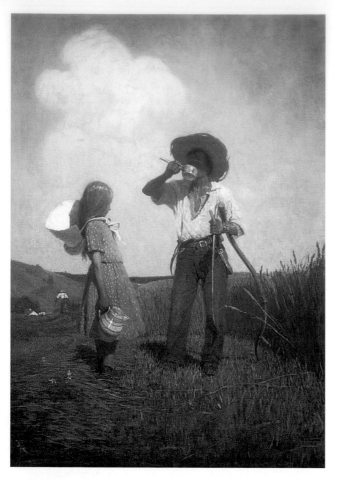

Mowing, 1907

Winslow Homer,
Gloucester Farm, 1874

to have a young daughter growing up with me. If Stimson only had skirts and we could live and work together."

As she raised Convers and his brothers, Hattie endowed every maternal action with a baffling mixture of closeness and distance. She never put her children to sleep with a simple kiss. One night away from Needham she wrote, "If it wasn't for Nat I couldn't stand it at all. I hugged him close last night, I'm afraid he'll be spoiled by the time we get home."

Needing assurance, Hattie asked the president of the Boston Young Men's Christian Union if he thought she was "calm enough" with her children. She wondered, too, why it was that although she "certainly cared much for my boys, still I didn't seem to have that confidence that so many *said* they felt in their children."

She took satisfaction in Convers's stormy overreactions to separation and change. When Hattie left the boy, at age eleven, with Newell in Needham while she took Nat to the seashore in North Scituate for a week, she "knew Convers would break down." He did, twice, howling before his mother left the house. "He gets that from me," Hattie proudly explained to Newell. "I used to be just like him when I was his age and haven't gotten over it by any means."

She encouraged Convers to feel homesick, made much of his "hot tears." "To be homesick," she told him, "is a natural feeling, and it really takes an extraordinary mind to try and overcome that." With Convers she imagined that she could have what she called her ideal state of intimacy—"a constant home conversation." Frustrated by her sensible, buttoned-up husband, Hattie could merge with her tempestuous son. As a result, it was hard for him to have feelings of his own.

Only much later in life would he reveal his confusion at the insensitivity of his oversensitive mother. Looking back on a Christmas present she gave him, N. C. Wyeth wondered how Mama, so filled with "true affection," could fail so dramatically to understand his needs. He was astonished that his mother had given him, at age five, "a parlor clock!!"

Looking back, he saw that "in some perverse manner" he had been impressed with the gift. The clock had a garish gold face held aloft by a pair of snarling lions; its chunky black onyx housing was surmounted by a miniature Grecian urn. But for all its gaudy promise, the present failed to live up to expectations. After a few months, "the damn thing stopped and never did run." Stranger still, he was forbidden to wind his clock. It came to rest near the family piano, where day by day young Convers spent hours attempting to satisfy his mother's musical ambitions for him. As he played scales, his foot keeping time, he would watch the frozen clock and, he recalled, "always associate its impotence . . . with the terrible hours I spent practicing."

But in his view, Mama was not to blame for the peculiar gift. For Convers, she remained always an ideal embodiment of love, an extension of himself. She was "the one" to whom he could, he said, "confide my innermost feelings" and from whom he could "receive my real and most valued consolation, sympathy, and appreciation." Without her, he felt incomplete.

In fact, the idealization of Mama only divided him further. By underestimating his mother's faults, Convers caused himself lifelong harm. Insisting always on her unlimited perfection, he denied himself the important step of recognizing her defects as a mother and therefore beginning the process of taking care of himself. Emotional stability eluded him. He would be dependent on others to maintain equilibrium all his life. From both women and men, he repeatedly begged "for human intercourse, warm, rich, sympathetic understanding and interest."

NEWELL never spent the day at home. Seven days a week for thirty years, Convers's father left Needham to measure bales of hay in Charlestown. In 1903 he tried to stop working on Sunday afternoons, but it took only one Sunday at home for him to run for the trolley and return to work. In response to Newell's daily absence—common practice for fathers of the new industrial age—Convers developed the indirection characteristic of neglected children. Instead of facing his disappointment, Convers saw the father he wished to see.

As an adult, N. C. Wyeth would remember only two celebrations each year when "even my father would be there." On the Fourth of July, Newell loosened up long enough to set off a few strings of firecrackers with his boys; and on Patriots' Day, April 19, the whole neighborhood, including Convers's father, ventured to the end of South Street to watch the twenty-mile bicycle race.

Patriots' Day had actual associations for Newell Wyeth. As a twenty-three-year-old Cambridge militiaman, he had participated in the centennial celebration of the Battles of Concord and Lexington, reenacted on a cold April 19, 1875. Later Newell told his adoring son that "more persons died from the effects of the weather of that day than was killed at the battle of both British and Colonials." In fact, however, there were no casualties in 1875. The Boston newspapers reported that the "raw, March-like air" at Lexington and Concord had been "intensely disagreeable," not fatal. But Convers never questioned his father's account, and he saluted him as a genuine hero of the American Revolution.

In the vacancy left by Newell, Hattie treated Convers as her spouse. She discussed his brothers—"the boys," she called them—as though Convers

were different. "The boys," she told him, "are my guiding stars, and you are the shining light, and we all look to you." It was up to Convers to fill Newell's shoes, to act as his father's substitute.

Ed, four years younger than Convers, had Wyeth sense without Zirngiebel sensibility. More like his father—dry, stiff, inscrutable—Ed shied from his mother's heated passions. "Edwin is so earnest, Nat even wonders," Hattie noted. She believed Ed needed remediation in social skills, and she turned to Convers to "open Ed up," to make him "feel." Convers thought his younger brother "civil but disinterested."

Nat, seventeen months younger than Ed, had "wheels in his head." He was the family inventor, the heir to Nathaniel Jarvis Wyeth's resourcefulness. Nat could always be found "twisted under somebody's machine, his legs protruding." By the age of ten, he had built a one-cylinder buckboard automobile to shorten the family's horsedrawn milk-delivery route. Meanwhile, he had gone slack in his studies, and when Nat's grades, in the seventies, dropped still lower, Mama begged Convers to "boost" him.

Stimson, the youngest—three years to the day younger than Nat—was an outstanding student, especially of French. He was the valedictorian of the Needham High School Class of 1909. Round faced, bespectacled, with plump cheeks and full, pouty lips, Stimson was known in the family as Babe. Whenever he tramped into the woods behind the Onions' farm and sat all day brooding over a campfire, Mama brought her worries about the "old plodder" not to Papa but to Convers.

With his brothers, Convers took his mother as his model, acting as the family manager of identity and emotion. Whenever Nat or Stimson lost confidence, Convers restored the "lost boy" to his "true self." He gave his brothers "new feeling." He "harangued" them, and they obeyed. Nat and Stimson admired their oldest brother absolutely. As far as Nat was concerned, "whatever Convers said or did was right, and that was the end of it."

Convers adored Nat and Stimson and wanted to guide them. He so badly needed a father that he simply became one. His model was Theodore Roosevelt, the bugle blower of all time—"our living example," he later called him. Led by Convers, the four Wyeth boys identified with the rambunctious, close-knit Roosevelts of Sagamore Hill and modeled themselves on the president's four sons. They heeded Roosevelt's preachings on the Strenuous Life, canoeing, skating, hiking, playing football and baseball, and shooting. "It was," their mother afterward recalled, "a continuous shoe and boot-drying life."

Feeling superior was a family weakness. Reporting back to his mother after a visit to a Philadelphia branch of the Wyeth family, Convers huffed, "I don't mean to say that they are bad or immoral or anything, but they are

shallow. . . . It is not a good example of a Wyeth family." The word the
Wyeth boys most often used to congratulate themselves on their own family
was *wholesome.*

In the hierarchy of the South Street household, each boy was account-
able for his conduct. Each had a moral obligation to obey his elders and
respect his siblings. Subordination of self to others was the central principle
of N. C. Wyeth's upbringing.

Hattie was a harsh disciplinarian, even by Edwardian standards. Family
lore tells of the time in N. C. Wyeth's childhood when he hid bread crusts in
a joist under the kitchen table. When Mama discovered them, she made
him eat every single one. On another occasion, she taught her boys a lesson
by depriving them of something they had set their hearts on. Swept up in
national hysteria after the sinking of the U.S. battleship *Maine* in Havana
harbor in 1898, the Wyeth boys bought tickets to a demonstration in Boston
of the Gatling gun, the rapid-fire forerunner of the machine gun, which
would become popular in America's "splendid little war" against Spain. On
the day of the exhibition, Mama caught Convers misbehaving. Playing a
game with his brothers, he had lashed his "prisoners," Nat and Stimson, to a
tree. Without a word, Mama stormed into the house, seized the treasured
tickets, and tore them up.

"For all my 'severity,' " she said later, "I don't think one of my boys would
ever think of anything else but sacrificing themselves for one another."

Hattie and Newell promoted, above all, the idea of duty. Beginning
with the family, and extending to neighbors, school, and village, Convers
felt bound to oblige. In the fall of 1887, at age five, he entered the Harris
School on Great Plain Avenue, a short walk up the newly renamed Green
Street (formerly Blind Lane) from the Wyeth homestead. Of the six local
schools, Harris had the lowest operating budget. It was the kind of school
that Winslow Homer painted: eight grades (about fifty pupils), taught by
one teacher, jammed into a single porous classroom. Autumn winds and
spring rains whistled through loose doors. In winter the school stove con-
sumed six feet of wood. In June, when temperatures inside rose to ninety
degrees, the children hauled water from the town well. Convers later
remembered the "depression of school days," the grind of "blackboards,
slates, cedar pencils, and musty books."

Yet he loved his teacher, Miss Mary E. Glancy, a plump, moonfaced
Irishwoman with pale blue eyes and a warm, humorous gaze. He treated her
as an extension of his mother. In 1893, Convers Wyeth never missed a day of
school. Independent minded, Miss Glancy imparted the same love of ideal-
ism and the outdoors as that contained in Louis Agassiz' motto, "Study

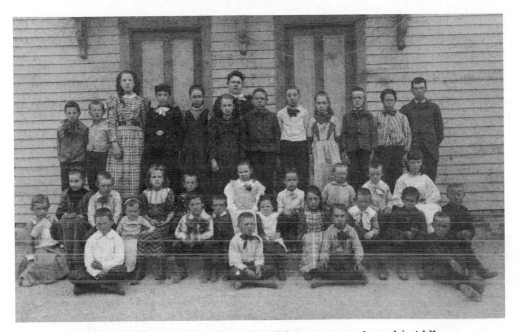

At the old Harris School, June 1893. Edwin sits cross-legged (middle
front row); Convers stands, seventh from left; behind him (left) is Mary
Glancy. NCW never forgot his teacher. They maintained a correspon-
dence for three decades, and when she taught his children in 1921, he
enshrined her as a "teacher of generations."

nature, not books." Leaving the classroom whenever possible, she took her
pupils on hikes through the Needham countryside.

From Harris School, Convers advanced in 1895 to Needham High
School. He was twelve years old, but remarkably impervious to influences
from outside his home. No one at Needham High School altered the alle-
giances already formed on South Street. No school friends superseded his
brothers. No young woman disturbed his feelings for Mama. None of his
high school teachers changed the way he saw the world. "I'm not a fellow of
much knowledge," he later remarked, "but what I have was born in me as
I'm sure I didn't acquire much at school."

FOR YOUNG N. C. WYETH, there was no *Robinson Crusoe,* no *Treasure
Island,* no *Last of the Mohicans.* He came to English and American literature
as a professional. "They represent what I missed in my younger days," he
realized later. Besides *Black Beauty* and *Ivanhoe,* only one title appears in the

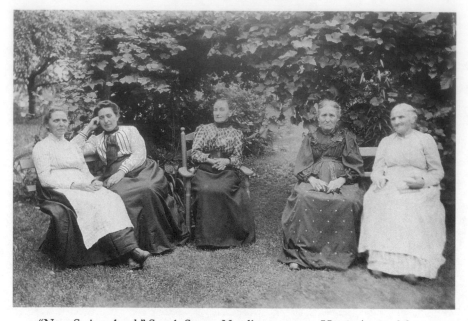

"New Switzerland," South Street, Needham, c. 1903. Hattie (second from
left) with her mother (second from right) and two unidentified women in
the last year of Henriette Zirngiebel's life. Between them in the armchair
is Henriette's half sister, Friederika Zeller Zollinger. "No one knows how
I miss it all," Hattie wrote NCW three years after this picture was taken.
"How I would like to hear Grandmama talk of Switzerland."

records of his childhood: *The Swiss Family Robinson,* Johann David Wyss's
chronicle of a shipwrecked Swiss minister and his family. Originally a fam-
ily tale told aloud by the Reverend Wyss to his sons in Bern, the story was
illustrated by one son, Johann Emmanuel, and finished by another, Johann
Rudolf, composer of the Swiss national anthem. It was first subtitled
"Adventures of a Father and Mother and Four Sons in a Desert Island."

It could have taken place on South Street. *Der schweizerische Robinson*
extols the virtues of an isolated domestic Arcadia similar to the one that
marked N. C. Wyeth for life. Despite hardship and danger, the castaways
remain a happy family, "full of true affection and willing subordination."
They name their South Seas settlement New Switzerland and structure
their model life along didactic lines. The father "leads the boys in their
adventures and enterprises." The mother "welcomes them home and
spreads the table with rich and wholesome abundance." The four "honest-
hearted, home-loving boy[s]" explore "a boundless range of field, forest, and
sea," all the while learning as much from play as from work. Even the maps
of their South Seas settlement resemble the contours of South Street.

Denys Zirngiebel was considered one of the finest florists in the United States. During Grover Cleveland's first term as president (1885–1889), Zirngiebel's prizewinning greenhouses supplied the White House, War Department, and other government buildings with rare flowers.

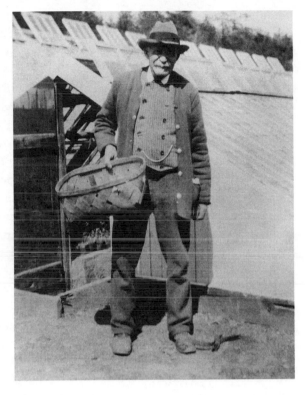

Like the self-congratulating shipwrecked clan ("that dreary family," groaned Robert Louis Stevenson), the Zirngiebels had made their colony into an exemplar of Swiss values. The South Street of N. C. Wyeth's childhood functioned in the insular, moralizing manner of a "New Switzerland." With immigrants like the Matheys and the Moellers, the Klausers and the Holzers—"being all Swiss and the families so intimate," noted Hattie—the Zirngiebels admitted a select few into the cult of the lost country. On Sundays, Uncle Denys played serenades by Schumann and Schubert on the violin, Uncle Gig on the flute, and Mr. Moeller on the zither, while Mrs. Lehman or a Holzer sang. Uncle Gig had a "thrilling repertoire of Swiss yodels," which he taught to his nephews. To sit on the porch and "hear Grandmama talk of Switzerland" provided the family with its happiest moments.

In the Zirngiebel greenhouses, Convers's indoctrination into the Swiss commune began early. Here, things were done properly; seeds were gathered by hand, seedbeds examined daily. According to a set schedule, seed was sowed broadcast in outdoor seedbeds in August, indoors from February to June, and transplanted in the fall. Depending on the variety of seed, mulch was laid over the beds in precisely measured amounts.

The Zirngiebel greenhouses were immaculate, and everyone had a job to do. Uncle Denys ran the flower stall at the Park Street Market, Uncle Gig helped in the greenhouses. At harvesttime, when the plants were placed in the shade for the seeds to ripen, neighbors were put to work at the long rows. "Eh, *là-bas*," Grandfather Zirngiebel would call to the Wyeth brothers, "I vill gif you tan cents if you vill pool some veeds."

Denys Zirngiebel was a figure from another world. The rooms of his house, in Convers's memory, had "a 'foreign' *tang*." He spoke French, answered questions "with that shrug of the shoulders so typical of the foreigner." He walked with a limp, and his wooden clogs thudded on the greenhouse duckboards. Squirrels ate from his hands. A chipmunk lived in the pockets of his walking coat. One day the chipmunk nipped Zirngiebel's finger and drew blood. Convers would always remember "with real horror" what happened next. His grandfather "dragged the chipmunk out of his pocket and, holding it in front of him, squeezed it to death in his hand." Then, without interrupting his walk, Zirngiebel tossed the animal into the underbrush.

Like the mythic figures N. C. Wyeth would one day paint, Denys Zirngiebel was out of place, out of time, yet made familiar by the visual world of his everyday surroundings. However foreign "Grandpapa Z" sounded, however exotic his actions, Convers could always picture him in his own backyard. The chance discovery of his grandfather's worn straw hat hanging in a closet moved him as an adult to "sudden yearning and recollection":

> My mind's eye would vividly see that familiar hat, resting lightly on my grandfather's head, move through his beloved sun-drenched greenhouses, the thin shadows from the close-spaced sash bars above him, flickering in quick succession across the shining straw dome of the hat. . . . I would feel a sudden surge of acute sadness and exhilaration and I would be plunged into a momentary surrender of voluptuous ecstasy!

Most important of all, his Swiss grandfather gave N. C. Wyeth a model for living outside the contemporary flow of time. No slave to the newfangled "time clocks," or to "train time," as Newell Wyeth's generation called it, Denys Zirngiebel had managed to make a national reputation without leaving the land. He had succeeded in an expanding urban marketplace, on his own time, in a glass-enclosed greenhouse behind his own home.

Theodore Roosevelt later raved that N. C. Wyeth "spoke well for the blood of New England." Wyeth himself spoke more convincingly of "two

bloods." Whenever biographical information was called for in later life, Wyeth proudly belonged to the Zirngiebels but tended to emphasize his New England ancestors, especially the Wyeths who fought the War of Independence. He liked to promote the proximity of Needham to Concord and Plymouth. He liked to think he had been raised on the ideals of Emerson and Thoreau. But for all the fuss about Pilgrims and Concord Transcendentalists and high-minded Wyeths, it was the home-haunted Zirngiebels—the colonists of South Street—who gave N. C. Wyeth his early American experience.

Switzerland was a longed-for, never-visited place. His mother made no effort to show her children the lost country. Hattie Wyeth rarely left South Street. After her Germanic Cottage had been built in 1882, Hattie ventured from Needham once or twice a year, usually to take a rest cure in the White Mountains of New Hampshire. She often said, "I don't really see how people are benefited by a change when they are longing for those that are dear to them."

The family never traveled to Thun. Instead they looked back at an idealized Swiss past from a supposedly diminished American present. For Convers, looking back was the authentic experience; nostalgia made people and places real. In his growing up, nothing was neutral. Everything was black or white, one or the other, dual. According to Wyeth idiom, *nostalgia* was another word for "home feeling."

Favorably associated with the family's severed roots, the South Street Wyeths elevated "home feeling" to spiritual status. Mama was worshiped as a medium forever in touch with past times and dead people. She, in turn, used nostalgia to feminize her sensible Wyeth sons. Hattie's lifelong wish for girls, for an intimate partner in her own image, was "made up to me in the character of my boys [who] seem to have more care and feeling for the home than many girls that I have seen." The expression of "home feeling" was seen by Convers as life's aim.

It was also a way to put a hearty face on the truth. For there was a discrepancy between the "wholesome" Swiss colony on South Street and the reality of life inside No. 284.

BY DAY, the kitchen showcased Hattie's Swiss Family activities: cooking, baking German cookies and cakes, putting up pear preserves, stirring vats of her own lye soap. By night it was a setting for anxiety and panic.

She called it "my condition," or "my old weakness," but it was more than hers alone. It overpowered everyone in the family. In the house of the half-hipped roof, no one knew what would happen when Mama's "condition"

started up, or when it would end, or how bad it would be. Unidentified, uncontrolled, it seemed to envelop the household. Disguised by Swiss folkways, it could last for weeks, with unpredictable consequences.

"When you're sick," Convers's brother Nat once told their mother, "you have a siege of it."

In a scrapbook, Hattie kept clippings about symptoms that resembled her own: dyspepsia, neurasthenia, morbid tempers, sick headache; and treatments: hypnosis, hydrotherapy, automatic writing, electro-galvanic massage. She came to think of her condition not just as a woman's problem but as a mother's affliction—in her words, "a weakness of the womb that's wearing to the nerves." She believed that men were immune to solipsism; whereas for women, "living this life of all interest in our own private lives, makes it all the harder to bear when things come to a turn."

Many forms of treatment lay within Hattie's reach. By the late 1880s Boston had become a capital for the treatment of women with "nervous derangements." Institutions such as the newly established Adams Nervine Asylum in nearby Jamaica Plain treated thirty female patients at a time, the largest percentage of them housewives suffering from nameless anxiety. Hattie Wyeth fit the profile exactly.

But whether out of fear or false economy, she took no treatment in Boston. Her condition went undiagnosed. When her head "felt strange," she tried pills recommended by the mother of a neighbor, or put her faith in climate and exercise. Typically, she promoted Needham as her cure, taking long walks, breathing deeply the air of the Needham tableland, which Boston physicians of the 1880s often recommended for its "pure, healthgiving" qualities.

Invalided, Mama became the focus of family feeling. Her sieges made premature parents of her children; her wishes, however extreme, became their command. Even on *their* birthdays—the one day a boy might reasonably expect to feel distinct and special—the Wyeth boys babied their mother. "She it was who was tendered the little remembrances, and she it was for whom we made ice-cream and procured a cake!" N. C. Wyeth recalled. At 284 South Street, the children's birthdays became one more occasion for spoon-feeding Mama. Typically, Convers later denied any negative feelings about the custom, which "always seemed to me to be as it should be."

If four auxiliary birthdays were not enough to lift Hattie's spirits, then at Christmas, attention was once again diverted from its natural focus and centered on Mama. December 25 was Henriette Zirngiebel Wyeth's actual birthday. On Christmas Day, therefore, it did not suffice to light

the Christmas-tree candles; the Wyeths also lit candles on Hattie's birthday cake. Putting aside Christmas stockings and toys to wrap birthday presents, Convers and his brothers concocted elaborate birthday tributes, in which, lest Mama feel overlooked by the accident of her birthday, they double- and triple-underlined her name. The Wyeth boys felt obliged to make Christmas "Mama's natal day." Yet whatever they did for her was never enough.

She blamed her condition squarely on herself, an attitude confirmed by the leading medical authorities. They routinely accused nervous women of "despotic selfishness," and of "conscious or half-conscious self-indulgence." S. Weir Mitchell, promoter of the then-popular Mitchell "Rest Cure," ridiculed Hattie's type as a "pest of the household," while other specialists cast nervous women as gossips, fakers, or oversensitive malingerers.

Hattie pasted into her scrapbook the story of a "nerve-worn woman," a wife and mother like herself, who "couldn't sleep . . . couldn't think . . . was melancholy and impatient . . . and spent a great part of the time in tears." The woman had gone to Boston to consult a "big physician." The great man had seen "too much of real misery to have much patience with hysteria," but he condescended to see the hysterical woman. He advised her, "Forget yourself. Get away from your own aches and pains, and shun sympathetic friends." The only cure for her was study. "Brain culture is a fine tonic," he said, "and you hysteria cases need mental stimulation more than sedatives." When asked what to study, the physician answered, "Anything but yourself and your absolutely unimportant feelings and sensations." He commanded her to "study the lives of the poor in this great city. Post yourself on the child labor question. Join the Consumer's League." Above all, "Be useful." The nerve-worn woman rushed home "indignantly," but she "took his advice—and she finds that life is not such a sad affair, after all."

In Needham, Hattie volunteered for the supper and entertainment committees at the First Parish Church. "I've tried to keep occupied in order to keep my mind occupied," she reported to Convers. Her scrapbook indicates the extent to which she depended on her children, especially Convers, to keep herself engaged. "My trouble is one that takes time and patience," she asserted, but "to keep quiet is what I don't like."

While Hattie remained outspoken about her turmoil, Newell was practically mute on the subject of health, mental or physical. More unaware than uncaring, Newell would say only that he wished Hattie would "not keep brooding over things that have changed." He discounted her sufferings, hoping that she would "get over that soon and live wholly for her boys."

If nothing else, Hattie was made to feel guilty for her "nervous" feelings, and when Newell began talking in the spring of 1897 about sending Convers away to learn farming, Hattie dug in for a siege.

"MY FATHER rarely went there," N. C. Wyeth later wrote, "but [he] dreamed intense dreams of Vermont as the paradise of farm life." Convers had his own ideas about paradise and the future. To begin with, Needham High School was "not worth 'shucks.'" Full of a "set of shallow, giggling yaps," it was "not practical at all," he contended. "It don't fit you for any practical college, such as Tech or Cornell. It only comes somewhere near fitting you for old, stale, rotten Harvard."

Driven by a "constant urge to draw," Convers had set up a corner of his bedroom with a drawing table. He filled the margins of his school primers with sketches of harnessed horses. He marked up copies of *Century Magazine*, indexing his favorite Frederic Remington drawings of the Great West. But his first subjects were his house, his mother, the barn, the spruces massed along South Street, the Jersey cow in the pasture, his pony, Bud. Those drawings are stamped with authority.

He gave his pictures titles: "Our Backyard," "Our Cowyard." And though his work was stiff, mechanical, his mother saw in Convers's drawings the same yearnings she associated with a family wish to reclaim the past—"Grandmama's old home longing." Out of the Zirngiebels' sense of loss, Hattie created in Convers a longing for Arcadia, which someday might be recaptured and fulfilled in art.

Art of any sort was far from Newell's thoughts when he considered Convers's future. In his mind, an artist was "someone unkempt, with long hair . . . living a disordered life, not earning enough to support himself." He hoped the boy would go into farming. It had been his own first ambition, and he held on to it for his eldest son.

As for drawing, Newell considered it little more than an expensive hobby. He had already shelled out for Convers's drawing: ten dollars for three months of lessons from Cora Jean Livingston, a neighbor and certified art teacher who had graduated from the Massachusetts Normal Art School. To Newell's way of thinking, it was absurd for a husky young man like Convers to be drawing pictures. So when Convers proposed to quit Needham High School and start formal training as an artist in Boston, Newell was appalled.

That spring of 1897, a parental duel decided the future. Seventy years later, Stimson Wyeth vividly recalled "the divided opinion of my father and

mother as to what should be done about Convers." The confrontation was "one of the memorable crises in our household."

Starting that summer, Newell decreed, Convers would work as a farmhand. If the boy would not go to school, then a year of farm labor in Vermont would knock "this artist nonsense out of his head."

Hattie opposed him. Taking her son's side, she gathered together a batch of Convers's drawings and marched them into Boston for the opinion of several art instructors recommended by Cora Livingston. Encouraged by what she heard, Hattie presented her case to Newell: Convers had real talent; he was the hope of the family; if he were to make his mark and better his lot in life, he must be allowed to develop his skills at drawing. The Mechanic Arts High School in Boston was the right place to start. Daily drills in drawing cones, cubes, and spheres would teach draftsmanship, which, if necessary, Convers could put to use in the office of an architect or engineer.

Newell gave way. He saw no good coming out of an "arts" high school, but if Convers would learn a trade, he had no objection. A trade was useful. An artist's life, by contrast, was "shiftless, almost criminal."

Practical Pictures

IN 1900 "PAINTING" meant canvases painted in oil by Old World masters. American museums were small and private, fine art was European. New works by American painters hung in vast juried exhibitions at a small number of institutes and academies. Few commercial galleries exhibited American painters, and, as the artist Guy Pène du Bois noted, the galleries "vied in coldness and aloofness with the museums. They were hung in horrible red velvet and a pall of stuffy silence. One was invariably attended in them by an excessively well-mannered gentleman in afternoon clothes who seemed incapable of looking straight at anything without looking down his nose."

"Pictures" belonged to everyone. Pictures—in magazines, books, steel engravings, and lithographs—were what people brought into their houses. By 1900 the invention of photoengraving had liberated artists from translating sketches onto woodblocks, which an engraver then cut by hand and turned over to a printing press. When artists like Winslow Homer had covered the Civil War for *Harper's Weekly,* or Frederic Remington mounted the Territories as *Harper's* "Western picture man," or George Catlin portrayed the frontier's vanishing Native American tribes, it had taken weeks to produce a single printed picture. The results were gray ghosts of the originals.

With photogravure printing, a picture could be made directly from the original painting, overnight and in monotint. For speed and clarity, no one had seen anything like it. As the speed of printing increased, costs decreased. In schools and colleges, the leading magazines became required reading. On rural free delivery routes, the monthlies brought pictures into places where they had never been seen before. *Scribner's, Century,* and *Harper's* became status symbols of the 1890s, displayed on hundreds of thousands of sitting room tables. By 1900 a single image in *Scribner's Magazine* appeared all across the forty-five states.

"A picture," N. C. Wyeth later wrote, "is the briefest method known to communicate an idea to the human mind." The idea that most interested

turn-of-the-century America was America itself. The convention of perspective placed the viewer at the center of the visual universe. Exaggerating the technique, American artists represented the universe as a place in which everything started from a single viewpoint and vanished into infinity. Thirty-five years after the Civil War, when the reconstructed Republic reinvented itself as an imperial nation, pictures made it look as if the sun really did rise and set on an American empire.

Pictures also consolidated the country's past and projected its future. They portrayed life, fortune, sports, money, people, national geography, and glamour. Calamities such as the 1904 fire in Baltimore drew teams of eyewitness illustrators to urban centers. Pictures sold papers and made artists rich. At a time when the average worker in the United States could hope to earn $400 annually, a celebrated illustrator like Edwin Austin Abbey earned $357 per picture. In 1903 Remington assigned reproduction rights for twelve pictures a year for four years to *Collier's Weekly* at the unheard-of rate of $1,000 per month. A year later, Charles Dana Gibson, creator of Edwardian America's ideal woman, the "Gibson Girl," signed with Robert Collier for $1,000 per drawing.

They became household names; their influence reached Europe. A twenty-nine-year-old Dutch painter named Vincent van Gogh asked his brother, Theo, "Do you know an American magazine called *Harper's Monthly*? There are things in it which strike me dumb with admiration, including sketches of a Quaker town in the olden days by Howard Pyle."

Pyle epitomized the American picture maker in an era when ordinary people had begun to question the new industrial age. Seeking refuge in the perceived virtues of the Middle Ages, society was divided between worship and despair of the materialism created by machines. Mark Twain's *Connecticut Yankee in King Arthur's Court,* Henry Adams's *Mont-Saint-Michel and Chartres,* and James Branch Cabell's *Chivalry* all testified to the spiritual emptiness of modern mechanization.

No one had done more to glamorize the prestigious new literature of medievalism than Howard Pyle. As both writer and illustrator, he reinvented medieval myths to suit the Gilded Age. Van Gogh was not the only reader hoarding tearsheets of Howard Pyle's double-page *Harper's* spreads. Mark Twain called Pyle's pen-and-ink version of *The Merry Adventures of Robin Hood* "the best Robin Hood that was ever written," adding that "one can never tire of examining" Pyle's *Story of King Arthur and His Knights.*

In oils Pyle painted yet another world in which the Gilded Age could recover its lost innocence. The creation of the Republic became his constant theme. In a Pyle picture, the American landscape of 1776 felt real, graspable. Pyle's colonists were specific, everyday people. His George Washington

looked as familiar as one's next-door neighbor. His backgrounds were researched with an attention to historical detail unknown in the popular graphic arts. When in doubt about the most minor element, Pyle would "run down to Washington and take a photograph."

The effect of his pictures was anything but scholarly. More than any illustrator before him, Pyle played to the audience. He costumed his characters and staged his scenes, creating excitement with diagonals, always turning the faces of his principal figures "toward the audience." He insisted that "as soon as the face is turned away the interest begins to flag." The filmmaker D. W. Griffith staged whole battle scenes as visual facsimiles of Pyle's mise-en-scène.

With color Pyle created effects that the movies would have to wait years to achieve. He manipulated the viewer's eye with bright reds, weaving it through a picture like *The Salem Wolf,* from the wolf's tongue, to the scarlet shawl, to the red cape of the man in the background, to the faint red face of the man behind the snowy ridge, back further to the red-brick blur of chimneys set against a yellow sky.

Howard Pyle had made pictures the fastest-growing and -selling art form in Convers Wyeth's youth. By 1900 the supply of qualified American picture makers could not meet the increased demand for pictures. A handful of established illustrators was "besieged by work." Art schools offered no instruction in picture making. Academies like the august Pennsylvania Academy of the Fine Arts flatly rejected the suggestion that illustration was an art worth teaching. Pictures, the academy claimed, were merely impersonating paintings. The young artist in Henry James's 1892 story, "The Real Thing," takes the side of highbrow culture when he calls his illustrations his "pot-boilers."

Pyle, however, saw "practical pictures" as the one true American art form. He was not interested in producing "illustrators of books, but rather painters of pictures." He believed that the greatest practitioners of this indigenous form were yet to be produced, and he saw it as his mission to train them. American picture makers, he decided, needed a school of their own. In the summer of 1900 he added a student wing to his studio in Wilmington, Delaware. When he opened his door to applications that fall, more than five hundred arrived. He handpicked twelve pupils. Overnight, the Howard Pyle School of Art became the mecca of American illustrators.

IN BOSTON THAT FALL, Convers Wyeth could not have been further from the action. Every morning, as the wunderkinder of Wilmington painted for *Scribner's* and *Harper's* and *Century,* Convers trudged into the

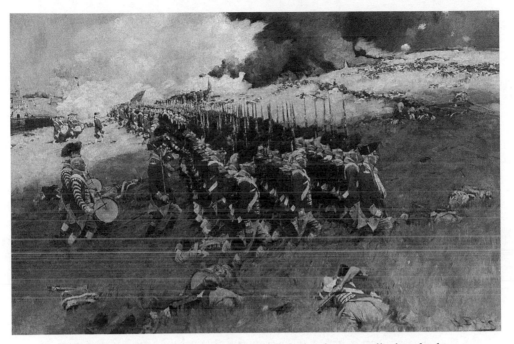

Howard Pyle was famous for "doing all the bricks in a wall a hundred feet off"—detail which, according to one Boston critic of the day, gave his illustrations "the authority of Pieter de Hooch." For *The Battle of Bunker Hill,* an illustration from "The Story of the Revolution," by Henry Cabot Lodge, published by *Scribner's Magazine,* Jan.–Dec. 1898, Pyle so painstakingly researched the victorious second advance of Maj. Gen. William Howe's Fifty-second Regiment that even smoke in the background accurately replicates the sky as it appeared at that hour over burning Charlestown.

Massachusetts Normal Art School at 29 Exeter Street. In drab classrooms, he listened as lecturers tried to "arouse in the minds of the despairing pupils an interest in combined angles, shadow planes, vanishing points, foreshortened circles, roofing timbers, and other hopeless mysteries."

The place lacked everything Convers felt his training should have. He wanted ecstasy. He wanted rigor. The boy from the dry town wanted to be intoxicated by art. He longed for the days when "an air of great seriousness, of religious fervor, surrounded the training of an artist." In its small-town way, the Normal Art School tried to become the "Paris of America." But Convers found no light in his classes, "no steadying influences of an intellectual nature" among the faculty, "no one to remind him that *art* and *life* are incorporate, that to grow in artistic power he must grow in character."

All was not lost, however. Richard Andrew had studied in Paris, exhib-

ited in Boston, and begun teaching at the Normal Art School the year Convers Wyeth arrived. Opinionated, direct, forceful, Andrew educated his students not just in anatomy and life drawing but also in the eclectic enthusiasms of an individualist. A burly, glowering Irishman, he kept students off-balance with caustic observations. When he evaluated Convers Wyeth's drawing of a fox's head, Andrew said that the work "had the qualities of a drawing made for illustration." Andrew suggested that Wyeth had the talent to become an illustrator—"and right there," Wyeth later remembered, "I jumped at a straw."

N. C. Wyeth rarely forgave himself for being two things at the same time. He could not be rational and emotional, practical and full of feeling. He had to be all one or all the other. But in the beginning, pictures were a unifying force, the very thing he had been looking for. A career as a picture maker offered him the possibility of being an artist and a moneymaker. Pictures, after all, were paintings. In their original form, before they were reduced to halftone images in magazines or books, pictures contained painterly passages of light and color, bravura brushwork, detail. For Wyeth, illustration served the dual purpose of satisfying the practical requirements of his bean-counting father while remaining faithful to his mission as his mother's family's artistic redeemer.

To achieve both, he needed a master for whom painting and illustration were indivisible. Yet Convers Wyeth apprenticed himself by fits and starts. With the Boston painter Eric Pape, he trained as an illustrator. With George L. Noyes, an American Impressionist back from France, he took summer instruction north of Boston, in the Cape Ann village of Annisquam. With Charles Harold Davis, a poetic American tonalist renowned in Paris, he studied landscape painting in Mystic, Connecticut. One spring he took commissions from polo enthusiasts at the Karlstein Polo Grounds in nearby Dedham, tossing off portraits of favorite ponies at forty or fifty dollars each—high prices—but in Wyeth's view, "the shallowest art a fellow could possibly do."

Rarely trusting his own instincts, Convers habitually set store by others' opinions. He had been reared to seek judgment from strong, highly regarded men. His mother had set the example: "I have been doing things all my life (even if I didn't like) by its being suggested by others," Hattie said. "I know my mind wasn't so strong but I've seen strongminded people fail by standing to their ideas." It was a family trait, she maintained, remembering how her brother Denys had always been "demoralized and weak under others' influence."

By the winter of 1901, while living at home, the nineteen-year-old Convers had attached himself to Charles W. Reed, a sour-faced Boston book

illustrator who had been a cavalryman in the Union army and a newspaper artist. Reed recognized the young man's gift for rendering horses and gave him what no school could, the impulse to use personal memory in putting life on paper. But Convers complained about Reed's "queer admixture of strange generosity and fierce impulsiveness"—a fair self-portrait of the young N. C. Wyeth.

For the rest of his life, Wyeth felt gypped by his "bum" early training, "bounced around," lacking in fundamentals. In fact, he never gave himself a chance. No sooner did he acquire basic skills from one instructor than he decided to switch to another. Having added little to his cumulative powers, he repeatedly started over again, each time putting himself back at the beginning. These wasteful partings were the first in a lifetime of bridge burning.

They had another effect as well. At each step in his training, Convers borrowed money from his father, whom he thought of as self-sacrificing. With a wife and four boys to support, Newell supposedly worked in the city for the sake of the family, and at the expense of his own best hope, which had been to farm the land. Dressed for Prison Point, in business suit, starched collar, and watch fob, Newell appeared to Convers "symbolic of practicality." Convers often wished that he could be "as practical"—as selfless—as his father. With that wish came the impulse not just to repay Newell's loans but to measure himself and his progress as an artist according to Newell's hay depot scales. Every cash outlay, every fresh tube of paint became a referendum on his attempt to become an artist. Was he being sensible, using this much charcoal or that much canvas for this much picture? Would it sell? Could he recoup his father's money with *this kind* of picture, or would he be better off trying *that kind* of picture? "Art is a thing that has to be studied right to achieve anything in the end," Convers would explain to Newell. But, as it worked out, the fitful early training of N. C. Wyeth laid a stronger foundation of guilt than of technique.

CONVERS WYETH was still living at home and looking for a master when Clifford Ashley returned from Wilmington, covered in glory, crowing about "practical pictures" and Howard Pyle.

A friend of Convers from the Eric Pape School, Ashley was among the first students picked for the new Howard Pyle School of Art. To hear Ashley tell it, the Pyle School had the atmosphere of a medieval guild, combining pride in work with brotherly feasts and a practical emphasis on craft. In the new century of tycoons and machines, Pyle's teaching offered respite from crass commercialism. Pyle measured worldly success by the old virtues—discipline, industry, thrift.

"Reached 907 Adams St. safe and sound at 7.45 last night," NCW wrote his mother on a card whose postmark records the date: *Oct. 25/930 AM/1902.*

Pyle, the "father of American illustration," in his studio, 1305 Franklin Street, Wilmington. More than one prospective student arrived at Pyle's door expecting to find "a grave, dignified figure vaguely resembling George Washington."

As at a Benedictine monastery, twelve men formed the core of Pyle's apostolic group. Newspapers had dubbed them "the twelve." Admission was considered an "honor as widely coveted as any scholarship." One man, Allen Tupper True, had been a lowly student at the Corcoran Art School. Included among Pyle's twelve, True became big news back home: HIGH HONOR FOR A DENVER BOY. The *Washington Post* claimed that "Mr. True's future is assured."

Here was the exalted apprenticeship Convers dreamed of. Hoping to be among the chosen in 1902, he sent his drawings to the school's sole admissions officer, Howard Pyle. Another friend from the Pape School, Henry Jarvis Peck, happened to be present when Pyle looked at the drawings. Afterward, Peck reported back to the Wyeths that "Mr. Pyle appeared to be very favorably impressed with them. He said they were very promising. He liked the 'go' there was to them."

Until officially picked by Pyle as one of the twelve, Convers would board in Wilmington, pursuing his work independently, showing Pyle the results. The only class he would attend with the elite group would be Pyle's famous composition lectures, held on Saturday evenings in Chadds Ford, Pennsylvania, until November, and thereafter in Wilmington on Monday nights at the Pyle Studios at 1305 Franklin Street.

Preparing to leave home that October, Convers looked the very part he would often paint: the local boy, barely out of knickers, setting off into the world. At age twenty, he stood one inch over six feet, had curly brown hair, a long, homely face, strong, square shoulders, and a powerful chest. Bold, arching eyebrows met above his straight, short nose. A look of purpose and of wistfulness mingled in his gray eyes. He was not handsome, a friend later observed, he was "winning." To strangers he looked formidable, much bigger than his 180 pounds. Holding his head high and his chin firm, he gave an impression of force when he approached.

His mother still saw him as a boy unable to control his feelings. She worried that Convers would go haywire away from home. But as he started down the drive, gripsack and portfolio firmly in hand, it was she who lost her head. All at once she realized what was happening: Convers was leaving her for good. The date, they always said, was October 19.

October 19

A S A MATTER OF FACT, Convers Wyeth left home on Thursday, October 23, 1902. He celebrated his twentieth birthday on South Street. That his last night at home, October 22, was also his birthday made his staying through until the next morning all the more important.

To his parents, the distance between Needham and Wilmington represented an epic separation. At a time when people seldom traveled more than fifty miles from home, the trip covered 350 map miles and involved a zigzagging cavalcade of southbound trains, an overnight steamship from Fall River, a ferryboat, and, on the last lap, unfamiliar streetcars.

Convers arrived in Wilmington on Friday evening, October 24, stepping down at the French Street depot after a tiresome but eye-opening journey. At his back were the shipyards and marshy green flats where the Brandywine Creek and Christiana River channeled south into the Delaware. Before him, Wilmington spread out like a fan, rising from slums and railroad-car factories in the east, through a grid of identical row houses inhabited by working people, to the leafy residential heights on the northwest side of town. Somewhere up there, under a skyline of emerald foliage, black roof cresting, and white church spires, stood the Howard Pyle Studios.

Convers had directions from his friend Clifford Ashley, who on October 21 had written to him in Needham about arrangements. Wyeth would room in a west side boardinghouse run by an elderly landlady named Griffith. He would take his meals with Ashley and Henry Peck at Mrs. Eva Simpers's boardinghouse. The night he arrived, Ashley and Peck, along with the rest of Howard Pyle's twelve, had already trooped out to Chadds Ford for a composition lecture. Ashley gave the newcomer the run of his room.

Unable to sleep, Convers awoke at five-thirty the next morning. He went out for a look at the Wilmington dawn. In the grimy lower town, he noted "plenty of factories." With a population of 76,000, Wilmington was a

small river town in a small coastal state. Sitting squarely on the Mason-Dixon Line, it had the feel of a southern backwater—a faraway place. Convers felt the distance at once, and it never left him; ten years later he could still say, "It makes me feel the pioneer to be way down here."

But the people did not move like southerners, and their manners were not southern. The town was full of Pyles. The famous picture maker had more than seventy cousins in Wilmington. The Pyles were tall, lean, fast-moving people, proud of their simplicity, their "soundness" of character. English Quakers, they no longer wore Quaker garb but still used "thee" and "thy" to strangers. Through three generations, the Pyles had been leaders in Wilmington's steadiest industry, the morocco leather trade. Howard Pyle was listed with his brothers in the city's business directory as a vice president of the C & W Pyle Company, specialists in book leathers. But prosperous as the world of fine leathers had been, the Howard Pyle Studios were something more again.

On the upper edge of town, where the iron-fenced Delaware Avenue mansions looked north into open country, a distinctive brick cottage stood eighty feet back from the sidewalk, its double-stack chimneys rising into the sky. Framed with an overhanging, half-timbered front gable, the brick studio was flanked by a student wing, together forming two sides of a courtyard, which by the fall of 1902 had grown glamorously webbed with vines. This was where pictures were being made, drawing the attention of the world. The place even looked like a picture, a finely detailed double-page spread of medieval England by Howard Pyle. At the entrance, five steps ascended to a long, leaf-strewn brick walkway leading up to the brass knocker on the master's studio door.

By 6:45 a.m., Convers could not wait another minute to write home. Returning to Mrs. Simpers's boardinghouse, nine blocks away, he dashed off a postcard announcing his safe arrival. Then, perhaps thinking of his mother's condition, and of her reaction when he left Needham, he wrote her a letter. He chose his words with care. Wilmington, he allowed, was "very pretty." He was going to "like the place better than I expected."

The postmark on the card is dated "October 25/1902." Yet, for reasons unknown, whenever Hattie or her son referred to this first separation, both said it occurred on October 19. In 1921 Wyeth uprooted his own children from the Brandywine Valley and took them back to Needham to live. He came home by train on October 19 and made the most of the apparent symmetry, giving the Boston newspapers and his mother to understand that he was returning nineteen years to the day—"within a few hours," he emphasized—after having left home for Howard Pyle's classes. From 1921 on, every telling of N. C. Wyeth's life would begin with the misconcep-

tion that on October 18 he tore himself away from his birthplace beside the Charles River and, the next day, started life anew in the valley of the Brandywine.

Back on South Street that first October, it hardly mattered what day it was. From then on, whenever Hattie spoke of Convers, she cast his absence in terms of death. She "has the idea," Nat reported to Stimson, "that we won't see much more of Convers." For Hattie, her "baby" was not so much going to Delaware as "going into another sphere." She could not be reasoned out of her delusion.

It was the same with the three younger boys. Each time one went out into the world, Hattie concluded that he would never return. Each time the family chalked up her feelings to homesickness. "I am sorry you have such nervous homesick feelings," Newell's sister Harriet wrote from Cambridge in 1909, when Nat, age twenty, left South Street for Ohio. Harriet Wyeth sympathized with Hattie: "I can understand that you must feel lost."

Hattie felt, she said, "lost to myself." As the departures mounted over the years, she gave in to "fits" of crying and panic, always accompanied by ceaseless, obsessive ruminations about the past. The panic came from a sense that she was losing not just a son or her health but her self. For Hattie, loss became an absolute state; any loss meant that all was lost.

When Ed departed for work in a horticulture nursery on Long Island in 1908, he tried to reassure Mama that he would "still be hers." She did not believe him. In her dreams she merged him with her dead parents: "I see you both then. I wake up and realize it's only a dream, then I cry a little and try to sleep again." Unable to bear the sight of Ed's empty room, she made Stimson—Babe—sleep as a substitute in his brother's bed.

When Nat announced his engagement the following year, Mama confided in Convers. "How can I bear to think of his going. . . . Well I must stop right here. The tears flow so fast. I can't see to write." Inconsolable, she drifted outdoors and picked flowers "in memory of Nat." Later that year, when Stimson enrolled at Harvard, Hattie broke down again.

The first to leave, Convers was the first to discover how serious a blow he had dealt his mother. "Every one of your letters has some sad story to tell," he observed on November 5.

He tried to reason with Mama by adopting the voice of Yankee practicality: "You say you are unhappy. Why? Let your past troubles go. Just think, three [sons] at home probably better able to keep you company than I. Twas apparently so sometimes. You said I was away for good. Not so, only for a few months then home for all summer and probably next winter. I will undoubtedly learn a good deal anyway." He tried to demonstrate his loyalty by making an elaborate show of self-denial, reporting to Mama that "all the

NCW's mother on South Street: "I will try and write you a few lines this morning as that is all that passes between us and I feel that I must cling to that. My head has felt bad for nearly a week."

fellows went in swimming this morning," then playing his trump: "I did not and will not until next spring in the Charles."

Hattie's reaction to Convers's absence bordered on mental disturbance. To her, October 19, 1902, was the day the clock had stopped and life had ended. For the next two decades, every year, Mama sent Convers a home-made wooden box. It was a square crate, knee-high, fashioned from rough boards. Packed by Hattie, nailed shut by Newell, it always arrived on or near the sacred date. The repetition, Wyeth once explained, "means a great deal to me." He told his mother, "I never want you to miss that [date] if you can help it—you know I left home on the 19th of Oct. and that box always coming down about that date has a great symbolical meaning to me." As with many things he loved and depended on for a sense of himself, he gave it a name: the Home Box.

Wyeth made an annual ritual of retrieving and opening the Home Box. He hefted the crate to his shoulder, brought it into the house, and placed it in the same spot on the living room floor. He pried open the lid "board by board," so that nothing inside would be disturbed.

Inside the Home Box, everything was densely layered as if packed for

the afterlife. On top sat feathery pine boughs or stiff sprays of arborvitae freshly cut from South Street. Sheltered underneath were flowers from his grandfather Zirngiebel's greenhouses, one for each year of Convers's life; and smokehouse apples from his father's orchard; and a flask of grape juice made on his mother's stove. Below was a birthday present; and in the corners dried grasses from the currant bushes or a clump of sweet-smelling hay from the barn.

Each object had the power to project the whole universe of Needham; a single fern could "create a phantom impression of moist black earth and tangled roots." Familiar sounds reached Convers's ears, the cry of the whippoorwill, the rumble of the henhouse door, as he lost himself in elaborate "visions," "whirls of dreams," "panoramic" fantasies about "the life that [the] box depicted," a life he could "probably never enter into" again.

Sometimes, all it took was the first fragrance of pine needles. "He would just burst into tears, just quietly," his son Nat remembered.

He saved the most sacred artifact for last. Deep inside the time capsule sat a layer cake, freshly baked from his mother's oven. It seemed redolent of the family's history of separation from home. Fashioned "by Mama's hands," it seemed "to sleep in a golden languor." The frosting was "white, of course, with shadows here and there," Wyeth's daughter Ann recalled. No matter how many days it had traveled or how often the ceremony was reenacted, the cake never lost its force. "It tasted like a large Swiss-German cookie."

In N. C. Wyeth's imagination, the box, the cake, the date itself came to have monumental significance. He used October 19 as a kind of almanac day on which each year he took account of his life, measuring the distance between his old and new selves, testing the pull of his mother and of Needham. He devoted thousands of words every year to describing the feelings "uncovered" by the Home Box. But he actually never uncovered anything new, and that of course was the point. Every October 19 was the same. In his heart nothing had changed.

A FEW HOURS LATER, on Saturday, October 25, the young Wyeth knocked on Howard Pyle's Dutch door. A secretary showed the new arrival into the vestibule. Beyond was a large room with shingled walls and thick rafters. Skylights drew the eye to the bright midatlantic morning.

Toward the back floated a scattering of authentic relics—muskets, powder horns, Spanish chests. Leaning against a wall were Howard Pyle canvases, full of color, sharper and more vivid than Wyeth had dreamed possible. Until now he had seen them only on the pages of magazines. "Just

think," he recorded as soon as he could, "Me—seeing Pyle himself and his original works." But what took Wyeth even more by surprise was that Howard Pyle appeared to be equally interested in seeing him.

The master waited by the fireplace, long legs spread apart. Broad and impressive in his dark suit, Pyle had a heavy, square jaw, high cheekbones, unusually deep eye sockets, and a penetrating gaze. To Wyeth he looked tall—Pyle stood six feet, three inches—and "very wide between the eyes." His "terrible strong face" and well-muscled limbs reminded Wyeth of George Washington.

Wyeth had scarcely caught his breath when Pyle asked about his background, noting with approval his New England upbringing, his horsemanship. None of the twelve knew how to drive a pair of horses; Wyeth would have important duties in the horse-drawn life at Chadds Ford.

Pyle was hypnotic. He spoke "gently but with unmistakable emphasis." Wyeth took note of every word, paying attention to "every modulation" of the master's voice. The reply to a question seemed less essential than the nuances of the question itself. Wyeth noticed the light pouring down from the ceiling, the sparks rising in the fireplace. Gradually, a feeling of heightened clarity and awareness came over him. He felt sure that in the master's face, with its "majestically severe" brow, he was seeing something "beyond the actual man."

Pyle glanced at the new sketches Wyeth had brought and told the boy that he was sorry he had not come earlier; Wyeth's work looked "practical."

Wyeth was, in fact, exactly what Pyle wanted in a student: a talented naïf. Pyle had no patience with beginners; Wyeth came trained in the fundamentals. Pyle accepted only those applicants "into whose minds he could instill his own theories," and Wyeth was twenty—the most "pliable age," according to Pyle.

In background and temperament, Pyle and Wyeth were remarkably alike. Pyle's provincialism was Wyeth's. Pyle's Wilmington, like Wyeth's Needham, was "a sheltered place, a protected enclave of family and friends where one read the newspapers to discover there was an outside world." Like Pyle, Wyeth had made his first step toward professionalism through the rendering of ponies—Wyeth at Karlstein Polo Grounds in 1901, Pyle at Chincoteague in 1876. Both were dedicated students of the horse. Both were mama's boys, favorite eldest sons of spirited but stifled mothers and reticent businessmen fathers.

Pyle the Victorian boy, like Wyeth a generation later, had been inclined to soften whatever had been hard in his "very bright and happy childhood." In Pyle's only memoir, his father scarcely appears, and remains an emotional blank. The loss of Green Hill, Pyle's childhood home—"the quaintest, dear-

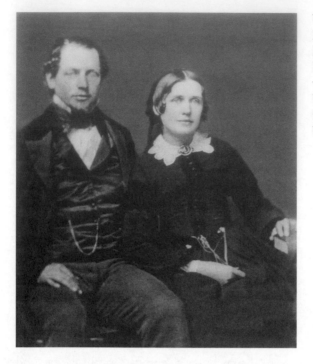

William Pyle and
Margaret Churchman
Painter Pyle. Howard
Pyle recalled, "My mother
was very fond of pictures,
but especially was she
fond of pictures in
books."

est old place"—is glossed over as "a sad time." Financial facts are costumed
in phrases like "straitened pecuniary circumstances." In reality, William
Pyle's leather business had failed; he had moved the family seven times
through two decades of harsh financial reverses. Yet Howard never found
fault with his father.

In Howard's eyes, Margaret Churchman Painter Pyle was "the best
mother that any boy ever had." Always "perfect in her devotion," in "perfect
sympathy" with her artistic son, she resembles Convers's idealized Hattie
Wyeth, and like her, Margaret Pyle had sacrificed intellectual fulfillment to
her first child. In both families, "Nothing would matter so long as her son
became an artist and thus fulfilled her own dreams."

Margaret Pyle had rejected Quakerism, with its strictures against imag-
ination, taking instead the broader philosophy of the Swedish visionary
Emanuel Swedenborg, whom the Quakers considered a crank. When
Quaker elders discovered the family's affiliation with the new Swedenbor-
gian Church on Fourteenth Street—Howard was seven—they "read [the
Pyles] out of meeting." As Howard grew up, Margaret Pyle encouraged him
to fulfill the Swedenborgian philosophy that imagination could be useful.
Art, she taught him, could be "practical."

Like Convers, young Howard Pyle had felt "called" to abandon his

father's world of trade in order to fulfill his mother's loftier goals. But Pyle's training was funded, as Wyeth's would be, "from the family purse." Pyle spent his early career worrying about how he would "pay off my debts to father *in toto.*" The answer, it turned out, was to be practical, to paint pictures that would be "useful," that would teach people how to perfect their present selves by looking at their past.

"My boy," Pyle concluded that first morning, and Wyeth would always remember them as magic words, "you have come here for help. Then you must live your best and work hard."

In Pyle's call to virtue, Wyeth heard "the spirit of earnestness and of love" that he had craved but never known in Boston art schools. He would remember feeling a rush of emotion for Pyle, "a deep affection akin to that which one holds toward his own parents." From that moment, Wyeth later wrote, "I knew that he meant infinitely more to me than a mere teacher of illustration."

Missing Sons

Less than forty-eight hours after arriving in Wilmington, Convers wrote home, "I have faint prospects of working for Sat. Eve. Post already." He reminded his parents that "the big, great wonderful thing is, that Pyle's name will get you more work than anything else in the world. Publishers know that he won't let his students do anything bad."

Be that as it may, Wyeth had yet to be admitted to the Howard Pyle School of Art. Pyle kept applicants—as he kept everyone—guessing. If accepted as a full-fledged member of the twelve, a student never knew how long his course of study would last. It could range from a few months to several years. Pyle, and Pyle alone, decided when a student was ready to "graduate." In the meantime, all other arrangements had to remain indefinite.

Pyle, however, had urged Wyeth to send home for his own collection of costumes, guns, and colonial relics. "Of course you'll probably be here for three or four years now," Pyle said casually, "and it will pay to get them."

"I don't know about that," Convers assured his mother, "but I better get them, I guess." He begged her to have Uncle Gig build a crate and have "everything I got in the line of old arms and relics" sent to Wilmington. "It won't cost much," he figured.

He was spending his father's hard-earned money—he had less than ten dollars to last until Newell's next bank draft—and he sweated every nickel. After equipping himself with an easel and supplies, he made a list of incidental expenses, toting up costs and savings down to the penny.

Meantime, in a photographer's studio on East Third Street, he had begun to draw. After three false starts he worried that he had lost his knack, which he put down to the "abrupt change" in his life. He reckoned it would take a week to "get my hand back again." Four days later he reported that he was making a first attempt at a picture for *Harper's*. Working on his "own hook," he was confident that "Mr. Pyle is going to criticize it and when he sees I'm doing it for publishing he will help me all the more."

Pyle promoted the New York and Philadelphia publishers. He knew them all; many came to Wilmington in search of fresh talent. Pyle looked back on his own first encounter with an art editor as "the turning point in my life." He considered the magazine art editor "the best trained critic in the world to tell you whether your picture will interest a million people and not a clique that may come into your studio and tell you 'your stuff is fine.' " He emphasized the short distance between the students' easels and America's newsstands. Every picture should portray one great idea, and one only, Pyle told them. "Don't make it necessary to ask questions about your picture. It's utterly impossible for you to go to all the newsstands and explain your pictures."

The Howard Pyle School had a near-monopoly in the magazines. Because of Pyle's efforts, his students would be well represented in Christmas issues that year. Jessie Willcox Smith and Maxfield Parrish, two of Pyle's earliest pupils at the Drexel Institute, had lavish spreads in *Scribner's*. Even a newcomer like Wyeth's studio mate, P. I. Hoyt, a Vermonter trying out for the twelve, had entered the market with full-page winter scenes of ice cutting and Christmas-tree gathering for *Harper's Weekly*. Wyeth longed for a taste of the glory. "I think that after half of the year is over I'll be able to get some work," he reported home, using practical arguments to point out the "one great advantage" of his new locale: "We're near all the big publishing houses and can see them personally."

He made a list. On the back of an envelope, he scribbled the names and addresses of the top ten art editors. "Chapin" at *Scribner's* at 153–157 Fifth Avenue headed the roster. Wyeth had never set foot on Fifth Avenue, nor did he know anything about Joseph Hawley Chapin, but *Scribner's Magazine* had been a significant part of his growing up. "The name of *Scribner's* had always been to me one to especially conjure with," he wrote later. "Principally I believe, because it was the favorite periodical to come into my boyhood home." His earliest dreams and ambitions centered on the idea, encouraged by his mother, of "painting pictures good enough to be used in *Scribner's*."

Next came Alexander Drake at *Century Magazine* on Union Square, followed by Thomas Bucklin Wells at *Harper's Weekly*, the renowned "journal of civilization," on Franklin Square. Along with *Scribner's*, they were the most prestigious publications in the country. "Of course there were other magazines and many other publishers whose presses were restricted to books," Wyeth would later recall, "but the Big Three were glamorous! They were our dream and goal." As fellow illustrator Wallace Morgan said, "For a young artist to get a job from *Scribner's* was like being admitted to Valhalla."

Taken together, Wyeth's lists show how quickly he subjected himself to

commercial publication. In years ahead he would blame his later struggles as a painter on his early pursuit of success. Illustration had started him off, he would come to believe, "on the wrong foot."

Rightly or wrongly, money was what counted to the twenty-year-old Wyeth. His duty to his family was to become a professional as quickly as possible. Self-sufficiency was a moral imperative. "I wish I could earn my living now," he wrote that fall. "I know that there are three more [brothers] to prepare for life and it makes me feel that it's not right for me here spending money, and Papa standing 'down there' [in Charlestown] in cold and rain earning it for me. I keep getting encouragement from all, that I'll be able to pay it back some time and I hope it will be true."

ELEVEN MILES NORTH of Wilmington, just beyond the Pennsylvania state line, Chadds Ford sat at a crossroads in the open country of the Brandywine Valley. Perched on the rim of the Piedmont Plateau, it was rolling green farmland, with tilted meadows and conical hills, "almost mountains," Wyeth exclaimed when he first saw them. Herds of Chester County fat cattle pastured in the meadow bottoms, grazing beneath rows of willows. Two railroad lines knifed across the hills, running on the same axis as the two narrow dirt roads, U.S. Highway One and the state road to West Chester. "This is a purely agricultural district," the Wilmington & Northern Branch of the Reading Railroad noted, "and has hitherto been mainly a grazing country." From the junction at Chadds Ford, the Baltimore Central Railroad shipped milk daily into Philadelphia, twenty-five miles to the east.

Convers Wyeth had a sense of coming home. Here for the second time in his life flowed a gentle, encircling river. Undisturbed by industry, the Brandywine Creek coiled around the valley like the Charles of his boyhood, descending six feet to the mile.

Home—everything looked and sounded like home. Southeastern Pennsylvania had been the nation's first center of horticulture; lush greenhouses and gardens flourished on a scale to rival Zirngiebel Inc. At 168 feet above sea level, Chadds Ford sat on a plateau like Needham's, its sugarloaf hills pushing up into the brilliant sunlight. By day the air had the pure, gusty vitality Wyeth knew from the hills of eastern Massachusetts.

That first night, Wyeth and the others went for a walk in the moonlight above Chadds Ford. The frosty air, the crackly cornfields, the American elms with their spreading shadows—"it was all magic to me and tremendously romantic," he later recorded. In the candle glow of village windows below, in the peppering of stars above, Wyeth found something he had not thought possible: a rival to South Street. From the start he wrote and

The Vedette, 1910

The Hermit, 1910

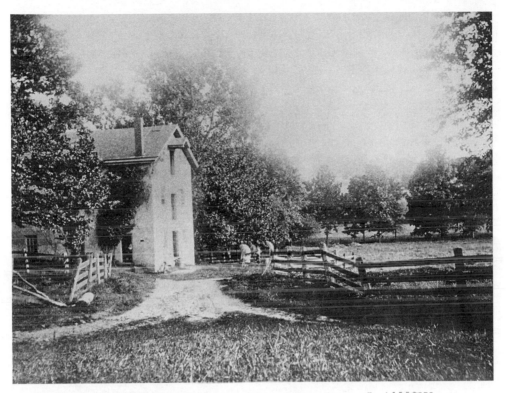

Turner's Mill, 1903. "Chadds Ford is not Massachusetts," said NCW, "but Chadds Ford valley looks more like New England to me than New England does itself."

talked of Chadds Ford with the air of sanctity he had always reserved for Needham.

Howard Pyle's mother had been born in nearby Painter's Crossroads; she was a Painter, one of the area's oldest Quaker families. During the hot summer months in Chadds Ford, Howard and his family still occupied the old Painter place, which the townspeople called Painter's Folly. It was a massive Italianate house with a cupola, deep piazzas, a broad lawn overlooking the village, and a tennis court. In summer, the Pyles hosted lunches and suppers and games on the shaded verandas. It was a world of sons. Mr. Pyle liked nothing better than to gather his students on the front piazza for tough, ennobling talks about life and art.

Fathering came naturally to Pyle. He treated young men as sons first, students second. He made special plans for their summers at "the Ford," dictating detailed memoranda to "my dear boys." He looked after every trivial expense. Allen Tupper True spoke for many when he wrote across the bottom of one Pyle memo, "He cannot do too much for me."

In Chadds Ford the twelve had Pyle all to themselves. Female pupils had not yet been completely excluded from Pyle's orbit, but their presence barely registers in Wyeth's letters or in the diaries and recollections of the twelve. Also left behind in Wilmington were the group of older, professional artists to whom Pyle made himself available each week for consultation. These were men and women not officially enrolled in the school but working as professional illustrators.

At Painter's Folly, the master enlisted his wife, Anne Poole Pyle, who was "very slim and pretty," to take care of the twelve. It was only a matter of months before Pyle, in a "fit of enthusiasm," confided in Wyeth, as he wrote to his mother, that "Aylward, Becker and myself were Mrs. Pyle's favorites both in work and character." Examining the honor, Wyeth preened. "That is of course a subtle way of giving me his own opinion."

Wyeth fit naturally among the Pyles. The family was an idealized version of his own, and when he first approached Painter's Folly that early November weekend, one of the high piazza windows framed a domestic scene that would serve as a model in years ahead. Inside, all was virtue. Among the shadows, their faces bright in the lamplight, Pyle and family sat, "his face of great character intently bent on a book, and flocked around the rest of the table were five of his children reading or drawing and on one side Mrs. Pyle with the youngest child in her lap and at her feet a cat and dog lay asleep."

Perhaps remembering Newell's daily desertion of South Street, or his mother's fear of abandonment, Convers made a point of telling his parents that "Mr. Pyle has never been away from Mrs. Pyle one night since their marriage except once and that was two weeks ago."

The perfect Pyles seemed also to have perfect children: four sons, Theodore, Howard Jr., Godfrey, and Wilfred; and two daughters, Phoebe and Eleanor. Ranged in age from sixteen to five, they gave family photographs a crowded, carefree appearance. But numerous and secure as the Pyles looked, the family portrait was incomplete. When Convers Wyeth arrived in their midst in 1902, there remained a space—a vacancy no one ever discussed—for a missing son.

IN FEBRUARY 1889, at the age of thirty-five, Howard Pyle had ventured outside the United States for the first time. He went with Anne, who was pregnant. They left their children in Wilmington: six-year-old Sellers, a beautiful, brown-haired boy with fine features and a delicate mouth, and two-year-old Phoebe. The children stayed with Howard's younger sister

Pyle and his father with
Sellers, born in 1882.

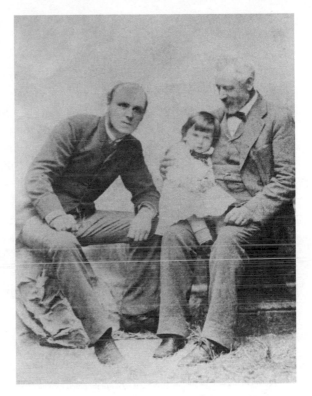

and sometime collaborator Katharine. An affectionate aunt, with one blue
and one brown eye and a disposition for nervousness, Katharine Pyle later
said that she had had a sense of foreboding when her brother sailed for
Jamaica.

It was an unusual destination for Pyle and would be his first glimpse of
the tropics. Although famous for his pirate pictures, Pyle had always
painted tropical settings in his studio, going only as far as the Delaware
beaches to verify some detail of a shore landscape. In Montego Bay, he
sketched and painted for *Harper's Monthly*.

Then, on February 23, a cable dispatch arrived. Sellers Pyle was dead in
Wilmington. The boy had died the day before. The Pyles sailed from
Kingston on Saturday, February 23. The homeward voyage was hellishly
slow. By the time their ship docked, the funeral was over, and the body was
buried. Sellers was gone.

Pyle's biographers give no cause for Sellers's death. Even decades after
the fact, they remained protective, but why they dodged the boy's sudden
death is not clear. Anne Pyle gave birth to a second son six months later, and

we are told that she never again heard Sellers's name without bursting into tears.

Sellers Pyle died of croup. Preceded by the common cold, croup strikes children under the age of three. The condition is caused by a viral infection or allergic reaction in the upper airway. Onset occurs at night, and symptoms include a barking cough, hard breathing, and spasms of the larynx, all of which can be treated at home with vaporizers. To new parents, croup can be terrifying. Convers Wyeth, at the age of one, had suffered an attack of viral croup "as bad as I ever want to experience," his mother later recalled to him. "Every cough you gave startled us."

Bacterial croup, a more threatening condition, appears in children between the ages of three and seven. Severe, rapid swelling of the epiglottis chokes the victim, cutting off the air supply. If an artificial airway is not opened immediately, followed by antibiotics to reduce the inflammation, the victim will strangle to death.

Sellers was four months shy of his seventh birthday. He may have had a severe case of viral croup, or an allergy that complicated the virus, or his windpipe may have been choked off by rapid bacterial infection. Antibiotics were unavailable. But in any of the three forms of croup, a lack of prompt medical attention would have worsened the ordeal. Katharine Pyle was alone with the choking child in the middle of the winter night.

For Howard Pyle, the trauma had no proper ending. There was no explanation and no one to blame.

Mourning continuously, Pyle channeled his feelings for "the little boy whom I loved the best of all" into story and pictures. Again and again, in word and image, he attempted to bring Sellers back to life. In 1891 he illustrated a poem by his friend William Dean Howells, who had lost a daughter to illness the same year Pyle lost Sellers. Both took refuge in Swedenborgian philosophy; Howells's poem "Question," an investigation of death's randomness, made a deep impression on Pyle. He lingered "in the shadow of the same valley from which Mr. Howells wrote." But instead of restating Howells's representations of death, Pyle abandoned the text altogether.

He chose his own image of horror. The finished picture stood on his easel as Pyle wrote to *Harper's Weekly*. He felt he must warn the editors: "If you publish the picture, people will say . . . it is . . . crazy."

Pyle had departed from the text to show the violent abduction of a little boy. No questions asked—the child is gone. Under the missing boy's feet lies an overturned cup, and behind the fatal event stands a solid wall of MELANCHOLIA. Pyle explained: "I have tried to embody in the painting pictorially what I felt psychologically."

Howard Pyle, *"Where did you come from, little boy?"* 1895.
Illustration for *The Garden Behind the Moon,* by Howard Pyle.

The endlessness of Pyle's grief was its chief characteristic. Without his having attended the funeral, without his having buried the boy himself, there remained always the fantasy that Sellers might someday reappear.

In a dream, Sellers did reappear. Pyle awakened one morning in 1894 with the clear sensation that he had just been with his son. "I was glad to see him," he later wrote. He looked on as the boy played with other children in a garden. Alive in the lush stillness of the dream garden, he was the same beautiful, brown-haired boy with fine features and a delicate mouth.

From the dream a children's tale emerged, *The Garden Behind the Moon,*

an allegory of premature death which Pyle dedicated to Sellers, identifying him as "the Little Boy in the Moon Garden." Sellers is in a budding, Brandywine-like paradise, surrounded by peers. One is a boy of the same height and build as Sellers. By coincidence, he could have been taken for young Convers Wyeth.

The ages matched. Convers and Sellers had been born four months apart. Their fathers were exact contemporaries: thirty days separated the birthdays of Howard Pyle and Newell Wyeth. But it was more than the coincidence of age that made Convers a natural replacement for Sellers. If there was one social skill Convers had become adept at, it was to substitute himself for the missing figure in a family.

As it happened, Convers had little competition in this family. None of Pyle's children had ever showed interest in drawing or painting. Eleanor, the youngest, would remember for the rest of her life the loaded phrase her father had used at dinner to announce the arrival of Convers Wyeth: "At last, we have a real talent, someone whom it will be interesting to teach."

Convers Wyeth would be as much a real-life son to Howard Pyle as Pyle would become father-in-art to Wyeth. Expressed through picture making, their intricate relationship began as master and pupil on Wyeth's first night in Chadds Ford, when Pyle critiqued one of his compositions.

ARRAYED IN "prayer meeting fashion," the twelve looked on as the newcomer's signed composition was removed from the charcoal sketches and "suspended like a family washing from a clothesline."

Pyle stood back, turned a cold eye on the sketch, paused. Without a word, he stared at the lines on the page. Firelight flickered over silent, quizzical faces as everyone waited in the darkness for the first sign: If Pyle wrinkled his brow and rubbed his nose, the picture would be panned. But if the master cocked his head, if his brow did not prune and he forgot to rub his nose, he would turn and say, "I like this and I'll tell you why."

Pausing over Wyeth's sketch, Pyle cocked his head and told them why. There was action in the picture, and the compositional idea was right. "Stick to your first impression of your picture," he told the newcomer. "You cannot improve it by changing it, as a rule." Then, with supreme confidence and a practiced hand, Pyle stepped up to the sketch and pointed to the stroke at which Wyeth had wavered from his original conception. Recounting the critique the following day, Wyeth was still awestruck. "He seems to read one's mind."

Pyle knew his thoughts as had only one other in Wyeth's experience. Until now, Mama had had a monopoly on his inner life. But in opening up

Wyeth to the world of pictures, the master quickly became part of his think-
ing on every matter. Wyeth scarcely put a stroke of charcoal on the page
without anticipating the moment Pyle's eye would freeze on a flaw.

Howard Pyle basked in his deification. He lived, by his own account, a
"humdrum, mossy" life. He rarely dined out, never entertained. He had a
"Quaker foot"—he preferred not to dance. He insisted that Wilmington's
quiet, genteel world suited him "to perfection." He was no Bohemian. Pyle
kept his collar tight at the throat, worked in necktie and suspenders. Seated
in front of his easel—pince-nez flashing, round head luminous in the sky-
light—he looked like a bank president on whom someone happened to have
planted a bunch of paintbrushes.

Six days a week, he arrived at work like everyone else, at eight on the
dot. His neighbors considered him Wilmington's "one real artist," but Pyle
presented himself as "any other respectable American citizen": clean shaven,
with "gray hairs, and children, and taxable property, and responsibili-
ties." He held ultraconservative Republican opinions and lived among the
new industrial entrepreneurs. He sent his daughters to the Misses Hebbs
School, where all the proper ladies of Wilmington went.

Pyle, the average citizen and modest neighbor, had at the same time
another identity. To publishers in New York and millions everywhere, he
was "the great Pyle"—a showman, a transatlantic celebrity. His friends were
Oliver Wendell Holmes, Frederic Remington, Henry Cabot Lodge,
Augustus Saint-Gaudens. He had the ear of the new young president of
the United States, Theodore Roosevelt. When he celebrated a friend's birth-
day in New York City, it was as likely to be the banquet at Delmonico's for
Mark Twain's seventieth as a gala dinner at Sherry's for William Dean
Howells's seventy-fifth. At home, too, he had important visitors. Professor
Woodrow Wilson of Princeton shuttled to Wilmington to confer with
Pyle about the illustrations for his life of George Washington and his multi-
volume history of the American people.

Pyle's income, averaging $50,000 a year, was the talk of Wilmington. It
was "considered fantastic in our town, considering what he did for a living,"
recalled the memoirist Henry Seidel Canby. Like clockwork, Pyle produced
three canvases every month to fulfill his contract with *Harper's*, and that was
only a fraction of his annual output, which included as many as two hundred
illustrations and one or two literary works. Pyle earned between $250 and
$300 per picture and happily made the fruits of his success—contacts with
publishers, lucrative commissions—available to his inner circle.

He considered the twelve his associates. A photograph shows Pyle pos-
ing with five favorites. The young men, with their dark suits, tight collars,
and broad air of staunchness, array themselves around the seated master in

Howard Pyle, *Washington and Steuben at Valley Forge,* 1896. Illustration for
"General Washington," by Woodrow Wilson, *Harper's Monthly,* July 1896.
"The third subject that suggests itself," Pyle wrote Professor Wilson at
Princeton on February 11, 1896, "is Washington and Baron Steuben
passing down the street of huts with a foreground group of soldiers
standing at the door saluting as the two officers pass."

the manner of faithful law clerks. The image is apt. Pyle welcomed only the most loyal and hardworking into a partnership.

He liked to say that his students were "as clean a set of fellows as ever lived." Not a rebel or chandelier swinger among them. They were to be as much like the master as possible: six feet of height, chiseled chin, good manners, and "wholesome" background seem to have been unwritten requirements of admission at the Howard Pyle School of Art. "I *couldn't* go wrong in this crowd," Convers Wyeth wrote to his mother soon after his arrival.

In the studios it was another story. Outwardly conventional, Howard Pyle taught the art of picture making as an act of self-revelation. "He tried to enter *your* thinking mind, whether it was your conscious or subconscious mind," said one student. Emphasizing the integrity of each student's individual reactions, Pyle schooled his artists in "mental projection," urging them to "project your mind into the subject until you actually live in it"— a novel approach in that day of academic training.

Working alone in turn-of-the-century Wilmington, Pyle had discovered that by merging his feelings with the factual reality of the world of objects, he produced pictures that made conventional illustration look wooden. At his easel, Pyle "fought, sang, struggled, and sobbed through his work." In the student studios, he set before the new arrivals not cones and cubes and spheres but deep feelings. Again and again he exhorted them: "Live in your picture." "Dig deep."

Before going to his own work in the morning, Pyle looked in on the twelve, visiting their studios once more after lunch and again before leaving. The previous day, he would have set one of the new arrivals to drawing a plaster cast of Donatello's unknown lady. Now, standing before the student's smudgy paper, the master identified the trouble at once.

"You are thinking of that head as a piece of plaster, and trying to copy its outlines and contours."

He urged the student to look again. Had the young man seen the curve of the eyebrow? The sensuous lips? Had he noticed the delicate feathering of the shadow over the cheek? Had he considered the most important fact of all? That there was a real woman involved here—a very beautiful woman. Had he seen *her*?

The student had seen nothing but a piece of plaster.

"I'd like you to think," said Pyle, "of the beautiful Italian noblewoman who sat for Donatello; of her rich, medieval surroundings, of silks and damasks . . . of her beauty."

It soon began to dawn on the well-mannered young man from Denver or Philadelphia or Boston that Howard Pyle wanted him to fantasize about a *real* woman, right down to her silk underdrawers. He wanted this private

fantasy harnessed and transformed into charcoal on paper. Pyle then wanted
it painted in oil and published in *Scribner's Magazine* and discussed over
Sunday dinner by thousands of people, including the artist's mother and
father, grandparents, aunts, uncles, and friends.

For the sons and daughters of Victorians, this was a terrifying proposi-
tion. Howard Pyle was asking them to look into forbidden places. It was,
recalled one of the twelve, "a sort of new language."

FRESH FROM his first composition lecture in Chadds Ford, Wyeth won
Pyle's endorsement for a sketch he intended for *Harper's*, only to abandon
the idea a week later for another sketch that "Mr. Pyle likes better." Accord-
ing to custom, students on trial waited for Pyle's permission before spring-
ing themselves on art editors in New York. As Wyeth would afterward
recall, "We were like so many impatient race horses, caged at the barrier,
each awaiting his release, his signal from the master to 'Go!' "

Wyeth postponed plans for an exploratory trip to the big city when Pyle
suggested that if he could "afford to wait it will be better for you in the end."
Lowering his sights, he aimed instead at Philadelphia and one of the oldest,
sleepiest magazines in America, *The Saturday Evening Post*. His timing
could not have been better. Founded by Benjamin Franklin in 1728, the
grandfatherly *Post* had just begun a new circulation drive aimed at a million
readers. Pictures attracted readers, and no page in the new *Post* was to be
without illustration. Wyeth presented his portfolio to Guernsey Moore, a
well-known *Post* cover artist and editor at the magazine, who praised his
work and welcomed material for future covers. They discussed a polo theme
and a western subject.

Back in his studio, Wyeth showed signs of stage fright. He begged
Mama to send his well-marked back issues of *Century*. "I really need them.
As I pose as an artist of western pictures I've got to have Remington's draw-
ings for reference of costume etc."

He borrowed more than spurs and chaps. Wyeth adopted Remington's
signature format, the single airborne horse and rider flying in a horizonless
picture space, with a lone smudge of shadow to delineate earth. To be sure,
Wyeth knew horses, and he put everything he had learned about anatomy
and motion into his bronco's stiffened forelegs and plunging mane. When
he presented the sketch for criticism at that week's composition lecture, he
was in for a surprise.

Ten students out of Pyle's twelve had tried to make covers for *The Sat-
urday Evening Post*. All but one had failed. Now they sat in stunned silence
as Pyle forgot to rub his nose. The master cocked his head and pronounced

Wyeth's composition "good enough to show the editors." To everyone's astonishment, Pyle urged him to take it without alteration the very next morning. "I'm going to do it," Wyeth wrote home, "but it means a dollar for carfare."

HAD HE BEEN ABLE to forgive himself his debts to his father, Wyeth could have avoided the commercial world for at least two more years. In Wilmington, he could have focused on learning the basics. But this would have meant additional financial support from home, which troubled him. He believed that he had reached the age "when a fellow should cease from being wholly dependent upon his parents, especially when he has three equally high-aspiring brothers." Even to contemplate asking Newell to "do so much and me twenty years old" made Convers feel "blue."

But how much, really, was "so much," when Newell Wyeth managed to send two out of four sons to Harvard, and Howard Pyle taught for free? Tuition and expenses for a year in Cambridge cost from $475 to $1,055, depending on a student's means and "power of self-command." In Wilmington, Wyeth's annual expenses came to less than $300, and he was his own disciplinarian.

To alleviate the family budget, Wyeth planned to spend Christmas in Wilmington, as he had done at Thanksgiving. Energized by a mounting sense of indebtedness, he threw himself into work. But as December 25 approached and the students cleared out for vacation, Howard Pyle discovered that Wyeth would be the only one of his flock not going home. Even the Pyles were leaving town. If Wyeth stayed he would spend Christmas alone in a boardinghouse. Pyle proclaimed that "every fellow ought to be home at Christmas," and when he learned that Ashley and Peck would be returning to Boston, he petitioned the railroad for a group fare.

To Wyeth, Wilmington had begun to seem more and more unreal: Mr. Pyle, the twelve, the beef red bricks of Franklin Street, the "monotonous daily routine"—it was all a kind of dream. When it became unbearable, he would run out to the Brandywine and peer into the stream, picturing his birthplace on the Charles. He could, he wrote, "now appreciate home and all its enjoyments, scoldings, and incidents more than I can describe." He imagined seeking equilibrium in the pages of a book. It seemed as if he had just "read a book—very, very interestingly told—of a boy's life in the country, and it had impressed me greatly."

He wanted to go home, but he was not sure how to say so. Calling on New England thrift, he notified Mama that "Mr. Pyle is trying to get us low rates on the Colonial express, and if he can, can I come home?"

Amazingly, Mama said no. The cost of a return ticket was extravagant, she said. She was fully prepared to let Convers sit out Christmas—and, therefore, her birthday—in Wilmington. If Wilmington was where he meant to conduct his studies, if Mr. Pyle was so important to him, then that was where Convers would stay.

Pitiless, punitive, Hattie held herself aloof, knowing that cold treatment would bring Convers to his knees. It did. As the Pyle Studios emptied for the holidays, he broke down. "I've held off as long as I could," he wrote, "and now I'm going to say I want to come home Xmas." He appealed to common sense. "It will cost me $6 or $7 a week to live [in Wilmington, over Christmas] so will be as cheap to come home and possibly cheaper."

Mama relented. As so often before on South Street, common sense won out over irrationality, but not for long. As soon as Christmas Day and "Mama's natal day" ended, the struggle began anew, reviving the question of Convers's future. A deep divide had opened between Needham and Wilmington. This time, though, when he got off the Fall River boat in New York Harbor, he took fate in his own hands.

Instead of going on by ferry to the New Jersey waterfront to catch the southbound train to Wilmington, Wyeth leapt ashore in Lower Manhattan. He set the peak of his new Stetson for the magazine offices uptown. Howard Pyle's entrée could theoretically open doors with the best publishers in the city; in practice, though, no one from the Pyle School had ever been commissioned on a first call to a New York publisher. As a rule, art editors rarely saw newcomers; when they did, they often appropriated the best sketches and passed them along to be "redrawn" by an experienced in-house artist.

Wyeth barnstormed the magazines. He worked his way up: Edgar Nash at *Frank Leslie's Popular Monthly;* William Henry Maxwell at *Metropolitan Weekly;* Martin Sommers at *Outing;* Ralph Tilton at *The Delineator;* Walter Russell at *Collier's;* and Albert Boyden at *McClure's,* the "most inartistic of all the magazines," according to Pyle.

At *Success,* a manuscript was placed in his hands: "The Romance of the 'C.P.' " by Edwin Markham, a story about the linking of west and east by the construction of the Central Pacific Railroad.

No one had ever before put so much trust in him so quickly. All of a sudden, he had "something to do that's got to be done and is to be used." All doubts vanished. The sense of mission, of authority, "gives me great enthusiasm," he wrote. He had been licensed to trust himself.

At ten-thirty that night Wyeth arrived back in Wilmington and went straight to his easel. It was the next to last day of 1902. By seven-thirty the

Two Surveyors, 1903. Illustration for "The Romance of the 'C.P.,' "
by Edwin Markham, *Success*, March 1903.

following morning, he was back at work. For five nights, he painted through
dinnertime. When he looked up it was 1903.

PAINTING IN black and white, Wyeth laid in his composition: a young
railroad surveyor on a precipice over a "canyon of terrible depth." He waves
to a barely visible second surveyor on a distant crag. At the surveyor's feet,
dividing foreground from middle and background, the rocky precipice

slashes across the picture plane. The first surveyor wears a wide-brimmed Stetson, like Wyeth's own. The silhouette of his cheek, the fold of his shirt-sleeve defining a muscular forearm, the heavy build, the scoutlike determination of the wave that communicates across the canyon—the picture is a self-portrait: Convers Wyeth perched on the brink of transformation, surveying the "terrible depth" he must somehow bridge between two worlds.

On January 6 he took the finished picture to New York and, without a word about carfare, was able to report home that *Success* had accepted *Two Surveyors* and scheduled it—for the third page of the March issue. At the *Post*, meanwhile, Guernsey Moore had gone "wild over my cover and [promised] me $60 for it—within $5 of their highest given."

Abruptly he informed his parents: "From now on, I can easily support myself. I don't think I shall have to ask you for more money."

His optimism came with the age, his own and the century's. Nineteen hundred and three would be a boom year, launching an era of momentous change. Orville and Wilbur Wright would fly at Kitty Hawk. Henry Ford would start the Ford Motor Company. Work would soon begin on the Panama Canal. With the widespread popularity of *The Virginian*, one of the best-selling novels of 1902, an easterner named Owen Wister had single-handedly created a market for a new entertainment genre: the Western. Moviemakers quickly seized the form—radio and television would eventually follow—and while the public waited for show business to reopen the frontier that Frederick Jackson Turner had ten years earlier declared closed, some of the most exciting new images of life in the American West would come from a twenty-year-old picture maker who signed his work N. C. Wyeth.

Likeness

THE WEEK OF February 21, 1903, no fewer than a million readers found N. C. Wyeth's *Bronco Buster* flying off the cover of their *Saturday Evening Post.*

In Philadelphia that weekend, at a birthday party for a cousin, Wyeth had his first brush with the strange immediacy of mass-market publication. The image he had created alone in his studio, only weeks ago, was here in this room, prominently displayed. "They had my Post cover there," he reported home, amazed to find his cousin John Wyeth "showing it to everyone."

The following week, his *Post* cover brought an autograph request from San Francisco and a batch of fan mail, including one letter from a man in Chicago offering cash for a freshly painted copy of the artist's original. By Howard Pyle's definition of fame—"to have people outside of your own town talk about work that you are doing"—this was the real thing, only now that it was happening to him, Wyeth was not sure he liked it.

In the heady early days of 1903, with *Success* marking his first step toward financial autonomy and *The Saturday Evening Post* offering a taste of national recognition, Convers waited until the last line of his regular letter home, then asked his mother to give his love to his father and to mention the news about his double triumph. He called it "my little success."

From Needham, Henry Peck's father wrote to congratulate Convers, but he made the occasion the more bittersweet when he reminded the new celebrity that "your mother, proud as she is of your achievements and opportunities, misses you and your work more than I suspect she lets you know. I hope you will someday bring back your work to Needham and find you can do it here—we can all then live in a sort of reflected glory."

Convers had intended to do just that. "Just as soon as I'm sure of work," he promised his mother, "I can do it [at] home and then I can be home a good part of the year." But the week the *Post* hit the newsstands, a summons came from 1305 Franklin Street. Pyle was ecstatic. He praised the bronco-

Bronco Buster, 1902. *Saturday Evening Post* cover, February 21, 1903.
NCW's first published illustration.

buster and before the week was out called Wyeth to his house on Broom Street.

There, on February 26, Pyle formally accepted Wyeth as a full-fledged student at the Howard Pyle School of Art. On one condition: Wyeth must immediately stop painting for the magazines and devote his entire attention to drawing from plaster casts. At the end of this term of hard work and study, Pyle promised, Wyeth would have more commissions then he had ever imagined.

Nervously, Wyeth wrote home. "I suppose Papa kind o' laughs at these promises, having heard them so much, but Mr. Pyle is no 'pipe dreamer' and always means exactly what he says, and has never been known to have made a mistake in his prophesies as to a student's success or failure." Then, for his father's benefit, he wrote out Mr. Pyle's one caveat to new members: IF YOU WORK AND ARE DETERMINED.

But self-sufficiency would not come as easily as Wyeth had thought. "Finances," he soon realized, were going to be the "bugaboo of [his] life." When *The Saturday Evening Post*'s check arrived, the promised sum of sixty dollars had been hedged to fifty. Wyeth accepted it without protest. Meanwhile, at *Success*, the editors had not told him how much he would be paid. More to the point, Wyeth had not asked. "I never counted the dollar," he later admitted, "an offense which is a part of my blood, I fear."

Unable to bring himself to be direct with the editors at *Success*, Wyeth felt "certain of getting $30 anyway" (as it turned out, he made forty-five dollars), but his reluctance to broach the subject of payment with his first editors shows how quickly he became accustomed to underselling himself. Another seventeen years elapsed before he trusted himself in a business negotiation with a publisher to "put it at them straight and solid."

Meanwhile, with his father he played two parts. Outwardly he vowed that as soon as he could show consistent earnings, he could "give help at home—then Papa will be able to run a farm and live his ideal life." Inwardly he was the guilty son, afraid to surpass his self-made father. "Does he have to work Sundays?" Convers asked his mother. "It makes a fellow feel mean to have comparatively such an easy time." Comparing his own start in Wilmington with his father's in Charlestown, he confided to Newell, "I wished mine had been as practical."

He meant increasingly complicated things by "practical." Picture making promised faster and greater material rewards than any Newell Wyeth had known in the hay depots on Prison Point. Nevertheless, money would not matter if picture making failed to put Convers where he believed he must be in order to earn his father's approval: on moral high ground. For the moment, though, pictures put a strut in his walk. Four years later, looking

back on Wyeth's sudden success, his fellow Pyle student William Aylward would write, "I often envied your optimism. I was I confess jealous of you for it."

Wyeth's three signal events of early 1903—acceptance by *Success*, by the *Post*, and by Pyle—were quickly ratified by a fourth. On March 5, in the studios on Franklin Street, Howard Pyle threw himself a fiftieth-birthday banquet. He invited none of his famous friends or provincial acquaintances, "only us fellows and Mrs. Pyle," Wyeth noted wonderingly. A grand dinner was served with wine. The group drank toast after toast. The twelve presented Mr. Pyle with an engraved silver loving cup. Pyle in turn awarded each man a decoration engraved with the school's name: a small red and gold medal dangling from a black and white ribbon.

Wyeth wrote that the evening represented "a marked point in [his] life." He had never before attended "anything so impressive" and could not get over the "H. Pyle" button on his chest. In his eyes, the red and gold "stand[s] for clean and beautiful color, in other words, 'painting,' and the ribbon stands for illustrating in black and white." He would wear the distinction on his sleeve the rest of his life.

At the moment, though, the Pyle button gave him nothing but confidence. In his own eyes, he had become something more important than a college man—a "Pyle man"—and when the master that night singled Wyeth out in a toast, raising a goblet to "the baby of the class," every Pyle man must have known that his own status was about to change. A new favorite had been born. As for the "baby," he promised his mother that he had not "partaken" of the wine. By eight the next morning he was at work before his new easel.

AROMATIC OF OILS and turpentines, the student studios felt churchlike, with sturdy, arklike beams, diffused, pearly light, a hush of high seriousness. The windows were huge, surmounted by skylights. Even on rainy days, the light inside was luxurious. With only three studios for twelve painters, the atmosphere was competitive; Pyle believed that hierarchy spurred students to do their best. He assigned places according to a pecking order.

Frank Schoonover and Stanley Arthurs, the top two followers, occupied the studio nearest the master's. These "august grandees" were treated with elaborate deference by their juniors. Next, in the middle studio, came the "middle-stage" students, including Wyeth's New England friends Clifford Ashley and Henry Jarvis Peck, as well as Aylward, Arthur Becher, Ernest Cross, and Gordon McCouch. "Babies" occupied the studio fronting the street.

The surroundings were pointedly masculine. Each studio featured a vast brick chimney; varnished mantelpieces stood loaded with rifles, trophies, model ships. The furniture was mahogany, the wainscoting shellacked. Pyle had deliberately made it a boys' club. In the beginning, he had given equal time and space to women students, many of whom remembered Howard Pyle as a devoted teacher. But Pyle began to see that whenever a female student married, she abruptly dropped everything—brushes, picture making, himself—never to return. By 1903 he had decided to limit female enrollment. He gave the decision an official-sounding gloss, concluding that "men were more to be depended upon to make a life work of illustrating than were women," but there was more to it.

Pyle's teaching was not the pure act of generosity that Wyeth and the rest of the Wilmington colony wanted to believe it to be. If magnanimity had been Pyle's motivation for teaching, then it would not have mattered whether any of his students went on to make picture making their life's work. But to Pyle it did matter. Students like N. C. Wyeth were his lifeblood. He admitted and graduated students only if their future, like Wyeth's, could be certified "a future of positive success."

As Wyeth soon learned, Howard Pyle had many sides, not all of them visible. When people did not do as Pyle did, he was easily hurt, quickly angered. The warm greetings of yesterday would become freeze-outs today. His eye could turn as cold as glass. Solemnly patient one moment, wildly irritable the next, Pyle sent all kinds of messages. Thus he asked inhibited twenty-year-olds to reach inside themselves and pull out half-conscious emotions, the more raw and real the better. But lest those emotions appear vulgar lest eroticism or self-indulgence splash across a student's picture—the plain Quaker in Pyle demanded that his pupils live a "worthy, principled life."

Pyle tolerated nothing less than absolute dedication to his crusade, the art of American picture making, which was another way of saying the art of Howard Pyle. He despised laziness. He expected his pupils to follow his schedule of regular working hours. He deplored slapdash work and pronounced trickery of any kind, especially "tricks of technical facility," fatal to the serious painter.

One day Gordon McCouch, a talented, well-liked student, drew an exquisitely detailed bluebottle fly on the edge of his composition paper. The illusion was so lifelike that when Pyle made his daily rounds in the studios, he fell for the trompe l'oeil. Hunching forward, squinting at the fly, Pyle tried—twice—to brush it away with little flicks of his fingertips. Furious at having been tricked in front of the class, he "froze in a cold rage." The crackdown came immediately. On the spot he dismissed McCouch from the Howard Pyle School of Art. McCouch left the studio at once, never to

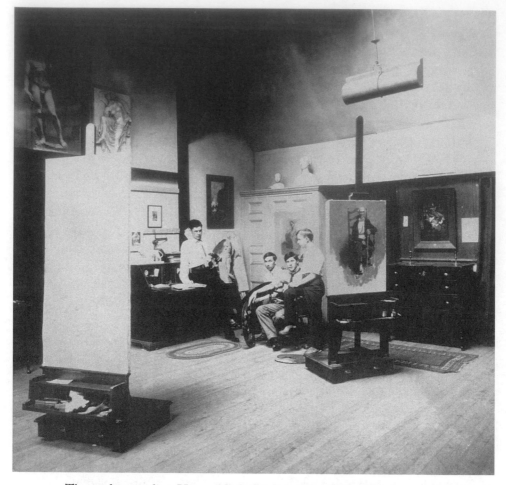

The student studios, Howard Pyle School of Art, Wilmington, c. 1903.

return. Pyle then faced the rest of the class and said, "If he'd been working hard, he wouldn't have had time to do that!"

As the students worked at their easels, drawing from costumed models in the morning and from memory in the afternoon, Pyle returned to his own studio. His last visit of the day, the one most anticipated by the twelve, was meant to appear impromptu. Actually, he gave a performance. Pyle had an instinct for display, and these ritualistic visits showcased his grand manner to phenomenal effect. Wyeth would later endow them with the aura of gospel events, cataloging the sounds made by the master's approach: the "dull jar" of Pyle's studio door, the "slight after-rattle" of its brass knocker, the rustle of ivy as Pyle's tweed coat brushed past the vine-laced doorway, the "faint sound of his footsteps" approaching on the brick walk . . .

"And then, as we had hoped, our own door was opened and he entered in the dim light and sat among us."

Pyle's students openly idolized him. Wyeth was not the only one with a devout view of his teacher. Many of the twelve later wrote memoirs in which, without exception, Pyle could do no wrong. The teacher was doubly parental for Wyeth. He spoke in familiar, totemistic words—"practical" one minute, "homesick" the next. When Pyle said, "Colonial life appeals so strongly to me that to come across things that have been handed down from that time fills me with a feeling akin to homesickness," he seemed to speak for both Hattie and Newell.

Pyle's emotional range went far beyond Newell Wyeth's. In these evening sessions, he revealed his feelings. As dusk descended on the sky-lights and the students sat with scraped palettes and dried-out fingers swabbed with turpentine, Pyle would talk in a soft, hushed voice. He spoke of his own doubts as an artist. He remembered how scared and homesick he had been as a young man in New York. To great effect, he deprecated him-self in the same language he used with colleagues, pointing out his "many shortcomings," his "stiff and halting pencil." He maintained that he was "an extremely slow worker," and as Jessie Willcox Smith recalled, repeatedly "put himself right down on the [same] plane" as the students. He appeared to be "one of [them]," and emphasized the point by exposing his own hopes as a painter, then in the next breath describing "his aspirations" for his students.

He saw them as painters. He told the twelve that he had something higher in view for them than illustration. He wanted, he told them, to create a "National Art Spirit" based on the highest spiritual and moral plane. He wanted to lift illustration out of all relation to commercial art and to put it in its proper, lofty place as the true American art form. It was a mistake, Pyle told them, to imitate Europe or the past. The possibilities for a new Ameri-can art had never been greater than they were now, in 1903.

LATE ONE AFTERNOON, Wyeth was called from his easel to the master's house on Broom Street. The news shot through the studios: Wyeth was spending the evening with "H.P.," helping to hang pictures. Still more astonishing, at the end of the evening H.P. presented Wyeth with a "mag-nificent gift," an original Howard Pyle, a framed black-and-white picture of a pirate fight, widely considered one of his best.

"Everybody is very curious," Wyeth noticed in the studios the next day, adding with a shrug, "Why shouldn't they [be]?"

The master had a new acolyte. Nor was it their first exchange of gifts. Returning to Wilmington after Christmas, Wyeth had mentioned that in

the hayloft of his family's barn on South Street sat a ship's figurehead—a beautifully detailed mermaid. According to Newell, the figurehead had once belonged to his grandfather Capt. Job Wyeth (1776–1840), who had been a privateer. Pyle was "wild" to see the family heirloom. "If there was anything I ever wanted," he said, "it was a figurehead."

Convers had never paid much attention to the object before. Now he surprised his parents by asking them to crate and send it to Wilmington. "I think if I get that for Mr. Pyle, he would cut off his right hand for me." The Wyeths shipped the figurehead. For days, Wyeth fussed over every detail of what he viewed as the importation of an exotic relic. "Tell them not to smash it, cause it will be *very valuable* to Mr. Pyle."

When at last the old figurehead arrived, crated, in Wilmington, it was as if a living creature had been sent in a cage. "Mr. Pyle went wild with it, actually staying from his work, viewing it for fully ½ hour." Unabashedly the teacher's pet, Wyeth reported home that Pyle "slapped me on the back and fell on my neck."

Afterward, Clifford Ashley observed that Wyeth had "certainly got a strong foothold with Mr. P."

Footholds imply ascent. Roped to Pyle, Wyeth was on the way up. He now sat with the Pyles in church, went for walks with the family, ate Sunday dinner under the high slate roof at 1601 Broom Street. He began to wear the master's hand-me-downs. On hearing that his prize student was avoiding a formal dance that Pyle students routinely attended in Wilmington, the teacher called Wyeth into his studio and presented him with a dress suit "which cost him $80." Pyle had worn the suit but once in Boston while delivering a speech. Wyeth accepted the gift, took the suit to a tailor for alterations, but, to his pleasure and surprise, found them unnecessary. "It fit better than any suit I ever had on or ever expect to have," he crowed. The fact that he had attended the dance and had a "fine time," dancing two dances, came as an afterthought. The big news was: master and student were the same size.

Literally grooming his pupil, Pyle lost no opportunity to institute Wyeth as his physical surrogate. When the master had an ingrown toenail operated on, an equally strong man was needed to hold him down. Pyle chose Wyeth.

Boasting about Wyeth's robust physique—"a thing that no other pupil of his has had"—Pyle was willing to bet the future on it. Wyeth wrote home, "Mr. Pyle says he expects a great deal from me as I have plenty of the necessary physical strength to back it up. . . . He is beginning to think that that is an absolute necessity and is going to demand that as equipment of future pupils."

Wyeth did everything he could to conform to Pyle's expectations. Looking up from his easel one day, perturbed to find wet paint on his shirt cuff, Wyeth was about to swear out loud when he saw the master step into the studio. Mr. Pyle tolerated no profanity, and certainly not the word on the tip of Wyeth's tongue: "Lord." He quickly rephrased it to "gosh," which came out as "losh." The revised curse earned him his school nickname.

"Losh" Wyeth excited more than the usual sibling rivalry among the favorite sons of Howard Pyle. His rise in the ranks had come faster than that of any other Pyle student. Promoted from the "baby" studio within months, Wyeth advanced to an easel beside Ashley and Peck. In his next reassignment, the following July, he realized one of his earliest ambitions: to be ranked with Aylward. By the end of his second year, Pyle elevated Wyeth to within reach of the summit: a studio with Schoonover.

Pyle now summoned Wyeth for regular talks. Intended to flatter, they were "*confidential* talks," in which Pyle issued oracular statements about the young man's future. Wyeth recounted that Pyle "had more confidence and faith in me than anyone he ever had and predicted that I would become a painter of renown."

Sometimes Pyle used these private talks to announce a shift in the arrangement of studios. He advocated rivalry as a spur to picture making and therefore put the foremost rivals into the same two-man studio. In proposing the move to each man, he would explain why the weakness of one would complement the strength of the other. Announcing to Wyeth his pairing with Schoonover, Pyle set Wyeth's "physically vigorous" approach to the canvas, as well as his "broader and bigger grasp of facts of life," against Schoonover's habit of "putting more time and thought to minor details."

If Pyle had developed a policy on praise, it was to administer the stuff as an opiate—to produce craving. In his Saturday night composition lectures, the teacher seasoned critiques with superlatives. The work under scrutiny was invariably the biggest, the finest, the best. Hosannas such as "genius" and "great" laced the air. "Gee whiz," Wyeth said after Pyle had taken him aside to glorify his latest composition, "you would think I was the only pupil (in quality) he ever had."

Wyeth called Pyle's praise "blow ups," and after receiving his first he vowed not to get a "swelled head" but admitted that "it makes me feel good and also encourages one to have a great man like H.P. say those things to one among so many."

One evening Pyle announced that Wyeth's new sketch was, without exception, as Wyeth wrote home, "the biggest one, in idea, composition, and thought that has been painted by any of his pupils of the present and

past." Later, taking him aside, Pyle said that if Wyeth worked it out right, he would see to it that the finished picture found its way into *Harper's*.

In another lecture Pyle told Wyeth that he was a genius. He announced that Wyeth had produced the best study ever made in his class, except for one flaw. As Wyeth told it afterward, Pyle proclaimed the work in question "all fine but one part of it, and if I had done that right he would have asked me to present it to him. I'm awfully sorry that I could not have done that one thing right. It was a matter of color."

IN THE SPRING OF 1903, Wyeth's real education began. The student had done well with fundamentals of light and shade; Pyle had advanced him from the drawing of casts to the rendering of facial construction. But Wyeth's attempts at cowboys and Canadian woodsmen were not deeply felt. According to Pyle, his work suffered from a lack of originality. Wyeth needed to look at cowboys for himself, and then to draw and paint not what he saw with his eyes but "what [his] heart and soul [felt]." Pyle concluded the criticism with a lavish, public recapitulation of his faith in Wyeth's talent.

Whereas at first Wyeth had thrilled at the supercharged atmosphere of praise, now he felt devalued by the heightening of expectation, and humiliated. Urged by Pyle to see himself as capable of great things, but failing immediately to fulfill the inflated ideal, Wyeth learned to turn back to the master at the least sign of failure. "So you are having your troubles again, my poor boy?" Pyle would whisper as he approached the young genius's easel. More than anything, it was this sound of fatherly tenderness, the light touch of sweetness in his voice, that increased the feeling of worthlessness.

"No one realizes what I've gone through," Wyeth wrote home one evening. "I don't mean manual labor but my thinking powers are about worn out."

In that morning's composition class, Wyeth had been "sat upon" by Pyle. The dark side of blow ups, "sat upons" were severe critiques. Each began with the same overture. "So you are having your troubles again, my poor boy?" Years later, describing these critiques, Wyeth emphasized, "How Pyle did reach *in* and *down* and fairly *tore* at one's weak spots!"

Wyeth was soon questioning why he, alone in his studio, never quite seemed to do as well as the "genius" that Pyle championed in composition lecture. Maybe the genius was not a genius. Perhaps Mr. Pyle had been mistaken.

Back in his studio after another sat upon, Wyeth again wrote Mama. "Oh! I'm having a struggle with my art. There is a great deal more to it than

Pyle was "a father to his flock," said one student. "He had a grand
sense of humor and could and did, not infrequently, loosen up
and be just one of the boys." NCW is second from left.

one thinks." But after two pages of self-laceration, he stopped, tantalized
once more by Pyle's prophecies ("He told me that I was sure to come out all
right in a short while"), yet paralyzed by doubts about his future: Would he
ever be able to regain the level of his first *Post* cover? Would Mr. Pyle go on
teaching someone who turned out consistently inferior work? What could
he do to please—to regain the master's high regard?

Three hours later, when Wyeth resumed the letter, he wrote: "I feel a lit-
tle better over my work. I think now I've got a hold of facial construction a
little better. People can talk about art being a 'dead cinch' but they are
mightily mistaken. It's grind, grind, grind all the time, from early until late."

He depended on Pyle for everything. If he liked himself, it was because H.P. had given him a "blow up." Discouraged—he had been "sat upon." When the master left for a trip to Chicago, Wyeth noted that "we are left for a whole week to battle alone with our troubles."

In Needham, Hattie sensed Pyle's power and did not like it. Howard Pyle was the first person in Convers's life to displace her, and she did not hesitate to check up on the master behind her son's back. Buttonholing Clifford Ashley and Henry Peck, Hattie asked about Pyle's methods, fretting that the famous illustrator was somehow altering her son. Why, she wanted to know, wasn't Convers drawing horses anymore? He loved horses, she insisted.

Hattie's correspondence with Clifford Ashley shows the extent of her meddling. Ashley spent pages assuring Mrs. Wyeth that Howard Pyle was going to be a good thing for Convers. "Either personally or as an instructor there is no one who could exert a better influence over a young man than Mr. Pyle does and the very esteem in which we hold him permits us to absorb his instruction the more readily." The confident tone of the reply apparently relieved her, and she thanked him. When Ashley returned the thanks, it was his turn to be relieved by Mrs. Wyeth's "approval of Convers's change, which before I felt you had withheld."

Word of his mother's prying reached Convers. "As to my not sticking to horses," he declared, "why I'm doing as much as it is *possible* to do in that line. I am known now among the fellows as the 'horse man.' I'll not tackle a subject that has not horses in it. Mr. Pyle is the last man to pull a fellow away from his specialty."

To demonstrate that nothing had altered his "clean habits," or his earnest efforts to live within his means, he carefully credited every instance of thrift and temperance to Pyle's influence. To prove that for Pyle worldly success must always be not only material but moral, Convers itemized for his parents the great man's charity. He exclaimed over the "$8,000 studio" Pyle had built "just for the 'boys,'" when in fact Pyle's students each paid a share of the monthly mortgage. He noted the "$5,000 worth of Mr. Pyle's originals" hanging on the walls of a student dormitory and remarked on the $100 the Pyles spent in annual upkeep of their country property.

In spite of his determination to prove that nothing had changed him, separation from Needham affected Convers deeply. In Wilmington he suffered mild forms of homesickness and anxiety. In June 1903, when the Pyle School shifted to an abandoned gristmill in Chadds Ford, he began to feel severely disoriented. One day the caw of a crow, much like the sound of the

Wyeths' pet crow in Needham, made him dizzy. If it were not for Howard Pyle and pictures, he said, "the least excuse would have made me pack up for home."

With the Fourth of July coming—his father's one true holiday—Convers's sense of dislocation became more real. The Brandywine Valley reminded him of home and yet was not home. He spent his few free hours on Saturday tramping the fields and woods and riverbanks of the valley, mulling ways to get "HOME."

He wished, he told his mother, that she "could experience the state of mind I've been in the last few days. If I was well enough acquainted with the study of psychological phenomenon I could tell you how I felt but I can't. I'm only waiting to meet a fellow with my same fundamental ideas and have a consultation with him simply to console myself." But he had found no such person among his fellow illustrators.

That summer, monstrous acts of racism and brutality swept the country—the "United States of Lyncherdom," Mark Twain called it. In the Wilmington suburbs, a seventeen-year-old high school student, Helen Bishop, had died on June 16 after being robbed and knifed on her way home from school. Neighbors had seen "a negro following her." Police arrested George White, a black farmhand. Locked up in a small iron cage at the county workhouse, White was held without bail or legal counsel to await a September trial. But that Sunday, in pulpits all over the city, clergymen demonized White as a "fiend" and a "devil," asking their congregations, "Should the murderer of Miss Bishop be lynched?"

The next night, a mob of some five hundred men, led by a Virginian who had been "imported for the purpose," swarmed into the workhouse, seized White from cell 13, and dragged him a mile to the "scene of the crime." They built a bonfire of straw and railroad ties and lashed their victim to it. Newspaper accounts reported that "although the preliminary torture was terrible and almost beyond endurance, the negro remained conscious and rational through it all and fully realized the pain of the final burning." The crowd swelled to five thousand, some in carriages; many "took pleasure in watching the torture administered" and took souvenirs of the corpse home in their "pockets or wrapped in paper." At the end, "a young and pretty woman was led to the inner circle of the ring and was shown the negro's body burning."

Although the country people in Chadds Ford favored the actions of the Wilmington mob, Wyeth recognized the execution for the atrocity it was. But when a local mob formed to hunt down another black man suspected of murder, he went along and "saw it all." He did nothing to stop "the excitement." Afterward, he eased his conscience by confessing to Mama.

He wrote her, "Nobody knows I saw it but the fellows I was with, and [we] wish to keep it quiet." Haunted by "the thing," he drew an oddly impersonal pencil sketch showing four faceless men looking on, as their victim, kneeling, hands bound with rope, appears to beg for mercy. The lack of feeling in the drawing, considering the rawness of emotions that June, suggests how successful Wyeth was at "keeping quiet." He never dared enlarge on the sketch, and he never broke his silence.

THE FOURTH OF JULY that summer was like none that Convers had spent on South Street. For once, the father was exactly as the boy wished him to be. At eight o'clock in the morning, Howard Pyle mustered his students on the lawn of the old Painter place for a flag-raising cannonade. The group exploded day fireworks until noon, then wine was served at an elaborate lunch on the veranda, with Convers again proclaiming his abstinence to Mama afterward. Parlor games followed. Pyle joined in. It seemed, Convers wrote, "as though Mr. Pyle felt as if he couldn't do enough for us."

From three in the afternoon until seven, the fireworks bombardment resumed. After a holiday supper, H.P. ventured onto the veranda and treated his entourage to "an account of his failures and successes up to the present time." Then came singing of college songs around the piano, accompanied by Anne Pyle. Although some of the twelve left as early as nine-thirty, Wyeth played a card game, "The Black Queen," with the Pyles and a few of the other boys until half past eleven. When Mrs. Pyle dropped out, the game continued, supposedly with more ginger ale and ice cream, until two in the morning. At that point H.P. repaired again to the veranda for more oratorical fireworks, this time an "exceedingly interesting talk" comparing the commands of Generals Grant and Lee. It proved to be warm-up only. There was more pageantry to come.

Within hours—six-thirty the same morning—the students got up and raced back to Painter's Folly to attend composition lecture. Pyle threw himself into his discussion ("the most interesting one yet heard") and spoke without interruption for three hours. Then, in what seemed another in his many acts of fatherly kindness, H.P. loaned Wyeth a pair of horses and a carriage and sent him out with three other students to spend the afternoon studying sites where the Battle of Brandywine Creek had been fought in 1777.

Galloping "home to Mr. P," the students gathered around as the master narrated entire battle scenes from his own Revolutionary War paintings. Wyeth pronounced it "the finest discourse I ever heard." He declared these

"the finest people I ever met and finer than I ever expect to meet" and told his parents that these had been "the most pleasurable and satisfactory days of my Penn.-Delaware life." Everything had seemed perfect because H.P. himself seemed perfect. H.P. put all things, even an extraordinary day like the Fourth, on a still higher plane.

Howard Pyle was "just like Papa," Convers told his mother, "very patriotic and enjoys the Fourth as much as the boys." But Newell Wyeth had not painted the American Revolution into the country's consciousness. A Charlestown feed merchant, even one who had served in the Cambridge militia and could produce complex drum rhythms on the kitchen table, was no match for a spell weaver like the painter of *The Nation Makers*. This Fourth of July, Convers concluded, "almost took the place of the numerous happy Fourths I have spent at home."

Ten days later, Wyeth was still in the grip of Pyle's images of national independence. He returned alone to the Brandywine battlefield, writing afterward, "I became so carried away that I got up in search of relics, which of course was useless, but nevertheless my enthusiasm spurred me on to hunt and hunt"—for the pure ecstatic pleasure of bringing back sacred objects to place in homage at the master's feet.

For hours Wyeth mooned around the battlefield, imagining himself in H.P.'s vivid scenes, "till at last my imagination made me almost believe that I could see a Continental soldier lying down beside the brook, drinking of the cool water, the perspiration dripping from his tense face."

This image of seeing one's reflection in a pool of water appeared continuously in Wyeth's pictures: beginning with his 1906 series on the woodland Indians of the Northeast—the "Solitude" series, a study in mirrors painted during the height of his struggle with Howard Pyle—later in *The Black Arrow* (1916), where two young men put their faces to the surface of a "starry pool," and again in *The Oregon Trail* (1925).

AMERICAN ARTISTS had long pledged allegiance to Europe. William Merritt Chase spoke for a whole generation when he exclaimed, "My God! I'd rather go to Europe than to heaven!" That first summer in Chadds Ford, Wyeth realized that he had "no enthusiasm to see Europe except perhaps the homes of my people and a mere curiosity to see the country but nothing deeper."

"I've fully decided what I will do," he told his mother. "Not altogether Western life, but true, solid American subjects, nothing foreign about them."

One evening, the twelve had a big argument, and it was Losh Wyeth who laid down the challenge, "that we should work for the benefit of American Art and that there are just as great subjects here to paint."

Until now his mother's cult of the lost country had been his touchstone. In finding himself in American themes, Wyeth took a first step toward separation from her. In admiring Pyle, however, he delayed the process of fixing his own artistic bearings and becoming his own man. On the battlefield in Chadds Ford, Wyeth's adulation of Pyle went beyond hero worship. Easily the most transforming experience of his growing up, it verged on self-hypnosis.

When his fellow student Harry Townsend turned down a $250 commission that had been passed along by Mr. Pyle, Wyeth tut-tutted, "Too independent."

Wyeth's one attempt at painting on his own that summer ended in near disaster. When at home in Needham for a month's vacation, he produced pictures for *Success,* delivering them to the magazine on his return to Chadds Ford at the end of August. The editors deemed the work unsatisfactory, stating that the "cafe and rum element" in two of the pictures would be objectionable to the magazine's genteel readers. Wyeth would have to rework the compositions. Shocked, he took himself to task: "I knew it! You see, I had no one at home to act as a competitor, which means of course competition, which we get down here in great force." He was sorry he had ever taken the job because, he said, "it practically did me no good."

But it was not a total loss. When Wyeth returned to Chadds Ford, he wrote, Pyle "gave me a welcome that pleased me much and showed that he had not forgotten me." The master complimented his student's *Leslie's* picture—Wyeth had received a commission to illustrate a hunting story about an old trapper and a parson who had learned to catch grizzly bears, as he emphasized, "by *hypnotizing* them"—which Wyeth had finished in Needham. Pyle expressed surprise that Wyeth had done "so well at home."

Autumn brought dry, golden afternoons to the Brandywine Valley. The twelve sketched outdoors. On October 19—"one of the most perfect days I ever have experienced," Wyeth noted—the group showed their work to Pyle. Sitting in his easy chair, Pyle was "the happiest man I ever saw after he finished gazing upon our works. And to my keen pleasure he turned around and congratulated me upon my summer's work and told me that MINE was the STRONGEST, most PRACTICAL and on the whole the *best* of all. He then ranked Oakley, Harding, & True respectively."

Later that day, Wyeth's pride peaked when Mr. Pyle refused to pose alone for year-end photographs but agreed to be shown with Wyeth and another student, "putting his arms around both of us."

Before returning to Wilmington for the winter, the twelve staged an evening of theatricals at Painter's Folly. Losh Wyeth played Narcissus—the youth who falls in love with his reflection in a pool of water. He said of the evening, "Mr. Pyle laughed until he cried."

It had been exactly twelve months since Wyeth had left Needham. More than once that first year he had quieted Mama's fears with promises. "You wait, I'll do it," goes a typical letter of 1903. "I'll settle HOME and in time build a studio and then—I'll be happy."

On January 2, 1904, after Christmas in Needham, Wyeth returned to the Pyle Studios in Wilmington. It was the last time he left South Street with expectations that matched his mother's. Had he not met Carolyn Bockius at a sleighing party later that month, N. C. Wyeth might well have gone home, stayed home, and remained Convers Wyeth the rest of his life.

PART TWO

Wilmington, 1904–1910

The Ideal

B Y ALL ACCOUNTS Carolyn Bockius was the prettiest girl in Wilmington. One can imagine the effect she had on Convers Wyeth as the black sleigh swept them over the snow white hills. Afterward, whenever he fantasized about ideal winter scenes, he pictured Carolyn as the one source of color, with her "black hair flying, [her] dark eyes, red lips, all capped with a scarlet tam-o-shanter and this against the beautiful still landscape, gray and somber with here and there a patchwork of hard crusty snow." He would call her "my model girl."

The real Carolyn Bockius wore simple, subdued clothing, without lipstick or makeup. Her eyes were the first thing most people noticed. In Convers's earliest reactions to her, he found Carolyn's big, black eyes soothing, consoling. He called them "impossible to withstand."

She was a natural beauty. In addition, her shapely good looks coincided with the *belle idéal* of the time: she had the arched neck, upswept chin, and hourglass figure of a Gibson Girl. People frequently compared her to the illustrator's ideal. People noticed her. Howard Pyle had once fastened his eye on Carolyn, but she did not like being singled out by her famous neighbor. Though a beauty, Carolyn was by no means a belle.

In her family she was known as "shy, beautiful Carolena." Shy—yet she posed for her cousin, the Philadelphia painter Caroline Peart, who thought Carolyn the best sitter she had ever had. Peart's *Carolyn* (1904) is artless, unaffected. She wears her lustrous black hair as if it were the plainest hat. The expression of regret in her large, round, watchful eyes makes her look the part of a provincial maiden, a stoic Sister Carrie.

Nine times a sister, Carolyn Brenneman Bockius was born March 22, 1886, at 1310 Van Buren Street in Wilmington, the oldest daughter and second of ten children of a leather tradesman, George W. Bockius, and Annie Brenneman Bockius. Her paternal ancestors were Palatinate Germans. Her great-great-grandfather Christopher Bockius, a Bavarian tanner born in 1755, traveled to Turkey to study advanced methods of leather making in the

Carolyn Brenneman Bockius, 1904.

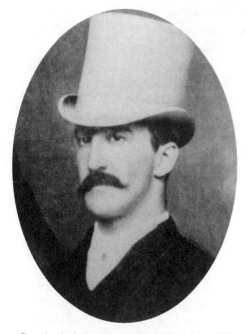

Carolyn's father, George W. Bockius III
(1853–1918), at the time of his marriage,
1882, Philadelphia.

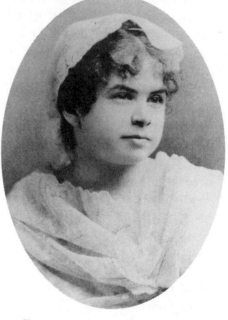

Engagement portrait of Carolyn's
mother, Annie Brenneman Bockius
(1859–1953).

Ottoman Empire. He married an Armenian, Sybilla Lutz, and brought her to America, where he introduced morocco tanning and coloring in Philadelphia in 1784.

Carolyn inherited Sybilla Lutz's high, white brow, "snapping black eyes," and blue-black hair. Named Caroline for her maternal grandmother, Caroline Stoner Brenneman, she had become Carolyn when the doctor filled in her birth certificate. Listed as Caroline in the 1903 city directory, she had begun entertaining suitors at the time of the sleighing party on January 14, 1904.

Closely chaperoned, Carolyn was timid, characteristically "half-afraid of what might lay before her." Had it not been for her friend Blanche Swayne, she might not have joined the party at all. The group, chaperoned by Blanche's mother, Mrs. Eva Swayne, numbered some two dozen young people. Among them were four Howard Pyle protégés, including Convers Wyeth, who boarded at Mrs. Swayne's. Carolyn seems to have liked him immediately. His curly brown hair, droll facial expressions, and small, sensitive hands charmed her. In their first conversation, she discovered that he was a Unitarian, like herself.

At her side Convers saw himself as a grotesque—Beast to her Beauty. They were a contrasting pair: she with her swanlike neck and slender carriage, he with his bullish, broad shoulders; she with her Delaware Avenue manners and Friends School education, he inflamed with the possibilities of art. And whereas her voice was soft, modulated, and gentle, his was high-pitched. He towered over her. Carolyn, at five feet, three inches, came up to Convers's shoulder.

Irresistibly drawn by her "subtle charm," her "fascinating and bewitching smile," her "delicate mouth," and particularly by her "dangerously fascinating eyes," he would afterward confess, "Until I met you, I can honestly say I never lost my head for any length of time."

Three days later, on Sunday, January 17, Convers wrote his mother. It was the second of his regular twice a week reports. Although he had never before discussed religion in their correspondence, he made a point of saying that he been to church that morning "as usual" and that the sermon had been "good." Then he announced a change. On Sunday, January 24, he would "go for the first time to [his] own church," the First Unitarian Church in Wilmington. He gave no reason for the switch except "I met a Miss Bockius the other day and she being a Unitarian asked me to go." Before changing the subject he added one more decisive sentence: "I accepted with pleasure."

Up to this point, Convers's letters to his mother appear to tell the story of his life. He was by nature confessional. She, in turn, felt entitled to know

all, and Convers was her confidant. With his first mention of "a Miss Bockius," another story begins.

THE BOCKIUSES lived three blocks from the Pyle Studios, at 1503 Gilpin Avenue. On his first visit, Convers waited for Carolyn in the parlor. In the months ahead he would listen for the brush of her skirts on the staircase above. That first evening, children ranging in height from three feet to five paraded around the tall visitor—boys in sailor suits, toddlers in lace-up shoes, and girls with bows in their hair.

They were like no family he had ever known. In sheer number they were a new world—four boys and six girls, including twins. Two strains of features divided the group, sandy and dark. The light, sandy-haired, blue-eyed children—Elizabeth, Robert, and Nancy (the youngest)—resembled their mother. Carolyn, Logan, Richard, Hildegarde, and Esther and Ruth (the twins) had their father's dark good looks, high, pale brow, and black eyes. George, the oldest, was "all Bockius—all our features rolled into one face."

The rambunctious troupe had been labeled the Crazy Bockiae, and they could not have been more different from Convers and his brothers. Whereas the wholesome Wyeths had been raised with a sense of duty, the Bockiuses had been instilled with a sense of delight. Whereas the Wyeths moralized, the Bockiuses indulged the senses. Whereas the Wyeths drew stern lessons from stories, the Bockiuses read aloud at the dining room table, shedding tears so freely over Dickens that the family copy of *David Copperfield* became literally "besplotched."

Carolyn's family was dreamy, romantic. "We weren't accurate," said Nancy. "Inaccuracy in factual matters and intuition in place of reasoning were characteristics of the Bockius clan. We were never quite sure where we were going."

The Bockiuses had lived at eight different addresses during Carolyn's childhood. In their latest move, they had left behind a comfortable house on upper Delaware Avenue, Wilmington's most fashionable and expensive neighborhood, and moved into rooms two blocks east of the Baltimore & Ohio railroad—barely the "right" side of the tracks.

Snooty Wilmington did not forgive failure. Gilded Age prosperity had transformed the town's "plain people" into a more than usually class-conscious bourgeoisie. Afraid of losing the ground they had gained, the newly rich put undue emphasis on appearances and manners. The fear of falling backward had produced a gentry of gatekeepers.

Easy to class in Philadelphia, where Carolyn's grandfather had been president of the august Jockey Club, the Bockiuses defied social category in

Wilmington. "We weren't in the social swim," said Nancy Bockius. "We didn't conform. I don't know where you'd put us."

No matter how elevated or reduced their situation, the Bockius children learned to take things in their stride. Carolyn's sister Elizabeth would say: "We're not poor, we're just having an adventure into poverty." Carolyn learned to laugh at adversity. Altogether, over twenty-eight years in Wilmington (1883–1911), the Bockiuses would make twelve round-trip "adventures" from gentility to poverty and back again.

The Bockius residence of 1904, a low, two-story brick dwelling, flouted the canons of bourgeois taste. Attached to the rear of 1601 Rodney Street, their rooms were entered from a side door off Gilpin Avenue. The place looked impossibly small. For a family of ten children, there was a single bathroom. Carolyn's bedridden Brenneman grandmother occupied the bay-windowed room through which everyone else had to tramp to reach the toilet.

Carolyn's mother defined the household. Fey, scattered, refined— forever unrealistic—Annie Brenneman Bockius raised her children without raising her voice, and by methods that Hattie Wyeth would have considered outlandish. When a Bockius misbehaved, Annie took the child aside, respectfully asking, "Do you think you should have done that?" Under her trusting gaze, the children governed themselves, playing wherever they wanted, sliding down banisters, climbing on top of one another.

Intent upon Carolyn, charmed by the family's unregimented ways, Convers at first overlooked the one element that had made Carolyn's upbringing so much like his own. Both families had a father who was rarely home.

Carolyn's father had followed four generations into the family business, C. Bockius and Company, a prominent morocco leather firm in Philadelphia. George was given control of the company in his twenties and ran it into the ground. He was not ready for responsibility. "He took it over too young," said one daughter-in-law. "He was out of his depth."

His father had died when George was seventeen. George was the oldest of five. He had been the adored child, spoiled by an indulgent mother who "cushioned him comfortably against the raw realities." Having grown up in the privileged world of Philadelphia brownstones and summers at Cape May, he went on pampering himself as an adult. For a life of riding, sailing, and dancing, he dressed the part of a dandy. He once hired a string orchestra to serenade a female conquest. When, at twenty-nine, George began courting Annie Brenneman, he was a bachelor living with his widowed mother and a staff of five. Marriage altered few of his indiscretions. Haughty and handsome as ever, George had mistresses, drank excessively, and disappeared for days at a time.

Having failed in Philadelphia, George was exiled to Wilmington. At thirty he started over as salesman for I. T. Quigley, a morocco leather manufacturer. He cloaked himself in Anglophilia. He became the model of a "suave gentleman, wearing his topper at just the right angle and tossing his cane like an Englishman." He moved his wife into modest rooms at 609 Washington Street, where their first child, George Bockius, Jr., was born in 1883. Three years later, George Sr. had done well enough to advance his growing family to 1310 Van Buren Street, a brick Victorian row house, where Carolyn was born in the second-floor front room. By 1889 George was promoted to clerk (he preferred the English pronunciation: "clark"); in 1892 he became superintendent. Two more children, a boy and a girl, had been born; a fifth child, Richard, arrived in 1892.

Then came a plunge. In 1893 George Bockius left I. T. Quigley and for the next three years dropped from sight. In each of those years, the family moved to increasingly drab addresses. Annie Bockius shielded the children. In one dumpy set of rooms after another she created a fairy-tale world. Carolyn and her sisters did not see the factories of downtown Wilmington before they were ten. Well into the children's teens and twenties, Annie spoke of fairies as real people and wishing wells as real places. She filled her conversation and letters with flowers, songbirds, sunshine. She called grapes "little sacks of wine."

The Bockiuses seemed to have, as the children remembered it, "a wonderful life." In fact, they were dangerously poor. No one knew where the money for the grocery bill would come from. For months at a stretch, even as the Bockius girls put on their white dresses and Sunday hats, the family could not afford basic staples. Often the children went to bed hungry.

"With us, it was always feast or famine, never anything in between," Nancy Bockius recalled.

Carolyn never knew her father as he really was. She knew only his letters, long, dull reports penned in a stiff hand. The less Carolyn actually saw of her father, the more her mother encouraged her to idealize him. Annie Bockius dressed up her husband's philandering by turning him into a romantic figure. She insisted that he "carried himself like a Russian Duke whenever he took command." No matter how neglectful he was—even after George had fallen down dead drunk in front of his children—Annie taught Carolyn and her sisters to see their father "turned out most elegantly, with a goodly dash of Thackerian snobbery in the carriage of his head." For the rest of her life, Carolyn would dress up alcoholic behavior whenever she found it in her own family.

"Carol's young artist," as the Bockiuses first called Convers, stepped easily into the needy, appreciative household. A year older than the oldest

Bockius son, Convers assumed the role he had played in his own family: auxiliary father. Carol, the serene oldest sister, presided over her siblings in a corresponding role. Bemused, unflappable, she appears in photographs like a good-natured schoolteacher among her pupils. The Bockius children made Carol their comforter and Convers their protector; in turn, the "Crazy Bockiae" became Convers's and Carol's first brood.

By February, Convers and Carol were trading letters once or twice a week. The romance developed quickly, perhaps more quickly than Convers was ready for. On Friday, January 22, he reported to his mother, "Have been very busy of late and this evening will be my first evening to myself for over a week."

He did not say how he had been spending his busy evenings: "To tell you the honest truth," he wrote, "*nothing* has happened of late worth relating—steady grind day in and day out." At the same time he admitted, "My mind is in a whirl just now, so 'twould be hard for me to write an interesting letter."

Convers also took precautions to keep his new life on Gilpin Avenue secret from Pyle. He instructed Carol to sign her letters Margaret. He, meanwhile, addressed his replies to "My dear Margaret." Anyone in the Pyle Studios would assume he was corresponding with Allen True's sister.

Having fun with Carol's "true" identity, Convers discovered that the privacy intoxicated him. Correspondence with Mama, for all its intensity, was never exclusive: Newell and his brothers were always there. With Carol, Convers was number one. Taking advantage of this powerful new intimacy, Convers shared his thoughts with Carol, admitting that he was "entirely overcome both physically and mentally" by her.

At first, the loss of control frightened him, and he quickly developed another set of feelings. Again and again, he canceled plans with Carol, saying: "You must think it strange or more likely think me a peculiar heartless wretch. Well, perhaps I am. An artist is bound to be if he conscientiously sticks to his work."

Carol saw him as two men. In the parlor, he was tender, charming, affectionate—a rapturous suitor. Back in his studio, writing to her, he deflated his own emotions. Then he would switch and profess abject devotion; then again, checking himself, would remind her how busy he was, painting pictures.

Actually, he was swamped. In February, acting as an eyewitness news team, the Pyle School had covered the Great Baltimore Fire, which had destroyed thousands of buildings; of the seven charcoal drawings submitted

by the team, *Collier's Weekly* had been most impressed with Wyeth's. February also found Wyeth deeply absorbed in a commission for *The Delineator*, a picture of "half-civilized frontier farmers" facing down the redcoats at Concord Bridge. In addition to his regular studio work for Pyle, there was also a small heading decoration that he had revised four times for *Leslie's*, plus three canvases for *Metropolitan*.

Wyeth's highest ambition—to paint for *Scribner's*—still eluded him, but with each commission he was building a reputation, and earning his way. By the end of the year, his earnings from pictures would amount to $1,000. But success had also raised the stakes. Now, whenever he produced new composition sketches, his studio mates would urge him to "make the jump" from the lesser world of *Leslie's* and *Collier's* to a Big Three magazine like *Scribner's*. Wyeth would then, he wrote, "debate in my mind as to whether I should risk taking [sketches] to the big magazines 'cause if they *should* happen to want them—Could I live up to their standard?" Back in the studio, alone, he would have to paint the approved sketch in oil. He fretted, "If I should [then] fall down with the work, it would take a deuce of a while to build a new reputation."

Meanwhile, he debated over Carol. Should he stay another hour in the studio, or pay a call at 1503 Gilpin Avenue? His visits had become for him "the source of great pleasure." These were "beautiful, heavenly evening[s] with the most fascinating company," he told Carol. Yet just as often, he backed out at the last minute, announcing, "I sacrifice this pleasure to my art."

Alternately, he felt needed by the Bockiuses. Happiest when in demand, he became the family's superman, their rescuer, a figure of trust and strength. In times of family illness, he fetched the doctor. He routed druggists out of bed, brought books for Carol's mother, made drawings for little brothers and sisters. He helped with household repairs. In return, Carol's family awakened undeveloped sides of himself. With the easygoing Bockiuses, he relaxed. He found his sense of humor, which matched the teasing, foible-finding humor of the Bockius family.

He also realized that he had tastes of his own, distinct from his parents', and that he could trust Carol to share them. One day in February, after Carol asked Convers to accompany the women of her family to the annual juried exhibition at the Philadelphia Academy and then to dinner and an evening concert, a small, exquisitely wrapped package appeared on Carol's bureau at home. Her sisters gathered as she broke the wax jeweler's seals and opened the box to find mother-of-pearl opera glasses.

To Mama, Convers tossed off these evenings with the Bockiuses as meaningless "invitations" from "some friends here in Wilmington." He pre-

tended to go along on the Philadelphia excursion, "as it's a duty to go to the art exhibit and I'm crazy to hear some good music." Nervous, he then blurted: "Have you and Papa been to any places of amusement of late? I hope so."

Places of amusement, he well knew, were for frivolous people; home-bound duty was for Wyeths. Two years later Hattie and Newell celebrated their twenty-fifth wedding anniversary: "Some would go to the theatre and have a big supper," Hattie mused, but for the Wyeths, "a frugal meal in the house you have passed twenty-five years seems the only place."

Carol's sisters responded to Convers's affectionate outpourings by insti-tuting him as the standard, the model for all future suitors. As the Bockius girls grew up, they compared every man they met with Convers Wyeth. "We thought he was wonderful," said Nancy. "He was a very loveable man."

Carol's mother took him under her wing. Educated at Miss Buffum's School for Girls in Philadelphia, Annie Bockius was a prolific reader. When N. C. Wyeth first came to the Bockiuses, Nancy remembered, "he hadn't read anything. It was Mother who introduced those New England writers to Convers. He came from that background but he hadn't read Emerson or Thoreau. He hadn't read any of those authors, and we lived with them."

Annie Bockius reopened the world for Convers. Yet the change, the test of his loyalties, may have been too much too soon. As he was getting to know Carol, he succumbed to flashes of severe, Wyethesque impatience with her family, which would reappear throughout his life.

One evening in February, interrupting his usual letter to Mama to pay Carol a visit, he arrived at the Bockiuses' to find the whole house standing by helplessly as Carol's brother George suffered some kind of fit— an asthma attack, it later turned out. Stepping into the parlor, "confidently expecting a very pleasant chat," Convers instead found himself man of the house, suddenly put in charge of an ambiguous medical crisis. As usual, George Bockius, Sr., was absent, no one knew where. Sympathetic to the family's helplessness, Convers was also outraged by it, furious at the peril into which *their* fatherless state put *him*.

The ensuing scene made Convers so irritable that when the crisis passed he could not sleep. He resumed his letter to Mama at one-thirty in the morning. But he described the entire evening without identifying the family.

BEHIND HIM at every step in this fatherless courtship stood Howard Pyle. That June 1904, a Sunday newspaper in Philadelphia, aiming to spice up its wedding pages, promoted Howard Pyle's views on the subject of mar-

riage. Pyle declared that "love and practical art are very likely to interfere."
Marriage had no place in the training of a "practical" artist; one's feelings
should be reserved for one's work. "Art and marriage won't mix," Pyle
insisted.

Pitting love against art, the master urged his male students toward the
romantic ideal of experience. To find expression of one's innermost nature,
one must explore nature itself, the wilder the better. Only through firsthand
experience could an artist come to know and reveal himself. Only in nature
would an artist paint what Pyle called "the big picture."

Women played no part in these odysseys. In addition, the expeditions
had an antiquarian flavor, as Pyle pressed his favorite sons to look for expe-
rience not through the eyes of the emerging modern generation but through
soon-to-be obsolescent forms of manual labor and handicraft: Frank
Schoonover would find it as a trapper in the Hudson Bay country; Clifford
Ashley as a knot maker aboard the whaling bark *Sunbeam* on a sperm-
whaling voyage to the West Coast of Africa; George Harding as a net
mender among Newfoundland families trawling the Grand Banks; Harvey
Dunn as a sodbuster for his homesteading neighbors in South Dakota;
William Aylward as a deckhand on the seagoing dry dock *Dewey*, bound for
the Philippines.

Wyeth's friend Henry Peck was perhaps the only Pyle man to pursue an
actual romance while attending the Howard Pyle School of Art. Peck had
gotten to know a young Wilmington widow, and Wyeth and the others
treated his involvement with Mrs. Eva Simpers as a moral outrage. "He's
dead in love with his landlady," Wyeth wrote home tartly. He asked Hattie
to "keep mum, and pray for Peck," insisting, "I don't see what in the world
he can see in her—she is not attractive to me in the least." He judged Eva
Simpers unsuitable on two counts: She was thirty-five, and she had an
eight-year-old son. Peck was twenty-three. "It's really pathetic," Wyeth
wrote, "and everybody is doing all they can to stop him before it's too late,
but he is strong headed and there is 'nothing doing.' "

Pyle treated a student's frontier initiation as a test of purity and charac-
ter. The twelve, therefore, admonished Peck as a corrupter of the master's
"art ideal." They saw him as a sinner, obstinate and impure.

To fulfill his vision, Pyle singled out his most advanced protégés, dis-
persing them far and wide. One Sunday evening, the master summoned
Wyeth to supper. The date was February 14, 1904. Six days earlier the Japa-
nese navy had launched a surprise nighttime attack on Czar Nicholas II's
fleet off southern Manchuria. The instant Wyeth entered the brick house
on Broom Street, Pyle said, "Would you care to go to the Russo-Japanese
War as a correspondent for *Collier's*?"

Pyle assured his student that he, Pyle, had complete confidence that Wyeth was the man for the job. In Baltimore, during the Great Fire, Wyeth had shown himself capable of plunging into the center of widespread crisis and emerging with "practical" pictures. Wyeth had an unfailing eye for detail and a natural facility for rapid draftsmanship. Moreover, he was "the only one in the class capable of taking such a trip, none of the others being fit, physically." But the offer, ultimately, had been based on character. No one, Pyle insisted, would "get along among a strange people" as well as the affable and outgoing Wyeth.

Emboldened by the master's trust in him, swept up in this classically grandiose Pyle gesture, Wyeth jumped at the chance. "Yes, by all means," he answered.

Pyle went to the telephone—a special occasion, for the telephone was rarely used. He dashed off a telegram to *Collier's* announcing Wyeth's acceptance and demanded a reply by early Monday morning. True to form, Pyle then devoted the rest of the evening to plotting every detail of the trip, as Wyeth wrote, "what I should take, do, etc." It was a major assignment. Wyeth would be among talented company overseas; Robert J. Collier had already signed up Frederic Remington and hired the celebrated war correspondent Richard Harding Davis at $1,000 a week. Pyle predicted that this would be the making of N. C. Wyeth. He was going to start as Winslow Homer had—as a war correspondent.

That was Valentine's Day. Convers and Carol had so far exchanged only polite cards. Two days earlier their relations had faltered. Disheartened by Convers's latest rejection, Carol had asked for her letters back. He answered, still addressing her under cover of Margaret True: "I did as you bid me as to all letters received from C.B.B. and sincerely hope you will do likewise with mine, please? I'm mighty sorry that you are all broken up and I feel strongly that it was my fault but am happy to think and know that you weren't 'playing' with me."

He was a free man—ready, as Pyle now prophesied, to make a name for himself in Manchuria.

Early the next morning, with Wyeth's expectations at their highest, the reply came from *Collier's:* "Two weeks too late. Would have been glad to have gotten him then, but [now] it's too late." He wrote Mama the next day: "I haven't lived in this world at all for the last two days," adding, "I have fallen back to earth with a *thump!*" His one consolation was that Pyle had thought highly enough of him to promote him to *Collier's*.

It was cold comfort when Carol invited Convers to go on courting her. Nor did she slam the door when she learned that the night before Valentine's Day he had accompanied Blanche Swayne and Etta Boulden, the

daughters of his landlady and boardinghouse cook, to the theater; or when he sent Carol stiff, formal notes, one of which informed her, probably truthfully, that a cousin had just arrived from Lancaster, Pennsylvania, and might stay overnight.

Carol accepted his statements without question or reproach. She offered several more dinner invitations, each of which Convers refused, claiming to be at work every night until one in the morning. She replied with a note of encouragement along with some oven-warmed buns. He claimed himself "not deserving of such sympathies." At one point she sent him something important by mail—we don't know what, but he called it "treasure" and promised to guard it with his life. Shortly afterward they met.

He wrote her that night. "Please, for my sake, forget what I told you this afternoon, I made it too serious. My spirit was low and has been low in fact for a whole week on account of my work and I'm afraid I put my condition in too dark a light." That night, when he said good night, he called her dearest and told her he was thinking of her. He asked her to "be careful of yourself for *me*."

But he was not always thinking of her. He continually reminded Carol that Mr. Pyle had warned him against "social pleasures." He then announced that it was Pyle, not Carol, who was "at the bottom of [his] present standing," and when his fellow disciples turned the studios upside down in anticipation of another banquet for the master's birthday in March, Wyeth shouted, "The Banquet!—that's all we're thinking about." Two weeks later, when Frank Schoonover returned from Hudson Bay, bristling with snowshoes, traps, furs, guns, stories of near starvation—primarily, with sketches—Wyeth could not get over the metamorphosis of his rival. Bland, baby-faced Schoonover was bronzed, unshaven, strengthened "both physically and in character." And "not only physically," Wyeth added, but "financially." Schoonover had "gained knowledge worth hundreds of dollars."

Schoonover had become a living advertisement for Howard Pyle. He had brought back pictures of himself, H.P.'s emissary, flying the HPSA flag at the edge of the wilderness. Schoonover's northern odyssey left Wyeth "strung up to the highest pitch of excitement." The trip had "made a man" of Schoonover, as well as "setting up" the artist "for life"; and Wyeth, more than any of the twelve, could not help but "realize the seriousness of it all." No matter how favorable his own status with H.P., he could not hope to supplant Schoonover as foremost projector of Howard Pyle's "art ideal" unless he himself acted. The message from Broom Street was clear: if Wyeth was serious only about Carol, he would fail himself, his teacher, and art itself.

The day Schoonover returned, Wyeth vowed to work harder, "which pleased Mr. Pyle," who took to dropping hints that Wyeth would be next in line to "do the same thing in a different part of the country."

BY 1904 PYLE had reached the peak of his powers. At the March 6 banquet in homage to their master, his students set up a large gold picture frame in the hall. It showed each man "costumed out absolutely correct in detail and color," striking the pose of a well-known character from the Pyle canon. It was a measure of Pyle's cultural supremacy that more than a dozen fictional characters were recognized as "his," as if Howard Pyle were the creator of Robin Hood, Sinbad, King Arthur. Even more potent was the idea that his pupils would become his paintings. Wyeth, the biggest, was Robin Hood's friend Little John. Pyle was so overjoyed by the uncanny mirroring of the tableaux vivants, Wyeth recorded, "he actually threw his arms about us in his wild ecstasy." After hours, still clad as Pyle's characters, the banqueters drew swords, ripping into one another in the darkened studios, as they enacted the very forms of aggression that Pyle's pictures had made alluring.

For Wyeth there was liberation in likeness. The closer he drew to Pyle—in image and in action—the less he worried about his own future. One week, working alone in Howard Pyle's studio while the master was away, he felt pleasurably dwarfed by Pyle. His own work seemed inadequate and "a continual keen disappointment." In the subordinate position, Wyeth found temporary reprieve: He would not have to be himself just yet. He could go on being what he knew best how to be, the favorite son.

The canvases of the female pupils at the Howard Pyle School of Art tell another story. None of the women who studied under Howard Pyle imitated him. The character of their work remained their own. The men in Pyle's hierarchy, however, "couldn't help it." For Pyle's male artists, especially the two torchbearers, Schoonover and Arthurs, the most gratifying professional rewards came when their work most faithfully resembled Pyle's. Years later, when trying to describe why "all our work looked like his and all our work looked somewhat alike and was all very dark in tone," Frank Schoonover decided that the master's "personality was so great and so strong that we were like chicks, still in the shell."

The *Harper's* historian Eugene Exman would argue that Howard Pyle's students were "too dazzled by the Howard Pyle convention." Schoonover, like many boys of the 1890s, had been trying to paint Pyle's pictures all his life. He had taught himself to draw by copying his favorite Howard Pyle

illustrations. But the fault, Exman believed, was with the teacher, not the students. "He failed to help them develop their own characteristic style."

EXAMINING THEIR SITUATION in March, Convers was ready to admit to Carol, "I'm dangerously in love." But "unless I'm wary and exceedingly careful my art career may be nipped in the bud."

As he saw it, there was no having both. Under the influence of Pyle, he framed his feelings for Carol as a death struggle between the poles of Art and Love. That Sunday, March 13, he wrote her, "I have been considering as to whether I should call this evening or not and after a careful and sincere consideration I decided not." He explained that a new development in his career had arisen, and "as tomorrow is a day of special importance I feel it is my strong duty to prepare for it." Without elaborating further, he warned her, "Don't blame me for this decision."

The previous Saturday, Stanley Arthurs had returned from New York with important news: *Scribner's Magazine* was interested in Wyeth's work. Arthurs hinted at the possibility of a meeting with Joseph Chapin, the "foremost art editor this side of the Atlantic."

When Convers wrote Carol the following day, he withheld any mention of *Scribner's,* delivering instead a stern lecture on a theme that would occupy him to the end of his life—the fear that loving interferes with painting. "It's a dangerous game we're playing," he warned her. "I'm young and you are younger and if you were as serious as I am I'd be afraid to say what might come to pass—I swear that I have never been in love as I am at present so *beware.*"

JOSEPH HAWLEY CHAPIN was thirteen years Wyeth's senior, a big gap for the twenty-one-year-old artist. When Wyeth described entering the six-story Scribner building on Fifth Avenue and Twenty-first Street on Monday, March 21, 1904, he pictured being ushered into Chapin's "majestic presence." Standing before Chapin "with fear and trembling," he saw himself as a supplicant and Chapin as "benevolent and austere," a figure whose name "crowned" the art department at Scribners. "He made me think of King Edward VII," Wyeth later wrote.

With Joseph Chapin, the comparison was appropriate. Praised by illustrators as "the beau idéal of art editors," Chapin was a natural ruler. He maintained judicious impartiality and "could tackle any temperament sympathetically." With kind eyes, a "nice chuckling friendly laugh," and a plump, balloonlike figure, Chapin had kingly appetites. "Wherever he

Joseph Hawley Chapin (1869–1939). *Self-Portrait.*

went," one Scribners colleague remembered, "champagne was ordered—presto!—and there was always a jolly party." Illustrators adored him; they felt understood by him.

Unlike most art editors of the day, Chapin cultivated personal relationships with artists—he had been one himself. Joseph Chapin was born in Hartford, Connecticut, in 1869. He had worked five years in the insurance business before attending art school. He became an illustrator for the Hartford *Times;* then, in 1897, after three years as art editor at *McClure's Magazine,* he joined Scribners, becoming the top editor at the top magazine in the great age of the monthly.

Power had at first troubled Chapin. Finding himself in a position to pass judgment on the work of more experienced artists, he stalled. He did not dare express his own opinion. Trying to "look wise," he managed only to give the impression of coldness and superiority. "I had what I afterwards found was called an 'inferiority complex,' " he later said. "I felt the need of other opinions."

One opinion he relied on was Howard Pyle's. Chapin frequently visited Wilmington in search of talent. With Pyle pupils there was "always a guarantee of conscientious application toward a distinct art ideal." Chapin had

bought drawings from older Pyle students like Jessie Willcox Smith, Max-field Parrish, and Violet Oakley. From the current twelve, he had launched the top three: Schoonover, Arthurs, and Aylward. Now, here was N. C. Wyeth.

Chapin handed the newcomer a manuscript for which an illustration was needed right away. Wyeth read it on the spot. The genre was historical romance; the story required close study of costume and customs. In addition, the pictures had to be painted at top speed. Together, editor and illustrator discussed the text and soon arrived at a sensible, if disappointing, decision. They agreed that the story's demands, along with the unusually short deadline, were wrong for such a thorough and painstaking picture maker.

Afterward, Wyeth recorded that it was he who had arrived at this tough conclusion, "for my own good." At the time it must have seemed a setback. But something about Chapin fortified him. Although Wyeth had wanted to jump at the opportunity, he was ready to admit that it might not be right for his talents. This proved a fateful choice.

Impressed by Wyeth's clear view of himself, Chapin immediately offered him another chance, a "Russian story." The subject matter and lead time would conform to Wyeth's talent. Moreover, this text—"A Strange Story," by Ivan Turgenev—would turn out to have a far longer life than a one-time romance in *Scribner's Magazine*. Appearing that November in *The Novels and Stories of Iván Turgénieff,* the painting entitled *I Could See Only His Shaggy Head, as Huge as a Beer-Kettle* marked N. C. Wyeth's debut, at twenty-two, as an illustrator of world literature. The sixteen-volume author's canon, introduced by Henry James, would remain in print for more than three decades.

What was immediately certain was that Chapin and Wyeth could work together. The solution they had arrived at for the Russian story would characterize their long collaboration. With Chapin, Wyeth perceived himself and his abilities accurately. Of his two mentors, Chapin in the long run would prove the wiser. Chapin, not Pyle, would draw from Wyeth his best work, for Chapin possessed a quality which was indispensable to the single-minded Wyeth, and which the single-minded Pyle also lacked: the "clear, broad, two-way avenue of his mind." Known as a "clairvoyant friend" to his artists, Chapin was able to see and serve Wyeth as Pyle could not.

SPRINGTIME ON the Brandywine seemed to offer hope for love. But as spring vacation approached in April, the duel Wyeth had been fighting, between Carol and Howard Pyle, reached a climax.

NCW's first commission as a book illustrator. *I Could See
Only His Shaggy Head, as Huge as a Beer-Kettle,* 1903.
Illustration for "A Strange Story" by Ivan Turgenev.
Frontispiece, *The Novels and Stories of Iván Turgénieff,* vol. 14.

Writing to Carol on Sunday, April 10, he addressed her as coolly as pos-
sible, not as Carol or as "Dearest," or with the intimacy of their secret code
name, Margaret, but as "dear Miss Bockius."

In another two days he would be going home. He announced plans to
embrace "dear old Needham" and to "lay back in her arms for at least ten
days." Instead of courtship paddles on the Brandywine, he intended to enlist

his brothers for overnight canoe trips up the Charles. Billed as a long-awaited reunion with his mother, the trip would distance Convers from Carol. When he returned to Wilmington, he hoped to "retain the privilege to pay you a call" but said he would no longer be free to "sink deeply into the luxuriant arms of social life."

As he explained it, a life that included Carol would be "right for me . . . [only] if I had already secured a foothold in my art, had seen the world, had gained the greater part of my knowledge."

He allowed that his feelings for Carol were stronger than she knew, but he dared not "succumb" to them. If he did, what would be the consequences? It "would mean," he admitted, "the ruination of my accomplishing the ideal Mr. Pyle has set before me which has become a part of my life and being."

While suppressing terms of engagement and marriage, he clearly meant for his words to push Carol away, "which action," he wrote, "I believe will be beneficial to us both." Finally, he hoped he would not lose her "as a friend," and in case she did not feel alienated enough he signed off "N. Convers Wyeth."

He added a postscript: "Don't be led to believe that I'm endeavoring to pose as a 'strong character,' and taking advantage of this opportunity to 'show off' so to speak, my will power. I've often scorned fellows who succumbed under these very conditions and from them learned a valuable lesson which I'm earnestly trying to follow."

THE DAY before Wyeth was to leave for Needham, he submitted a new canvas at composition class.

The sepia-toned oil depicted an Indian in a canoe lifting a moose call over a glassy moonlit lake. Pyle liked it. The picture was Wyeth's strongest work to date, and though it just missed being "the big picture," it was good enough for *Scribner's*. Pyle advised his star pupil to stay "in the spirit of it," finish it up, then take it straight in to Joe Chapin's office. Pyle predicted that Wyeth would sell it instantly.

Wyeth did as he was told. Delaying his departure for Needham, he put in a week's work, then took the not quite dry canvas directly to the Scribner building at 153 Fifth Avenue. It was a rainy Monday morning. Wyeth unfastened the hinged carrying crate and lifted the painting into the watery gray light.

Chapin regarded the picture in silence, tilting his expressionless face first to the right, then to the left. Abruptly he rose, announcing that he would like to show the canvas to Mr. Scribner. In ten minutes he returned. He seated himself behind his desk. "We'll be glad to buy your picture and can offer seventy-five dollars for it."

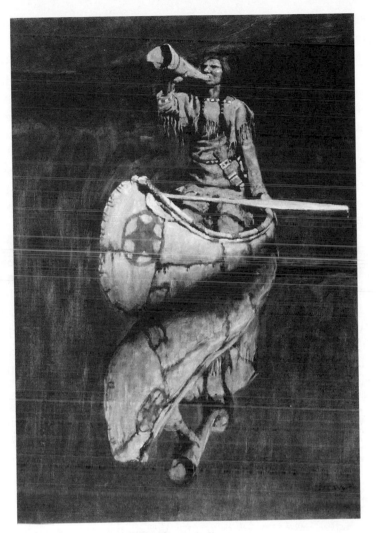

The Moose Call, 1904.

. . .

CAROL accepted Convers's rejection gracefully. Marking her first indulgence of his "artistic" temperament, she wrote him an understanding letter and sent a wrapped package to coincide with his arrival at home.

In Needham, reunited with his family, Convers knew at once who the package was from, but since Carol Bockius was still a secret from his parents, he had to pretend, for "two days of puzzled wondering," that the parcel was a "deep mystery."

Genuinely amazed to find a framed photograph of Carol inside the wrappings, he wrote her on April 27.

> I can tell you it was a surprise and a *mighty* pleasant one too. The picture I like very much and am happy to have it but honestly speaking I don't think it does you justice. A second surprise was in store for me and that was the letter. Of course I remember I asked you to write but hardly expected you would do so. I enjoyed it much and must thank you again for the kind way in which you looked at my actions. I often think of the night I wrote my "confession" as you call it, and wonder, would I repeat that action if it were now? Well, I guess I'd better quit seeking trouble.

Back in Wilmington, their relationship revived, Convers courted Carol on the Brandywine. In June he ordered his brother Nat to send down his birchbark canoe by freight. He told his mother that the canoe "would be an extremely valuable bit of studio property for me. My future important work will be Indian stuff so you see a canoe is VERY appropriate."

While waiting for the canoe, Convers hired a horse and runabout and ferried Carol out to Chadds Ford, telling Mama that he had gone "in company with Miss [Etta] Boulden." He and Carol went unchaperoned. The day was dazzling, and "the Ford" looked like paradise. With Carol he did all the things in Chadds Ford Convers would have liked to have done at home on South Street, if he had been able to present Carol there. He introduced her to old friends and showed her all his shrines and sites: Painter's Folly, the mill where the class had painted, the cornfields and pastures he had walked in. Probably, they kissed.

In any case, they had together established Chadds Ford as their "enchanted realm." Afterward Convers predicted that they would someday "go again into the country *alone*. Free, as we did, into the hills, lost to the noisy world. We shall do it again and again won't we? What a simple and wholesome life—full of energy, full of a vigorous life, and full of healthy inspiration. We *will* live it!" For her part, Carol would never forget "that day at the Ford."

Howard Pyle had meanwhile given up on Chadds Ford, discontinuing the summer class. Back in Wilmington that summer, Wyeth missed the outdoors keenly, but his professional aspirations were at last coming true. He completed the Turgenev frontispiece in three days, "the record time down here." Chapin offered him a second book commission, *Boys of St. Timothy's*, a school story for which Wyeth made quick work of a football picture and another of a boat race.

Carol and Convers, cornfield, Chadds Ford, 1904. NCW to CBB:
"The effect and impression of *that* day at the 'Ford' still clings . . .
and will never leave me."

Carol on the banks of the Brandywine, 1904.

In the hot summer silences of the studio, a third book commission was giving him trouble. Sweating out an illustration for P. F. Collier & Son, he was blocked but did not know why. "I've made an absolute failure of the 'romantic' picture for Colliers," he told Mama, "and Mr. Pyle has got to (for the first time) help me out. He is trying hard but can't seem to do it. It seems so funny after I got along so swimmingly with my Russian picture and then not able to pull out a much easier subject."

Was romance so easy? He told Carol that he felt happy now that they had "fallen back into those 'old days' of 'close friendship.'" Once again, he signed his letters "Convers." At the same time, he felt so synchronized with his mother that it was "possible for us," he reminded her, "to understand a greater meaning with a mere suggestion." And yet, in the thirty-nine letters he had written her since the January day he had met "a Miss Bockius," he had still not owned up to his new life with Carol. He wrote instead of leg cramps at night. He called them "growing pains."

An Old Weakness

ONCEALMENT WAS ONE of N. C. Wyeth's lifelong traits. Before he left home in 1902, the turmoil of his mother's emotions had been among the first things he had learned to suppress. During his years in Wilmington, her condition had worsened, and Hattie had come to depend on Convers—on Convers alone—to sympathize with her depressive moods. Now, as her oldest son's life and affections increasingly divided, his mother's need of his assurance redoubled.

Every evening, when Newell and the boys got sleepy, Hattie's pulse quickened. With her husband in bed by nine o'clock, and Ed, Nat, and Stimson asleep or studying, she remained by herself in the kitchen, writing letter after letter to Convers. She filled every inch of every page with her crabbed hand. On as many as twelve sheets of writing paper, front and back, she stacked sentences like cordwood—dense, airless piles of words, as many as would fit. Jumping from topic to topic, she reported events of the day, town prattle, trifles, muddled bits of thinking in which she freely mixed the living with the dead, the past with the present. In thousands of letters she seldom separated thoughts into paragraphs.

As she wrote, she worried. Health, safety, money, buried relatives—her fears rolled out under her pen. "All the time fearing, that seems to be my way, and I realize it," she wrote to Convers. One night her "head was sorely troubled with football events." Turn-of-the-century football, played without helmets, understandably provoked Hattie's anxieties. In 1905 no fewer than nineteen players were killed in high school and college football games. The Wyeth boys played on the village team, which scrimmaged against neighboring Wellesley and Wayland. One afternoon Newell had persuaded Hattie to join him at the Wayland game, but then Papa himself failed to show; he had gotten tied up in Charlestown and missed his train. Stranded, Hattie had to watch the "awful game" by herself. After every rush, "there was a man out—twice the doctor was called—my limbs were weak and trembling."

Another night Hattie imagined that her children "feared" her. She had once asked Ed and Nat if they were afraid of her. They said no, "never." But she was not so sure.

The boys at home differed from Convers in their understanding of their mother's condition. For the most part, they accepted her nervous energy as proof of her exceptional sensitivity. Her ability to "feel" furnished more evidence of her spiritual nature. Nat and Stimson were affected by her depressive moods, but Ed refused to identify with her illness.

During sieges Ed tried to be kind to Mama but succeeded only at being detached. Afraid of her ups and downs, he appeared practical—the usual Wyeth antidote. "If a young man has a fond mother and the circumstances are such that he can leave home," Ed observed in 1908, "it only makes it harder the longer he waits."

Nat was devoted to his mother. According to Hattie, Nat made "a fine nurse," but he always ended up playing second fiddle. For Nat, "there was never the closeness that existed between Convers and his mother," Nat's daughter Gretchen later said.

Hattie believed that Stimson had empathic powers beyond the others. At fifteen he seemed "magnetically connected with my mind and feels only too much for his age." Perhaps it was much too much; whenever sieges began, Mama noticed that "Babe always acts dazed and scared."

Hattie described every detail of the illness to Convers: "I do not feel that the boys should realize how I feel, as they can do nothing and it only makes them unhappy." She believed that he alone would not shrink from her "agitations." He did not. Only later in life, in the course of illustrating "Chavero," a story by the novelist James B. Connolly for *Scribner's Magazine,* would N. C. Wyeth produce a portrait of a son imprisoned by the ambiguity of a mother's undefined illness.

Warranted or not, Hattie's worries came pouring out as she wrote Convers from the kitchen. The more she worried, the more she wrote. The more she wrote, the longer she kept her sleepless vigil. The longer she went without sleep, the more convinced she became that she was right about all her morbid worries. The strange, sinking feeling in her chest—surely, *that* must be a mark of advancing age.

Eventually she would take herself up to bed. Though tired, she had a physical dread of falling asleep. Her heart would pound in her ears, her mind would race ahead, anticipating nightmares she had been having. In 1907 they would recur—"baby nightmares," Newell called them.

No matter when she shut her eyes, she awakened at dawn, her mouth dry as dust. When she consulted Dr. Pease in Needham, she got no relief. Hattie asked if the "continuous strain on [her] mind had anything to do

NCW, with his parents, on a visit to South Street, 1904.

with making her nights restless." She inquired about the "depressed feelings about [her] chest." Pease told her that her symptoms were "due to too much thinking." The doctor advised Mrs. Wyeth to stop writing. "My only pleasure left is writing," she moaned. "Now I'm supposed to drop that."

She felt miserable for herself, resentful of Newell. During one siege, when Hattie's head had "felt bad for nearly a week," Newell had "been out every night, both socially and on business." Her husband's neglect galled Hattie, but she was too afraid, she wrote, to tell him "how it preys on my mind." Instead, she protested to Convers. "I hardly think [Newell] feels that I realize it, or else he doesn't say so—if so he'd arrange differently."

She complained that she would sleep better if there were more air in their bedroom at night. "But if we have night air, then Newell catches cold," and since Newell's habit of overworking made it impossible for him ever to recover his health, "if Papa has the least cold, he has that little cough that hangs on."

In letter after letter to Convers, she begged for sympathy. She ended one night's epistle with a kind of self-benediction: "And peace to myself—for having a family of strenuous boys, I certainly deserve sympathy in a way." Listing imagined wrongs, she upbraided Convers for not writing, when, in reality, he wrote as often as she. Stubborn, self-pitying, she plagued him with peevish lamentations.

He saw everything in the best possible light. Only after her death would he acknowledge that "Mama burned up much of her physical vitality by her inability to put into more satisfying and coherent form the intense agitations of her emotions." At the time, he denied his mother's condition. Perhaps it was the only way he knew to get on with his life.

ON AUGUST 12, 1904, Pyle notified Wyeth that he had graduated from his classroom studies. Not a commencement day in the conventional sense, it was still "a day of joy to me," Wyeth wrote. No one could believe the rate at which he had developed. He had been a Pyle man for less than two years. "You have grasped things more quickly and more solidly than any fellow I ever knew," Stanley Arthurs told him.

Pyle had taught him to paint. At the same time, Wyeth was still very much his master's creation, doubtful of his own power. He planned to "launch forward 'full force' into illustrating and painting," yet he would still seek Howard Pyle's judgments, if not on every sketch, still on every completed picture.

"I think I'm on the right track, and now a great deal depends on my natural talent of which I'm a little afraid," he confided to his mother. "A fellow

has to have a certain amount of the latter to produce fluent and attractive works."

Yet he resisted moving forward. After almost two years in Wilmington, he felt he could still "go right home and fall back into the old routines, as if nothing has happened." Wishing himself into the past, Wyeth concluded, "That feeling will always cling to me until I die."

In Wilmington that summer, his eye turned again and again to Needham. Some recent snapshots from home reactivated his melancholy. He wrote that he wished he could "identify [himself] again with that snatch of ideal life placed upon those meager bits of sensitized paper." He worried that the photographs might actually do him harm. "At times I'm in such mental conditions that it would take but very little to set me off—out—away from . . . this unhealthy city, its depraved populace swarming the garish sidewalks, their conventional methods of living contrary to the Laws of Nature."

With Carol out of Wilmington for the summer, enjoying the "satisfying influence of nature" at her aunt Martha Peart's shaded summer estate in Rosemont, Pennsylvania, Convers's loneliness revived. He could honestly report to Mama that "Mr. Pyle is the only solid rock that keeps me here and to that I will cling as long as I see fit."

He remained unsettled. Launched "full force"—though neither fully into illustration nor fully into painting, a splitting of energy he would increasingly emphasize—Wyeth flailed in the studio. Bereft of Carol, he depended on the approval of the men he had enthroned, especially Joe Chapin, but also Edward Livermore Burlingame, the bald, bewhiskered editor in chief of *Scribner's Magazine*. One Friday in early September, Wyeth set off for an appointment at Scribners feeling timid, with what he described as a "total lack of confidence in myself or work." After learning that his pictures had proved "very successful in the eyes of Messrs Chapin and Burlingame," Wyeth returned to Wilmington "full of hope and a new determination to work harder than ever."

The success of this trip prompted Pyle to suggest that the time had come for Wyeth to embark on his own official HPSA odyssey. The master proposed a monthlong journey to the American West. "The *great West* is the place for me," Wyeth agreed. "It has never been painted except by Remington and he has only pictured the brutal and gory side of it and not the sublime and mysterious quality of those limitless plains and their heros." Wyeth negotiated with *Scribner's,* which offered to pay travel expenses in exchange for first refusal on pictures from the expedition.

Now that a journey was in the offing, now that there was no chance that either of the women in his life could keep him from this last initiation as a

Pyle man, Convers felt free to tell Carol that she was the "girl I love *more* than any other person in the world, except my mother."

Before packing for the big trip, he made a visit home to Needham to say good-bye to Woman Number One. But the night before he left for Boston, something happened in Wilmington that changed the course of his feelings and of his life. His landlady, Eva Swayne, suddenly asked if he was in love.

"She spoke lightly and made fun of it, which brought me to a fever heat," he told Carol. "I don't know exactly what I said but I guess she knows the truth." Worried that Mrs. Swayne "might say something," he had "closed her up." He warned Carol to be on guard. He worried that Eva Swayne would gossip about Carol, damaging her reputation on Delaware Avenue. For himself, the incident had a liberating effect. On the Fall River steamship *Puritan,* he wrote:

> My Own Dear Carolyn,
>
> From the very instant I awoke this morning I have felt lovesick, blue, or whatever you may call it, I don't know. The parting last evening was heart-rending; it was dangerously so—I never came so near giving up a trip in my life. . . .
>
> Carolyn, I never knew what love meant, but now I *do.* You are the only girl I ever cared for or ever will care for, and please, please no matter how long I'm away *don't* go back on me. *As sure* as I'm alive, if you do, I'll *never* return to Wilmington. . . .
>
> My mind is made up and *never* will be changed. . . .
>
> I'm desperate now and I don't care who sees this letter. My efforts in life will all be for you, no matter what happens.
>
> Don't think I've lost my head, because I've had all day to think over things. I won't read this letter over at all so excuse my spasmodic style of writing, I can't help it. With hundreds of kisses, Convers.

Carol replied the following day:

> Dearest! I love you with every fibre of my being, devotedly, unfearingly, so loyally that I could make any sacrifice for you in the advancement of your art. What a dower you possess, talent, pure conscience, and physical strength to sustain it. . . .
>
> I hope you see your mother. I feel sorry for her sake to have you set out on such a long journey without giving her goodbye. . . .
>
> I think of you, dream of you, and long for you Convers dearest. Carolyn.

Four days earlier Convers had written his mother in New Hampshire. Hattie, accompanied by her cousin Margarette "Gritli" Holzer, had been safely tucked into the "green paradise" of New Hampshire for her annual rest cure. On September 14, she heard from Convers that he would be coming home before his trip out west. He would arrive in Needham "probably the last of the month." He promised to let her know the exact day.

But Convers came home two weeks early, on September 15. Having done his duty by returning to say good-bye, he at the same time failed to tell his mother the truth about when he had arrived. She was still in the mountains, still in the dark. Once home, moreover, when he could wire New Hampshire, he decided that it would be unwise to disturb Mama with a telegram. Citing her "condition," he waited a day.

For nine months Convers had sustained the fiction that nothing had changed. If he now revealed that an eighteen-year-old girl from Wilmington was going to alter their lives, there was no telling how Mama would react or how long it would take her to get used to Carol. Convers was still struggling to win Hattie over to Howard Pyle. It would be another year yet, and it would take the death of her own father, before Hattie would begin to see Pyle as a second Agassiz—doing for her son what she imagined the great Swiss naturalist had done for her father. "I can seem to feel a thrill of satisfaction in the regard he has for you and your work," she would tell Convers at the end of 1905. "Apropos of your closeness with Mr. Pyle, nothing reaches me closer than that. Your devotion to him," she would advise, "should be loyal."

But Carol was no Agassiz. Carol was a powder keg. Every day Convers kept Carol from his mother only compounded matters. He knew that the minute he announced himself, his mother would come running down from the White Mountains. Once home she would see exactly what he was afraid she would see. If Eva Swayne—his landlady!—could read him like a book, imagine what his mother would do. She of all people knew his "moods and characteristic ways of expression." She would recognize instantly that Convers was head over heels in love. One look in her son's eyes and Mama would know everything he had been keeping from her.

He waited another day, and another. As he waited, Needham itself began to change. For the first time in his life, South Street no longer seemed to be the only thing he would ever want.

IN ALL, he kept silent for three days. He waited "until the last minute." Just before returning to Wilmington to pack for the West, he let Mama know he was home. Hattie instantly cut short her rest cure. As Convers had

feared, she made a beeline for home. They barely had time to say their good-byes.

Did she guess? When Hattie next wrote Convers, she asked him an odd question about his friend and fellow Pyle student Frank Masters. She had never before in their correspondence raised the subject of marriage, nor was there evidence that Masters was considering it. Yet she asked, "Do you think he intends to get married just yet?"

Convers did not answer. Lighting out for the Territories, N. C. Wyeth donned the disguise that his heroes—Roosevelt, Wister, Remington—had adopted at moments of personal crisis. He became a cowboy.

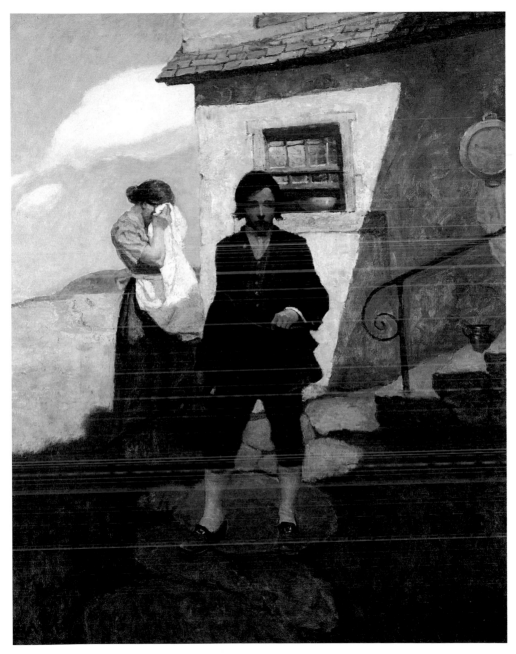

Jim Hawkins Leaves Home, 1911

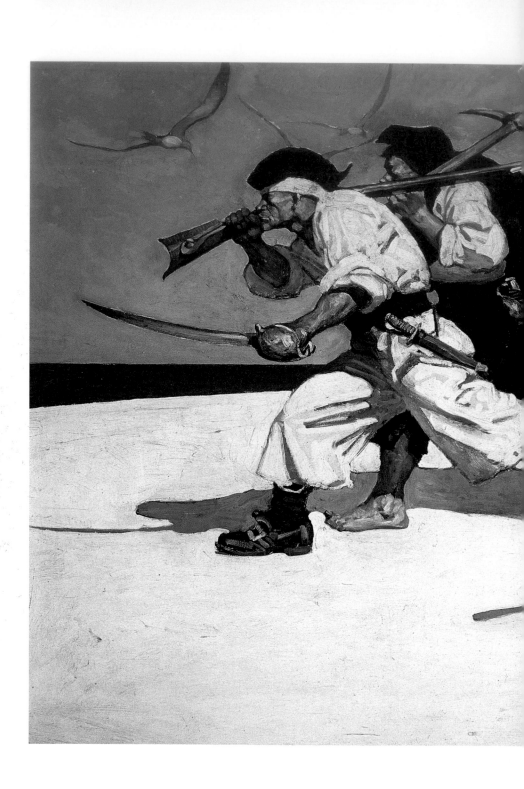

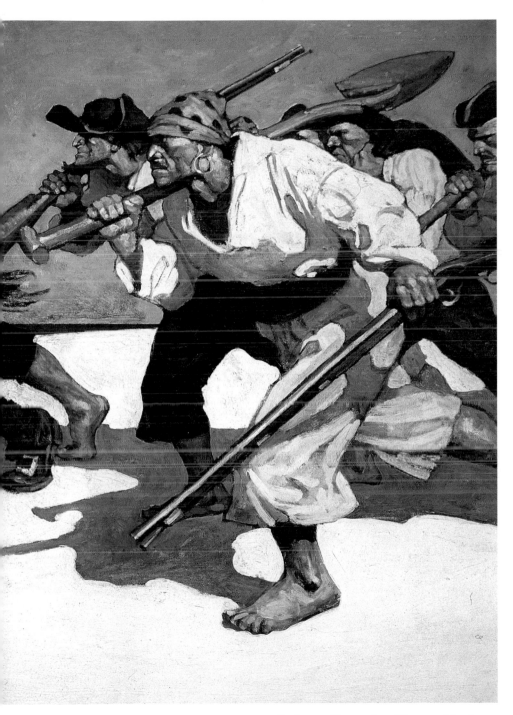

Endpaper illustration, *Treasure Island*, 1911

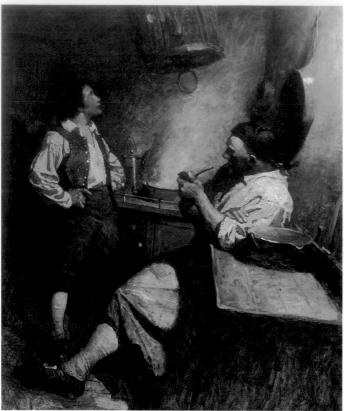

Long John Silver and Hawkins, 1911

The Hostage, 1911

Shoot-Out

THE ADOBE HUT had four windows. The view from each was the same. No matter where he looked, he saw the incessant sameness of naked plains. On the morning of October 5, 1904, on the sunscorched banks of the Big Sandy River, in the treeless cattle country of eastern Colorado, fifty miles from the nearest house, Convers lifted his sights and his pen.

> My dear Carolyn,
> Out of the north window, plains; out of the south window, plains; out of the east window, plains; out of the west window, plains . . .

No way to vary it. In every direction, all the way to the horizon: plains. But vary it he did.

> Dear Mama,
> Out of the west window, plains; out of the east, plains; out of the north window, plains; out of the south, plains . . .

He had dutifully echoed every word of every report for the last eight days, sometimes as many as sixteen pages in a single letter.

On September 23, at the start of his western odyssey, he told his mother, "Things look bright and favorable now, and if I don't succeed it's *my* fault and no one else's." Varying the syntax, he repeated for Carol, "Things seem to open right up for me, and if I don't make a success of them it's entirely my fault."

"Just as I start this note we are leaving the West end of Lake Erie," he began. Five pages later, he wrote Mama, "As I start this note we are looking out over the west end of Lake Erie."

Arriving in Denver, he wrote Carol, "At last the long dreamed of 'great west' and I tell you it is *great*." Then, like a rider changing horses, he started over with Mama: "Here I am in the *great west* and I'll tell you it *is* the great west."

To his mother he rattled off details from his days on horseback, emphasizing always the practical effect his experience as a cowpuncher would have on his future work and finances. To Carol he described his feelings about the land and the animals, the cowboys, and his works in progress.

Tailoring each sentence, he presented the women of his life with custom-made versions of his westernized self. From Mama's pages he eliminated news of physical mishap, meanwhile playing up his injuries to Carol. From Carol he cut out any suggestion of fear on the trail, but he trusted his mother to love him even when "my nerve and grit foil me." From Mama's letters he barbered graphic descriptions of the dirt and mud in his various adobe living quarters. From Carol he withheld the constant talk of small economies and personal hygiene that played so well on South Street. Inspired by a piece of scenery, he added to Carol's first Denver letter a sketch of a mud hut and standing horse. It turned out so well, he repeated the same drawing for Mama, although in Mama's version, the line that in Carol's drawing had been rough and free and full of life came out tight and studied.

It was a shoot-out. Firing off one letter to Carol, then another to Mama, or sometimes Mama first and Carol second, Convers stubbornly kept them apart throughout his three-month journey. He roped horses, rode the range, drove cattle, crossed the Rockies, slept in the open desert. He grubbed with cowpunchers, bedded down with the Navajo, ate horsemeat, gambled with traders, exaggerated the number of kills he made with his Colt 41, had his money stolen by Mexican bandits. To earn his way "back to the states," he carried the mail up and down the border between New Mexico and Arizona. But at every step in "the trackless wilds," the pattern of his life irresistibly imposed itself. As so often with N. C. Wyeth, the real contest took place neither on horseback nor under distant skies but nearer home, in his divided nature.

HE HAD LEFT a mess in Wilmington. The night before he boarded his train for Chicago, his landlady, Eva Swayne, had given a send-off party in his honor. She had invited his friends, including the Bockiuses. Out of politeness, and as a matter of duty, Convers felt he "couldn't very well refuse." But he did not make his appearance at the Swaynes' until nine-thirty that evening, and by then the Bockiuses had come and gone.

Puzzled that Carol and her mother did not wait to say good-bye to him, Convers felt trapped in the Swaynes' parlor. He "begrudged every minute." When the party broke up near midnight, it was too late to call on Carol, and his train left first thing Saturday morning.

"Why in the world didn't you stay?" he asked Carol from the west end of Lake Erie at seven-thirty Sunday morning.

What he did not realize was that by flattering the Swaynes he had insulted Carol. In his eagerness to keep everyone happy and his romance concealed, he had failed to make his real feelings for Carol sufficiently known. By assenting to the Swaynes' kindness, he had given the impression that he had no special interest in spending his last evening with Carol. Behind Carol's back, the Swaynes' daughter Marion had reported to Carol's sister Elizabeth that Convers had no interest in Carol. As a result, Carol had refused to attend the party. Annie Bockius, however, had made her go, but when the Bockiuses arrived at the Swaynes' and Convers was not there— probably he was at his studio—it seemed to reinforce the gossip.

At the Swaynes', meanwhile, Carol was "heartsick" and offended. To make matters worse, Blanche Swayne and Etta Boulden treated Carol so coolly that even Annie Bockius noticed. "I must say it was 'the unkindest cut of all,'" Carol recorded. "I am so sorry I called there. Maybe I am prudish, childish, and foolish, but I can't help it," she told Convers. "I am sure no social function could have tempted me from you on the eve of a three months' trip."

As Convers doubled the distance between himself and the East, he began doubling his dispatches.

In a second letter, also dated "En Route to Chicago/7.30/Sunday morning," he wrote to his mother, telling her about the Swaynes' going-away party. He explained that his landlady had "prepared quite a send off" but that he had not had "much time to spend with them." He gave no further details and mentioned none of the guests, as he often did when describing social events, especially those that included "the fellows" of Howard Pyle. Then, still omitting all names, he added, "Some friends presented me with an 'emergency box' of bandages, vaselines, safety pins, plasters, etc."

He had never gone quite this far before. This time, he was not only writing double versions of the same event but lying.

To Carol he recalled how, after not finding her at the Swaynes', he had trudged upstairs to his room, and there, to his amazement and relief, "a surprise awaited." It was the "emergency box." Carol had given it to him as a going-away present. Genuinely anxious about what might happen to Convers out west, she had tiptoed upstairs and left it in his room.

"I will surely keep it within reach at all times," he told Carol, and

thanked her for her thoughtfulness. He informed Mama that although he had packed this first-aid kit in his trunk, he did not intend to carry such a cumbersome thing in his saddlebags when he got out on the trail. He then addressed his mother as if she had given the gift. In the most bizarre twist of the whole performance, he assured her, "Nevertheless, I'll take the carbolated vaseline, don't fear."

The episode at the Swaynes' was on his mind all the way out to Denver. "Please do not say anything about it again," he begged Carol. "If I have cursed myself once, I have a thousand times, for the way I ran into that 'trap'—It was not right, and I was entirely wrong I must confess."

She absolved him without even hearing his apology. "I believe you are dominated by pure motives and that in the Friday night affair you were merely a victim of circumstances. . . . I know the situation was such that you could not help your self. . . . I shall always love you no matter what happens."

But there was one matter that nagged at Convers. That night at the Swaynes', he had promised to write to Etta Boulden from out west. If he kept his promise, he knew that Carol would hear about it. Once again he tailored the truth: "The Bouldens asked me to write, so toward the end of my trip I'll drop a line to them. You won't care, will you?"

Carol replied with the same directness as before: "Do I mind you writing to the Bouldens? Of course you mean Miss Boulden. Certainly not, as I have always said, do as you think best. I have implicit confidence in you."

She made just one request. Although she had not gotten "the last good bye" when Convers left Wilmington, she wanted "the first greeting" when he returned. "Can't you promise me that?"

HIS PLAN had been to observe and sketch a cattle roundup for *Scribner's*. But as soon as Wyeth was mounted and facing a herd, he became a cowpuncher. Outfitted from hat to stirrup, he hired on at the Gill Ranch and set out with thirty-five cowboys to "hunt and to bring together thousands of cattle scattered over a large part of the country known as the free range."

His first day in the saddle, he helped round up 300 head of cattle from a range of six square miles. He also got his "first bad spill into a gulch," hurting his arm, but confided this incident only to his pocket diary.

The energy of the frontier released him from his mother's grip. The roundup boosted his confidence. After two weeks with the Hash Knife outfit, he believed that he could now "go into anything anywhere with the best man."

Gill Ranch, Limon, Colorado, October 1904.

Instead of Mama and Needham, he thought incessantly of Carol and Wilmington. "I was never in such a state of mind before in my life," he told Carol. "It makes everything appear like a dream. . . . I seem to be floating around in the land of happy dreams."

The exaggerated size and scale of the land suited him. "I feel perfectly at home here," he said. "All but with the cowpunchers." After days of over-hearing their "foul and filthy talk," the whole experience sometimes seemed unbearable. To Carol he confessed that he had grown tired of "Dutch Lou," "Tug" Simpson, and the laconic boss, "Date" Middlemist. He recalled his "heavenly evenings" at the Bockiuses', remembering how talk with Carol

always quieted him down, and how simply to be in Carol's presence "seemed to relieve [him] of unnecessary worrying."

He felt understood by Carol and not only because he was getting "almighty lonesome" out on the trail. He recognized that he could depend on her to understand him. Carol, for example, understood—surely more than Mama could—the perils of Wyeth sanctimoniousness. "Please," she begged him, "please don't attempt to bring anyone to justice that has done you an injustice. I am so afraid they might take revenge on you. Let everything go."

Both his mother and Carol were terrified of what might happen to him out west. The risks made Mama feel that it was *she* who deserved sympathy. She felt miserably sorry for herself and worried about "Indian smallpox" and "the characters you might meet in that part of the country." She wrote, "It's hard to think which is the worst, you out there or the other boys at football."

Reading his mother's letters alongside Carol's, Convers recognized, perhaps for the first time, that Mama did not see him as he was. His birthday marked the change. On October 22 he was thrilled to hear from Carol and scolded his mother for her overwrought letters.

"To begin with," he explained, "we're not strenuous in *your* sense of the word." *Strenuous* meant "virile," and Convers was proud of the Strenuous Life. To shock his mother with his Rooseveltian marksmanship, Convers claimed to have killed fifty-two rattlesnakes, only much later admitting that the real count was two rabbits and a few rats, some chickens and a cow, all of which had "soured" him on killing.

On October 13 he noted in his diary "a bad foot—the result of a kick received from a horse." The next day he carried the mail for the Hash Knife outfit, riding eighty miles in twelve hours. On October 15 he recorded: "Foot worse but had to ride about a ten mile circle."

It turned out that his foot was broken. To keep it rigid inside his boot, he needed a splint and bandages. He found he had both—the famous emergency kit came to his rescue. Fifty miles from the ranch, he bound his injured foot with Carol's bandages, then rode all the following day, not learning until he reached the ranch that he had broken a bone in his instep. He kept the accident from both Mama and Carol for a full two weeks before reporting that, "thanks to a tight-riding boot and spur strap, my foot was not deformed."

The news upset Carol. Though she was glad Convers had the emergency kit with him, she disliked the tone of his letter. "When I spoke of that foot," he replied, "I was not looking for sympathy and trying to impress you with the idea that I am living a hazardous life—for I am *not*. I only wished

to show you that the thoughtfulness of yourself and your mother had proven a great help to me."

He smoothed over the incident by promising Carol that she would be first to hear from him when he got back to Denver.

ON OCTOBER 18, he returned to Denver and rented a studio in one of the finest downtown office buildings, the Charles, at the southwest corner of Fifteenth and Curtis Streets. He wrote no letters that day. He boarded with Allen Tupper True's parents, Henry and Margaret True, at 608 Clarkson Street, a modest two-story brick prairie bungalow with an attic dormer.

The next day he wrote his mother. It was October 19, and he labored over a report describing "the wildest and most strenuous three weeks of [his] life." He did not write Carol that day, and by the time he sat down with pen and paper on the following day, he must have been feeling guilty about having put Mama "first." He had failed to keep his promise to Carol. Two days after returning to Denver, he told Carol he had arrived "one hour ago."

In his one-room studio on the sixth and highest floor of the Charles Building, Convers began working from his sketches, "afraid after so long away from a brush that [he] had lost my grip." The studio, though large and with a view of the Rockies, seemed confining after weeks in the burning light and clear air of the range. "How much harder the struggle is," he wrote, "to shut oneself up in a studio and dig; dig for that mental conception of some fact of life and to place it on a canvas, than it is to go into the open air and fight with nature."

With eyes dazzled by desert light and the jumpy movements of broncos, he painted quickly and with remarkable assurance, inasmuch as these were among his first full-color subjects. In the next twelve days he completed four canvases: *Roping Horses in the Corral, A Bucking Horse in Camp, Rounding Up,* and *Around the Grub Wagon.*

He painted on his own. For the first time he had to sustain his work without competition, and without "blow ups" or "sat upons." He stared at his new pictures "day in and day out," uncertain "as to their qualities of merit." He was baffled by the absence of a master. Without Pyle he did not know what to think or how to help himself. He admitted to Carol, "I *don't* know what I've got. I have a few fast friends who come in once in a while, but [they] are so quiet and modest [they] dare make no criticism."

In Wyeth's earliest western pictures, with Remington as his guide, the West had appeared manufactured, static. In his later, freer, most successful westerns, the frontier would become an Arcadian pastoral, sun drenched as

Sketched at Gill Ranch, then painted in Denver, *Above the Sea of Round,
Shiny Backs the Thin Loops Swirled and Shot into Volumes of Dust* (1904)
appeared with six other western pictures, including *Cutting Out* (opposite,
top) and *A Night Herder* (opposite, bottom), when *Scribner's Magazine*
published NCW's article "A Day with the Round-Up," in March 1906.

Cutting Out, 1904.
"Cutting out is a hard, wearisome task," NCW wrote in "A Day with the Round-Up."

A Night Herder, 1904.
"As I lay there I heard the faint singing of a night herder floating across the plains."

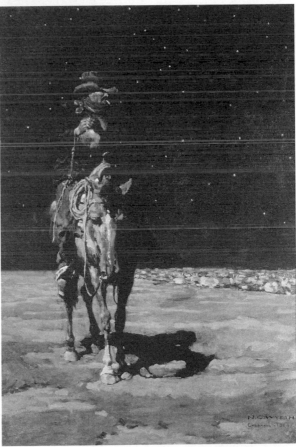

Switzerland, with sheepherders of the Southwest standing in for the shep-
herds of Helvetia and Arcadia. In between, N. C. Wyeth's 1904 western pic-
tures were richly textured, radiant with prairie light and alkaline dust,
authentic to the last detail. They were especially effective in their economy
and restraint. "I have made every effort to get all the brilliancy of the coun-
try without exaggerating," Wyeth noted after finishing the "Roundup" pic-
tures. Still indebted to Remington for the set-piece format, Wyeth had
established his own western color, a simple, stern palette of muted grays,
sober blues, understated ochers.

The day before he packed up the canvases, he received the benediction
he had been missing. A "prominent Denver man" visiting his studio offered
to buy the entire set of pictures. Under contract to Scribners, Wyeth had to
decline, but he was thrilled to hear the man say, "Those pictures should not
go out of Denver." To Carol he breathed a sigh of relief, mingled with antic-
ipation: "This sort of talk has made me feel very much encouraged, but I
will really find out what they are in Wilmington, won't I?"

The thought of resuming their struggle with Howard Pyle made Carol
uneasy. She hinted at her true feelings when she wrote, "I do hope Mr. Pyle
will see no falling off in the merits of your work. If he did what would he do?
Do you think he would send you off so that you could not communicate
with anyone to divert you? Wouldn't that be heart-rending?" She realized
that everything would have to wait. "We will know on your return what this
separation has meant to us. Won't we?" To allay her apprehensions, Convers
promised to put Carol before Pyle, before everything and everyone.

On November 5, just before he left for Arizona and two weeks of
sketching on a Navajo reservation, he announced to Carol that the owner of
Denver's largest art store had persuaded him to leave the four new pictures
on exhibit. He boasted that the local paper had come around for a "write up"
and a photograph. Although neither appeared, the possibility of attention
fell on Convers like strong sunshine. "Oh, I'll tell you," he drawled to Carol,
"there's nothing like being popular!"

HE CROSSED the Rockies on November 7, arriving in Durango, Col-
orado, in the evening. Election returns were not all in; President Roosevelt
had not yet been declared winner of his first full term, but the streets were
jammed with celebrating miners and cowpunchers and "hundreds of Indi-
ans," Wyeth noted, "silent as foxes, wearing beaded moccasins."

The next day he took the stagecoach from Durango to Farmington,
New Mexico, going on alone another thirty miles into the desert on horse-
back. At Simpson's Trading Post in Cañon Gallegos and at Navajo reserva-

tion lands scattered across the desert, he studied and sketched Navajo weavers and potters. For safekeeping he deposited $85 at a government trading post in Muddy Springs, New Mexico. On November 10, the post was raided by Mexican bandits, who cleaned out $500 in cash, including Wyeth's savings. The night of November 12, he ate horsemeat for the first time and slept in a hogan "with 5 Indians." He gambled until two o'clock in the morning, losing another $5.50. In the morning, he joined a posse to hunt down the thieves. At noon the posse struck the Mexicans' trail but by evening had lost it at the Rio San Juan. He went without supper that night and rejoined the posse for another day, in vain. To earn his way back to Needham, he got a job.

Was it coincidence that he chose work that would keep him ceaselessly divided, going back and forth across the desert? As an express mail carrier and messenger between Two Gray Hills and Fort Defiance, Wyeth cantered fifty miles each way over "these damned sand hills." His pay was $1.25 a day plus horse feed.

Day after day, including Thanksgiving Day, he crisscrossed the alkali sands, straining to find the "long dim trail that lay over the desert":

"Hard ride to the Two Gray Hills," he noted in his pocket diary.

Cold as hell.

Back to Ft. Defiance with new horse.

Back to Two Gray Hills.

Again to Fort Defiance (heavy mail).

Heavy mail, indeed. No wonder Convers was relieved to be heading home. In the few reports he managed to write for Carol and Mama, he transcribed descriptions of harsh weather and arid landscape directly from one woman's letter into the other's. At the end of the trip, he gave up the pretense of varying syntax and sent identical bulletins. By trail's end he had loaded the mail in Carol's favor, sending his mother a total of fourteen letters and Carol sixteen.

Windburned and saddle sore, he reached Needham five days before Christmas. As soon as he arrived, he wrote Carol. He announced plans to be in Wilmington by New Year's Eve: "Remember my promise to see you first? *Just watch me!*"

The Saturday Evening Post also wanted to see him right away. The editors notified Wyeth: "Anxious to find work the minute you arrive."

He felt peculiar at home, inept. Unable to reveal his secret to Mama or Papa, he had no truth to tell. All the old routines in which he had always felt so assured seemed flat, dull, useless. "I cannot stand it here," he told Carol. "The life, although plenty to do, seems empty, lacking something vital, and I *know* wherein it lacks. I am uneasy and very restless to see you, to live again near you."

Hattie could not help but notice Convers's lack of "home interest." She thought him selfish and inconsiderate. He shortened the visit and fixed the Wednesday after Christmas as the new date of his arrival in Wilmington.

But even that was not soon enough. As never before, Convers felt from Mama "a certain skeptical spirit." He felt it in everybody at home. But just what had made his family skeptical about him or his future, he preferred not to examine. Instead he vowed to "knuckle right down and get rich." He promised to pay off his $500 debt to his father as soon as he met his *Scribner's* deadline. "I'll show you," he told his mother, "I'll show Papa, I'll show the world!"

Only two days after the combined celebration of Christmas and "Mama's Natal Day" on South Street, Convers headed for Wilmington. Feeling "downright guilty," he gave his disappointed brothers to understand that he was sacrificing the time at home "for the sake of art," leaving early "to get back at [his] easel, to mingle again with [his] fellow workers." Even with Nat, the brother to whom he felt closest, he would not reveal the real reason.

At Convers's rooming house, Carol had reasserted her claims. A hand-delivered note, along with freshly baked buns, awaited Convers, "as you are likely to reach your room tired and hungry."

No record of their reunion survives except a fantasy version that Convers had imagined days earlier. It reveals the winner of the shoot-out. Within minutes of his Wilmington homecoming he intended to be—as it turned out, he was—"looking into [the] face that has urged me on, *inspired* me, and *consoled* me."

Pyle, too, awaited his arrival. Of the four Denver pictures, he approved only one, pronouncing the others "too much Remington." It would not matter. Scribners would use the journey itself to make N. C. Wyeth a celebrity, showcasing photographs of the artist "in his cowboy costume," while promoting the idea that "the artist spent several months in the cattle country actively engaged in the work of a cowboy in order to become thoroughly familiar with his subject."

As for Wyeth's deadline at *Scribner's,* Pyle would be indispensable. He started his student writing an article that would accompany the pictures,

supplying both its organizing principle and its title, "A Day with the Round-Up."

Thrilled to be "back at the old stand," Wyeth gulped as if it were edible the rich aroma of oil paints waiting on a freshly made palette. After the first "delicious and scathing" critique from "H.P.," he said he felt that his teacher had once again set him "on the right track."

At midnight on December 31, Convers ignited a large brass cannon at 1503 Gilpin Avenue. The long fight of '04 was over, and his feelings for Carol were decided. But after eleven months and seventy-two letters home, Convers had yet to reveal Carol to his family.

THE MORNING of January 1, 1905, writing to his mother, he admitted that he had seen in the New Year at "the Bockiuses'."

That was enough to trigger Hattie's suspicions. Using the same maneuver as before, Mama went behind Convers's back to pry the truth from his fellow illustrators. She canvassed Frank Schoonover first. Schoonover hesitated, but pressed by his friend's mother, he admitted that Convers now had an "attraction here in the city."

Exposed by Schoonover, Convers surrendered. On January 20, 1905, he confessed to his mother that he had met Carolyn Bockius over a year ago. He now introduced her as "a young lady of great sensibility," emphasizing Carol's appreciation of art and of nature and "in many ways of [his] mind." Defiant, he refused to announce an engagement, but he nevertheless made clear that he would brook no objections to Carol. "I shall stand by this girl my life throughout, and nobody can ever stop me."

At some point, the date is not documented, Convers secretly gave Carol a diamond engagement ring. In early June 1905, on a spring visit to Chadds Ford, the Wyeths met Carol. In July, Carol came to South Street, first glimpsing the Wyeth house from a canoe paddled down the Charles River by Nat. In December 1905, Convers and Carol settled on March 1906 as the month for their Wilmington wedding.

Home in Needham for Christmas, Convers let his father, not his mother, in on their plans. His relief at telling the real story showed immediately: "But oh! *I'm happy.* I have confided in my dear old dad. He is *very much pleased.* He is glad!" Newell set one condition. Convers's bank account must first reach a "certain figure."

During 1905 Convers would have few worries about his power to earn. His western sketchbooks had given him artistic capital that would pay off his debts and beef up his bank account for years to come. The prestige of

Scribner's Magazine would lift him into the upper echelon of picture makers; in the next three years N. C. Wyeth's western work would be in such demand he never failed to appear in print with fewer than two pieces each month. Pictures such as *The Prospector* (1906), *The Ore Wagon* (1907), *On the October Trail* (1908), *The Pay Stage* (1909), and *McKeon's Graft* (1912) became classic images of western life.

The West freed N. C. Wyeth to marry. It also helped him take a step away from Howard Pyle. The first change in their rapport came soon after his return from New Mexico, on January 6, 1905, when Wyeth finished a sketch for a revised version of one of his Denver canvases. Pyle had entered the studio to examine his work. Standing close, he turned excitedly from the paper and slapped Wyeth on the back, as he always did at the start of a "blow up."

But before Pyle could cover him in "sloppy words of praise," Wyeth turned, hardened his jaw against his teacher, and said, "You don't *mean* that, Mr. Pyle, and it won't help me."

No student had ever silenced the master before. "It was all up with me," Wyeth wrote later.

Pyle lifted his chin. "Wyeth," he said, his gaze intensifying, "I know now, although I *always* thought so, you are in dead earnest."

But ambivalence still dominated Convers's life. Despite the gains in his work and the new certainty in his feelings for Carol, he had moments of complete disbelief about what he was doing. In May 1905, on a visit home, he went for a walk in the Nehoiden Woods, the scene of many of his boyhood memories. Sitting on a rock under a tall pine tree, he found himself thinking of Wilmington and then moments later denying his attachments there. He told Carol afterward,

> I thought of the past three years and what they meant to me and of all the things I'd done and seen during that time, and suddenly, as if wafted away by a chance breeze, my true consciousness left me. I couldn't realize the truth. I could hardly believe I had ever seen Mr. Pyle nor could I believe that I ever was in his class; it seemed ridiculous in my own mind to think that I had ever worked for a great magazine; I felt like a boy, dreaming of great accomplishments, looking far into the future.
>
> And when I thought of you, you passed before my eyes as in a vision, or like the princess in a fairy story. You looked so beautiful, so enchanting that I dared not think you could be my own. . . . All I wanted was *you*, and had you truly appeared I would have *kissed* you to death.

In December 1905, Convers broached marrying Carol to Pyle. The master was "very much pleased with my plans," according to Convers. "In fact," he recorded, "it was his own suggestion that I should get married. He knows Carolyn and appreciates her influence upon me, and his judgment to me is almost infallible."

The Bockiuses had no objections to the match. But with his mother, Convers went right on discussing his career as if nothing else were happening in Wilmington. He announced no wedding plans; Hattie offered no blessings or congratulations. On learning in 1905 that her twenty-two-year-old son was in love, Mama did unto him as he had done unto her throughout 1904. She froze him out. She punished him with silence, "and it *has* been punishment," Convers complained to his father. Hattie said as little as possible on the subject of Miss Bockius and avoided all discussion of marriage and of Convers's future, except of his future as an artist and as "an individual." For his part, he had good reason not to upset his mother further.

Siege

ON NOVEMBER 16, 1905, Jean Denys Zirngiebel died of a paralytic stroke. His last words to Hattie had been: "What do you hear from Convers?"

Her father joined her mother and her dead brother Rudolph in the family plot in the Needham Cemetery. Hattie became a frequent visitor to the hillside grave, where she wrote, "I feel I can gain a little sympathy in communing with myself." Taking her father's favorite pansies to the Zirngiebel plot was the only thing that made her feel better.

Her father's death at seventy-six seemed to spell Hattie's decline. Without her sole surviving parent, she felt lost. She grieved as if she were not only motherless and now fatherless but childless too. More than ever she needed Convers to be the family hero. Everything that Denys Zirngiebel had invested in South Street—the continuously flowering world of the Swiss greenhouses—she now reinvested in Convers's painting. In her grief, Hattie clung to Convers's western pictures as if they depicted the closing of her own frontier.

Next door at the Zirngiebel homestead, Hattie's father's affairs were being settled. "It upsets me completely," she confided to Convers. Forced by Newell to keep quiet—her grief "grated" on his ears—Hattie wrote: "How I miss Grandpapa and the old home. Everything seems so changed."

Behind the house, under snow, the pastures looked as they always had. Beyond, the river stood silenced. Sealed with solid ice from shore to shore, the Charles remained for Hattie a source of distress. The Wyeth boys skated constantly. "There has been a number of accidents by drowning this season," she noted. Hattie was never seen on or near the river.

Following her father's death, she got "all turned around." She thought Wednesdays were Saturdays and Fridays were Mondays. On her rare excursions, she wore full mourning. At home, she tried to keep present the order of her father's last days, pasting up a railroad timetable that Zirngiebel had borrowed and faithfully returned to Hattie one day in October.

Undone by this second death in two years, Hattie saw herself as "clinging to the last straw." She nursed a ceaseless flow of nervous complaints. "The fact is I feel so lonesome, but it is termed otherwise," she said. "They tell me I *shouldn't* feel so, and in my trying to explain matters I do not always get what I'm feeling for." A continuous thread of unidentified remorse ran through her letters. "If I don't deserve to be understood it must be a punishment for my wrongdoings, which I hope some day I may be able to see."

In January her head "felt bad for nearly a week." One morning in particular, she found it hard to "collect" herself and agreed to see the doctor. This was the morning of January 12, 1906, the morning she read Convers's "letter of intentions."

SIX DAYS EARLIER, following his father's advice, Convers had attempted, as Newell put it, to "tell things just as they are." Writing to his mother, he could not, however, bring himself to use the word *engagement* or *marriage*. He gave Mama what he considered the vital news of his life in Wilmington—three pages of career advancements—before announcing that he had "something to say that comes from my heart as *sincere* as *deep* and as *serious* as anything I ever thought."

Rather than be direct, he tried instead "to speak it in such a way that it will emerge into your mind as smoothly as it leaves mine." He wrote that instead of the "usual custom" of a wedding ceremony, which he felt would "taint" him, he wanted "to sort of melt into this new life." He assured Mama, "I don't want to feel that I've made a terrific jump that must needs sever me from my old home ties and thoughts to make room for new ones."

His father had married the girl next door, and his brothers would follow Newell's example. Nat would marry Gladys Ella Pond, the daughter of a prosperous Boston lumberman who lived on a gentleman's farm less than a mile down South Street. Edwin and Stimson would also marry Needham women, both of French-Swiss background. Only Convers set a precedent, marrying a "Delaware Avenue girl."

He stood firmly beside Carol. "*I know* her and that's all that's necessary," he declared. "The soul of the girl is *simple, pure,* and *sincere.*" He would "*never* appraise to *anyone* again" her fine qualities. He asserted Carol's place at the center of his life. She was the one who "stimulated" him and gratified his need for "close human sympathy."

After months of dishonest silence, Convers was at last telling the truth. "To come to the point," he said finally, "I am preparing for a small restful home which I hope to take up in the spring."

As the unspeakable news seeped into the kitchen on South Street, Hat-

tie reacted. She decided to rearrange the family photographs in the big room the Wyeths called the library. Over the mantelpiece in the snow glare from the pasture hung oval-shaped portraits of her sons.

She had no intention of including a future daughter-in-law's picture. But as soon as Hattie came face to face with the most recent portrait of Convers, she realized that merely varying the *position* of the photographs was not going to be enough. Instead, as she explained it, she would "resort to a little freedom of mind."

She stripped the wall bare, replacing the whole batch with a single photograph—one much older than the rest. She then stood back and called her remaining boys into the room. Convers's brothers came in to look at the picture that Mama had hung over the mantel. "All seemed satisfied," she noted afterward.

It was a photograph of a baby.

"Your large baby picture," she told Convers. "I felt I must get you back in that form."

THE "MARRIAGE SIEGE," as Convers came to call the next four months, was on. Not so much a test of wills as a contest of injuries, it was waged through a lavish, tearstained correspondence so well preserved that we can trace, as if it were archival footage, the splices at which thoughts melted into tears.

On January 12, 1906, Hattie bit her lip and attempted a proper reply to his engagement. "I know, Convers, what all this means, and I earnestly wish you all joy and success in your life's undertaking."

But her tone changed quickly. Noting that Carol was "even young for her years," she condescended to Carol's youth and inexperience in the manner of an older woman forsaken for a younger replacement. She defended her role as Convers's earliest supporter: "I've always had faith in your work in years when few thought so much about it. And earnestly tried to have you prove it. Others now can do more than I."

She argued that Convers was too young to marry. "Twenty-three is *very young* for a man." She had counted on a more gradual withdrawal. "I was not looking forward to my son's development for two or three years hence." Acknowledging that although Howard Pyle might know best, she pointed out that "other men connected with Mr. P did not take the advice he has given you." A teardrop splashed onto the end of the sentence. Another fell on, "I hope all is for the best." And then another. The thought that "we've had our last Xmas as *children together*—" choked her up, and she could not go on.

. . .

CONVERS DEFENDED his position. "I can see very well how you have . . . been shut outside of my life (or mine out of yours) and how sudden, certain happenings of my life have reached your ears without much forewarning. But I must confess that I did try to emerge the idea of marriage into your mind . . . as gently as possible, and one means of mine was to work like the devil and to accomplish everything that was placed before me."

She held her ground. "Your being away and your life being among strangers and a new world of interest, your going into another sphere, your making of yourself away from home, others looking after your clothes and those things . . . [seem] like *great* changes in our lives."

He defended himself. "I came down here to live alone. I mean apart from close human sympathy, without [which] I could do nothing. Luckily I found one who was sincerely and naturally sympathetic to me, and I definitely say this: that she has inspired me and stimulated me to do better—better and better and I can't help but feel that to her I owe a great deal of my success."

Hattie tried to protect her son from his future wife. "It sounds nice for you to give so much credit to Carolyn but as years go on and things look different to you, you will find that a strong individuality of your *own* must be the means of your success."

He defended Carol. "She has taken a sincere interest in me and my work and it helps me to accomplish what I hope to do for *you*, for *Papa*, for my *brothers*."

"Remember, Convers," Mama answered, "not to lose *your* individuality."

Carol, in fact, showed no inclination to interfere in his work. In all matters concerning Convers, Carol was as compliant as possible. She tried from the beginning to share the intensity of Convers's feelings for his mother. She wrote faithfully and affectionately to Mrs. Wyeth. But the correspondence limped along. For although Hattie occasionally replied to Carol, she saw herself as the injured party.

Carol willingly put her own interests second to the gratification of her mother-in-law's feelings. "I want you to feel that although he is establishing his own home, he is none the less farther away from you, and is always just as interested in all the little home doings as ever. Even now we talk of how much we shall enjoy our home visits to Needham."

But the younger woman's concern was no match for the older woman's aggressive self-interest. Again and again, Hattie waited for Carol to make the overtures. Hattie would "look for a letter from her, as I felt that an inter-

est in me and us all would be very gratifying," only to suffer "after long wait-
ing" a sense of letdown. Carol's "nice little" letters were never enough.

On January 15, Convers pressed Mama to come to Wilmington accom-
panied by Stimson. A change of scene, they all agreed, would do her good.
Convers arranged everything, paid both round-trip fares. Newell said that
Convers had "used good tact" to "make her more satisfied with your future
plans." But something happened to Hattie on her first night in Wilming-
ton—she would not say what—and after returning home to Needham, she
vowed that she would not return to Wilmington under any circumstance
whatsoever.

THAT WINTER AND SPRING, N. C. Wyeth received commissions and
fan letters at the rate of two or three a week. He had never had so many
offers. "New York editors are agog with appreciation of my late work," he
wrote to his mother. In February, joining the ranks of Frederic Remington
and A. B. Frost as one of *Outing Magazine*'s "leading artists," Wyeth made a
second trip west. Sponsored by *Outing,* he traveled to Grand County, Col-
orado, to gather material for a series of mining pictures and came home to
his pick of Big Three commissions.

Hattie did not see it that way. "The more I hear of your success," she
wrote him in March, "the more I feel, 'If he'll just come up to the ideal,
won't that be grand?' " She concluded, "I am only fearing lest you fail in the
great work you have in store."

Again and again that winter both Hattie and Newell tried to kindle the
fear that Carol would consume Convers's energy and threaten his success.

"Do good work now," his father advised. "If you can keep your name up
there no one can say that you are going backward. The next year will be the
time to show all that getting married would not in any way depreciate your
work."

In fact, with Carol at his side, his work was solid. Marriage would dilute
one thing only: Convers's power to gratify his mother. She would no longer
have him in an ideal "form"; they would not be "children together"; she
would not be his "one and only," nor he her "shining light."

In March, *Scribner's Magazine* promoted "A Day with the Round-Up,"
and Wyeth moved with Schoonover, Dunn, Ashley, and Peck into a colony
of brand-new "Swiss chateau style" studios at 1616 Rodney Street. At the
Pyle Studios, he was now a returning celebrity; new students crowded
around begging for critiques, asking his opinion of the latest pictures. The
word was, Wyeth had found himself. New York art editor gossip had it that
he was about to achieve what they all dreamed of: the big picture.

Despite the attention, Wyeth felt neglected. "I hear good reports from everywhere which is indeed gratifying," he told his mother. Yet approval from others was not enough. Without Mama, without his special status with her, his pictures seemed empty, incomplete. "How do *you* like them?" he wanted to know.

She would not say. She noted that the river had been thawing for a week. Soft sun sparkled on the black water and "a canoe now and again lends a little life."

Pressed to say something about his work, she remarked, "They certainly keep you well versed in your success and congratulate you from all sides."

She would praise Convers that winter for one thing only: her father's grave marker. It was a low-relief bronze tablet, which Convers had designed in the manner of the Swiss coat of arms. Centered upon a raised Swiss cross, a large letter *Z* swooped down from the upper-right-hand corner, bracketing the cross. From the lower left came an interlocking stem of edelweiss.

For Hattie the grave marker was a touchstone. It reconnected her to Convers and to her parents. "It really embodies all that is intended for," she wrote, "—strength, simplicity, and reverence for the old Swiss mountain homes." The day it arrived, she became very excited. Pulling on her coat, she rushed to show Convers's design to her father. She had just grabbed the back doorknob when she realized that her father was dead.

IN MARCH, well before the new date for their wedding—April 16—Convers and Carol settled on a rented house in Wilmington. Looking ahead, he announced, "After April 16th, I'll have a home, a home located in the heart of my working atmosphere."

The small brick row house at 1331 Shallcross Avenue stood a block from his new communal studio, two blocks from the Brandywine. Supervising every detail, Convers planned to furnish the house with Mission pieces designed by Gustav Stickley. He hoped that the dark wooden furniture, though avant garde, would emphasize the wholesome outdoor virtues he had grown up with in Needham. Stickley, editor of *The Craftsman*, abhorred the artificial luxury and wasteful habits of Gilded Age America. Like Wyeth, he preferred virtuous craftsman's values against those of the pampered rich. Using functional handicraft as a kind of bully pulpit, Stickley preached "the sacredness of the home," "the big fundamental principles of honesty, simplicity, and usefulness." In Stickley's furniture, as in everything Wyeth embraced, memory would serve an aesthetic function. Stickley designed furniture for "the kind of houses that children will rejoice all their lives to remember as 'home.' "

With all this nest feathering, however, Convers still felt banished from *"home"*—"ostracized from [Mama's] thoughts."

"Why don't you ever mention my future?" he demanded in March. "Say something for heaven's sake."

HOWARD PYLE spoke about his future. Taking Wyeth aside for a confidential talk one night, Pyle "expressed great desires." He talked "far into the night," imploring Wyeth to quit making illustrations and to paint the "big picture."

Magazine and book illustration no longer satisfied Pyle as they once had. Popular tastes were changing. The prestige of medievalism was fading. Picture making had begun to slip from its lofty place in the culture. To apply the term *illustration* to a canvas seemed all of a sudden to devalue it. At an exhibition of Howard Pyle's works that winter in Boston, only eight of sixty-three pictures sold. As Pyle's income dropped, his expenses mounted; he depended more and more on his regular *Harper's* contract. But illustrating for *Harper's* now looked as if it might endanger Pyle's reputation. *Harper's* stories were mediocre. "They lack a permanent literary value," Pyle protested to his editor.* He felt entitled to better. "I feel myself now to be at the height of my powers, and in the next ten or twelve years I should look to do the best work of my life."

His eye fastened on posterity, Pyle measured his pupil's work as though it were an extension of his own. He pronounced one Wyeth canvas "the biggest picture" any of his students had ever painted. Another, completed that March, was "the biggest picture" ever painted in Wilmington. Wyeth had begun to recognize that Pyle's exaggerations had to be taken with a grain of salt. At the same time, he still depended on Pyle's advice, and as often as not the master's praise turned him on, made him "wild with delight," carried him through a picture. "Not that I want praise," he said, "but I do want *encouragement.* I suppose it seems rather small in me to crave that, but I must have it to get along."

Pyle satisfied the craving. On hearing that Wyeth intended to publish an Indian picture, *The Silent Burial* (1906), in Caspar Whitney's *Outing Magazine,* Pyle "put his foot down with a crash." He told Wyeth he was making a colossal mistake. Pyle guaranteed that if Wyeth would only "paint it big"—"as he thinks I can"—big enough anyway to exhibit it in a biennial

*The names of the authors Pyle illustrated for *Harper's Monthly Magazine* in 1905 bear him out: Warwick Deeping, Henry Loomis Nelson, Robert W. Chambers, Justus Miles Foreman, Alice Brown, Mrs. Henry Dudeney. Only James Branch Cabell rings a bell.

show, the picture would win Wyeth medals, admission to the National Academy, fame. "He said all this and ten times as much before a crowd of people and it embarrassed me much."

Wyeth nonetheless followed Pyle's instructions, painting *The Silent Burial* as a "big picture" and substituting a lesser canvas to fulfill his obligations to *Outing.*

BETWEEN H.P.'s prophecies and Mama's silences came an unexpected change: Convers's father's tenderness.

Newell had been put in an odd spot that winter of 1906. Whenever the neighbors in Needham or his sisters in Cambridge asked about Convers, Newell was not sure what to say. On the one hand, there was Convers in Wilmington, setting the date for a wedding. On the other, here on South Street the boy's mother refused to utter the word *engagement*—refused, in fact, to talk about it at all.

Newell was determined to go to Convers's wedding and, in the meantime, to lend his son the family's support. Stepping into the unfamiliar waters of emotion, he vowed to put things right between Hattie and Convers before April 16.

First, he needed someone to talk to. Without ever mentioning it to his wife, Newell turned to the younger of his two unmarried sisters in Cambridge, Harriet—Convers's "Aunt Hat." She understood the situation immediately, noting that a "quiet" wedding "cannot be helped." On Harriet's advice, Newell secretly began assembling a list of people to whom the wedding would be announced. He kept the list at his office and conducted all matrimonial bookkeeping from there.

Unbeknown to Mama, Convers joined Newell, listing names and addresses for wedding announcements. He admitted, "It makes me feel very bad that Mama takes no hand in the proceedings. She seems to have dropped the subject from her mind almost entirely." He apologized to his father for "putting you in a position that I'm sure must make you feel bad" and thanked Newell once more. "I must say again I'm sorry Mama does not supplant Aunt Hat."

"It may seem strange to you that Aunt Hat should make this list," Newell replied on office letterhead, FLOUR, GRAIN, BALED HAY AND STRAW, "but Convers I have to have someone that I can talk these matters over with." He wanted every family friend in Cambridge and Needham "to know that we approve you in your choice." And he wanted Carol to have the good wishes of all the Wyeths. Newell broached the subject of a present. "We want to give you something for your wedding, and what I want to know is

what you would like it to be. I was thinking of getting some silver spoons and possibly some good knives and forks."

"My golly," replied Convers, "it makes me realize what's really going to happen when I see 'wedding' in writing." He and Carol agreed that spoons would be superb and thanked Newell for "a mighty sensible and practical gift."

For the first time in his life, Convers was talking realistically with his father. Without Mama standing between them, father and son could connect. Yet no matter how close they drew, they always seemed to end up as far apart as before. One evening, after Convers had visited Needham, Newell left his son at the southbound train at Back Bay Station, Boston, then hurried back to board his own westbound local for Needham, which was leaving immediately.

Newell found a seat by the window, and the train set off. After a minute or two, he noticed another train running alongside. In the window opposite his own, suddenly, more real than life, sat Convers. It turned out that he had boarded an early section of the six o'clock train. Flushed with surprise, Newell waved but could not catch his son's eye. Convers sat in profile, his short, straight nose bent to a newspaper. The trains were running at about the same speed, and the pooled yellow light from the car windows sustained the illusion that both trains had briefly joined in the dark. "I rapped on the window," Newell told Convers later, "but of course your train was running faster than mine so you were soon out of sight."

On South Street, as Hattie gleaned bits and pieces of Convers's plans for the future, she dwelled on his baby picture. She noted that Newell had been out of the house every night, except one evening for a meeting with her brother Denys and his wife, Etta, about the settlement of the Zirngiebel estate. With both her parents gone, she had no one with whom to speak French and worried that she would fall out of practice. She praised the sons who remained beside her. Edwin, hardworking, frugal, respectful of his "home duties"—*he* was a "mighty good fellow." Nat had taken Convers's place as perfect son. "In him I find much comfort," Mama told Convers, "as he remarks he thinks our feelings are alike."

In the midst of his mother's machinations, Wyeth received a letter from the muckraking magazine *McClure's*—a sugary pitch from "the big desk," as illustrators called the art editor's office. As one of many such offers, this would not have set Wyeth's teeth on edge had the new art editor been anyone other than Howard Pyle himself.

To everyone's surprise, Pyle had signed on at *McClure's Magazine* at the

astonishing salary of $18,000 a year. It was an unexpected move; *McClure's* was not Howard Pyle's kind of magazine. Its gritty, crusading editor, S. S. McClure, had turned a ten-cent illustrated monthly of the 1890s into the most exciting magazine of the new century, publishing the latest stories of literary realists Stephen Crane and Jack London alongside muckraking exposés by Ida Tarbell, Ray Stannard Baker, and Lincoln Steffens. *McClure's* sharpness, its graphic accounts of greedy financiers and unsafe railroads and lynchings, represented everything that made Pyle uneasy about the new reformist era.

Pyle was of the old order, a creature of his own habitat. He relished his importance, and Wilmington reinforced it. In a town with one big hotel, Howard Pyle was the one big artist. In a world of nineteenth-century decorum and Quaker prejudices (champagne at parties was considered vulgar in Wilmington), Pyle's superiority went unquestioned; among his pupils he went unchallenged. His school was "a snug arrangement," and Pyle "had a weakness for snugness." In the student studios on Franklin Street, he was worshiped, loved, feared, imitated. At S. S. McClure's magazine at Twenty-third Street near Fourth Avenue, he would be just another employee, working for a notoriously volatile editor in chief.

The Irish-born Samuel Sidney McClure was impulsive, grandiose. He spent money recklessly. When McClure bid $15,000 to serialize Rudyard Kipling's *Kim* and a rival magazine offered $16,000—already a sensational sum for those days—McClure won the auction by jumping the price to $25,000. He spared no expense on good writing and had the highest-paid staff writers in the business. *McClure's* writers were encouraged to spend months, years if necessary, researching a single topic. For McClure, success was as much a matter of treating his staff generously as it was of getting "the right people to help you." He hired Willa Cather as managing editor; attracted big-name writers like Robert Louis Stevenson, Sir Arthur Conan Doyle, and Mark Twain; and presented the early work of newcomers Booth Tarkington and O. Henry. Howard Pyle was only the latest talent to be, in Oliver Wendell Holmes's phrase, "lured and McClured."

McClure's Magazine was in turmoil that spring of 1906. McClure had put a new publication, *McClure's Journal*, on the drawing board and had hired Pyle to be art editor of the new monthly at the infamous $18,000 salary. (Art editors generally earned about $8,000 a year.) The extravagant sum was McClure's way of punishing his business partner, John S. Phillips. To McClure's editorial staff and board of directors, meanwhile, the expenditures on the new *Journal* appeared negligent, crazy.

Pyle shied from McClure's "fancy fee." He was deeply anxious about his own financial future, but the prospect of exchanging the self-controlled

cocoon of Wilmington for out-of-control New York was even more fright-
ening. Pyle compromised—or appeared to. He turned down the offer to
help start *McClure's Journal*, which in any case never got off the ground.
Instead, he agreed to take over at *McClure's Magazine*. He appeared in the
office three days a week and took home a weekly paycheck of $350.

Pyle insisted that the job in New York still left "fully half [his] time to
devote to serious work." He also announced that as art editor of *McClure's*,
he would be "of direct and practical use to the younger artists," a pretext that
complicated the situation for Wyeth and others. For no sooner had Pyle
assumed his new duties on Twenty-third Street than he asked his star pupil
to come with him. He had "very important work" for N. C. Wyeth at
McClure's, and he wanted Wyeth to sign a contract immediately. Pyle was
sure that now that he had an important magazine under his control, Wyeth
would rush to have his work put directly before the eyes of a half million
readers.

Wyeth just as quickly vowed to "stick out against it." He wanted to be
free to capitalize on offers coming in from other magazines and at the same
time to paint. That, after all, was the plan that Howard Pyle himself had
urged before taking the job at *McClure's*.

His father, meanwhile, wrote to Convers, complimenting him on "the
good tack" he was taking in his business dealings. It was another first. Newell
had never before shown respect for Convers's ability to handle his affairs.

ON SOUTH STREET, Hattie was still withdrawn. The snow had melted.
"We see the ground again," she commented on March 22. Robins had come.
The house was being painted—two coats. In Cambridge, she happened to
know, Aunt Hat had suffered an attack of neuralgia. In Needham, "we are
all about as usual." The only serious matter she could find to discuss was
Aunt Hat's prejudice against the Irish: "She is terribly afraid an Irishman or
woman will get some of their land."

On the same March day, Convers lamented to his father, "If she only
knew how I—yes, how [Carol and I] both—want her interest and sympa-
thy, I'm sure she would do so. Not to go into it elaborately but to just casu-
ally be interested."

He could stand it no more. He delivered Mama his ultimatum later the
same day: "I think you treat me, or us, rather cold and in a very unsympa-
thetic way. You were in love once (I hope) and were married, and if you
didn't receive sympathy and attention during that period, I'm mighty sorry.
Nevertheless, I want it and I think you should give it to me."

She hurled back: "I did try. I kept on writing twice a week. I felt you had

other things to do. I don't believe anyone ever felt the change more keenly than I . . . [and] you can imagine how I feel to find that I'm trying to be connected into characteristics described, such as *cold-heartedness, unsympathetic, severity,* and no facility for womankind (fortunately the faculty for mankind was kindly not supplied)."

Furious salvos followed. They took turns enraging each other.

He thundered, "Just because I'm going to get married a few months earlier than you think I'd ought to, that's no reason why you should act so cold."

"I don't drop you coldly as you think," she countered. "But . . . it doesn't seem right that I have to open up and defend myself. It seems that I ought to be understood. To bring up my own troubles I know grates on the ears, but I seem driven to it. I know no one can feel for me, but come as near to it as you can. You certainly was able to once and *I know can again.*"

Standing by his wife to be, Convers challenged his mother: "We both want and need you as a mother and look forward to it if you will only give yourself up to us. Think it over please."

She was unmoved. "How can you expect me to be exultant with congratulations and joy? I should be happy with you, you say, Convers. I feel that *I* need the sympathy—you don't. You have all your desires and so does Carolyn."

Back in January, when Convers had coaxed her down to Wilmington for a change of scene, he had tried to make her feel that his future life would mean something for her. Their new house would suit her "to a T," he assured her. She would always be welcome. But when she arrived, it all looked and felt alien to her. That night, in a strange bed, not able to sleep, Hattie had been jolted by the realization that not only did Convers have a future of his own but he had a past, and it had taken place right here without her.

She was bitterly envious. As far as Hattie was concerned, Convers and Carol had not a care in the world. They were "enjoying all to the fullest extent." And why shouldn't they? "You are at your best, happiest time of life. You are surrounded by your life's work and interests and certainly in your present conditions you feel we all must have a part."

But *she*—what was *she* getting from all this bliss? She felt entitled to better. She made clear that "any little token of affection, a little gift, a letter from either" Convers or Carolyn would "go a long way.

"I also feel," she persisted, "that I should be understood withal, and I'm not *so* cold that I do not feel any little attention."

GROWING UP in his mother's black-and-white world, Convers had developed blinders. Since leaving home at twenty, he had maintained a one-sided

image of his mother. He insisted on her capacity to empathize and he praised her "abundance of true sympathy."

He had not understood her true condition. He ascribed qualities to Mama that are denied by the evidence of her letters. In reality, Hattie excluded others by pouring out sympathy for herself. Her need to find herself in her children prevented her from seeing and responding to their needs. Convers was fortunate to feel as loved as he did by a woman who was wounded by the fact that, except as a painter, he could not be an extension of herself.

It was years later when Convers first perceived his mother, accurately, as a woman who was able to feel connected only when the line between herself and another became indistinguishable. At age thirty-six, he would warn Hattie against "being swept into the feelings of anyone you come in contact with." He would find that he had the same trouble himself.

For now he knew only that a defense of some kind was needed. To fortify himself against this feeling of hers—that *she* was the one who during *his* engagement deserved tokens of his affection; with its monstrous hidden message: that she had no actual feelings for him, except when gratified by his feelings for her—he made believe it didn't bother him a bit.

He spoon-fed her with apologies. On March 24, the day after Mama's counterattack, having reread her blistering letter a third and fourth time, he said he could now "understand it perfectly. It was a simply stated letter and very convincing; it was grand! I have it in my pocket now. I say grand because it was written with a big thought that was meant to help, to explain, and it did."

He was very sorry he had provoked her to reveal herself. But their exchange, he said, had "made me think, and it made me feel first, very bad and then very much better; and I feel better now about it too."

"We both have probably said things we shouldn't," agreed Hattie.

"Please let me take back what I said," Convers replied. "I feel mighty sorry for my thoughtless insinuations and please don't feel that you have to write me a letter on the subject. It would, I know, be as painful to you as to me. Try to think of me as you always have and I'll do my *utmost* to be the same."

But how could he be the same, when the entire landscape of his life was changing?

Unhorsing the Master

O N April 7, 1906, Wyeth turned Pyle down. He told his old master that he would not sign with *McClure's*. Afterward, he thought he had made a "very logical and reasonable stand and *for once* [Pyle] saw my position and agreed with me that I was in the right."

In fact, the situation was not so reasonable. Wyeth refused to contract with *McClure's* on the grounds of a prior commitment to Caspar Whitney at *Outing*. At the same time he felt he owed his teacher allegiance, and his sense of duty got the better of him. He, not Pyle, refused to let the contract drop. Wyeth left the door open by telling Pyle that since Whitney was on a trip, beyond the reach of negotiations, Wyeth would only appear nasty if he switched to *McClure's* and welshed on Whitney.

Naturally, Pyle agreed. He proposed they reopen the matter in June. He then let his star pupil in on a secret: S. S. McClure himself had said that N. C. Wyeth was "the only man in the United States that can do the work *McClure's Magazine* wants."

Thinking it over afterward, Convers exclaimed, "That sounds preposterous, don't it?"

As the wedding drew nearer, Hattie's head "felt mean in every way." On April 3, she announced, "I'm not just right yet." Three days later, she had still "not got well-balanced as to [her] condition." She had managed an excursion to Boston to help Newell pick out the spoons for the wedding present, but the errand had made her head feel "strange." Back at home she dosed herself with tonic and tablets that a neighbor had given her.

One day, as if awakening from a long sleep, Hattie was startled to find that Newell had taken it upon himself to draw up a list for wedding announcements. She had had "no intimation of it."

She tried welcoming Carol to the state of domestic bliss: "I have fortunately been happily situated in my married life and can almost see the same

future for you," she told her daughter-in-law to be. She tried steeling herself
to the change in Convers's life. "No one knows how I have missed him and
how I looked forward to having him with us again for a while, but of course
I can see that is impossible and I *must* give up thinking of it."

She tried to accept that South Street could extend as far as Wilmington:
"It's hard sometimes for me to realize that there is a part of our home being
established in Delaware. I'll come to it in time no doubt."

She was trying to find her way forward. Whenever she thought of the
wedding itself, though, she remained stuck.

"Some [people]," she wrote (meaning Newell's sister Hat), "may talk
gaily over such matters," but for her part, Hattie admitted, "I don't know as I
ever could do it. It's always been a matter of much severity with me. Perhaps
it would have been better if I had been made different."

She seemed vengefully set against going to Wilmington.

Newell, meanwhile, asked Convers to tell Carol that "she is not forgot-
ten by me and she can rest assured that she will be received with open arms
as my future Daughter."

Looking back at the word he had capitalized, Newell paused. "Don't
that sound funny?" he said, and underlined *Daughter*.

CONVERS AND CAROL planned to be married by the Reverend Alexan-
der T. Bowser in the First Unitarian Church, West and Eighth Streets, at
seven-thirty in the evening, Monday, April 16. In attendance would be
Carol's mother, her oldest brother, George, "and that's all," Convers
reported home. The Wyeths would stay in Needham and send flowers.
Hattie hoped to "try and feel the sacredness of the occasion, of the hour,
7:30 p.m. and try and be with you in spirit if not in person."

Convers pretended not to mind. "I think that's fine," he said. April, after
all, was shaping up as the "most strenuous month of my life." He had just
received a manuscript from the Associated Press "for illustration at my own
price" and also "a big offer from the Ladies Home Journal." On top of that
he had started four pictures of woodlands Indians for *Outing*. "Gee! it's
pouring in. I hope something won't bust! It's hardly understandable," he
wrote home. "But I feel in bang-up condition and equal to every bit of it."

To demonstrate that marriage would not change him, Convers boasted
of working overtime on his woodlands Indians pictures "right in the midst
of the most distracting time possible." He later wrote: "I painted my best
picture of the Solitude pictures during the 'marriage siege.' "

Hattie sent Carol her version of a reconciliation: "When Convers, the
dear boy, is yours, kiss him for me and tell him to write me when he can as

that is all I can have of him at the present time." She signed herself "Yours affectionately, H. Z. Wyeth."

The next day Convers reminded his mother of her promise to him—to send down the "Home box" laden with South Street violets. He admitted he would be hurt if she failed him in this request.

But the Wyeths changed their minds. At the last minute they hurried to Wilmington, just in time to see Convers and Carol take their vows. George Bockius, Sr., also surprised everyone by attending. Carol wore a white muslin gown printed with a design of pink roses and looked very much like the long-necked angel carrying calla lilies in the stained-glass altar window.

Recalling his bride years later, N. C. Wyeth would remember "a frail little thing, about a hundred pounds, with a countenance that sparkled with Oriental luster, framed as it was in luxuriant and wavy, warm, black hair." He suspected that "many of her friends looked at us, as a couple, with considerable sympathy and pity for *her* as they viewed my 200 lb., six-foot-one bulk looming beside her."

The day was bright, cheerful, cool for April. Afterward, the two families gathered in the Bockiuses' parlor. Nancy Bockius, at four, was present that afternoon. She could still see, almost ninety years later, the "forbidding" look on Mother Wyeth's face when the newlyweds entered. "When she saw what Convers was marrying into she was probably horrified," Nancy later ventured. She never saw Convers's mother smile that afternoon. Even as Mother Wyeth dispensed homemade gingerbread cookies brought from Needham for the Bockius children, the little girl was afraid of the unhappy old woman.

THEY HAD no honeymoon. Instead, Convers planned to take Carol to Needham that summer for six weeks of pure painting. He painted only six days. Stuck in Wilmington, he slaved over his commissioned illustrations: three westerns for *Scribner's*, due July 15; an Indian cover for *McClure's*, due August 1; four pictures for *Outing*, and three pictures and another cover for *McClure's*, all due October 1.

Telegrams arrived daily, interrupting his progress. H.P. needed another cover. H.P. wanted Wyeth in New York immediately. H.P. must have a new canvas by Sunday. H.P. required Wyeth's presence at a meeting with McClure. Wyeth must rush his other work to make room for the work of *McClure's*. Wyeth must not let any other commissions stand in the way.

"Mr. Pyle expects *so much* of me," he said crossly at the end of June.

But the work was paying the bills. The N. C. Wyeths now slept in a sturdy Mission bed, sat in solid Mission chairs, wrote letters at a Mission

desk. Served by a cook who did the marketing and laundry, they ate at a heavy Mission table under a somber Mission lamp. They bought a parlor piano. "Convers's success made everything possible," Nancy Bockius said later.

In the evenings, Nancy would sneak over to the newlyweds' "dollhouse-like" rooms. The younger "Bockiae" had been ordered by their mother to keep away, but the cook, Rachel, would hide five-year-old Nancy in the pantry as the N. C. Wyeths sat down to supper—"just the two of them," Nancy recalled. "Carol would light the candles on the table, very formal and everything." Nancy remembered these tableaux all her life. She remembered how happy Convers had made her sister.

Two or three nights a week, they had other couples to dinner. Allen True, still single, uncertain about his work after a string of failures, stopped in for dessert; Carol mothered him; Convers gave advice. They picnicked in Chadds Ford and went on trolley rides in the summer evenings, the women chatting together in their sashed white frocks, the whiskerless young men with their pipes and ardent talk of pictures and Mr. Pyle.

As early as May 1, during one of Pyle's recruiting efforts for *McClure's*, Wyeth had recognized that his teacher was "clean off his trolley these days. All worked up over the *McClure's* business." At *McClure's*, dissension among the editorial staff had led to a full-scale mutiny on May 10. In the upheaval that followed, sensational accounts filled the newspapers. McClure lost "the most brilliant staff ever gathered by a New York periodical," including his star muckrakers, Tarbell, Baker, and Steffens.

The defection of the magazine's big names must have made Pyle nervous. The pretense that he had taken the *McClure's* job in order to be "of direct and practical use" to his students had worn thin. Pyle had become more and more impulsive, blowing into Wyeth's studio "like a whirlwind." In another instance, he followed Wyeth around "like a shadow, requesting [him] to hustle out work [for other magazines] to make room for [*McClure's*]." Yet Wyeth went right on abetting his teacher's exaggerated states.

Three factors complicated the *McClure's* drama. First, Carol was pregnant. They had, however, told no one. She had conceived close enough to their wedding day that they felt constrained to keep the pregnancy under wraps.

Second, N. C. Wyeth had become a hot commodity. Attending a gala magazine publishers' dinner at the Marlborough-Blenheim Hotel in Atlantic City that May, he found himself the peer of celebrity illustrators like Howard Chandler Christy, James Montgomery Flagg, the brothers Leyendecker, Charles Schreyvogel. Although gratified that "quite a few

Kidnapped, cover label,
illustration, 1913

The Wreck of the "Covenant,"
1913

At Queen's Ferry, 1913

artists of note asked to be introduced to *me!*" he still could not allow himself full credit. He felt he owed his success to his teacher, and the more dutifully he enacted this sense of indebtedness, the longer he remained the student, the favorite son, with Howard Pyle the all-powerful master.

Third, Wyeth had become dangerously caste conscious about everything he painted. That summer and fall, as his illustrations appeared regularly in a variety of best-selling books and popular magazines, and as additional commissions followed, Wyeth calculated the prestige each picture would confer on him. The more successful he became as an illustrator, the more he discriminated between pictures painted to illustrate texts and pictures painted for exhibition. Never mind that his pictures had made him independent of his parents, had made his marriage possible, had made him famous. The more popular N. C. Wyeth became, the less he seemed to count as a real artist. "If only someday I can be called a *painter!*"

On one of Pyle's relentless dragnets through the student studios that summer, he played to that wish. He said that Wyeth seemed overburdened. Commissions from no fewer than four magazines at once—no wonder Wyeth wasn't able to paint: He was taking on too much commercial work. What he needed was a fixed income from one magazine for a limited amount of illustration—say, $4,000 for thirty weeks a year, with the rest of his time free to paint. As art editor of *McClure's*, Pyle made this offer on June 11, effective July 15.

Wyeth neither accepted at once nor declined. He would afterward remember the "discouraging atmosphere" of this duel with Pyle: "How many times he told me that he doubted my real ability to paint a big picture because he felt sure I was in the clutches of commercialism. Even allowing for his impulsiveness, that did not relieve my mind of such a terrible foreboding."

Carol remembered, "It troubled him so much how things would turn out."

In reality Wyeth would have been foolish not to sign on with Pyle. He was doing Pyle's work anyway. He had published western pictures in the last three issues of *McClure's*. He had accepted when Pyle had offered in May the cover article for the November issue. Another offer had followed from S. S. McClure directly, an order to illustrate the September cover story, an exposé of bribery and fraud in Montana's election of a U.S. senator in 1900; Wyeth had taken on that job too. Why not sign a contract and get better pay for the same work?

When the magazine agreed to Wyeth's one stipulation, that he remain free to illustrate for other publishers, he signed the thirty-week, $4,000 contract, promising himself that the arrangement would give him "time to paint."

He had no time to paint. As Carol sewed baby clothes, Convers sweated "to satisfy Mr. Pyle in his wish for a 'big' cover." Determined to do everyone—his parents, his wife, his master—proud, in August Convers put aside all other work and "poured every bit of [his] inner self" into three pictures for Pyle's first issue at *McClure's*.

AS EARLY as May 20, Pyle had made up his mind to quit *McClure's*. He had known at once that he was going to fail as a three-day-a-week art editor. The truth of the matter was that everyone else had been right: Howard Pyle was all wrong for the job. His point of view was provincial, his ideas about American pictures old-fashioned. He clung to exhausted visual forms and revealed himself inadequate when working with artists who did not create pictures in his own manner.

The painter John Sloan, for example, had tried to get assignments from Pyle. Sloan had been trained as a newspaper artist in Philadelphia and was beginning to break from the decorum of conventional illustration in favor of a more integrated rendering of urban life. He wanted to paint the modern city and its people without idealizing any of it. He would show that beauty and squalor could *coexist* in the twentieth-century artist's vision. Pyle could not accept this view. Unwilling to integrate grime with glory, high with low, Pyle treated Sloan evasively, pronouncing the painter's submissions to *McClure's* "good in character" while also "sourish or kindly." Sloan retaliated by declaring Pyle "poisonous" and his costumed romances worthless. The future cofounder of the Ashcan School reserved his harshest judgment for Pyle's "poor little imitation hemorrhoids of pupils."

To fulfill his own responsibilities as editor, Pyle leaned heavily on friends. As always, he relied on personal magnetism and the false excitement of inflated expectations to carry the day. But when his contemporaries declined to submit pictures to *McClure's*—A. B. Frost, "yearning for something better," had given up illustration entirely—Pyle was stunned. He had assumed that everyone would want to work for the cause, for the "benefit to American Art," for *him*. When it became clear that Frost's rejection was just the first of a series of similar "shocks," Pyle saw his best chance to salvage the wreck. He leaned hard on his tried and true pupils, sending Schoonover out west, all expenses paid. He snared Wyeth with the thirty-week contract.

But by then Pyle had all but quit *McClure's*. Cutting short his losses, Pyle agreed to keep a hand on the wheel until a replacement could be found. At his urging S. S. McClure tried to lure Joseph Chapin away from Scribners with promises of stock options and a percentage of profits. When that failed, Pyle raided his own stable. On June 4, he turned to Allen Tupper

True. "You are the man I want," he announced, promising that if True would only sign on now as his assistant editor, "large opportunities would lie in [True's] path." He promised True, who had just turned twenty-five and felt wobbly about his future as a painter, that within weeks he would ascend to the big desk, becoming art editor of *McClure's Magazine*. "He got True to believe at one time that it would be only a matter of hours," Wyeth later wrote. Hopeful, gullible, True canceled the few commissions he had signed up for and waited for the good news.

On August 10, Pyle resigned, leaving everyone treading water. His artists' contracts were immediately revoked. Allen True lost his chance at the job Pyle had promised, as well as the commissions he had given up to take it. Schoonover returned from the West with $2,000 in itemized and documented expenses; Pyle refused to honor any of them, leaving Schoonover no choice but to sue *McClure's* for the money.

Once again Pyle was the talk of the publishing world. It was all over town that "the great Pyle" had welshed on his obligations. Back in Wilmington, Carol Wyeth came closest to understanding what had happened in New York. She knew her old neighbor better than any of them. "The trouble is," she wrote on August 17, "Mr. Pyle has not been out in the world. He is narrow, down to his little circle of friends in Wilmington." The Howard Pyle she knew from childhood had always been stuffy, backward looking, and, like many of his class and background, deeply bigoted. Carol would never forget the time when Pyle refused to shake the hand of a black man who had fought in the Civil War.

So PYLE WAS HUMAN. "And *oh!* how relieved I feel," Wyeth exclaimed. "Actually I feel like a new man."

In Pyle's collapse he had at last found a way to free himself. "To tell you the truth," he wrote home, "I'm tickled to death. The stringent obligations I was under [were] like a millstone around my neck. Not the obligations to *McClure's* so much, but to Howard Pyle." Wyeth understood at last that Pyle had "blinded [him] by keeping [him] enthusiastic and interested. He manipulated me like a puppet."

On a blazing August day, he confronted his old master in the same studio where he had first been "hypnotized" by the Washingtonesque face of Pyle. This time he saw the man whom people in New York were calling "a notoriously selfish overbearing hypocrite." Wyeth had no trouble being forthright. He battered Pyle with reproaches. He accused Pyle of "using [him] for personal betterment." He took Pyle to task for lying to the magazine about Wyeth's last pictures; Pyle had claimed that if he, Pyle, were not

associated with *McClure's*, then his "student" Wyeth would not want to have his work appear with that of inferior illustrators.

"That's damn bad talking, you know!" Wyeth exploded.

Pyle outmaneuvered him, as always. He agreed with Wyeth. He admitted that his former student was justified in his anger. Pyle held his head high and in a clear voice said that it meant a lot, it meant more than anything else, to hear the truth from Wyeth. *McClure's* had cost him his reputation, but perhaps it was worth it, for this.

Pyle did not go to pieces in front of Wyeth, but his position as an idol disintegrated. "The whole thing is nauseating to me," Wyeth wrote. "I'd like to shake myself like a dog from the water to rid myself of Mr. Pyle and his present influence." He knew that Pyle had "given me invaluable training up to this point, but now that he has degenerated into something incredible, it's my duty to myself and to everybody else to break away."

H E H A D A F A M I L Y to plan for. Convers and Carol's first child, a girl, arrived December 16, 1906. They named her Carolyn. Born a month premature, the baby weighed five pounds. A day after birth she was "doing splendidly," according to the new father, "perfectly and beautifully formed, with lots of hair and a fine-shaped head." Carol had delivered at home, and Convers could not get over her transformation "from a young fly-away girl into a *real* wife and mother."

The child's health seemed exceptionally good. Nevertheless, Convers hired a trained nurse from the city hospital, explaining to his parents that "the next two weeks mean a great deal." Five days later the baby died.

Outside on Shallcross Avenue, Carol's sisters and brothers gathered under the Wyeths' windows and sang Christmas carols. Inside the small brick house, grief overwhelmed the couple. Wyeth wrote, "The great sorrow has been to me one of the greatest things that ever took place in my life." He did not give out the cause of the baby's death. "But how it has lifted us," he exclaimed, "and how much nearer together it has brought us."

During their courtship on the Brandywine, Carol and Convers had often stopped to read the stones in a small country graveyard on the way to Chadds Ford. On December 23, Convers went alone and buried the little girl there.

In Needham, the sudden death produced something new in Hattie Wyeth's letters. She chose Christmas Day, her birthday, to reopen her own tragedy.

"Why is it that from the first moment I read your first telegram, I felt a tinge of sadness. *It was not* that I doubted your word, but the laws of nature

are such that we cannot understand or control them and a child of eight months not so often lives but many, such as Grandpapa, live to be large and great men."

Despite Hattie's inverted diction—she meant: "a child of eight months not so often *dies*"—the unintended revelation was true. Hattie's baby brother had lived eight months, twenty-eight days. Forty years after being swallowed up by the Charles River, Rudolph Zirngiebel had surfaced.

Secret of the Grave

AROL OPENED THE family record book in which she had intended to keep track of their baby's progress. She wrote, "Most unhappy Christmas I ever spent."

On Christmas Day she had received a letter from her mother-in-law. "We must console ourselves with the thought perhaps she was too good for us," Hattie wrote Carol, "or that she may have been spared a life of trouble, who knows?" It had been "a trying week for me," Hattie announced to the mother who four days ago had lost her firstborn. "I did not feel very well and the little [birthday] celebration and Xmas coming so close together made me a little tired."

With Convers, Hattie was no less insensitive. "I'm glad," she told him, "that Stimson is with me, as I'm really tired of my own face, and it relieves me much to have the interest of another. I want to write a few lines to Carolyn, [but] Papa is breathing hard in sleep this hour."

She found it "hard to realize that you, my oldest baby, was having this, his first experience of sadness in his seemingly short career. Those four years [that Convers had lived in Wilmington] seem sort of lost to me, although I know they have been most valuable, but to a mother and her home, her oldest boy is a great part of her life. *You* never *can* realize that."

Hattie felt sorry for "poor Carol" and envisioned her "crying in the very stitches she put into those little garments, and dreaming dreams of the happy moments to come, and after all [that], to have all pass away so quickly." She rightly understood that for Carol, "babyhood was particularly attractive and beautiful."

Hattie listed her own Christmas presents, then closed with remarks about a family friend named Nils who had telephoned that day with news of the death of his infant son. "No particulars as yet," she commented, adding: "Sad Xmas for them indeed. Hope this will find you all as well as usual. With lots of love from Mama and all."

· · ·

THE CHILD'S DEATH lifted Wyeth out of "a chaos of semi-serious work."
It seemed to place him "on a pure high plain of intense and deeper thought."

He was twenty-four years old. Until now he had walked to and from
his studio with a bounce in his step. He wore the brim of his Rough Rider
hats low over flashing gray eyes. In his western pictures, serialized monthly
in *The Saturday Evening Post*, he now had "no equal in his field." His
recent Cream of Wheat advertisements had been a success all across the
country. The Solitude series of woodlands Indian pictures published by
Outing had stirred the publishing world, bringing an unusual outpouring of
congratulations from ordinarily tight-lipped rival magazine editors, all of
whom commented on the "poetry" he had managed to get into his work.
Packaged as a portfolio to sell subscriptions, the series made him widely
marketable—"one of our greatest, if not our *greatest* painter of America out-
door life."

Scribner's Magazine had also broadened his audience, selling *The Moose
Call* as a ten-by-fourteen-inch photogravure reproduction. His fan mail
included a letter from Gen. George Armstrong Custer's widow, Elizabeth
"Libbie" Custer, who admired the naturalness of Wyeth's bare-armed Indi-
ans and felt that the series was valuable to American history; Libbie Custer
had placed Wyeth's work in a fireproof storehouse with the bulk of the
Custer papers "from the far back days of the Plains."

None of it seemed good enough. He had a sense of falling short. N. C.
Wyeth had higher goals.

IN PHILADELPHIA, the Pennsylvania Academy of the Fine Arts stood at
the corner of Broad and Cherry Streets. Established in 1805, it was the old-
est art museum in the United States. That winter no fewer than 2,500 can-
vases had been submitted for the annual exhibition; only 220 had been
accepted. Wyeth had worked three months on his submission, an Indian
subject, and though he professed "very little confidence in its passing the
array of judges (six best artists in America)," he decided that their judgment
would "at least give me an idea where I stand."

The academy judges confirmed his fears. They rejected his picture. In
January he attended the exhibition from which his work had been excluded
and stood cowed by what he saw. "These pictures are so wonderful that they
have caused me to realize my inability to paint a real big picture. My argu-
ments with *myself* are long and wearisome."

He was in a "terrible rut." He wanted "to be *able* to *paint* a *picture*, and that is as far from the realms of illustration as black is from white." The more he succeeded as an illustrator, the more "every piece of work that I turn out is a pain to me, because I can clearly see that it is inferior to that *great* thing, that might be done."

Vowing to cut down on his magazine commissions, he announced "very severe plans" for painting. He would punish himself for his success with "a year of stiff hard labor." He begged his mother to share his conviction that by renouncing illustration he would be "striking for a higher, yes, the *highest* plane of art."

Hattie thought he was "taking things too seriously." She told him his standards were too high. "Remember you're *very* young. Why not be content with developing with years (as you certainly will) and be better for it in the end. The mature work I believe will then show itself. You say perhaps I do not imply that your mind is mature. How can it be when you've been illustrating other people's minds all this time?"

She pointed out that Convers had had so much success and so few disappointments "you hardly know how to handle them." She believed he had overtaxed his nerves; therefore, she insisted, "the result of what you can do will probably never be satisfactory." She thought he had "not given a chance to your own [mind] to show what it might portray." She wanted him to paint more thoughtful pictures.

She concluded, "All this is your lesson that you are profiting by. I often have wondered how you did as well with so many about you. You are using yourself up [in illustration] . . . and I think your plan of secluding yourself for a while is the best you can do. Then your mind will have free play."

He took her advice to heart. Conceding that he needed to escape Howard Pyle, Wyeth packed up Carol and his Wilmington studio and spent the summer in Chadds Ford, painting in an old mill and renting rooms in the tower of a village house called Windtryst. It would be a place to do his own thinking "in an atmosphere not polluted with the minds of all the fellows [and] *his* powerful influence."

THAT SUMMER Wyeth painted Chadds Ford as he had first seen it. In his western pictures, he had depended on basic attractions. He had titillated the viewer with big skies, bad men, violence. His *Saturday Evening Post* westerns were tightly controlled set-pieces, stopping the action, fixing it often at its harshest climaxes. In the "Farm Series"—a group of four pictures commissioned by *Scribner's* to accompany "Back to the Farm," a poem by Martha Gilbert Dickinson Bianchi, niece of Emily Dickinson—Wyeth

relaxed the narrative. He opened up the picture frame. Bringing the action up close, he released it from a single climactic moment.

In the foreground of *The Scythers* (1907), a young farmhand cuts a diagonal path across a hayfield. Behind, in the middle ground, stands a fellow scyther, a young man stopped for a rest, drinking from a ladle and pitcher offered by a younger girl—a posed pair we will next encounter from a more conventional angle in a companion painting, *Mowing* (1907). But here we track past the fixed scene of the ladle-and-pitcher pair. We follow the first scyther as he steps into his swing, his back arm rising into sunlight, his front shoulder dropping into shadow. In one more step he will be out of the picture plane. Wyeth invites us not so much to ask what happens *next* as to relish the emotional effects of the ever-widening here and now: the fuzzy light of the hayfield, the soft clover-scented air, the subdued wind, the poet's "deep green calms of summer."

Chapin praised the work, saying that no magazine had yet published pictures with the quality and refinement of the Farm Series. Wyeth allowed himself a rare moment of pleasure at his editor's encouragement and was even more pleased to think that he had at last come close to fulfilling his mother's aims for his art. "I believe it's the very thing you have always wished me to paint," he told Hattie. "I think I have at last got that feeling of lonesomeness which you feel when you look at a Swiss mountain picture."

TRYING TO DECIDE whether he would be a crowd pleaser or a poet, he had not yet given up the struggle with Howard Pyle for control of his brush. He still needed trial by fire. After finishing the first picture in the Farm Series, he brought the canvas into Wilmington on July 1 and put it on Pyle's easel.

Pyle's face turned red. Sweat popped out on his neck in tiny beads. He turned to his former favorite, put his arm around Wyeth's neck, gave him a hard squeeze. He praised the picture to the skies. He told Wyeth he was as proud of this painting as he had ever been of any painting in his studio. He called it "the first *big* note ever sounded under his teaching."

Wyeth repeated this ritual in July. He took the still-wet canvas of *Mowing* into Wilmington and set it on the master's easel for critique. Pyle and his latest protégés gathered around. The picture, Pyle declared, was Wyeth's best work.

Satisfied to have his master's approval, Wyeth second-guessed him. He suspected that *Mowing* had appealed to Pyle because the picture told a story. "But I want to go beyond that and tell of the *spirit* of harvest and

the sumptuousness of the hayfield." On July 25, on the eve of a trip to New York, Wyeth decided he would cast aside the narrative picture. The next day, after studying the paintings in the Metropolitan Museum of Art, he looked again at *Mowing*. It struck him as trivial. The figure of the little girl with the water pitcher bothered him especially. He thought she "predominated" the composition and "subordinated" its theme, "the bigness of the harvesting."

Actually, *Mowing* has very little story to tell. It stands as fixed iconography. Moreover, the composition is derivative. Deliberately or not, Wyeth had reproduced the two figures from Winslow Homer's *Gloucester Farm* (1874)—a girl carrying water for a farmhand who pauses in his work and drinks. In Homer the props are bucket and hoe; in Wyeth, pitcher and scythe, but the essential elements of staging are the same.

On August 1 he again sought Pyle's approval, this time for *The Scythers*. Pyle came down hard. Still praising *Mowing* extravagantly, he criticized Wyeth's latest attempt at its most elementary level of drawing. If that was not enough, Pyle "continually mentioned the 'delightful little girl with the water pitcher.'" He could not say enough about that little girl. Even when Wyeth "had every fellow believing" that the new picture was superior in conception, Pyle refused to be shaken from his conviction that the little girl was one of Wyeth's best pieces of painting and characterization.

Wyeth suspected Pyle of deliberate sabotage. Praise had always been H.P.'s way of maintaining a tight grip on a student's brush. But praise for the most inferior element of a picture, indeed, the one element that firmly grounded the picture in the world of illustration—H.P. had tipped his hand.

Wyeth returned from the "brick confines of Wilmington" to the sticky freedom of a damp August in Chadds Ford. "I am not discouraged," he professed, "but it makes me feel bad to hear H.P. cling to lesser ideals."

Yet when he faced the new canvas again, he faltered. On August 9 he wrote, "I have worked and worked on that hayfield picture until I don't know what I *have* got, so now I have dropped it for a few days to do a picture for *Century*." Since Pyle's critique of *Mowing*, Wyeth had not been able to "get back at it in the same spirit." He was sure of one thing only: "I shall go ahead now and finish up the remainder of the set alone with no help or interference from him."

In September, Joseph Chapin praised the finished set, immediately making plans to publish the series in five colors in the all-important August number the following year. The originals would be displayed simultaneously in Wanamaker's department store in Philadelphia. Pyle, by contrast, offered no encouragement when Wyeth showed him the completed Farm Series.

Wyeth noted, "The fellows were astounded at the cold, indifferent reception he gave me and they seem disgusted with his actions."

For Wyeth, this Pyle was unrecognizable. But he vowed to tolerate him, flaws and all. He took it as a matter of duty to accept "the man's personal weaknesses." As strong as his sense of duty was, though, Wyeth could not square this imperfect Pyle with the ideal man, "the grand and noble Howard Pyle of 1903–1906," as he would soon label *his* Howard Pyle.

Meanwhile, he was to be a father again. Carol had become pregnant in January. Understandably, she was feeling "anxious and nervous as to how things will turn out." Convers had his own worries about this second pregnancy, and they only made Pyle's falseness the more vivid. "My mind is too tense and sensitive this summer to be battered around like a student—I can't stand it! If he would use tact and consideration with an older fellow that would be all right, but he continues to thrust his own ideas (excellent for himself but not for another) into the place of your own."

The renewed struggle with Pyle left Wyeth with "that eternal lingering consciousness that is saying, 'I know what I want to do—but how?' And then the self-criticism starts, the introspection—I even dream of it."

THAT SPRING, every couple of days, uncomplicated, newsy letters arrived from Hattie. Her mental health seemed to have improved. Mama wrote wonderfully predictable accounts of life on South Street. Then, at the end of May, she wrote about a visit to her family's grave.

On the outskirts of town, the Needham Cemetery was a peaceful place, visitors the rarity rather than the rule. Hattie liked to visit on spring evenings, when the grass and trees looked "clean and becoming." Placing a handful of cut flowers among the gravestones made Hattie feel reconnected to her family.

One evening, when "there was not a soul about," she happened to flush a squirrel from behind the Zirngiebel gravestone—a large gray squirrel with dark, shiny eyes. It stood, watching, tail twitching. Then, without warning, the squirrel leapt at Hattie's throat. As she later continued the story, "He jumped on me twice, from trees and tombstones. He tried many times. He went for my neck and bit me there severely, besides in the arm and third finger of right hand. I threw vases and anything I could get."

Shielding her head with her arms, Hattie ducked into the groundskeeper's shed. The squirrel pursued. He jumped on the roof, and Hattie heard him running from one side to the other. The squirrel, she believed, was "waiting for me to appear."

She took a long stake from the shed. Cautiously opening the shed door, she stepped outside. The squirrel "made another leap, but when he saw I had a big stick he seemed to be a *little* more timid. But I had to go out into the open, away from trees in order to be able to leave the cemetery. For ten minutes I fought hard, my hands and face bleeding. It seemed [like] one hour. However I had my bites attended to and am getting along all right."

The story spread rapidly. It appeared in the Needham *Chronicle,* and Hattie contended that "the article printed is by no means exaggerated." Traps were set, and a small posse of townsmen tried to shoot the animal. "But he is wily," Hattie reported. Of course the town talked: "Some say there is no such thing as a crazy squirrel." But Hattie guessed he was crazy. She never questioned that the squirrel was male, and she hardly questioned the attack itself, except as a matter of happenstance. "It was a strange coincidence especially as I seemed to feel so comfortable otherwise," she concluded, adding, "I somehow feel that peacefulness so profoundly and to be so furiously attacked was really sacrilegious."

The story upset Convers, "stirred me all up," he told Mama. It seemed to him ominous, and the night after reading Hattie's account, he had a dream. His mother, bitten and bloody, had succumbed to the malevolent squirrel and died. The dream was so vivid and his feeling of guilt about having had it so powerful that for the next four days he did not trust himself to write his mother a letter.

The practice of trading intimate weekly letters was not uncommon for mothers and sons poised between the Victorian and Modern worlds. What made the Wyeth correspondence so charged was the manner in which Convers and Hattie pursued their intimacy well into his marriage. Both seemed unaware that new boundaries had been drawn. If anything, marriage had increased the flow of feeling between mother and son. Letters were now the only way to "have a conversation with you all to myself," Mama lamented.

She went on emptying her thoughts onto paper every Friday. "I don't feel right if I don't dispatch a letter to you on Friday," she said. Convers received the thick, bundled clumps the next day. "Saturday morning always finds me rolling out of bed a *little* earlier, a *little* more wide awake, because of that letter," he wrote. He proclaimed himself "ravenous for every word," and instructed Mama, "Don't ever restrain yourself when writing but *let it all out.*" She freely admitted, "I seem to be talking to you all the time in my mind."

Carol noticed the heavy traffic. "There is such a wireless going on back and forth from your home and ours, that just to think of you all seems as if I had written."

Carol was their go-between, regularly alerting Hattie to the latest show of Convers's affection. "You can't imagine how Convers loves his home [on

South Street], his devotion to you even if he is away from you is sublime. I feel at times as if I were in the way—keeping him from you—I feel it many times."

In reality Carol had done nothing to stand in their way, and she never would. On Convers and Carol's eleventh wedding anniversary, Convers would still write to his mother that he could "think of no better way to celebrate the occasion than by writing home, and to you in particular."

As Carol's pregnancy progressed that summer in Chadds Ford, Mama's letters became for Convers "rich and full and weighty," an unstopped flow linking Pennsylvania and Massachusetts. "Oh! Mama," he gushed during Carol's ninth month, "those letters pour into my soul like some wonderful soothing fluid, and into Carolyn's too."

He repeatedly drew Carol into the milky romance, reporting to Mama every new demonstration of Carol's affection and need for Hattie. "Carol is continually thinking of you," Convers wrote. "You have filled a spot in her heart that has long been empty."

"Her regard for Mama is supreme," Convers told Stimson.

When Carol had first visited the Wyeths in July 1905, Hattie had decided that the Wilmington girl was too skinny, and she put Carol on two glasses of milk per meal. Two years later Carol still appears in Convers and Mama's correspondence as an undernourished near orphan, severely neglected by an absent father and a feckless, fairylike mother. Over and over, to the point of histrionics, Convers insists on *his* mother's salutary, "wholesome" effect on his emotionally bruised wife: "O! how hungry that girl is for the companionship of a big sane woman! She has been sickeningly surfeited with the other kind, and I pity her to the bottom of my heart!"

Carol kept up her letters to Convers's mother, but the effort strained her. She could never think of what to say to Mother Wyeth. "When it comes to writing, I get stiff, am too conscious," she confessed. She wished she could put her feelings down on paper the way Convers did—"all at once."

Carol pictured herself as a happy convert to Wyeth ideals. One day that summer of 1907, after a visit with the Wyeths in Needham, Carol told Convers, "I feel as though your mother was my mother too!" And though this remark might be interpreted in a number of ways, Convers at the time needed no further evidence of Carol's feelings. "That just took my breath away," he quickly wrote Mama, "because that's all I wanted."

With Carol inside the magic circle, Convers was free to love and be loved by wife and mother, without conflict or conditions. He wanted Carol—he wanted everyone—to pay homage to Queen Mama. In September, Wyeth passed along one of his mother's letters to his fellow Pyle alumnus Stanley Arthurs, "to show him the big healthy and alive interest" his mother took in her sons.

Alive the letters might be; healthy they were not. In November, Hattie's physician suddenly declared an embargo. For the sake of her health, Mrs. Wyeth and her son must stop writing each other at once.

THE COMPLICATIONS had started when Carol gave birth to Ann Henriette Wyeth on October 22, 1907—Convers's twenty-fifth birthday. The child was given the first names of both her grandmothers, but it was clear at once whose grandchild Henriette Wyeth would be, starting with the pronunciation of her name: *on-ri-ETTE*.

Despite his joy at Henriette's arrival and Carol's steady recovery, Convers focused on his parents' reaction to the birth. He felt neglected by Newell and Hattie. On November 1, he wrote his mother, complaining, "Poor Carol has looked for a letter from you in every mail since Tuesday, and I am awfully sorry that she hasn't got one. It has made her feel kind of bad." Once again he maintained that Hattie was Carol's mother too. "Carol listens more to you by far than to her own mother because she knows that your remarks are substantial and not impulsive."

For his part, he felt sorry not to have heard from his father about Henriette's birth, and he hoped that "all the above disappointment may be redeemed in tomorrow's mail."

His frustration was barely justifiable. Newell had last written on October 13, his standard four-page letter in a reddish orange envelope. Not inattentive, Newell had complimented Convers on the acceptance of the Farm series at *Scribner's*. "Each year seems to see you steadily advancing in your art," he added, "and all this is very gratifying to me." Newell had also remarked on the impending birth. "Tell Carolyn I am looking for a good report from her and even if I have got to be 'Grandfather' it will not make me feel any older."

As for Mama, she had knocked herself out over this year's Home Box, she had written an affectionate letter to Carol on October 21, as well as a fat birthday letter to Convers on October 22, and a long, effusive congratulations to Convers and Carol on October 26. For Convers, though, it was as if a faucet had shut off. The "soothing fluids" of that summer had dried up. Although Hattie was writing as often as ever, there were not enough letters to satisfy him.

When his November 1 complaint crossed in the mail with yet another long letter from his mother, he apologized. "Perhaps I was a little hard in saying what I did, in regards to the scarcity of letters, but my mind was so ruffled that I probably expected too much." He had said much the same thing when he had announced Henriette's birth: "My mind is not my own

about now." But he seems not to have considered that his mother might also be distraught. He remained oblivious to the warning signs in Hattie's letters, as well as to the undeniable fact of Carol's transformation. Try as he might to present Carol as an undernourished child, or as some variation of that "slip of a girl" he had married in April 1906, Carolyn B. Wyeth was a sturdy, twenty-one-year-old woman, his legal wife, and, most threatening to Hattie Wyeth, the mother of a daughter.

THE APOLOGY came too late. On South Street, Mama had darkened the rooms, taken to bed. On November 6, in the evening, Nat described the situation at home:

> That last letter you wrote seemed to bother her a little as she has always been so faithful in her writing and you know too that she is sort of sensitive, especially when there is another woman in the case (you know what I mean). We had quite a talk the other day and she told me she was not feeling well (at the time she was in bed). I told her I thought she worried and worked herself up over a good many things that did not need it, and I brought up this letter writing business.

Symptomatic again, sleepless, with a "depressed feeling" in her chest, Hattie at first decided that her troubles were simply a matter of age. Twice as old as she had been when she started having children, she saw herself as half the woman she had been. According to Hattie, her chances in life had all gone by. When she consulted with Dr. Pease, he advised her that the cause of her recurrent nervous condition was not age but "too much thinking."

She decided at once that it was her letter writing. She had been too faithful, too generous with Convers and Carol. The effort had overtaxed her. The doctor agreed. She must stop writing and receiving letters.

She dropped one last bombshell on Wilmington. In the spiteful, self-pitying voice she had often used during the marriage siege, she told Convers and Carol, "I suppose you are both happy in your family's acquisition, the baby, so you'll not miss it (the [weekly] letter)." She went on, "I mean, I suppose everything is going on swimmingly, and of course I feel that to have a daughter (so much wished for in our home) should, and no doubt does demand every attention."

Then she fell silent under the new ban. But it made no difference. Her sleeplessness recurred, as well as the feeling that she had been swept aside by

the new mother and the new Henriette in Convers's life. At her kitchen window, facing the pasture, her eye was drawn daily from the Wyeth household to the Zirngiebel homestead. That fall, one of the brightest she could remember, her brother Denys had been making some changes on the old property. She noticed every new development in her childhood landscape and fretted over the smallest alteration. "Any change they made kind of worked on her mind," Newell recorded on November 8. "She did not seem to want to see any improvement made over there at all."

Newell believed that both Dr. Pease and Hattie were mistaken about the letters. Hattie's resistance to the changes next door were causing her far more turmoil than weekly letters from Convers. Newell clashed with Dr. Pease and argued vehemently with Hattie. But neither would listen, and he began considering a radical departure. "I sometimes think I will sell my place and go somewhere away from here altogether, so that she will be away from her old home associations, and perhaps she would get in normal condition again."

Baffled as always by his wife's torments, Newell urged Convers to keep writing Mama. "Don't change the style or tone in the least," he insisted. "She has always looked for your letters and always will and I hope you will continue right on in the same way."

Dr. Pease, meantime, wrote a confidential warning to Convers, pressing him to refrain from writing directly to his mother. Convers must instead address his letters to the rest of the family.

He ignored the doctor's orders. He also overlooked Nat's suggestion that Hattie's feelings had been complicated by "another woman in the case"—in other words, by Carol. Instead, he sided with Newell but at the same time disregarded his father's remarks about the Zirngiebel homestead. He saw *himself* as the source of his mother's suffering. "I shall try," he offered, "to keep my letters *down* in temperament and spirit and that may eliminate the real cause of her mental nervousness."

On November 10, he wrote what he believed would be the most ordinary, untroubling letter. He announced that he had bought a baby carriage. It was still a little early to take the baby outdoors, he explained, but they would use the carriage until springtime as a downstairs crib.

He then asked what he thought would be an equally harmless question: "By the way, where is the old one we all used?"

THE NEW SIEGE lasted thirty-three days.

After being asked about the baby carriage, Mama refused to pick up her pen. As before, Papa filled in as the family correspondent, his weekly letters

sealed in odd-looking envelopes, each the same red-orange color. Newell happened to have found a batch of these envelopes in a drawer, and, no matter how silly they looked, he was determined to use them until the supply ran out.

Convers, meanwhile, addressed his mother in a new, more reserved tone. "Although I am perfectly happy with Papa's letters I shall welcome a letter from Mama again." But it was not long before he had raised his voice: "Tomorrow I look forward to the letter from home. Home letters are more precious than ever now since you've stopped writing. I'm glad if it will do you good of course to rest a while, but I will be very glad when you start again."

The next day another of his father's red envelopes appeared. On December 6 Convers warned Mama, "Tomorrow I expect letter or letters from home. The latter script is my weekly stimulant from home and I won't leave for Chadds Ford until I get them."

Still she would not reply. Another alarmingly red letter appeared. Convers wrote Mama two days later, begging for some word. Again she refused. Five days later he took another stand: "My hopes lie in the morning's mail." That night was Friday the thirteenth. The next morning there would be "either a 'scarlet letter' " from his father "or possibly one from you! I've been wondering all day which it will be."

GETTING AS LITTLE as two hours rest a night, his mother had dosed herself with the usual pills and tonics. She had "tried mental science and all." She had "[gone] out all I can." Nothing had worked. In her choppy bouts of sleep, Hattie had unspeakable dreams about babies.

On Friday the thirteenth, buoyed by the celebration of Ed's twenty-first birthday, and refreshed by the best night's sleep she had had for two months, she took her place by the kitchen stove. She had given Dr. Pease her promise ("I was going to keep nice and quiet"), but once more she set down the words with which she had started so many other letters: "Home—Friday/Dear Convers—"

This time, she let it all out. After thirty-three days of silence, Hattie was ready to answer the question about the old baby carriage. She explained that she had tried to accept the fact that Convers had started his own life. Insofar as she had succeeded, it had been on account of Convers's letters, which had welcomed her to treat his new home, his marriage, even his feelings, as if they were her own. But now that Convers and Carol had a child, she could not go on, in her nightly reveries, "following you through Wilmington, Chadds Ford . . ." She felt stymied by the new situation, pushed to her limit. "I cannot realize you with a baby carriage," she said.

Triggered by the death of Convers and Carol's first baby, her convoluted prose had recalled a child who had lived "eight months." In the same letter Hattie had reported for the first time that she had had *three* brothers. Then, four days after Henriette's birth, Hattie revealed one of her life's "*greatest regrets*": None of her sons had been named after her father's or mother's ancestors. "Only Ed's middle name which is so pretty and suggestive—being the family name of Grandmama [daughter of Rudolph Runge] and also of [Jean Louis Rodolphe] Agassiz, our great hero of nature."

It was also the name of her dead brother. But Hattie had not said a word about Rudolph Zirngiebel when she gave the "suggestive" name to her second son, Edwin Rudolph Wyeth. She made no overt acknowledgment, then or ever, that a baby brother named Rudolph had lived and died. She erased his death from the record of her life; and at least two branches of her family—the Edwin Wyeths and the Nathaniel Wyeths—would also omit Rudolph Zirngiebel from every account of family history. Nat's children came to believe that Hattie had given Edwin his middle name in memory of "an old flame."

What is known of Rudolph Zirngiebel's death survives because N. C. Wyeth passed on the story to his children. Oldest to youngest, they would grow up with "a clear image" of Rudolph's drowning in the Charles River. Their grandmother's part in the fatal outing, they agreed later in life, had been covered up. The record appears to concur with them. The town clerk's unusual four-month delay in recording the death, as well as Hattie Wyeth's omission of Rudolph through thousands of pages of intimate correspondence over forty years, and finally the cryptic diagnosis "dropsy in the brain," all support the possibility that Hattie was somehow responsible.

Any reconstruction of the events of August 25, 1866, would be conjecture, but if the family story is to be trusted, it appears that Hattie had been pushing Rudolph's baby carriage along the riverbank that Saturday when the carriage rolled out of her control and turned over into the stream. Rudolph's death by drowning was theoretically an accident. But, as N. C. Wyeth understood it, eight-year-old Hattie Zirngiebel had not lost her grip on Rudolph's baby carriage. Nor did the wheels hit a bump and toss the carriage's helpless passenger into the water. Hattie had lost control of herself. According to the version he gave his children, N. C. Wyeth concluded that his mother had deliberately pushed her baby brother into the Charles.

CHRISTMAS, the doubly vested holiday on South Street, appeared to be trebly important in 1907. As Mama told Convers on December 13, "I'm getting along—50 years this Xmas. I feel older than that many times."

Understandably, she felt older. She had just become a grandmother. Both her parents were now dead. She was anxious, sleepless, disturbed. But was she really turning fifty?

No record of Henriette Zirngiebel's birth survives in the city clerk's office in Cambridge, Massachusetts. If Hattie is taken as the source for her own age, then the year of her birth would be 1857. In Needham, however, her death certificate, obituary, and gravestone all give 1858 as the year of her birth. Yet on December 13, 1907, at the height of the emotional crisis that marked a turning point in her life, Hattie went against doctor's orders to write a deeply manipulative letter. Its premise was that in this year, of all years, Mama's needs would take precedence, even over the needs of a newborn.

Hattie built her case by claiming to want to go to Wilmington to see the baby, but not until "later—when [Hattie had] gained [her] equilibrium." She told Convers:

> Unless I get to where the Doctor wants me, I shall have to hope . . . to get down with you soon after Xmas. Nat says, "Tell them we can't spare you." That sounds good, but how am I going to manage and see [Convers, Carol, and the baby] if I don't go? I'm so homesick at times I feel like flying somewhere. I can see you and mother and father—but I'll say no more. I was going to keep nice and quiet, but somehow letters seem to draw just so much from me.
>
> I trust you will have a merry Xmas with your grand present of your birthday [meaning the baby, born on October 22] and Carolyn will be happy, beyond doubt to have [her family] with her. . . . I wish you all success with your work and may you all keep well. With best wishes from one who always thinks of you. Mama.

Convers ignored the medical reasoning and pressed his mother to come to Wilmington *before* Christmas. He had offered to buy her a full-fare railway ticket plus a stateroom. All Mama had to do was board the train in Boston, install herself in her stateroom, and the next morning he would meet her at Wilmington. When she refused, Convers made arrangements to return to Needham with Carol and the baby in time for Christmas and Mama's birthday. The doctor in Wilmington approved the journey for eight-week-old Henriette, but then, on second thought, Carol and Convers decided against it. They had lost one seemingly healthy baby, and they refused to risk another.

But Convers could not imagine going to Needham and leaving Carol on Christmas. The Bockiuses were busy or unreliable. "I can't depend on any

of them to stay with Carol, and I *can't* leave her alone!" Henriette was an even greater concern: "My heart has gone out to her completely—I never knew or imagined the *real* pleasure one derives from his own offspring." Nevertheless, the idea that his mother would be having a milestone birthday provided the necessary counterweight to his newly awakened feelings for his daughter. A mere forty-ninth birthday, even Mama's forty-ninth, would probably not have been enough to tip the scales.

On December 15, he wrote his mother: "To compromise, I shall come home Xmas day, leaving Carolyn at 10 o'clock in the morning and arriving in Boston about 8:30 that night. In this way I will be a few hours with Carolyn and Henriette on her *first* Xmas and also with my brothers and parents *besides* celebrating *especially* your 50th anniversary."

For all that, he felt entitled to a concession from Mama. "I want this promise before I come home," he told her: If by himself he returned to Needham on Christmas Day, then two days later Mama must accompany him back to Wilmington to meet her grandchild. "The change is bound to do you good," he argued. "It will give my life and surroundings a more commonplace reality which will undoubtedly ease your mind. . . . To remain tied down to one rut of living and thinking (particularly in that deep, heavy atmosphere of thinking) is something that you should break up for a few days."

It took two weeks, four letters, seventeen pages of dogged campaigning to close the deal. Convers saw it as a compromise, Mama took it as a victory, which it was. On Christmas Day, 1907, Convers tore himself away from Carol and Henriette and boarded a train in Wilmington. When he reached New York City late that morning, he cabled Carol: AM ALL ABOARD FOR BOSTON. LOVE TO YOU AND BABY. At five in the afternoon, outside Providence, he sat down in the observation car on the New York, New Haven, and Hartford Railroad and wrote Carol: "I have never felt more bewildered! To leave *our* little home in the midst of the Xmas spirit, and to ride nine hours alone and *lonely* through country that in itself stirs up a certain remote feeling, and further, to know that I shall soon see my parents and brothers, all adds to the bewilderment and confusion of my mind." He begged Carol to "be very careful of everything you do [with the baby] for I worry like the deuce!"

But what was *he* doing, dividing himself between Carol and Mama, spreading himself thin between two homes and two Henriettes, his mother and his child? Why not decide on one, at least for the day, and let the other go? Why make *himself* the family outcast?

"I feel so elated," his mother wrote when she learned that Convers would come to her, alone, on Christmas Day, "that it seems as if I could almost fly."

That day on South Street, as she waited for Convers, Hattie Wyeth left the house by herself. "No one missed me," she decided, and took herself to the cemetery where her Swiss family lay buried under the snow. Reproaching herself for not inviting her sister-in-law Etta to accompany her to the family grave, she added: "I find myself getting like father. The thing nearest my heart fails to reveal itself at the proper time."

Later in the day she sent Carol a consolation Christmas present, "a doily I made from a bag that my father kept his treasured pansy seed in." She added, "I hope Convers can stay three days at least, as they are counting on having all the grandchildren at the Wyeth home on Thursday night for all night."

Convers did as his mother wished, remaining in Needham through Friday. Then Mama fulfilled her part of the bargain, setting out with him from Boston's Back Bay Station. They arrived in Wilmington at eight in the evening.

Awed by the size and beauty of the N. C. Wyeths' Christmas tree—it was the largest she had ever seen in anyone's house—Hattie could not get over the number of presents for the baby. She had not prepared herself to find "another home" decorated for Christmas. To emphasize her sense of alienation, she commented that 1331 Shallcross Avenue was "small for such large bodies." And while acknowledging that Carol's "good care and loving has certainly been to good avail," Hattie could not resist a touch of envy: "She has all the comforts and luxuries of life and can want for nothing her heart can wish. Certainly Convers must be very successful."

The next morning she recorded her first sight of Henriette, who looked to Hattie "like a good healthy baby." Uneasy with herself to the end, Hattie added, "Unlike my own [children], she went to sleep easily with me after her bath and a meal."

On the last day of the year, still at Shallcross Avenue, Mama received a letter from Nat. He had suspended the usual caution. Overcasual, he asked, "How do you like the kid? Do the shoes fit?" Then he tacked on: "Papa is afraid you'll have baby nightmares when you get back. Be sure and enjoy yourself nevertheless."

Whatever had made her sleepless so long—baby nightmares, baby carriages, the helpless child gasping for air in the black water of the Charles River—Hattie released something in herself in Wilmington that New Year's Eve. She returned to Needham "a different woman." Newell and the boys could not get over it. For the first time in many years, Hattie Zirngiebel Wyeth strapped on a pair of skates and ventured out on the frozen river.

Moods

B Y 1908 N. C. Wyeth was a celebrated illustrator of national life in a
new era of reds, yellows, blues. Color reproduction—the muddy,
tinted beginnings of a revolution in mass communication—had
expanded the immediacy and impact of pictures. His old black-and-white
images were being "colorized," reissued in "vivid red and yellow." Most pop-
ular among Howard Pyle's 130-odd heirs, Wyeth stood out among those
credited with setting the standard for a golden age of American illustration.
In return, he could have had a big name, driven a big car, gone as far and fast
as he cared to in the unlimited new century.

He wanted no part of it. When the New York *Herald* tried to lionize
N. C. Wyeth in an article that described the "millions" that illustrators
earned and "their automobiles and luxurious homes," he felt "more ashamed
than ever at being ranked as one." He declined to participate. As far as he
was concerned, the Golden Age of Illustration had turned black.

Wyeth had of course pleased everyone but himself. His apprenticeship
now appeared to him shallow and degrading. The Pyle School had been
nothing more than a factory where successful pictorial journalists had
been—his word—*manufactured.* He and the others had been "whipped into
line," taught artificial shortcuts, trained to think as the audience thinks, not
for themselves as artists. "We were taught essentially the art of journalism,
to be rendered in the *manner* of painting." Reviewing the last four years,
Wyeth could "hardly believe that it was myself that produced that flashy,
superficial succession of work."

"None of us know *anything*," he complained to Allen True. "Howard
Pyle's teaching is a terrible blight to all who studied with him. He is respon-
sible for spoiling the possible opportunities of a number of fellows—and as
for me, I *know* his short-cut training has brought me a success that has been
wholly misleading and which has placed me in a position from which it is
questionable that I will ever be able to disentangle myself."

In the spring of 1908, Wyeth decided to start over. Recognized as an illustrator of national life, he would remake himself as a painter of personal themes. He vowed to rebuild himself from the foundations up. Half measures would no longer work. The only way to paint, he believed, was complete removal to the countryside.

Strictly limiting his commissions, he vowed to "paint only for *myself,* not even for exhibitions, until I feel established." In this new beginning he would "study nature as closely as possible," and "learn to love and appreciate its moods" as he gave himself up to a comprehensive study of trees and hills and skies. In March, as soon as he put the finishing touches on a *Scribner's* commission, he predicted that "this move will mark a big change in the quality of my work." His emancipation from Wilmington would mark his true beginning as a painter.

He rented a house that backed on a hill overlooking the village of Chadds Ford. The old Eli Harvey homestead had once been the headquarters of the Revolutionary War hero Gen. Nathanael Greene. Wyeth dubbed it "old Outside Inn." He made his studio in the carriage house and planned to spend the next five years taking commissions in order to salt away savings that would "allow ten good solid years of painting."

He would paint in color, but life itself would remain black and white—all one way, then all the other. Once again he was dead sure of one thing only: "Painting and illustration *cannot* be mixed—one cannot merge from one into the other. The fact is you have got to drop one absolutely before attempting the other."

He burned his bridges systematically—first to his colony of fellow artists, then to Pyle, then to the city itself. Taking a last look around himself in Wilmington, he raged: "God damn this *scum* of humanity that sloughs around you like *sewage* in a cesspool. I *hate* them, simply loathe them, the damnable self conscious slimy minded herds. They won't let you be pure minded, they won't let you even commune with nature with their vile minds."

He saw the whole urban world as purgatory. In February 1908, the same month that John Sloan and seven rebel painters, "the Eight," thrust the real life of the city before the blinking eyes of the New York art establishment—a year when the Gibson Girl still represented "the peak of inspiration" to aspiring illustrators—N. C. Wyeth chose Nature as his stimulus. Only the earth, he decided, the very dirt of farmland, was honest and wholesome, and from it he wanted "to leave out the *stinking rotten filth* of human nature."

Having cast aside Father Pyle for Mother Nature, he raged against Pyle. Fixating more and more on his teacher's imperfections, Wyeth began to

imagine that he had been "contaminated" by his former idol. He turned once more to the cleansing dream of a Zirngiebel Arcadia. He imagined that the immaculate Swiss village of his ancestors, reconstituted in Chadds Ford, as it had been in Needham, would be his salvation. In Chadds Ford he would live in a "sublime state," in a pre-Pyle world of purity and simplicity. Closing himself to Wilmington, to commercialism, to competition and criticism—returned, in short, to an impossible innocence—he would once again reclaim the "healthy state of mind" with which he had left home in 1902.

THE VILLAGE had one small fieldstone inn, three stories tall with a mansard roof and a gray mule tied up outside. There was a grocery and a general store along with Newlin Arment's wheelwright shed and George Scuse's barbershop; after one customer George would close his door and go fishing. In the village church the minister preached to a congregation of no more than six. On a quiet spring afternoon at the Eli Harvey place, the Wyeths could hear the dink-dink-dink of the blacksmith shoeing a horse.

They had moved to an island. Wilmington and Philadelphia lay to the south and east like distant ports on the mainland. Once settled, Carol did not return to Wilmington for ten weeks, and then only to "do a little shopping." In the years ahead, her half-day excursions would come but twice a year. Recalling the move from Wilmington, Convers would later write, "I brought a provincial, young, and timorous Delaware Avenue girl out into a strange country which, in spite of its charm and beauty, was in those days, an inaccessible and lonely place for any town-bred girl."

Carol, too, saw herself as a city girl. She had brought her maid, Rachel, to Chadds Ford. But her letters show an appreciation for the country, for birds, trees, flowers. She grew wary of Wilmington, and before her first return to town that spring, Carol noted, "I don't look forward to it." She credited Chadds Ford with her good health and took pride in her self-sufficiency as she sewed clothes for her family and herself.

The new parents reveled in Henriette. "She is *so* alert to everything," Convers recorded. At eight months she was willful, and one morning when her parents took some lettuce away from her, Henriette held her breath in protest. Her face turned purple and she passed out. Convers and Carol were "scared to death." After reviving the child, they decided that the cause of the tantrum had been "too much temperament."

Convers pronounced it a marvelous spring. His nose filled with the perfume of new whitewash on farm buildings. His senses came back to life as he walked the warm meadows and felt the air on his skin and watched

blackbirds flock through the trees. "I *worship* it," he exclaimed, looking around the valley. "I never realized what a serious and profound act it was to kiss the earth as did the old Spanish explorers, but I know now. I feel as though I could eat the dirt, it is so honest and wholesome! Those great, old trees that I learned to know so well last summer mean more to me than most human beings." He added, "I could just *hug* them! and I *will!*"

He had no time to waste. He divided his days, pushing himself to do more than one person could. In the mornings he made studies in the open fields around Chadds Ford. After lunch he cranked out pictures for *Scribner's* and *The Saturday Evening Post*, then returned to the open air in the late afternoon. As the evenings lengthened in May, he remained in the fields and on the riverbanks, sketching, often through supper. "Convers spends every spare moment to sketch besides illustrating," Carol reported.

He acted as if he were making up for time lost in Wilmington. He berated himself for having "never worked." Dawn to dusk, it was "*study, study, study*" and "paint paint paint." After nightfall one Saturday—his one evening off that week—Convers and Carol and the baby swung in a hammock on the porch, looking up into the "great mysterious night." Convers had never lost his earliest sense of awe at the immensity of the universe. Ever since hearing a series of subterranean rumblings on a camping trip as a boy, he had kept his ear tuned to the music of the planet. In Chadds Ford, as he sat enraptured by "the thousand mysterious voices in the grass, in the trees and hedgerows," a long shaft of light flashed across the meadow. Some friends had driven out from Wilmington in an automobile. There could have been no better foil for his duel with present time.

The lost paradise he yearned for, the isolated farm village, had already been strangled by one technological monster: the railroad, the "octopus" of the nineteenth century, which had squeezed the life out of open spaces, even as its long arms linked country villages like Needham and Chadds Ford to the cities of the expanding urban nation. Now came the automobile.

In Wyeth's account of that May night, the "huge machine" throbbed, shuddered, coughed, spat oil and smoke. Chugging up the driveway, it transformed the "still hot night" with its "cold . . . merciless glare." All vast and cosmic mystery shrank to "microscopic minuteness" when the "brazen glare" came "to search out our very souls." The "long, white" light leached color from the grass, trees, fences. Old boundaries—even railroad lines—would have to be redrawn for this new monster.

But common courtesy still demanded that the Wyeths greet their friends. Nauseated by gasoline fumes, irritated by social pretense, Wyeth was forced into small talk about automobiles. He pitied his friends the "unwholesome, empty, and selfish life" that the automobile afforded. He

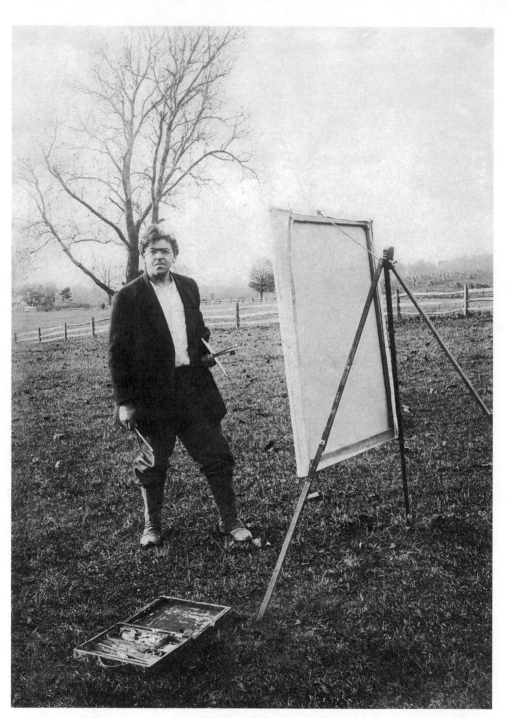

Chadds Ford, c. 1908. NCW was determined to free himself from illustration. On a typical afternoon he would spend "considerable time" on a study of an apple-tree trunk.

begrudged them their fun as they shot "through the night like an arrow, veils fluttering, coats and hair blowing." He deplored "the great mistake" he believed they were making.

Wyeth was often a sorehead about change, but the automobile was a special case. For if the world he loved could be remade this easily, flipped from hot to cold, from big to small, from dark to light, from real to unreal, there was no telling what extremes this "vibrating machine" would make of the things that mattered most to him as a painter: space, time, memory. His joyriding friends may have happily covered miles of countryside that night, but Wyeth appointed himself their conscience. He was outraged to realize that his friends would have "no remembrances of their outing other than fleeting recollections of fantastic blurred objects."

WITH A GROWING SENSE of superiority about his view of nature, Wyeth held himself aloof from the fraternal order of the Pyle colony. He felt better than all of them. *He* was the real painter. Wyeth believed that among his peers Harvey Dunn "comes nearer than anyone," but all the same, "there isn't a fellow down here that will ever paint!"

His friends got the message, but his reputation as an illustrator would not go away. "Orders still pile in," he noted in May 1909. When an ammunition company offered a hundred-dollar bonus on a rush order, the new, high-minded N. C. Wyeth asked, "Can a poet write real verse with an idea in his mind where it is to appear and how it will impress people, or will the editors like it? *No*, a thousand times *no!*"

He took it as one more example of "the uselessness of clinging to illustration and hoping to make it a *great* art." Which of course had been Howard Pyle's cardinal promise. Unforgiving of Pyle, Wyeth missed no opportunity to raise his voice against the "faked" art of illustration.

Naming his new masters, Millet, Constable, Whistler, Monet, Velázquez, Wyeth wondered if he could be the exception among illustrators: the one who crossed over from early potboilers to mature works of high art. Pictures, he believed, had "killed them *all*."

He was mistaken. Artists draw from many sources. New ideas in art often begin with the elevation of pictorial techniques previously considered too low or too popular to count as art. But Wyeth clung to the shopworn idea that if he closed himself off from the more popular mode of illustration, "a higher and better work" would "come with maturity." By preoccupying himself with the high-low split between "artists" and "illustrators," Wyeth deprived his easel work of the diversity and excitement—the freedom—that comes with blending styles and techniques.

He was his own jailer. That first full spring in Chadds Ford, 1908, as the market for Wyeth originals grew, with collectors vying to buy the big oil canvases that had been reproduced in *Scribner's* and *McClure's*, Wyeth unloaded them as fast as he could. His new, more "serious" work he kept to himself. "I am *not* making pictures to be looked at," he said. "*No* one knows what I am really striving for and *therefore* I shall *not* suffer the humiliation of showing my work to *anyone.*"

Forever the uncompromising aspirant, never the confident journeyman, he became a master at defying recognition. In his own opinion, the landscapes of N. C. Wyeth remained experimental and unfinished, "merely sketches." He refused to let his work qualify on any terms, and it became a point of honor to convince others that his efforts were noble but failed. It made no difference whether the painting in question had appeared in a dog-eared magazine or a juried exhibition at a big-city art institute.

At the 1910 midwinter show at the Pennsylvania Academy of the Fine Arts, four of Wyeth's *Scribner's* illustrations won a prize and a hundred-dollar purse; three of the four canvases sold. "But this does not mean much to me," Wyeth insisted. "How eager I am to paint paint paint!" When the federal government requested that one of the four illustrations represent the United States at the 1911 International Exhibition in Rome, Wyeth answered: "The cry is exhibit! exhibit! But I feel '*Wait,* you people, wait until I do something *good!!*' "

That summer he received an even more important opportunity to join the ranks of contemporary American artists. The Macbeth Gallery, founded in 1892 by William Macbeth, had been one of the first commercial galleries in New York to break the stranglehold of European painting. Macbeth dealt exclusively in the work of new American painters. His most famous exhibition, the Eight, brought 300 visitors per hour into the gallery on Fifth Avenue and Fortieth Street. Howard Pyle exhibited at Macbeth's in 1908 and 1909. In the summer of 1910, Robert Macbeth, who had joined his father in 1902, asked Wyeth to submit three landscapes for exhibition in the fall. Wyeth declined. "The pictures would not have represented me truthfully," he said. "No two are alike hardly; they are all experimental. I got a little good out of each one, but not *one* contained to any degree accumulative power."

He rejected an offer from the Marshall Field Galleries in Chicago for a one-man show, supplying the same excuse: he had failed to develop a consistent, "mature" style in his landscapes.

The following year a Wilmington judge privately offered to buy several Wyeth landscapes and one illustration. But when Wyeth "found how earnest and serious he was to surround himself and family of seven children

with *good* art," he refused to sell any of his paintings. "I advised him to wait until I could offer him something which I considered better, something that he would grow to like, rather than grow to tire of."

The year after that—1912—Wyeth exhibited twenty-five landscapes and ten illustrations at the Sketch Club in Philadelphia. Reviewing the show, the Philadelphia *Press* noted that some of Wyeth's pictures "already wear the 'sold' sign" and praised his landscapes for their "individuality and force." The *Press* especially admired two Chadds Ford landscapes, *Snowy Day* and *Early Summer*, remarking on the artist's "boldness and treatment." None of the newspaper critics distinguished between serious painting and popular pictures. They mentioned only that Wyeth's illustrations "attract general attention" and that "in everything, Mr. Wyeth shows a grasp and an understanding that humanizes his canvases." Another Philadelphia paper commended Wyeth for trying to "break away from his usual style" and lauded the landscapes as "an intimate view of the artist's softer side."

A THOREAUVIAN brittleness more and more entered Wyeth's relations with admirers and friends. When he and Carol attended Harvey Dunn's wedding in Wilmington, Wyeth anticipated cold shoulders and "glassy stares"—"considering the way we have slighted everybody." He served as Dunn's best man and was surprised that "everyone seemed glad" to see them.

Since moving to Chadds Ford, Wyeth had read *Walden* for the first time. As he replaced H.P. and T.R. with Henry David Thoreau, the restless, me-first individualism of the American West was supplanted by the rigid, me-myself iconoclasm of Walden Pond.

The sense of being romantically fated to find his true self in Chadds Ford was heightened by the likeness Wyeth found in Thoreau, the "New England narcissus" who had located himself in the shape of every leaf; the mama's boy who went alone to the "wilderness" a mile from his mother's house and chose the property of a surrogate father, Ralph Waldo Emerson, on which to build his cabin. In Howard Pyle's summer village eleven miles out of Wilmington, N. C. Wyeth could also "travel a good deal" without leaving home.

Thoreau, he believed, would be the most important influence on his life as a painter. He claimed that "close, hard study" of *Walden* soothed him, released him from the expectations he had labored under as Pyle's favorite son. He claimed to feel calmer, less "wild." In truth, he could not have been more wound up. The more he read Thoreau, the harder it was to like the world, far less himself. The more he held himself in contempt, the easier it became to know what was best for everyone else. Judgmental, sometimes

tyrannical, he sermonized to the friends of his youth in letter after epigram-
matic letter:

> Start in on a solid beginning of study. Show your work only to those
> who can give you elementary criticism. Be content to lay aside pop-
> ular acclaim for years. Fit yourself for a higher and better work that
> comes with maturity. . . .
>
> Clarify your vision, forget that you are in competition, look into the
> future intent upon satisfying your *own* soul, in this no one can help
> you. Get *close* to nature first; that comes only by studying her
> secrets. . . .
>
> It is utterly important that you compare your work, *not* to Pyle,
> Keller or Abbey, but to your individual ideas of what you hope to
> make of your art. . . .

They were all the same letter: a set of instructions nailed to his own
easel.

HE THOUGHT he had had enough—enough of Pyle's influence, enough
of competition and critiques. But had he?

Putting himself in front of the mirror, he made a list of the weaknesses
he most needed to fight: "My impulsiveness, my enthusiasm, my natural
desire to please, and my craving to hear from people whom I respect that I
am gaining ground." He meanwhile admitted, "I was always sensitive to
competition and a little bit now would help me."

He craved rivalry. Two men in a studio had always had a "blood tin-
gling" effect on him. The give-and-take of an intense creative partnership
had been the central force that had transformed Convers Wyeth into N. C.
Wyeth in the space of three months in 1902–3. No period of time in his evo-
lution as an artist would compare until he began his adult work as an illus-
trator of literary classics for Charles Scribner's Sons under the guidance of
Joe Chapin. Meanwhile, the sibling rivalries on Franklin Street had brought
out the best in him. Alone with Carol in Chadds Ford, he was bound to
wonder in his untrusting moments if his wife could create the kind of ten-
sion he needed. Carol was accommodating, nonconfrontational by nature;
he would bring her up to the studio to explain his pictures, and she would sit
there with her sleepy smile, uncritically murmuring, "Yes, Convers, I see,
I see."

As each new canvas stood wet on his easel, he wished he could submit to the comfortable subordination of a "sat upon," courtesy of Howard Pyle. "We all have weaknesses," he wrote, "and if I have any, as I surely must, I wish that people would kindly *sit* on me! It's a blessing to know *where* to mend one's self!" He wanted to be liked, but he had not yet found a way to like himself. He needed competitors to like—or dislike—his work for him. One day when he started to take visitors into his studio, Carol had to remind him that he had vowed to keep his work to himself.

Independent of a dominant older man, rudderless without rivals, he felt listless. Impatient to be a real artist, he had still not answered the essential question he had first faced in a studio in Denver. What would happen to his work if he were left completely to himself? "The fact was," he later realized, "that as soon as I got away from the competitive atmosphere [in Wilmington] I had to rely on my own, naked resources, [and] these I found weak and vapid."

Looking for approval in Chadds Ford, he felt for the first time a sense of isolation. When he learned that his old friend Clifford Ashley had been in Wilmington on a visit and had not come out to the country, he was hurt. He complained to Ashley about the slight, saying that if he had only known, he would have come into town. Ashley replied swiftly, explaining that he "had planned to run out to see you, but several of the fellows said that you were very busy and did not like to be interrupted in your work."

Wyeth's anger against the Wilmington colonists dominated his household. Carol understood that "he needs soothing every once in a while," and she became deft at crafting justifications for his outbursts. "Convers gets so impatient to paint, but it's his impatience that makes him succeed."

Patience, he would agree, "is the *hardest* thing I have to contend with." Concocting limericks at Christmas about each of his brothers, Convers offered a clear, if one-sided glimpse of himself:

> *And now there's that cus in Chadds Ford*
> *Whose long letters make everyone bored*
> *He thinks he can paint*
> *And is sure he's a saint*
> *But what a mistake—O Lord!*

He was impatient with others. At the first sign of a flaw, he became "so indignant and upset generally . . . that I am temporarily blinded to [people's] finer and more substantial qualities which exist beneath all their failings." He treated fellow painters the way he treated his own paintings, alternately idealizing and shelving them. "How often I have placed a new

acquaintance on a pedestal," he observed, only to "suffer the reversal of opinion built upon the solid substance of association and experience."

His old friend Harvey Dunn came under renewed attack. Wyeth had idealized Dunn as his "compatriot in art." As students they had both taken painting as a high calling. But now that Wyeth was painting nature and Dunn was living in style in Wilmington, Wyeth curled his lip.

Dunn had married a young woman from Wilmington, Johanna Louise Krebs, who happened to be a friend of Carol's, but there the symmetry between the two couples stopped. The Harvey Dunns could be seen flouncing around town in their cushy Pierce-Arrow touring car. According to the Wilmington *Star,* Dunn had become an "enthusiastic autoist." Dunn's father-in-law, president of the Krebs Pigment and Chemical Company—a self-made Danish immigrant who would later sell out to the Du Pont Companies—was the actual owner of the Dunns' automobile.

In Wyeth's eyes, Dunn had chosen as his wife a woman who represented a standard of living that Wyeth and Dunn had together fought against as art students. "Tulla" Krebs was all wrong for Harvey Dunn. Wyeth felt sure the marriage would ruin Dunn, lure him away from "real" painting, tempt him into commercial work, "take away his edge."

Carol was troubled to find her friend Tulla a victim to Convers's moralizing. She began to realize that there was more to her husband's bad moods than irritability about painting. He judged harshly and absolutely. Once he had made up his mind about someone, there was no seeing the other side. "Convers wasn't the sort of husband you had certain friends with," Nancy Bockius recalled. "I remember Carol talking about how she'd felt cut off from certain friends and had to sacrifice other friends for her marriage."

One Sunday that June, Harvey and Tulla drove the luxurious Pierce-Arrow out to Chadds Ford. The Wyeths had already had one set of unexpected visitors that morning. Convers was not in the mood for more company, and certainly not for an automobile that was the last word in snob appeal. "He wanted to do so much that morning—sketch, work in the garden, mow the grass," Carol remembered. Fortunately, the first set of dropins had taken the hint and not stayed for dinner. Even so, Wyeth was still fuming over the earlier intrusion when Harvey and Tulla's automobile sputtered into his driveway. He went berserk. He became crimson with rage and stormed through the house. Dunn had gotten out of the car to come in, but as George Harding told Allen True, "Wyeth sent word out that he was too busy painting to see [Dunn]."

He would not come out and see his friend. Carol faced Harvey and

*Mrs. N. C. Wyeth
in a Rocking Chair,*
c. 1910

*Robin Meets Maid
Marian,* 1917

King Mark Slew the Noble Knight Sir Tristram, 1917

NCW painted Sidney Lanier's *The Boy's King Arthur* between May and August 1917. He used Carol's sister Nancy as his model. (Carol was pregnant—Andrew was born on July 12— and then nursing.) In *King Mark* the figure of La Belle Isolde is Nancy's body, and the face is Carol's.

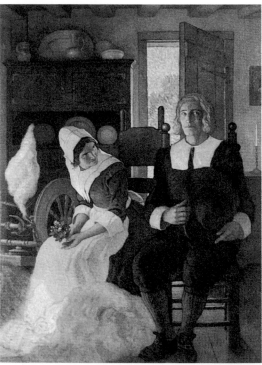

Why Don't You Speak for Yourself, John? 1920

Tulla alone, and sent them away. Bewildered by her husband's tantrum, afraid to make him answer for his anger, Carol said only, "My, Convers gets mad when people come."

The following April, when the Dunns lost a child, Wyeth sent flowers and a letter of sympathy, to which Dunn replied with earnest thanks. Otherwise, silence. For another six years, Wyeth would see only the "corrupted" side of Harvey Dunn.

DEPRESSIVE MOODS overtook Convers in the valley. His first October 19 as a permanent resident of Chadds Ford proved to be "one of those 'homesick days.' " He worked hard through the afternoon, "but after four o'clock my grasp of what I was doing suddenly left me; the bottom seemed to drop out of everything."

Severe space-time dislocation had incapacitated his grandmother and his mother. Now it afflicted Convers. He called these "my Needham and Concord Days," and they would recur more and more frequently in Chadds Ford. They would eventually plunge him into chronic, debilitating states of depression. His desire to "fly to Concord," or to be "suddenly transplanted back into my home" never left him. He regularly indulged in long, swooning letters in which he projected himself back into his childhood. "Oh! sometimes I want to go *home*, to see everybody, to walk up the back stairs, to go into the house, *anything* as long as it is *home*."

Needham, always more real than Chadds Ford, was very much present during the unpacking of the annual Home Box. "*Never*, in all my reminiscent moods have I been so vividly transferred into my past life," he wrote on his birthday, October 22, 1909. "Spasms went through my whole body—a vague infinite appreciation of the terrible fact that the past is *gone*, gone *forever!*"

Encircled by its river, preserved in memory, Needham existed in perfect unity, unto itself. It seemed always fresh and clean, no matter how many times he remembered "the river in the spring, the flooded meadows, the alders along the banks, the boat and the water lapping against it—*all* when we were younger, when there wasn't competition, struggle, worriment, money, diplomacy, and a *career* to look after. And what is this damn nuisance we call *career*?"

After yet another Home Box summoned up the panorama of South Street, he realized, "I must stop! I could keep on *forever*. How I enjoy it—and how painful it is!" He called his recollections "home visions," and they most often came to him at his easel:

I can't fathom the cause of these visions that suddenly rise like great phantoms at irregular intervals, but I know one thing, they are star- tlingly impressive and are so sacred to me that I always lend myself to the mood. Unless disturbed by someone's presence, I can be liter- ally carried away. I seem to lose all consciousness of my surround- ings and become a living part of the dreams that flash through my mind. . . . These imaginings are all built on the solid rock of home, of the mother and father and brothers. It is as though one were lying within the embraces of [one's] parents and listening to won- derful music. This sort of thing is *my* religion.

Convers made rituals of his yearnings. Every night, last thing before bed, he would stride out onto the hillside in Chadds Ford and face toward Needham. He loved to think that if he could only follow his eyes it would "not be long before the tops of the old spruces in front of the house would loom into view." He called this "mental projection," and over the next fifteen years, 1910 to 1925, as he tried to make sense of himself in Chadds Ford, he insisted that he needed "only to stand on my hill here and face the direction of Needham to be religiously moved to do my best."

But there were consequences to nightly home worship and to the annual ceremonies of October 19. Escaping into his past, he could also lose control there. "God damn it," he exclaimed, "it drives me almost *mad* some- times; it seems as though I could fly, and overtake the *past* that is vanishing so rapidly." He learned that if he let himself "go too long and too intensely this way I reach a point of *desperation* almost."

HE HAD MADE a fetish of Needham. He did the same with landscape painting. Over the next three years, and for the rest of his life, he would try very hard to paint brooks, hills, rocks, barns, haystacks, farm animals, field hands—studies and full-scale canvases by the hundreds. Although he loved the work, little of it satisfied him. Between 1908 and 1912, whenever he fin- ished a canvas outdoors, he would announce that it only demonstrated how much further he had to go before making what he never stopped calling a "real mark."

"If I could only [paint] what I can *feel*," he lamented over and over.

Yet in his landscapes he ignored his gift for creating feeling with light. Wyeth had learned about light as an illustrator. He was trained to paint in black and white and started with a classical advantage. Without color, he had learned how to create atmospheric effect at the most basic, rigorous

"How I did enjoy a little study I did of a group of haystacks! I *loved* them before I got through and I have an affection for the picture too! It is not a remarkable picture in *any* way, but it is truthful, it is not *faked.*"

level—with form and composition, with light and shade. In his illustrations, far from diminishing the quality of painting, the play of light on faces and foreground action often *enlarges* the sense of atmosphere and landscape.

Looking back at his life as an illustrator, Wyeth was aghast to see how far from "the true realms of painting" he had been lured. He would be damned if he would ever again paint in a mode in which "the eternal sunlight is discarded for plunging broncobusters; the glint on the brooks is passed by for raring and tearing automobiles; the wind in the trees gives way to the diving airship!"

He felt that anything he had learned in Wilmington must now be suppressed. Drawing a group of haystacks under a rum cherry tree, he exulted in the simplicity of the scene. "There are no horses running, kicking and snorting all over hell in it, there are no scenic mountain passes, raging torrents, soaring eagles or boiling clouds in it, just three or four silent haystacks." He called it the "*one* and *only* picture that was supremely delightful to do."

Painting landscapes in Chadds Ford, he would not allow himself to

express pictorial excitement. He stubbornly refused to bring the graphic lessons he had learned in Wilmington into the new country of pure painting. But rather than emancipating N. C. Wyeth, landscape denied him the full range of his resources as a graphic artist. As a landscape painter, Wyeth became the victim of his tendency toward excess. He refused to integrate genres, as Winslow Homer had managed in *The Life Line* (1884) and as Wyeth's fellow *Scribner's Magazine* illustrator and contemporary Edward Hopper would do in *Chop Suey* (1929). Wyeth worried about "tainting" higher art with lower art. By trivializing illustration, he diminished his source of power: his ability to make the viewer feel. Determined to be a "pure" painter instead of a "contaminated" illustrator, he would not accept what was authentic and useful about the visual language he already knew.

IN THE YEARS known as the Golden Age of Illustration, Wyeth's dissatisfaction with his chosen medium was well-founded. In January 1909, *Scribner's Magazine* published his article "A Sheep-Herder of the Southwest" with four illustrations. Everyone knew that *Scribner's* had the best illustrators and the finest color illustration available anywhere in the world, and the reaction to N. C. Wyeth's latest pictures was, as Chapin had predicted, "bully."

Few viewers realized the full extent of the diminution to Wyeth's original work. Only another frustrated artist, Clifford Ashley, noticed that "perhaps the pictures had not reproduced very well."

They had not. Wyeth's oil paintings in color had been "reproduced in tint." No onlooker could have known that the pictures had been painted, or that they had surfaces, or that the scale of the canvases was enormous, or that the artist had any color sense whatsoever. Tinted, cut to fit the page, the *painting* was invisible. The credit line read, "Drawn by N. C. Wyeth."

In the background of *Mexican Shepherd*, the brilliant light and atmosphere in the recesses of the mountains had been reduced to engraver's lines and muddy monotint. No color survived the half-tone process. In *Pastoral of the South-west*, the vibrant turquoise of the original sky was a dull olive in the reproduction. It had a sad, smudgy look. Scored by dark printer's lines, the once buttery clouds lost their peach, pink, and lavender hues. Under the engraver's knife, the foreground became as gray as a newspaper.

Some golden age. Rightly, Wyeth was disgusted. Submitting his work to photomechanical reproduction was a setup for continual subjugation. Even for one who had flowered under the masochism of Howard Pyle's "sat upons," month after month of ruined pictures in national magazines was humiliating.

Book illustration was worse. In books Wyeth tried to liberate himself by pushing the limits of the form. In his view, the typical book illustrator was no more than a property man in a theatrical production, equipping the players with historically accurate accessories. The illustrator merely "meddled" with the author's work. But Wyeth aimed to merge illustrator and author, even as he liberated the picture from the story.

Preparing to take on Mary Johnston's Civil War novel, *The Long Roll,* he wrote in July 1910, "I want to avoid pure illustration and to practically paint a series of war pictures." He chose the right author with whom to reinvent the form. Mary Johnston had gained enormous popularity with her second novel, a swashbuckling romance, *To Have and to Hold* (1900), but she, like Wyeth, was determined to break out of the comfortable conventions of her proven genre. To put the "breath of life" into her book, Johnston made use of eyewitness accounts of the war; and the vivid reality of her characters and incidents inspired Wyeth to paint the war itself. He gave titles to his illustrations that would suggest their universality: *The Battle, The Vedette, The General.* The war would no longer be a historic event, *The Long Roll* no longer a novel populated by historic personages. N. C. Wyeth would be free to paint real people.

The gentlemen editors at Houghton Mifflin in Boston could not have been more enthusiastic. They printed posters, launched an advertising campaign promoting the "luminous quality" of Wyeth's paintings, and hung the finished canvases in bookstore windows. Wyeth believed that the series "will show me at my best." The editors predicted "a sensation wherever it is shown."

The inevitable rift came with the proofs. "*You* know what my pictures were," he moaned to his parents. "Now look at the proofs!" The pictures as they appeared in *The Long Roll* proved to be—his emphasis—"*miserable smudges.*" Wyeth's paintings, especially his portrait of Gen. T. J. "Stonewall" Jackson, became the lightning rod for a well-publicized protest made by Confederate veterans against the novel. Mary Anna Jackson, the general's widow, aired her grievances in the *New York Times Magazine.* She denounced Wyeth's portrait as a "hideous caricature" and contended that the portrayal of Jackson's warhorse "alone is enough to condemn the book."

Wyeth felt abandoned by Houghton Mifflin, since "I get the heave for poor, anemic painting," while the publisher went right on advertising "the feature of the book's illustrations, and then turn out such damnable workmanship!"

It was a common complaint. Disillusionment runs all through the statements of Golden Age illustrators, especially those whose expectations had been raised by Howard Pyle. Allen True once again spoke for them when he

said, "I would work my heart out over a series, and then it all seemed small and fleeting when transferred to the magazine page which people turned over and forgot on the instant."

A month after the turquoise skies and buttery clouds of Wyeth's Sheep-Herder paintings had been turned into minuscule, monotint "drawings," he abruptly decided, "All that I have done in the past, all that I could do in the future (in illustration) would be utterly forgotten in a preciously few years except by a few friends and relatives."

IN THE WINTER of 1909, he devised a plan that he believed would free him from all his conflicts in one stroke.

He would give up Chadds Ford and move home to Needham. At the age of twenty-seven, with another baby due in October, Convers would move Carol and Henriette and the newborn into 284 South Street with his father and mother and Stimson. For a salary of fifty dollars, he would teach two days a week at the Eric Pape School in Boston, leaving the rest of his days free for painting.

His father, not surprisingly, liked the idea of Convers moving back in and making Mama happy again. It was the prospect of N. C. Wyeth throwing away his good name and good earnings that irked Newell.

Undeterred, Convers tried to convince his father that if he went on with illustration, it would "prevent my ever doing anything that will *live*—that will last after I am gone, to constitute a vital part of the world's art."

Newell replied: "You seem to put great stress in creating some picture or pictures that will give you a name that will live after you. Now that is all right but I like to see a person get a name and a little benefit besides while one is still living."

Newell admitted that he himself might not be "the one to give you advice or to criticize what you are thinking of doing." While acknowledging that "in some respects we think differently," he tried to encourage Convers to see his own work in a better light. "You must realize that you have been and are doing *good* work in the way of illustrating. Now to give that all up, [and] take a position as teacher in a place which from your last account [in 1902] you did not think much of, seems to me to be taking an intensely different road. Of course I may not fully understand just what you intend doing."

Convers did feel misunderstood. He had frequently told his father that "*practical* ideals and *artistic* ideals are as foreign to each other as black is to white." But it went deeper than that, too. "I have *always* felt that you have never quite understood me, rather because I never expressed myself clearly,

and partly because your life has been one of *facts* rather than *intangible* hopes."

Discouraged, Convers complained to Mama. "There's just this thing in painting," he contended, "and please tell him. The man who starts out to make money at it never does. The man who works hard, in the proper direction, with his eyes always on the highest of ideals—money is bound to come to him ere long, and in great quantities. Tell him, too, that there isn't a successful painter today who is making less than $15,000 a year, and many [are] making $200,000 and $300,000 a year."

By May he had dropped the plan to move back home. Once again he cast illustration as man's work, using it to prove to himself and to his father that he was a practical man doing sensible work. Painting was therefore the act of an irrational man. That May, while working on a commission for *Scribner's*—a series of four canvases to illustrate "The Moods," a seasonal quartet of poems by George T. Marsh—he surprised himself with a renewed sense of optimism. "The Moods" series was "the first bright light I've experienced for two years." Working again in the luminous world of woodlands Indians, creating skies which for the first time in his painting became sources of light, he felt that he had regained a sense of himself.

The same thing happened when he illustrated a series of Arthur Conan Doyle historical romances, *Through the Mists*. The moment his canvases filled with armored men, with shields and horned helmets, with the portrait of a hermit, he began to like himself again. "Strange as it may seem," he wrote, "I am enjoying the work immensely." The fact was anything but strange; the wonder was why he held it against himself.

It was only natural that Wyeth should find himself in images of defiant outcasts defending themselves against the advance of time and progress. Painting directly from nature located him in the immediate present. But *The Hermit Crouched in the Shadow of the Rocks* (1910), for Conan Doyle's short story "The Coming of the Huns," brought him into the emotional world of his own battles.

The story's protagonist, Simon Melas, a "strenuously earnest" hermit who has "escaped from the contamination of heresy" to live in self-denial on a "rocky hill" at the farthest, western edge of the Roman Empire, allowed Wyeth to take aim at his own oppressors, time and progress. As the hermit peers out from behind Brandywine-like boulders and trees at the advance of Huns trampling the plains below, "he alone, of all civilized men, [knows] of the approach of this dreadful shadow." Wyeth, from his own hilly outpost, would never stop wishing to halt history.

Time is what N. C. Wyeth felt most intensely. He was enraged by change. His illustrations tell more than his landscapes because the illustra-

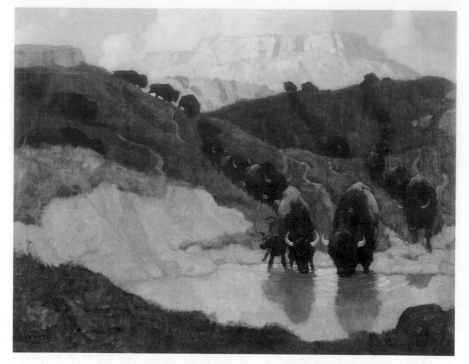

The Water-Hole, 1925. Endpapers for *The Oregon Trail,*
by Francis Parkman.

tions are about falling out of time, losing land and a way of life. The Indians
in Wyeth's western pictures, the cowhands, train robbers, riverboat gam-
blers, prairie buffalo, even the water holes—all are doomed by an industrial
civilization. Wyeth's illustrations are alive with the tension between the
artist's wish to preserve the present in some plastic form and his constant
urge to revive and re-view an unspoiled past. Barbarians, Pierce-Arrow
motorcars—it did not matter what century he was in. Time was the
destroyer.

HE DEVISED a second plan of escape from illustration. Reviewing his
finances in August 1909, Wyeth laid out a scheme for five years of painting
during which he would accept no commissions from publishers. He figured
his bare-bones expenses at $1,000 a year. "If ever I needed help," he told his
mother, "I need it now." He asked to borrow $5,000 in an interest-bearing
loan.

His father, not his mother, replied three weeks later. The answer was no.
It was not feasible for the Newell Wyeths to make a loan. Behind Newell's

back, meanwhile, Hattie mailed Convers a token of solidarity, a money order for fifteen dollars. "It was impossible for me to reason or try to talk with Papa," she explained. "He was firmly convinced and of course he has us there. When he tells us of his business affairs and outlook, I know nothing. All I know is, he is trying to be careful and do the best he can for us all. His income now is small and I have to look to him for everything. He seems so sensitive on money matters."

Replying to his father, Convers tried to sound judicious. He made no passionate appeal, as he had to his mother, for the high calling of art. He merely stated that once again Newell had failed to understand him, and he all but apologized for asking to borrow money, claiming, like his mother, never to have had any knowledge of his father's financial situation. He conceded that Newell's suggestions were "practical, but not adaptable."

It was time, once more, for Convers to be practical. The household was expanding. He had been hoping for a boy. On October 26, 1909, at four o'clock in the afternoon, at home in Chadds Ford, another daughter—their third—was born to the Wyeths. They named the baby Carolyn.

She arrived at a time of tension in the marriage. Carol, suffering isolation in Chadds Ford, felt even lonelier after Carolyn's birth. In the year before Carolyn arrived, she had left the house just once—to visit Convers's mother in Needham. With a second child now demanding her attention, the strain became severe. In early April 1910, Convers and Carol planned to separate for a week. While he remained in Chadds Ford with Henriette and his work, she took the baby to 1513 Delaware Avenue, her father's latest address in Wilmington. From there, as Convers explained to his mother, Carol would be able to "call on her friends without the direct responsibility of the house on her shoulders." He described the break as a "slight setback." In truth it was the first serious rift in four years of marriage:

Monday night
Dear Carolyn:

Our separation only three hours old, and here I am—writing! Why? I don't know. I've nothing to say. I said *all* this morning. However, I do *feel*, but one cannot express feelings in words, so this letter is doomed to be nothing but poor English.

It is needless to tell you how empty and cavernous the house seems. Little Henriette looks almost pathetic busying herself with this thing and that; she looks so tiny, like a babe left on a desert island, unconscious of the empty spaces about her. . . .

Well, Carol, I've taken a radical stand in sending you in town— it will be harder on me than on you. Now that I think of it all, it

seems natural that we should be apart. I feel those same pangs of longing to be with you even now, which I have felt in N.Y. when there over night; everything seems so strange and queer.

The separation lasted until Friday morning.

Not long afterward, on a business trip to New York, Convers witnessed a sequence of accidents. Outside Trenton his train killed two men on the tracks. He was in the first car when the locomotive's cowcatcher threw the men high and to one side. One of the dead men sailed past his window, "not three feet away." He was called as a witness to answer questions for the railroad.

The next day, three miles from the same spot, Convers's homeward-bound train ran down another man, severing the victim's leg. The sharp, shrill engine whistle and the fierce grinding of the air brake sent "the shudders through me," he recorded. Home in Chadds Ford, he could not stop thinking about "the marked coincidence" of the inbound and outbound accidents, and "the horror." The first train had had to back up over the mutilated bodies of its two victims.

In October, Henriette, almost three, was struck with infantile paralysis. She lost control of her right arm. She could move the arm and hold paper, pencil, and a spoon, but she could not "manage it well enough to use." In November Convers recorded: "She is recovering slowly. There is every chance that she will regain full use of her limbs. A slight weakness is the worst we fear." He massaged her arm every night.

Whenever he left Chadds Ford, he suffered anxiety. "My attachment to this place," he wrote, "is beyond words." In July 1910 he departed by railroad for Warm Springs, Virginia, to meet Mary Johnston, author of *The Long Roll*, and to research settings for the companion volume, *Cease Firing*. The local railroad tracks seemed to offer a connection to Carol and the children:

> My feelings reached the height of torture (and it *was* torture) when our train sped past and away from those two little shining rails that lead back through the hills toward *home*. I mean where the Pennsylvania R.R. leaves the P and R about a mile south of Greenville— *you* know! Even as I looked over into the city of Wilmington and thought of all *our* history that had transpired within its environs, I blessed the old place as I never have before. To return to the dear old single track that swept away from us in the shining curve—it seemed almost to *coax*, as it disappeared into the haze of a distant hill which I could imagine just hid our home from my eyes. By

heavens, *never in my life* have I suffered such a strain, that verged between tears and intense anger.

Without his realizing it, Wyeth's eye had been altered by the valley of the Brandywine. One day, puzzled by "a peculiar livid yellow" striking on Taylor's Hill, he had made note of color so intensely illuminated by sunlight that "the hills appeared as though one were looking through stained glass." He cataloged the "poison green" of the foreground meadows, the "wonderful inky purples"; the birds darting like "white spectre-spots against the black"; and "great mountains of purple and black clouds hurtling through the sky."

For four years in Wilmington, he had made skies blue and sunlight yellow "because H.P. first told [him] to." Then one day in the valley, while painting an illustration for *Scribner's,* he had discovered the beginning of a change. "It is a remarkable sensation to me, as I never had it before, to actually *feel* color combinations." In a few years, he predicted, "my color will be my own."

And so it would be. But in hues and shades he could not have guessed at, the valley he had come to paint as a landscapist would color and bring greatness to his work as an illustrator.

Chadds Ford/Needham, 1911–1929

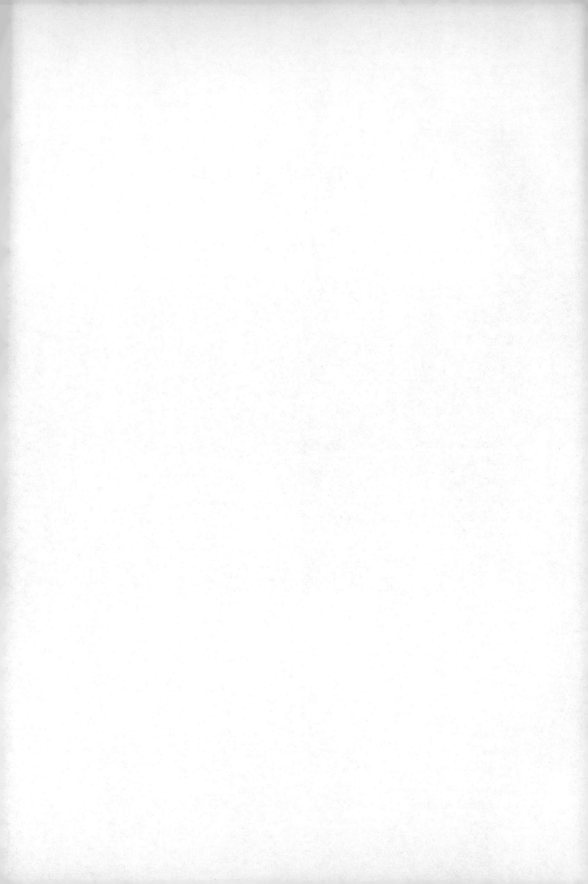

Treasure

TWO EVENTS TOOK place in 1911 to pattern the rest of his life. In February, Charles Scribner's Sons asked Wyeth if he would undertake an "elaborate edition" of Robert Louis Stevenson's *Treasure Island*. His fee would be $2,500. On the strength of the offer, Wyeth bought a piece of land. Putting down $1,000, he took out a $2,000 mortgage on eighteen acres of Rocky Hill, a wooded, northern-facing slope about two-fifths of a mile from the center of Chadds Ford. He called the lot the "most glorious site in this township for a home."

Situated between a one-room schoolhouse on its western slope and an orchard to the east, the place had a rock-bound brook flowing through it. There was a grove of black walnut trees, a pasture, and an arable field below. Above the building site, high on the crest of the hill, was a perfect spot for a studio.

Seven years earlier, playing father to his own father, Convers had written Newell, "It's a happy day that I'm looking forward to when I will see you settled on a strong little farm, good buildings, rich soil, fine pastures, blessed with numerous brooks, all surrounded and protected with the green billows of mountains." In other words, the old family dream of liberating Papa Wyeth from the city to live as the Zirngiebels had: "the farm life in snug little homesteads."

Now here was Convers fulfilling the dream himself. On March 7, he wrote, "I'm totally satisfied that this is the little corner of the world wherein I shall work out my destiny."

ROBERT LOUIS STEVENSON had begun with an image—a map of some land. One rainy afternoon in 1881, fooling around with some watercolors to impress his stepson, Stevenson painted a map of an island. Some nine miles long and five miles across, the island had two natural harbors, three hills, a spring-fed stream, and a swamp. Stevenson named the anchorages and gave

soundings to the coves. The contours of the hills pleased his eye. More than
the romance of buried treasure, the factual cartographic reality of the island
was what first sparked Stevenson. He then sat down and wrote a novel that
conformed to the map.

Stevenson's gifts were those of a graphic genius. He brought to story-
telling a painter's eye. "If things had gone differently with him," his friend
Henry James observed, "he might have been a great painter of battle-
pieces." If he had lived a century later, he might have been a cinematogra-
pher, proving now as he suggested then that a story should "repeat itself in a
thousand colored pictures to the eye."

N. C. Wyeth came to *Treasure Island* much as Stevenson had—torn
between impulses and frustrated by years of divided, seemingly unfulfilled
work. Stevenson, at thirty-one, had a reputation for essays and short stories;
he burned to write a Romantic novel. With a "succession of defeats" behind
him, he stood, like Wyeth at twenty-eight, on the verge of a breakthrough.
In *Treasure Island,* the dual-minded future author of *Dr. Jekyll and Mr. Hyde*
discovered an oddly simple truth. Romance, if it was to become art, had to
be made gritty and real, "pedestrian," as Stevenson put it—"practical" would
have been Wyeth's word. Stevenson plotted his novel by fitting the dramatic
action of a mutiny, including the maneuvering of the embattled ship, to the
measurements and plausible limitations of his watercolor projection.
"The map was the most of the plot," he later wrote. "I might almost say it
was the whole."

IN MARCH, after presenting his initial scheme for *Treasure Island* to
Joseph Chapin, Wyeth returned from Scribners "*boiling over* to get at [his]
work." He started with the endpaper decoration, making his "first mark
for *Treasure Island*" on April 3, a day after signing contracts for "the erec-
tion and completion of a certain brick dwelling-house, at Chadds Ford,
Pennsylvania."

The seventeen *Treasure Island* canvases were due at Scribners on July 1.
The new house and studio on Rocky Hill were to be completed by Octo-
ber 1. Meantime, he moved his family into rooms at Windtryst and went
on painting at the old Harvey stable, a mile down the road. He made two
round trips a day. Under a newly installed skylight, he wrote, "The gods
have smiled upon me!!"

He loved the work. It had been years since he had allowed himself this
much excitement over a set of pictures. For a change he came to his easel
undivided. He noticed the difference at once. "My conceptions are fuller,

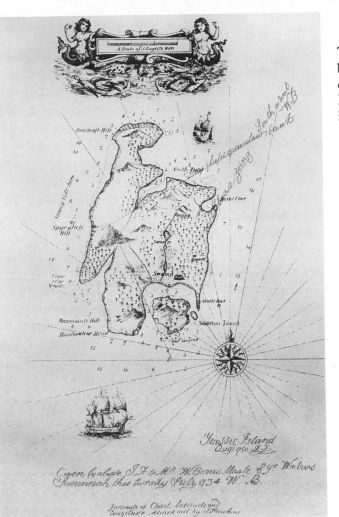

Treasure Island, based on the map drawn by Robert Louis Stevenson in 1881.

NCW and Carol with Carolyn as a baby, Henriette standing between them, 1910.

more significant," he realized. "Besides, I do things with more *authority*— put statements down with a clear knowledge and directness."

To meet a deadline for the book salesmen's dummy, he moved rapidly through the endpaper decoration, cover design, title page illustration, and the first of fourteen major pictures. Painting not less than nine hours a day and often more, Wyeth gave himself up to *Treasure Island* as he been able to with no other text. It is easy to see why. *Treasure Island* was written to be seen.

Studded with "characters," the narrative of Jim Hawkins's adventures deliberately unfolds as a sequence of illustrative events—"culminating moments," Stevenson called them, giving as his classical models "Crusoe recoiling from the footprint, Achilles shouting over against the Trojans, Ulysses bending the great bow." Characterization, Stevenson asserted, must be imprinted on the eye by a sequence of visually startling moments. "This is the highest and hardest thing to do," he noted. "This is the plastic part of literature: to embody character, thought, or emotion in some act or atti- tude . . . which stamps the story home like an illustration." With Bill Bones, Black Dog, Blind Pew, Long John Silver, Ben Gunn, and of course Jim Hawkins, Stevenson consciously wrote to "arrest the eye and solicit the brush." He was the rare author who believed that illustrations "should nar- rate." A "picture in a storybook . . . should be the handmaiden of the text, competing with it upon equal terms," Stevenson wrote in 1885, after admir- ing the first illustrated edition of *Treasure Island.*

Wyeth worked from a 1909 Scribners edition, which was illustrated with Walter Paget's 1899 drawings. Making notes in the margins, he picked out one culminating moment after another: "Hawkins leaves his mother"— "Silver in the galley talking to the parrot"—"Hawkins gives the slip to Sil- ver"—"Capt. runs up colors"—twenty-four in all. He hunted for incidents in which he could develop emotions that the author had only hinted at.

Stevenson depicts no scene in which Jim Hawkins leaves home. Jim merely reports saying "goodbye to mother and the cove where I had lived since I was born." Jim mentions his jealousy of another boy who has already been hired to replace him as his mother's apprentice at the Admiral Benbow Inn, where Mrs. Hawkins is the newly widowed innkeeper. He admits to an "attack of tears" at the thought of this rival, but he does not mention his mother's emotions at the moment of his departure. Working with the same text in 1899, Walter Paget had framed the boy's departure as a long shot, depicting Jim as a tiny retreating figure in the rolling landscape of Black Hill Cove.

Wyeth depicted Hawkins *and* his mother at the crucial, wrenching moment. In *Jim Hawkins Leaves Home,* the sudden break between mother

and son commands our whole attention. Wyeth painted a scene full of unexpressed longings. Both figures hold back, and the tension between the two is palpable. The boy has just said good-bye. In one hand he carries his hat; in the other, his travel things, bundled into a red kerchief, tied to the thick end of a stick. Turning to go, he steps into shadow. A stoic expression crosses his boyish face. The faintest suggestion of grown-up guilt darkens his eyes. Poking out from his thigh, the stick and sack are unmistakable allusions to his new manhood.

In the sunlight behind Jim stands his mother. Her color is high, her long hair wound tightly in a bun. She's been restraining herself. But now, as Jim steps away from her, as they suddenly become two isolated figures, she sobs into her apron. We do not see her eyes, but we can imagine them, as Jim does. Above her head floats a cloud, milk white and sunlit, with a stroke of dark at its lower edge. Before her, leading back into her house, are three stone steps. She is a young and appealing woman, with "very little company" except the rough trade of the Admiral Benbow. The impact of the image comes not from her explicit allure but from the more powerful idea that there may never have been a man in that house as close to her heart as the one leaving now.

Drawing in black and white, the previous illustrator had failed Stevenson. Paget consistently chose to depict the most violent moment in a scene, yet his pictures have no dramatic intensity. In his frontispiece, for instance, we find Jim, high in the crossbars of the *Hispaniola*'s rigging, confronted by the wounded pirate Israel Hands. But Paget's Jim has already shot at Hands; the pirate, falling from the shrouds, is already dead. The crisis has passed, our interest has been given no chance to develop; the "supreme moment," as Howard Pyle called it, has been resolved without us.

Wyeth instead fixed upon the moment *before* the climax. He had learned about timing seven years earlier. "To put figures in violent action is theatrical and not dramatic," Pyle had taught him. "In deep emotion there is a certain dignity and restraint of action which is more expressive." In *Israel Hands*, Wyeth draws us not into a killing but rather into a negotiation between an experienced, stupid killer and a cornered, intelligent innocent. Jim by now has learned much of what a man needs to learn; this confrontation with a half-dead man is his penultimate test. He must master his fears and kill to survive.

Hands has climbed to within arm's length of Jim's perch. With upturned face, he reaches back for his bloodstained knife. "One more step, Mr. Hands," warns Jim, "and I'll blow your brains out! Dead men don't bite, you know." Dead men don't keep our interest either, and Walter Paget's dead Israel Hands makes for a dead picture. Wyeth's *Israel Hands* bristles

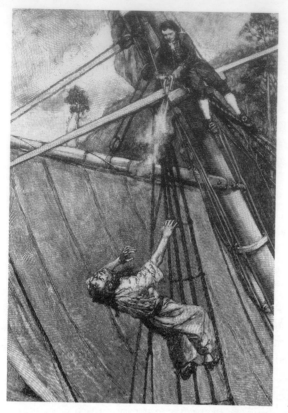

Walter Paget's version of Israel
Hands, 1899.

Israel Hands, 1911.

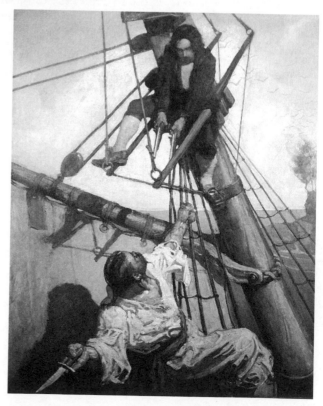

with tension and uncertainty. It is literally all about *hands*—reaching for bloody knives, brandishing pistols, pulling triggers, manipulating.

Paget, like many illustrators and filmmakers and theme park impresarios afterward, treated *Treasure Island* as spectacle. In nearly all of his forty-five vignettes, Jim Hawkins is shown in the picture plane, enacting the drama for us. When Paget brings Blind Pew onstage, he brings Jim with him. The sightless pirate, who appears on the day of Jim's father's funeral looking for Bill Bones, has caught Jim in his viselike grip, and we watch Jim struggling to get away. Jim is our hero, and we are the audience.

Wyeth's great leap forward was to make us Jim. Painting from Jim's "sight seen," as Wyeth called it, he conceived *Treasure Island* so that "the reader is actually the boy at all times." Only six of Wyeth's seventeen paintings tell us what Jim is doing; the rest show us what Jim is seeing. They endow us with Jim's senses and emotions. As Wyeth intended it, the reader "sees, hears, tastes, or smells nothing but what [Jim] did."

Wyeth used the medium. In literature, as in films, time advances, stories develop. No single paragraph or frame can tell the whole story. In painting, however, everything is visible all at once. The act of "seeing everything" in one supreme moment has particular potence in childhood, when it feels possible to experience all of time in that one moment. For a child, as for the onlooker of a painting, each single, present moment is the whole story. Past and future do not exist; and if emotions are keyed high enough, a single picture can be felt as an eternity.

Wyeth's paintings for *Treasure Island* charge the viewer with the danger and excitement of seeing "everything all at once." We are not only seeing forbidden things but seeing *without being seen*. We are free to look in on terrible happenings, unnoticed by the objects of our gaze. This is universal fantasy: in picture after picture, we find ourselves in the middle of the action, living among menacing people, without ourselves being menaced. Guns are at hand, knives within reach; in *Preparing for the Mutiny,* one of the cutlasses on the table is held out to us, the hilt almost in our grasp. We are given the erotic power of omnipotent invisibility.

Sight had been a kind of occult passion for Wyeth—"visionary pleasure," he called it—in correspondence with his mother. As he read her letters, he would visualize Mama sitting in the kitchen on a winter's night. With "the curtains silently parted," he told her, "I saw you, your environment and your visions, as clearly as my own."

He continuously looked "into" Needham, declaring that "it is easy for me to project my sense into the Home. I can hear, see, taste, smell, and feel with almost perfect completeness any object I chance to think about. The vision is exceedingly clear." When at home on South Street, he made the

parlor window his "shrine." In Chadds Ford, during one rapturous unpacking of the Home Box, he had fantasized his mother looking in on him and his own children: "I'd have given a very great deal if you could have been peeking in the window at the time."

Wyeth attached the word *treasure* to things from home. He spoke of "treasure-words" in his mother's letters and of the annual "treasure-box" in which Mama had cached "hidden treasures." Events that had taken place in Needham were "treasurable incidents never to return." He described for his mother the lack of nurturing Carol felt from her own parents, adding, "She finds that treasure in you and Papa, in *our* home." Mama's letters "represent a veritable *treasure house* of mood and spirit." Needham, of course, was the island, the timeless place in which he was forever a captive—the place where the past, no matter how carefully buried, always surfaced.

In *Old Pew*, the outstanding painting in the series, the horror of sightlessness is intensified by the diamond-sharp clarity of the wintry night. Through Jim's eyes, we confront the blind beggar under a bright-as-day moon on the lane outside the Admiral Benbow Inn. Tapping with his stick, calling out in a voice "cruel, and cold, and ugly," Pew gropes for us from the dark recesses of his cape with an enormous outstretched hand. Not only do we experience the thrill of confronting a predator up close but we have the grisly satisfaction of absorbing every detail of one who would like to catch us but cannot.

In the background, luminous in the moonlight, stands the Admiral Benbow Inn. It is the point of departure for Stevenson's narrative. Here the pirates first converge in search of the newly discovered treasure map. From here Jim Hawkins sets out into the unknown. But when we look closely at Wyeth's inn, we do not find a typical seamen's bed-and-breakfast on the Devon coast. Wyeth's Admiral Benbow, with its distinctive half-hipped roofline, is a portrait of the household whose hidden flaws he had blinded himself to all his life.

Wyeth painted *Old Pew* from memory. Its foreground perspective rises to a nearly realistic rendering of 284 South Street as it appeared from the lower cow pasture throughout his childhood. Across South Street, a huge cedar tree had stood on the corner of South and Green Streets. A mysterious old signboard, posted up in the tree, had been "nearly smothered from sight, and all gray and dirty." In childhood it had puzzled Convers. The sign said "Green Street," yet people called the street "Blind Lane"—its original name. Wyeth in 1911 remembered that as a schoolboy he had "dared not trust my own knowledge," even though he knew that "green" was not the word for "blind." Wyeth now let the "mystery that used to surround that nameboard" filter into his *Old Pew*, which portrays a blind man tapping

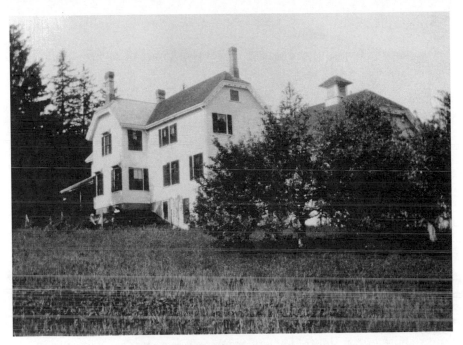

284 South Street, from the lower pasture.

Old Pew, 1911.

down the lane opposite the artist's childhood home, the empty sockets of his eyes covered with a green eyeshade.

THE MOMENT Jim Hawkins leaves the inn and his mother, *Treasure Island* becomes a timeless fable. Subsequent action occurs in a nowhere place where people and events are all good or all bad. No one is in-between. Hawkins's mentor, Long John Silver, is first good, then bad.

Based on Stevenson's broken friendship with his closest friend, the crippled editor and poet William Ernest Henley, the portrait of Hawkins's disillusionment at the hands of the duplicitous John Silver was tailor-made for the N. C. Wyeth of 1911. Hawkins—the boy who must confront danger as a grown man—is ideal material for one who, faced with grown-up responsibilities, wished to remain a boy. That spring in Chadds Ford, Wyeth had noticed a "decided change" in his relations with his neighbors. As a new property owner, he no longer felt free to wander over the hills, regardless of fences and property lines. "They treat me now as a man of affairs and judgment, and I dislike it," he wrote. "I would rather always be the *boy*, more or less irresponsible and dependent."

In John Silver, Wyeth saw his own ruptured relationship with Howard Pyle. Silver's resemblance to Pyle is uncanny. Tall, strong, with a "great, smooth, blond face," Silver not only evokes Pyle physically but shares with Pyle, as with William Ernest Henley and with Stevenson, the trait of grandiosity. He is "no common man." At their first meeting Silver flatters Jim excessively; one look at Jim and Silver declares the lad "smart as paint." Silver takes Jim on as his star pupil. He calls Jim "my son." He acts the part of glamorous surrogate father that Pyle played in the first summers at Chadds Ford. He helps Jim prepare for his shore trip, worrying over his lunch the way Pyle fretted over railroad timetables and restaurants for "my boys." Yet for all his solicitousness, Silver is capable of treachery. His personality swings dangerously from one extreme to another; even his face changes from moment to moment, now "beaming with good nature," now turning on Jim "with a deadly look."

Silver turns out to be mercurial, ambiguous, a "changed man"— ultimately, a "monster." Creature of extremes, Silver embodies the quintessential transformation of best friend into worst enemy. Late in the story we discover that he has seen Jim as "the picter of my own self," and this likeness of himself as a handsome young man has been, Silver admits, the sole source of his interest in the younger man.

Jim, meanwhile, struggling with his shock at having been betrayed by

his idol, reacts as Wyeth had during the *McClure's* episode in 1906. When Silver uses his star pupil as a hedge against his own downfall, as Pyle had done at the helm of *McClure's,* there seems to be no defense against the older man's duplicity. While hiding in a shipboard apple barrel, Jim learns that Silver is "playing double." He overhears Silver tell the youngest seaman on the ship, "You're young, you are, but you're as smart as paint," and it is this revelation, that his teacher has been "addressing another in the very same words of flattery as he had used to myself," that makes Jim wish he could kill Silver.

In the series' fifth picture, *Long John Silver and Hawkins,* Wyeth painted Howard Pyle into the congenial phase of the master-pupil relationship. Here, the one-legged but masterful sea cook is in his galley, grandly puffing on his pipe and flattering Jim. Eight pictures later all has changed. The theme of *The Hostage*—a young man's subjugation by an older man—gave Wyeth the chance to represent his own enslavement by a "master."

The picture is about amputation—the loss of a trusted friend—and about the imbalance of falseness. Its compositional center is the ominous black hole under Silver's square-tailed coat where his leg should be. Bristling with false appendages (including the parrot on his shoulder), Silver is nevertheless strong enough to hold Jim in one powerful fist. As they climb to the treasure cave, Silver's single good leg is exaggerated and out of step with the figures marching up the hill.

Hawkins's legs, meanwhile, are noticeably longer than in previous images. Has he grown? Has adversity matured him? At any rate, he is not yet finished struggling with his master nor his master with him. Between their silhouetted forms runs a rope, knotted at Jim's navel—the umbilical cord linking them still. To emphasize the peculiar complexity of their interdependence, Wyeth shows master and slave in each other's clutches, simultaneously assisting and hindering each other.

At the same time, nimble, long-legged Jim, with only a pair of spindly trees to back him up, holds his own against the full weight of Silver and the mountainside. Silver's high-cheeked profile is a reversed foreground portrait of the entire sunlit mountain face, incompletely seen. Its two shadows form the brow, nose, and left temple of a monumental head. Rushmore-sized, the single head combines the faces of Silver, Pyle, and Washington.

PICTURES GREAT, Chapin wired from Scribners.

Measuring forty-seven inches tall by thirty-eight inches wide, the canvases had a grandeur that, under the skylight in Wyeth's studio, made them

appear to the six-foot, one-inch painter "almost as big as I am." By June 2, he had a second batch packed and ready to send to New York.

The engraver's proofs of the first four paintings had meanwhile come back. They had been miniaturized to six and a half by five and a quarter inches, a reduction of 98 percent. For once, the results did not disappoint Wyeth. Scribner's *Treasure Island* proofs were unlike those produced by Houghton Mifflin. The rich, golden tones of the canvases shone through on the page. The aquamarine sky of the cover design was still piled high with salmon-colored sunset clouds. Compared with the "miserable smudges" in *The Long Roll*, these were "corkers." Chapin, too, was pleased. With his characteristic directness, the art editor admitted that "sometimes the process is a bit freaky," but this time Chapin had no complaints either.

On the opposite slope of the valley, workmen had arrived on Rocky Hill. Wyeth had borrowed $7,750 from the Building and Loan Association of Kennett Square. Ground had been broken, and artesian well drillers had now joined the builders, digging down through solid rock at three dollars a foot. A week passed with no sign of water at fifty, then seventy-five, then eighty feet. At one hundred feet, the well was costing the artist the equivalent of two weeks at his easel.

At 126 feet, with still no sign of water, Wyeth flipped a coin to decide whether to continue digging or to start another shaft higher on the hill. The coin supposedly hung in midair over Rocky Hill, as, just then, from 130 feet underground, clear, bubbling, cave-cold water began to gush at the rate of twenty gallons a minute.

By the end of May, the foundations for his studio had been laid on the hilltop. In the house below, the cellar wall was finished. Brickwork would begin in June. At the work site, whenever the Wyeths appeared, the contractor's men were climbing around the skeleton of the house. Carolyn described "men sticking their heads in every window." Back in his studio, Convers took a break from *The Attack on the Block House* to note: "I am writing dangerously near to a fiendish bunch of godless men scrambling over a stockade! It's surprising how quietly they are doing it too, loaded down as they are—first, with *rum,* and all manner of arms, guns, pistols, cutlasses, and knives!"

After the day's work, his greatest satisfaction while painting *Treasure Island* was to walk across the valley to Rocky Hill and stand in the rooms of the skeletally framed house looking out through unfinished window frames at a future that seemed to exist already. Nothing pleased him more than to "actually look from the windows upon scenes which will become so familiar to us."

The house had valley views from every window. It stood two stories high, with a wide brick fireplace at the west end and a columned veranda facing north. The upstairs had three bedrooms, a sewing room, a linen closet, and a bath. Downstairs, one vast room, ever after called the Big Room, ran the length and width of the structure, joining a kitchen and pantry. The house seemed to Wyeth "positively ideal in every way." He would therefore call it the Homestead.

He had never inhabited his life and work with such joy and conviction. "I feel myself on a well-rounded basis," he exulted. During the creation of *Treasure Island,* his usual eighteen-page letters home became hurried one-page notes, covered in paint smears. He had always loved to celebrate the birthday that his brothers Nat and Stimson shared—May 29—but this year Convers managed to fight off the urge to return to Needham. He found new contentment with Carol in Chadds Ford; one June night as they sat on a slope in the moonlight, Carol remarked that spring and summer had never meant so much to her.

Convers was his own master, and for once he knew that too: "Work is coming splendidly! I never felt so strong in my life. There has been a great change in the past year, a transition from experimental, vague gropings for truth to that of clear and keen purpose."

He even changed his mind about the automobile. Imagining how invigorated Henriette and Carolyn would feel driving through the hills at sundown, he bought an Oldsmobile. "Glorious machine! Glorious sport!" he now declared. But in no time at all, he saw that the new machine "dragged me away from the little things I love so much—the quiet amble in the evening, the pause by the brook, the sound of the birds and wind." He kept the car exactly one week, and "the week was one of real pain and suffering to me until late one evening Carol and I were listening to Beethoven's minuet, and I came to the end of my torment. In two days the machine went back. . . . The dream faded quickly." The nineteenth century still had the upper hand.

WYETH'S OUTPUT tells the story of his new nonjudgmental mood. In two weeks in April he had finished "four huge pictures." By the middle of June he had finished and packed off another eight canvases. Before starting the remaining five, he quickly painted a western picture for *Century.* In July he worked through a heat wave; for three days the temperature in his studio reached 101 degrees. But his interest in *Treasure Island* never wavered.

The last pictures came more easily than the first, "a rather unusual

occurrence for me," he noted, "as in a long series I am apt to tire or lose enthusiasm owing to repetition of subject matter." For sixteen weeks he had painted at the rate of slightly more than one large picture a week.

On July 26, he wrote:

> Treasure Island completed! I write that as though I were glad. In one way I am. . . . I've turned out a set of pictures, without doubt far better in quality than anything I ever did. . . . All this gives [me] the right to feel jubilant and with no little satisfaction from the illustrating viewpoint. On the other hand, it was with regret that I packed the last canvas in the big box tonight. I so thoroughly enjoyed the work; I was for some reason, able throughout the series to keep my pictures fresh and brilliant and striking in their variety of composition and color, dramatic incident and emotional quality. These features are what appealed to Scribners and which will, I am convinced, appeal to the public.

After the last of the canvases had been crated, the Wyeths took Henriette and Carolyn to Beach Haven on the New Jersey shore. Carol was expecting again; she had been tired all summer. She wore a full-dress bathing costume with black tights and a mob cap. Convers, as always, could make her blush by drawing attention to her shapely legs. But this summer she did not feel like swimming or walking. "Really, this time I have felt so heavy and useless," she wrote.

When they returned to Chadds Ford, Convers slipped back into old habits. With *Treasure Island* finished and a Canadian railway camp story for *Scribner's Magazine* sent off, he tried to paint landscape, with the usual results. "I am feeling utterly disgusted with my present attempts in the studio, besides otherwise suffering a week of depression." He knew what was lacking. "I wished a hundred times," he told Stimson, "that I could turn to someone"—he crossed out *someone*—"some man who could understand my deepest thoughts—who would solemnly sympathize and heartily believe in my hopes and intentions."

He left the letter to run errands in the village. When he returned to it after supper, he noticed a silence in the house. Carol usually bustled around after supper straightening up. Tonight she was in their bedroom, sitting in the dark, "very much depressed and quietly sobbing." She had read the letter to Stimson. She blamed herself, she told Convers, "for not being able to give you that spiritual aid necessary for your work."

For an hour they sat in the dark, talking. Tension over Carol's intellectual "deficiencies" had been building. Earlier that year Convers had

defended Carol against her own feelings of inadequacy. In reality Carol was perceptive, with a mind of her own. As Convers pointed out, she never missed "the subtle things. She seems always to search for the inner motive and consequently obtains keen delight where some would see nothing." Her confidence, however, remained limited. She had hated school and viewed her mother as her real educator. She had been a compliant fiancée; for Convers's sake, she had learned to ride horseback; she had allowed herself to be concealed from her future in-laws. Married, she had made a home and Convers had supported it. Outside the house she had no sense of authority. The move to the country had been his idea, and it was his idea that she write letters and read regularly.

Supposedly, Carol's reading began with Dickens, whom Convers dismissed as "the Gilbert and Sullivan of literature," and ended with the *Ladies' Home Journal.* In fact, she made it a point to struggle through the books Convers cared about. In the spring of 1913, she read *The Scarlet Letter.* Two months later, when he and Carol together finished reading *War and Peace,* Convers announced his satisfaction, writing what amounts to a report card: "Her mind is unusually broad and comprehending," he told his parents, "and if more self-confidence was a trait, what truths could she speak!"

He looked on Carol not as she was but as he and his mother wanted her to be. With shortcomings in crucial areas, Carol left plenty of room for Mama. When Nancy Bockius came to live with Convers and Carol in December 1913, she was struck by the strength of Convers's attachment to his mother: "She established something in his thinking that he couldn't get away from. She held him in chains."

He was fixated on the South Street model of a woman's life, imported from Switzerland: *Kirche, Küche, Kinder*—church, kitchen, children. According to Convers, the wife of an artist could be her husband's "spiritual aid"; she could "bless [him] with a spirit of love and faith that supersedes all other stimulus or encouragement." But it was "impossible for a woman to enter into [his] special work and stand before [him] to lead—to take the *initiative.*" She could be half of *his* self, but not all of *herself.*

His feeling of masculine superiority rendered Carol all but useless as peer and partner. After talking in the dark that night with Carol, he "emerged feeling better, and more determined than ever to carry out our ideals and aspirations." Over the years, however, Convers would repeatedly express regret at Carol's "lack of philosophical outlook." His struggles were "all so beyond her." He held on to the idea of an energizing male figure, a Teddy Roosevelt, or a Howard Pyle, who would activate his talent. Now, in Chadds Ford, he gave that power to Henry David Thoreau. "I have my worshiped friend," he reminded himself. "Without him my life would be a half

blank." Then, perhaps thinking of what he had learned about worshiping idols, he added, "But I need one in the flesh."

WITHOUT THE HELP of a mentor, Wyeth had found the artistic form for his life. On October 22, his twenty-ninth birthday, the *New York Times* announced that "a very attractive edition of Robert Louis Stevenson's 'Treasure Island' has just been published. It appears in a volume 9½ inches by 7½, printed in large, clear type on fine white paper, with illustrations in color reproducing admirably spirited drawings by N. C. Wyeth."

Noting that the "pictures by Mr. Wyeth are, of course, the feature of the fine housing that has been given to Stevenson's great story," the *Times* rightly emphasized that it was Wyeth's illustrations that made this version of the classic adventure tale an unusually intense experience. Not so much a pictorial translation of text, Wyeth's images "confront us as we turn over the pages."

In Wyeth's *Treasure Island,* the reader never knew when the next "confrontation" was coming. Unlike a conventionally illustrated book, such as Paget's *Treasure Island,* in which halftone drawings appeared regularly throughout the text, Wyeth's pictures had been printed on special stock and tipped in at randomly spaced intervals. Arriving at the image became an instant of pleasurable dread as well as an aesthetic surprise.

Each picture was veiled by a sheet of tissue and printed on the kind of coated stock that in 1911 was found only in art folios. Their impact was immediate, long lasting, and personal. The compositions shimmered with chiaroscuro. The pictures had texture; a Wyeth illustration was a tour de force of brushwork, so painterly and expressive that a parrot came alive with six dabs of paint. Above all, they addressed the senses. They evoked in readers remembered places, deep dreams.

Wyeth editions, as the format would come to be called by Scribners and widely imitated by other publishers, were a surprise to anyone familiar with the tight decorum of Howard Pyle's set-pieces. "More genuinely human and personal than any of the American illustrators who have specialized in tales of adventure," N. C. Wyeth had gone "a step beyond his predecessor," the Boston *Transcript* announced.

In one stroke Wyeth had liberated adventure literature by making it a medium of both sensuous and aesthetic pleasure. He gave the English characters of the genre a new American masculinity. Blind Pew, Bill Bones, Long John Silver—he yanked them one by one from the mossy green past and thrust them into a vibrant American present. Wyeth swept the cobwebs out of illustrated books, letting air and light—an intensely remembered

The Studio, c. 1911. At his easel NCW could "hear the distant
reverberations of the trains' whistle far up the valley."

light—into the crabbed, inky world of post-Victorian book publishing.
With *Treasure Island* he established himself as the foremost book illustrator
of his day.

At the rate of 900 copies a week, the first printing sold out by Decem-
ber 18. Scribners shipped a second printing to cover the Christmas trade,
and that also sold out. *Treasure Island* sold steadily—54,355 copies in fifteen
printings through the next two decades—and would eventually be seen as a
landmark in book publishing.

The mold was set. The Scribners Illustrated Classics became a cottage
industry. The words "Pictures by N. C. Wyeth" came to stand for literature
as it had never been pictured before. The next volume in the series, *Kid-
napped,* sold better than the original American edition of the Stevenson
classic, published by Scribners in 1886. The Wyeth edition of *The Boy's King
Arthur* outsold Howard Pyle's *King Arthur* in six fewer printings. At certain
times during the 1920s, such as the Christmas season of 1926, Scribners
simultaneously turned out 50,000 copies of *The Black Arrow, The Last of the
Mohicans, The Mysterious Island, Westward Ho!, The Scottish Chiefs, David*

Balfour, and *The Deerslayer.* In all, some 350,000 copies of Wyeth editions sold through 1930.

The series became self-sustaining. By the late 1930s, contemporary best-sellers like *The Yearling,* published first in an adult trade edition, had a second life in the series. Although authors were not always happy to be classified among "juveniles," Scribners itself had never made any distinction between children's and adult books. The legendary editor Maxwell Perkins had to reassure Marjorie Kinnan Rawlings that *The Yearling* had found its best, most permanent place among the Illustrated Classics: "Most of the books in that series are adult books," Perkins wrote, adding: "Most of the best books in the world are read both by children and adults. This is a characteristic of a great book, that it is both juvenile and adult, and that is the thing that assures it a long life."

UP ON ROCKY HILL, the painters had finished. On October 13 the furnace began producing heat. The Wyeths prepared to move. Carol's pregnancy had reached full term. Convers worried that if she lifted things she would strain herself. In an illustrated letter to his mother, Convers drew himself as a giant, the family piano in one hand, his easel in the other, taking a huge step. A road sign points the way toward HOME.

At 9:00 a.m. on October 24, under the sloping ceiling in the northwest corner front bedroom, Carol gave birth. It was her easiest delivery yet; the spell of the summer's creation was with them still: TREASURE ISLAND BROUGHT AN EIGHT-POUND BOY, Wyeth telegraphed Chapin, who wired back, HEARTIEST CONGRATULATIONS, (SIGNED) CAPT. BILL BONES, SILVER, AND HAWKINS.

They named their son Newell Convers Wyeth, Jr.

Alan Breck

THE NEWS CAME from a stranger, which made it all the more shocking. Howard Pyle was dead.

A newspaperman telephoned from the Associated Press for a statement from Pyle's most famous pupil. The date was November 9, 1911. *Treasure Island* published, his son born, his teacher dead—all in two weeks' time.

Pyle had been in Italy a year. He had gone to give his work a lift; he had taken his family to live in a villa outside Florence. There he died of Bright's disease, a chronic inflammation of the kidneys. Pyle was fifty-eight.

Appalled at being confronted with Pyle's death by a reporter over long-distance telephone, Wyeth declined to comment but promised to write a half column by morning. At 2:00 a.m. he was still at his desk, sorting out his feelings, tearing up what he wrote. Finally, he went to bed, rising at dawn to eke out four paragraphs. Six months later he would say, "Nothing ever struck me in quite such a shocking manner as the news of Mr. Pyle's death. To this day, I am conscious of a sinking feeling inside whenever I chance to think of it."

He had last seen his teacher a week before the Pyles had sailed for Naples, in November 1910. Pyle had looked overworked, his face jowly, full of worry. The sparks were gone from his eyes. As always, though, he lit up in Wyeth's presence. He paid his favorite son the grandest of compliments, insisting that Wyeth had not only fulfilled his early promise but had come nearer to carrying out his teacher's ideals and principles than Pyle had ever dreamed possible in a student.

They had parted on an ambiguous note, however. Mr. Pyle's valedictory blessing rang hollow; Wyeth still had his guard up. Like David Balfour in *Kidnapped*, puzzling over his mentor's flattering endorsements, Wyeth might have asked "whether it was because I had done well myself, or because I had been a witness of his own much greater prowess."

Pyle's death changed all that. Wyeth instantly let go of the Howard Pyle

who had stoked and then shattered his youthful idealism. The restoration took place overnight. On that November morning, a clean, bright Howard Pyle emerged from the ruffles and flourishes of Wyeth's Sousa-like elegy. This Pyle "has risen to glorious heights and ever to remain there in the annals of art and education!" Wyeth no longer cared to dwell on Mr. Pyle's "downfall," and certainly not in public; privately he saw it as "only temporary," caused by "nothing more than [Pyle's] own discontent and restlessness."

At last Wyeth had Pyle where he had always wanted him—on a pedestal. As long as Wyeth concealed his own success, they could be master and pupil forever. In reality, of course, he had long since become his teacher's peer. He was invited that winter by the Contemporary Club of Philadelphia to join in a dual tribute to Howard Pyle and Pyle's fellow illustrator the late Edwin Abbey. Wyeth was to share the stage with the long-winded Henry James and three-time presidential candidate William Jennings Bryan. Wyeth declined. Terrified at the idea of appearing among great men to speak about the great man of his youth, he held out through weeks of coaxing, insisting that he was unworthy. He told himself that he would satisfy his duty to Pyle's memory by someday writing a formal treatise on illustration, "my main theme to revolve about Howard Pyle in all his greatness."

HE WAS NOW TWENTY-NINE, a heavy man, with a powerful chest and strong arms. His shirt collars, which he seldom buttoned, were said to be size 20. His dining-room table was seen as "a table for a huge trencherman." He was sure that he could think better and accomplish more if he were lighter. "But I do eat," he admitted, "and can't help it." Ballooning to 250 pounds, he set himself a regimen of wood chopping and dropped back down to 228. Even so, to one young painter visiting his studio he looked like a blacksmith. Doors seemed to "shrink around his towering form." According to the *Boston Post,* he looked "more like one of Roosevelt's Rough Riders than a painter of fantasies and murals."

Turning thirty in October 1912, he could have taken pride in the fact that his illustrations were now being seen as works of art. *Old Pew* (1911) and *Captain Bill Bones* (1911) received a place of honor at the 1912 exhibition at the Pennsylvania Academy of the Fine Arts. During Wyeth's November exhibition of landscapes and illustrations at the Philadelphia Sketch Club, a Philadelphia newspaper pronounced his work "epic." A month later the *New York Times* declared N. C. Wyeth's paintings for *The Pike County Bal-*

lads "simply splendid. They are high art as illustration." The *Times* especially admired the tenderness in Wyeth's portraits of John Hay's roughnecks.

But Wyeth judged his illustrations worthless. "I know so thoroughly upon what a weak basis my work is built," he said during the winter of *Treasure Island*'s success, "it is like putting salt to a raw wound to have to accept praise."

He deplored work which a year earlier had pleased him. Looking back on the *Treasure Island* pictures, he now felt "as though I never wanted to see or hear of the things again. They were crudely done, and ill-considered in every department, excepting perhaps in dramatic choice and spontaneous presentation." And while he acknowledged that "the book seemed to interest people both here and abroad," he appointed himself its harshest critic. He thanked his friend and fellow Pyle alumnus Sidney Chase for an encouraging word about the pictures, then needled Chase for not being "severe enough."

No one was severe enough. Letters of praise appeared regularly; they stung him like a "lash." Requests of all kinds now "choked" his desk: invitations to exhibit, to speak, to lecture, to teach. In Wilmington he won first prize at exhibitions of Howard Pyle's students two years in a row and was embarrassed. Believing that he alone recognized his true worth—or, at this point in the cycle, *worthlessness*—he became angry when no one else judged N. C. Wyeth by the standards he had set for himself. He decided, "It is hopeless to expect anyone to realize the truth of my conflicting inward impulses." He felt bitter. "No one has yet broken through my outer crust and assailed me as they should. I bear that grudge toward my relatives and friends."

When friendly admirers—"people of real judgment and discrimination"—welcomed him in New York and Philadelphia, he insisted that he was "unfit" for praise. Then, as if swayed by the power of his own suggestion, he would become unable to accept approval and would squirm in his shoes whenever anyone spoke well of his work. He set exorbitant prices on his canvases, hoping to scare away buyers. He felt that if he accepted payment for an illustration as a work of art he would be taking money "under false pretenses."

The Opium Smoker (1913) serves as a model for Wyeth's self-sabotaging streak in this period. Illustrating the anonymous "A Newspaperman's Story of His Own Experience with the Drug, by No. 6606," the picture caused a stir when it appeared in *The American Magazine* over the caption "Finally I Became a Daily User of Opium." Wyeth had researched the story on his own, investigating an opium den in Philadelphia. Disgusted by what he saw

and perhaps by what he smoked, he rushed back to pastoral Chadds Ford. "It took days to wring the stuff out of my system," he confided to Stimson. "My mind and heart suffered the worst twist and distortion I ever experienced. But now thank God! I am free once more, and the trees and sky can move me to tears again and all those I love take their familiar places."

Using complementary color accompanied by heavy shadow, Wyeth created a convincing image—a picture of a newcomer's last moment of revulsion before succumbing to the drug's euphoric effect. He claimed that the painting had "an air of novelty, a certain theatrical cleverness, which gives it a literary flavor." *The Opium Smoker* attracted invitations to exhibit, as well as buyers, but it enticed only the Puritan in Wyeth. He set what he believed would be a prohibitive price on the canvas. When one buyer with connections to Harvard University offered to pay it, Wyeth balked, saying he felt ashamed to take $1,000. "No illustration ever painted is worth that much."

Judging his illustrations bad, he decided once more that landscape painting was good. As before he insisted that landscape would make him the painter he wished to be. In the outdoors, he wrote, with "nothing to stand between myself and the winds and fields and woods, by God I could be *somebody!* Now I can't. I'm on a greased incline pointed *downward!*" In letter after letter to Stimson, he gushed over the "uplifting purity" of robins, the "mystic power" of brooks. Sitting by his own wooded brook on Rocky Hill, he cribbed from Thoreau. "I deeply and so seriously wish I were a tree or a stone—the world would have one less deformity and one more ornament."

Telling himself that he was buying time for "real" painting, Wyeth went on taking illustration orders by the dozen. In March 1912, he proudly listed his latest commissions: thirty-three large pictures, four small pictures, and thirty pen drawings for four different publishers.

Starting each new set of pictures, he pushed himself to do better than the last. With *The Pike County Ballads,* he consciously tried to "knock *Treasure Island* into a cocked hat." When Scribners settled on Robert Louis Stevenson's *Kidnapped* as the next Wyeth edition in the Illustrated Classics series, Wyeth told Chapin, "Unless I outclass *Treasure Island* I want you to cancel the entire scheme." He negotiated increasingly higher fees—$3,350 for *Kidnapped*—and allowed himself the satisfaction of watching his earning power grow with his family, although he still saw the higher fee as "an almost too adequate reward."

He took pleasure in the work itself. After seven hours immersed in the costuming of Saxons, Huns, and Romans in a Conan Doyle picture, *The First Cargo* (1910), Wyeth enjoyed imagining himself as one of them. "When I walk up stairs my legs bend stiff with bronze kneecaps and shin

guards, and I duck my head in the doorways lest I knock my shining helmet to the floor."

But when the canvases had left the studio, he was of two minds:

I have thoroughly enjoyed doing the book, every minute of it, and were it not for the matter of time would feel genuinely sorry to say finis.

Now that the books are done, I feel very eager to do some really *good* stuff.

When he saw his paintings reduced to proofs, he felt shamed.

In the fall of 1912, he declared himself "sick of it all." Unable to reconcile "good" and "bad" pictures, he wrote in October, "There has been in my cosmos two factions warring ever since I can remember. As the years have passed, this struggle has grown. . . . The din of the conflict is deafening, and I can hear nothing else for the noise; but I can surely detect that my better self is, at present, uppermost, for now and then the opposing faction subsides."

Wyeth had used his clashing selves to give popular literary forms a graphic concreteness they had not had before. He had succeeded in making westerns, folktales, historical romances, and stories of adventure and exploration his own emotional property. Yet whenever he tried to give aesthetic shape to his experience as a son of Victorian Needham, the results had not been as convincing. Failing to find himself in images of his own past, he chose renunciation. If he could not be the painter he wished to be, then he would refuse to be the illustrator he had become. "I want to start over," he concluded. "I want to wipe the slate clean of everything but my family."

AT THE AGE OF FIVE, Henriette astounded her father with "her powers of perception and her sense of logical reasoning." She was quick, bright, authoritative. She "forms indelible impressions so rapidly!" he exclaimed. "I cannot but feel that she will do something in the way of creative work some day."

Three-year-old Carolyn was Henriette's opposite: dark, burly, with explosive enthusiasms. N. C. called her "the big noise." She "pounds through the days like a war horse and seems never to weary," he wrote. A strapping baby, "as broad as she is long," Carolyn had become a husky toddler, wrestling with the family dog until her clothes shredded.

The boy, called Baby Brother, had blond curls, an apricot-colored complexion, and a "Napoleonic frown." N.C. found him "astonishingly alert to every sound and movement about him" and felt more enthusiastic about his namesake than he had been with either of the girls. "There's a certain pathos about the little kid that reaches me clear down," he wrote.

The idea of a clean start meant one thing: Needham. By going back to his beginnings, he would discover where he had gone wrong. He would start over in a simpler way. By simplifying his life, he would accomplish the painting he was capable of. Like his mother in the 1890s, he imagined that Needham had a healing purity that would be his salvation.

Leaving the Homestead in the care of neighbors, Mrs. Hanna Sanderson and her bachelor son, Christian, he moved home to 284 South Street with Carol, the two girls, and Baby Brother. Carolyn lamented that "Chadds Ford was all broke up," but according to N.C. the three children "merged into the new surroundings with hardly a ripple to be noticed." The water tower that had fed the old Zirngiebel greenhouses still stood by the river. N.C. turned it into a second-story studio. Then, as his mother put it, he "fell back into place."

On South Street his eye was drawn to his youngest brother, Stimson. The last Wyeth boy at home, Babe had grown into a serious-looking young man, with wire-rimmed spectacles, large, watery blue eyes, drooping eyelids, and sandy brown hair. Twenty-one, a senior at Harvard, Stimson seemed to have opportunities that N.C. felt he and his brother Nat had missed. "It is reported that Stimson Wyeth has more than ordinary talent as a writer," the local newspaper had announced when Stimson graduated from Needham High School as class valedictorian in 1909. As early as freshman year in college, Stimson was reportedly "preparing for a literary career."

Still untested by life, Stimson fascinated N.C. It had become an article of N.C.'s faith that his youngest brother would be a writer. Stimson's letters, though infrequent and slight, seemed always to contain a promising paragraph. "Not a day, I can almost say not an *hour*, has passed," he told Stimson, "but what flashes of thoughts connected with you and your work have come into my mind." He advised Stimson to keep a pad and pencil in every coat pocket to record thoughts as they occurred to him, "by the river, in the barn, under the apple trees."

During the fall of Stimson's senior year at Harvard, N.C. had proudly relayed to Sid Chase the news that his youngest brother was deeply involved in a series of literary fragments to be gathered into a book entitled *New England Boy*. N.C. described the work as an "intimate personal record of events, work and play, around home" and added that Scribners was "enthusiastic."

Portrait of Stimson, 1909. "He is odd," Hattie said of her youngest son, "but he is a true character."

On these winter evenings in Needham, as N.C. left his water-tower studio, he would pause at the sight of his youngest brother's desk lamp burning through the spruce branches outside Stimson's South Street window. One night, with the house flooded in moonlight and his brother working inside at his desk, N.C. sat on the doorstep "for a long time." Worshipful, moonstruck, he took the lighted lamp as a sign that Stimson had been as moved to plain and simple artistic expression as he himself had been that day. Needham, N.C. supposed, pierced them alike. In his mind this was the most meaningful life one could live. Here was Stimson, living it.

Stimson had stayed at home throughout his college years. Student rooms in Cambridge could be rented for fifty dollars a year, but the young man's attachment to South Street went beyond money. He had begun Harvard on shaky ground. His entrance examinations had been poor. With failing marks in English and Ancient History, and no grade higher than a C+ (in French), he had been admitted to college on trial. That first fall his mother had noticed that whenever Stimson was at home he looked worried. She wanted to help and began by assisting with his homework.

In October of his freshman year, she wrote: "My baby seems to consume much of my time. His trip to and from Cambridge takes so much valuable time that I help with translations etc. all I can." She wondered if Stimson's

work would improve if he lived at college. Perhaps he should be alone, in a room of his own in Cambridge, but if he did move away she "couldn't stand it."

Even as she hooked him in, she seemed to know that she was burdening Stimson by holding over him the threat of her own disturbed behavior. By keeping Stimson at home, by making him commute to Cambridge, by translating French and German for him, she was repeating family history. During the first siege of homesickness in her marriage, she had forced Newell to commute to Charlestown so that she could move home to be with her French-speaking mother on South Street. With her studious son, she wanted to be still closer. As a boy Stimson had been "magnetically connected with [her] own mind." Now she treated him as if he had no mind of his own.

Hattie decided that by doing Stimson's translations for him, she would "just tide Stimson over and get him out of the way of worrying." She did not report on Stimson's feelings about being "tided over" but took pride in her own authority at rendering as many as twenty pages of French or German into English every day. The time spent on Stimson's work alleviated her own worrying, and she justified it by saying, "It's matter that he can read himself so he's practically losing nothing."

By March of freshman year, Stimson Wyeth was officially off trial. The long grasp of his mother's hand can be seen in the Harvard record. His freshman grade for French improved from the entrance exam C+ to an A. The C in German became a B. However, in his three other subjects— botany, English, zoology—he could not crack a C. The sequence repeated itself in each succeeding year: straight C's in English and sciences; D's and an E in philosophy and economics; but, consistently, A's in French and B's in German. With the sole exception of an A in Spanish and, curiously, a C in an *advanced* French course in his senior year, Stimson Wyeth's only outstanding college performance came in subjects that his "housemate" knew well: the languages of Switzerland.

Stimson made no literary mark at Harvard. No intimate account of a boy's life on South Street survives in any early form in the *Advocate*, the undergraduate literary magazine. No finished typescript made its way to an "enthusiastic" Charles Scribner's Sons. Nor is there record of formal interest by any other publisher in Stimson Wyeth's youthful scribblings. Nearly everything about *New England Boy* has N. C. Wyeth's exaggerated hopes stamped on it.

Separated from Stimson by nine years, N.C. had been the first "baby" to leave home, the first son to marry, the first brother to make a life apart. He had managed, in spite of every impulse, to grow. At thirty he was in a posi-

tion to offer his youngest brother perspective on their mother's suffocating grip. Instead, like his mother, N.C. saw himself and Babe as one and the same. "His life," Convers wrote of Stimson, "is my life"—at a time when their lives could not have been more different.

It was not only Stimson. Even N.C.'s most uncommunicative brother, Ed, was subject to the powerful correction of his older brother's eye. Before Convers and Carol's wedding in 1906, Ed had summed up his sentiments to the bridegroom on a postcard, yet to judge by Convers's reply, one would think Ed had composed the kind of eighteen-page letter that characterized Convers's correspondence with Mama. With Ed's message in hand, Convers took time in the tense days before his wedding to let his family know that hearing from Ed had "meant a *great* deal to me." Ed had written one word: "Congratulations!"

Convers went to extremes to invent the emotional intensity he wanted from his brothers. To Nat, his next younger brother, he rejoiced, "I read more in your letter than you really wrote," exulting that their likeness was so great that even Nat's most banal jottings "meant pages to me" because "you look at things of life in about the same way I do."

He had for years overinvested in Nat. "I have always been *peculiarly* interested in Nat, why, I don't know," he wrote in 1907, then listed Nat's sterling qualities: gentleness, honesty, sensitivity—"humanity." He believed that behind Nat's deep, soulful nature "there lies a great masterful power ready to strike when the time is ripe." The following year Nat decided on his future. He would go into the rapidly expanding automobile industry. But Convers took it upon himself to warn Nat that in future the automobile would mean nothing: "The automobile's usefulness (consequently its opportunities for growth) is pitifully narrow and trivial." Within three years, however, Nat Wyeth had started the Wyeth Motor Car Company in Waltham, taking orders on two models of a car he had invented, the 1912 and 1913 Quiet Wyeth. Even though Nat's business ultimately failed, Convers went on placing his brothers, he proudly admitted, "on the highest of pedestals, not for effect but because I *most* sincerely believe they are the best and *cleanest* and most high-minded set of brothers I ever saw, and I've seen and studied many."

The truth was, his brothers loved him, but never as much as Convers wanted and never with passion equal to his own. Ed was "all closed up," his letters, "childish." Convers resented Ed's "effort to cover two pages saying *nothing*." Nat's letters were no more intimate, and when he and Nat saw each other, "the flow of conversation merely passes the time, merely skims the surface." Yet the more his brothers disappointed him, the more he overlooked their actual personalities, the grander his expectations became for them.

Stimson's postgraduate letters positively beguiled N.C. He treated them as purposeful, meaty, literary texts, when actually they are passive and thin, a sleepwalker's diary. To N.C. it was "exasperating to get a sheet of paper from Babe with three or four facts stated and a last promise that he will 'write later' which he never does." Receiving Babe's mild account of a fishing trip on the Charles River in 1915, N.C. had to admit that it was necessary to "read between the lines—I built my emotional story on your inventory of facts."

IN FEBRUARY 1913, while Wyeth was in Needham, the International Exhibition of Modern Art opened at the Sixty-ninth Infantry Regiment Armory in New York. The Armory Show introduced Americans to the European avant-garde; Marcel Duchamp's *Nude Descending a Staircase* depicted an idea that ought to have interested N. C. Wyeth: action made continuous by extending the depiction of a figure through all phases of that action. But Wyeth scarcely noticed. He was attending a horticultural show in Boston—an "important occasion," he noted, because he found it "difficult not to think that I saw Grandpapa talking to a group of men in the midst of the flowers."

He had been home three months. For thirty years Convers and his brothers had been their mother's anchor. Urged by Newell to "get over" her nervousness and "live wholly for her boys," Hattie had done just that. All four Wyeth sons had responded by mistaking their mother's "homesickness" for love. Yet after this latest winter on South Street, N.C. asked his mother, "Do you ever realize what unutterable tragedy it is to be always living in the past or anticipating the future?"

They had cheated each other out of the present long enough. N.C.'s memories of the winter of 1913, though "precious," he told Mama, "mean no more to me than did the moments of transpiring." Chadds Ford, for a change, seemed as alive to him as Needham.

Dedicating himself to "the moment," N.C. moved his family back to the Homestead in March and began work on *Kidnapped.* Once again he started off with high hopes.

In Stevenson's novel about a boy coming of age, David Balfour grows from complete ignorance about himself into honest self-discovery, but only with the help of Alan Breck Stewart, a Jacobite adventurer who is part older brother, part alter ego. Over the course of three months, as Alan leads the fatherless young man toward his goal, David records the day-to-day mechanics of a complex relationship unfolding in severe isolation.

Kidnapped can be called an adventure novel only in the sense that its

exotic settings shape the story's external action. *Kidnapped*, like *Huckleberry Finn*, is foremost an account of a young man's life outside society, beyond the law, in nature. The Scottish terrain, ever shifting, now threatening, now protective, demands a response. If one is to know where one stands on moral grounds, the answer offered here is: plunge into nature.

Wyeth embraced the theme. He had planned to use a portion of his earnings to finance an advance research trip to the Scottish Highlands. It would have been his first time ever outside the United States; instead he had gone home to Needham. Without having seen Scotland, Wyeth captured exactly the qualities Stevenson had remembered from his single visit to the island of Earraid: "the rude disorder of the boulders, the inimitable seaside brightness of the air . . . the sudden springing up of a great run of dashing surf along the sea front of the isle."

The *Kidnapped* pictures are tonal, moody; a new sense of color harmony emerges in Wyeth's greens and blues. But it's not only atmospherics and painterly technique—impasto for heather fog, the wet slap of marbled ocean seething over the weed-covered rocks—that make *Kidnapped* one of Wyeth's masterworks. For the first time he was using the medium of illustration to create visual metaphors for states of mind. With *On the Island of Earraid* he had achieved his aim of painting pictures with universal themes. David Balfour's precarious stance conveys the larger message, the struggle for balance in a world of extremes.

As usual Wyeth had gone outside the text for his stimulus. Stevenson had conceived of David Balfour and Alan Breck as opposite sides of himself, the pragmatist and the romantic, the "man of duty and man of passion." Wyeth had long wanted someone to look up to as well as someone to watch over. He pictured David as *his* current alter ego, his brother Stimson. N.C.'s winter-long absorption in Babe now appeared on canvas.

"There has been a certain feeling in my conception of David coincident with your position today," N.C. wrote to Stimson on May 26, the last regular day of Stimson's college life. On Wyeth's easel that morning stood *On the Island of Earraid*, in which David, shipwrecked and cast ashore among rocks and seething sea, must now find his way alone. "As David Balfour stands there wet and disconsolate . . . in the mist and spray on my Isle of Earraid," he told Stimson, "the form and features of yourself come and go."

N.C. imagined Babe meeting the blind beggar on the Isle of Mull, witnessing the murder of Colin Roy Campbell of Glenure, and finding his way over the heather with Alan Breck's guidance. "I hope," he told his brother, "you may meet with an 'Alan Breck'—that marvelously courageous man whose frugal praise and stinging but vital criticism meant so much to David."

His letters to Stimson throughout the six months he was painting *Kidnapped* indicate how seriously N.C. took the role of adviser to his youngest brother. If he himself "wanted to be Alan Breck to Stimson," as the editor of N. C. Wyeth's letters suggests, then he also saw his chance for a last fling at being David Balfour to Howard Pyle. For if Wyeth's David is a portrait of his brother on the eve of life, Alan Breck is a memorial to Wyeth's late master.

Howard Pyle bears even stronger resemblance to the literary character Alan Breck than he does to John Silver. Alan, like Pyle, is a gentleman with a cause, a well-dressed nationalist leading an oddly narrow, parochial life. He is vain, self-absorbed, grandiose. Though Breck has "a great taste for courage in other men, yet he [admires] it most in Alan Breck." As a teacher he takes erotic pleasure in having the upper hand over his student. His lessons are full of teasing and scolding; he is the kind of perfectionist who makes every task "somewhat more of a pain than need have been." David feels he can "never in the least please my master." But Alan is also tender. He treats David as a younger brother, sometimes as a son. He feeds him, worries over him, stands guard, even acts as legal adviser. By adventure's end David considers him the "chief spring of my success."

Like Howard Pyle, Alan rewards his pupil for his progress by giving him a button bearing his personal insignia; he encourages David to use the button for worldly benefit. As with the buttons Howard Pyle gave his students so that New York art editors would instantly recognize them as his followers, Alan's silver button will bring "the friends of Alan Breck" to David's service.

More important, Alan, like Howard Pyle at *McClure's*, takes advantage of his pupil, betraying his trust, and, as N.C. reminded Stimson, it is David who afterward must be "big-hearted and strong enough to rise up and forgive Alan Breck."

In Wyeth's portrayal, Alan has Pyle's high brow, deep-socketed eyes, and long, straight, high-bridged nose. He also has Pyle's stature. According to Stevenson, Alan is short; David is a full twelve inches taller than his mentor. Yet N.C. paints Alan as the bigger man. In *The Torrent in the Valley of Glencoe*, Alan looms over his pupil. Alan appears to be master not only of the thundering white falls but also of David. Wyeth emphasizes his dominance by depicting Alan in full Jacobite regalia—plumed hat, great coat, belted jacket, frilly cuffs, sword—while David leaps to safety in what look like schoolboy's short pants.

Clothing had been an integral feature of Wyeth's work since his western pictures. He had made a point of treating clothing, even the most complicated sets of medieval armor, as if it were "ordinary and commonplace garb."

Light, he had learned, was the secret. Depicted in everyday, nontheatrical light and shadow, clothing becomes fabric rather than costume. Fabric and its individual folds reveal the wearer, whereas costume reflects a historic period. Singularity expresses character *and* time. "Those folds will never be the same again," he would emphasize to students as they painted the fabric of a shirt. "This is the one time they'll be this way."

Wyeth had never been more expressive or timeless or specific than in *Kidnapped*. Here, he used clothing to render individual states of mind: Alan's vanity, David's illusions, David's uncle's indolence and greed. Some of his finest painting in the series turns the pirates' shirts in *At Queen's Ferry* into the sunlit gossamer of choirboys' robes. The vision of bad men angelically clad joins the viewer to David's naïveté.

In the series' final canvas, *The Parting*, David's short pants and torn jacket are gone. The frayed elbows are no longer a condition of adversity or an attitude of youth. Both Alan and David are dressed as men; David's tailored coat exaggerates the broad musculature of his shoulders. At last the same height, the men are equals.

Their uneasy silence, as they stand on the hill looking back at the city, carries hints of the cooling of Wyeth's relationship with Pyle. On the horizon, smoky Edinburgh conveys the message of Wilmington's distance from Chadds Ford: the unclean city seen from the green hills of the Brandywine Valley, the two worlds connected by a river.

PYLE'S PEDESTAL remained empty. Looking for a replacement, N.C. found none. "Everyone seems so depressingly silent, so unwilling to speak, so constipated within themselves as to be *oppressive* in their muteness. . . . I yearn for frank criticism—I give it," he asked, "why shouldn't it be my lot to receive it?"

When he met his colleagues in illustration at a dinner at the Dutch Treat Club in New York, he was disheartened by the evening's artificial atmosphere. "How I would like to have really *talked* with some of them," he said. He felt a strong connection to the Boston painter William Paxton, thirteen years his senior, "in whom I firmly believe I've found an inspiring friend." At other times he had given the part of older male "sympathizer" to Frank Schoonover or Sid Chase, both five years older than Wyeth. Chase, he said, had "appealed to me as a father almost." All but Chase had let him down, and from Schoonover he had recoiled, as he had from Harvey Dunn. The latest, Paxton, would go from "inspiring friend" to "besliming nincompoop" within five years. None had the temperament, the capacity for intimacy he craved. None was open enough. "How seldom they showed

themselves," he once said of his male friends. "Must men always meet guardedly lest something honest slip out in some 'weak' moment?"

He kept trying to find among his peers the degree of emotional intensity he had achieved with Howard Pyle. "It is the search for living co-workers and the everlasting failure to find *one* that can measure up to one's active standard that is the constant source of my depression," he wrote.

He had been lucky to know an editor whose opinion he valued. After nine years of working as "Mr. Wyeth" with "Mr. Chapin," Wyeth felt proud to have "arrived at the point where I can call you *Chapin*."

Artist and editor joined forces in August 1913 at the engraving house to huddle over the *Kidnapped* plates and proofs. As always, Wyeth appreciated the ease with which he could talk to Chapin about subtleties that other art editors would brush aside. He valued his editor's informality; Chapin was always available, "never hiding behind a screen of preoccupation or dignity." Meeting at the engraver's, visiting artists in their studios, consulting with them after hours, Chapin had pioneered the working friendship, which was then the exception rather than the rule in publishing. For Wyeth, Chapin's cardinal characteristic was flexibility: he saw and understood both sides of an issue. Forever divided between illustration and painting, Wyeth could not have found a more sympathetic editor to keep him on track.

Yet he continually wished Chapin would hold him to higher standards. He wanted to be challenged, not only aesthetically but morally, spiritually. Wyeth's search for an omnipotent male figure had an Eastern quality; he felt that the ideal master should be something of a mystic. In 1912, he had decided that J. Adams Puffer, the Unitarian minister in Needham, might fit the bill. As a young man in church, Convers Wyeth had thrilled to Puffer's astringent preaching. He had felt "a sort of communion, a mixture of thrill, enthusiasm, and vision." He also admitted that Puffer's sermons could be "dangerously close to harangue," and when he tried to put his finger on what precisely stirred him about Puffer, he realized that he had been moved "mainly because I was able to sense between the lines"—the same reflex he had developed to fill in the blanks of his brothers' communications.

"I'm not crazy," he insisted to Stimson, though as N.C. began his thirties, his search for a spiritual guru often left him feeling unreal. "I'm not holding a living or dead man up as an example of what I should be; I go beyond that—I want to be myself, and better, to be myself without the whole damn world knowing anything about it!"

But he *was* holding up a dead man as his model. Taking *Walden* as his guide, he contended that Thoreau "is my springhead for almost every move I can make," with one practical exception, "in the intimate matters between

a man and a woman—here he is utterly deficient, as is Christ, on account of his lack of experience."

Under Thoreau's spell, N.C. made pilgrimages to Concord and to Walden Pond. There, he said, "the present [could be] utterly forgotten, and I could see that homely figure in his faded sack coat and brown cap, winding his way in and out the oaks and pine trees, stopping now and then to pick up a leaf or stick." He liked to think that if Thoreau were alive, if they could talk an hour every evening, Thoreau would understand him. With *Walden* in hand, N.C. could "feel his approval surging within me now, and I lay my hand on his precious book . . . with the deepest reverence I am capable of."

In March 1912 the Reverend Mr. Puffer visited N.C. in Chadds Ford. At first N.C. saw him as "a big sane being," meanwhile perceiving himself as unworthy of reciprocating a churchman's friendship. "I am no more capable of acting his good principles than I am to fly—and I have laid awake many hours over this damning failure!" He tried out Puffer on Pyle's pedestal, but Puffer proved to be too much the minister, too little the mystic. In May, balking at Wyeth's spiritual communion with the green world, Puffer rapped his knuckles: "It is very nice for you to talk about the pleasure of the feel of the wind against your face, but there is real work to be done."

That was enough for the frustrated son of Newell Wyeth. "You and I must keep this in mind as we turn to any strong man or master for sympathy or help," N.C. advised his brother Stimson.

He yearned to find "a sympathetic resourceful friend," a guide, "some man who could direct me in the true path"—a real Alan Breck. Just as he finished *Kidnapped*, Theodore Roosevelt stepped into the breach

ROOSEVELT had been a popular Scribners author since the publication of *The Rough Riders* in 1899. Joe Chapin arranged the meeting at Scribners for eleven o'clock on the morning of August 27, 1913. Wyeth arrived first. The publishing house had hung his *Kidnapped* canvases on the office walls and spread the latest color proofs on a table for the two men to inspect. N.C. Wyeth would meet his hero surrounded by his own images of David Balfour and Alan Breck.

Roosevelt appeared on the dot of eleven. The former president was now fifty-four, a political and social outcast. The year before, having left the Republican Party to become the newly founded Progressive Party's presidential candidate in 1912, he had placed second in a bitter four-way fight with Democrat Woodrow Wilson; the incumbent, Roosevelt's former friend, William Howard Taft; and a Socialist Party candidate, Eugene V.

Debs. In two months Roosevelt would plunge into the Brazilian jungle, permanently ruining his health on an unmapped tributary of the Amazon. Blinded in his left eye in a White House boxing match, shot in the chest before a campaign speech in Milwaukee, the stocky, barrel-shaped, twenty-sixth president looked to Wyeth that morning like an unstoppable locomotive. T.R. seemed to enter the room on wheels. He surged forward, thrusting in and out among the office desks "like something on tracks."

"His approach was, in a way, kind of fearful," Wyeth decided afterward, then crossed out "kind of fearful" and settled on "awe-inspiring." He described the Roosevelt handshake as an electric shock, as if a live current were passing from the great man's body into his own.

The Roosevelt jaw meanwhile jumped into its famous grin. Chapin had alerted the visitor to the artist's 1905 exploits, when Wyeth, with Harvey Dunn, had masqueraded as a cowpuncher in Roosevelt's inaugural parade. "I am *dee*-lighted," the ex-president declared, "to meet at last the *only* and *original* cowpuncher!"

Turning to the pictures, Roosevelt flashed his half-blind gaze across each canvas. He liked especially the figure of Alan. Then his good right eye landed on Wyeth's cover illustration of Alan and David racing grimly across the heather.

"Where are Breck's side arms?" demanded Roosevelt.

N.C. explained that the picture was consistent with Stevenson's description—Alan had carried no pistol on his flight across the heather.

"He *should* have had and *would* have had," Roosevelt roared, "and *you* should have strengthened Robert Louis Stevenson with the correction!"

When his hero thundered out of the office a half hour later, Wyeth was exhausted. He dreamed of Roosevelt that night and the next night. In the following five years, as Wyeth crossed paths with Roosevelt in New York, he credited every advance in his painting to the former president's "broad, virile, progressive spirit." He claimed to be keeping an open mind about the artistic innovations of Fauvism and Cubism, but with Roosevelt at his side he did not have to accept the avant-garde. After spending one April evening in a "nest" of Postimpressionists, as well as Marcel Duchamp, "the nude-descending-the-staircase man, and all the other nuts," Wyeth found the new artists patronizing and vain. It was the hour he spent trading stories with Roosevelt that made him feel connected to something real.

STIMSON WYETH graduated from Harvard that June. He spent the summer of 1913 on South Street, then made his start in life as a teacher of modern languages—the profession his mother had set her heart on before she

married Newell Wyeth and raised four boys. He found a job at the Kentucky Military Institute in Lyndon, Kentucky.

Weeks before Stimson actually left home, N.C. saw it as his job to prepare Mama for the change. Hoping to "tide over the void that is sure to occur," N.C. arranged for Carol's sister Hildegarde to live with the Wyeths on South Street.

In September, when Stimson arrived in Kentucky, he immediately wrote to his brother. "Everything is lacking in the refinement I have been accustomed to. . . . Railroad stations, hotels, homesteads, and all lack thrift and neatness." He complained that people out in the world were superficial, fickle. "I fail to find anywhere what that little town of Needham contains in the way of worthwhile people, outside of our family."

The Kentucky Military Institute was a tough place. Stimson taught French and Spanish but also served as athletics coach, which meant refereeing bare-fist fights—basically a blood sport. It was all "very distasteful, owing to the demoralized conditions, both academical and moral." Stimson was homesick.

"I would wonder if [he] wasn't," his mother said.

Newell, too, was gratified by Stimson's homesickness. "Of course it was nothing but what you would expect. In fact, I should rather feel bad if he was not so."

After three weeks in Kentucky, Stimson concluded that he was not "built" for life away from home. It was both wrong and foolish, when he "could be living a rich, infinitely rich life, in my home, with my people." Impatient with the shallowness of the world, he "longed for a talk with one who says something beneath the surface of his mere words."

Against his father's advice, but with N.C.'s approval, the youngest Wyeth quit his job and returned to 284 South Street in time for his mother's birthday. "I am glad for Mama that you are to return," N.C. wrote. "You are life itself to her and I am proud of you for it." For the foreseeable future Stimson wanted nothing more than to "breathe that unaffected, sweet, and wholesome aroma of our home." His "start in life" was now recast as "a leave of absence from home."

The family seemed unaware of the cost of staying home. Only one family member ever acknowledged that Convers Wyeth and his brothers needed to get away from South Street. Uncle Gig, Hattie's brother Augustus, asked Convers an interesting question: "Where would you have been supposing you hadn't lit out when you did?"

The Skies of Chadds Ford

THAT AUGUST—1914—the Wyeths spent a week at the Jersey shore. While they were away, war broke out in Europe. Three publishers instantly fell on N. C. Wyeth to cover the war. When the Wyeths returned home, relieved to be back in the little brick house on the hill, special-delivery letters began arriving at the rate of one a week. Telegrams followed. No sooner had these dispatches appeared at the door than Wyeth whisked them away without comment.

Following the style established with his mother, he now kept important information from Carol and the children. Thinking he knew best, N.C. concealed from everyone the news that the family dog, Tring, had been run over. For two days he maintained the fiction that the dog had run away, but the constant calling of Tring's name by the children became unbearable, and he revealed the secret. The train had run over the dog. N.C. noted that it was "our third dog lost from this cause."

He kept quiet, too, about his temper. When the Wyeths decided to fire their Danish housekeeper, Dagmar, N.C. discharged her, giving six weeks' notice and a severance bonus. Dagmar's husband did not think the terms fair, and he protested, flying into a rage in the barn, kicking at N.C. with his boots. N.C. at first tried to pin the man's arms but ended up knocking him out with a single punch—the first time in his life he had knocked anyone unconscious. Emerging from the barn with a bloodied shin, N.C. fibbed to Carol, saying he had hurt himself loading potatoes into the wagon. Then, telling part of the real story to his mother, he asked for her complicity in his deceit.

Now, in September 1914, he hid from everyone the news that William Randolph Hearst had summoned him to start for Poland immediately. Six months earlier Wyeth had expressed his first desire to travel abroad. After years of rejecting Europe on the grounds that it would interfere with his individuality as a painter, he vowed in April 1914, "I want to retrench enough so that another year will find me in Europe." In July he had talked of visit-

ing Milan to see the works of the great Alpine Expressionist Giovanni Segantini.

He had also said, "When I think of those dear little kids, *Europe* has no significance whatever."

Europe now vanished as if in an earthquake. With the Austrian Archduke Ferdinand assassinated by a Serbian terrorist in the streets of Sarajevo, Austria allied itself with Germany to declare war on Serbia. Russia then mobilized, drawing in its ally France. On August 1, Germany declared war on Russia and that night marched on France. Eyewitnesses in England were instantly transformed by the "horrible violence & shock of the change of consciousness," as Henry James wrote from Lamb House in Sussex. In a single night the world had broken from its past. By 1915, the year Wyeth had hoped to "retrench" on the Continent, Europe itself would be entrenched along the Western Front.

Few Americans in 1914 expected to fight in Europe's war. William Randolph Hearst, the combative press lord who had already "furnished" images of one "glorious little war" for the sake of circulation, was once again on the trail of war artists. Hearst offered Wyeth a chance to join two writers covering Cossack regiments in Poland. The job would mean spending the next eighteen months in Eastern Europe.

Wyeth had reasons to go. He had good health; he was ready for a real-life adventure. In his studio he saw "no particular direction or progression." The books and stories sent him by publishers offered no special chance to refine the advances he had made in *Kidnapped.* Hearst, by contrast, was offering serious money and exciting pictorial material.

Although Wyeth felt sure that war imagery would add to his "repertoire in illustration," he had qualms about working for the press lord. Hearst knew exactly how to arouse his desires, and Wyeth felt trapped. "Flying cavalry! barbaric dress! glitter of clashing steel! roar of cannon! rattle of musketry! the cry of victors!—all these enticing descriptions poured into my ears," he wrote in a fury. "My God! I've got an old fellow working out in the sun in my truck garden, just as picturesque and a damned sight more vital to me and the world than all the crazy Cossacks in Russia."

As always he preferred ends to means. If the result of eighteen months' work in Poland was a pile of drawings printed in a jingoistic "yellow sheet" like Hearst's *New York Journal,* then he would be wasting his time. He was almost thirty-two and had just spent two months with three children racked with contagious whooping cough. "My responsibilities here are entirely too important and vital to fool with life that way," he concluded. Insisting that his decision was final, Wyeth declared, "There is nothing more interesting

or important going on in those fields of carnage than what happens in this little house every hour."

Hearst upped the ante. For a year's worth of pictures from the battle-field, he would double Wyeth's present earnings.

In spite of his resolve, Wyeth saw in the money a chance to decide once and for all between illustration and painting. With a fortune from Hearst, he felt he could buy the time to be the painter he should be. If he survived a year and a half in Poland, he could abandon illustration and devote him-self entirely to painting. The two forms, he still imagined, were mutually exclusive. Moving between them would always be "a jump from white to black."

He intended to resist Hearst and hustled into New York to "dispel the whole thing." Hearst counteroffered with still higher sums. Looking back on the situation, Wyeth remembered it as a "bigger tax on my powers of decision than I thought possible." In the end, he stuck to Chadds Ford and his family. All the same, he wasn't sure he had done the right thing until he had reached home and the "dear little kids jumped all over me as though I had been away for months."

OVER AND OVER he opened himself to the landscape. With each attempt the result was the same. As a landscape painter Wyeth could not be him-self—or at least not the spiritual self he imagined himself to be in nature. "I can't do it," was his new refrain. "I try and try, and I cannot! I seem to be fit-ted neither by training or professional habit to satisfy these Religious Crav-ings." None of his true feelings for nature had "yet emerged on canvas in its pure state." He had so far used his emotional experience only in illustra-tions—to "garnish a pirate picture, an Indian scene, or some meaningless fantasy"—and there, he felt, he was "diverting the golden stream into the gutter."

In fact, his Chadds Ford landscapes are for the most part banal. Paint-ing the countryside, he produced quiet idylls, pictures of unspoiled perfec-tion. The trouble was, like so many idealists, he had little to add to Paradise. When observers pronounced his landscapes "commonplace," Wyeth had to agree with the "terrible verdict." Any good Sunday painter could have painted them. They were forced, overworked. For all its technical skill and peaceful charm, *Summer Days* (1909) has none of the authority or expres-siveness of *Autumn* (1909), which appeared in the "Moods" series. Similarly, the pastoral world Wyeth painted into the background of *The Sampo: Hero Adventures from the Finnish Kalevala* (1912), a "retold" legend by the Indiana-

born storyteller James Baldwin, reveals more about Wyeth and Chadds Ford than any landscape of that period.

Invited in 1915 to exhibit at the prestigious Panama-Pacific Exposition in San Francisco, Wyeth reluctantly sent five canvases—landscapes and illustrations. He won the gold medal for illustration. Meanwhile, in the Delaware Valley at New Hope, Pennsylvania, Wyeth had become friendly with the landscape painters Daniel Garber, Edward Redfield, and W. L. Lathrop. Although encouraged by each of them to exhibit his landscape work, Wyeth declined. The art critic and promoter Christian Brinton, a neighbor and admirer of Wyeth—Brinton had introduced modern Russian art at the Armory Show in 1913—also joined the chorus, urging him to exhibit as a landscapist. He held out. "I could 'put it over' now (to use the popular term), but there is no earthly sense in that," he asserted. "I don't want to be rated as an *illustrator trying to paint,* but as a *painter* who has shaken the dust of the illustrator from his heels!!"

He was rebuffed both ways—as painter and illustrator. In 1913 the Pennsylvania Academy of the Fine Arts accepted two Wyeth landscapes, marking "an important moment in my life—my first attempt to exhibit as a *painter.*" The day before the exhibition was to open to the public, Wyeth strode into the galleries "keyed to the highest pitch of eager anticipation." But he could not find his paintings. Mortified, he stalked up and down, checking each canvas on "the line"—the long sequence of accepted entries which had been hung at eye level in the galleries. Finally he looked himself up in the show's catalog. His heart sank. Only *one* painting had been included. He spotted his canvas hanging in its assigned gallery, but not "on the line." His picture had been stuck, by itself, up near the ceiling. In the language of group shows, he had been "skied."

Seeing how little he could trust the politics of exhibition, Wyeth realized "how fortunate I am to have a *practical* streak." He was not going to earn a living by being skied. But being an illustrator meant "that I can go through life giving necessary comfort to those dependent upon me."

Three years later, at the Philadelphia Art Club, he was skied again— "conspicuously *skied,*" he told his father, "so much so that it is funny." This time the galleries were hung with two lines of paintings, one above the other, all the way around the room, interrupted only once—by a doorway and its high wooden molding. Wyeth once more entered the room expecting "to enjoy the sensation of strutting the floors of the Philadelphia Art Club gallery with my picture beautifully hung on the line with the best of my contemporaries." Halfway around the gallery, he spotted his picture.

A banquet scene, it had appeared as a color illustration in the December

1915 *Scribner's Magazine.* The Philadelphia Art Club jury had expressed doubts about it for the show. Conceding that the canvas was well painted, the jury still questioned whether it was a legitimate painting or "just a common illustration." They deliberated at length. Fortunately, Wyeth had a supporter among the jurymen, Edward Redfield, the New Hope painter; Redfield persuaded the others to vote for the picture. They then turned around and hung the ugly duckling by itself, over the doorway, a few inches from the ceiling.

The incident touched off a furor. Fellow artists and influential art patrons demanded a new annual show to be held at the Academy of the Fine Arts and to include the work of Philadelphia artists. There would be only one requirement for inclusion: the contributor must be "a serious worker in some distinctive field of graphic art." Wyeth endorsed the plan. He told his father that he did not "feel hurt or exasperated." On the contrary, "I feel sufficiently recompensed that my picture was the straw that broke the camel's back."

HIS LIFE AS A FATHER was giving him real reward. "With all the professional restlessness and dissatisfaction of the past months," N.C. wrote, "deeper relations than ever have opened up to me in my home."

More and more, he mothered the children. Against the infantile paralysis scare of 1916 and the "gray, thundering background of the great war across the seas," he worried endlessly. He fetched doctors and nurses during medical crises, recorded the dramas of toilet training, the pounds and ounces before and after weaning.

By Carol's decision, the Wyeths employed cooks and housekeepers. Carol's sisters Esther and Hildegarde often came to help. But "Papa" was the one who cooked them all breakfast and gave them olive-oil massage treatments to increase their weight after illnesses. Trading off with Carol, he fed, bathed, measured, weighed, and put the children to bed. N.C. would be the one the children remembered getting up in the middle of the night when one of them had a bad dream. He "took care of us like a great, wonderful nanny," Henriette later remembered.

On March 15, 1915, another girl was born at home. They named her Ann. A chunky, rosy-cheeked baby, she looked, N.C. thought, like himself and his brothers as infants. He pronounced her the most attractive, most interesting baby in the family.

In the weeks after Ann's birth, N.C. carried Carol down to dinner each evening. "He carried everyone," Nancy Bockius remembered. "He carried

everything in his hands." Much later a grandchild remarked, "He was both patriarch and matriarch."

On the last day of January 1915, Carol's father wrote from wartorn London. George Bockius had been living abroad for four years. Although their father wrote letters that spoke of "doing his bit" as a munitions worker, none of the Bockiuses knew what he was really doing over there. Increasingly at a loss, Carol's mother shuttled the youngest children between her rich sister's house in West Chester and an alien "little house" in Wilmington.

N.C. had changed his view of the Bockius household. Instead of an enchanting troupe of kids, he saw a slovenly bunch of mistreated youths. Carol's mother was irresponsible, abusive, all but insane. Carol's sisters should go at once to Needham or come to Chadds Ford to live "along sober, earnest, and constructional lines." Stepping into his familiar role as surrogate father, N.C. fed Carol's sisters, clothed them, gave them work. "I can't see them slamming around with no home," he said.

Carol was pregnant again when Nancy Bockius came to live with the Wyeths in 1917. Carol was feeling "healthier, stronger, and better in every way this time." N.C. thought she looked better than she ever had and painted her into *Robin Hood*.

He frequently asked Carol to pose, sometimes substituting her for male figures, sometimes posing her with a long Kentucky rifle or asking her to stand in for Abraham Lincoln. In *Robin Hood*, he cast Carol in her own right as one of the great heroines of romance. Maid Marian Fitzwalter's eyes were "beautiful as stars." Carolyn Bockius's eyes had been so large and dark at birth, according to Annie Bockius, she "seemed like a star." Marian's eyes had remained "always in [Robin's] memory," as Carolyn's had in Convers's.

Robin Meets Maid Marian (1917) captures the lovely tilt of Carol's head, the shy but inviting expression of her eyes and lips. This is the beautiful young woman Convers Wyeth courted and married. Later, in an illustration for Charles Kingsley's *Westward Ho!*, Carol's portrait reappears in *Rose of Torridge* (1920). She is no less lovely but now more dutiful, a bit remote. In *The Courtship of Miles Standish* (1920), Carol's evolution is complete; we find her doing housework, the woman who in her twenties and thirties would spend a total of 242 weeks pregnant and twenty years lowering hems and raising children.

N. C. Wyeth's *Robin Hood* and *King Arthur* contained some of the best painting he had ever done. He was surprised by the "present terrific conditions" and attributed the upswing to Carol and the children. "My family," he wrote, "is the source of my power, I am but an instrument at its service, and at its mercy." His stronghold on Rocky Hill made him feel more generous

toward former rivals and the world. Able to "enjoy so many more people than I once did, people whom I had inclined to frown down upon," he admitted, "no one realizes more than I do how narrow and pinched I have been in my attitude toward people."

Wyeth began teaching. He took four young men into his studio from as far off as Denver and Ohio. He gave one composition lecture a week, followed by a sketch class on Saturday afternoons and Thoreau readings Sunday night. His teaching had a streak of Darwinism. Influenced by his apprenticeship with Pyle, he preferred the natural selection of a shared studio to the politics of academy exhibitions and juried competitions.

He found that he was a naturally gifted teacher. He had been so powerfully influenced himself that he understood the power of influence. Modeling himself on Pyle, he formed a partnership with the best of his students, called them associates, and made available to them his contacts at Scribners; within months Dwight Howland was appearing in the magazine and Clark Fay had a book deal. Like Pyle, Wyeth made his students feel that their commitment to painting had mystical significance.

For Wyeth teaching was a revival. Students, he discovered, to his great joy, supplied the kind of emotional intensity he had been looking for in his brothers. Pitt Fitzgerald, a sensitive twenty-two-year-old who had studied at the Pennsylvania Academy of the Fine Arts, gave back passion to match to his own. Five-feet-ten, slender, with a sweet smile, Fitzgerald also attracted Carol's sister Ruth. They were engaged to be married. It was the first in a long line of Wyeth students who would deepen the attachment to the teacher by proposing to the women in his family.

Teaching and family grew entwined. N.C. entered into his children's lives as if fathering were his real work and saw the children as "an incorporate part of my body and soul." When he wrote a letter he felt "their hands helping to guide the pen." He called Henriette "the Transmitter—the connecting link of communion between myself and Nature."

Of the four children, Carolyn most clearly resembled N.C. "She's an enthusiast, anarchist, pugilist—and angel, all in one!" he exulted. By age seven Carolyn was a Convers in miniature, appointing herself guardian of her siblings, corralling them indoors during thunderstorms, spending the days before Christmas worrying over whether she had forgotten anyone's present. She had "this absolutely cherubic, charming face," Henriette remembered, "and she always ate too much, always did everything inordinately over-expressive, over-everything."

Newell Convers Wyeth, Jr., had been officially renamed Nathaniel Convers Wyeth, to be known as Nat. N.C. had noticed that the boy was "such an astonishing counterpart of his uncle in so many particulars,"

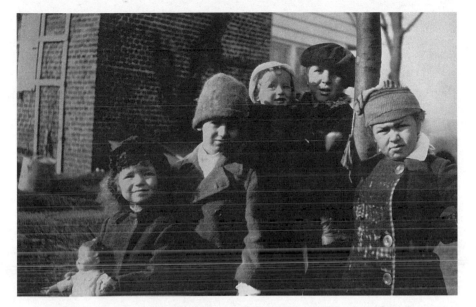

Ann, Nat, Andrew, Henriette, and Carolyn, 1918. Note the frayed
condition of Carolyn's coat: she refused new clothes, believing her old
clothes would feel hurt if replaced.

including his interest in wheels and machinery, that he renamed him for his
brother Nat. But that did not stop N.C. from identifying with his son and
crediting him with "my unquestionable growth this summer."

Ann's easy laughter buoyed him, too. "She interests me as an infant
more than any of the others did, on account of her sense of humor and good
fellowship. Honestly, you can bang her 'round and really jar her severely in
rough and tumble, and she'll laugh it off." He called her "my 'joker.'"

N.C. taught his children the lesson he had been taught by his mother.
Invest things with feelings and they will stay alive. Four-and-a-half-year-
old Henriette one day decided that bunches of bloodroot, her favorite
spring flower, were making her hands dirty; the root of the white, starlike
flower contained a scarlet red sap, once used in cough syrups and red dyes.
Henriette suddenly stopped picking bloodroot on her daily rambles around
Rocky Hill. That night N.C. told her that she was hurting the blood-
roots' feelings. The next night, tucking Henriette into bed, N.C. asked if
she had picked bloodroots that day. She replied that she had picked a new
kind of pink flowers. She had left the bloodroots alone. N.C. again sug-
gested that this had hurt the flowers' feelings. "I believe they cried," he told
her.

"I didn't hear them cry," she said.

"Perhaps if you had listened carefully, you would have heard them."

Eyes widening, Henriette asked, "Do bloodroots cry when I don't pick them?"

"Don't you think when they see you go by and you won't even look at them, that they cry? I do," said N.C. "Why, when the bloodroots see you coming over to the woods in the morning they say 'O, here comes Henriette! Aren't we happy!' and if you listen carefully you will hear them say 'Good morning Henriette!' and then when they see you go right by without saying a word, don't you think that they feel sorry?—and cry?"

As N.C. would later tell it, Henriette lay still, thinking this over. He could hear her breath quicken and see her big, black eyes "looking a thousand miles away." He was about to leave the room when Henriette sobbed. She asked, "Are they asleep now?"

"Yes."

"Are they nice and warm in the leaves?"

"Yes."

"Will they wait for me tomorrow?"

"Yes."

"Will the nice rain give them a cool drink of water?"

"Yes."

Bursting into tears, Henriette begged her father to please go and tell the bloodroots that she would come out in the morning and say, "I love you, little bloodroots." She promised that she would say "good morning and everything."

Immediately afterward, recounting the episode for his mother, N.C. noted that he had cried with Henriette, adding, "It is hard for me not to go out and feel my way through the dark drizzle to deliver her message to those sleeping bloodroots."

He taught his children to feel everything. He took them on daylong expeditions up the Brandywine to Brinton's Bridge, or over to Cleveland's meadow to pick mushrooms. "Memories," he wrote, "will give them untold pleasures, and *perhaps* be the basis upon which they can build an important life work."

For the moment, though, memories, exaggerated by the habit of anthropomorphizing, opened N.C.'s children to the painful part of rapture. The romancing of things made separation and loss central to their sense of themselves and the world. For if everything has a life, even a loose sheet of wrapping paper blowing around in the wind after Christmas, then everything must die a death, and the pain of each death was felt by the Wyeths.

Evenings, N.C. drew for the children and asked for drawings in return. Supplying them with pencil and paper, he taught them to sit still and look—

to *observe*. He was astounded at their loose, freehand draftsmanship. When he brought home from New York a book of Dürer's works, he discovered that the children got as much pleasure as he did from the woodcuts and pen drawings. He marveled at Henriette's and Carolyn's enthusiasm over "a collection of drawings that would leave eighty percent of grownups cold."

At Halloween, with the fireplace roaring in his studio, he surprised them with elaborate tableaux vivants—living pictures—of jack o'lanterns. Before Valentine's Day and Easter, the Homestead was like a "night art school," everybody drawing, making things for everybody else. Christmas shone brightest. It was the main event, the climax, "the most wondrous day of the year for us," said N.C. He called it "the source of my work."

WHEN N. C. WYETH disguised himself on Christmas mornings in Chadds Ford, he emphatically rejected the Santa Claus invented by an American illustrator—the jolly, bearded, deed-counting St. Nick created by Thomas Nast for *Harper's Weekly* in 1863. Instead, he became the mysterious Germanic figure "Old Kris."

Early on Christmas morning, in costume, he climbed a ladder to the roof of the house. Stamping his boots, ringing sleigh bells, quieting the reindeer, he called down the bedroom chimneys. Hidden behind a long-whiskered mask with spiky white eyebrows and a peaked red hat, he would visit each child's room, filling stockings, carrying "the beautiful illusion of 'Old Kris' as far as possible." When doubt first crept into the children's minds, N.C. rigged up a dummy, which, with the concealed apparatus of a small screw eye in a ceiling beam and a string tied to the dummy's foot, made Old Kris come alive from a sound sleep in an armchair. The children looked on from the Big Room doorway, believers once more. With the youngest child, N.C. would eventually carry the illusion so far that one of Andrew Wyeth's earliest memories of Christmas was of the humiliation of being so terrified by the bearded apparition that he lost control and peed in his pants.

Each year, in disguise, N. C. Wyeth enacted a drama that electrified and terrified his children. He staged his appearances so that each child had to come forward into the hallway to shake the mittened hand of Old Kris. Then the strange and wondrous figure withdrew. Minutes later he reappeared in their midst, once more their father. Throughout the entire sequence, reality was supercharged because something miraculous was happening in a normal place—for N. C. Wyeth, the most real place of all: home.

This indeed was the source of tension in much of his work. In N. C.

Wyeth's pictures, fantastic things happen, extraordinary figures appear, but the atmosphere, the setting, feels normal. The past, no matter how exotic or long ago, seems to be happening now, in a concrete and plausible present. Wyeth's pictorial world, no matter where it is or when it takes place, has a recognizable, reassuring center of gravity. His folk heroes enter our own backyards.

The skies in *The Black Arrow, The Boy's King Arthur,* and *Robin Hood* are not English. They are the mid-Atlantic skies over Chadds Ford. The trees of Sherwood Forest are not the ancient oaks of England but the silver beeches of the Brandywine. The sandy lee of Robinson Crusoe's island is the New Jersey shore. The colors of Camelot are those of Pennsylvania crops.

The green knight of *It Hung upon a Thorn* (1917) isn't preparing for a Pentecostal joust near the Welsh coast. He is blowing his horn toward Sugar Loaf, Wyeth's favorite hill in the valley. He's summoning his armor bearers to come galloping on a dirt road between the Wyeths' neighbors' corn and rutabaga. The thorn tree in *King Arthur* was adapted from a tree that stood atop Wyeth's property; likewise, the silver beech roots and rock outcroppings behind which Robin Hood and his men lay in ambush in *Their Arrows Flew Together . . .* (1917) are the roots and rocks of Rocky Hill.

The novelist Dorothy Canfield wrote from Tuscany that she had discovered in local galleries certain Italian masters whom she felt sure Wyeth must have studied to achieve his "adequate distances." "If she only knew," he remarked, "that Sugar Loaf was the farthest I'd been."

Wyeth painted the landscape of the valley into his illustrations because he could paint it nowhere else. While painting *Rip Van Winkle* and *The Scottish Chiefs* in 1921, he wrote, "If it wasn't that I was enabled to pour snatches of sunlight and shadow, storm or moonshine, into my [illustrations] I could never stand the strain."

In the background of his post-Wilmington illustrations are N. C. Wyeth's landscapes, the ones with spontaneity and character. Behind the foreground action is a living world made real by light. Here are skies, hills, rocks, trees that have more feeling than in any canvas Wyeth painted for the sake of a "higher" art.

Yet he made a point of telling visitors that every Saturday he put aside his latest illustration job and painted a still life or an outdoor study directly from nature—"just to prove that I can." The point was not that studying nature improved his work as an illustrator but that nature studies were a "better" pursuit for a serious painter. In fact, his nature studies were for the most part dull. One study, *Gilpin's Rock,* painted behind Wyeth's studio, is

typical of what happened when he tried to redeem himself from the "taint" of illustration.

In *Gilpin's Rock* the shadows are muddied and the rock is lifeless. In illustrations of the same period, the background is indistinguishable from formal landscape painting—every line certain, spontaneous, freely painted. Wyeth believed that he had sullied himself by becoming an illustrator, but only when camouflaged as illustration did his rock formations become as complicated and real as Winslow Homer's.

Wyeth's method of incorporating the Chadds Ford landscape into the narratives of world literature elevated his work above all other pictures then being published. The poet Robert Frost recognized his "strong bent toward the near, the homely, and the American, and so I look for it in the pictures and think I find it in them, romantic as they are." Frost wrote in March 1917 that he wished Wyeth had illustrated his second collection of narrative poems, *North of Boston*, which was a literary sensation.

Wyeth was painting quickly now. Between May and November 1916, he produced forty-three canvases for publication. Yet as soon as he turned to a "real" painting, he faltered, making twenty-five sketches before laying a single stroke of paint on *Cows in Moonlight*. With typical overstatement, he took all the violence out of nature. Struck, for example, by the sight of a neighbor's mules lying inert in a pasture—the animals had been killed by an electrical storm—Wyeth put the gray-white mules not into a Chadds Ford landscape like *Cows in Moonlight* but into a picture he happened to be working on for *Hearst's Magazine* in 1916—*A Fight on the Plains*.

In "Buffalo Bill" Cody's memoir, "The Great West That Was," Cody and his companions have been caught on the open range by an Indian war party. Shooting their own animals, the three frontiersmen take cover behind "dead-mule barricades." Indians are the source of danger in the scene, but in *A Fight on the Plains*, the attackers are rendered as blurs of color out near the horizon. In the foreground Wyeth focused on the hides of the dead mules. The arrows penetrating the animals—not the attacking Indians—are the objects of menace. Our sympathies are entirely absorbed by the sight of arrows piercing gray-white flesh.

As a landscapist, Wyeth saw one side of life only. The three men in *The Fence Builders* (1915) are good men. They have all the time in the world and nothing much at stake except to do an honest job on a fine day. Paragons of the simple life, they go unhurried about the work of building a split-rail fence. Their lack of haste is an emblem of their uprightness. Behind them spreads the valley, monochromatic, misty, uncorrupted.

In *The Fence Builders* Wyeth was preaching. On the same turf, painted

Cows in Moonlight, 1917. NCW was convinced that this was among his strongest easel paintings—"the kind that will disarm the critics that say that 'an illustrator can't paint.' "

A Fight on the Plains, 1916.

two years later, at the height of World War I, the men in *The Boy's King Arthur* are fighting for their lives. The armored knights seem to have tumbled into a corner of rural Pennsylvania from a movie set. The setting for *They Fought with Him on Foot More Than Three Hours . . .* (1917) is the same valley as in *The Fence Builders*. Here, however, is a different world altogether. There is freedom in the painter's hand, color on his palette. The foreground landscape, fully textured, is rendered without a sermon. Painted for its own sake, the rural pasture blazes with sinewy strokes of broken color. This countryside feels alive because something is at stake. Out of sheer artistic frustration, Wyeth has brought the heroic past crashing into the domestic present. Men in armor are fighting in the middle of a summery afternoon under a bright, mid-Atlantic sky. The counterpoint is what makes this valley vital. There is mutilation under these cottony white clouds, and the *sounds* of mutilation. No noble fence builder's tools here—these swords clash, draw blood.

Wyeth's illustrations make the viewer not only see and feel but also hear. For fifteen years the acoustics of memory had filled his recollections with train whistles, cowbells, South Street trees that had "dripped the water of a thousand rains," the slam of the screen door at his grandparents' house, and the chain on the front gate that his father looped over the post when leaving home each morning. Remembering the "even, dull staccato" of his Uncle Denys's footsteps, Wyeth savored the detail that "about every third or fourth" step came "a slight scuff."

Likewise in his illustrations, we "hear" the clatter of dishes and goblets breaking during a fight, coins falling on heaps, sand squeaking under the feet of the stretcher bearers carrying Captain Harding. In Wyeth's valley landscapes, nature is silent and uncorrupted, devoid of the motifs that twentieth-century illustration had popularized: the automobile and the airplane. Puritanically cleansed of such intrusions, a characteristic Wyeth landscape such as *Last of the Chestnuts* (1917) basks in a wished-for, Walden-like silence.

In illustration Wyeth put aside South Street pieties and Chadds Ford idealism and painted nature as he really saw it. His earliest westerns had documented the effects of sun, wind, dust, snow, and ice on the faces and bodies of men. His classic book illustrations went even further. From the icy nighttime seas of *Kidnapped* to the killer winds and rocky ledges of *The Sampo*, from the hard white dunes ("a Switzerland modeled in sand," wrote Jules Verne) of *The Mysterious Island* to the relentless beating of the sun in *Robinson Crusoe*, *The Courtship of Miles Standish*, and *The Oregon Trail*, Wyeth painted the elements to express the idea of sustained exposure. Not only exposure to obvious extremes (sun, snow) or to exotic perils (wild ani-

mals, cannibals) but also to time (fallen leaves form the imprisoning cocoon in *Rip Van Winkle*) and to the unforeseen terrors of nothingness.

Jules Verne's *Mysterious Island* castaways are carried in a balloon from Richmond, Virginia, in the last year of the Civil War to an island in the middle of nowhere. They are pictured under wide skies in *Marooned* (1918) and seem no longer present even to each other. Where their lives used to be, stand empty spaces: sea, sky, horizon. They are Zirngiebels, facing survival or extinction in a dangerous new time zone: they must colonize.

Nature in Wyeth's narrative paintings is violent and tender, very much like himself. Compare the studied poses of the three men in *Fence Builders* with the figures of the three men in *The Passing of Robin Hood* (1917). Not only is there always more at stake in Wyeth's narrative images but with Robin Hood and his men the artist separates himself from the material. In *The Fence Builders* he has too much to prove to too many rivals about the valley on which he has staked his professional aspirations. In *The Passing of Robin Hood* he is freer. Painting without considering painterly ambitions, he brings a startling, intimate scene to life. He underscores one of his favorite themes—life's impermanence—by taking the attention from the dying man and directing it to the more powerful struggle behind: two men watching a friend die. He subdues their clothing and weapons—their historicity—and emphasizes the commonplace form of hanging heads and heaving shoulders. He paints these faraway figures, as he put it, "in the light and air as you see and breathe it."

It was the discovery that would sustain his career. Book illustrators had always put the people and landscapes of literature into illustrations; N. C. Wyeth painted the people and landscapes of life—his own life—into books. He summed up his breakthrough in a letter to Frank Schoonover: "Whatever isn't contemporary in a picture is dead."

ON APRIL 6, 1917, the United States entered the war in Europe. By June every young man Wyeth knew had answered the draft call. When Pitt Fitzgerald tried to enlist in the army's new and experimental "camouflage" unit, Wyeth wrote to the War Department on his student's behalf. Privately, he admitted that it "disturbed me more than I imagined it would to see him go."

"Mothers are getting depressed everywhere over the draft bill," Hattie Wyeth said.

Meddling in Stimson Wyeth's foundering romance with a local girl that April, Hattie was having "a depressed spring." Later that month an explosion in an ammunition factory in Chester, Pennsylvania, not far from

They Fought with Him on Foot More Than Three Hours, Both Before Him and Behind Him, 1917

The Fence Builders, 1915

In the Fork, Like a Mastheaded Seaman, There Stood a Man in a Green Tabard, Spying Far and Wide, 1916

Robin Hood and His Companions Lend Aid to Will o' th' Green from Ambush, 1917

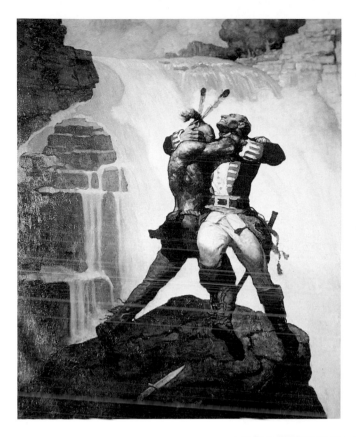

The Battle at Glens Falls, 1919

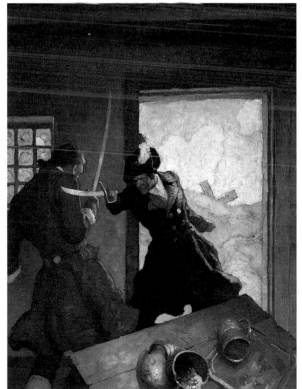

The Duel, 1924

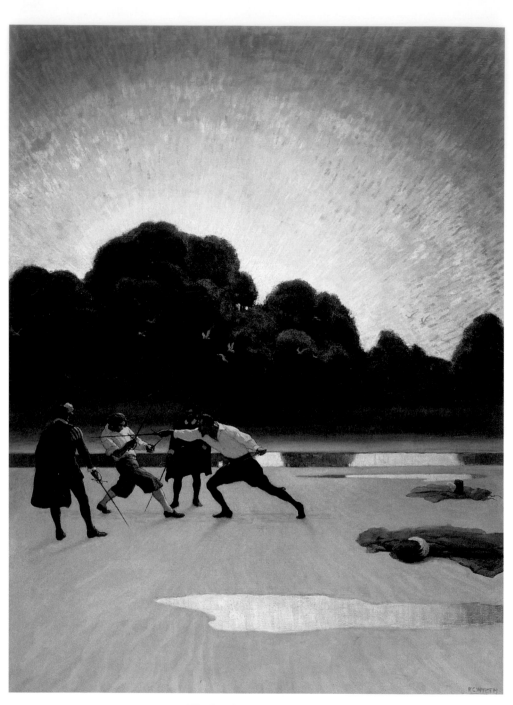

The Duel on the Beach, 1920

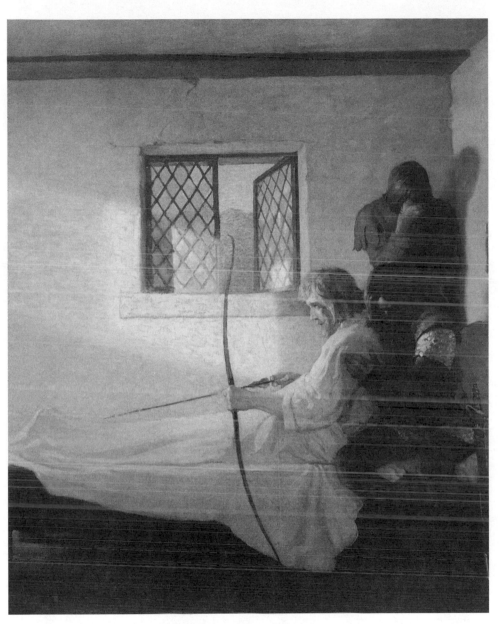

The Passing of Robin Hood, 1917.

Chadds Ford, brought her to the point of hysteria. Her brother Gig had taken a job as supervisor at the plant. Gig's wife, May, known for her morbid curiosity, had dispatched an exaggerated account of the explosion to Needham, tantalizing Hattie with "the terrible conditions of the city, with the dead and wounded."

Furious that his mother could be so easily swept up in war rumors, N.C. drove to Chester, investigated at the factory, then wrote Hattie the facts, which he had learned from one of Uncle Gig's co-workers. "You speak of Uncle Gig's 'escape' from the Chester explosion. He never in his life was in the building that blew up, nor within half a mile of it. He left the works several days before the accident." Admitting that he was the last person to object to an "intense" letter, N.C. upbraided Hattie for her "exaggerated attitude of blackness and misery toward events, even to the point of inventing excitement that never existed."

YET THE WAR, with its manias, threatened him, too. He found himself out of step with mass movement of any kind. Unmoved by Teddy Roosevelt's saber rattling, Wyeth did not at first rally behind the grand old flag. Parades, patriotic tunes, spy scares flew in the face of his bent for "things remote." He believed that he must keep himself in a "passive state of mind" if he was to succeed as a real painter. As requests for recruiting posters arrived from Washington, he chafed at the disruption in his work, taking time out from *King Arthur* to do his bit for the U.S. Navy publicity department: a six-by-ten-foot poster of an American Neptune protecting the freedom of the seas. Later that year he painted posters for the Red Cross but thought the results nauseating. "I'll be glad," he confessed, "when my share of this work is done."

On July 13 he was called to action. The War Department offered N. C. Wyeth a first lieutenant's commission. With the former newspaper artist Wallace Morgan, he was to report for duty as an official artist at the front.

He was flattered. Some of Wyeth's earliest boyhood drawings depict the events of a bellicose American Empire. In one picture he drew the U.S. warship *Maine*, sunk in Havana harbor. In another he cartooned Mrs. Dewey yanking the laureled Admiral Dewey from a pedestal inscribed THE NATION'S PRIDE. As a mature illustrator he had painted the bloodiest moments of Gettysburg. Here was his second chance to witness war in his own time—a new kind of war: total war. By spring 350,000 doughboys—the first of 2 million, the largest army ever to leave American shores—would be engaged on the Somme.

Honored, Wyeth was also disinclined to let Carol and the children live

NCW, 1916.

on $1,800 a year, the annual pay of a first lieutenant, which was luxurious compared with Allied officers' earnings or the dollar a day paid to American infantrymen. He announced, "I see no reason why I should go."

He took a realistic view of the stalemate on the Western Front. With Europe dug in from Switzerland to Flanders, immobilized on both sides, producing body counts in the millions, Wyeth recognized that even for a noncombatant the war would be a meat grinder. "Told them I thought 'twould save time if they would send me out to Armour's or Swift's in Chicago," he joked, adding, "I wouldn't mind a crack at a Boche or two, and would be tickled to death if I could disembowel their divine leader, but no war on canvas for me!"

He had been able to turn down Hearst because America was not yet at war. One might be surprised by this second refusal—the love of fighting informs so much of his work—except that Wyeth's life had taken another turn homeward. Two days earlier, upstairs at the Homestead, Carol had

gone into labor. Nancy Bockius was with her. Carol sent Nancy running to get Convers, who was up in his studio. Convers, in turn, dispatched Nancy to fetch Dr. Betts. Then, in the early hours of July 12, 1917, a boy was born in the northwest-corner bedroom. It was the easiest birth Carol had had; within a day she looked and felt better than after any of the other deliveries.

The baby weighed nine pounds, had sky blue eyes and a "gentle sweet nature." He was "built exactly like Papa," N.C. decided. He had Newell's broad back, high, square shoulders, and wide-set eyes. "Few babies measure up to what I admire in a child," N.C. had once observed. This baby had been born on the hundredth anniversary of Henry David Thoreau's birth, and from the moment he appeared, he more than measured up. They named him Andrew Newell Wyeth III.

Teutonic

AJOR GENERAL William Murray Black, the army's chief of
engineers, still needed artists to sketch the war for permanent
historical records. On December 12, 1917, General Black submit-
ted the names of four artists to Gen. John Joseph Pershing, leader of the
American Expeditionary Force (AEF) in France. N. C. Wyeth's name
headed the list. Of the four, among them Wyeth's old friend and rival Har-
vey Dunn, Wyeth was to be given the highest rank and salary, that of cap-
tain; the others were to be commissioned first lieutenants. By January 1918
Wyeth had been urged to report at once for this special duty abroad.

This time he felt he must go. Still he resisted. Why leave "this glorious
valley in exchange for the redder field of France"? It seemed foolish, danger-
ous. Who needed him more—General Pershing or Carol? The army or his
children? He decided to try a loophole. He would offer the War Depart-
ment "a way to send me and if I am needed bad enough they will meet my
arrangement and I'll go."

For starters he requested higher pay than a captain's salary, which he
considered paltry. Why should artists lend their services to the war for any
less than munitions makers? "They ask me to take my talent, my business
abroad for a mere pittance, and yet they would not think of requesting
Charlie Schwab to make quick guns for them for next to nothing, not even
one!"

The week he waited for the War Department's reply proved a "period of
real torture of mind to decide between *duty* and *duty*." He was merciless
with himself, vacillating wildly about the effect of the war on his painting.
On the one hand, he imagined that the "immensity of things" at the front
would so completely overwhelm him, he would be incapable of painting
"big stuff for some time after the excitement had subsided." On the other,
how could he turn away from all-out war?

Wyeth had a gift for painting the human figure in a death struggle.
Duel to the death is the constantly repeated theme of N. C. Wyeth's life and

work. Over and over again, at least once in each major set of pictures, Wyeth painted two men trying to finish each other off: *Captain Bones Routs Black Dog* (1911), *At the Cards in Cluny's Cage* (1913), *Captain Harding Slays a Convict* (1918), *The Battle at Glens Falls* (1919), *The Fight in the Forest* (1919), *The Duel on the Beach* (1920), *The Huron Flew Through the Air* (1925), *The Fight at Volusia* (1939)—dozens upon dozens of unresolved fights set in formally structured paintings. Without realizing it he was producing self-portraits. The extremist who never let himself be two things at once repeatedly expressed his conflicts in scenes of life-and-death combat.

In early February word came. The War Department would not accept his terms. They offered the standard captain's commission. With tremendous relief Wyeth refused, although he satisfied his conscience by once again appending "provisions" to his refusal.

Instead of recording the war for General Pershing and posterity, he painted himself. Turned three-quarters from his easel, Wyeth revealed himself in a weirdly carefree mood in *Self-Portrait, 1918*. The picture is a defiantly self-conscious image: *He* is going to be the subject of 1918.

He has painted himself into a studio where the shutters are closed, the world at bay. Behind his thick shoulders stands an immaculate canvas. Pulled tight over his skull is a green and red tasseled skating cap, knitted by his Swiss grandmother. The cap had first appeared in one of Convers Wyeth's earliest self-portraits, a pencil sketch of 1896, in which he portrayed himself, age fourteen, dressed for the Strenuous Life in the Nehoiden Woods. Hats with histories would recur in self-portraits: in 1928 a family top hat, in 1941 a slouch hat from his early days out west. For Wyeth, it was not enough to show himself as he was in the present; there must be something from the past, a costume, a disguise. Photographs of his father in the uniform of a Massachusetts militiaman preview what would become a multigenerational family tradition of dressing up for but not actually going to war.

He completed the painting on February 22 and immediately pronounced it a success. For once he was elated by what he had done. He felt sure that he had made a definitive statement. *Self-Portrait, 1918* demonstrated that he had now harnessed the "power to see things truthfully." But if this is truly Wyeth, then why was he, who has had such trouble satisfying himself, suddenly pleased? Why now, especially? The man who all his life had done his duty—at school, for his village, to his master—had done an about-face on his country.

By now the captain's commission that Wyeth had resisted had gone to his old rival, Harvey Dunn. In March 1918 Dunn left his wife and two children, pulled on a captain's cap, and embarked with a portable sketch box to

Self-Portrait, 1918.

the front. Dunn would depict the war as he saw it—"the shock and loss and bitterness and blood of it"—while Wyeth, in his noncombatant's Swiss cap, would see the war through the German in himself.

B UT THE WAR forced him into the public eye. He often said that nothing in the world was more painful to him than public speaking. Yet, as his daughter Ann later pointed out, "once he started, you couldn't stop him." At the "slightest contact with others" he became a madly effusive promoter, tossing his head, roaring "Bully!" Afterward he loathed himself. He considered himself "cursed" to have a "disposition for show" and preferred exaggerating the strengths of someone else.

On April 6 a noontime crowd some eight thousand strong assembled for the third Liberty Bond rally outside the U.S. Sub-Treasury Building in New York City. Below the speakers' platform men's hats filled Broad and Wall Streets. With no public address system, silent movie idols Charlie Chaplin and Douglas Fairbanks pantomimed their Liberty Bond pitch for

the audience. Then came Wyeth's turn; he would have to speak directly to the crowd.

After the unveiling of Henry Reuterdahl and N. C. Wyeth's *Over the Top* bond poster, a ninety-two-foot-long canvas stretched across the pediment of the building, the artist strode out under the huge bronze fingers of George Washington, lifted a megaphone to his lips, and spoke. In response, a sound like surf lifted from the packed street below. It set Wyeth "reeling." Afterward he called it the "most terrifying experience I ever went through." Two weeks later he was still "suffering from the feel of it."

THE WAR brought on spells of depression. Even a few years earlier N.C. had been able to call them "blue streaks" or "growing pains." Now he seldom went a season without an episode of black despair. Depressive moods usually followed a spell of concentrated work and lasted anywhere from six hours to several days. At such times he felt the "very piers and pillars of my life's work and ideals crumble to dust."

He hid his true condition from Carol and the children. Feeling an attack coming on, he would leave the house in the middle of whatever he was doing. His family scarcely knew what they were up against. " 'Oh, heavens,' we would say, 'Pa is very low this morning,' " Henriette recalled. "We would talk about it without any understanding of it at all. And when it was better, we'd say, 'He's recovered.' "

Camouflaged by "artistic temperament," quick anger lay just below the surface of his darker moods. When a neighbor criticized N.C. for overreacting to his children's health emergencies, he exploded. Another time he had a fistfight with "an ugly drunken Irish family," during which he was bitten by a sheepdog.

Nancy Bockius believed that N.C. would "never hurt a person, physically. But he could be scary. You could never tell what kind of mood he was in." Approaching the Wyeth Homestead on the road from the village, Nancy and her sister Elizabeth felt a sense of dread. "Going under the railroad bridge, we'd feel sort of sick, wondering what kind of mood he'd be in. We'd want to turn back."

As on South Street, homesickness gave a name to the problem, and home was seen as the cure. But N.C. now had two places he called home, and he began to run from one to the other.

In May 1918 his feelings of general hopelessness became excruciating. Consulting with Carol, he decided that the only solution would be to go to Needham for a visit. Dropping everything, he wired his parents and started from the Chadds Ford depot. As his train pulled out, a storm swept into the

valley. From his train window he caught sight of Carol and the children standing on Rocky Hill, forlornly waving handkerchiefs and tea towels. Had the train been going slower, he would have jumped off. He forced himself to stick it out and got as far as Philadelphia. Reversing the message to his parents, he took the next train back to Chadds Ford.

Like his mother he sought no help from physicians. He kept his torments in the family, realizing, even as he did, that Carol, "being very naturally sensitive to my state of mind," was "inevitably saddened by my own depressions."

"Carol led a kind of tense life because of Convers's moods," Nancy said.

Carol blamed herself for his unhappiness. Stuck with her own self-doubts, she gladly lived by Convers's extremes. She also blamed herself for the children's illnesses—a bad wife, she must therefore be a bad mother. If only she had been as devoted a mother as Mother Wyeth, perhaps she could have protected the children. In her sleep Carol fretted, talking aloud about sterilized bottles and nipples with the right-sized holes.

Having successfully weaned Andrew, she reveled in the praise N.C. passed on to his mother: "No wonder the children are such fine specimens of color, size, and temper. Their care seems to me perfect." But when Andrew lost weight, eight ounces in ten days, Carol reproached herself for mixing the wrong formula. As N.C. told his mother, "In all her eagerness to do just right, she slipped—her very *overeagerness* did it."

From 1917 to 1920 Carol almost never left the house. Once, on November 14, 1919, N.C. noted, "I've given Carol a day off." It was the first time she had been out of the house in two months. She took Henriette to Philadelphia for a winter coat.

Carol comforted herself with finery. Elegant things had given ballast to her unstable upbringing. She loved to open her linen closet and count her monogrammed bed linens. She seemed touchingly naïve as she ran the Homestead. "Nothing could be wrong," a grandchild would later recall. "Everything was always beautiful and very prim and proper."

During their courtship Convers had indulged Carol with grand gestures; he would still stay up all night to fill a room with flowers for her. But they rarely enjoyed themselves together; they had not taken an overnight trip away from home in six years. Inevitably, Carol's luxuries brought on Convers's stormy refrain, "Our home is too richly appointed with accessories that demand attentions which I should not divert from my work." If expenses kept up this way, he would have to go on illustrating the rest of his life, never to become the painter he felt he should be.

In the midst of N.C.'s severe depression of May 1918, Henriette wondered in her diary if she had the talent to become a professional singer. "If

I would and made lots of money I would support Mama and Papa. Papa could paint as many landscapes as he wanted and Mama have as many pretty things as *she* wanted."

THAT SPRING N.C. shifted the weight of his distress between Carol and his mother, testing to see who would console him more. With Carol's confidence diminishing, he decided that "those nearest to me are the least able to stand my outpourings when my feelings happen to be on the unpleasant side of things." Assured of his mother's "staunch" support, he wrote her when he was feeling blackest. Mama obliged, but her letters only partly satisfied him. He blamed her for one letter which "contained so much sympathy, so much understanding, until the last page, where you pretty nearly spoiled it all."

Hattie had waited until the last page to call his latest attack of depression mere "restlessness." She had said that she was sure it would "pass away as whims and fancies do, mostly."

Outraged that she had failed to take his mood seriously, he threw a tantrum. "No one in the world can know the gravity of situation I am in at the present moment," he told Mama. "Even Carol, whom I succeed in deceiving in this matter more than anyone else, for the reason that I love her so much, cannot penetrate the problem, for I have not let her, nor *you* even, see it, except in sporadic outbursts."

He carefully controlled the flow of emotion in the house. In March 1918 sad news reached Rocky Hill. Carol's father had died in England. The information came to N.C. on March 12, but he did not immediately share it with Carol. He was on his way to New York for several days to work on the *Over the Top* mural, and he left without telling Carol or her sister Ruth. He later explained that he "did not want them to suffer the pangs of intensified loneliness while I was away."

When he returned on March 14, he told Carol that her father was dead. Writing to his mother the next day, he admitted, "Even now I have not told them of the nature of their father's death." He then described for Mama "the blowing to pieces of Mr. Bockius last Saturday during an air raid on London."

The story passed immediately into fact. The Wilmington evening newspaper ran a brief, reverential obituary stating that George Bockius had died in London on March 11, "the victim of a German air raid."

Yet in truth, on March 11 no German zeppelins or "Giant" bombers had appeared over London. The British capital was bombarded twelve times by airship and nineteen times by airplane during the war. The air raid nearest

the date of George Bockius's death occurred four days earlier, on the clear, moonless night of March 7, when five German Giants penetrated London's air defenses, killing twenty-three people and injuring thirty-nine others. George Bockius could have been injured that night and died later, but his name appears in none of the casualty reports, and his last known address, No. 1 Kings Cross Road, was well clear of each bomb that fell that night.

He had died for other reasons. But at first the Bockiuses did not wish to know what those reasons were. As the facts of George Bockius's death would show, his family needed a story to explain their father's lifelong neglect.

ON SOUTH STREET, the observation of Swiss customs had taken on the embalmed look of waxworks tableaux. In 1916, when Convers's white-haired great-aunt Mrs. Heinrich Zeller Zollinger turned ninety-one, Holzers, Zellers, Zollingers, Zanggs, and Zirngiebels arranged themselves for a photograph in the Wyeths' Germanic Cottage. Henriette Zirngiebel's maid, Lena, and several of the other younger women wore full-scale dirndls. They sang Swiss and German folk songs. Then, all together, nine women in various forms of national costume turned to face the camera with "hearty" expressions. Hattie Wyeth captioned the photograph "A 91st Birthday in 'Switzerland.'"

It might as well have been. For Hattie it was always as if they had just arrived. She felt inferior in classically immigrant ways. She imagined that lack of education was "our failing." When her second son, Ed, had graduated from Harvard in 1907—the peak year of immigration at Ellis Island—he was anything but a newcomer, the *ninth* Wyeth since 1760 to earn a Harvard degree. His mother acted as if he were the first. On Class Day, when someone asked Hattie what the initials of Ed's degree stood for, she found she did not know. But instead of making light of the situation—after all: *B.A.S.?*—she felt ashamed and let her sense of shame carry the day. As soon as she learned the answer, she warned Convers and Nat and Stimson, "Don't be as stupid as I was." She rehearsed her sons to reply, "Bachelor of Agricultural Science," as if the family were learning the local language.

During the war she peppered her letters with sympathy for German friends. N.C. agreed that Germans deserved sympathy but warned her that "this Germany let loose today is *not* the Germany you know." He told her she was "wrong when you try to cover up their enormities by claiming like enormities in all wars." Yet six months later, with a book of old photographs in his lap, he joined her in dreaming the old Zirngiebel dream, projecting himself into images of a small, German town—Buigen on the Rhine—

terraced with tidy vineyards and fruit trees, crowned with an ancient castle. It seemed to N.C., "Sometime or other I must have lived over there."

He made a cult of his Teutonic ties, treating all things German as if they were supernatural phenomena. In October 1915, on a trip to New York to accept the commission for Mark Twain's posthumous novel, *The Mysterious Stranger*, he met a German immigrant on the train. The man told Wyeth the saga of his coming to America. Wyeth noticed that the German resembled his Swiss grandfather, but when it then turned out that the stranger had actually *known* Denys Zirngiebel in the flower business in Needham, the coincidence "infused [Wyeth] with an energy that comes as near being Holy as it is in my power to conceive."

Wyeth used *The Mysterious Stranger* as *his* German book. Twain's fable about man's moral sense was ready-made for him. It is set in Austria in 1590, in the village of Eseldorf. Like Hannibal, Missouri, and Needham, Massachusetts, Eseldorf is a world apart. It lives by its river and "drowse[s] in peace in the deep privacy of a hilly and woodsy solitude where news from the world hardly ever [comes] to disturb its dreams." Eseldorf is "a paradise for us boys," snow covered, untouched by evil—until Satan's nephew invades the idyll.

The mysterious stranger, known to the villagers as Philip Traum (*Traum*, in German, means "Dream"), functions as a Howard Pyle–like spell weaver. He illustrates the history of the world for the narrator, Theodor, and his friends. He also reads their minds, introduces them to feelings of rapture, to their own essential cruelty, and to their fates. Like Pyle, he knows the boys better than they know themselves. Traum demonstrates for Theodor that there is no advantage to choosing among "several possible careers" or even to altering the choices of a life. One must accept oneself. The fatal mistake is fighting oneself.

This Wyeth-like theme had been fully dramatized in early drafts of the novel, which were later dropped by Twain's literary executor in the rush to produce a posthumous illustrated volume for the 1916 Christmas book trade. In one earlier version Young Satan creates duplicate selves—"fleshed duplicates"—for the narrator and his friends. Each duplicate is so perfectly matched that when the original gets angry with his duplicate for being angry, the ensuing fight is always a draw.

Wyeth's canvases vibrate with the radiant remembered light of his Swiss childhood. He merged his Swiss-German cousins, the Holzers, with Twain's Eseldorf village boys. He kept his colors pure. Painting under the influence of Giovanni Segantini, he applied unmixed paint in ropy strands; when looking at the work from a distance, the eye mixes the adjacent colors. In Segantini's Alpine meadows, pure greens and scarlets mingle; the dense

weave of strokes makes the surface of the painting seem to jump. Woven of unmixed strands, the brilliant light in Wyeth's 1916 illustrations, including *Black Arrow* canvases like *"They Cannot Better Die . . . ,"* have the weight and plasticity of Segantini's mountain landscapes. Wyeth allayed his misgivings about depicting the supernatural events at the climax of *The Mysterious Stranger* by borrowing the effect of lighter-than-air figures from Segantini's *Punishment of Luxury* (1891) and *The Evil Mother* (1894).

Segantini represented the painter Wyeth believed his mother still wished him to be. A family man, a romantic figure, the large, powerful, barrel-chested Segantini had lost his own mother at a young age. Like Wyeth, he spent much of his adult life in "a constant and almost unbearable yearning" for the vanished world of his childhood. Even with four children of his own and an established studio in the country village of Maloja, Segantini kept searching in images of nature and of farm and village life for the lost paradise of childhood. In the first of three of his most ambitious paintings, *Birth* (1898), he rendered motherhood and nature inseparable, intertwining a mother's legs with the roots of a tree.

WHEREAS N.C. remained in Chadds Ford with Carol and the children, Stimson Wyeth had enlisted. On December 5, 1917, he applied for enlistment in the army's Twenty-third Engineers. He waited eight days before telephoning his parents in Needham to break the news. "There was little eaten at dinner on that day," Hattie recorded.

Her one hope was that Stimson's eyesight would keep him from the trenches. But the army's need for men who could speak French and German outweighed bad eyes. Stimson joined the Twenty-third Engineers at Fort Slocum as an interpreter. N.C. dreaded to think of his brother going to the front. On July 2, 1918, he wrote to the Military Intelligence Division at the War Department, suggesting that Stimson, with his command of German, French, and Spanish, would be of value in military intelligence. Within days, though, the army reversed the decision, and Stimson was relocated, on account of poor eyesight, to the quartermasters, the army department responsible for food, clothing, and equipment. Newell still hoped Stimson would distinguish himself in battle, but Hattie and N.C. were relieved that "Babe will not be allowed to face the Boche's bullets."

Still imagining Stimson capable of literary greatness, N.C. had exerted terrific pressure on his brother's postgraduate life. Four years earlier he had used his high standing with Scribners to get Stimson a job at the New York publishing house. But Stimson quietly sidestepped his famous brother's influence. He settled instead for a teaching position in the nearby suburban

Boston mill town of Stoughton. Starting in February 1914, at $600 a year, Stimson taught languages at the high school and lived at home with his mother and father. He took the same attitude toward teaching that Convers had taken toward illustration. Nothing more than a stepping-stone to his real—his higher—aspirations, it "may lead me eventually into something which will claim my interest more genuinely." Yet he must have been good at it: within thirteen months he was offered the position of principal. He was twenty-three.

If Stimson wrote to tell his oldest brother that he had been made principal of Stoughton High School, the letter does not survive. N.C. learned that his brother was principal from a local newspaper clipping Stimson stuffed in an envelope and mailed to him.

N.C.'s ferocious disapproval became clear on May 29, 1915, when, for the first time in thirteen years, he deliberately forgot Babe's birthday. In retaliation, Stimson refused all further communication. He felt "browbeaten" by N.C.'s expectations and constant harangues, and he fell into a silent fury. N.C. broke the deadlock, begging for a reconciliation. Admitting that his tendency to instruct could be "Germanic in its logic," he promised to restrain himself. He would do his best "not to let the dribblings of an agitated mind come to the surface and molest others." He recognized that his own wife and children "may be a little afraid of my 'insistent German ways' as Carol calls them."

THE NEWSPAPERS in the spring of 1918 were full of slaughter and spies. Photographs of an unsurvivable place called No Man's Land burst onto the kitchen table in new Sunday rotogravure sections. On South Street an article in *The Atlantic Monthly*—"Torpedoed!"—had ignited a siege of nerves.

Roused by war news, Hattie tried to soothe herself with letters. Her twice a week ramblings heaved with panic: bombs in boat holds, censored letters, torpedoed transports, poison gas. N.C. wondered that she could not see how impulsive she was being, whipping herself into a needless frenzy. The war would never touch American soil. He wished she was more like the sensible farm wife he had just depicted for Theodore Dreiser's "Rural America in War-Time," calmly standing by her farmer husband as she opened an envelope to read "the letter from Over There."

He begged Mama to see reason. Stimson, after all, was utterly out of danger. Babe was deployed to France with the quartermasters, then transferred to England with the AEF Student Detachment in March 1918. He attended classes at Cambridge University and lived with the family of the mayor of Cambridge.

N.C. remarked that Babe was "certainly in for distinctive experience in this war." He added that his brother "no doubt will comport himself as honorably with biscuits as he would otherwise with bullets."

The answer sizzled back from South Street. How could Convers be so unfeeling? Did he mean to minimize his brother's war service? If he planned to keep himself out of action, he had better not make fun of those who *had* answered the call. "I have a boy doing 'his bit,' doing a man's part," said Hattie, "and my heart is with him."

But on South Street the next day's mail brought no letter from Stimson. It was a sharp March day. Newell had left for Cambridge with the eggs. Hattie was alone, with only "a northeast storm to cheer me." She was apprehensive. A small steam engine had recently blown up in her brother Denys's face, injuring one eye and ending his farming days. No one was sure what would happen to the Zirngiebel house next door.

Furious that her eldest son no longer sympathized with her, she fired off another letter. "I'm not the strong-minded woman you think—weak, maybe I'll acknowledge." From now on, she vowed, she would try to be more careful in the phrasing of her letters, but after all, with a son like Convers, who refused to serve overseas, she couldn't expect to be understood. She hadn't carried on about spies and bombs out of maliciousness. She was reporting things as she saw them—"recounting my doings," she said. But maybe it was too much for Convers. He might not care anymore, but some people understood that a mother with a fighting son deserved sympathy. Why, even the newspapers "try to cheer us mothers."

N.C. wrote a twenty-one-page essay about the thousands of letters they had exchanged since he had left home in 1902. He had saved every one of hers. She had been the one true confidante of his life. His "most virile thoughts" had gone to her first, and "in the majority of cases, to [her] *only.*" Despite what she had said about her weaknesses, she remained "the *one* who offers me the most fertile mind as an audience." He too felt isolated. He too felt deprived of intimacy. "To me, that is the one terrifying lack I feel amongst my contemporaries and younger—that lack of *personal* relations."

Their correspondence had been his salvation, not so much in spite of, but because of, "its painful moments," and if his last letter was "apparently the cause of some more of them," he knew "of nothing that would hit me harder than to think I must stop off my real thoughts to you for the sake of family diplomacy."

She let the weekend pass before answering. It now looked as if Denys would sell the family homestead. She felt sad that her brother would no longer poke around the old property—"he sort of filled Grandpapa's place." No one except Stimson had substituted for Convers. She often thought that

after living apart for what felt to her like twenty years, she and Convers had been "left to grope around almost." With Convers gone she had been "spoiled in a way with Babe." Stimson, she wrote, "felt what I *had* to say." She could tell Stimson her innermost thoughts. But he had shipped out for France, leaving her with a sensation of coldness pressing down on her chest.

It had been the *Atlantic Monthly* article, she now realized. When she had finished "Torpedoed!" a nervous chill had run through her and she had decided once and for all to give up reading "accounts of terrors." But on February 7 she had glanced at the newspaper. A troop transport had been sunk. The image of Babe drowning consumed her. Nothing could make her believe that Stimson was not on that torpedoed transport.

The young man killed in the *Atlantic* article, known only as E——, had been the last of three brothers. By his mother's account, he had been taken out of the trenches and given a "safe" job at the base, sent home by passenger ship "so that one of her boys might be spared to the bereaved mother." And yet, as the story stressed, *even so the Fates had followed him!* With a "lovable habit of mothering people," the young man had lingered too long trying to save others—he had gone down with the ship.

Hattie was sure that *her* son was fated to die that way. Even when a printed card arrived in Chadds Ford on August 12, 1918, signed by Stimson, THE SHIP ON WHICH I SAILED HAS ARRIVED SAFELY OVERSEAS, she went on nursing herself with a South Street ritual. Every morning she filled a vase with pansies and a Swiss flag and set this tribute before herself in the kitchen "in memory of Babe."

It took the Atlantic Ocean and a world war to separate Hattie Wyeth from Stimson. For N.C., his brother's absence revealed the truth about Mama.

Death by Misadventure

THE WAR BECKONED a fourth and last time in September 1918. The American Red Cross wanted N. C. Wyeth overseas to sketch refugees and maimed and blinded soldiers. The job would take a few months that fall and put him at considerably less risk than the other commissions he had been offered. It was the best chance he would have to witness the war; he knew he must go.

He discussed the opportunity with Carol and with his mother. Both agreed that it was his decision and resigned themselves to his departure. Carol insisted: if he felt it was vital to him as an artist, he must not hesitate on her account.

Undecided, he walked out to Sugar Loaf on a cool evening. He climbed to the top of the hill and sat down, wrapping himself in a blanket as night came on.

Suppose he went to France. Imagine that he saw with his own eyes the crack up of civilization. How different the world would look to him in the years ahead. How much he would learn about himself. He recognized that a glimpse of the Great War would help "not only to meet the demands in the field of illustration for the coming years, but to get that *something* into my blood which all vital painters of this generation will have to have."

Yet he was unwilling to go. When he looked back on another turning point of his life—his decision to leave home at age twenty—it appeared wrong. He believed that by separating himself from Needham he had contaminated what was good and pure in himself. In his "eagerness to achieve" as an illustrator, he had "lurched into a new country," where he had "forsaken the intimate relationships" and "sacred associations" that would have brought proportion to his life as a painter.

He vowed not to lose his family—and therefore himself—again. Fatherhood, he believed, was the source of his most significant feelings. "My art," he wrote, "vanishes into the merest speck when suffered comparison to the one Divine and tangible sensation bequeathed to us: parent to child, child to parent."

To N.C., Carol's father seemed contemptible. George Bockius had run off to England, deserting his wife and ten children. After liquidating the family leather business in 1910, George had absconded with what little cash remained and, with a mistress in tow, sailed for London. Over the next seven years, the Bockiuses "had to figure out how to justify their father leaving the family, which was a big humiliation in Wilmington in those days," Carol's nephew Larry Bockius later said.

These facts were known to the family: George's father—Carol's grandfather George Bockius II (1820–1870)—had been a friend and campaign contributor to President James Buchanan, his fellow Pennsylvanian and Anglophile. Offered the post of minister to England in 1857, Bockius had been unable to accept. His three-year-old daughter, Maria, was too sick to make the trip to London. He refused the appointment to the Court of St. James's. Maria died a year later, and George Bockius III—Carol's father, four at the time—grew up embittered over the lost embassy. "He wanted to be an English gentleman," said Larry Bockius, "and he always felt that the family had missed its chance for glory: they should have proceeded to London and been presented to the Queen."

Now he went, settling first in the London suburb of Warrington. He dressed the part of a gentleman, with a tall beaver hat and walking stick. Later he moved into London, to No. 1 Kings Cross Road. At some point the money ran out. When news of George Bockius's death reached Chadds Ford, N.C. invented the story about an air raid blowing her father "to pieces" in order to protect Carol. It remains unclear whether N.C. knew the truth about George Bockius's death, but having succeeded in cushioning Carol with the air-raid story, he stuck to it and passed the fabrication on to his children.

Previously unexamined records in London show that a coroner's inquest was held on March 14, 1918. It revealed that George Bockius killed himself. Bockius had been dead for an unknown period of time before his body was found in his flat on March 10. The cause of death was "carbon monoxide poisoning from inhalation of coal gas which issued from a gas bracket in his bedroom." England forgave George Bockius his suicide. The coroner listed it as an accident, a "death by misadventure."

N.C.'s OWN FATHER had reached the age of sixty-five. Diminished in stature, with stooped shoulders and a droopy mustache, Newell looked milder, more taciturn than ever. As seen by N.C., however, Newell was still an exemplary self-made man.

Fifteen years earlier, comparing his own fast rise in picture making with his father's slow and steady advancement, Convers had felt "small." Newell

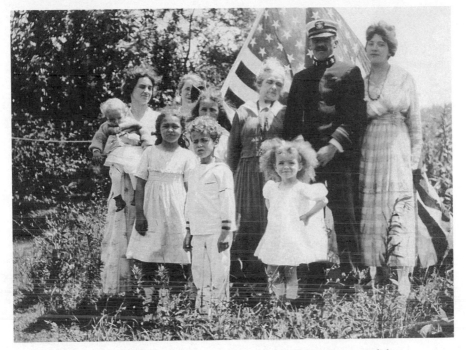

July 4, 1918. Carol, with Andy in her arms; Carolyn, Nat, and Ann.
Nancy Bockius stands behind Henriette and the flag. Carol's mother,
Annie, with Ruth Bockius (far right) and Richard Bockius. After being
torpedoed and sunk on the oil tanker *Orleans,* Richard had emerged a
navy war hero. At the time of this photograph, he was posing for NCW
as Captain Harding in Jules Verne's *Mysterious Island.*

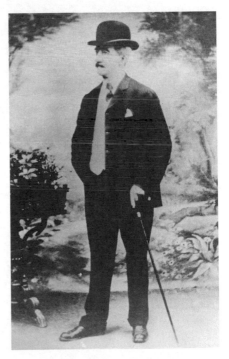

George Bockius, London, 1917.

had slaved for his family in a virtuous, dead-end job in the city. Convers, by choosing a more self-centered, profitable profession, felt inferior to the man who had sacrificed for him. Painting pictures was something to be ashamed of. When Newell at last retired in 1913 to raise chickens on South Street, the relief for N.C. was immense. "I dream incessantly of Papa at home," he wrote. "I feel a happiness about it so acute as to almost make me cry sometimes."

He still thought he owed his father a debt. He assumed that Newell would prefer to dress every morning in overalls, stay in Needham, and spend his life in the country as a farmer. In actuality Newell had long ago given up dreams of farming to join the economic revolution of his time: the transformation of agrarian America into an urban market economy. Hattie may have been justified when she accused Newell of being slavish; she wrote about the way he "still leaves home to go to the city (he so dislikes) always with the same thought that the boys [must be provided for]." And Convers might guiltily chime in with his refrain, "I hope soon you'll not have to go in town at all." Indeed, all through his twenties, Convers had devoted himself to the goal of "liberating Papa from the city." At the age of twenty-nine, after a two-day visit to 284 South Street, Convers sent his father a check to cover "board," adding, "I wish I could send fifty times the amount every six months, and see you constantly tending to your cow, chickens and garden."

But Newell needed the city and the escape it offered as much as Convers needed the myth of his father's sacrifice in order to cover his mother's flaws. Convers claimed that Newell's continual absence was the "one drawback" in an otherwise perfect childhood on South Street. In reality, Newell's seven-day-a-week withdrawal from the house was rooted as much in Hattie's emotional instability as in the family's financial needs. In 1911, the first year Newell could have afforded to stay at home, he instead dressed for work as usual—suit, tie, watchfob—setting off each morning for the ten-to-six train. Convers would be stunned to discover that his father actually "*enjoy[ed]*" those jolting, stuffy cars with their inevitable loads of miserable inhabitants."

Now that N.C. was a father as well as an artist, he was torn by the idea that to achieve an important body of work, he must put art ahead of his family. It seemed to him senseless to "shatter the actuality of family unity for any calling whatsoever." Art made him feel selfish. "The true artist," he contended, "must accept the responsibility of married life and a family." The superior man, he believed, must sacrifice for his children.

Buying his children beautiful toys had always comforted him. On one visit to the Homestead, Joe Chapin remarked that he had never seen so

many toys assembled in one place "outside of Schwartz's store." Another frequent visitor recalled that Andy was "absolutely choked with toys as a little boy." Paying his parents' monthly bills satisfied N.C., too. With Newell retired "to the farm," the elder Wyeths were hard-pressed for cash. Nat Wyeth had suggested that Newell take out a mortgage on the South Street property; the mortgage would put some interest-bearing capital in the bank, and the four Wyeth sons would split the monthly payments. But Newell refused. N.C. began sending a monthly check to help with South Street property taxes. In 1925, straining his own finances, he loaned Newell $3,600. No matter how N.C. prospered, no matter what sacrifices he made, he found ways to imagine his father in a superior position.

HE STAYED OUT on Sugar Loaf all night. When the sky lightened, he walked, bleary-eyed, back across the valley. Mist hung in the meadows. As he approached Rocky Hill, the solid shape of the red-brick Homestead appeared under the green trees.

Four years earlier, when there had been three children, he began to sense the influence that Henriette, Carolyn, and Nat would eventually have on him. He could not foresee the sense of completion and fulfillment that Ann and Andy—the "youngers," they were called—would bring to the family. Yet even in 1914 N.C. had predicted, "My life will go over to them completely sometime, and then I won't waste time trying to become a *bigger and bigger* artist."

This was the morning he surrendered himself. The sacrifices of fatherhood—the chance to put his children before himself—would from now on fulfill him in ways that apprenticeship and friendship and marriage had not. As he climbed the hill and saw the house he had built, the apple orchard he had planted, and the studio looming over all, the "decision came." Within thirty minutes he had replied to the Red Cross.

It would be the decision of his life. In September, Wyeth would tell Joe Chapin that his reasons for staying home from the war were personal, not isolationist or antiwar or even financial. "It was not the Red Cross's fault," he asserted, "but the overwhelming feeling in regard to my family." Trusting his mother to find virtue in his decision, N.C. revealed as much to Hattie: "In the last analysis, my feelings of sentiment toward the family overwhelmed me."

Until September 1918 he had thought of his susceptibility to "feelings of sentiment" as his great strength as a man and as an artist. After 1918 nostalgia was gone. The war, the magnitude of it, the insanity of it, stripped the very meaning from a word like *sentiment*.

Andy Wyeth, 1923.
"How's old Skinny?"
NCW wrote on a
postcard. "I'll be
home to tickle you
Sunday."

Ann Wyeth, c. 1917.

He wanted his abstention from the war to be valid on aesthetic grounds, however. For years after 1918, and especially in 1921, when an important mural commission in Washington, D.C., fell through because N. C. Wyeth had not been Over There, he argued that the greatest war memorials had been created by artists with limited experience of war. He offered as proof Augustus Saint-Gaudens and the Shaw Memorial on Boston Common.

He was unable to see that he had narrowed himself in 1918. He believed that he was enlarging himself through his children. The youngest would come to recognize that their father's sacrifices were self-destructive. Devotion drained N.C. The cost to his work was irreparable. "We kids slowed him down," Andrew Wyeth later insisted. "We got a lot from him, and it was his great willingness to do it—to give and give and give. But I don't think it was worth it. I wish it had gone into his painting. You've got to be selfish to paint."

Carol had known it for years. Her husband's absorption of himself in others was beyond his control. "I tell him he is too obliging and thinks of me too much, but he says he is born that way," she observed in 1910. Carol was sure that the daily demands of child rearing had kept Convers from his real work.

HE NEVER WENT to Europe, in war or in peace. N. C. Wyeth had no use for a U.S. passport. In his entire life he did not leave the United States. During his second trip out west in 1906, he had written to Carol, "I'm afraid I was never a born traveler because I'm so homesick." He was the kind of traveler who discovers that "it was worth the while to go just to *come back*."

The longer he lived in the valley of the Brandywine, the harder it became to separate himself from Carol and the children, even for a few days on business. Panic accompanied his departures from Chadds Ford. In 1920 when he traveled to Jefferson City, Missouri, to paint Civil War murals in the State Capitol, he suffered a Swiss soldier's sense of doom, as if he might blow away and die out there in the open, empty spaces away from home.

With the Armistice of November 1918, he found himself "not as ecstatically happy" as he had thought he would be. "The strain of the past year looms up and one feels more than ever the responsibilities in life particularly to do with the rearing of children." He was relieved that the slaughter had stopped and grateful that his brothers were coming home—Nat, stationed in Paris, had served without rank as an engineer for the army. But N.C. took no satisfaction from the Allied victory. Reports of peace competed with the personal news that Ann had "just [woken] up after a long nap from *1:30* to *4:30*!"

N.C. pleased his lofty-minded self by refusing William Randolph Hearst one last time ("I lost a $2,700 job but saved my soul!") and by forcing Houghton Mifflin to give him carte blanche in illustrating Thoreau's journals. At a time when Thoreau was viewed as an amateur naturalist, his journals mere catalogs of grasses, Wyeth delighted in persuading Boston editors to take the Concord author seriously as a philosopher and moralist.

On January 6, 1919, the other moral superman of his life gave up the fight. The Great Roosevelt, as N.C. still called him, had succumbed to heart disease at Sagamore Hill. For N.C. it was "a calamity," equivalent to losing a father, and he took the loss personally.

With Roosevelt gone the centuries no longer felt connected. "The last rags of the old puritan standards in which good was white and bad was black went under in the war," wrote John Dos Passos.

Thrown out of step, N.C. groped forward. Big-Stick America was dead. The codes of puritanical South Street were unrealistic in the new age. Pursuit of the ideal was giving way to pursuit of the dollar. The World Series could be "fixed." For the first time ever, a letter N.C. posted to Needham was lost by the U.S. mail. In New York the express companies Wyeth regularly used to ship canvases were often on strike. Henriette warned in her diary: "America helped with the war—won it, in fact. But there are big problems ahead of us with Bolsheviks."

For Wyeth the artist it was a problem of sight. He had not seen the war that was shaping the modern eye. For *Pictorial Review*'s "Series of War Paintings," he still painted with the palette of *The Boy's King Arthur*. Framed by pink clouds, his images of modern combat—stereotypical American doughboys charging with fixed bayonets at Cantigny and Bois de Belleau—told only the old story of fleecy romance.

Wyeth's student Pitt Fitzgerald was back from the Western Front, suffering a new nervous disorder called shell shock. Fitzgerald had seen some of the worst fighting at Château-Thierry and the Argonne, and the memory of it was intolerable. Unable to function, he broke his engagement to Ruth Bockius. He had a complete mental collapse and withdrew to a sanitorium, while Ruth, "slowly mending," took refuge with Mama Wyeth in Needham.

Wyeth did not—could not—understand. To him the terminology was meaningless. What was "shell shock" when, as far as he was concerned, Fitzgerald possessed all "the qualifications that [Wyeth had] always admired"? Surely Fitzgerald was of sound mind—"aggravated no doubt by depression, but sane nevertheless." Wyeth could comprehend depression, as he knew it in himself, but when Fitzgerald hospitalized himself, Wyeth took it personally. He had counted on Fitzgerald "as upon a brother." He denied that the old standards might not apply. For the very token that

Wyeth most wanted from his "brother"—a show of feeling—was precisely what the emotionally spent veteran of the Great War could not give.

Declaring that Fitzgerald had "broken [his] whole faith in young men," Wyeth acted as if he were the disillusioned one. Vowing never to take another student into his studio, he wrote, "I do wonder why I've been singled out to suffer so with young fellows whom I have tried, deeply, to help so much."

When Cpl. Stimson Wyeth returned from France, N.C. put aside their misunderstandings and once more treated Babe as his hero. All flags flying, he wildly inflated his brother's war record while praising his "extraordinary sensitiveness, his genuine nobility, his rugged and stimulating masculinity."

But the war had profoundly disturbed Stimson Wyeth, and as Babe took refuge once more at 284 South Street, N.C. wrote his brother seemingly sympathetic letters spelling out the ambitions he should have, the choices he should make, the "creative expression" he should now take up. Intended as pep talks, the letters were boorish manifestos, so out of touch with Stimson's real accomplishments and mental suffering they could not help but undermine what little confidence he retained.

N.C.'s postwar instructions to Stimson completely disregarded the real extent of his dependence on their mother. N.C. took no account of Mama's death grip on Babe. Stimson would later reveal to his Harvard classmates that "in the peculiar state of my mind for nearly two years after my discharge from the Army, I could not seem to adjust myself in any permanent way to any sort of work, except strictly out-of-door work, on the farm about home."

That summer of 1919 N.C. was home in Needham, painting James Fenimore Cooper's *Last of the Mohicans.* In late August a labor strike shut down the express companies in Massachusetts. Scribners had been badgering Wyeth to stay on deadline. There was nothing to do but drive the last five canvases down to New York himself. When he arrived in the city, a shock awaited him. To stay on schedule, Scribners had sacrificed the quality of the engraving of his first twelve paintings. The proofs were *"terrible failures."* They bore "very slight resemblance to the original canvasses."

Wyeth had taken great care with *The Last of the Mohicans.* Out of his own pocket he paid for two research trips to Glens Falls, New York, and the Lake George country, cooking his supper over a fire in a cave. The second trip prompted him to scrape and repaint ten of the canvases for greater atmospheric verisimilitude. Through the summer he had worked seven days a week for eight weeks to finish the set. He beat the deadline. It was his longest sustained period of concentration on a single set of pictures since *Treasure Island,* and the work showed it. His color—and therefore his

light—had a new brilliance and subtlety, especially in the variety of blue: from turquoise through cobalt and midnight blue to violet.

The trouble, in part, was the letterpress technology. The same three colors of ink—red, blue, and yellow—had to be used to print the broad range of color in seventeen N. C. Wyeth canvases. The thin glaze of turquoise reflection on a lake, the dark violet of cloud shadow on a mountainside, the opaque cobalt and velvety midnight blue of several Adirondacks skies: all had to be evoked with a single kind of blue ink, which could be deepened or lightened depending on the inclusion or reduction of the red, yellow, or black inks.

Wyeth stayed in New York several days, working with the engravers, who, having just been on strike, were in no mood for meddling from a perfectionist. When Wyeth fumed and raged, the local union ordered him out of the print shop; when he refused to go, a gang of men threw him out.

Back in Chadds Ford he resolved to forget the botched images. For the next six weeks, however, he brooded over the disaster, convinced that "the appearance of this book is bound to bring vigorous condemnation from my friends." The color in the first copies would appear faintly recognizable, but anyone who bought a copy from the end of the print run would find color that was muddy, blurred, out of register.

Not willing to stand by the work, Wyeth personally warned two large book dealers in Philadelphia, Wanamaker's and Campions, about the poor workmanship of the new Scribners classic; both firms cut their orders by half and spread the warning.

The real trouble was the prestige of the series. Scribners was coasting—on N. C. Wyeth's name, among others'. They were guaranteed a regular number of annual sales and did not have to improve workmanship to attract buyers. If thousands of people bought Wyeth editions every year regardless of color quality, why use a better, more expensive process of reproduction?

Scribners had also begun to fail Wyeth in quantity. Each of the Wyeth editions first appeared with fourteen color pictures, plus a cover image, matching endpapers, and a title-page cameo with scrolled-edge banderoles left blank for the printed title—seventeen images in all. To save money in later editions and reprints, the publisher routinely omitted as many as five of the color pictures from Wyeth's careful arrangement. Without notifying the reader, Scribners charged the price of a fourteen-picture edition for a nine-picture edition.

Until now Wyeth and Scribners had produced the Illustrated Classics without a formal contract. Wyeth had received a flat fee for each set of pictures, with no royalties. He sometimes shared in the proceeds from sales of the original canvases. Scribners was unusually generous to Wyeth; of the 261

pictures the artist had produced for *Scribner's Magazine* and the Illustrated Classics before 1919, 116 had been sold to collectors on a shared basis, 75 had been returned to the artist, 65 had been retained by the firm, and 5 had been destroyed or damaged. Yet since the start of the Illustrated Classics, Wyeth's highest payment—$3,500 for *The Last of the Mohicans*—represented only a 40 percent increase over eight years of work. For a number of reasons, however, he thrived under Scribners patronage.

To the son of Newell Wyeth, financial insecurity was paralyzing. "If I worry in the least about bills I cannot do a thing," N.C. once said. Before starting work he had to know where his next job was coming from. Every January, regular as clockwork, Joe Chapin proposed the next title in the series. The dependable supply of classics anchored Wyeth without binding him; and now, as popular literary culture turned to new subject matter, Wyeth more than ever relied on Scribners for *his* kind of story: the old-fashioned masculine adventure tale.

The Great War had created a new taste for sensation. Without torpedoed ships and body counts to satiate consumers, an expanding entertainment industry was turning to scandal, kidnappings, gangsters, sports heroes, and movie idols. Wyeth feared that in publishing a "shallowing process" had begun. In the surviving "Big Three" magazines of his youth, photography had supplanted drawing as the preferred medium. Painted illustrations, or "pictured pages" as Wyeth still called them, were no longer the only way to convey the world of the twentieth century, and photographic portraiture was now old enough to provide images of the past.

Literary tastes were also changing. The all-male adventure story by Stevenson or Kipling dropped from serious literary consideration in the aftermath of the war. A younger generation, represented by the new Scribner authors F. Scott Fitzgerald and Ernest Hemingway, had come of age "to find all gods dead, all wars fought, all faiths in man shaken."

Scribners allowed Wyeth to pick and choose among the classics. As early as 1912, following the success of *Treasure Island*, he campaigned for titles with a "deeper purpose and a more individual impulse." Knowing that he first had to "find something that echoe[d] within [him]," Wyeth put *Kidnapped* before a volume of retold Finnish legends, preferred Jules Verne's *Mysterious Island* (with its practical hero, the Wyeth-like American engineer Captain Harding) to his *Thousand Leagues Under the Sea* (with its supernatural hero, Captain Nemo), and rejected a title sent him by Scribners' editor Maxwell Perkins on the ground that *Gulliver's Travels* left him cold.

There was no doubt, however, that Wyeth enjoyed the prominence of Charles Scribner's Sons. He liked the association with the publisher of

Theodore Roosevelt, Henry James, Edith Wharton, and John Galsworthy. In return for Wyeth's loyalty—he routinely turned away offers on books that would compete with the Scribners Classics—the publisher gave him a preferred place in the house as well as in its showcase magazine.

Yet even as he recognized that Scribners had been "getting the very best of [his] work very cheaply," it was the cheapness of payment that ensured the excellence of the work. Wyeth felt most comfortable when undervalued. As squeamish about payment as he was about praise, he routinely secured commissions without rigorous negotiation. "*Contracts,*" he emphasized in 1916, "are a blight on my ardor, and turn me into too much of a machine." Working without a contract was his way of controlling expectations. The 1918 in-house memoranda of Houghton Mifflin reveal, for example, the editors' continual surprise and delight at "Mr. Wyeth's omission of the mention of money."

But 1918 was also the turning point in his relations with Scribners. "I really lost money on *The Mysterious Island* work and Scribners have *got* to come across with more next year," he decided that December. When the David McKay Company offered him *Rip Van Winkle* with his originals back, and then the Cosmopolitan Book Company asked for *Robinson Crusoe* with an advance on royalties plus originals back, he realized that he had been given "a club to hold over the Scribner Co."

For the first time in his career he was not afraid to use it. He worried, of course, how Joe Chapin would react. He felt guilty for being disloyal. But after the ruin of *The Last of the Mohicans,* Wyeth at last took a stand.

Writing to Chapin, he explained that with magazines now willing to pay him $500 per picture, and advertisers handing out $1,500 for a single, hastily done canvas, and four different book publishers offering as much as $7,000 plus originals back—proposing that they "tie up" N. C. Wyeth to paint the sea stories of Joseph Conrad—he could no longer afford to confine himself to one Scribners title a year. He warned, too, that Scribners' economies would kill the goose laying the golden eggs, and after emphasizing, "the Cooper plates almost make me sick and I have not yet thrown off the gloom when I think of that book appearing," he could not resist softening his aggressive letter by taking the blame himself. "In no sense do I blame you for the poor results," he told Chapin, "but am exasperated beyond measure at my own inability in not getting the pictures to you weeks before I did."

He demanded three concessions: the return of all his originals, the freedom to take on one other illustrated classic each year for another publisher, and unless guaranteed better results, he would not accept the commission for *Westward Ho!,* Scribners' Illustrated Classic for 1920.

The publisher reacted swiftly, agreeing to Wyeth's requests and promising at once to make new plates for four of the *Mohicans* originals and to spend money to rework the color on the entire set from the existing plates.

The "Crisis," as he came to call it, resolved in his favor, though as always he gave away as much as he received. In December, while Wyeth was spending the day in New York with Chapin, Arthur Scribner made a point of asking to see the illustrator. The younger brother of Scribners' president Charles Scribner II, Arthur Scribner explained that the company would be glad to pay a higher fee for *Westward Ho!*—Wyeth had only to ask. Wyeth did not ask. As a matter of principle, he declined to "take advantage" of Arthur Scribner and accepted the same fee for *Westward Ho!*—$3,500—that he had taken for *Last of the Mohicans*.

ONE SUNDAY, he looked up from the midday meal to see a preposterously long and elegant town car pulling up outside his door. Inside sat Joseph Hergesheimer, the newly celebrated novelist who lived nearby and had become friendly with the Wyeths. Hergesheimer alighted to announce that he had driven Lillian Gish over in his new automobile. Could Miss Gish say hello? N.C. rushed to find some shoes. He could not receive a moving-picture actress, the star of D. W. Griffith's *Birth of a Nation*, in his stocking feet.

Another day Hergesheimer brought the author of *The Great Gatsby* to meet his fellow Scribners loyalist. Scott and Zelda Fitzgerald had moved to a Wilmington estate called Ellerslie. The Fitzgeralds and the Wyeths had Wilmington friends in common, Judge John Biggs and his wife, Anna. At the Homestead they all made a "large evening" of it and repeated the party several times. As the Fitzgeralds left the Homestead after one of these boozy nights, Zelda declared that their car needed "a washing," and, as legend would tell it, she ran it over the riverbank and into the Brandywine.

The Jazz Age had come to Chadds Ford. The tempo of the new decade eluded N.C. Everyone was in a hurry. Modern life had a snappy, sassy edge. People spoke in wisecracks. N.C. did not have a zinger in him. His humor depended on overstatement, repetition, the naughty prank. He liked to wave the fumes of Limburger cheese under a sleeping person's nose, then shake with silent laughter at the contortions on his victim's face.

The world had turned fast, loose, promiscuous. Men flew. Women flew. Architects sent steel towers soaring into the sky. N.C. remained right where he was, earnest, stern, incorruptible, and permanently sentimental. When two-year-old Andrew sang the Marseillaise, N.C. wept. The aspirations of the last century—solemnity, grandeur in nature—impressed him so much

more than sophistication and skyscrapers. In a decade that worshiped the air, he refused to fly. "I love to see things unchanged," he said. In 1927, when Capt. Charles A. Lindbergh "did it"—flying solo nonstop across the Atlantic—N.C. saw the young aviator's feat as a lesson in modesty. He never rode in an airplane. Until the day he died trains defined his sense of time and space.

Pictures, too, were now in motion. The movies fascinated—and alarmed—N.C. He fretted that magazine publishers were "trying to do the impossible," expecting the picture on the page to behave like the picture on the screen. But Hollywood was still in debt to painting for pictorial standards, and when the great silent filmmaker Maurice Tourneur, who had been a painter, released *The Last of the Mohicans* in December 1920, N.C. was flattered to see that Tourneur, his assistant director Clarence Brown, and the highly regarded art director Ben Carré had "very obviously followed my pictures with marked fidelity, even to the selection of facial characteristics and certain poses and postures I represented. At times I felt as though some of my pictures had suddenly come to life. The sensation was singular indeed."

He would not be lured, however. As the 1920s went by, Wyeth refused offers to work in Hollywood, repeatedly turning down Douglas Fairbanks's and Mary Pickford's enticements to direct pirate pictures. In 1926, drawn into one deal as assistant director, Wyeth got so nervous he bolted the room.*

While the rest of the country rushed forward, N.C. longed for the world of his childhood. His letters were redolent of the passing age of morality. His slang savored of his youthful trips to the Old West. He went on exclaiming "My gorry!" and calling food "grub." Something wonderful was still "a corker." Radio broadcasts invaded the Big Room at the Homestead, but to N.C. the word *broadcast* would always mean the method by which his grandfather Zirngiebel had sown pansy seed in August. Called on to write an illustrator's preface, he laced his prose with antiquated adverbs, "Verily" and "mayhap." Between 1918 and 1921, the underlined word *sacred* appears in his letters as often as that other High Victorian shibboleth, *home*.

N.C.'s letters from the first two decades of the century are tainted by popular racist views. In the 1920s he fell for inflammatory polemics like

*Even when talking pictures came in, Wyeth's illustrations went on being models for Hollywood directors. After seeing a private screening of Metro-Goldwyn-Mayer's production of *The Yearling,* the author, Marjorie Kinnan Rawlings, reported that "they copied *exactly* several of his *Yearling* paintings. That is, as exactly as physical 'properties' and human beings could copy the greater art of his brush."

Penny Tells the Story of the Bear Fight, 1939. Illustration from Marjorie Kinnan Rawlings's *The Yearling*.

Movie still from Clarence Brown's *The Yearling*, M-G-M, 1946. Brown faithfully reproduced in scenes no fewer than eight of NCW's fifteen original pictures, "and they were the highlights of the film," wrote Rawlings.

Madison Grant's *Passing of the Great Race*. He heartily agreed that Nordics, as the superior race, would be "utterly submerged" if they did not guard against their "inferiors"; and, like Scott Fitzgerald's Jazz Age reactionary, Tom Buchanan, he claimed that it had all been proven by "profound scientific knowledge." Yet serving on exhibition juries a decade later, he took bold, unpopular stands in support of the work of black and Jewish artists. In a West Chester shoemaker's window in the 1930s, he discovered the work of Horace Pippin, a self-taught African-American artist, and urged the critic Christian Brinton to show Pippin locally. Within a year Pippin's paintings were on exhibit at the Museum of Modern Art.

He despised modern conveniences. The Homestead in Chadds Ford would not have electric lights until 1923. He scorned time-saving devices. Having made a religion of his mother's baking, what was he supposed to do with a cake "mix" made by someone named Betty Crocker? He did paint advertisements for the Aunt Jemima Mills Company, as he had for Cream of Wheat, but when a delegation of big-city admen appeared in his studio to offer a big-money contract, he refused so emphatically that the three men looked at him "with that startled look of men who had [been] unintentionally offended."

Prohibition, voted into law in 1919, was a matter of indifference to N.C. He was stimulated by extremes: floods, hurricanes, fires, blizzards, storm seas—local threats that kept him in touch with what he liked to call primal experiences. "Canned life is not agreeable to me," he said in 1926.

At heart he was a villager. He loved Chadds Ford. For several summers he managed the village baseball team. As Chadds Ford's strongman, he fought every fire and flood in the village during the Great War. In one episode it was N.C. who had to carry a wounded West Chester fireman down a ladder after a spike had pushed through the fireman's foot. He liked to help valley farmers, often combining his natural generosity with his muscle. After an afternoon ramble he would pitch in for a neighbor, carrying a milk can in each hand, loading them onto the milk train. Once he grabbed hold of a friend's front bumper, single-handedly lifting the car out of a ditch. He saved another neighbor's son from drowning. One friend seemed to speak for the whole community when he said of N. C. Wyeth, "I don't think he knew himself, how much he gave."

CHADDS FORD was changing. Before the war N.C. had blamed the valley's decline on rich people building weekend houses for gentleman farming. The explosion of "du Pont millionaires" was just beginning. The postwar wealth of Wilmington's gunpowder and munitions dynasty, E. I. du

The Last of the Mohicans, endpaper illustration as it appeared in the first Wyeth edition (New York: Charles Scribner's Sons, 1919)

The original canvas shows how much of the painting was lost in reproduction in 1919.

The Captives, 1919

Pont de Nemours & Company, along with some of the most lenient laws governing corporations anywhere in the world, produced vast green estates crowned by hilltop mansions. No longer would the wind blow "sweet and pure from the remote and innocent vales and valleys behind Sugar Loaf." Fences now closed off hayfields that N.C. had freely roamed as a Pyle student. The woods of his courtship had been posted. Atop the hills of his valley new palatial houses appeared—"Babylonian brothels," N.C. called them.

"The invasion of wealth without brains or fine feeling is terrible," he wrote in May 1918, echoed by Henriette, who two weeks later recorded in her diary: "Some fashionable people have come. They are up with Papa. I shall not breathe until they go."

Wyeth sided with the small farmer. His Chadds Ford neighbors could not afford to compete with hilltop millionaires, who paid "huge prices for everything from hash to help." But by 1919 postwar inflation had doubled prices, and N.C.'s local Mr. Potters had expanded to include the steel, arms, and munitions manufacturers who had flooded the valley with wealth, raising prices across the board. He felt that he himself was living "too well, too luxuriantly for the proper disciplining of my nature."

To go on living in Chadds Ford, N.C. calculated, he must earn a base annual income of $12,500—about $10,000 more than the established minimum needed by an American family for a modest living. From a flat 1 percent in 1913, he was now taxed at the highest basic rate: 12 percent. He managed to meet his obligations by producing about fifty canvases for three books each year. Magazine illustrations and murals boosted his income, sometimes considerably; the Missouri State Capitol murals brought in $8,000. *Buttonwood Farm* (1920), a landscape in oils, fetched an additional $500, although the thought of moving away from the valley prompted him not to sell four large landscapes.

He calculated that he *could* stay in Chadds Ford, if he painted advertising pictures. One New York firm offered him $20,000 a year for the exclusive rights to his work. Another, Charles Daniel Frey, begged him to name his price. He tried on the idea of dividing his time: two or three months a year to earn advertising money in order that he might paint real pictures the rest of the time. But he was wiser now: "I am beginning to see that it is not in me to do it that way."

The answer, he decided, was Needham. Yet again he vowed to chuck the corrupt valley of the Brandywine and realign himself once and for all with a moral ideal: South Street. New England still had integrity the rest of America had lost after the war. In Massachusetts people were honest, the very air was pure. Around a cultural capital like Boston, he would find "better minds and better lives." Henriette could apprentice with Boston painters; the

younger children could be educated by the same saintly soul who had taught him: Miss Mary Glancy. N.C. could cleanse himself with expeditions to Concord and Plymouth.

But not everyone in the family felt a need for Puritan straitening. By her own account, Carol was relatively content, if somewhat confined, with her life in Chadds Ford. N.C. nevertheless justified the move in Carol's behalf, declaring that Chadds Ford had become as incompatible to her interests as to his. To hear N.C. tell it, Carol was feeling as isolated as he was: "Both Carol and myself are starving hungry for closer contact with my parents." He imagined that Carol would come to life under his mother's care. As he painted *Rose Salterne and the White Witch* (1920) for *Westward Ho!,* depicting Carol as Rose and Hattie as the White Witch, he set in motion the relationship he had imagined for the two women of his life.

The children had little reason for a change. Their world was self-contained. The five Wyeths depended on one another for games and theatricals; together they developed elaborate fantasy lives. Inside the house they were steeped in "pictures, pictures, pictures; music, music, music; reading, reading, reading," one visitor recalled. "All the things of Western civilization surrounded the children." Outdoors Rocky Hill offered a year-round paradise. In winter they coasted incessantly. On spring afternoons they ran free on the open hills and through the woods, tanned from May through October. Evenings they could be found bent over tablets of paper. "*Drawing!*" exclaimed N.C. "That's the outstanding stunt in this house, and to see the whole five around the lamp at night, one would guess it were organized night art school—or that all were nutty in the same way!"

"We thought we had a world that couldn't be beaten," Henriette later said.

Why, then, go to the trouble of disassembling the family's present happiness in order to "reclaim a lost life," as N.C. described the move to Needham? He called it "the greatest question that ever confronted us."

He came up with practical reasons. The cost of local schooling, he asserted, had become "prohibitive." Yet in the fall of 1919, N.C. had taken Henriette into his own studio; she had begun formal training as an artist and was showing "phenomenal results." He had meanwhile started Carolyn and Nat at the only school in the valley he considered worthy—eleven miles away in Media, Pennsylvania. As they departed each morning at seven o'clock, intense anxiety gripped N.C. He felt "homesicky" the rest of the day. He complained that getting the children to and from school was interfering with his studio hours, but it was their absence from the house that bothered him more. By January 1921 he had hired a tutor to teach the children at home, three hours a day, four days a week.

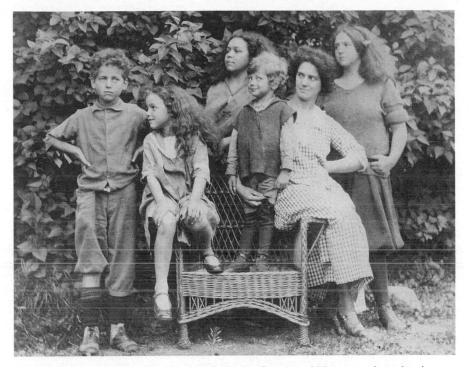

Nat, Ann (seated), Carolyn (rear), Andy, Carol, and Henriette (standing), photographed by NCW, 1922. Visiting the Wyeths, Joe Chapin was impressed by "the frank relations of father and children." NCW was "more like a big brother to them all than a father."

His daughter Carolyn despised the idea of moving. She hated to change anything she loved. Like her father, she strongly identified with places and things. At twelve Carolyn believed in the lesson N.C.'s mother had taught: things had feelings. Clothes, for instance, felt rejected if they were not worn. Carolyn wore her clothing until it hung in tatters.

Nat, ten years old, would remember his father telling him that he wanted Nat and the rest of the children to know their grandparents better. The move, however, was a "hell of an upheaval for all of us," Nat later said.

Ann Wyeth, at six, thought that the family was moving from Chadds Ford so that her father could paint murals in Boston. She did not realize that N.C. intended the move to be permanent and only later understood that her father was "homesick for Needham, for his family, for the past." For his mother. In every explanation for the move, the one omission was Hattie.

. . .

WITH MAMA ABSORBED in undefined illness, and Papa puttering among his fruit trees, and Stimson marooned in his room, the Wyeth household more and more resembled that other mossy Massachusetts homestead haunted by successive generations and lost time—the House of the Seven Gables. One after another the Wyeth boys had departed. One after another they were returning.

In March 1921, N.C. made a third real-estate foray to Needham. He intended to buy land from his father in the pasture to the west of 284 South Street. Adamant that nothing should "destroy the appearance and spirit of the Home," he planned to build "moderate quarters." He hired a Boston architect and invested $500 in architects' fees.

Then he learned that Uncle Denys's "dollar-hungry" in-laws, the Freemans, had put the old Zirngiebel homestead at 286 South Street back on the market. His uncle and aunt had been waiting patiently since first trying to sell after Denys's eye injury in 1918. With no other good property on the river for sale, they had reckoned that "some rich man will be sure to want it soon." In fact, a house-lot speculator had made an offer. But if the deal were made, the Old Homestead and greenhouses would be demolished, the land chopped up into three house lots.

It was unthinkable. N.C. prophesied that "if that dear old place, every foot of which is *sacred* to my mother and us boys, should fall into the hands of strangers, and for *house-lots!*—it would shorten my mother's life, I know, for she lives in memories of her father and mother." Declaring himself the logical owner of the Old Homestead, he called off his architect and vowed to come to the rescue. He imagined that by reinhabiting his grandfather's house he could save his mother, bring her back to life.

In November 1920, Hattie had gone into the hospital for an operation. N.C.'s letters do not identify the procedure or the diagnosis. He suppresses the "trouble" under generalizing phrases: "a very depressing period"; "a very critical operation"; "a risky proposition"; "a complete recovery." By December 1 she was back home. Her Needham physician, Dr. Pease, gave away some of the diagnosis when he wrote to reassure N.C. that there was "no sign whatever of recurring trouble."

Undeterred by the past failure of South Street homecomings to alter reality, N.C. maintained that this one would be different. A permanent move back to his birthplace would "mark the turning point whence I shall advance into really important work." His grandfather's property would replenish him as no ordinary place could.

But the same conditions that had inspired past substitutions of South Street for Rocky Hill were again present in 1921: dissatisfaction with all forms of his work; disappointment at not finding an older Socratic figure

My Grandfather's House, c. 1929. NCW: "The last 'private' canvas of the old house (grandpapa's) after a heavy snow is considered by those of discrimination who have seen it my best."

whose approval and support would advance his easel painting; untreated bouts of depression; a sense of Carol's inadequacy in dealing with his problems, much less her own and the children's; fear of being invaded by a promiscuous, polluted world that threatened his integrity; and, most important, the idea that by his acting gallantly toward his mother, a revival of their old exclusive intimacy would provide the answer not only to his lack of fulfillment as an artist but to her "trouble."

The gallantry of saving the Old Homestead from destruction provided the cover he needed—he could conceal himself as he bid on the house. Using a Needham friend as a decoy, he resumed the negotiations he had laid aside in 1918, and, in the midst of painting Washington Irving's *Rip Van Winkle* that May, managed to save the old place from the house-lot speculator by posting the sum of $12,000. It was the second New England property he had bought in two years. With his friend Sid Chase, he split the $3,000

purchase price of an old captain's cottage on the St. George River, which would give his family, along with his mother and father and brothers, a "foothold" in Port Clyde, Maine. He would take care of everyone, shelter them all.

As the time to move approached, he found himself waking up in the middle of the night and wondering what he was doing. By day he made himself believe that the move marked the "dawn of a new and better era for all of us." Then, in the village, one more Chadds Ford farmer would stop him to say how sorry the farmer and his family were to know that the Wyeths were leaving. "The village," wrote N.C., "is making it a little hard to pack up and go."

Caught between impulses, he decided not to put the Homestead up for sale as he had planned. He rented his fields to a neighboring farmer, asked the village wheelwright to act as caretaker, and rented the house for the summer to Carol's brother Logan. Whenever anyone asked how long the Wyeths would be away, N.C. said he intended to return twice a year, autumn and spring, for periods of landscape painting. Somehow he would find a way to oblige everyone.

Painting *Rip Van Winkle* that summer, Wyeth used old Needham neighbors. The Onions had lived across the Charles in a farmhouse that antedated the Revolutionary War. Over the years Wyeth had kept in his studio a powder horn that as a boy he had "found" on the grass beneath the window of the Onions' barn, much as Rip had stolen drafts from the Catskill liquor keg "when no eye was fixed upon him." Wyeth's childhood memories of old Mr. Onion served as the model for his portrayal of Rip's return from his twenty-year sleep. Wyeth hoped that Miss Onion would be alive when he returned to Needham; the still-spry neighbor "would help tie over the lapse of nearly 20 years away from home."

The Wyeth edition of *Rip Van Winkle,* published that fall, would come to be seen as one of his most penetrating sets of narrative painting. "Perhaps even more than Washington Irving's tale, the pictures tell the weird swiftness of human life," *Time* later commented, adding that "no other illustrator ever achieved such a poignant mingling of psychological truth and natural mystery."

Rip Van Winkle, the obliging villager, awakens from a grog-induced nap to find that while he slept twenty years passed and he himself is an old man with a long, white beard. Having fallen asleep a subject of King George, he awakens a citizen of the United States of America, returning to his village during the presidential election of George Washington. Rip first

blames his ordeal on the old Dutch dwarves whose keg of liquor he had helped carry up the mountains the night before. But despite Rip's laziness and duplicitousness, the one weakness that seals his fate is his willingness to oblige others at his own expense.

Before shutting down the studio on Rocky Hill, N.C. wrote his mother a valedictory letter: "The whole event of getting back home with you all, and in those beloved surroundings, looms even greater than I really thought. . . . Do you realize that I am returning just eighteen years to the day (within a few hours) after leaving home for Howard Pyle's classes?"

His arithmetic was wrong, and he was mistaken about the anniversary of his first departure. But this time it really did fall on October 19, and for N.C. that was enough to make the entire nineteen years away seem as if only a day had passed since he left.

Rip

H E CAME HOME TO the spruces at the foot of the drive. Home to
the broken niches in the cellar concrete and the rumbling roll of
the henhouse door. Home to the bread smell in the pantry and the
grape juice bubbling on Mama's stove. Home to the fallen apples in Papa's
orchard and the cow dung in the barnyard. Home to the incessant calling of
the whippoorwill and the river flowing by.

He came back hoping to find the Needham he had left in 1902. A larger,
more prosperous trolley suburb stood in its place. He came to where Gay's
pine grove had been. No sign of the childhood landmark remained. In place
of the whiskery old firs he discovered a dismal crevice in the ground called
Birds Hill Station. Lawton's Woods, too, had disappeared, and with those
trees had gone "another living symbol of our blessed life together in the
early years."

Everywhere he turned, things had changed just as surely as in Rip Van
Winkle's Catskills village. The old high school, with its dark, forbidding
windows and scaly mansard roof, had made way for a lifeless pile of cement.
On Great Plain Avenue there were houses he had never seen before, and
strange people. The Wyeths had lived among farmers. Now there were bank
presidents on Great Plain Avenue, the main residential street in town.
Swells like Frederic Curtiss, the president of the newly created Federal
Reserve Bank in Boston, owned summer houses in Needham.

N.C. himself was fashionable. No fewer than three of the Boston Sun-
day papers remarked on the change that had come over him: "N. C. Wyeth
left Needham practically unknown as an artist" and "returned 'America's
greatest painter of costumed romance.' "

He built a new studio behind his grandfather's house. The shingled
room commanded a view of the river and the woods beyond. He settled in
to paint. Less than a month later a storm blew up. WORST SLEET STORM IN
LOCAL HISTORY DEVASTATES TOWN, blared the Needham *Chronicle*. On
December 3 the newspaper reported that "of the stately trees of a century's

growth, of the beautiful maples, of thriving orchards, not a single tree could be found unscathed." As the sleet cut across the valley, coating branches with icy shrouds of freezing rain, N.C. stood on his studio steps watching with "grim irony" as the boughs that he had played under as a boy, and that he had planned for years to paint, broke into pieces before his eyes.

Afterward he turned to his son Nat and said, "Well, I'm glad they can't tear down the sky."

He managed to salvage one image from the disaster. At the height of the storm, the local paper had said that it was as if a giant, striding over the town, had swung a scythe. The image of the striding giant would become the central motif of the first of four bank holiday posters Wyeth painted that year for the U.S. Treasury, as well as for the cloud-swept mural he painted in 1923 for the Westtown School in Pennsylvania, *The Giant*.

TIME ITSELF had been corrupted. Needham no longer lived by the natural clock of the sun or by local measurement of time. Daylight savings time, which had been created during the war to synchronize the nation and to economize on electricity and fuel, now extended daytime by one hour, a measure farmers had bitterly opposed. Along with the new standard time zones, it was another step away from localness, another wrenching of the pastoral world N.C. had imagined was still here.

"How the so-called spirit of modern progress galls me!" he exclaimed. "I feel at times that it is eating my heart out. I can hardly turn my head these days [than] something I have grown to love is being destroyed—trees cut down, beautiful old homesteads demolished, winding roads straightened, and even wandering brook-courses disciplined."

The biggest change was in his mother. The unnamed operation of a year earlier had dramatically aged Hattie Wyeth. Her face pinched by continuous pain, she rarely smiled except with her grandchildren. Wearing high-laced shoes, voluminous skirts, and starchy blouses, she more and more resembled the portrait N.C. had painted of her in 1914 as Thorgunna, the severe Viking wife glowering before the mouth of a glacier.

Ann Wyeth would remember being a little afraid of "Aunt Ma," as the grandchildren called her. To a six-year-old she was "scary, a big woman." Nancy Bockius had for years been hearing her sister Carol say that Mother Wyeth's trouble was homesickness for Switzerland. Nancy sensed that it went deeper: "She had something a little sick about her."

N.C. still attributed his mother's chronic insomnia—"my foolish habit," she called it—to external influences. He begged Newell to get her to stop drinking tea, especially tea boiled twice with old leaves. At the same time he

recognized that the qualities he had thought of as virtues—generosity, sympathy, self-sacrifice—were actually symptoms of a problem. He chastened Hattie for "giving yourself in sympathy and nervous concern to *anyone* who makes a demand on you." He ordered her to curb her outpourings. "For the sake of all of us, put a limit upon your nervous giving. You can't stand it, neither can we."

Only Boston was the same. Still the cultural capital of the nineteenth century, it was the same stuffy city of Convers Wyeth's early art studies, and he immediately embroiled himself in a minor local scandal. Having agreed to teach at the Child-Walker School of Art on Newbury Street, he signed Henriette up to attend the school's life drawing class. All went well for the first few weeks. Both Wyeths commuted into town, and Henriette got off to a good start, impressing everyone with her drawing. Then one day Miss Child and Mr. Walker thought to inquire about Henriette's age. In 1921 it was illegal in Boston for anyone under the age of eighteen to attend a class in the presence of a nude model. Henriette was fourteen. Though sincerely sorry to lose such a talented student, Miss Child and Mr. Walker had to ask Wyeth to remove his daughter from the school. He quit his teaching post instead.

Following in her father's footsteps, Henriette attended the Massachusetts Normal Art School, studying life drawing under N.C.'s first teacher, Richard Andrew. Nat and Carolyn enrolled at the Harris School, where the immortal Miss Glancy was now principal. Ann was placed in a lower grade. Andy, too young for school, remained on South Street, happily drawing.

For N.C., being home was a form of spiritual communion. His brother Nat, working in automobile sales in Boston, had settled in a house on Green Street, opposite the South Street houses, with his wife, Gladys, and daughters, ten-year-old Natalie and Gretchen, seven. Stimson lived at 284 South Street with Newell and Hattie. N.C. could walk to his mother's kitchen. He could see Stimson's desk lamp from his own bedroom. A stone's throw put him at Nat's front door. The Wyeths were rejoined. They sledded, caroled, yodeled.

Repetition would always uplift and transport N.C. All his life he would stand on shorelines mesmerized by the reiteration of crashing surf. For him Needham was the place where opposites merged: past and present, birth and death, freedom and discipline, facts and dreams, parent and child. Herding his children home, he had naturally assumed that *his* children would fuse with Needham. He had somehow not foreseen that for them Needham would mean something different.

He had deceived himself. In vain he realized "how intensely I have been living *through* my family." Before the move it had seemed to him that he and

the children were emotionally one and the same. Their feelings had been his feelings. Their reactions had been his reactions: "It was as though I had six live points of contact with life instead of one."

But each took Needham differently, Carolyn hardest of all. Homesick for *her* Arcadia, Carolyn built a scale-model replica of the Rocky Hill Homestead and its outbuildings. Contrary to family mythology, Carol, too, was homesick for the Brandywine Valley, as Annie Bockius's letters to her daughter show. "You surely have good friends in [Chadds Ford] and in Wilmington," she wrote to cheer Carol up. "I don't wonder that you miss it all at times. It's perfectly natural for you to be so strongly attached to your own birthplace and that of your children."

Christmas came to South Street, and with it Hattie Wyeth's sixty-third birthday. The day before school let out, a blizzard hit New England. It was bitter cold, with wind sweeping the snow into mammoth drifts under the spruces that fenced South Street. N.C. would not be stopped. He pulled on his seal mittens, his bearded mask, the peaked red hat. He loaded a large sack with presents he had wrapped, then marched through the drifts up Green Street. To the children at the windows inside the Harris School came the sight of Father Christmas bringing toys and presents through the swirling snow. N.C. would much later tell his son Nat that in all his years of doubling as Old Kris, he had never felt more convinced that he had become his other half.

STILL, despite his initial happiness at being in Needham, N.C.'s letters of the following year reveal growing impatience. The record shows that both he and Carol had become dissatisfied with the "surroundings" on South Street and that N.C. was aware that Carol was "feeling bad" about living at the Old Homestead. He acknowledged that the "back-home move" had upset Carol and the children, dividing them as a family. By September 1922 he promised Carol that he would "show something for the sacrifice you are making."

On June 14, 1923, on the advice of her doctor, Carol Wyeth submitted to sterilization—a hysterectomy or a tubal ligation (family accounts disagree). In either case the operation was a blow. At age thirty-seven Carol could not bear the thought of a future without more children, and she fell into a depression. When the crisis abated N.C. drove Carol the two hundred miles to recuperate by the sea at Port Clyde, Maine. "Many things have gone wrong this last five or six weeks due to Mrs. Wyeth's critical condition," he wrote his editor at Houghton Mifflin, "and I will tell you, now that it is all over, that I almost lost her."

But it was not all over. On the first of August, in Maine, Carol suffered a serious relapse. Within a week she had stabilized, and N.C. was confident enough to record, "We seem to be out of difficulty again and there appears to be every hope that Mrs. Wyeth will entirely recover."

On August 12, still concerned about Carol's condition, N.C. nevertheless departed Port Clyde for South Street, leaving his wife in the care of a trained nurse. Carol convalesced at the Hotel Wawenock as N.C. made the twelve-hour journey back to Needham to pack up the Old Homestead alone. He intended to rejoin Carol and the children on August 20 in Wilmington. For by now Convers and Carol perceived themselves and their future in a new light. "It is as though our journey together had been interrupted by a 'detour' this past two years," he wrote her in August, "a 'detour' not without its pleasant days and prospects but considerably spoiled by bad roads."

They decided to settle once and for all in Chadds Ford. N.C. would rent the Old Homestead to Stimson, who in June had married a Needham girl, Constance Louise Twigg. The newlyweds lived with Stimson's parents.

N.C. arrived back on South Street and wrote Carol at once:

When *will* the confusion of emotional reactions cease? Here I am, over 200 miles away from you, clearing up the last stray vestiges of our settlement here, living for the few days in the house where I was born; attached to it, and yet dreaming of our reestablishment in old Chadds Ford. . . . It does seem as though I will not regain poise or serenity until we are well settled in our little Pennsylvania home.

He wrote Carol incessantly during the four days he spent packing up the Old Homestead. It was as if, having "almost lost" her, he delighted in her anew. He longed to see her, thrilled to hear that she was feeling fine. He lamented that before they met again in Wilmington, a whole other week would pass, "the longest period that we have been away from one another." He noted, as well, "I miss Henriette too so much. She is indeed a real bulwark in the family."

At this turning point in the family history, Hattie is notably absent from N.C.'s discussion of his plans. In these four transitional days in August, N.C.'s letters to Carol overflow with hope for the future. Full of renewed affection for his wife, he does not speak of his mother.

In later years the family would debate why they had left Needham in 1923. Some of the children pointed to their sister Carolyn's homesickness for Chadds Ford as the deciding factor. One Wyeth cousin who grew up in Needham contended that N.C.'s wife and mother had not "hit it off," and

Carol's sister Nancy confirmed that Carol was "ready to go back to Chadds Ford in a hurry. She wasn't happy there. You could sense it the minute you walked into the place. The mother-in-law lived too near." Ann Wyeth and Andrew Wyeth, meanwhile, would insist that they knew their mother better, and that she had been devoted to her mother-in-law. Indeed, Carol Wyeth was rightly known as Hattie's favorite daughter-in-law.

The decision was N.C.'s. As was often the case when he felt bewildered by separation and loss, his omissions tell the story of his choices.

Hattie Wyeth had cancer. The medical record shows that she was diagnosed with carcinoma of the bladder in August 1923. It was not until nearly a year later that her physicians declared her cancer terminal. The episode that led to the final diagnosis—a flow of blood from her bowels—would be described as "a recurrence of her old trouble." By the time N.C. packed up to leave Needham, he was aware of her disease. Unwilling to discuss it, much less accept it, he would have had to do still more—to watch his mother die—if he had remained on South Street through the following year.

But in truth, no one was discussing it. In July 1924, when Hattie's new physician, Dr. Brewster, diagnosed her cancer as inoperable, he took Newell aside to reveal the prognosis. Hattie was left out of the conversation. Brewster advised radium treatment, and by the end of the afternoon Hattie had been admitted to the Philips Home on Charles Street, attached to Massachusetts General Hospital—"almost the next building to Suffolk County Jail," Newell noted resignedly. It was as if Hattie *had* been sent to prison. Newell made a point of telling none of their friends or neighbors that he had admitted his wife to a hospital for cancer treatment. He vowed to do his best "to keep Mama from worrying" and that meant, as it had in the past, keeping the truth from her.

In an ordinary year N.C. wrote his mother about a hundred letters. In all of 1924 he wrote her just once—a rather meaningless note in November. The few letters he tried in the remainder of 1923 looked, in his eyes, like "half letters." On returning to Chadds Ford that fall, he would often sit down to start one of his usual outpourings to Mama. After only a page or two, he found that he could not go on.

This was a total departure. At a time when she most needed his attention, N.C. ignored the reality of Hattie's final illness. Another year would pass before he acknowledged that she was very sick. He admitted to a business colleague that he could not resign himself to looking on as his mother wasted away.

In August 1923 he made one thing clear about his exit from South Street. He could not get away quickly enough. After the first two days of packing up the Old Homestead, he wrote Carol: "I am marking time. If it

were not the weekend, with so much traffic on the road, would leave for Chadds Ford right away, but will not do so until Monday morning. As pleasant as the folks are making it for us I am restless to get along."

He belonged to Carol. And she to Convers. Wilmington was where their story had begun. Proprietary, gallant, bursting with his old wish to sweep her off her feet, he itched to be at the depot when Carol arrived. He sent her an itinerary which emphasized the climactic moment when she would "Meet husband in Wilmington and accompany him to CHADDS FORD!"

HENRIETTE came back to the valley a self-assured young woman of sixteen. Headstrong in childhood, perceptive and quick, she had grown rigorously truthful, powerful beyond her years. At the Homestead she was now a second mother, taking charge of the younger children, especially Andrew. "She ruled the place—all of us," Ann remembered. "She was always telling us what to do, what to wear, and what everything else."

She was also, in some ways, a second wife. Small—she hated to be called petite—Henriette could be a little tyrant. N.C. delighted in her "autocratic" ways. He was stunned again and again by the strength of her mind and will. When Henriette spoke, her voice round and full of conviction, adults listened; even to peers and cousins she was "fascinating to listen to."

N.C. considered Henriette's critical acuity nothing less than a miracle. For directly behind this bright, mothlike daughter stood a bruiser—Carolyn, burly, thuggish, big-footed Carolyn, who still felt more comfortable living with animals than with people. "She is our farmer," N.C. had decided, noting that Carolyn was the only one of the children "with whom the chickens feel free to associate—walk all over her and do everything but get in her mouth."

When the family moved back from Needham, N.C. built a chicken house for Carolyn. She kept bantam chickens, white rabbits, jackrabbits, a pet possum, and pouter pigeons. Carolyn spent most of her time in her chicken house, drawing and painting the animals. "She always liked to do things utterly different from anyone else and resented any direction whatsoever," Henriette recalled.

As N.C. and Henriette traded novels and magazine articles, discussing them with a depth of penetration that amazed him, N.C. found the intellectual companionship he had missed in his marriage—indeed, in all his adult relationships. In the studio, meanwhile, he had been depending on Henriette for years. With her powers of concentration and decision, and especially

her drawing—he considered hers already better than his own—N.C. more than took her seriously. "I am getting so that I take her judgment on certain things as final," he recorded in August 1918, when Henriette was only ten. Her natural ability to draw and paint was, to N.C., "so astonishing I hardly know what to do about it." Worried that it would go to her head, he made a point of praising Henriette as little as possible, but he was sure she had the makings of a real painter. His only fear for her was the "inevitable disease of sophistication."

In the fall of 1923 she had a quality that N.C. had come back from Needham in great need of: hope about the future. Henriette was full of vitality. She enrolled that fall at the Pennsylvania Academy of the Fine Arts, commuting from Chadds Ford.

One evening, on the local train to Chadds Ford, Henriette overheard the conductor giving directions to a young man, telling him the way from the depot at Chadds Ford Junction to the Wyeth homestead on Rocky Hill. The conductor turned to Henriette and said, "This young man is going to visit your father."

His name was Peter Hurd. A month past his twentieth birthday, he was blond, with a lithe, graceful body and luminous blue eyes. Hurd was the son of a proper Bostonian who had moved west for his health. He had grown up in Roswell, New Mexico. He was determined to paint and had resigned from West Point in 1923 to transfer to Haverford College. There he had met the art critic Christian Brinton. Brinton, in turn, had introduced Hurd to Charles Beck, Jr., the engraver whose company made the plates for Wyeth editions at Scribners. Peter Hurd had long been smitten by N. C. Wyeth's pictures. When Beck invited him for Thanksgiving dinner and promised to introduce him to the "big guns" of illustration, Hurd felt for the first time that his earliest aspirations might be fulfilled. Still financially dependent on his father's relatives in Boston, he hoped that the Beck connection might lead to a start in the lucrative world of illustration.

In December 1923, at Haverford, Hurd was called to the telephone. N. C. Wyeth's high-pitched voice crackled over the line, inviting the student to Chadds Ford for a talk. Hurd would later say that it was as if the Lord Jehovah had called him. He was even more astonished when he arrived at the Chadds Ford railroad depot and found Wyeth waiting with a station wagon. After examining a canvas Hurd had brought along, he showed signs of liking the student but advised Hurd to enroll in drawing classes at the Pennsylvania Academy of the Fine Arts. Wyeth was no longer taking pupils himself.

The following March, after a hard winter of painting on his own, Hurd tried again. Returning to Chadds Ford unannounced, he arrived at the

Peter Hurd, Chadds Ford, 1920s.

depot, Henriette noticed, with another rolled up canvas under his arm. To Henriette, who had seen uncounted hopefuls turn up with work rolled under their arms, this canvas looked unusually ambitious—about seven feet long, she later said. She followed the visitor up to her father's studio, where, after introductions had been made, Hurd unrolled his vast work. It made quite a spectacle. The painting depicted medieval ladies accompanied by peacocks strutting on wide Renaissance terraces overlooking cypress gardens on the azure-colored Adriatic. Henriette knew at once that it was dreadful.

Wyeth regarded the painting solemnly. Pipe in mouth, he asked Hurd which yellows he was now using. Hurd answered quickly, explaining himself with great earnestness and cadetlike precision. Wyeth advised removing the yellows from his palette. Hurd later called his reaction a "masterly act of restraint."

Wyeth's hesitation to take Hurd on as a pupil went beyond technique. Pitt Fitzgerald had broken Wyeth's heart after the war. And Wyeth had had other disappointments as a teacher. One student, William Clothier Engle, of whom he had been fond—"poor Engle," Wyeth eulogized him—had "broken down" under the strain of his teacher's high expectations. After Engle's departure in 1918, Wyeth had concluded, "I am not an easy taskmaster." He had not let a young man into his studio or his life since.

Henriette sensed that Peter Hurd was different. Hurd's childhood had been shaped as much by absent, sometimes sadistic parents as by the sanctuary he had found in N. C. Wyeth's pictures. His external geography contained two landscapes that overlapped with Wyeth's early life—the narrowness of Boston and the immensity of the Southwest—and as the blue-eyed young man with the bright blond hair described his determination to make a start as an illustrator, Henriette could see her father warming to Hurd's charm and youth.

For herself, she decided that if her father took Hurd on as a pupil, she would "annex" him as one of her beaux. She thought him very handsome, with a "lovely body, narrow hips, almost like a dancer." He was well-spoken, with a tenor voice; and behind his correct manners she could tell there was another side to Peter Hurd—a Bad Boy waiting to bust out of the parlor. She was soon calling him Texas Pete.

Wyeth changed his mind. He would try one more student. "But if you work for me," he warned, "West Point will seem like child's play."

WYETH WORKED seven days a week, and "work began early," Hurd recalled. Wyeth was up every morning at five, chopping wood until six-thirty. Regular exercise had improved his stamina to the point where he could paint "like a steam engine until four o'clock and not feel it."

At seven o'clock, fortified by grapefruit, eggs, pancakes, and coffee, Wyeth climbed forty-five flagstone steps to the studio on the hill. Before donning his smock and attacking the canvas, he liked to write a letter "to settle my breakfast." Often he would mail it right away, zipping into the village in his station wagon. On the way he looked in on Hurd, who had moved into a farmhouse a mile away from the Wyeths and used an adjacent wheelwright's shop for a studio. There, at eight-thirty, Wyeth would review Hurd's progress, sometimes staying to give the student a "working criticism," during which he would take control of Hurd's brush and work on Hurd's canvas.

Back at his own easel, a nine-foot-high colossus made for him by Clifford Ashley, Wyeth pulled on his smock over his work clothes: a khaki shirt,

white linen knickerbockers, long black leggings, high-topped sneakers. Then, clamping his pipe between his teeth, hooking an enormous palette onto his left thumb, and glowering "like a caveman," as one grandchild would later say, he strode forward to his canvas, brushes in hand.

He worked fast. Proud of his speed, he marked the upper-right-hand corner of one still life: "3HRS." For murals, he built steps reaching up twice his height. Back and forth he strode across the floor, now painting, now stepping back, bobbing his head to the left and right, scowling, frowning, never satisfied. "If you look at that studio," Andrew Wyeth said later, "you can almost see the floor worn down where he walked back and forth."

When he was having trouble with a picture, Wyeth would tape a piece of cardboard to the side of his glasses. The card would block his side view of the studio's big north window, helping to focus his attention. When he broke for lunch, he would sometimes return to the house with the card still attached. "When you saw him coming with that card on his glasses," his older son later recalled, "that was a good time to stay out of his way because it meant things weren't going well, and he wasn't in a good temper."

When he was beginning a new picture, he worked right through the day. Otherwise, Carol served him a cooked lunch at one o'clock. In the afternoon, while he worked, the younger children played around him, a "contagious stimulant" to his work. Ann often posed, taking the part of many of the little girls in the Scribners Illustrated Classics.

As he painted, Ann would notice "that beetling brow. And that big palette. And he'd walk back and forth with high sneakers on. That sound, back and forth, up to the picture. Then he'd come over and maybe fix something, my hair or turn my chin. No talk. We didn't talk. But after it was all done, he'd take me down to Gallagher's store and get me some chocolate-covered marshmallows in a brown paper bag, which we both loved."

Daylight was crucial to his output. He rarely worked under artificial light. Time therefore always seemed to him desperately short. He begrudged the passing of every minute of daylight. He loved to work and worked until he could no longer see. "It's the hardest work in the world to try *not* to work!" he once said. Without a picture under way on his easel, he was "fundamentally unhappy." He lived to paint. At the end of the day, he often wished that "there was another day right away."

"He hated to leave the studio," Carolyn remembered. Sometimes he would stay and build a fire, catching up on his "home letters."

A desk that had belonged to his grandfather Zirngiebel stood in the vestibule of the studio, near the black-and-white prints of his grandmother's lost village in Switzerland. In that old desk he kept his mother's letters. Late

In 1924, back in Chadds Ford, NCW built an extension on his studio for mural work. Here he pauses over *The Elizabethan Galleons* for the First National Bank of Boston.

in the day, covered with paint, frustrated with his work—it never seemed good enough, never seemed to be *his*—he would sit down with these letters, plucking one at random from the hundreds in the desk.

N.C. had preserved every one of Hattie's letters. The loss of even a small batch, accidentally destroyed in Wilmington in 1904, remained for him after almost twenty years "a matter of the keenest regret." Once, during a buggy ride in 1910, an opened but unread letter from his mother slipped from Convers's pocket, falling out somewhere in the countryside around Chadds Ford. It was only Hattie's usual Friday letter, but when her son later discovered it missing, he dashed back out, hitched the horse up again, and retraced his steps over nine miles of country roads. He asked at various houses about the letter and stopped everyone he met, to no avail. The man he had been riding with—a farmer named John McVey—was "quite disturbed that I should take a matter as that so seriously, that it should upset me so," Convers wrote afterward. McVey "talked to me considerably about the unimportance of letters etc. I couldn't of course expect to make him understand what home letters meant to me." So Convers fibbed, telling McVey that he had glanced at the letter and seen that it contained important news.

Home letters meant that time was repeatable. In the studio fifteen years later, he solaced himself with the idea that his original experience could be relived. Removing a folded bundle of pages from its small, tight envelope, he smoothed out the cool, musty sheets and peered at his mother's tightly packed prose. Every image, every revelation of her "emotional state of mind at the time . . . brought back innumerable details of [his] own life of the same period." Frequently he had to read between the lines, but that was where he had always found the clearest mirror of his own emotions. He felt he understood her better than anyone else. Little wonder that his daughter Henriette would later say that Hattie Wyeth was "the only woman he would ever know."

AFTER FOUR WEEKS of radium treatment, the doctors in Boston knew that Hattie Wyeth had as few as three and as many as twelve months to live.

Hattie meanwhile was told that the treatment had "worked" and that she had every expectation of living a prolonged life despite the disease.

They kept the truth from her but not from Newell. He kept it from Ed and Nat and also from Stimson, whom he did not trust to keep secrets from Mama. He told only Convers, the one son who had always been trusted with the secret of Mama's condition.

Puzzling over Newell's remarks about the latest developments, Nat

wrote Convers from Glendale, California, where he had moved that August. "The letters all have a mysterious tone," he said. "Perhaps you can verify a suspicion which I harbor that there is no permanent cure for Mama's trouble (just what it is I don't know). Am I right? Do you believe the doctors know? It just seems to me that Papa has been trying to get this point across without saying so outright. . . . I know he does not want to cause undue alarm."

Newell lived in fear of what might happen if Hattie gave in to nervous worry. And, indeed, she came home from four weeks in the hospital with all the standard diagnostic criteria of depression. Day and night she stayed in bed. She wanted someone with her all the time. She had no interest in food, and at night she had insomnia. She was addicted, after four weeks in treatment, to sleeping pills. Newell tried replacing the pills with whiskey and ginger ale, but found it "rather hard to make her believe that whisky is better than pills."

Putting on his most rational face, Newell tried to make Hattie believe that she was getting well. A neighbor came in to help with the cooking, and Newell enlisted her and her son in the subterfuge. "We must permanently convince her that she will probably go further in years than any of us and that her sickness is checked and therefore cannot be shortening her life," the son wrote Convers.

At the end of September the Boston doctors joined the sham, telling Hattie that since her radium treatment had "worked," there was now no need for further treatment.

Hattie began to regard her husband with suspicion and the doctors and neighbors with contempt. She demanded to know if anyone besides herself was aware that she had a disease. In October she became delusional. Believing herself contagious, she fretted excessively. Newell, true to form, tried to reason with her, but Hattie's sense of malignancy was stronger. Newell called in Dr. Pease to lecture Hattie on cancer and to leave a prescription, to no avail. She swore that she was toxic to everyone around her. With a six-month-old infant, especially, her sense of guilt about being "bad" and "harmful" was acute. John Wyeth had been born to Stimson and Constance in April, and for Hattie it was as if the saga of her life on South Street had come full circle. John Wyeth was a new version of Rudolph Zirngiebel.

One night that October, Hattie telephoned Stimson at 286 South Street. She said that as long as she was "feeling right" she wanted to say some things. She told her youngest son how grateful she was that he was raising his family next door. She said how much she enjoyed baby John— "pulling him up etc." She told Stimson that she hoped he would under-

stand—it was not that she didn't love John, but she could no longer pull him up on her lap, or hold him, much as she would like to. She was sorry, he must understand, but if the baby came close, she would "harm him."

On November 2 she became violent. Her frenzy escalated to the point where Newell had no way of controlling her. He dashed across to the Old Homestead to get help. Stimson came running. He realized at once that if his mother were left alone she would kill herself. With two neighbors holding her down, Stimson drove Mama to Dr. Wiswell's Sanatorium in Wellesley and committed her. Reports from the sanitorium emphasized that Hattie, though calmer, still saw herself as a source of "Contagion." The doctors believed that Mrs. Wyeth was "so self-centered in her thoughts," and so sure that she had been "bad," she might try again to commit suicide. Unknown to Newell, Hattie had attempted to persuade a neighbor's son to smuggle drugs into the sanatorium.

IN THE MIDST of all this, Ann's appendix ruptured. For a week the nine-year-old was in critical condition at Jefferson Hospital in Philadelphia, then she struggled seven more weeks with peritonitis before recovering. N.C. was at her bedside every day.

If two medical crises were not enough, Houghton Mifflin began lobbying Wyeth for a bedside visit to the Harvard philosopher George Herbert Palmer, who was eighty-one and in failing health. Houghton intended to reissue Palmer's landmark translation, *The Odyssey of Homer,* and the publisher insisted that the author's dying wish was to see his great work illustrated by N. C. Wyeth. Palmer was scheduled for an operation in Boston on the first of October. He was counting the days until Wyeth came. The promise of a sickbed visit had become the signal event of the childless, twice-widowed professor's days, and since no one was optimistic about the old man surviving the operation, it seemed it would be Wyeth's one chance to see him.

As if to compensate for all the bad news, Wyeth dedicated himself to Palmer's *Odyssey* and recited for himself, as much as for his Houghton Mifflin editor, the year's accomplishments: for Scribners, Robert Louis Stevenson's *Kidnapped* sequel, *David Balfour;* for the Cosmopolitan Book Corporation, Thomas Bulfinch's *Legends of Charlemagne;* plus eight large murals—five for the First National Bank of Boston and a triptych for the Roosevelt Hotel in New York. He concluded, "I've been busy."

"Look out," warned Roger Scaife at Houghton Mifflin, "or the combination may be too much for you."

Wyeth made several plans to come to Boston to meet with Professor

Palmer, but each time a deadline or a medical crisis intervened. The work and stress of 1924 took ten pounds off him. For the first time in five years, N.C. weighed 239 pounds. He worked harder still, the necessity of commercial projects more than ever on his mind.

In September his mother's medical bills began coming in: $200 for examinations, $100 for radium treatment, $213 in hospital charges. On top of that the sanatorium began at $50 per week, with additional fees of $75 to $100 for attendants needed to stand guard over Hattie lest she try to take her life again. Six months of sanatorium bills—eventually totaling some $2,500—were his to pay. During the course of his mother's disease, N.C. carried the Wyeths.

He was now responsible for the financial well-being of two families, including a dying mother and a wandering mother-in-law. Sympathizing with N.C.'s "Herculean burden," Annie Bockius nevertheless sent a cable in October asking for money. She had been supporting herself with what proved to be an improperly claimed government allowance paid to destitute mothers of U.S. naval officers. When she departed for an extended sojourn in the Far East, N.C. had told her that if she got into a tight spot to call on him. In China, with funds dwindling at the Grand Hôtel de Pékin and no return ticket, Annie Bockius took him at his word, dunning him for $150. He wired back $250—the equivalent of half his fee for a single magazine illustration. The following June he helped his brother Stimson buy a car, putting up $200 of the $350 cost. The son deemed least likely to succeed, the impractical artist, now bankrolled the whole family.

IN THE SPRING OF 1925, Hattie's doctors announced that she could be brought home to South Street. Her "rational periods" had prevailed to the point where she herself did not realize that she had gone crazy. By April 30 she was "home sweet home," Newell announced, "and seems happy." The only issue was what sort of nursing she would need, a regular "hausfrau," as Newell hoped, or "someone intelligent on nervous troubles," as Dr. Spaulding, the sanatorium physician, had advised. Stimson was apprehensive: "Even though she asserts she will not let herself go again etc., I hope & feel that it will be O.K. but I'd hate awfully not to be reinforced & supported by competent aid."

Through May and June, Hattie appeared serene. She ate and slept well for the first time in years. Newell, Stimson, and Convers took it as a sign of a miraculous recovery. By the middle of July, however, she was having "little spells" again. Calling family members to her bedside, Hattie would blurt out that she had been "bad." At the hospital they had accused her of unspeak-

able things. She begged Stimson's wife for discretion: Babe must not know she had been bad. She begged the same of Newell.

N.C. planned twice that summer to go to Mama's bedside, but no record survives of either visit. On July 26 a letter reached Port Clyde, where he had moved the family for the summer. The letter was from his mother. Things, she said, seemed to be going on about the same. The garden was producing beets, carrots, peas, and "beans galore." She imagined that Maine would be quite a change for Carol and the children. "But," she concluded, as if looking back over her own life, "one must sacrifice in one way to gain in another." She sent her love to everybody and signed herself affectionately.

Weeks later, while putting the letter with the others in the Zirngiebel desk in his studio vestibule, N.C. wrote on the envelope: "Last letter from My Mother."

The cancer had spread. She slipped in and out of consciousness through the first ten days of August. Helpless, Newell stood by, watching Hattie die. She was sixty-six. They had been married forty-four years.

On the morning of August 11, Newell wrote Convers a brief letter. He wrote again in the afternoon: "Another day the same as yesterday. Very quiet and no suffering. . . . Will phone you at once when the end comes." He never mailed the second letter. The end came that night. At 9:15 p.m., after a final hemorrhage of the bladder, Henriette Zirngiebel Wyeth died.

N.C. arrived from Maine the morning after next. The house was strange and still. The open coffin stood in the parlor. Afternoon sunlight burned behind the shades. N.C. sat beside his mother, looking into her face, and then it was night. The next morning he buried her in the Needham Cemetery beside her parents and her baby brother Rudolph.

IN THE TIME that followed, Newell lived on in the house without touching it. Hattie's dresses hung on the hooks they had always hung on. Nearly every morning, when Newell awoke to the empty house, he had the sense that Hattie must be at the sanatorium; surely he would see her later in the day. Then, in the next moment, he would "realize the true facts."

Through August and September, Newell took up Hattie's post in the kitchen and wrote the weekly letter to Convers. Convers replied as often as he could, but the wind had gone out of his letters home. Instead of telling the story of his life, he now accounted for his days. Gone the long tracts on his struggles as an illustrator, the manifestos on art, the catalog of memory and feeling, the pulpit and the soapbox, the sermons and brickbats.

What was left? Looking at his book illustrations in the light of his mother's death, he noticed "how little I have expressed the *true me,* and how

much there is of *me* to express." His mother had meant so much to him. How could he have failed to reveal his feelings for her in his best work?

Determined to right the wrong, N.C. unleashed himself on paintings that marked, he believed, "the beginning of more important self-expression." Between 1925 and 1929 he painted *The Harbor at Herring Gut* (1925), *Untitled (lobsterman)* (1927), and *My Grandfather's House* (c. 1929) and in each case proudly called this kind of work "a canvas of my own." To the contrary, he was now painting in the style of Russian folk artists, the latest in a series of styles he had adopted for easel work. It was the same old sabotage. He deliberately intended these paintings to be taken as statements of his most personal feelings, yet he left out or deflated the very pictorial elements that made his canvases most his own. In his narrative pictures Wyeth routinely devoted as much as half and up to two-thirds of the painting to complicated atmospherics. Great blue domes dominated by well-modeled cloudbanks define N. C. Wyeth, yet in the canvases he now presented as "his own," he reduced sky to inches, clouds to cookie cutouts, sunlight to experimental "prisms."

Wyeth believed that when he painted as a real painter, his "tendency to nostalgic meditation" was the "strongest sensation" he had to work with. Nostalgia, he wrote, "is a personal experience I hallow as another might a religion."

But nostalgia worked on him as it had on his mother and grandmother. It blinded him to what was real, bound him to a single idealized image, turned him cold. Nostalgic sentiment gives the human figure in works like *Portrait of My Mother* (1929) and *Walden Pond Revisited* (1932) a forced, wooden quality. In these self-conscious attempts to make works of art—Wyeth considered *Walden Pond Revisited* his "highest form of expression"—there is a curious lack of feeling. The artist portrays his mother alone in her kitchen surrounded by baking supplies. He champions the unworldly, self-sacrificing part of Hattie's life and encourages the viewer to see her in light of her commendable activities, as a neglected and therefore noble figure, a martyr. But Hattie Wyeth is miscast as a saint. For this kitchen was also the staging area for nightly "attacks," in which Hattie fired off angry, self-pitying letters to Convers, literally sprinkling the pages with tears. In the portrait his mother is as faceless as a dummy.

He was painting her after death as if he felt guilty about how he had rendered her in life. For he had painted her in disguise in his best work. The shape and quality of his mother's face in the 1929 *Portrait of My Mother*—the high, craggy cheekbones, the dark hair pulled back behind the nape of the neck, the strong chin, the very *eyelessness* of the face—are first found in the 1911 *Treasure Island* masterwork *Old Pew*. The hand that holds the

baking tin in Hattie Wyeth's kitchen is the same hand that holds the blind man's flailing stick. Pew's outstretched, clutching fingers can be seen at rest beside the rolled dough. With the detailed rendering of 284 South Street in the background, *Old Pew* is the artist's least labored, most direct expression of his mother's actual life. *Old Pew* portrays precisely the figure we find in Hattie Wyeth's letters: moonstruck, groping away from the house on South Street, fighting for balance, blinded to others, making a mad lunge for her own Jim Hawkins.

He had already shed her—in 1902—left her there in front of his childhood home. No matter how often he returned, he had never been able to heal the wound. He had never faced her as she really was, not even when she was dying. Hattie Wyeth's true portrait had been painted as an illustration, a "practical" picture—N. C. Wyeth's first true fusion of forms.

THE EVENING OF October 22, 1925, his first birthday since his mother's death, he came down from the studio on Rocky Hill to find a full-fledged surprise party awaiting him in the Big Room at the Homestead. Carol had known how depressed he would be and had hoped to raise his spirits with old friends and neighbors.

He fled to his bedroom. Dazed, demoralized—how could he celebrate this day of all days, with his mother in the grave?—he wondered how he would get through the evening. "I just couldn't stand it," he recorded afterward. "I had to do something desperate."

Twenty minutes later N.C. rejoined the party, transformed. He had painted his face and put on a false nose. His hair, soaped, lay plastered on his skull like a ludicrous little cap. Heavy golf stockings shot up over his knees, and a pair of knickers ballooned absurdly high on his thighs. He wore a pink hair ribbon for a necktie and a too-small dress coat and vest. He looked the way he felt: grotesque.

He had turned himself into an illustration—more Tenniel, maybe, than Wyeth, but in later years one of his family would remark, "*That* is N. C. Wyeth. He was awfully good at covering himself up. He could go into masque very easily." Dressing up, N.C. explained to his father, "saved the evening for me."

Now that N.C. was home to stay in Chadds Ford, Newell again paid attention to Pennsylvania items in the Boston newspapers. That fall the collision of an automobile and a locomotive on the Pennsylvania Railroad caught his eye.

A branch of the Pennsylvania Railroad ran parallel to the Wyeth house on Rocky Hill; the Homestead was situated two pastures back of the tracks.

If not literally part of the property, the railroad had always been a part of the Wyeths' daily life. Chugging past twice a day, the train was "special, an event," Ann recalled. The Wyeth children knew the faces of conductors and brakemen, and they came to associate the sound of the locomotives' whistle with N.C.'s high, forceful voice, calling them indoors.

Newell wrote Convers, "It always starts a shiver in us when we read of any accident on that [rail]road down in that direction, and I trust all is well with you all." Newell, with his abiding faith in a universe governed by practicality, added, "It does seem as though there was no need of such collisions with all the systems of signaling the Rail Roads have at the present time."

Shoemaker's Children

IN THE FALL OF 1925—an unusually hot Indian summer in the val-
ley—eight-year-old Andy started school. It was a month since Hattie's
death, and within a few days N.C. had removed his youngest child from
class. The hot weather and the "excitement" had taken a toll on Andy's frag-
ile nerves.

Since early childhood Andy had been plagued by ill health. Most
alarming to his father was a recurrent sinus infection, which required that
N.C. poke medicine-soaked swabs far up into Andy's nostrils. N.C. regu-
larly slept in Andy's room, monitoring the boy's breathing. Even on holiday
he stood guard over Andy; when the family spent their summer week at the
New Jersey shore, he would not allow his younger son to swim.

Keyed up by his first days of school, Andy was unable to sleep. N.C.
decided to keep the boy at home and try again the following year. But the
next year Andy was tutored at home. The year after that N.C. reported to
his father that "Andy is showing phenomenal ability in drawing, which is
beyond doubt more than a phase." He predicted, "I may establish a man
Wyeth in my studio to carry on after all."

One day while looking for a pencil in his studio, N.C. discovered that
his supply had been taken. Calling it "a case of 'shoemaker's children,' " he
exclaimed, "By Georges with four children drawing almost *all* the time, it's
really impossible to keep pencils and paper on hand."

In nineteenth-century usage the phrase *shoemaker's children* meant that
the children of the shoemaker were invariably the last in the village to have
shoes. In the Wyeth household, however, the reverse was true, and the chil-
dren came first. The famous illustrator did without pencils so that his chil-
dren would be properly equipped.

Drawing, he had decided, was their talent, not his. "I'm afraid I shall
never be a good pen man," he concluded in 1920—in the midst of what was
actually a period of genuine success with pen and ink. As his drawings

in *The Mysterious Island* demonstrate, he had evolved into an impressive draftsman, especially of animals and the human figure. Despite the evidence, N.C. considered his pen and ink work clumsy.

He never let on that he saw the children as superior draftsmen. With a confidence that Andrew Wyeth would later compare to sleight of hand, N.C. kept his approval so well concealed that Andy grew up with a sense of having been overlooked in boyhood.

N.C. was determined to give his children the structured training that he felt he had missed. "I don't give a damn what you do in the future," he told them, "but I want you to know fundamentals." Another time he said, "I want you to learn to draw so that when you want to express yourself, you won't fumble."

The studio on the hill became their schoolroom as one child after another took up formal academic training under their father. Henriette had begun to use charcoal at age eleven, studying perspective and applying it to the basic solid shapes: sphere, cube, cone, pyramid. In 1925 Carolyn, age sixteen, followed suit. Hours were disciplined and regular. Charcoal blackened the children's fingers for months at a time. Their signed and dated drawings filled file cabinets. "Work," Paul Horgan noticed, "was the honor of that family."

Under their father they learned how to be literal and romantic at the same time. "Never paint the material of the sleeve," he instructed. "Become the arm!" He taught them how to feel emotion for things and to enter into the essence of an object. He taught them to empathize with an object "for its own sake, not because it is picturesque, or odd, or striking, but simply because it is an object of form and substance revealed by the wonder of light that represents a phase of the great cosmic order of things." He also taught them to allow past and present to coexist.

He himself loved to think of everyday objects remaining in their place in a household for twenty years. "The stain round a thumb-latch may look shiftless or unclean to some," he wrote, "but how much it means to me." The sense of identification was so strong that when beloved things were moved or altered or destroyed, he felt as if he himself were being torn apart. "My affections are so much alive in personified objects and these objects are so acutely identified with those dead and living whom I love, that, like the mutilation of my own body I suffer continual torture," N.C. wrote in 1927.

N.C. worked seven days a week, but unlike his father he integrated his children and his work. "It was ideal," said Nat. "Father was right there in the studio."

"He wanted people to be working," Ann Wyeth recalled. "I used to feel

ashamed when he saw me reading movie magazines. I didn't want him to catch me. He never said anything about it but I didn't feel right—that was light stuff."

The studio gave N.C. an unusual degree of control over his children's lives. Its clifflike front and monumental Palladian window loomed larger than the house itself. In many ways the studio was the center of family life. Even the nonpainters among his children became N.C.'s apprentices. Ann brought musical compositions for his approval and frequently spent whole days in the studio posing for her father. She had grown into the talent her father had early on recognized. At five she had regularly awakened N.C. "at dawn to the music of her humming." A year later he nicknamed her Beethoven for the quality of sternness he saw in Ann's broad brow. By sixteen Ann had begun serious musical training, studying with private instructors. She practiced at the grand piano her father bought for her and in 1931 gave her first recitals. N.C. was "always very supportive," Ann later recalled, "but afterwards he'd say, 'Well, now, we'll see what you do next.' It was never the end. He always expected more."

On Ann's nineteenth birthday—March 15, 1934—she auditioned one of her piano compositions for the celebrated Leopold Stokowski, conductor of the Philadelphia Orchestra. That December, at the Academy of Music in Philadelphia, before an audience "some 5000 strong," Stokowski performed Ann Wyeth's first orchestral piece, *A Christmas Fantasy,* in a program that included Tchaikovsky and Wagner. With her brothers seated beside her in the audience and her parents looking on from chairs in the stage's right wing, Ann received a thunderous ovation.

Summoned to the stage by Stokowski, she bowed. "The reception was deafening," N.C. wrote afterward. "I met Ann in the wings as she left the stage. She fell into my arms sobbing. The applause was renewed and a voice called 'Go out again, quick! They're calling for you again!' But Ann heard nothing. I shook her by the shoulders, sharply, told her to brace up and go. She took one long snuff, wiped her eyes with both hands and bounced to the stage again. This time Stokowski took both her hands in his and the audience cheered."

In December drawing and shopwork accelerated as the Wyeths made things for one another. Nat had developed his talent for designing and building. At twelve he presented his sandpapered woodwork—model ships, quarter-scale ladderback chairs—for his father's approval. "Nat's benchwork is quite remarkable to me," N.C. wrote. Nat's latest boat, a skiff, was "as true

Ann at the piano, early 1930s. NCW's *Cannibal Shore* hangs behind her.

and fine a model as one could wish for." But as often as not N.C. would send Nat back to his bench demanding—and getting—better results.

For Christmas 1927 Nat built Andy a castle that N.C. helped paint in such realistic detail that he added urine stains to the castle wall, explaining, "That's where one of the lazy guards had to go to the bathroom and just let it go out the window." Nat and N.C. collaborated on small pieces of doll furniture for Ann's collection of dolls.

To all of them N.C. was a "mentor in general awareness." He rarely talked about aesthetics or technique, instead urging his children to know the world. He might suddenly lead them outdoors to examine a tree or the light in a field. Back inside he would fling open William Rimmer's *Anatomy* to clarify a point and then use the works of Velázquez, Rembrandt, Vermeer, Constable, or Segantini to show that in all great art there is a vast store of technical knowledge from the world itself. "A thing done right," he told them, "is done with the authority of knowledge."

Basic training, Wyeth style, could be severe. Andrew would never forget seeing "grown men come out of the studio pale after his criticism." Scold-

Nat, 1923.

ings, tongue-lashings were the least of it. N.C. used his authority to cut to the heart of a student's character. The flaws in a painting exposed weakness in the student's personality. In Peter Hurd's canvases he detected laziness, a lack of intensity. N.C. suspected that if someone did not come down hard on Hurd, he might try to get by on his charm.

N.C. was a stern drillmaster. He watched his children's progress with flashing eyes. No sooner had Carolyn let her charcoal go unsharpened than N.C. would glare over the top of his glasses. "Carolyn," he would call out, "that looks as dull as the devil." He commanded her to work on her drawing until it satisfied *him*. She seldom spent less than a month on a single draw-ing, sometimes as long as two months. Every morning N.C. would order her, "You get to work on that."

He was especially hard on Carolyn. Whereas he prodded Henriette and challenged Ann, he bullied Carolyn. "Maybe I was some part of him he didn't like seeing," she later suggested. "We were alike in many ways." Twenty years earlier Convers had told his father: "I have *always* felt that you have never quite understood me because I never expressed myself clearly."

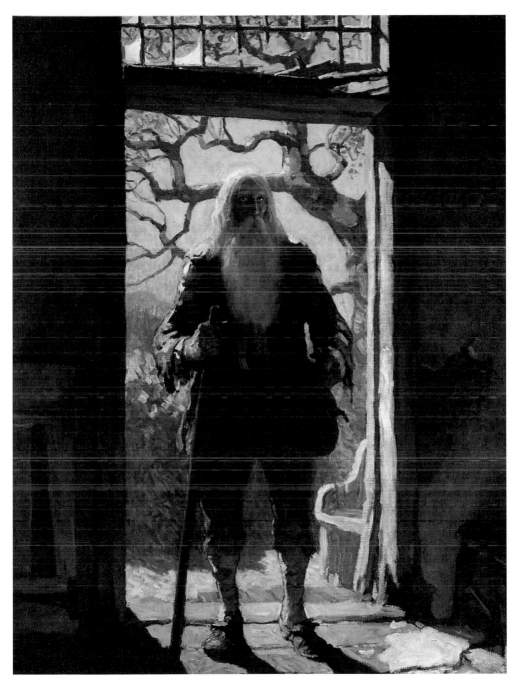

*It Was with Some Difficulty That He Found His Way
to His Own House*, 1921

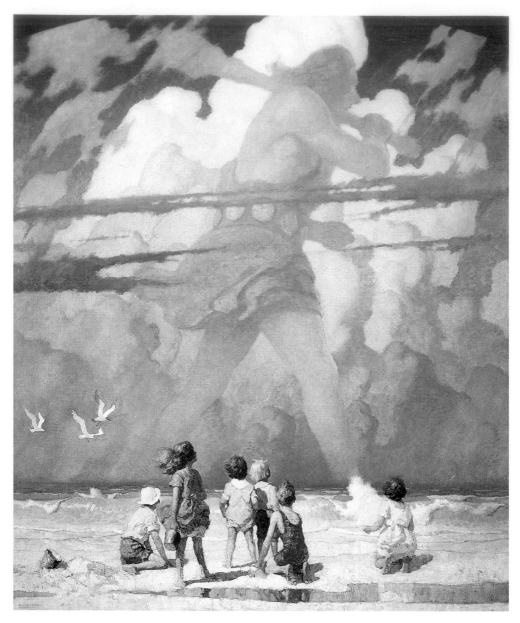

The Giant, 1923

My Mother, 1929

Still Life with Iris and Oranges, c. 1924

Harvey's Run, c. 1912

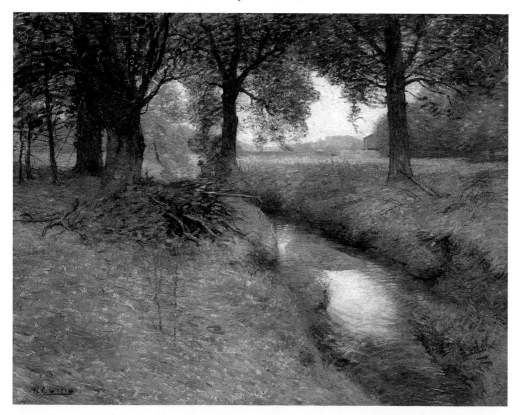

Now N.C. lectured Carolyn as Newell had lectured him. "Think clearly," he constantly exhorted her. "Think *clearly*, Carolyn."

When a student entered the professional part of his or her work, N.C. raised the bar higher. His critiques "cut like a sword through butter," Henriette remembered. Taking her brush, he painted corrections directly on the canvas. Once he repainted the entire background of her painting as she stood behind him, tears running down her cheeks. Another time, while critiquing one of Carolyn's paintings, N.C. took a piece of charcoal to the fresh paint on her canvas and corrected the proportions of an apple tree. Carolyn was thirty-five years old. The next day she restored the picture to the way it had been, but she never faced her father and told him he was wrong.

WITH HENRIETTE winning student prizes at the Pennsylvania Academy of the Fine Arts, with Carolyn drawing under her father's eye, with Nat a day boy at Swarthmore Preparatory School and Ann taking private instruction in piano, Andy drifted along the "outskirts of the family." He liked to linger on winter afternoons in the studio's unheated vestibule. Studying the black-and-white steel engraving of Switzerland hanging by the door, he would imagine himself back in the lost land of Thun.

In the storeroom off the vestibule, Andy examined stacks of his father's past canvases, learning from the illustrations. He loved N. C. Wyeth's pictures and felt that through them he knew his father in a different way than his sisters and brother did. Alone among the children, Andy studied the work, returning to it day after day, year after year as he grew up.

He never attended school. Mornings he was tutored by Chadds Ford neighbors. Still too young for formal training under his father, Andy continued to draw. First it was English grenadiers and pirates that filled his drawing pad, then crusaders in armor. In 1925, when Andy was eight, N.C. took the children to see King Vidor's new silent movie, *The Big Parade*. Andy would long remember his father's "vibrant enthusiasm when he told us about it." Starkly realistic, *The Big Parade* was a war movie that really looked like war, and Andy would never lose his first ecstatic feeling for it.

The Great War intoxicated the child born in 1917. He pored over sheaves of sepia-toned images from Sunday rotogravure sections that N.C. kept in the studio vestibule. He played with a collection of lead soldiers and made drawings of entrenched doughboys going over the top, advancing across No Man's Land. N.C.'s earliest boyhood drawings of the Spanish-American War had been stiff and conventional. Eager to please, he had wanted to get everything right. Andy's drawing was fluid, wild. Bombs

burst across his pencil drawings in splashes of red watercolor. N.C. envied Andy's carefree hand, his wide-eyed gaze. "How wonderful it is," the father marveled, "to do things with no traditions or sophistications of the past to bother one!" He envied Henriette and Carolyn no less.

Henriette had become the professional equal N.C. had hoped Stimson would be. He credited her with "lifting me clear of threatening stagnation." She had "unlocked a potentiality which I never knew I had," he wrote. N.C. had never let Carol replace Hattie; now he would hang on to Henriette.

She had begun to pull away. In early January 1927, while N.C. painted murals for the National Geographic Society, he wrote to his father announcing Henriette's engagement to Peter Hurd. "It's been an old story for us for a year," he said, "so it's no shock."

For a year Henriette had been expanding her social life and painting portraits of fashionable people. Her apprenticeship over, she was at nineteen a commissioned portrait painter, an "enchanting, small creature" whose calendar included supper dances given by one of the oldest, richest families in America. In the social system of the valley, the du Ponts exerted a solar pull. On their hilltop estates around Wilmington, life was clannish, insular. Every great house was "filled with relatives and friends and they all [knew] each other," observed Henriette's friend the novelist Paul Horgan. "They ride together—everyone keeps horses, and they play tennis and polo at *home*." In the leafy, sun-streaked days of summer, when the Brandywine stood flat and still as a castle moat, the valley reminded the novelist of a royal court. "Henriette," he added, "had become a dancing member of that court."

Limousines arrived at the Homestead at all hours to pick up Henriette Wyeth. She went to parties around Wilmington, dancing until dawn with people whose values were the antithesis of what N.C. believed an artist's ought to be. The "disease" he had feared had now struck. Henriette had become sophisticated. She had begun to foxhunt. Bills from Bonwit Teller appeared in N.C.'s mail—ball gowns, jodhpurs. His face would turn white as he confronted Henriette with the latest frill. "Well," she would reply, throwing a look at her sister Carolyn, "someone in this family has to dress right."

"He must have wondered about me as a painter," Henriette later ventured, "—whether I was really good or not." Unsure of herself in 1927, she still brought her work to N.C. "I begged for criticism," Henriette recalled. N.C. gave it to her. He had too long indulged her with cash—padding Henriette's trips to the ballet with fifty-dollar bills—for money to remain the real source of power in their relationship. Withholding approval of her work had become his way of controlling her. "As soon as a limousine

appeared to whisk her off to another Wilmington party, he'd lost her," said Henriette's daughter, Ann Carol Hurd. "But as long as he was critiquing a painting of hers in his studio, he had her."

Late in life Henriette would realize that she had needed some means of escape from her father. "I was so relieved when I had a party to go to, and he was so annoyed with my social life, but I couldn't help it—I thought it was marvelous."

With men she acted the reckless flirt. The belle of Chadds Ford, Henriette had no sooner taken up with Peter Hurd than another suitor had appeared on the scene. John Harriman, grandson of the late Edward H. Harriman, the railroad magnate, was willing to divorce his wife to marry Henriette. Hurd demanded that Henriette make up her mind. He had already been so maddened by jealousy that when William E. Phelps— "Uncle Willie"—the Wyeths' friend and valley neighbor, appeared to be making inappropriate advances to Henriette, Hurd socked him in the jaw, breaking his glasses and incurring N.C.'s wrath.

N.C. lectured Henriette continuously about Harriman. It was immoral to carry on this way. She was being heartless, unfair to Hurd, who expected to marry her. This was not sober behavior for a talented artist. Henriette, apparently, agreed. She dumped Harriman, resuming her engagement to Hurd.

N.C. admired Henriette for putting her real feelings for Hurd before the "blinding glamour" of Harriman's millions. But when it came time to announce Henriette and Peter's engagement, N.C. felt oddly disappointed. He liked Hurd but could not reconcile himself to the loss of his daughter.

Marriage, N.C. said over and over to Henriette, must not impede her painting. She must not allow her supremely rational self to be blinded by passion. Once engaged she must wait at least a year, perhaps two, before marrying. She must first establish herself in her own right as a painter.

It was exactly what his parents had told him. Just as his parents—and, at first, he himself—had seen Carolyn Bockius as the chief impediment to his life as a painter, N.C. imagined Peter Hurd responsible for Henriette's lapses from painting into high life. Noticing a decline in Henriette's health and vitality through the spring of 1927, he summoned Hurd to the studio for a talk one Sunday afternoon late in June.

PETER HURD admired N.C. to the point of emulation. N. C. Wyeth was the one man in Hurd's life whom he respected without question. He was therefore surprised to learn in the studio that Sunday that N.C. was wrong; Peter and Henriette were no longer carried away by passion alone. "The first

flush of our love has been replaced by a tranquil understanding of one another," he explained to N.C. that night. "Where once in our meetings a great degree of nervous force passed between us, there is now the delight that comes in the companionship & mutual sympathy of two people who are genuinely devoted to each other."

To dramatize the point, Hurd cast his feelings in terms to which he knew N.C. would respond. Hurd had grown up deprived of his parents' love; his father was uninterested in Peter's hopes to be a painter; his mother, a cold, bitter woman, had been cruel to Peter, sometimes violent and abusive. "A great deal of what I now seek & find in Henriette is a maternal love," he admitted. But since Henriette was notably unmaternal at this time in her life, it is equally certain that the maternal figures to whom Hurd had attached himself were Carol and N.C.—Ma and Pa, as Hurd called them.

In Chadds Ford, Carol Wyeth had embraced Hurd from the moment he first walked in the door. She was fond of saying that Peter Hurd could do no wrong. All the Wyeths had fallen in love with Peter, and he with them. "Christmas at Chadds Ford," he wrote, "is a wonderful combination of Dickens, Irving, and Alcott all plentifully spiced with Père Rabelais. I thoroughly enjoyed it this year."

Peter Hurd was marrying a family, and N.C. could not have been happier to hear it. Indeed, Hurd now offered his hand to N.C. in a special bond of kinship: "I know how you would welcome in anyone, particularly in one near you in age and in advancement, a strong bond of sympathy—How you thought for a while you had found such a person in Harl, and the subsequent realization of his limitations."

Hurd had introduced Harl McDonald to the Wyeths. A talented young composer, McDonald had begun his musical career six years earlier, at age twenty-two, premiering his own piano concerto with the San Francisco Symphony Orchestra. McDonald had studied in Leipzig, lectured in Paris, and, in 1926, joined the music department at the University of Pennsylvania. Even before taking on Ann Wyeth as a private student, McDonald came out to Chadds Ford to play recitals for the family. He had an enthusiastic, muscular manner (he'd been a welterweight boxing champion in California) and played Beethoven and Sibelius with a command N.C. could only dream of.

Here, N.C. imagined, was the "one" he had been searching for all his life—the ideal other half, in whose perfect sympathy he would be understood as the artist he was meant to be. McDonald, too, had struggled to find time among his "lesser" commitments to accomplish his "real" work as a composer. In addition to teaching at the university, McDonald worked as a choral conductor, a private music teacher, and a researcher for the Rocke-

feller Foundation in acoustics. He sought N.C.'s advice on career matters. He let it be known that he thought N.C. a great man. As the relationship deepened, McDonald in 1931 dedicated the first of his two piano trios to N. C. Wyeth.

In 1935 McDonald was offered the chairmanship of the music department. Should he accept? In 1939 the question arose again: Should he take on the job of general manager of the Philadelphia Orchestra?

N.C. argued against both opportunities. He preached the gospel of the independent artist. McDonald *must* devote himself to composing. No less an extremist than his double, McDonald each time accepted the job and each time threw himself into the work. Afterward, whenever he appeared in Chadds Ford, the music department and the orchestra were all he talked about, embroidering stories about the faculty, the musicians, their love lives and intrigues. "I know that must have bored my father," observed Ann.

It did; N.C. constantly harangued McDonald to give up his day jobs and devote himself to his higher calling. In fact, McDonald went on to become a prolific and much-performed composer; by 1938 the Philadelphia Orchestra had performed and recorded four of his five symphonies. Without giving up any of his jobs, McDonald would receive performances and recordings of *San Juan Capistrano* and his popular choral work, *Lament to the Stolen*, composed at the time of the Lindbergh kidnapping. At the Homestead, however, he felt browbeaten by N.C.'s sermons—wasn't N.C. really preaching to himself? Abruptly they fell out.

Now here was Peter Hurd, offering himself as McDonald's replacement. After the Sunday talking-to in the studio, Hurd told Mr. Wyeth, as he would go on calling N.C. for another ten years, that he hoped "one day when the difference in our years and experience has lessened I will fill this niche. Meanwhile, I regard you with a reverence and affection such as I feel for no other man. Transcending the tepid admiration of friends, my feeling toward you makes me say that I can brook no thought of rift or misunderstanding between us two."

ON FRIDAY, June 28, 1929, Peter Hurd married Henriette Wyeth in the same Unitarian Church where N.C. and Carol had said their vows.

N.C. attended the wedding in good spirits. He felt he had "successfully suppressed most of [his] selfish feelings in the matter." He had not, however, let go his apprehension that marriage would disrupt Henriette's painting. He feared that she would live in her husband's shadow and had more than once warned Henriette that she would be "doing nothing but washing

Harl McDonald (1899–1955).

Henriette in her studio in
Wilmington, 1928.

dishes and scrubbing floors." He worried that she would sacrifice too much to children—it was in her character. Like N.C. she was absolute in everything she did.

For N.C.—for all the Wyeths—the day was "a high glorious moment," Paul Horgan recalled. At the reception, twelve-year-old Andy got drunk on the dregs of everyone else's champagne. The couple left immediately for their honeymoon. They spent the summer in a cabin at the head of Ruidoso canyon in the Capitan Mountains of New Mexico. By July, Henriette was pregnant. The Hurds decided to return east so that N.C. and Carol's first grandchild, Peter Wyeth Hurd, would be born in Chadds Ford.

Meanwhile, with Henriette gone, N.C. sought approval from the other children. The ritual of calling the family to his easel had become more and more important. "When he'd finish a picture," according to Nancy Bockius, "there'd be quite a little ceremony: He'd say, 'We'll all go up to the studio.' " Then he would walk everyone up to the studio, sit them down in front of the easel, and unveil the picture. If it were greeted in silence, he would often talk everyone through the painting, explaining what he had been after.

He resisted showing his work outside. The old fight to "shake the dust of the illustrator" from his shoes and emerge into the art world as a "real" painter still found him begging off exhibitions on the grounds that his work as a painter was not yet "worthy." He might send an occasional landscape or oil portrait to the Pennsylvania Academy of the Fine Arts or to the Corcoran Gallery in Washington.

But Wyeth himself was no more sure of his work at the end of the 1920s than he had been at the start. His earliest conflicts remained unsolved. "Professionally I am at a positive standstill," he wrote in 1926. "It is a precise warning of what lies ahead of me for heaven knows how long!" He summed up his latest work as an illustrator in much the same terms as his earliest: "In each case I have loathed the thing done, and therefore have suffered the torments of hell." Unwilling to settle for narrative painting, he went on thinking, as he had in 1914, that he could have made a name for himself as a landscape painter "had I not *bitched* myself with accursed *success* in *skin*-deep pictures and illustrations!"

A group of art students, visiting his studio one day in 1929, asked to see the original canvases for *The Odyssey* and then looked on as the famous illustrator showed them *Polyphemus, the Cyclops* (1929) and *Odysseus and Calypso* (1929). Wyeth imagined from their silence and their "sniffing" that the students were sneering at his work, and he flew into a rage.

Before the students left he turned around a canvas for them to see. It was *Portrait of My Mother*. As he afterward told Peter Hurd, the students "figuratively began to bootlick, craving to see more of such. But I closed the

show, being careful to insinuate that I had dozens such efforts facing the wall (which I haven't of course!)."

Forever split between illustration and easel painting, with the occasional mural and the odd advertisement, he had become so experimental that even his illustrations no longer looked like N. C. Wyeth. The man who had painted *Treasure Island* in the white heat of sixteen weeks had taken ten years to sort himself out over George Herbert Palmer's *Odyssey of Homer.* He made three false starts, destroying an entire set of canvases, a measure he had rarely taken in earlier years, even at his most frustrated. With its blatantly borrowed modernistic influences, its stiff, prismatic treatment of form and color, the Wyeth edition of the *Odyssey,* published by Houghton Mifflin in 1929, confirmed how disgusted he had grown with himself as a "storybook painter."

HIS LONG LIFE as a son was drawing to a close. Newell Wyeth, at the age of seventy-six, had suffered attacks of angina. The younger children, Ann and Andy, along with Stimson's son, John, had loved to run and throw themselves at "Aunt Pa." But by the summer of 1929, the old man's heart had grown frail.

Newell's decline coincided with the passing of an age. All through the 1920s speculators had been dividing dilapidated farms into house lots for modern homeowners. Everywhere you looked in Needham, barns had collapsed, tools had rusted, fields had gone back to spruce and alder. The world Newell had long ago wished on Convers was finished. Yet more than ever N.C. felt sure that he and his children still belonged to another, earlier, unpolluted time. Comparing Henriette with Andy, N.C. had predicted as recently as 1927 that while Henriette would become the family's great painter, Andy, then ten, would "probably end up as a farmer."

On July 29, 1929, Newell's heart stopped. At five past five in the afternoon he died. The Wyeth brothers gathered with friends and neighbors, the last of South Street's fossilized farmers, to honor Andrew Newell Wyeth II. One neighbor, Miss Adah G. Fuller, whose voice Newell had long admired in church, sang "Abide with Me." N.C. and his brothers buried their father not among the Wyeths at Mount Auburn Cemetery in Cambridge, nor in Charlestown, where Newell had spent every day of his working life, but in Needham, under the Zirngiebel family stone with his wife.

N.C. painted a final portrait of his father from memory. He showed Newell not in the town clothes Newell had worn every day to catch the ten-to-six train into town but in blue overalls. Newell's death certificate gave his occupation: *Farmer.*

. . .

FUNERAL FOLLOWED FUNERAL in Needham. Uncle Denys Zirngiebel died a month after Newell. Mary Glancy hung on another two years. The Stimson Wyeths moved to another house on South Street, which meant that N.C.'s birthplace would have to be sold.

A certain myopia set in on South Street. Stimson Wyeth would teach modern languages in the Boston public schools for another twenty-five years; at home he assumed his father's role of the reserved, reliable Yankee doing his duty to village, church, and family. But Stimson was never the same after 1925. Mama had been "connected," he realized, "with my whole scheme of things." And though Constance, his wife, "replaced my mother," becoming an "inspiration in all my undertakings," Hattie dominated in death as she had in life.

"Whatever I have been able to preserve of equanimity & serenity," Stimson wrote, "is due unquestionably to her heritage more completely passing into me; just as the hearing of a person becoming blind is so much the more acute."

PART FOUR

Pa, 1930–1945

Colony

B Y 1930 N. C. Wyeth looked noticeably older, grayer, heavier. He fought to keep his weight at 230 pounds. Worry lines seamed his forehead. His eyes flashed with interest but more often looked dark and sad. One frequent visitor in the 1930s noticed that N.C. sometimes looked as if he were "beyond seeing."

"Papa is most horribly down two-thirds of the time," Henriette reported to Paul Horgan in November 1932. "The old, old story of having to do a certain amount of work that *pays*."

Returning to the house after a bad day in the studio, he would stomp into the Big Room and play a symphony on the windup Victrola. For an hour or two each evening he would make a show of keeping his troubles to himself. He hesitated, he said, "to risk bothering anybody with depressed feelings," adding, "I'm not one to fake cheerful pretenses when I haven't got them." He never sought treatment for depression, never took any medication stronger than Bromo Seltzer. "It was his old-fashioned grounding," one family member said. "Psychiatry wasn't for him, it was for crazy people."

Sometimes he trudged upstairs and took a movie fan magazine to bed. Usually he just leaned farther into the music. The family would find him sitting in the dark, his head buried in the Victrola. "Naturally, it worried us," Nat said.

"You could see that the man was burned out," remarked Carol's sister Nancy. "I can remember him coming down from the studio, throwing his brushes into the laundry tubs where he washed his brushes, and saying, 'I'm going to stop this. . . . But then we'll have to change our life.' "

The 1930s were palmy days at the Homestead. The Great Depression, characterized elsewhere as the Big Bad Wolf, never showed its teeth at the Wyeths' door. At a time when tens of millions of Americans had no income at all, N. C. Wyeth's earnings grew—$12,000 per mural and $5,000 for a set of illustrations. His publishers' contracts gave him complete control over his original paintings.

Among the rock outcroppings on which he had built his house, there were visible signs of N.C.'s liberation from penny-pinching parents. A tennis court, scandalous on South Street, had been built behind his studio after his mother's death. Next came a croquet court, installed in 1930, a year after Newell died, and equipped with a "very swell English set of mallets." The old Buick had been joined by a showy, four-door 1929 Cadillac with a stylish dove gray cabin and running boards. A maid and butler team now appeared in uniform. Paul Horgan, a family intimate in those years, observed, "They didn't live ostentatiously, but they did live richly."

The desire to recapture paradise in Needham had been replaced by an impulse to colonize Chadds Ford. "He wove a great net of possession around his children," said Horgan of N.C. New wings were added to the east end of the Homestead and to the schoolhouse that N.C. had bought for Henriette and Peter Hurd at the corner of the property. Onto the studio he added a skylight made of forty panes of glass, giving the crown of Rocky Hill the look of a Zirngiebel greenhouse.

No longer paced by Needham and his endlessly repeatable childhood, N.C.'s whole experience of life was finally concentrated in one place at one time. Like Crusoe on his island, he had to live here now: the past was beyond reach. His children had called him Papa all through their childhoods; in the 1930s a shorter version came into use: Pa.

Inside the enlarged Homestead, Pa's solid, bricklike presence announced itself in every room. Each morning he awakened the household with a thunderous outpouring of chords at the piano in the Big Room. He cooked breakfast, indulging Nat and Andy as they added sliced fruits to pancake batter—oranges, bananas, even grapes—and experimented to see who could eat the most "barely-cooked, liquid pancake possible." He took pleasure in watching them eat. "He always made sure the children ate well," Carol would later recall.

At evening meals he presided at the head of the table. The dining room was narrow, paneled with oak. Heavy beams hung low overhead. Their faces flickering in the candlelight, the family squeezed around the long refectory table. "Everyone felt close to everyone else," Horgan said. Meals were keyed to opinions, prejudices, convictions, contests, jokes. "The main thing [was] to feel very strongly about things," Henriette recalled. "Not to be lukewarm. Wade into it and make a big mistake because you learn that way."

At the table N.C.'s moods prevailed. He could be playful and animated, more often gloomy and tense. Nat remembered that if N.C. "came down from the studio and had a lousy day, it set the tone for the evening." He kept his feelings "tightly bottled," Horgan recalled. "Pa is so austere and withdrawn when he's deeply troubled," noted Henriette. Ann and Carolyn

NCW with his brother Nat and the Wyeths' new 1929 Cadillac.

The Wyeths' dining room, Chadds Ford, 1930s.

would work to pull him out of his mood, showering him with hugs and kisses. He always seemed to rebound. Surrounded by a sympathetic audience, Pa poured out the day's tensions, his hands gesturing as he held forth.

After supper he led the way into the Big Room. A quarter century later here was the Stickley furniture from Convers and Carol's early married days in Wilmington, the bust of Beethoven on the windowsill, the family cameos on the chimneypiece, and all around the room the embrace of bookshelves and uncurtained windows. N.C. had forbidden curtains when the house was built; he wondered why a perfectly good view had to be covered up with "petticoats." Ever after the windows of the Big Room, the uncovered breadth of them, seemed to everyone "so much like Pa."

Gathered around the Mason & Hamlin piano, the family would listen to Ann's latest piece. Her father's daughter, Ann lived to please Pa with her music. Every year at Christmas Ann sat at the piano and played *My Grandfather's Sleigh*. Based on one of N.C.'s landscapes, it was one of Ann's finest compositions.

Some evenings he would read—Tolstoy, Emerson, Goethe; or whatever he was going to illustrate next; or Paul Horgan's latest effort in *The New Yorker*, which everyone would pass around and discuss. Schooling himself as an illustrator, N.C. had educated himself. He took an autodidact's pride in his reading and allowed it to exert considerable influence on his moods. In August 1934, Peter Hurd noted that *Death in Venice*, Thomas Mann's novella about an aging artist who falls in love with an adolescent boy, had "had a deep effect on Henriette and her father, the latter becoming terribly depressed for several days after reading it and ending up by re-reading it."

After supper Carol read the *Ladies' Home Journal*, put away her china, folded her monogrammed linens. Dowdy, lovable, with silver hair tucked in a bun, Carol had become matronly. From a slender beauty with a neck like the stem of a tulip she had changed to a large, ample woman with a double chin. Motherhood, the experience of her life, had left her feeling inadequate. "Mothers are so needed," she had written in 1904. By the 1930s she felt "totally useless." Paul Horgan remembered her as "the most self-effacing, self-deploring woman I knew." Among her gifted family, she saw herself as ridiculous; she would turn to a visitor, saying, "Look at them, they can all *do* something."

House pride was Carol's defense. She never learned to draw or paint or play piano; she showed people her things. Her top bureau drawer was a yellowing hoard of dried and dusty corsages from weddings past, loops of golden baby hair, mementos from the days of family glory when her grandfather had been president of the Jockey Club in Philadelphia and the Bockiuses had vacationed at Bedford Springs with President Buchanan. "She was

all conscious charm," Henriette said later, batting her eyelashes in imitation. "She was always delighted and sweet and amused. She'd die laughing— unless she happened to break one of her dishes."

Leaving the cooking and housework to servants, Carol increasingly occupied herself with appearances. She liked to see the wood trim on the Homestead cleaned and washed, gleaming white against the red brick. She would tell visitors how Mr. Stone at the bank in Wilmington had always said that her father was a "great addition to Wilmington society."

"And a 'great subtraction from the bank,'" went Nat's lifelong retort.

N.C. chafed under Bockius family myths. Over the years his contempt for Carol's family had grown. After the suicide of George Bockius in England in 1918, the Bockiuses had scattered and with them the apparatus of respectability. Three out of Carolyn's four brothers went to sea, George with the navy, Richard with the navy and the merchant marine, Robert as a career officer in the navy. By 1919, when the youngest, Nancy, entered Swarthmore College, the diaspora was complete. In the fast-moving 1920s the nomadic Bockiuses became the antithesis of the homebound, archivally inclined Wyeths. "We moved about so much that the accumulation of family mementos was impractical," said Nancy. Annie Bockius, widowed, insolvent, followed her brood around the world. With children and grand-children spread from Connecticut to California, she was constantly "on the wing," making extended visits to one household after another—"moving my tent," she called it.

N.C. took it as his duty to be the voice of reality. "I do my best to prevail with sound reasoning," he said, "but nothing seems to recompense Carol for her hopeless mother and artificial and trifling family. She feels it so deeply that it is becoming a menace to her happiness."

He, in turn, had never trusted Carol to be sensible or to manage her own affairs. "He treated her almost like a daughter he had to take care of," said Henriette. He kept tight control of finances, putting only enough money into Carol's account so that she could pay minor bills. He made every decision for her.

Into the thirtieth year of their marriage, they were still Carol and Con-vers. He never had a pet name for her; she occasionally called him Old Sweet. In their letters they followed Peter Hurd's lead, calling one another Pa and Ma. They hated to be apart. During Convers's infrequent research trips, they wrote affectionate, wistful letters, boasting to each other of the weight each was losing in the other's absence.

They shared the same cramped, canopied double bed in which Carol had delivered the children. Once they removed the bedroom door so that the two adjacent rooms would function as a suite. "The intention," N.C.

explained, "was that I should occupy the bed in the spare room so as to give us *both* more room." The experiment lasted one night. "Ma comes with me!!" he insisted.

The second floor of the Homestead was surprisingly small. Convers and Carol Wyeth were big people. Yet for thirty years they shared one bathroom—one face bowl, one toilet, one tub—with five children and sundry guests. The bathroom door was rarely closed. Bedroom doors also stood open. Visitors were mainly Wyeths or far-flung Bockiuses. Uncle Dick Bockius, a merchant marine officer—N.C.'s model for Captain Harding in *The Mysterious Island*—would stay a few nights at the Homestead between long ocean voyages. Annie Bockius, back from China, would talk the ears off anyone who would listen to embroidered tales of Old Cathay. Uncle Nat—N.C.'s younger brother, by now a veteran automobile engineer—would have arrived in the middle of the night, and the children would awaken to the sight of some new or experimental car parked outside the kitchen door, "streaked with mud from end to end after a furious drive." In the afternoon Uncle Nat would take the children on a horse-drawn wagon out into the pasture. Ambling around for the fun of it, he would call out the cackling cry of the old fishmonger on South Street: "F-i-i-i-s-s-s-h!"

The Wyeths rarely left the Homestead. When they socialized in the valley, they went as a family. Engraved invitations from the important houses arrived all year round: recitals at Longwood, fireworks at Granogue, du Pont weddings at Dogwood, supper and dancing at the du Pont Biltmore "in honour of Miss Aletta d'Andelot Laird" or "to meet Miss Savely Sovine."

Keeping the wider world of princes and luxury at arm's length is both a Swiss and a Yankee tradition; N.C. sounded doubly puritanical when he grumbled in 1931, "They are a backward lot—these Wilmington people, with lots of money, and a growing desire to know more about things in the art world." But he went to their celebrations and traded on the prestige of their newfound interest in painting, if not for himself then for his children; and he poured on the charm. Ann recalled that "Pa was awfully good about going out. He was never mean or begrudging or disgruntled. He did it for all of us."

He preferred familiar faces, Chadds Ford neighbors. The Wyeths maintained lifetime ties with village figures such as country doctors and schoolteachers, elderly farmers and maiden aunts. They championed the work of undervalued local painters and engaged the valley historian, Christian Sanderson, to tutor the grandchildren. They saw themselves as permanently local. They had no vacations; when they took a break from life at home, they merely removed themselves from one world apart to another.

Each June, as the first summer heat lay heavily on the hayfields, they broke camp, loading trunks and paint boxes and pets and supplies onto the night sleeper bound for Boston and the cool, foggy seacoast of Port Clyde, Maine. There they remained until October. But the pattern of leaving one permanent home for an equally ritualistic homecoming at another was not enough to solace N.C.'s ferocious separation anxiety. Each year as June approached, he found the breakup of the Chadds Ford colony hard to reconcile.

Sometimes his commissions mounted so high that he stayed behind to finish a job. Carol would go on ahead, leaving N.C. "feeling a little queer, almost a little alien" as he "got a good taste, not a pleasant one, of what it would mean to be without a family, and especially," he told Carol, "to be without you."

In Carol's absence one summer, he became depressed. Work was at a standstill. Ann and Henriette quickly stepped in to fill the breach, bringing lunch, making his bed, inviting him to supper. Thoroughly attended to by his married daughters, he could work again.

N.C. had not lost Henriette to Peter Hurd as he had imagined he would. In the ten years since marrying Peter, Henriette had moved all of a few hundred yards. Forestalling a permanent uprooting to New Mexico, where in 1934 Peter had bought forty acres on the Rio Ruidoso to start a small ranch, the Hurds rented a farmhouse in Chadds Ford. Fall, winter, and spring they used the schoolhouse at the foot of Rocky Hill for their studios and asked N.C. for regular critiques.

The arrangement put Hurd in conflict with himself. After the aridity and struggle of a New Mexico summer, he appreciated the damp luxuriance of Chadds Ford. He enjoyed the "lush opulence" of Wyeth life and the "feeling of security and safety" in the patriarchal den of Rocky Hill—"a feeling that here the struggle for existence is reduced." Stimulated and supported by Wyeth resources, he was at the same time appalled at his own weakness. "I feel much like a tadpole swimming dangerously near the open maw of a whale," he wrote in 1930. Feeling "overcrowded" and "surfeited with cocktail parties, deb parties, & dinner parties," Hurd would grow disgusted with himself as, with each finished work, the father-in-law he loved and admired would descend from the studio on the hill, stand at his elbow, seize his brush, and repaint his canvases.

N.C. dominated his students. Collaborating with Peter Hurd on book illustrations, he left a heavy imprint. Many of Hurd's illustrations—including *The Story of Roland, The Story of Siegfried*—were little more than secondhand Wyeths. In a 1928 Hurd edition of *The Last of the Mohicans,* Wyeth supplied his son-in-law with a pencil drawing for the warrior's face and pose

in *Discovering the Trail,* and it showed in the finished work. Hurd noted that his illustrations were "right in every detail but the signature!"

"This is not the way I want to paint," Hurd concluded, but all through the 1930s the cycle continued. In the wide open Hondo Valley, painting landscape, he could be his own man, he had elbow room; in Chadds Ford, overshadowed, he turned out illustrations on which, as often as not, N. C. Wyeth had made considerable "improvements." Realizing that he had "not yet struck any individual note in this work," and finding it "depressing to think of going on aping the Wyeth manner with none of the distinguishing verve of the original," Hurd tried again and again to pull away. He began a lifelong pattern of philandering, straying with younger lovers when he was out west and Henriette was back east. Each year both Peter and Henriette remained longer and longer in New Mexico, but each year Henriette returned to Chadds Ford, unable to break from "her abiding clan loyalty," as her husband put it. He was forever amazed at the "tremendous solidarity of the Wyeth clan." From September to May, Henriette had lunch with her father every day at noon.

On the occasion that Carol had to be away from the Homestead, Ann came over in the mornings to make Pa's bed and fix him breakfast. She regularly cut his hair. In 1933 Ann met John McCoy, a quiet, dignified young man from a valley family. The son of a Du Pont executive, McCoy had ambitions as a painter. He had gone to Cornell and painted in Paris. He quit the Pennsylvania Academy of the Fine Arts to study with N. C. Wyeth. To promote competition, N.C. matched McCoy with Andy in the studio. McCoy took his meals at the Homestead and felt immediately "like a member of the family." He and Ann started dating and became engaged. Ann was then eighteen; obeying N.C.'s wishes, the couple waited two years to marry.

On October 26, 1935, Ann and John McCoy exchanged vows in Wyeth's studio, standing in front of his altar triptych commissioned for the Chapel of the Holy Spirit in Washington's National Cathedral, for which Wyeth had posed the real-life bridegroom as the model for Christ's hands. Ann and John bought a farmhouse on forty acres and settled no more than a mile away from the Wyeth homestead. Throughout her marriage Ann doted on N.C. "Talk about competition," said Andy. "She was so bound up in my father that it was difficult for John."

Then there was Carolyn. Famously unwelcoming to outsiders, she believed that "outside blood waters the family down." With the sole exception of Peter Hurd, she resisted all new family members. As Henriette increasingly brought around fancy friends for cocktails and tennis and croquet, Carolyn found herself disaffected by high living. She despised anyone

Rehoboth Beach, Delaware, 1935. N.C.'s student John Willard McCoy II
the summer before John's marriage to Ann. Carol sits under the umbrella.

who would alter the family's original togetherness. "She didn't like it at all,"
Henriette said later, "and she accused the whole family of becoming very
artificial in their pursuits and likings."

It would take more than decadence to alter the Wyeths. For husbands,
each of N.C.'s daughters had chosen—Carolyn, too, would choose—a
handsome young man who had come into her life through her father's stu-
dio. Each daughter would conduct her marriage under N.C.'s wing, and
each would depend on her father in her career as an artist.

WHEN HIS FATHER had been dead a year, N.C. painted Newell into the
latest Wyeth edition of the Scribners Classics. He had hidden aspects of
Newell's practicality (indeed, the whole history of Wyeth resourcefulness
and Zirngiebel colonization) in the two work tales, *Robinson Crusoe* and *The
Mysterious Island;* Crusoe, like Newell, is the prototypical self-made man,
and survival is an enterprise like any other. In John Fox's *Little Shepherd of
Kingdom Come,* Scribners' most successful best-seller ever, Wyeth depicted
his father and son in a candlelit yet determinedly masculine scene entitled
*He Looked at the Boy a Long Time and Fancied He Could See Some Resemblance
to the Portrait* (1930).

That year he went still further with fathers and sons. While installing a large mural, *Washington's Reception by the Ladies of Trenton on His Way to Assume the Presidency of the United States* (1930), on the wall of the First Mechanics National Bank of Trenton, Wyeth narrowly avoided falling from a scaffold twenty-five feet off the floor. A sense of shock stayed with him all day. That night, in a dream, he found himself standing on a twenty-five-foot-tall scaffold overlooking the Brandywine Valley.

As N.C. stood on the dream scaffold, George Washington emerged from a woodlot to his left, riding a white charger. The uniformed general walked his horse up to N.C.'s level, then nonchalantly threw his leg over the pommel of his saddle so that he could have a chat with the artist. N.C. was dressed in his characteristic white shirt, white knickerbockers, black leggings, and high-topped tennis shoes. He faced Washington holding his paintbrushes behind his hip. Washington spoke in a Virginia drawl studded with "Yankee idioms" and a "burst of New England seaboard colloquialism" that reminded the dreamer of his father.

As artillery sounded and cottony puffs of white smoke bloomed on the dark hills, as shells burst close to a long column of infantrymen marching from left to right below N.C.'s scaffold, as the young French general Lafayette appeared in a nimbus of light off to the left, Washington began to narrate the Battle of the Brandywine, just as Howard Pyle had done when N.C. had come to the valley as his student in 1902. Reminiscent of Newell, Washington was the very essence of Pyle. N.C. felt again as he had as a newcomer, impressed by his closeness to the great man and struck by Washington's "shrewd and capable expression" and by how "convincing" he was.

Hooking his thumb toward the column of marching troops, Washington confided in N.C. about the various Pennsylvania and Massachusetts regiments, rating them according to their victories and defeats, just as Pyle had made a point of ranking his students and revealing the rankings confidentially to each man. The column of patriots seemed also to express everything that had since happened to Wyeth and his fellow illustrators, for as the soldiers in the dream first appeared on the left, N.C. could "see the individuals" and "name the men." Then, at the right, they "became impersonal and eventually merged into the earth."

But why, N.C. asked Washington, "Why is this battle going on now?" He pointed out that "this scrap was over 150 years ago." The general answered that his men wanted to show the present government in Washington—the failing Hoover administration—"what kind of fuss was kicked up in these hills in '77."

In the dream as a whole, three sets of father-son figures had thus far appeared: Newell (as Washington) and Convers; Pyle (also as Washington)

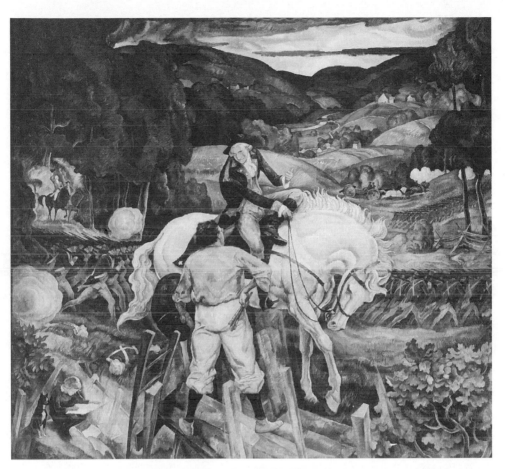

In a Dream I Meet General Washington, 1930–31.

and Wyeth; Washington and Lafayette, who on the eve of the Battle of the Brandywine had established a lifelong father-son relationship.

A fourth—manifestly the most important—set of father-son figures now appeared as N.C. became "incessantly conscious" that below the scaffolding sat his son Andy, firmly planted on a rock, serenely drawing the "inevitable battle picture." Andy was so involved in his work he would not look up, and it made N.C. furious. Instead of being pleased and proud that his son was creating art from the dramatic scene unfolding in front of him, N.C. was "outraged" and "indignant" that for the umpteenth time Andy refused to pay attention to the real world. Wholly absorbed in his drawing, Andy seemed unaware that "his own father [was] talking to General George Washington."

Haunted by the dream in the days following, N.C. set aside his commissions and devoted himself to *In a Dream I Meet General Washington*, a richly colored, densely woven canvas painted on the monumental scale of his best murals. In the painting, as in the dream, N.C. is the protagonist, standing between his idealized father and his clear-eyed son. High up on the scaffold of art, time stands momentarily stilled. Below, in the valley, where the old fight is repeating itself, the young men march toward death. Meanwhile, balanced on a rock, young Andrew Wyeth is alive to the present. Uninterested in the repetitive battle, he concentrates instead on his own fresh rendering of the past; he is already drawing—and living—wholly for himself. He refuses to inherit his father's restrictive fathers, with their "Yankee idioms." He dares to be artistically selfish, declining to join his father in refighting old battles. Andy has his own struggles ahead: he needs discipline, training; ultimately he will also need to break his father's emotional hold on him. But that is still in the future.

In October 1932, at the age of fifteen, Andy entered the studio on Rocky Hill to begin his apprenticeship. He would have as his teacher a father who meant for his son to be the better craftsman. "If you're not better than I am," N.C. would tell Andy, "I'm a rotten teacher." He was the only teacher Andrew Wyeth would ever have.

LESS THAN five years later, in early January 1937, Andy took examples of his work—twenty watercolors and two black-and-white drawings—to New York City. On his father's advice he left the portfolio at the Macbeth Gallery at 11 East Fifty-seventh Street and went home.

A response came quickly. Robert Macbeth, president of the gallery since the death of his father in 1917, believed that Andrew Wyeth had "something quite new to offer." Macbeth was impressed that in watercolor, a medium notoriously difficult to control, Andrew Wyeth showed mastery even as he painted with abandon. Coming from a nineteen-year-old, watercolors combining technical maturity and emotional freedom were unheard of. Macbeth proposed to give Andy his first solo show later that year.

That summer N.C. monitored Andy's progress. "The boy [is] really aflame!" he reported to Macbeth. "A parent cannot, I suppose, judge dispassionately of his children, but I believe very deeply that Andy is headed toward splendid accomplishments."

With Andy he had been an altogether different teacher than he had for the older children. From the boy's first studies in perspective, through cast drawing and still-life painting and finally figure study and landscape in oil, N.C. had done everything he could to make himself invisible. "I have been

careful at all times," he recorded, "not to clutter his mind with the noise of my own complications." He then crossed out "the noise of my own complications" and substituted the still knottier "irrelevant and complicated argument and theory."

In later years N.C. would make the mistake of trying to neaten up Andy's compositions, but in the beginning he succeeded at freeing himself and Andy from the kind of dependency that had characterized his relationship with Pyle. N.C. rarely altered Andy's work, as Pyle had done to young Wyeth and as N.C. had done to Henriette and Carolyn. Instead of drawing directly on Andy's pictures, he would make a sketch on Andy's paper—to demonstrate possibilities.

For the sake of starting a career, Andy made concessions to discipline and efficiency. Under N.C.'s regimen, for example, he signed and dated his drawings. He completed his first academic study on October 19, 1932. In October 1937 the coincidence recurred. Robert Macbeth sent a brief reminder to Andy in Maine. "This is just to let you know that your exhibition is definitely scheduled to open here on the 19th of October."

ANDY KEPT to his own schedule. He showed no special awareness of the date that year by year had meant so much to his father. At twenty he was suspended in a life of painting, swept forward from picture to picture by his own rapture. He had no calendar, no datebook, no address or telephone except his parents', no steady girlfriends—no need, in short, for language of any kind except line and color. As N.C. observed, "Andy eats, dreams, and sleeps with a deep faith that watercolor has infinite possibilities of power and beauty which have never been touched."

N.C. was always the one to put art into words. Andy would never find an analogue for painting in writing of any kind. Words failed him as line never would. Time, too, had meaning for N.C. that it did not for Andy. No one ever knew where Andy was or when he would next appear. Sometimes he spent days at a stretch outdoors. With oversize, custom-made sheets of watercolor paper spread across his knees, and a paint box and three sable brushes, Andy immersed himself in Chadds Ford cornfields and in the rocky seacoast around Port Clyde. "It is with envy and glory that I watch Andy," N.C. wrote. He envied Andy his "energy, enthusiasm, and stunning accomplishment." Time was "endless and infinite" for Andy. N.C. looked at his own summer's work and wrote, "Never have I felt so depressed by the phenomenon of passing time."

By the end of September 1937, Andy had forty-eight watercolors to send to his first New York exhibition. But he did not ship his new watercolors to

Maine, 1936. NCW with Andy on Cannibal Shore.

New York. Instead, staying in Maine so that he could go on with his work, Andy sent his paintings to Chadds Ford. He wanted his father to see them first.

The work astounded N.C. The pure, bright images of early Maine mornings, lobster traps, coastal farms, and clam diggers were deeply expressive—of Andy. "Every mark or color-note on paper was eloquent of a degree of poignant yearning to reveal and assert something of *himself,* and not merely to draw or paint pictures of *things.*"

N.C. saw at once the solid foundation in craftsmanship that he had wished for himself. Technical mastery made Andy's work exciting, but it was more than that; Andy was the rare artist who had freed himself to think and feel in paint. For Andy, watercolor had become an act of "talking to himself."

Spreading the papers all around the studio, N.C. "feasted" on Andy's work. He was as happy, as satisfied, as he had ever been looking at any paintings anywhere. "They represent the *very best* watercolors I ever saw!" he wrote Andy in Maine. "This remark from your old dad may not mean much to you, but I believe what I say and I'm certain I'm right. You are headed in the direction that should finally reach a pinnacle in American Art and so establish a landmark for all time."

Before the work could go to Macbeth's, there were practical considerations. The watercolors had arrived in Chadds Ford unmatted, untitled, uncataloged, and unsigned. It was typical of Andy. Ever since Bob Macbeth had offered to help the boy make his debut, N.C. had been pushing Andy to be practical about business affairs. Did Andy know, for instance, that he, the artist, would be responsible for innumerable costs in putting on the show? Andy was expected to pay for catalogs and mailings as well as for advertising in five metropolitan papers. Framing for the whole show was likely to run between $75 and $100. Prices for his watercolors would be set at $100, $75, and $50, but with the country still submerged by the Great Depression and the art market flattened, expectations of sales were lower than usual. It was hard enough at any time to launch a career in painting, but the fall of 1937 was among the worst of times.

Acting as Andy's manager, N.C. threw himself into preparations for the opening. He supervised mounting and matting. He cataloged the paintings by size, giving each work a number and a title. N.C.'s titles—*Fisherman's Son, Lone House, After the Shower, Patching the Roof*—established a Homeresque idiom for hundreds of images that would follow in the coming years. He then shipped the pictures to the city, making sure that they would not linger in the express office over a weekend.

With Andy in Maine, N.C. approved Macbeth's final list of titles and wrote a brief, unsigned foreword to the exhibition catalog. On Andy's behalf, N.C. conferred with the gallery about every detail, from framing and hanging the show to advertising and mailing invitations. Drawing up a guest list, only to revise it twice, N.C. filled page after page with the updated addresses of Wyeths, Bockiuses, family friends, and associates from the worlds of publishing and illustration.

Finally, as Pa and Ma Wyeth and the rest of the family prepared to follow Andy's bright blue watercolors into New York, N.C. could not resist one last practical reminder to his son about what the artist should do when he came face to face with his paintings at Macbeth's: "Sign them."

Oil and Water

WHILE N.C. READIED his younger son for his professional debut, he seemed to forget about the older. Tailoring Andy's catalog to the New York art world, N.C. omitted Nat, the non-painter, from the family history.

"The serious practice of the arts prevail in Andrew's family," N.C. wrote. "His father and two sisters are painters, and a third sister is a musician and composer. From the beginning [Andrew] has been steeped in the spirit of the creative arts. Drawing became, almost at once, his favorite vehicle of expression. . . ."

No mention of the brother who had just graduated from the University of Pennsylvania with a degree in mechanical engineering. The unsigned introduction emphasized Andrew Wyeth's provincial life, his "good fortune to have been born and raised a country boy," as well as his "intensive contact with the farmers and fishermen" of Pennsylvania and Maine.

Almost the same story had appeared in 1934, when Ann debuted as a composer with the Philadelphia Symphony Orchestra. After the premiere that December of *A Christmas Fantasy,* the Associated Press reported that Ann Wyeth was "one of four talented children. The other three are painters." Again, no reference to the family nonconformist, who, in 1932, with a Pathé newsreel camera rolling, had launched his airfoil-shaped speedboat, the *Silver Foil.* N.C. wrote a nine-page letter to Bill Phelps documenting the launching and extolling Nat's accomplishments, but it would remain buried among Phelps's personal papers for the next sixty-five years.

Nat scarcely seemed part of the family. Coming of age in a household that valued feeling and emotion, he won attention with two other Wyeth traits—practicality and resourcefulness. During his college years Nat proved himself to the family circle by making daring scientific claims at the dinner table. Challenged by N.C., cheered on by his siblings, Nat would back up his boasts with on-the-spot demonstrations, showing, for example, that by

using only his dessert spoon and a scoop of ice cream, he could freeze water right there at the table.

Even to an insider like Nancy Bockius, Nat "didn't seem like a Wyeth." When Henriette and Carolyn began to exhibit and win prizes alongside their father at annual exhibitions in Wilmington and West Chester in the 1930s, they were identified as N. C. Wyeth's "two talented daughters who paint almost as well as he does." Andy had shown his earliest oils alongside Henriette, Peter Hurd, Carolyn, and N.C., receiving favorable notice as a "talented member of a gifted Chadds Ford family." ART SHOW ALMOST A FAMILY AFFAIR became a typical headline of that era in local Chester County newspapers. By 1937 influential art magazines would review Andrew Wyeth's debut at Macbeth's by presenting him as the "son of a famous artist-father, brother of two sister-painters and one sister-composer."

Nat did not mind the anonymity at first. Fair haired, blue eyed, at twenty-six he was lean and boyish, six feet tall, with a long, friendly face and an eager smile. He was unfailingly kind and generous. To N.C. he was the straight man. Whenever Nat was presented as the "only non-artistic Wyeth," as *Time* tagged him in November 1937, N.C. defended him as "the one that has to keep the family straight." As N.C. faced middle age, he came to depend on Nat more than on the others.

Nat in many ways was his father's emotional duplicate. From Nat's first day at grammar school to the early years of his marriage, he wanted always to be home. Nat felt homesick when he was away even for a night. "He clings, even at this early age, to traditional things connected with his home," N.C. noted when Nat was nine. As a schoolboy, Nat made a particularly Wyeth-like point of endowing inanimate objects with his yearnings for home. "Nat would hate to leave something at school because it would be lonely, so he'd bring it home," Nat's son Andrew later recalled.

When Nat decided on college he chose a university situated twenty-seven miles from home. When he joined a fraternity there was no question of living at the fraternity house. "Father persuaded me not to stay in Philadelphia but to come home daily," Nat cheerfully remembered.

N.C. bribed Nat to stay home. He had been prepared to foot the bill if his older son wanted to live at college. Instead he offered to buy Nat a car: Wouldn't Nat prefer the freedom of driving to classes, of coming and going as he pleased? For an engineering student in 1932, a Ford roadster with a rumble seat and gas money meant the world. For a father who wanted to keep his son at home, the shrewdest plan was to offer him the world.

Six days a week Nat motored back and forth to college, studying at home in the alcove at the head of the stairs. As Stimson Wyeth had com-

Nat relaunching the *Silver Foil,* 1938.

muted to Cambridge as a Harvard undergraduate, so Nat Wyeth remained sheltered under his father's roof "just so that we could all be together and I would still have the influence of home."

In the evenings N.C. and Nat often acted less like father and son than like college roommates or fraternity brothers. From the foot of the stairs N.C. would call up to the study alcove: "Nat, have you got much to do tonight? Have you got much studying to do?" To which Nat would always reply that he was free, inviting N.C. to suggest going to Philadelphia to watch "a good wrestling match," or to Wilmington to see the fight card: "It's Jack Bates against Judge Bates, and I'd like to go to it. Will you drive us up?"

The more Nat did for N.C., the easier it became to put his own work aside. During college he never said no to his father. He loved going to the fights and also to Marx Brothers movies; father and son would sit in the balcony, and N.C. would laugh, tears streaming down his cheeks, while Nat vainly tried to tell him that he was missing the next gag. No matter how much work Nat had on his desk, he always agreed to drive back into Philadelphia. Henriette later recalled that Nat was a selfless follower. "He

always understood why you wanted something a certain way and he would put away his ideas and follow you."

Nat kept part of himself always covered up. "There's so much more to Nat than he allows anybody to know," said Henriette.

It took Nat five years to get an undergraduate degree from the University of Pennsylvania. He was twenty-four when he graduated in 1936. He would later insist that he was having too good a time at home to have wanted an independent life at college. He had no regrets; for Nat, the secure center of life was home and Pa. His mother, all but invisible in his memories of growing up, appears in cameo, sitting at the far end of the dining room table "listening intently." Nat's wholehearted acceptance of N.C.'s version of home set a precedent for the more complicated, later stages of their relationship. In matters closest to the heart, the family engineer rarely questioned his father about how things worked.

ABOUT WOMEN, N.C. sent one message to his daughters, another to his sons. Women, he taught Henriette, Carolyn, and Ann, were creatures of feeling, not intellect. "He had this built-in concept of women not understanding anything," said Henriette. Even in later years, when his grown-up children opposed him on issues of painting or politics, they would never, Henriette emphasized, try to turn him around about women.

To his sons, women were presented as dangerous. For a promising mechanical engineer and a rapidly developing painter, women were little more than enchantresses, tempting their boats and careers onto the rocks. Unless strong, Nat and Andy would be tricked. Monitoring Andy in 1935, N.C. wrote, "How he'll manage it when he is tripped up by some designing and beautiful girl, or if he meets up with some other unforeseen obstruction, no one knows. That's when he will test his metal [*sic*]."

N.C. was especially suspicious of a young woman named Caroline Pyle. She was Howard Pyle's niece, and she lived with her mother, two sisters, and a brother at Westbrae Farm, a country estate in Greenville, a few miles from Chadds Ford. The farm was built on the second highest point of land in Delaware and covered thirty-eight acres of rolling hills and woodland. A clear stream ran through the woods, and a spring-water business came with the property. The main house at Westbrae, a three-story gray stone mansion, sat high on its well-tended hill. Under a broad gambrel roof were twelve large rooms, two kitchens, bricked terraces, screened porches, a porte cochere to welcome visitors, and cellars for coal, food stores, and wines.

Caroline, the youngest of three sisters, had a wild streak. She was known for dating men two at a time, sometimes both on the same night.

Caroline Pyle, c. 1930, with an unidentified young man.

When one young man would drop her off at Westbrae, another would hide in the bushes, waiting to take her out for a second date.

Caroline's dark good looks, her natural way with men, encouraged her reputation. She was a boys' girl, with a cloud of black hair worn high on her head, flashing black-coffee eyes, and a figure that men would remember fifty years later. Demure one moment, coquettish the next, Caroline smiled seductively at the home-movie camera. "I think my mother was very conscious of being pretty," one of her sons later noted. Some days, though, Caroline could appear plain and unremarkable. When *Gone with the Wind* was published in 1936, it became Caroline's favorite novel. She could never decide which heroine resembled her most: tough, headstrong Scarlett or good, trusting, sweet-faced Melanie.

After noticing Caroline at a basketball game at Wilmington Friends School in 1930, Nat began a worshipful pursuit. He was sentimental about her from the start. At the end of one of their early dates, he drove Caroline home; as they sat in Nat's roadster in the dark under Westbrae's porte cochere, one of the Pyles' cats leapt on the hood and marched across it. For weeks afterward, whenever Nat washed and waxed the car, he worked around the footprints the cat had left, putting aside his usual love of neatness to preserve the moment with Caroline.

Andrew Wyeth, *The Lobsterman*, 1937
Watercolor on paper

Andrew Wyeth, *Pennsylvania Landscape*, 1942
Tempera on panel

Heidi, 1940
Oil on gesso

Andrew Wyeth, *The Forest and the Fort*, 1942
Tempera on panel

The Doryman, 1938

During Nat and Caroline's first year of courtship, N.C. waited up nights at the Homestead. Once, when Nat crept in at three in the morning, N.C. raged. His anger terrified the thirteen-year-old Andy, who was upstairs in bed. Andy would long remember the tension in the household when Nat came home late from an evening out with Caroline Pyle. "I'd lie there under my covers shaking, thinking, Why didn't Nat get in earlier?"

But why wasn't N.C. delighted that his older son was dating Howard Pyle's niece? The Pyle family had been his earliest touchstone in the valley. Moreover, Caroline's mother had been among Howard Pyle's earliest pupils. Before marrying Howard's brother Walter in 1904, Ellen Bernard Thompson had contributed illustrations to best-sellers like Mary Johnston's *To Have and to Hold* and Jacob Riis's groundbreaking study of ghetto conditions on Manhattan's Lower East Side. After marrying Walter Pyle, Ellen put down her palette and brushes to raise their four children. Then, in 1919, at the age of sixty, Walter died suddenly of Bright's disease, the same kidney infection that ended Howard Pyle's life.

Ellen was forced to resume her career to support the family. She returned to illustration at a time when *The Saturday Evening Post* had become a national institution, its cover functioning as a graphic proscenium for American life. Painting covers for the *Post*, Ellen Pyle made a specialty of idealized youths, for which her children often posed. Through the 1920s and 1930s, images of Caroline and her sisters, first as bob-haired demigoddesses, later as soda-sipping bobby-soxers in saddle shoes, helped to define the succeeding eras of boom and bust.

But not the Pyle connection or the freemasonry of illustrators or the sudden death of her father disposed N.C. toward Caroline and her family. To the contrary, ill will had been building between the Wyeths and the Pyles for years.

They were competitive families. As Ellen Pyle once said, "Nearly everyone in the house was either painting or being painted." Both families exhibited in the small world of the valley; both were dominated by the legacy of Howard Pyle. In the three decades since his death, Pyle's reputation had rebounded. He would increasingly be seen as the founding figure of a "Brandywine School" of painting. For his nieces and nephews, two of whom had begun to exhibit work in Wilmington, and for N. C. Wyeth's colony of artists, the Pyle name and the "Brandywine tradition" had become something to reckon with as each established his or her own career. "Pyle was one of the leading figures in our lives," Ann Wyeth remembered.

Walter Pyle, Jr., Caroline's brother, felt the burden of living up to the Pyle name, especially in view of the shadow cast by the multitalented Wyeth children. Walter Jr. had studied illustration with his mother; he took occa-

sional illustration jobs; he painted with the Federal Arts Project in Delaware and worked at the post office to support himself while painting. Eventually, however, Walter Jr. would follow Howard Pyle's sons, Theodore and Godfrey, into chicken farming.

When Howard Pyle's legacy led to the formation of the Delaware Arts Center in Wilmington, the Wyeths took exception to the Pyles' patrician airs as the two families differed strenuously about the museum's location. The Wyeths wanted the museum downtown, so that anyone could walk in off the street and look at pictures; the Pyles lobbied for—and got—a site in the more exclusive uptown corner of Wilmington.

Each family pointed to the other as the source of bad blood between them. When Wyeths and Pyles entered the same exhibitions of Delaware painters, the Wyeths took first prize year after year, with a Pyle often coming in second. An article in *Time* magazine, "Pyles and Wyeths," reminded the world that Carolyn Wyeth had beat out Walter Pyle, Jr., for first prize at the Wilmington Society of the Fine Arts. The Pyles complained that the Wyeths had stacked the jury.

As for Caroline herself, she made N.C. suspicious. She had a bent for recklessness that seemed at times desperate. In N.C.'s opinion, Caroline Pyle was not to be trusted. On one of her first visits to the Homestead, she developed a crush on Nat's Bockius cousin Ralph Sargent. Somebody had spotted Caroline and Ralph down in the woods, smooching. Nat, meanwhile, knew what was going on behind his back but remained characteristically genial and self-denying. "He was easygoing about it," Nat's son Andrew later said. "He wasn't going to let that stop anything. But Grandpa thought Nat was getting taken for a ride."

To N.C. it seemed sordid and immoral. Caroline Pyle was running wild, and something should be done about it. He advised Nat to slam the door in her face: "When a dog shits on your rug, Nat, you don't invite it back into the house."

N.C. dismissed her as a "lightweight, out to have a good time"—a judgment Caroline herself agreed with years later. "He was right," she told her son Andrew, "that's all I cared about in those days."

CAROLINE WAS SIXTEEN the year she entered the Wyeths' lives, a girl without a father. A sense of unfulfillment—of something forever out of reach—characterized her relations with men. She seemed to yearn for an unnamed Ashley Wilkes. Years later, when one of her sons exclaimed, "Boy, you sure had a lot of boyfriends," Caroline replied, "Yes, but I never got the one I wanted."

With the men in the Wyeth family, she played the part of Scarlett from the start. The first time she stayed for dinner at the Homestead, she challenged N.C.'s authority. Caroline was appalled to see that the Wyeth children gave all their attention to their father. She turned her bench the other way to have a conversation with Carol.

With Andy she had established a relationship of taunts. She mocked him in the summer of 1934 with the fact that he did not have a steady girlfriend. That summer, while Nat was in Maine, Andy, now seventeen, and Caroline, twenty, happened to meet up at a Haskell wedding in Chadds Ford. The Haskell family owned several thousand acres of land in the valley; it was a big wedding with a pavilion and a tent. Andy and Caroline danced. While they danced, according to Andy, Caroline made a play for him, locking him in a deep embrace. She then announced that she and Nat had broken up, leaving Andy to infer that she was available. By way of follow-up, she invited Andy to join her at an after-wedding party at Breck's Mill, a fancy tavern on the Brandywine. They drove in Andy's car to the tavern, where he ordered champagne. "I thought I was pretty hot stuff," he said later. "She was a voluptuous, beautiful girl, we danced, and I drove her home to Westbrae. I kissed her and she wrapped her arms around me." Just then Caroline's brother, Walter, materialized at the front door, arms folded.

"You're really a son of a bitch," Walter sneered at Andy. "Playing around with your brother's best girl."

"And I realized then what she was," Andy later recalled. "She was a Siren."

Andy, a master of the tall tale, may not be completely trustworthy in his recollections of Caroline Pyle. But one part of the story is true beyond doubt: the vicariousness, without boundaries or limits, that would characterize so many of the family's intimate relations.

Within two years Caroline and Nat were back together. Despite continuous ups and downs, they were discussing an engagement. What had started, in Caroline's words, as "a boy and girl romance," had matured, she wrote Nat in March 1936, into "a love like ours." Now, whenever they were apart, Caroline wrote Nat long, plaintive declarations: "I am so unbelievably in love with you. I've never felt even half what I feel for you for any other man." On June 6, they became engaged.

That spring—Nat's last before graduating from college—while he made forays into the automobile industry to hunt for a job, Caroline went on dates with whoever happened to be available. She made no secret of it. She trusted Nat to withstand the competition. "You know, darling," she wrote him, "you shouldn't really grudge other men dates when you'll have me for every nite [*sic*] in your life."

But they were not always completely honest with each other either. "I felt so terribly yesterday," Caroline wrote on June 22, "because I feel that a lie, however well meant, breaks down trust, and you know that trust is an all-important element in marital bliss. Please, dearest, remember that—I don't want a shadow of untrust between us ever."

In July, with the help of the uncle for whom he had been renamed, Nat landed a job at General Motors. Leaving home for Ohio "wasn't the easiest thing to do," Nat later recalled. But he made a start in Dayton. He lived at the YMCA and worked the night shift, nine in the evening to six in the morning, assembling shock absorbers for the General Motors car. Caroline wrote him every day—long, passionate, lonely letters.

The first Monday evening Nat was away, N.C. telephoned Caroline to suggest that it might help to be around people who missed and loved Nat as much as she did. He had never indicated that he had changed his mind about Caroline, but he now invited her to join the Wyeths in Chadds Ford as a member of the family. As Caroline told it to Nat, his father was "very nice . . . although no one," she insisted, "could miss you as I do. I need you so desperately now—I'm only half alive without you."

Nat lasted a week in Ohio. He quit General Motors and moved home, "where my love is." He found a menial job at Auto Car, a small automobile testing firm in Ardmore, Pennsylvania, twenty-four miles from Chadds Ford. Through the summer he commuted, bringing his lunch—sandwiches made at home by Pa—to work.

That summer Ellen Pyle's health declined. The Pyles' financial future hung in the balance. The estate at Westbrae had been partially supported by the sale of its own spring water; but the house, with its twelve rooms and servants, could not be maintained without Ellen's income. "The way things look," Caroline wrote Nat on July 6, "we will have to sell the house, and Mother and I live someplace near the spring and exist on its income." Caroline began looking for a job, hoping to find an opening in a dress shop in Wilmington.

On August 1, 1936, Ellen died in bed at Westbrae. "I was over there last night," Nat reported to N.C. in Maine a few days after the funeral. "Everybody was home and yet there wasn't a sound—Gosh, it made me feel morbid." Nat had been expected to join his family in Port Clyde, but now that Caroline had lost her mother, he did not feel right about leaving her. More to the point, he felt even less inclined to bring her home.

Four days before Ellen Pyle's death, N.C. wrote to Nat from Maine. He had promised Nat that he would not try to coerce him into doing what he, N.C., thought best. Still, he reserved the right to argue against Nat's marrying Caroline. But Ellen Pyle's death swept all rational argument aside.

"Caroline is clinging to Nat," N.C. reported to Henriette. "The apple-cart has been overturned, and I am not too dumb or too prejudiced to see what psychological effect it might have on the future."

Carol, too, was opposed to Caroline. The night Nat announced his plans, he heard his parents talking through their bedroom wall. "Pa," he heard his mother say, "why does he have to marry that girl? Haven't we made a nice home for him here?" Early that September, when Nat and Caroline visited Port Clyde, Caroline and Carol sat beside each other in edgy silence.

But if Nat held his mother's hostility toward Caroline against her, he did not show it. Besides, he had absolved his father, and that was who counted. "I don't blame you," Nat replied to N.C. that August,

for the way you feel about Caroline—her family etc. but I feel sure there is a side to her that you've never seen, whether it's due to the strained feeling that's always existed between her and our family, or due to the fact that a general prejudice against the family caused by one or two of its members has kept you from seeing that side of her. On the other hand, Papa, a great many changes will have to take place in our relation to each other (Caroline and I) before I would think of marriage, and as far as I can see at present the fundamentals we differ on will never be agreed upon. But, damn it, propinquity plays such a strong part in an affair like this. I guess I never did realize the meaning of that word. Thank heavens I have a father that can make me see things in black and white.

Meanwhile, through N.C.'s friendship with the chief engineer at the Du Pont Company, Nat had interviewed with Mr. G. M. Read, who had "made my mouth water by the way he talked about engineering and its relation to art—I almost felt like a young artist when I left there."

Still working at Auto Car and living under his father's roof, and having conceded that his feelings for the woman he intended to marry were actually no better than ambivalent, Nat closed with a boyish question. "Say, Papa, if the job in the Du Pont Co. materializes would it be O.K. if I quit at Auto Car a week ahead and give myself a chance to finish the *Silver Foil*?"

In September, Du Pont offered Nat a job in the mechanical engineering department. He started at $125 a month, almost double what he had been making at Auto Car. Both he and Caroline considered it a "phenomenal" salary. "On that basis," Nat later explained, "I guess we decided to get married in January, because I'd had such a big raise and was doing very well."

Only five months of the obligatory year of mourning for Caroline's

mother had passed. Out of respect for Ellen Pyle, the wedding ceremony was performed not at Westbrae but in New Castle, Delaware, at the house of Caroline's older married sister, Ellen. Only members of the immediate families attended. The bridesmaids, Caroline's sisters, wore black. Caroline's brother, Walter Jr., gave her away. Filmed by N.C. on the family movie camera, the occasion looks gloomy. Pale January light casts the shadows of bare tree limbs sharply across the faces of bride and groom. Caroline, somber and puffy, appears in her mother's wedding dress, clutching a prayer book. Nat looks apologetic.

"It was a depressing day, a depressing ceremony. I could feel it," Andy said later. "My father's picture, *The Tide Pool,* which Felix du Pont later bought, had been turned down by the academy, and he had just heard that news. And maybe my father had already had feelings about Caroline, I don't know. It was a strange marriage. They weren't right for each other."

TEN MONTHS LATER, on October 19, 1937, the family gathered in an altogether different mood for Andy's opening. The excitement in the Macbeth Gallery was immediate and unusual. Here, in two square white rooms on East Fifty-seventh Street, and earlier at 237 Fifth Avenue and 450 Fifth Avenue, Macbeth had presented the work of twentieth-century American artists such as Edward Hopper, Charles Sheeler, John Sloan, and "The Eight." None had ever done what twenty-year-old Andrew Wyeth was about to do.

Earlier in the day the *New York Times* had sent its second-string art critic, Howard Devree, who wrote that Andrew Wyeth's watercolors "bear evidence of a very real talent." Two hours later, Edward Alden Jewell, the first-string art critic, slipped into the gallery mumbling to Macbeth, "I guess I better handle this show myself." Royal Cortissoz, the aging antimodernist who for almost fifty years in the *Herald Tribune* had extolled the virtues of Renaissance beauty, whispered to N.C. as he left, "Don't tell the boy, but let him read it in the paper that I think it a corking show." Writing for the *Sun,* Henry McBride, among the driest, most discriminating of the influential art critics, compared Andrew Wyeth with Winslow Homer, praising the young Wyeth for his fearlessness with wash and color.

By the morning of the second day, word had spread. Mrs. Cornelius Vanderbilt Whitney had bought *The Lobster Trap.* Individual collectors had bought three and four paintings at a go, and art dealers from all along the eastern seaboard were snapping up what was left. Doll & Richards, the Boston gallery that had given Winslow Homer his first one-man show of watercolors, booked Andrew Wyeth for the fall of 1938. When Andy reap-

peared in the gallery, on his way home to Chadds Ford that second afternoon, a red foil star gleamed on every frame: a complete sellout.

The show was a record for the gallery. Twenty-two watercolors had been cataloged for sale. Twenty-two had sold. From the stock held in reserve—forty watercolors, thirty-seven drawings—an additional thirty sales had been made. The public's embrace was complete and unequivocal. "This in itself is something new in the annals of American art," noted Robert McIntyre, the gallery's treasurer.

It was something new in the life of N. C. Wyeth. He had often been wrong about young men and the future. Ever the idealist, blind to flaws, he had misread character. With his brothers, with his long parade of ideal young men, from Harvey Dunn to Harl McDonald, he had let himself in for repeated disappointment. Ashamed at having put so much power in another, afraid of being left vulnerable and abandoned, N.C. needed to turn absolutely away from the one he had absolutely turned to. With Andy, the pattern changed—as N.C.'s "George Washington" dream had foretold. Early success certified Andrew Wyeth. A painter in his own right, Andy could remain in his father's studio without fear of being overpowered. He had no need to abandon N.C.

Returning home the day after his triumph, Andy bounded off the train in Wilmington, bursting with the latest news from Macbeth's. N.C. was waiting. For once he had no sermon to preach, no high ideals to trumpet. Reality had exceeded his highest hopes. N.C. was speechless. Stepping forward, he took his son in his arms and hugged him.

The very next day Andrew Wyeth went back to work in the lower level of his father's studio, studying anatomy.

Egg Tempera

ONE MORNING IN MAINE, there was a knock on the door. Answering it, N.C. found himself looking into the face of Howard Pyle—the same large head and wide-set eyes, the same straight nose and cavelike eye sockets. The man resembled his old teacher so exactly that N.C. felt he might faint.

But the visitor was Merle Davis James, editor of the rotogravure section of the Buffalo *Courier Express*. James was a Sunday painter who had been urged to look up N. C. Wyeth by a mutual friend. James wintered in East Aurora, New York, with his wife, Elizabeth. They had three daughters, Louise, Gwendolyn, and Betsy. Until now the Jameses had summered in a cottage across the St. George River on Muscongus Bay. This summer they had moved to an old saltwater farm in Cushing. Merle James described Broad Cove Farm for N.C. and Andy, remarking on its starkness and simplicity. The date was July 11, 1939. The next day was Andy's twenty-second birthday.

Andy had been painting every day for four months without a break. Tall and slim, his wheat-colored hair cropped close on his suntanned head, he cut a lonely, romantic figure as he moved up and down the seacoast painting watercolors for his second show at Macbeth's. "Give no thought to money-making, you can always do that," N.C. had advised Andy. "There is no one I'm counting on more than you."

Andy had not lost his larkish, exuberant side, and on July 12, thinking he would try to find the Jameses' farm, he took the day off and drove over to Cushing.

The property was announced by a sign: M. D. JAMES. Andy decided that James must therefore be a medical doctor. When the housekeeper, Anna, opened the front door of the white clapboard house, Andy asked if the doctor was in. Anna told him he had the wrong place and started to close the door. Just then a young woman appeared.

She was a shocking sight—standing in high heels on the wide floor

Betsy James, 1939.

planks of the austere New England farmhouse. She had bare, sun-browned shoulders and bare, sun-browned legs. Full breasted, with a slim waist, she was wearing a homemade halter top and tight shorts. Her hair and eyes were brown, shining. She regarded the visitor with a disarmingly level gaze.

"Are you the wood man?" she asked.

"No," he replied, "I'm Andy Wyeth."

She introduced herself: Betsy James.

They wandered into the front parlor, sat down. Betsy was seventeen, starting at Colby Junior College in New Hampshire that fall. She hoped to study archaeology and thought her life would have something to do with skiing and digging up bones. She asked where Andy was going. "Oh, I'm a premed student at the University of Pennsylvania," he answered—still confident he was in the house of a doctor and hoping to impress the doctor's daughter.

By then Betsy's mother had appeared and invited Andy for lunch. Afterward he asked to visit the treeless coastal pastures around Cushing. When Betsy learned that Andrew Wyeth was really a painter, she took him down Hathorn Point Road to a place she had gone every summer since she was ten. She called it "Olson's."

The three-story, weathered gray clapboard house stood high and alone on a wide open hill, looking out the St. George River to sea. The isolated place was inhabited by Christina Olson, a forty-six-year-old woman disabled by polio, and her brother Alvaro, who had given up his life at sea to

take care of Christina. Christina was the trusted friend of Betsy's girlhood summers. She had often gone over to the Olsons' to comb Christina's hair. "Imagine what Andy thought of me," Betsy said years later. "Taking him to see an old crippled woman."

Andy was fascinated by the dry old house. He took out his watercolor box and sable brushes, sat on the hood of his car, and quickly painted a watercolor. He went inside and met Christina; each was charmed by the other. At the end of the afternoon, Andy asked to see Betsy again. She told him he would have to ask her mother's permission. They arranged to go dancing in Rockland in a week's time.

Andy returned the next day. This time he came by water, pulling alongside the Jameses' pasture in his father's motorboat. He walked up through blowing grasses to the house. "I'd never seen that," Betsy remembered. No one had ever come visiting by way of the St. George River.

Andy wanted Betsy to meet his father. Betsy brought along her older sister Gwen. When the boat pulled up at the Wyeths' long dock, the bright mood changed. In wide, flapping knickers, N.C. bestrode the dock. Eyes cast down, his pipe gripped in his teeth, he addressed Andy. "I thought," he said, "you were going off to paint on the islands."

N.C. glared at the James sisters: their bathing suits, their brightly painted fingernails, their red lipstick.

"But," he said, "I see you've brought back a couple of covers for *The Saturday Evening Post*."

Andy ignored his father's remark; Betsy did not. "I instantly disliked him," she later said. It made no difference that Betsy and Gwen were asked to stay for lunch. "My sister and I weren't covers of *The Saturday Evening Post*, thank you very much."

To Andy's embarrassment, his family showed no interest in Betsy or Gwen. Conversation swirled around the table, full of opinions, convictions, laughter, never pausing to include the newcomers. The Wyeths were fascinated by one another, and carried on as if no one else were at the table. They created a high level of energy simply being in one another's presence. To Betsy, they were sealed, a closed circle, glamorous and exotic.

After lunch Andy showed the sisters his studio. Gwen, an art major at Syracuse University, gushed over Andy's watercolors. Betsy was silent. She did not like to talk about art. She had grown up with her father's talk about the Armory Show and modern art. She was tired of art talk.

Andy asked Betsy why she was so quiet. She had noticed a picture, unframed, sitting on its side in the dust of the studio. It was a portrait of a sandy-haired fisherman, Walter Anderson, Andy's closest friend in Maine. The surface had a kind of flatness, a smoothness and austerity

that caught her eye. She had never seen anything like it. She said, "I think *that's* wonderful."

IT WAS A PAINTING in tempera. New to Betsy James, new to Andrew Wyeth, egg tempera had been introduced to the Wyeths by Peter Hurd. An ancient medium, first used in Egypt and Babylonia, tempera is literally *tempered*—brought to a desired consistency—by mixing dry mineral pigment with an adhesive such as the yolk of an egg. Far more difficult to work with than oil on canvas, egg tempera is thinned with water and stroked onto gesso-coated board, drying instantly. Within months—ultimately, over centuries—the smooth, unshining surface of a tempera is as durable as egg yolk on a porcelain dish.

Peter Hurd had learned tempera technique in Mexico in 1933. Its brilliant earth colors and translucent surface were ideal for capturing the dry light of the mountain canyons and plains of the Southwest. Hurd supplied practical instructions to Andy, who wrote them out by hand.

Andy was ready for a new medium. Returning to Chadds Ford from his first sellout at Macbeth's in 1937, he mistrusted his success in watercolor. He considered his work impulsive and messy, "too free, too deft, too popular." He wanted to reestablish control over his eye. He found two antidotes for his natural state of undiscipline. One was anatomy, which he studied under his father; the other was egg tempera, which he learned on his own, by trial and error.

Tempera naturally imposed strict craftsmanship and patience. The process, as Andy developed it, began with weeks of preparatory study in pencil. Next he applied two coats of hot plaster to a panel on which he drew with black Higgins's ink. Then came the engineering of the paint itself: grinding powdered pigment, separating egg yolks from whites, thinning with water. Finally he was ready to paint. Whereas a watercolor had appeared under his brush in a half hour rush of excitement, the demands of a single work in tempera—building up a surface with careful brushwork, painstakingly layering and weaving his strokes—could occupy Andy for months.

The discipline of tempera deepened his focus. It brought familiar objects closer, forced him into a more intimate relationship with his subject matter and its form. As months of work mounted around the trunk and branches of a 400-year-old buttonwood tree, tempera forced Andy to go beyond the facile "swish and swash" of watercolor to the essence of the thing itself. Tempera allowed him to explore the powerful feelings he had accumulated about the countryside he knew well. The dry powdered pigment—

earth colors, ochers, greens—reconnected him to the hills he had wandered as a boy; the texture of the paint itself felt like the dried mud of the Brandywine Valley.

Tempera liberated Andy from his big-city success. It made him invisible again, freeing him to resume life as his father's son in the valley he loved. It also allowed him to see things and people with a depth he had not found in any other medium. In early November 1937, less than two weeks after his sensational start at Macbeth's, he began a self-portrait in egg tempera.

As Andy taught himself the new medium, he gradually became the leader, N.C. the follower. That fall of 1937, as N.C. looked over his son's shoulder, he decided that he would give egg tempera a try. "After seeing Andy's I'm fired up about the possibility of free handling which I had thought impossible."

But N.C. had his doubts about tempera and about Andy's use of color. As the time spent on each work in tempera mounted, months on end without a sale, N.C. wondered why Andy wasn't getting any color into his work. Color sold paintings. "You won't sell any of those pictures," N.C. warned. He said they were not "real paintings."

N.C. advised Andy to use more color. Over and over the father prodded the son to put more color in his work, even in his winter scenes. He suggested that if only a gun and a dog were added to *Turkey Pond,* Andy's 1944 tempera portrait of Walter Anderson, the picture might sell.

In Betsy's eyes, N.C. failed to understand Andy's early tempera panels, and his failure, she admitted, pleased her. It underlined the excitement that she, a new force in Andy's life, was able to bring to Andy's work. N.C., she wrote, could not be expected to understand his son's temperas—"he was bogged down in the *past.*"

And so he was. But N.C. was also writing to Henriette about Andy's "truly remarkable temperas." As early as September 1938, N.C. had been boasting that "Andy's summer's work is nothing short of magnificent and his tempera panels are superb." A year later, he put aside his feelings about Andy's "hectic interlude [with Betsy] in Cushing" to report to Bill Phelps that Andy had "just turned out a gorgeous tempera panel." The tone of these letters suggests that N.C. understood that tempera was Andy's medium.

He had turned to Andy to find the fulfillment he could no longer take from his own work. Slowed by ill health, he announced from Maine in August 1938, "The bulwark of my stay here this summer will be Andy's accomplishments. His watercolors have so definitely advanced into an impressive maturity." For N.C., looking at the sixty-one new pictures Andy painted in the summer of 1938, it was "hard to hold back tears. What magi-

cal power that boy has! I am at once stimulated beyond words to new, purer effort, and plunged into black despair."

As their roles reversed, with teacher now depending on pupil, N.C. experimented with gesso, the smooth mixture of chalk and glue on which Andy was painting in tempera. N.C. painted in thin oil on a gesso-coated panel and liked the translucent effect of sunlight he got from the thinned paint on the smooth white surface. By 1939 he was using oil on gesso in his easel paintings as well as in the thirteen panels he painted for Marjorie Kinnan Rawlings's *The Yearling.*

During the summer of 1939, Robert Macbeth visited the Wyeths in Maine. Andy's second New York exhibition of watercolors had been scheduled for December, but Andy changed his mind, deciding that October was his lucky month. Macbeth then offered to give N.C. a special exhibition in the December slot that Andy had given up. Looking at N.C.'s recent work, Macbeth especially admired a large panel in tempera, four feet tall and nearly five feet wide. Painted with the breadth of Brueghel, it was a panoramic view of mourners at a funeral on a small island off the coast of Maine. Macbeth decided that seven or eight of N.C.'s recent temperas centered upon *Island Funeral* would "make a mighty handsome show." Nearly thirty years after Robert Macbeth had first asked N. C. Wyeth to exhibit his work, the painter accepted.

In October, Andy repeated his first success. His brash, bright watercolors once again astonished the art world. This time the critics wrote even more respectfully. As before, he sold everything, N.C. noted, "in [the] face of the terribly dull picture market." Nearly all of the work had been bought before the show opened.

ANDY WAS NOW the family's undisputed star. Henriette had recently had her first solo show at the Reinhardt Galleries in New York. Peter Hurd had won first prize in watercolor at the Art Institute of Chicago and was being called "one of the white hopes among young American painters." John McCoy had painted murals for the Du Pont Company building at the 1939 New York World's Fair and would have his first solo show at the Vose Gallery in Boston in 1940. Carolyn had gone on edging out the Pyles for prizes in Wilmington, and Ann was composing for Main Line orchestras. Andy's early success reinforced the Wyeths' group identity and turned N.C. into the group leader.

As "the daddy of them all," N.C. was asked, "Aren't you proud of it all?" Tossing his head, he would answer with a laugh. "Of course I am! The

unfolding of all the younger members of the family is a glorious episode of my life." Privately he confided to Henriette, "My answer is always restrained because I am still in the battle myself, in spirit at least." He could see that as a group the family "*have got something* and that there is a real promise of sound achievement—of *major* achievement in the offing." For himself, though, he still maintained a "clear vision of what lies ahead before a real mark is achieved."

On December 4, 1939, the whole family, except Nat and Caroline and Peter Hurd, returned to Macbeth's for what N.C. termed "my first appearance in N.Y. as a painter of something other than illustrations." But N.C.'s exhibition would also prove to be a demonstration of the new collective aura of the "Clan Wyeth," as the art press called them in stories such as "The Clan Wyeth Presents Its Famed Patriarch." For his first metropolitan appearance, he not only came to town on his children's arms but arrived as " 'Pa'—the jovial patriarch," as *Newsweek* caricatured him.

At the gallery the family gathered for a press portrait. Andy was late—without telling anyone he had been shopping for an engagement ring—so the Wyeths missed the deadline for the *New York Times* Sunday rotogravure section, much to Robert Macbeth's disappointment. But they made a crowded, Sunday-best picture for *Newsweek*. On the wall behind them, *Island Funeral* hung in the dominant spot opposite the door. Peter Hurd had written the introduction for the exhibition catalog, announcing the twelve oil and tempera landscapes and seascapes as the moment of N. C. Wyeth's liberation from the art of illustration. Some 300 guests appeared, jamming the room all afternoon. Among them was the author Marjorie Kinnan Rawlings.

Earlier in the year N.C. had traveled to Florida to research *The Yearling* and meet Rawlings. He had gone with some trepidation. Maxwell Perkins's author was upset that N. C. Wyeth was illustrating her Pulitzer Prize–winning novel. Despite a letter N.C. had written to calm her fears, Rawlings remained disturbed by the prospect, as Wyeth acknowledged, "that an illustrator is about to invade *The Yearling*." As it turned out, however, N. C. Wyeth's oil-on-gesso panels added to the status of the novel. The Wyeth edition of *The Yearling* would have a long life as a Scribners classic, just as Max Perkins had predicted. In November 1939, Rawlings wrote N.C. in reconciliation, praising him so strongly that he answered, "If I were to meet you face to face, I would blush furiously in profound gratitude and humility."

At Macbeth's a month later, Rawlings slipped into the artist's reception under a big black hat and bashfully presented her collaborator with, as Henriette described it, a "huge and violent bouquet with every known flower in

it." Blushing furiously, N.C. could hardly bring himself to take the flowers. He looked so surprised that the world could be this good to him he seemed on the point of tears. Ann Wyeth later remembered it as a characteristic moment for her father.

Ann had been practicing at the family piano when a telegram from the Corcoran Gallery in Washington, D.C., was telephoned to the Homestead. In the 1932 Corcoran biennial, *In a Dream I Meet General Washington* had won a prize, a fourth prize—the fourth of four William A. Clark Prizes, accompanied by $500 and a Corcoran Honorable Mention certificate. N.C. had always told Ann and the other children that prizes didn't matter—an artist went ahead, did the work. He had won prizes, first prizes and gold medals, but always as an illustrator. Each time he had shrugged them off. To be honored as a painter, even in fourth place, was something else again. He had come away from the telephone that morning in a wash of tears.

At his opening he still did not know how to accept praise. The reviews for N. C. Wyeth's show at Macbeth's were torture. More admiring than either he or Robert Macbeth had expected, the critics applauded the artist for his light and color, his disciplined sense of line. Macbeth summarized: "*Tribune* fine—as expected; *Times* excellent—and (knowing Jewell) better than expected; *Brooklyn Eagle* (unfortunately of little help) fine; *Sun* pretty good for McBride, who doesn't like things that are well done; and, of course, the fine general publicity of *Art Digest* and *Newsweek*."

Two paintings sold. *Fox in the Snow* went for the established gallery price, $750. But on the sale of *Sun Glint*, N.C. found an opportunity to sell himself short, sacrificing $300 so that an impecunious buyer could afford to buy an Andrew Wyeth watercolor at the same time. All told he had posted expenses of $1,390.64 and gallery commissions of $337.50, for a loss of $528.14.

Within hours of returning to Chadds Ford, the "inevitable reaction set in and I've felt pretty low ever since," he told Paul Horgan. He knew he "*ought* to be encouraged and reasonably happy," but he only felt frustrated now that he could see "with cruelly clear eyes" how short he had fallen, and "how little time there seems to be left in which to make up the distance."

PEOPLE IN NEW YORK had begun to identify N.C. as "the father of Andrew Wyeth." The following spring he would be called by the title that had once belonged to Howard Pyle: "dean of American illustrators." He was fifty-seven, and feeling his age. As so often before, he had kept an important truth about himself from those closest to him.

Two years earlier, on the annual pilgrimage to Maine, N.C. ran a high fever. Ignoring his temperature, he reached Port Clyde racked with cough

and cold. The cold turned into pneumonia. He was ordered by doctors to stop working, lose weight, and convalesce through August. Illness embarrassed him. "Isn't it all fantastically silly?" he asked Ann.

In the fall, at Johns Hopkins in Baltimore, he was diagnosed with a heart-artery condition. He had a double family history of heart trouble. His Wyeth grandfather had died of a sudden heart attack. His father had died of angina pectoris. His uncle Denys Zirngiebel had died of chronic valvular heart disease. His brother Stimson would die of a pulmonary embolism. All this, combined with his ballooning weight, made him, at fifty-six, a classic candidate for a heart attack.

Obeying doctor's orders, N.C. lost twenty-eight pounds by April 1939. He refused speaking invitations at Harvard University and the University of Pennsylvania and turned down mural commissions from Columbia University. He hated to stop painting. "The doctor says go slow, Poor Pa has so many pictures to do, it's hard to hold him back," wrote Carol. He had promised Houghton Mifflin that he would finish their *Anthology of Children's Literature* by Christmas. Yet for the first time in his life, he was forced to limit his work hours, restricting himself to the "ridiculous schedule" of three hours a day at the easel.

He focused on his children. "After all these years of active and intense relationship with them, it is not easy, I suppose, to taper off and fade to a discreet and serene silence," he wrote in February, admitting, "Perhaps I never can." He discussed their every cold. He interceded in their business and personal correspondence and ran interference with museum curators and private patrons. In Maine he would turn from his easel to tell Ann how much salt to add to boiling lobsters. He could not stop mothering them.

Andy's health, particularly a bout of jaundice in 1939, allowed N.C. to worry as his mother had. "Watch your eating," he continually warned. Far into adulthood Andy remained "so utterly unmindful of anything to do with his physical self," that N.C. gave himself the "job of constant urging and watching that he carries out [doctor's] instructions."

He would have done well to watch himself. By the end of 1939, N.C.'s heart-artery condition was worrying his Wilmington doctor, Lewis B. Flinn. Early in January 1940, at a Wilmington dinner party, Dr. Flinn revealed to Henriette that her father's condition was grave. "Unless he takes perfect care of himself he might die at any time," Henriette whispered to Paul Horgan, adding, "Keep this about Pa quiet, he must not know, or Mama either."

Replying to a neighbor's concern about his health, N.C. gave a characteristic answer: "Don't worry about that, the children will do it. I don't know how it is but they always seem to paint just the way I would have painted."

Left Out

NINETEEN THIRTY-NINE looked like a year of losses. In September, Hitler's armies invaded Poland, drawing Britain and France into war. N.C. dreaded the idea of Nat and Andy giving their lives to fight another war in Europe. "It just made him sick," Nat later recalled.

On September 22, Joe Chapin died of pneumonia. A week earlier they had been working together, correcting plates for *The Yearling*. All told, their collaboration at Scribners had spanned some fifty books and uncounted magazine illustrations over thirty-five years. N. C. Wyeth had proved to be Chapin's great contribution to literature; without him, the Scribners Illustrated Classics would have been just another set of gift books. For Wyeth, the partnership with Chapin had been the longest-sustained professional relationship of his life as an artist. Wyeth would remain ambivalent about Howard Pyle to the end; with Chapin, despite years of disappointments and printer's errors, he looked back without a single complaint. "I wish that we had it to do all over again," he said after Chapin was gone.

Another important assisting figure had also died—William Betts, the country doctor who had brought each of the Wyeth children into the world. N.C. attended the funeral, impressed that Dr. Betts's life was "one of constant and genuine sacrifice." In August 1940 still another lifeline for the Wyeths would be severed when Robert Macbeth died at the age of fifty-six after a month's illness. "What an invaluable person the American painter lost when he passed on," N.C. wrote to Andy.

On top of all that, he was losing Henriette to the Southwest. Neither father nor daughter wanted to face the inevitable, but this would be Henriette's final winter in Chadds Ford. After a visit with Pa to the Old Masters Building in the World of Tomorrow at the New York World's Fair, Henriette wrote, "I have never felt so close to him, and found myself so deeply touched and stimulated by the youthfulness and passion of his delight and regard."

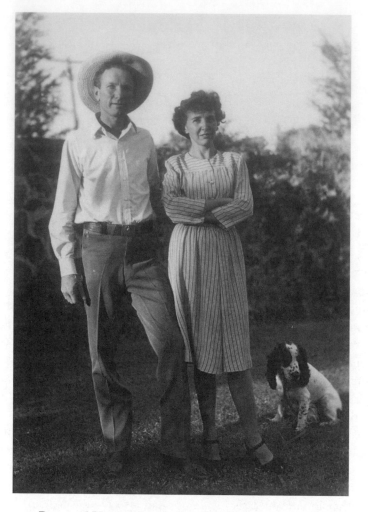

Peter and Henriette with their English cocker spaniel,
Saturn, in New Mexico, 1944.

In November, a week before N.C.'s show at Macbeth's, Henriette finally
made up her mind about where to live. "I am hideously relieved and excited
over my having at last decided," she wrote a friend.

No matter where she lived, Henriette's role as N.C.'s perceptive daugh-
ter was not going to change. If anything, her observations about her father
and the family circle sharpened with distance. Far off in a river valley of her
own—the Hondo Valley in southeastern New Mexico—she would realize
that it was Andy, not she, whose painting had become their father's "great
reward, the reward of his entire life."

On June 15 the Hurds left Chadds Ford, this time for good. "He hated

letting go of my mother," Henriette's daughter, Ann Carol Hurd, said later. "And then Andy came along and he was so extraordinary and that took over."

Until 1939 only Henriette had shown signs of jumping ship. For ten years Pa had had two of his married daughters as neighbors, one under his own roof, and all three bringing him their works in progress. Nat's career at Du Pont had forced a move to New Jersey, but Caroline happily spent weekends with the Wyeths in Chadds Ford. Andy, meanwhile, had no thought but to live at the Homestead with Pa and Ma and Carolyn. "The remarkable thing about Andy and his father was the lack of rebellion," Betsy later observed. Even though Andrew Wyeth was now well-known in New York and Boston art galleries, he had no plans to live or paint outside the valley. "He lives, literally and figuratively, at his father's feet," *American Artist* magazine noted when it put Andrew Wyeth on its cover.

During the 1920s, whenever N.C. went to New York to confer with Joe Chapin, the children had assembled in front of the Homestead. Although their father would be home by nightfall, the five little Wyeths formed a solemn delegation high on the hill, waving tea towels until N.C.'s train pulled out of sight. Whenever one of the adult children left Chadds Ford for any length of time, they all gathered at the Homestead for one last meal with Ma and Pa. Nineteen thirty-nine turned out to be Andy's year to leave Chadds Ford—on Christmas Eve, of all times—for East Aurora, in western New York.

"THIS HAS BEEN a perfect year—in every way," Andy wrote in his studio log in December, underscoring "*met Betsy.*"

A week after they met in July, Andy proposed and Betsy accepted. Engaged without telling their parents, they made an important discovery: both liked to keep secrets. Both were youngest children who had grown up on the outskirts of their families. "I had two lives," Betsy later remembered, "a very social life and a life no one knew anything about, and so did Andy. I just fit immediately into Andy's way of thinking. I think that's what fascinated him about me. It was almost as if he were marrying himself."

Unbeknown to N.C., Andy had bought a diamond ring in New York City on the day of his father's opening at Macbeth's. Andy planned to put the ring on Betsy's finger as soon as he got off the train in East Aurora, 350 miles to the north. They would then make the announcement surrounded by the James family. At the Homestead there were tears as Andy said good-bye. N.C. afterward wrote Henriette: "He was quite broken up; I've never seen him quite so emotional. But he's doing the right thing and we all urged him to go."

N.C. felt certain that Andy had "made a most fortunate choice." He predicted that Betsy would be "a magnificent complement to him and his aspirations." But N.C. had watched all through the autumn of 1939 as Andy devoted himself less and less to painting and more and more to Betsy. He saw Andy writing as many as two and three letters a day—passionate, illustrated outpourings to "my precious Betsy." And when Betsy came to Chadds Ford for Thanksgiving, everyone in the family noticed how "Andy and she danced and spoke and looked as if they were floating." Just when Andy was poised to make the next crucial steps in his development as a painter, N.C. saw him losing his concentration. He decided to intervene.

N.C. argued, as his own father had, that marriage would add intolerable financial burdens to Andy's life. In spite of Andy's promising start in the art world, N.C. was doubtful that even a celebrated young painter could produce a "steady enough income to meet the responsibilities which follow marriage."

Reflecting later in life on his father's fears about his future as a painter, Andy observed, "Everyone else, all the other children, had stopped, and I was sort of the last foothold. John married Ann and didn't want to pay for the music lessons. Carolyn had stopped. Henriette was painting, but she had a family. So he tried to bribe me."

N.C. offered Andy a deal. If Andy would postpone marriage, N.C. would build him a studio in Chadds Ford and pay his monthly expenses, leaving Andy free to paint.

Andy hedged. Unlike Nat, he would not be bribed into staying home. Unlike John McCoy, he would not delay. N.C. tried again. On December 15 he wired Andy in East Aurora, urging caution and common sense, meanwhile begging the Jameses to insist on a long engagement. Looking back on N.C.'s efforts to stall the marriage, Betsy would later observe, "I think he felt that Nat's marriage wasn't the best, Henriette's wasn't the best, and he was careful to watch over Andy."

"I don't think he wanted any of us to marry," said Ann Wyeth McCoy. "He wanted to keep all of us around."

FIVE MONTHS LATER, on May 15, 1940, Andrew Newell Wyeth III and Betsy Merle James were married before the fireplace in the Jameses' house at 814 East Fillmore Avenue. The bride was nineteen and wore a fingertip veil held in place by a tiara of gardenias; the groom, twenty-two, was decked out in white tie and tails. About a hundred guests jammed the room. Standing shoulder to shoulder, the Jameses and the Wyeths surrounded Betsy and Andy as they exchanged vows.

Betsy and Andrew's wedding day, May 15, 1940, East Aurora, New York.
NCW, at right, in black tie.

Betsy would later remember "a sea of faces"—all waiting for the climax of the ceremony. But before Andy could kiss Betsy, there was an intrusion. Andy's father's hand came up, then his arms, and then suddenly N.C. came forward, wedging himself between the bride and groom, his back to Betsy.

"N.C. was just there, instantaneously," she later recalled, "and he and Andy fell into an embrace, both weeping." The tearful hug lasted no more than a couple of moments, but to Betsy, standing by herself in that circle of faces, the embrace seemed to go on for an hour.

Back in Chadds Ford, disconsolately working on mural commissions in his studio, N.C. inserted himself into the honeymoon. "How many times a day I think of you two in Port Clyde," he wrote. "It is always a tonic to my spirit, but it is also agitating and induces a deep restlessness."

By July his distress redoubled as he imagined himself receding from Andy's life. "I seem to see him as [if] through the big end of a telescope, a little miniature figure, in sharp detail, but so far off." As for Betsy, he was still keeping a weather eye. He liked Betsy—her sensitivity to Andy's work, her "keen intuitions," her "energy and good ideas." Unquestionably she was the woman for Andy, but as he told John McCoy, "with all her aliveness and attractiveness, she is still to me an 'academic' daughter-in-law."

The truth was, she scared him. He could not relax around Betsy. She was like no other woman in the family circle. Not devoted and unquestioning like Ann or overtly self-dramatizing like Henriette or accommodating

like Carol, Betsy James Wyeth was maddeningly self-reliant, eerily percep-
tive. She seemed to know that when he sat down at the piano in the Big
Room and pounded out chords, it was as much to get attention as to make
music. Yet she would not give it to him. N.C. wanted her in his thrall, but
she would not cooperate.

In the Homestead dining room N.C. made a point of sitting Betsy on
his right. That was to be her official place at family meals. But she refused to
use her front-row seat to *his* best advantage. As N.C. held forth, recapitulat-
ing his trials as an artist; and as the assembled family offered their sympathy
and understanding, Betsy was silent. She would not affirm his authority as
the others did. "I was tough on him," she later acknowledged. "I gave him
no love, no affection."

N.C. reminded Betsy of how it had felt to grow up with a father who
talked about painting without fulfilling himself as a painter. Merle James's
first one-man show at the Currier Gallery of Art in Manchester, New
Hampshire, was still twelve years in the future. Betsy was tired of frustrated
artists making an audience of their children to sound off about art. She
thought N. C. Wyeth was overbearing, an egotist. "Why does he talk so
much?" she wondered. "If he's any good, why doesn't he shut up and paint?"

When Betsy did applaud him, she made sounds N.C. did not like to
hear. One night Betsy said she thought *Old Pew* was the greatest painting
N. C. Wyeth had done—an original observation for 1940; another forty
years would pass before art historians and tastemakers admitted N. C.
Wyeth's illustrations into mainstream American easel painting. In 1940
N.C. was his own worst critic. After Betsy had made her case for *Old Pew,*
the famous illustrator glared at her from under knit brows. "You'll grow up
someday," he said coldly.

That summer, when N.C. and Carol joined the honeymooners in
Maine, things did not go well. N.C. felt Betsy recoil from him. The visit was
trying for everyone, contrasting sharply with the stopover Pa and Ma had
just made in Pompton Lakes, New Jersey. There, in Nat and Caroline's
orderly, well-run household on Cedar Road, N.C. found it possible to "relax
into a state of contentment and bliss." He felt a surprising sense of belong-
ing, as though he had returned to his first home. Caroline was the big sur-
prise.

Ten years had passed since wild, "lightweight" Caroline Pyle had first
appeared in his life. Now, at twenty-six, she possessed a new seriousness, a
concern he had not noticed before. She had been changed by loss. In
November 1938 Caroline had given birth to their first child, a girl, Katharine
Pyle Wyeth. Katharine was injured during a forceps delivery and died
hours after birth. Nat blamed the obstetrician, a woman, who had delivered

Caroline Pyle Wyeth on the front lawn at Cedar Road, Pompton
Lakes, New Jersey, July 1940.

the baby at the end of a long, tiring day. "A man would have had more
stamina," he contended. In Nat and Caroline's grief, N.C. saw himself and
Carol, the loss of a firstborn carrying him sadly back to the death of the first
Carolyn Wyeth.

On the way to Maine in the summer of 1940, Caroline changed. The
exact moment is undocumented, but at one point Caroline revealed a new
side of herself to N.C. Sensing that his heart condition was giving him
pain—pain that he was keeping to himself—she looked straight into his
eyes and said, "Mr. Wyeth, how are you feeling?" He returned the look, say-
ing, "You really care, don't you?" With Caroline's unexpected concern, he
felt a burden lift. Unadored by Betsy, he was gratified by Caroline's solici-
tude. Days later in Maine N.C. and Carol arrived to find that although
Andy and Betsy radiated their own happiness, something—Pa and Ma
Wyeth knew not what—had turned Betsy solidly against them. Her ani-
mosity "worried us sick," N.C. reported to Henriette.

After a day or so relations improved. Betsy showed goodwill again but
continued to puzzle N.C. When they passed each other in the kitchen, or
when he was alone with her, he did not know what to say. Her imposing
beauty, her thorny resistance to his covert subject—himself—pierced him.
When he offered ringing pronouncements on life and art, Betsy was atten-
tive, polite. At the same time, she drew a line.

Caroline and Nat, with Lupe, the Wyeth family dog, Port Clyde, Maine, 1940. Photographed by Carolyn.

NCW and Carol on the Wyeths' dock, Port Clyde. "Try to diet please," NCW urged Carol in June 1938. "It's really so necessary for our later comfort." Ann in bathing suit.

Peter Hurd had married the whole family. John McCoy, whether he wanted to or not, had also married them all. But Betsy James had married Andy. She had not come to Chadds Ford to be N. C. Wyeth's latest protégée. Betsy recognized that her father-in-law was intimate only with those willing to let him dominate. The more she refused to compete for his love and attention with the other women in his life, the harder it became for her to have any relationship with him at all.

The word *giant* appears over and over in descriptions of N.C. in this period. His family enlarged him. Pa strode through their imaginations untouched by time or age or reason. They treated his studio as if it were a lair. According to Andy, a groove had been worn into the boards under his father's pounding feet. In reality the floor was no more worn around N. C. Wyeth's easel than at any other spot in the studio. But to his wife and children he appeared larger than life.

Of the younger generation, only Betsy and Caroline would object to the mythology. Both daughters-in-law would come to emphasize N.C.'s generosity—intellectual and financial—and his emotional intelligence rather than his physical power. "All this about N. C. Wyeth being massive," Betsy mused later. "He wasn't big. His explosions were big."

"It is difficult to believe," Caroline complained to *Life* magazine in 1957, "that N. C. Wyeth, a man of tremendous intellectual power and profound sensitivity, could have left any of his descendants an impression of himself as 'a combination of Paul Bunyan and Santa Claus.'"

But playing up a folk hero's gargantuan size and appetite, especially as an infant, is a convention of traditional American tall tales. Ann Wyeth put their father's birth weight at thirteen pounds. Andy imagined that N.C. had weighed eighteen pounds at birth and more than three hundred pounds as an adult. They may have known the true facts, but they preferred always to astonish people and create in others the same sensation of wonder that their father had created in them.

TENSION BRIMMED AGAIN that autumn when the Wyeths returned to Chadds Ford. Andy and Betsy moved into the schoolhouse vacated by the Hurds at the foot of the Wyeth property. As neighbors neither N.C. nor Betsy succeeded in putting each other at ease. Although no longer hostile, they had grown embarrassed by what each knew about the other.

Life among the Wyeths was "sort of like going to a very strict school," said Betsy. "Whenever he—[N.C.]—wasn't there, it was like the teacher was away." She even lived in a schoolhouse—*his* schoolhouse.

Every morning, as part of his regular routine, N.C. delivered the mail

and a *New York Times* to Andy and Betsy. He thought nothing of entering their bedroom. Even when Andy and Betsy lingered in bed, N.C. would pound on the door until Andy let his father in. N.C. often stayed the better part of the morning, talking with Andy about painting, or reminiscing about the old days in the valley. Although Betsy heard quite well that N.C. thought he was talking about painting, to her it sounded "as if life itself had come to a finish, all excitement in living gone. Nothing new remained but the horror of World War II—and memories of past Christmases, past intimacies." She would remember wishing that it would snow so that she could "go somewhere and ski in this godforsaken place [she'd] landed up in."

To shine in Chadds Ford, she would have to paint or compose or invent. To shine in N.C.'s eyes, she would have to be a cook and a mother. But motherhood eluded her. Not only was Andy resistant to children—any intrusion on his painting terrified him—but three miscarriages over the next two years would postpone until 1943 Betsy's hope of starting a family.

In the meantime, on Thanksgiving Day, 1940, she contributed a dish of her own to the family feast at the Homestead. Picking berries had been a passion since childhood. To Betsy's first Thanksgiving as a Wyeth, she brought wild cranberry jelly, molded in the shape of a rabbit, turned out on an oval platter. More than fifty years later, she would remember it as the first time she had succeeded at "*really* pleasing Pa."

Living under N.C.'s schoolmaster's shadow brought Betsy and Andy closer together. Together they rebelled, keeping secrets from Pa. There were numerous things N.C. was now being left out of—pranks, adventures, romantic entanglements. Even more significant in the Wyeth household: N.C. was being edged out of the work. As Andy painted, he for the first time turned to someone besides his father. He depended on Betsy, talking to her about subjects he could no longer discuss with Pa. "Ever so gradually," Betsy later wrote, "we built our life together. 'Pa' was left out."

N.C. SENSED a great shift that autumn. In November he wrote, "The chasm between the past and the future yawns astonishingly."

Over the summer N.C.'s brother Nat suffered a complete breakdown. His career in the automobile industry had come to a halt. He was hospitalized in Detroit, then committed to a sanatorium. He underwent a series of Metrazol treatments. In 1940 patients suffering severe depression were treated with one of three forms of convulsion therapy. Electroshock, the most recently developed, had just come into clinical use in the United States. Metrazol, a fast-acting drug, had replaced the huge doses of camphor that had been used since the late eighteenth century. Though more

Nat Wyeth with his daughters, Gretchen and Natalie, Big Bear, California, c. 1924.

Nathaniel Wyeth (1888–1954) and Gladys Ella Pond Wyeth (1887–1966), Palm Springs, California, c. 1941.

effective than camphor in producing convulsions, Metrazol was also the most traumatic. Injecting chemicals into the patient's body created severe psychological stress. According to the clinical literature of the day, each injection was invariably followed by a "needless moment of terror."

Nat Wyeth received eight injections. N.C. stood by helplessly in Maine. Guessing at the sources of his brother's breakdown, he decided that Nat had learned self-denial from Newell. "Like my father," he wrote, "he conceals so much concerning his physical and emotional disturbances." Yet N.C. drew no parallel between his brother's hospitalization and the similar collapse at the end of his mother's life. Hattie Wyeth seems not to have entered his thinking at all; if she did she remained beyond compare. Instead N.C. blamed Nat's disintegration on his wife, Gladys. According to N.C., Nat's "fear complex" had been "brought on by the ten years of apprehension and worry over the endless crises in Gladys's amazing invalidism."

N.C. did not know the truth. Nat had kept it hidden from everyone except Gladys. Nat was gay; and, as his daughter Gretchen would later recall, "it was a matter of terrible guilt for my father, a cross that he had to bear. In those days being homosexual was a criminal offense, and he believed that he was a criminal. Today he would have had a normal life."

N.C.'s letters in 1940 show no evidence that he understood his brother's breakdown. He tried to explain it this way: "My brother Nat is a victim (partly) of a submerged and hidden cynicism. He always had it, and I can't figure out where he got it. No other of us brothers are that way, though doubtlessly we have other defects."

The burden of Nat's secret fell on Gladys. She agreed to keep it from their daughters, from her parents, and from the world. Gladys was taciturn and reserved by nature, and she loved Nat deeply. She suffered from asthma, but her "invalidism," as N.C. called it, had its actual source in keeping the truth concealed. In 1937 Nat and Gladys moved their family to California for Gladys's health. They lived there for six years. "But my mother's asthma was diagnosed as psychological not physical," Gretchen Wyeth Underwood said later. "She was harboring a secret. She had told Daddy that she would never tell anyone that he was gay, and she never did." She stood by Nat for thirty-eight years. They divorced in 1947. In 1966 Gladys Ella Pond Wyeth—she used all four names to the end of her life—died of asthma.

DURING THE SIX MONTHS of Metrazol treatments that Nat underwent in 1940, N.C. awaited bulletins from Gladys. He kept the "unpleasant" details to himself so that no one at the Homestead would know the depths of Nat's depression or the horrors of his treatment. It is striking that N.C.

Carolyn, Maine,
August 1938.

still believed in innocence. He had often suppressed shocking truths to protect the family, but that he would still do so in 1940 seems remarkable, considering everything the Wyeths had been through with Carolyn.

She had more and more become Hattie Wyeth's granddaughter. Big footed, overemotional, fiercely attached to the land and the past, Carolyn hated change. At the end of a day of painting still life, she would feel a deep sadness at having to leave overnight the things she was painting. Known around the valley as the wildest, least marriageable of the Wyeth children, Carolyn had painted little in 1940 except her well-received *Life Mask of Keats*. She chain-smoked, overate, drank in binges, shunned company, slept with her dogs. "I do what I damn want," she told whoever asked. She hunted fox. Sometimes she rode armed with a pair of six-shooters, galloping around the valley as if it were a battlefield. She looked forever blown by the wind.

Inside the family Carolyn prided herself on being the outcast, the teller of fantastic truths. In childhood she had loved to shock her more conven-

tionally minded sisters by accusing them, as Henriette remembered it, of "incredibly imaginative sins that we never committed." Now, in her unreconstructed thirties, Carolyn would tell tales to her sisters' husbands—family fables that Peter Hurd or John McCoy had not yet heard from Henriette or Ann. Only afterward would Hurd learn that Carolyn was going around Chadds Ford weaving *him* into her histrionics. It worried Hurd that Carolyn might go "to Andy with yarns about Betsy and me. I was fearful of this when [Carolyn] would come to me with wild stories about the rest of the family, afraid that Andy while not *believing* yet might have real seeds of distrust sown in his mind, for Carolyn can tell the wildest stories with such an air of quiet conviction."

N.C. had no idea what to do with her. Ten years earlier, when Carolyn was twenty-one and suffering a "perplexing problem," he had sent her to Johns Hopkins for observation. The problem, the family had learned, was "an extraordinarily upset mental condition, coupled with thyroid gland complications." According to one of her Johns Hopkins psychiatrists, Carolyn's emotional instability could be traced to unresolved feelings about her father. Her father, however, had no use for psychoanalytic theory. Even while acknowledging a connection between Carolyn's "singularities" and the family's history of mental illness, N.C. minimized and blurred Carolyn's excesses, calling them "nothing more than holdovers from my own mother." He saw Carolyn's irrational self as "fundamentally a physical and chemical error which was wished on her by that inscrutable element of chance that Nature metes out many times."

He was made of the same stuff after all. The difference was, he had spent his life trying to control excess. Painting "practical" pictures had been N. C. Wyeth's answer to finding the irrational in himself. Training his fair, brilliant children—Henriette and Andy—to succeed him as painters had been another step in that direction. With Carolyn, however, he had had to struggle. Wild, freakish Carolyn had always reminded him of what he was really like underneath. He had spent nineteen years with her in the studio, nearly a third of his life. Through sheer force of will, his as much as hers, he had trained his unmanageable child to paint.

In February 1941, after six weeks of erratic behavior, Carolyn took a strange turn. As N.C. reported to Henriette, "the delayed adolescence seems to be arriving which is causing new complications which are at times bewildering to say the least."

On April 30 Carolyn vanished from the Homestead. Without telling anyone where she was going, she eloped with a Wilmington art student who

had once attended lectures in her father's studio. When she returned with her husband to a rented apartment on Market Street in Wilmington, she made no announcement of her marriage. She sneaked back to Chadds Ford, slipped into the Homestead, and, for the next six weeks, went on living at home with her dogs, as though nothing had changed.

Then, on a torrid Friday in late June, Carolyn disappeared once more. This time she did not return. An unknown person telephoned N.C.: "Carolyn and Frank have an apartment somewhere in Wilmington and she is determined to make a go of it as Mrs. Francesco Delle Donne."

The heat had reached the upper eighties. The air was stifling and humid. N.C. had just had an operation to correct a fissure in his coccyx. The next day, Andy's dog, Lupe, a Boston terrier much beloved by the whole family, slipped into a coma and died. The job of burying the animal fell to N.C. Meanwhile, a letter from Carolyn had arrived, explaining why she had eloped and who her husband was.

Francesco Joseph Delle Donne, Jr., was ten years younger than Carolyn, lantern-jawed and handsome, with broad shoulders and bright, expressive eyes. He was the son of Italian immigrants. For a wedding present Frank's father, a grocer in Wilmington, was giving the newlyweds their groceries "at cost." The family store, at North Lincoln and West Howland Streets, was the corner grocery for a neighborhood in Wilmington's Little Italy. The Delle Donnes lived over the store, went to Mass at St. Anthony's up the street, had a car—the only one in the neighborhood. Frank clerked for his father. He had never finished high school. He wanted to be an artist.

In 1936 Frank had enrolled in the Wilmington Academy of Art. There he heard a lecture given by N. C. Wyeth. Afterward Wyeth had critiqued student work, and Frank never forgot the words N. C. Wyeth used when praising one of his earliest efforts: "direct and final." Frank idolized the great illustrator. Whenever he caught sight of Wyeth around Wilmington, he had the impression of a "Mister Big of a man, a tall-in-the-saddle kind of person with a great booming voice." A few years later, when Wyeth gave a series of lectures at his studio in Chadds Ford, Frank signed up. After the first talk the student asked if he might see more of the master's work; N.C. suggested that Frank come out to the Homestead one Sunday afternoon.

Frank came several times. One Sunday, he would later recall, while Wyeth was discussing a canvas on the wall of the Big Room, "in through the French doors walks this most attractive, vivacious girl. Like all the Wyeths she had a tremendous smile. Came in with a riding habit, and the hat bit, the whole thing."

Wyeth introduced Frank to his daughter Carolyn, mentioning that she was a painter. Frank afterward suggested to Carolyn that it would be nice to

get together and "compare notes, artwise, whatever." She was not so sure. Months later, when Frank proposed marriage, Carolyn hesitated again. "Well I am sure what I want to do," Frank told her. "We're going to get married." They drove south in the Delle Donnes' car, a black six-cylinder Plymouth. By the time they crossed the Potomac River, it was night. They got a hotel room in Arlington, the first town over the Virginia border. Frank, a practicing Roman Catholic, felt uncomfortable; before spending the night together they must be married. They searched the Arlington telephone directory until they found a justice of the peace. The justice's wife acted as their witness.

When Carolyn wrote her father from Market Street on Friday, June 20, the reaction at the Homestead worried Frank. "We could hear the rumble in Wilmington from Chadds Ford." Then, silence.

The family's annual Fourth of July supper was coming up. Carolyn screwed up her nerve and telephoned the Homestead. Breathless, sounding anxious, she said that she wanted to bring "Fran" to the family supper. Frank later remembered, "We wanted so much to be with the family and be accepted."

HENRIETTE AND HER CHILDREN had been visiting the Homestead. Nat and Caroline had come down from New Jersey; Nat looked overworked, Caroline "especially becoming," N.C. noted. Missing only Andy and Betsy, who were in Maine, and Peter Hurd, still in New Mexico, the clan assembled in high suspense for what Pa billed as "Carolyn's first entry into the family circle with her husband."

N.C. sent Nat to pick up the newlyweds in his car. When they arrived everyone threw himself into welcoming "Fran" into the family. Ann and John McCoy offered to help find the couple new living arrangements and studios in the country. Ma Wyeth laid on a feast. Nat projected two hours of home movies, which turned the newlyweds into an audience and everyone else into a narrator. Frank, of course, fell in love with them all.

The Wyeths would be slow to learn his name. Two months later N.C. would still call him "Francisco." Others knew him as "Francesca." Henriette referred to him alternately as Carolyn's "poor frugal husband," or "her very nice and sensitive Italian husband." At the Homestead, Frank would always be on guard, sensitive to slights. Whenever he tried to warm up to Caroline Pyle Wyeth, he sensed a deeply ingrained prejudice against him as an Italian-American. At one family dinner Frank took umbrage when N.C., carving the tail of the turkey, offered the "pope's nose" to Frank.

That first night it seemed to him that all he heard from the Wyeths was

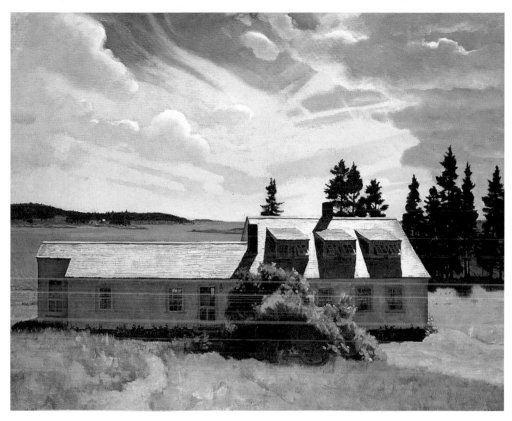

Bright and Fair—Eight Bells, 1936

Cowboy Watering His Horse, c. 1937

Island Funeral, 1939
Tempera on panel

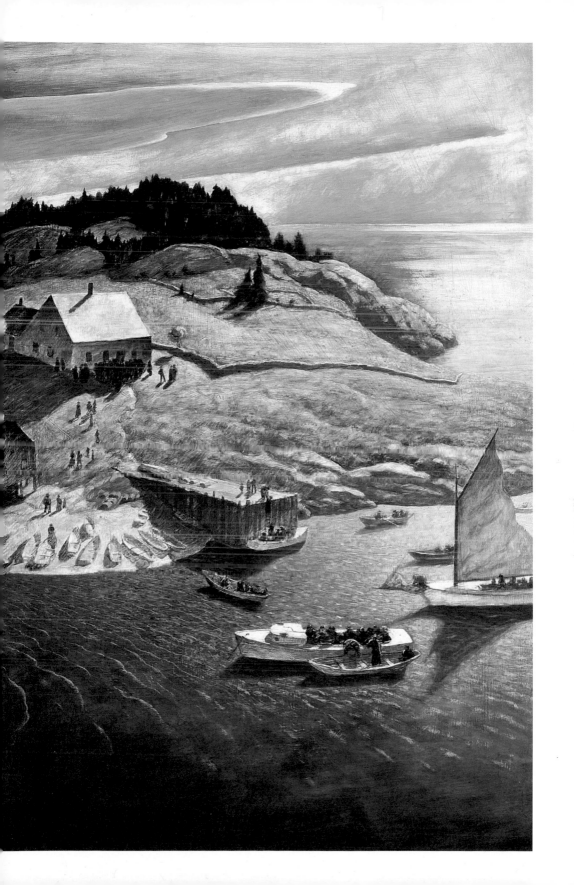

The War Letter, 1941
Tempera on panel

carefree laughter. Frank had never before known a family that laughed that way. He also saw his idol and onetime teacher in a new light that evening. "I found a lot of myself in him, and him in me."

The comparison, especially from Carolyn's point of view, was in many ways true. In Francesco Delle Donne, Carolyn had found a born enthusiast, with a booming voice and a high-pitched laugh. Frank believed himself a born artist. Like N. C. Wyeth, he was the product of haphazard training: a high school dropout whose business-minded father did not believe he could "put food on the table with paint and a paintbrush." Like Newell Wyeth, Francesco Delle Donne, Sr., thought Francesco Jr. would "starve to death."

N.C. that night made his best effort to welcome his former auditor into the family as a son-in-law, but he could not completely hide his reservations. He was relieved at least that Carolyn seemed serene. He had not seen her behaving with this much self-control in years. "Everything went surprisingly well," he reported to Andy. "Regarding Carolyn, we are very naturally in a state of uncertainty; but so far so good. Dr. Flinn has talked to both of them pretty thoroughly and is keeping a close watch in a supreme effort to keep matters on an even keel until Carolyn's new existence 'takes' sufficiently. A well-known psychiatrist is also to be brought into the affair in order to substantiate Flinn and to further stabilize matters." He closed: "We all feel hopeful. But it's been hell, believe you me!"

The new couple moved into a small tenant cottage on a farm in Dilworthtown, up the road from Chadds Ford. They lived over the garage and saw it as a place where they would be able to "be [themselves], together, away from everything and everybody." But they did not live happily ever after. Carolyn was like her father—she "did everything in a big way." Groceries came by the carload, paint supplies by the gross. She never bought just one or two of anything, she bought in bulk, without any sense of proportion or rationale. With Frank she tried to cooperate, making attempts at thrift and practicality, but she had been raised to value extravagance as an expression of artistic temperament. "Do it in a big way!" she would declare, echoing her father.

N.C. prophesied that Frank would not be able to handle her. Frank's five-dollar-a-week salary did not come close to covering Carolyn's day-to-day expenses, let alone her doctors' bills. Complicating the situation still further, Frank would not accept help from the Wyeths. It was a matter of fierce pride. He had been raised to put bread on the table for his wife. "In my family, it's part of our heritage, our tradition, that we are responsible for our spouse, and we do what we can to take care of our spouse the best way we can *ourselves*. We don't want anyone to do anything to help, unless I ask and say: I need help."

Frank worked that summer for the Coca-Cola Company, printing signs for local use in advertising. He drove a secondhand car his father had given them for a wedding present. He chased commissions—"portraits, landscapes, whatever I could get, whatever I could sell, whatever I could get ahold of that would scrape up a living." He ignored N.C.'s warnings. "I pointed at that man and said I don't care how big and strong he is, he can't say that to me because I'm going to take good care of her."

Carolyn's health improved. "For the first time in years she looks fundamentally contented, and even happy!" N.C. reported to Andy on July 24. Frank, too, relaxed. He worked on a portrait of Henriette's son Peter in the lower half of N.C.'s studio and became more flexible in money matters, allowing John McCoy to intercede with Mrs. Irénée du Pont, who drew up plans to rent Carolyn and Frank a converted house on the Brandywine. They would move in by winter, paying only a moderate rent.

Over and over that summer and fall, N.C. was struck by the amazing change in Carolyn. She had begun painting landscapes again. When Dr. Flinn pronounced Carolyn in "perfect condition," N.C. put aside the last of his worries.

Then one Saturday night in November—Frank would always remember it as a hot, humid night—Carolyn ran into trouble. The Wyeths had warned Frank that Carolyn sometimes walked in her sleep, but until that night he had never seen any sign of it. He was a light sleeper and awakened at the sound of feet crossing the floorboards of the bedroom. Silhouetted against the window, which was wide open for ventilation, was Carolyn. Without a word she pushed through the screen. Frank leapt up and rushed to her, but too late. She slipped through the hold he managed to get on one leg and fell fourteen feet to the ground.

She was in serious condition when he reached her. He ran a quarter of a mile across the neighboring hayfield to the nearest telephone. An ambulance took Carolyn to Chester County Hospital, where she was admitted with a fractured pelvis and a shattered leg and ankle. An operation was performed immediately. For the next fifty days Carolyn remained in the hospital.

N.C. intervened at once. Frank had no insurance, no means to cover the bills. N.C. installed Carolyn in a private room and placed her under the protection of round-the-clock nurses. He shouldered the whole cost of her convalescence. Frank's pride mingled disastrously with N.C.'s determination to regain control of his daughter. "A big tremor came from N.C. about my being uncapable to take care of her. There was a rumbling about my not knowing what to do with Carolyn. And between that and prescriptions and stuff, I just had no control over her."

Frank withdrew, and Carolyn gladly put herself back under her father's care. Scandal meanwhile took over. In one version Carolyn had deliberately jumped. In another Frank had pushed her. In another it was Carolyn who had "defenestrated" Frank after suffering a "sexual shock." Gothic tales of Carolyn's marriage remained in circulation long after she and Frank had separated. Her own brother Nat would ever after remember the accident as having taken place months earlier, on Carolyn's wedding night.

Analyzing the "family bombshells" from afar, Henriette sympathized with her parents. "Poor Pa and Mummy went through hell," she told a friend.

Into December, N.C. took charge at the hospital every day. He and Betsy were visiting one Sunday afternoon when a nurse came hurrying down the corridor with a flash radio bulletin. The Japanese had bombed Pearl Harbor.

The climax to months of uncertainty and waiting, America's entry into World War II rallied the nation. For N.C. it was the opening into an abyss. On February 16, 1942, when President Roosevelt ordered all men between ages twenty and forty-four to register for active military service, N.C. was certain that everything he had built on Rocky Hill would now be swept away.

Nat, thirty years old, registered at once; although he had a wife and child and a high-ranking war job at Du Pont, Nat had no assurances during the spring of 1942 that he would qualify for deferment from overseas duty. Peter Hurd, the ex–West Pointer, now thirty-nine, signed on as a war correspondent for *Life* magazine, later becoming a captain in the army air transport command. John McCoy, thirty-one, 4F because of allergies, got a war job at Du Pont. Frank Delle Donne, twenty-two, enlisted in the army air corps special services, painting signs in the art department at Lubbock Air Base, Lubbock, Texas. Andy registered with his local draft board in Maine. He was twenty-four and planned to wait until called, then enter the army as a private.

With his family's fate hanging in the balance, N.C. felt helpless. Infantry duty would be fatal for Andy; he knew that. When N.C. thought of how far Andy had come as a painter, only to be thrust into a foxhole with gun and bayonet, he could not help himself. He was overcome with bitterness at the cruelty of fate, especially now that Andy was "carrying, in such full stride forward, the fundamental study and discipline I *should* have followed."

Registering himself for nonmilitary service, N.C. painted war bonds posters for the Treasury Department; one sold $200,000 worth of bonds, another took in $1 million. According to the poet Archibald MacLeish, who

had become director of the Office of Facts and Figures in Washington, the government's effort to catalyze a reluctant citizenry was "the principal battleground of this war." Wyeth took nothing but a sense of emptiness from his own contributions to the war effort. "In common with countless others," he wrote, "I suffer mainly from the oppressive sense of personal inadequacy, of my inability, in this time of supreme crisis, to be really effectual in *anything*."

"The war," Henriette observed, "gets him down *hideously*."

N.C. found nothing in world events to invigorate his brush. On the contrary, as he wrote to Stimson, "What creative power I have depends fundamentally and at all times upon my acute awareness of the past."

The war made him feel like an old storybook painter with a damaged heart. Over the next four years N.C. listened to war bulletins on the radio and read daily newspapers, but the substance of the war remained absent from his own account of contemporary life. In his letters the conflict never advanced, the antagonists had no names. The war was shapeless, felt only as a "suffocating pressure," a "rush of diabolical events," an "ugly and perfidious state." Until D-day, June 6, 1944, there would be no discussion of any military operation or of the outcome of any specific campaign. The main theme in N. C. Wyeth's Second World War was his own sense of incompletion.

Two-Headed

B Y 1942 HIS NAME WAS stamped on the spines of a long shelf of
world literature, more than a hundred volumes end to end. It was a
remarkably complete body of work, encompassing Greek and
Roman mythology, Bible stories, legends of the Holy Grail, English myths
and epics, European folktales, American prose and poetry, adventure sto-
ries, children's classics, historical novels, works of American history and
Western civilization—remarkable especially for an artist who felt as incom-
plete as N. C. Wyeth still did.

Over the next three years he would be honored with degrees and prizes,
including the Medal of Achievement, the highest award presented by the
Philadelphia Art Alliance. In April 1940, Wyeth came up for election to the
National Academy of Design, the oldest art institution in the United States
governed and controlled by artists. Candidates submitted a self-portrait to a
jury of academicians; a two-thirds vote was required for election. When
Wyeth's self-portrait was placed on the easel, the academicians broke into
spontaneous applause—the only applause given to any canvas during that
year's elections. N. C. Wyeth was elected a National Academician by a vote
of 126 to 4.

As a young man Convers had written, "To me, the most glorious phase
of the great man's career is that final period of divine serenity—not self-
satisfaction, but at peace with himself." N.C. remained in conflict. No mat-
ter what his accomplishments, no matter what honors came his way, he still
had not found his proper place, his true home.

Cornered in his studio, he took inventory, hoping to find in forty years
of picture making something permanent and significant. Everything he had
done seemed insufficient. In the glare of 1942, his illustrations looked naïve,
sentimental. "These times banish the dream," he wrote, "and the pageant of
my painted pictures dissolves into the misty nebular from which they came."

His letters were full of disappointment, his rages more frequent and
unpredictable. His voice resonated with regret. "All sense of serenity and

security has crumbled away, and all I can do, when I think about it all, is to gawk stupidly at the retreating pageant of my dreams and hopes. I am working furiously; that is my one salvation."

Strained by higher taxes in 1942, he forced himself to produce on demand, mainly commissions for calendars and educational posters. He took on Coca-Cola ads. The images looked manufactured: the skies always cobalt, the sunbeams ever golden, the cowboys never discouraged, the horses so clean and unmuddied they looked as if they had been soaking overnight in bubble bath.

In the midst of one project he became "too disturbed" to finish the job. "At my age," he wrote, "I simply cannot jam things through as a duty to accomplish." Increasingly he felt certain that there was a "curtailed limit to the time [he had] left to put things down."

Worried about his health, he sold his grandparents' house in Needham, the Old Homestead, at a substantial loss. On October 30, 1943, N.C. discharged the second mortgage he held on the Zirngiebel property on South Street. "I am forced now with the imperative need of settling up the matter," he wrote to the Boston lawyer handling the sale. "Very confidentially (for I do not want my brother Stimson to know this), I am facing a constant crisis in health due to the thickening of the coronary artery. So far, this has not yet affected my profession as an artist, and I am not at all worried about it, for it may be that I can continue my professional life for an almost normal allotment of years."

He labored over easel paintings such as *Mrs. Cushman's House* (1942), *Pennsylvania Farmer* (1943), *The Springhouse* (1944), and *Nightfall* (1945). No sooner had he finished a painting than the old cycle of self-sabotage resumed. Every sale was a wrenching loss; when Wyeth sold his tempera painting *Walt in the Dory*, in June 1945, he hated to let it go, but the buyer had paid his price—he could not refuse.

In his easel work he tried to "escape into that world of . . . memories and imaginative projections." If he could only hurl himself back *there*, his true identity would be revealed and original unity restored. In *The War Letter* (1941), he revisited an image he had painted in the oil *Spring—1918* (1932). The 1932 version commemorated his struggle with his mother and Stimson during the First World War. Painting in tempera in 1941, he once again populated *The War Letter* with signs of Needham: the Onions' distant barn and meadow, the river, the Jersey cow.

He posed his parents in the foreground, as he had in 1932 for the oil version. A freshly opened letter holds his mother captive. It is one of several in the morning mail. The day's newspaper, with all the latest horrors from overseas, has also been delivered. His mother, clad in dark, heavy town

clothes and a hat, has come down into the pasture and seated herself on Newell's wheelbarrow. Newell, pitchfork in hand, looks on passively as Hattie reads the letter to herself. The same gigantic tree dominates the pasture, looming over the two figures, the same river flows past. But in this version, painted with a darker, heavier palette, the tree's spiky branches uncoil like razor wire along a penitentiary wall. In 1918 and 1932 it had been a sheltering tree, a golden bough in a still-magical world. By 1941 its embrace imprisons.

MORE AND MORE N.C. resembled his mother as she had looked in the midst of South Street sieges. Deep furrows scored his forehead. At the temples his curly brown hair had turned silver. He faced cameras with a grimace. In his National Academy self-portrait of 1941, he depicted himself with a smile of sad resignation.

On March 4, 1942, the day before Caroline Pyle Wyeth's twenty-eighth birthday—her first as a mother—N.C. sat down after work and uncapped his fountain pen. "A birthday to me," he recited, "is first and last a memorial anniversary to the mother of the celebrant."

The commemoration of birthdays had always been his duty—he rarely let Carol have the "privilege" of passing on greetings from both of them. With one notable exception. From the time Caroline Pyle had joined the family in 1937, N.C. had shown no interest in taking notice of her on her birthday. That changed in 1942. He made a special point of honoring her as a mother, and he sent his own love apart from Carol's.

When he descended from the studio that March evening, the war seemed omnipresent. In the valley the sense of danger was real. E. I. du Pont de Nemours & Company, which had supplied 1.5 billion pounds of explosives for the First World War, had again become one of the world's great arsenals. The government had issued special defense instructions, warning residents of the valley that they lived in a "No. 1 danger point in case of bombing attack." "It gives one a funny feeling in spite of what seems to be so remote a possibility," N.C. told Andy. "But crazy things can happen in this diabolical world."

In the Pacific on June 6, the American fleet defeated the Japanese at Midway, while in Europe, Maj. Gen. Dwight D. Eisenhower took command of American forces. Andrew Wyeth spent two weeks that July perched on a tall stool in the middle of the Brandywine Creek, painting a fragment of the riverbank between the railroad and roadway bridges in Chadds Ford. N.C. marveled, "What ability that boy has to concentrate in the face of the upheaval before him."

By August 1942 men who had married before December 8, 1941, had not

yet been called overseas. But when the director of the Selective Service System announced on August 21 that married men would be reclassified in October, the nightmare of Andy being shot at became a reality for N.C. He confessed to Stimson that his anxiety had grown even more "intense and wearing because I felt duty bound to conceal my true feelings as far as possible from Carol as well as from Andy himself."

For N.C. suppression of feelings was followed by depressive moods all through the summer of 1942. He had no taste for life. Sights that usually pleased him—the nut trees surrounding the Homestead with their slender, graceful boughs—now resembled the bars of a cage. "The 'old days' were continually referred to," Betsy later recalled, "golden years, when the five Wyeth children were growing up together."

One night, after reading a letter from Henriette, N.C. found himself slipping into a "nebulous state of mind." As he told it to Henriette,

> Last night, just before I fell asleep, my thoughts full of your letter and experiences, you merged back into my mother and grandmother amidst a fantastic pageantry of Swiss Alps, mountain peaks, little chalets, cattle and steep hayfields, and even village streets and the sound of thin-tones bells. . . . I . . . saw to my painful astonishment the transfiguration of you into my mother and thence into my grandmother. The horrifying part of it was that you were eliminated from life in this metaphysical process.

With Andy he put on the usual facade of Swiss heartiness and New England practicality, peppering his son with instructions: to follow up his leads in Washington; to fire off multiple, paper-clipped copies of magazine articles about Andy's career to ranking officers; to be sure to remember to send letters of recommendation by *first-class* postage.

"Again let me remind you," he warned Andy in September, "that the moment your number is called there is no retreat from being railroaded into the Army as a private."

Unknown to N.C., that was exactly Andy's plan. Andy's conception of army life had been formed by years of soaking up a war movie that N.C. had taken him to see as an eight-year-old boy—King Vidor's silent classic about three enlisted men in World War I, *The Big Parade*. "This film made such a deep impression on me," Andy later explained, "that it got into my bloodstream." Eventually he came to own a copy of the film and would screen it four or five times a year all through his adult life. Forever linked to his deepest feelings about his father, certain frames of the movie would form, with-

out his realizing it, the basis for some of the most important images in his art.

By August, Andy showed no signs of changing his mind about the infantry. N.C. warned: "You realize that the moment your number is called there is no chance whatsoever of selecting the kind of thing you might be best fitted to do. In short, a gun will be put into your hands and that's that."

Andy went forward with his work. Painting in Maine for his next exhibition of watercolors, he produced his best yet. N.C. did the worrying for his younger son. Unable to sleep, the father lay awake at night planning alternatives for the son. By day he pulled strings in Washington, writing letters to everyone who might help place Andy in some kind of special assignment. He was touched when Nat telephoned one evening to say that if it were possible for *him* to take Andy's place in the army, he would leave Du Pont at once and volunteer for overseas duty.

At Du Pont, Nat proved indispensable, the epitome of Joseph Stalin's description of the United States as a "country of machines." Nat invented automated machinery that produced detonators for antiaircraft guns. That summer of 1942 he had some three thousand defense workers under him in Du Pont's explosives division in New Jersey. The plant operated twenty-four hours a day. Nat regularly returned to the house on Cedar Road in Pompton Lakes no earlier than midnight, often after two o'clock in the morning.

THREE YEARS had passed since the death of Katharine Pyle Wyeth, Nat and Caroline's first child. They had tried to conceive again, to no avail. Then, as Nat later told it, just as they resolved to adopt, a boy "came sort out of the blue." He was born November 14, 1941. He was fair, blue eyed—a beautiful baby. In honor of N.C., they named him Newell Convers Wyeth II, to be known as Newell.

The house on Cedar Road was small, the neighborhood modest. Caroline found herself "immersed in [a] hideous medley of radios, squalling children and barking dogs." She was alone with the new baby in a drafty stone bungalow heated by black-market heating oil, frequently anxious, tense, afraid. Fears she had had since childhood resurfaced—of abandonment, of burglars at night, of unclean strangers coming to the door, of rats.

She wished that she and Newell could move back to the valley for the duration. After one two-week holiday at home—they visited Pa and Ma Wyeth and Caroline's sisters—Caroline returned to Cedar Road aghast to find herself "surrounded with noisy and meaningless people again."

NCW with his grandson and namesake, Newell Convers Wyeth II,
from a 1942 home movie.

She spoke every day on the telephone to her sisters, Katie and Ellen.
"They all three had a sense of longing that they couldn't put their fingers on,
and family was the answer to that," said Ellen Pyle Lawrence's daughter
Alice. Outside of her sisters, Caroline had no intimate friendships. She had
made no close friends in Pompton Lakes. Nat had acquaintances every-
where. Gregariousness was his lifelong trait. On Caroline's first visit to
Maine, as one after another of Port Clyde's villagers greeted Nat with hellos,

Caroline invented an old acquaintance for herself. "Oh, look! There's Jake Summers!"

Their marriage was shaped, too, by Nat's perfectionism. When Nat built an exquisitely detailed working model of the Wyeths' twenty-eight-foot boat, the *Eight Bells,* as a Christmas present for his parents in 1938, Caroline made a little felt pennant for the model. Without quite coming out with it, Nat let Caroline know that even with its eight tiny bells stitched onto the felt, the pennant was not quite up to the standard of his pond yacht, and she burst into tears.

The one person Caroline could depend on for understanding was N.C. She wrote to Pa and Ma Wyeth together, always addressing both, but in fact writing to him. It was Pa who sympathized with her loneliness, Pa to whom she could admit her fears.

"Oh hell!" she finished one doleful outpouring from Cedar Road. "My resentment will pass of course and I shall settle once again into our pleasant routine and count myself lucky to be in a sweet house in a nice community—But just now I long so passionately to be 'home' again in every sense of the word."

For him, the magic word. If anyone knew what it was like to have, as Caroline wrote, "nostalgic regrets from being cut away from your family and friends," it was N.C. He took her feeling of exile as his own. He approved of her resentment of the war and of her "impatience with the general character of the people you are more or less forced to associate with." He appreciated her homesickness with the deep respect of a connoisseur, of one who *knew.* Whereas Nat might try to dispel Caroline's anxieties and outbursts, for N.C. they were evidence, as they had been with his mother, of her exceptional sensitivity.

In Caroline there were many reminders of Hattie Wyeth. A strict, maternal temperament showed in everything she did. She ran her house like clockwork. She wore simple, unstylish clothing and took great care of herself during pregnancy. She kept impeccable family records. In scrapbooks she noted each stage of Newell's development, preserving even the red paper hat worn on one of his birthdays. N.C. loved the archivist in her. Using objects to reanimate the past, she found life's meaning in the creation of memory and emotion.

Caroline had a mind of her own. "Caroline's on her high horse again" was her sister Ellen's refrain. In Caroline's letters her opinions and her worries brewed a Hattie-like mixture of indignant superiority, pathos, self-congratulation. They aroused N.C. as his mother's letters once had. The arrival at the Homestead of a letter from Caroline would set in motion (he later relished telling her) a "sort of prevailing hum." Then, as the letter was

opened and read and admiringly passed around, the hum would become "a din of magnitude and excitement." When he read the letter to himself, it gave him "pangs."

N.C. replied to Caroline by addressing her together with Nat, but the literary topics he covered—Emily Dickinson, Thomas Hardy, William Blake—made clear to whom he was actually writing. Nat had no interest in books. Among the Wyeths he was the certified nonreader, while Caroline was seen as an "intellectual, a terrific reader, a sort of solitary person." With only one year of high school, she too was a proud autodidact and, like N.C., was disappointed to find herself with a spouse who "never read anything, not even the newspaper."

N.C. treated her as he had treated few women in his life: as his intellectual equal. On his birthday in 1940, when Caroline presented N.C. with an engraving of Blake's *The Soul Leaving the Body,* he felt honored and moved. None of his daughters, not even Henriette, had tried to change his mind. Henriette had battled him knowing that he would win. With Caroline, it was different. She challenged him to use his mind instead of his heart. "She argued with him and began to change his views, not just in art but in current events," said Caroline's son David. "This was what he thrived on, not just her coddling him or giving him love."

IN 1940, while illustrating the *Anthology of Children's Literature,* Wyeth had urged Houghton Mifflin to reconsider the selections for pictures. *Heidi* appeared in the anthology, but the editors had turned thumbs down on illustrating it, arguing that Johanna Spyri's sentimental Swiss classic "has been done so much." Everyone knew that Heidi was a little Swiss girl, a cupid-faced cherub with a head full of curls. At the time of the anthology, Hollywood's most recent Heidi had been no less an icon of curly-headed innocence than Shirley Temple.

Wyeth, however, felt he could "do something new and refreshing" with *Heidi.* For all its bland charm, it was still the story of an orphan who, expelled from paradise, exiled to the city, is consumed by suppressed homesickness before being returned on doctor's orders to her longed-for home in the Alps. "My mother was from Switzerland," he told Houghton Mifflin, "and I may have something to say about the mountains around Zurich (where my grandmother was born) that will be different."

Heidi is a story of redemption. Finding new life in her old home, Heidi redeems others. Only one chapter of the novel could be included in the anthology; Wyeth selected chapter 3, "In the Pasture," in which Heidi first

reveals her true character as a force of solicitude and spiritual purification. On February 27, 1940, Houghton Mifflin relented, and Wyeth went ahead and did something altogether new with Heidi.

He gave her Caroline's face. N. C. Wyeth's Heidi has a grown-up woman's head on a five-year-old girl's body. She has a thick black bale of hair. Standing on a boulder-strewn hilltop in immaculate Alpine sunshine, this Heidi is no lighthearted sprite. Her brow darkens, and her searching black eyes are cast gravely down. Wyeth's portrait shows Heidi in the act of comforting a lost mountain goat. "What is it, little Snowflake?" she asks the bleating goat. "Why do you call like that as if in trouble?" Caressing the animal, Heidi peers into its eyes with deep concern, much as Caroline had done that same summer, asking, "Mr. Wyeth, how are you feeling?"

In the foreground the young goatherd Peter eats a cheese sandwich— the very image of Nat Wyeth, with his long, genial face and sandy hair, munching one of Pa's homemade sandwiches at work. From Peter, Heidi learns that poor little Snowflake is an orphan, like Heidi herself—as Caroline Pyle had become before entering the Wyeth family in 1937. In a voice so sympathetic that the author calls our attention to it, Heidi soothes the lost goat with her pledge that Snowflake "will not be alone any more." Eventually Heidi does the same for every important figure in the novel, reinvigorating all the lost, uprooted souls as she returns them to their original place in paradise.

N. C. WYETH was exhausted. He was entering his fifth decade as a professional illustrator; his vitality was gone. Always a rigorous technician, he had lately allowed his working methods to deaden his usual enthusiasm for the process of composition. Now, instead of working directly from his imagination, N.C. transposed rough sketches onto canvas with the help of Kodak slides and a huge slide projector. When at last he took up his brush, he painted thinly, without building up surfaces. His brushwork no longer created form, as it had in the days of *Treasure Island.* "Yes," he conceded, "canvases covered, hours applied, but little accomplished."

At the Homestead he found no one to inspire him. For years Carol had dutifully climbed the stone steps from Homestead to studio. Ever the painter's good wife, she had listened to his windy explanations of what he had been after and where the composition had gone wrong. She had greeted each canvas with her sleepy smile and a fumbling phrase of encouragement. Once she dared to venture an opinion, and was abruptly dismissed. Exploding with rage, N.C. told her that she did not know the first thing about art.

The incident changed things between them. Carol never again took part in any discussion of her husband's painting. "I decided," she later said, "I wouldn't upset things."

After Henriette's departure to the Southwest in 1940, Carolyn had tried to fill in as Pa's other half in the studio. Then came her marriage, the move to Dilworthtown, her fall from the window. By March 1942, Carolyn's convalescence had progressed to the point where she was pegging around the Homestead on crutches. Gradually she began to paint again in her own wing of N.C.'s studio. He leaned heavily on her. When N.C. finished a picture he liked, Carolyn was now the first person he brought to his easel for a critique. No matter what Carolyn said, however, he never quite believed her. She was too much like him. He was too much his own debunker.

Only Andy, he believed, had the power to lift him out of himself. Stimulated by daily visits to Andy's studio, he ascribed any improvement he saw in his own easel work to Andy's influence; he took Andy's word as final judgment. It was the same authority he had once given to Howard Pyle.

In July 1942, as Andy and Betsy prepared to trade Chadds Ford for Maine, N.C. faltered: "How I shall miss him! He's been a tower of strength to me this past year." In August, when at last Andy left, the departure came as a blow. Saddled with commissions, N.C. stayed behind, "slowly pushing [his] work along." To Andy he exclaimed, "How I could profit from a critical talk from you at the present moment!"

For Andy it was a painful period. The erosion of his father's life as an illustrator saddened him. His father remained for Andy the creative genius he had always been. The idea that Andrew Wyeth was now influencing N. C. Wyeth made Andy uneasy.

Fated to play first fiddle to his father, Andy made an idol of him. Over the years, as Andy became more and more prominent, he would always take himself down a peg by crediting his father, as his father had once credited him, with the greater talent in drawing.

In 1942 cracks began to appear in the idol. Andy submitted *Spring Freshet,* painted in tempera that July on the Brandywine, to the "Artists for Victory" show at the Metropolitan Museum of Art in New York. For the same show N.C. contributed *Summer Night,* a tempera painted in 1942. Word came of Andy's acceptance; Andy rushed to tell his father. To Andy it was unthinkable that N. C. Wyeth's work would be turned down by the same jury that had accepted his. But *Summer Night* had been rejected, and Pa had just heard the news when Andy came bustling into the studio. "That was the worst experience I ever had," Andy said later. "I felt like a shit."

Two years earlier, at age twenty-three, Andrew Wyeth was the youngest member ever elected to the American Watercolor Society. But if Andy saw himself outdistancing N.C., he never let on. He never pulled rank on his father in the art world, although increasingly it was Andrew Wyeth's painting, his temperas, that drew the kind of attention N.C. had longed for all his life. On opening night at a major group exhibition at the Museum of Modern Art—"American Realists and Magic Realists"—Edward Hopper approached to tell N.C. how bowled over he was by his son's work. Hopper, who was born in 1882, was N.C.'s contemporary, but that evening it was twenty-five-year-old Andrew Wyeth with whom Hopper connected.

THROUGH THE EARLY FALL OF 1942, Andy and Betsy stayed on in Maine. N.C. thought of Andy incessantly. "I dream again and again of the ecstatic pleasure it would be for me to drop into your studio, and with the sound of the tide washing in around the rocks in my ears, to feast upon the sight of your watercolors, as you would present them one by one."

He decided that a correspondence "might prove of some interest to [Andy] and some pleasure (in the writing) to me." He wrote Andy twelve letters in the course of the summer of 1942. But something was wrong. Andy was not interested in writing letters, and the correspondence, to N.C.'s great disappointment, never got beyond "objective matters and practical affairs."

Wounded by Andy's withdrawal, he confided in Caroline. To her he could admit, "It is highly possible that I am fundamentally at fault [about Andy], that I may parade an unconscious chip on my shoulder!" The chip, of course, was Betsy. Without coming right out with Betsy's name, he nevertheless acknowledged that it was he who had alienated her. He dared to joke about the dinner table filibustering for which Betsy had been on his case. He trusted Caroline enough to take a slap at Betsy: "I've been blamed for this, but I think that those who feel this way about me mistake my enthusiasm for egotism, or whatever else it is they feel."

THE *Anthology of Children's Literature* gave him another chance to reveal his feelings about Caroline in pictures. The English fairy tale "Jack the Giant-Killer" offered Wyeth four giants to choose from, including the eighteen-foot-tall Cormoran. Wyeth ignored the superstar and chose to paint a lesser two-headed Welsh giant whose reputation had been made not by acts of strength but by "private and secret malice under the false show of friendship."

He depicted Jack inside the giant's castle, standing on the giant's chair,

holding the giant's spoon. Wyeth's Jack is blond, fearless, an armored Teutonic knight boldly facing his foe. The giant has set before Jack the steaming bowl of poisoned pudding with which he hopes to trick him. Literally two-faced, the giant turns one head and winks at Jack while tilting the other head at a sympathetic angle and murmuring encouragement. As Wyeth has painted it, the drama is not in wondering whether Jack will eat the pudding but in watching two minds work to achieve the same evil end.

Painted in the summer of 1939, after a visit in June to Nat and Caroline in Pompton Lakes, *Jack the Giant-Killer* is one of the most powerfully auto-biographical images N. C. Wyeth produced. From the kneecaps up he rendered the giant as recognizably male, including beard shadows on both chins. The right-side head, however, has a sympathetic forward tilt, a fore-lock of raven hair, and an expression of concern around the eyes and mouth which are unmistakable characteristics of Caroline. To the left head N.C. gave the droll, teasing expression of Nat. By using Nat and Caroline for the giant's double head, N.C. was able to include himself (in the form of the giant's body) in a romance that excluded everyone else in the family circle.

The painting also figured importantly in the unfolding of his relationship with Newell, who had begun making regular visits to N.C.'s studio—"a sure sign of Grandpa's favor," another grandchild later noted. Around Christmas 1942, at the age of thirteen months, Newell first saw the original of *Jack the Giant-Killer*. He asked for it by name the following September. Newell "insisted upon looking at picture after picture," N.C. wrote, "until I just had to call a halt. He has a real imagination and was sharply disappointed that I hadn't the two-headed giant which he remembered seeing last Xmas."

From the beginning N.C. had identified Newell as unusually quick and attentive. The more Newell visited N.C.'s studio, the more the boy took an interest in *Jack the Giant-Killer*. Newell was "transfixed by it," his brother David later wrote. "In the way of children, he shrank from the image even while being fascinated by it. No visit to the studio was complete until he asked, 'Can I see the Giant?' "

ON OCTOBER 16, Andy and Betsy returned to Chadds Ford. Andy had not yet been called by the army, and N.C. allowed himself a moment of unguarded joy. "They both look so well!" he told Henriette. "Betsy with some much needed added weight, and Andy lean and bronzed." Best of all, Andy had come home with a commission for a book illustration that had to be finished to meet a publisher's deadline.

Jack the Giant-Killer, 1939.

Father and son had been collaborating on book illustrations since Andy was sixteen. In the mid-1930s, before his emergence as a watercolor painter, Andy had illustrated several books with which N.C. had helped. Andy, in turn, had assisted his father with the pen-and-ink work in N. C. Wyeth's *Men of Concord*, a selection from Thoreau's journals. Andy had produced twenty-four pen-and-ink drawings, and Houghton Mifflin and the public had never been the wiser.

In 1938, a year after his first success at Macbeth's, Andy went on taking jobs as illustrator under N.C.'s wing. That June the father-son team had received a $300 paycheck for their collaboration on *The Red Keep: A Story of Burgundy in the Year 1165,* illustrations by N. C. Wyeth and Andrew Wyeth. Somehow, perhaps because N.C. still had hopes that Andy would be his successor in the field of illustration, he decided that his son deserved the larger share. He put $200 in Andy's bank account and kept $100 for himself.

In terms of illustration, Andy never saw himself as anything but the lesser Wyeth. For him, illustration was hallowed ground, the medium of the Great Pyle and of his father's masterworks; and though Andy gamely tried his hand at commissions that came his way, he quickly established a new set of priorities as a painter. With watercolor exhibitions to prepare for each fall, his summers remained inviolate. When illustration even for a moment appeared to intrude on the time Andy had set aside for painting watercolor and egg tempera, he turned the offers away.

In 1942, however, Andy was in no position to turn down good money. His and Betsy's finances were in the dumps. During the first year of America's entry into the war, the art market had plunged. At the Macbeth Gallery that fall, Andy's previous buyers were not buying, and new buyers were nowhere to be found. "These are not normal times," warned Robert McIntyre. He encouraged Andy to take on illustration.

In October Andy had finished a $175 commission for a single illustration for *The Forest and the Fort,* the first in a projected five-volume historical saga of Pennsylvania by the best-selling author Hervey Allen. Appearing as a formal frontispiece, the picture, as Andy had conceived it, would seem to be an authentic Colonial portrait of the novel's hero, Salathiel Albine, a soldier and adventurer adopted by Indians on the western Pennsylvania frontier. Andy meant for the smooth-surfaced tempera to be seen as a reproduction of an imaginary 1763 oil portrait painted at Fort Pitt by an imaginary portraitist, Lt. James Francis of the Royal American Regiment. A tiny credit line would announce that the "original" portrait had been "projected by Andrew Wyeth, Esq."

Andy had started the picture in Maine and worked quickly to complete it in Chadds Ford. Salathiel's head, disguised as Native American, had given

him some trouble, but as soon as he had worked it out, he showed it to Betsy. She liked it. She thought Andy's conception of the picture was original, singular. He had painted, in effect, a trompe l'oeil. Unless you looked at the fine print, your eye believed that you were seeing a reproduction of an authentic oil portrait painted at Fort Pitt and signed by Lt. James Francis.

Andy asked his father to come down to the schoolhouse to look at the finished work. N.C. praised it but saw that he could help Andy sharpen the details of Salathiel's head. As was their custom, N.C. preempted Andy's place in front of the painting. He took Andy's brushes and dipped into Andy's paints; and, as Andy stood aside, the master sat down to repaint the weak passage.

Just then Betsy came in. She was now twenty-one. Still savoring the independence of their summer away from Pa's schoolhouse, Betsy was startled by the scene before her. The wonder was not that N.C. would take a brush to Andy's work but that Andy, at this point in his life as an artist, would still allow his father so much authority. Andy, she knew for a fact, hated it when his father tried to "neaten up" his work.

She read the situation instantly: Once again Andy was bolstering his father's confidence by seeking his help.

At the moment, though, Andy could think only of Betsy, standing there, breathing deeply, jet eyes blazing. He thought she was behaving foolishly, especially when, without a word, she swept from the room, slamming the door behind her, leaving Andy with a "Lady or Tiger" choice: his father or his wife.

In the Wyeth patriarchy there had never been a businesswoman. Carol had barely been trusted with household accounts. Henriette was hopeless with finances, Carolyn a nightmare. At the end of one period of Carolyn's life, she had accumulated twelve unused coffeemakers. N.C. worried that Andy, too, would be forever unrealistic about money.

Acting as Andy's business manager, N.C. administered accounts, corresponded with the gallery and the bank. Since Andy and Betsy's marriage, he had gone right on drafting statements for exhibition catalogs, passing along illustration jobs, and offering stern advice to Andy about how to earn his living as an artist. As much as Andy had wanted to please his father in the old, pre-Betsy days—"You are the only person that really understands what I am after . . . and I only hope that in the future I can really make you feel happy," Andy had written his father shortly before his first show at Macbeth's—N.C.'s meddling had finally strained relations to the breaking point.

On October 22, 1942—N.C.'s sixtieth birthday—Andy and Betsy made it official: "Andy threw up his arms," Betsy wrote to Macbeth's, "and gave me full charge of business."

Betsy had a natural sense of order and could be committed and disinterested at the same time. She was not unnerved, as the Wyeths so often were, by directness. Amicable but assertive, she proposed to come into Macbeth's to straighten out the numbering system for Andy's watercolors.

She asked for and received an answer about a questionable check the gallery had sent. "All of us were dumbfounded that he should get only $180," Betsy wrote. According to Andy's contract with the gallery, the correct fee from the $300 sale should have been $200. Macbeth's acknowledged their mistake at once and sent along full payment.

It was the sort of discrepancy N.C. would have let slide. His habit of selling himself short had never changed; when fielding offers and commissions for himself and Andy, he still avoided asking tough questions about price and payment in advance, accepting without additional negotiation whatever was finally offered, usually a pittance.

Supplanted by Betsy, N.C. never again involved himself in Andy's work. He had hung on a long time, but his days as his children's alma mater were over, and it hurt. What he wanted most he could not have, not even from the son he had taught to paint.

He yearned to start over, longed to mold a "fresh mind."

Delaware Avenue Girl

To UNDERSTAND what happened between N.C. and Caroline Wyeth in these wartime summers in the valley, it is important to know that her parents had met and fallen in love in Chadds Ford in the summer of 1898. To Caroline in the summer of 1944, her parents' story remained vivid. With its taboo romance, adulterous passions, tragic deaths, and sensational twists, it had a forbidden, hopeless quality that still exerted a strong influence on her thinking, especially in her relations with N.C.

Caroline's mother had been a promising pupil of Howard Pyle from the Drexel Institute in Philadelphia. Ellen Bernard Thompson, then twenty-two, would later say that the events of her life in the valley would make a good dime novel. Ellen had one wish that summer of 1898—to make painting her life's work. Then one day Howard Pyle's younger brother Walter came out to the valley.

Walter and his wife, Anna Jackson Pyle, had been married thirteen years. They lived in Wilmington, where Walter was secretary and treasurer of the family leather business. For the first seven years of marriage, the Walter Pyles had remained childless. Then, on April 2, 1893, Anna gave birth to a son, Gerald. He was a normal, healthy baby, but immediately after childbirth Anna found herself unaccountably plunged into despair. She was suffering from a severe form of postpartum depression, a condition no one then understood, and as the days of her despair stretched into weeks and then months, Anna was judged to have "gone hopelessly insane at the birth of their son."

Walter met the ordeal with his usual calmness and fortitude. Everyone who knew him remarked on his strength. "He was wonderful when things were really serious," one sister-in-law would later recall. But Anna did not improve. No treatment was then known for what is now called psychotic postpartum depression, the symptoms of which include suicidal thinking and violent urges toward the child. Anna Jackson Pyle was shut away in an asylum, the better, everyone presumed, to keep her from harming herself or Gerald.

Walter Pyle (1859–1919) and Ellen Bernard Thompson Pyle,
(1876–1936), the first summer of their marriage, 1904.

The summer that Walter met Ellen in Chadds Ford, Anna had been institutionalized for five years. Walter was then thirty-eight. With the blue eyes and broad face characteristic of the Pyles, he was strong and rugged and at the same time kindhearted and thoughtful. Walter and Ellen felt they were made for each other, and, as Caroline put it, they fell "violently in love."

Their feelings may have been intensified by the pitiful shell of Walter's marriage. The state of Delaware had outlawed divorcing a spouse diagnosed as insane. After their summer idyll Walter and Ellen were forbidden by the Pyle and Thompson families to see each other. Their "love seemed hopeless," Caroline later wrote in an unpublished memoir. Futility in love was a theme to which Caroline would return again and again in her own life, especially in her writing in the summer of 1945.

Three years of enforced separation followed for Walter and Ellen. Caroline emphasized that these were "years of frustration and loneliness." Ellen got a studio in Philadelphia. She launched her career as an illustrator. Then one day in 1902, Anna Jackson Pyle, forty years old and still in an institution, hanged herself.

Ellen and Walter were married, January 23, 1904. For the next fifteen years, as Caroline told it, they lived a "deeply happy life together." They were "everything to each other," so much so that when Walter asked Ellen to put down her palette and brushes to start a family, she happily complied. She had four children. With servants and nurses the Pyles also maintained a brisk social life in Wilmington, attending masquerades, bridge parties, balls. Their house, Carcroft, at 2504 Delaware Avenue, was the scene of many parties. In 1918 they decided that the country was a better place to raise children, and the family moved out of Wilmington to Westbrae Farm—the thirty-eight-acre wooded estate in Greenville.

For a year the Pyles lived in paradise. Then, on August 27, 1919, at the age of sixty, Walter Pyle died of Bright's disease. Ellen was forty-three. "Mother barely retained her sanity so great was her grief," Caroline recounted.

Ellen found herself with four young children, an enormous estate, and a dwindling income. Gerald Pyle, Walter's son by his marriage to Anna, was twenty-seven; he returned to help out. He gave up his job as lecturer in philosophy at Columbia University to run the Westbrae spring-water business. He also tutored Caroline in philosophy and added another chapter to the family saga by developing a crush on his widowed stepmother. It is not known whether Ellen returned his interest, but Gerald scandalized the family by appearing in Ellen's bedroom at inappropriate times.

Ellen had meanwhile taken her husband's place as treasurer of the C. W. Pyle Company. When it failed in 1925, she remodeled the Westbrae hayloft into a studio. To make ends meet she took up her brushes and palette, "untouched for fifteen years," and painted *Saturday Evening Post* covers that became the envy of fellow *Post* artist Norman Rockwell, who admired the loose, "broadly painted" quality of Ellen Pyle's idealized youths.

Ellen never again spoke to her children of their father. He was "not a subject for conversation." Caroline and her sisters "grew up feeling there was something shameful about having a father who was dead and unmentioned." One of the girls, Ellen, did not know how their father had died, even though she was eleven at the time of Walter's death.

Her mother spoke about her father only once in Caroline's presence. It happened toward the end of her mother's life, as she sat in her green upholstered rocker by the window at Westbrae. Without looking at Caroline, she faced the window. "The terrible thing is," she said, "I don't believe I'll ever see him again."

CAROLINE WAS FIVE when her father died. In later life she could picture him "very, very faintly." She grew up wanting to know Walter Pyle. "I have always yearned," she wrote, "to know my father."

In childhood she linked the feeling of yearning to a strange figure who appeared at Westbrae Farm on hot summer days. While playing outdoors Caroline and her sisters would "become conscious of a still, lonely figure standing at the edge of the west lawn." Sometimes he would materialize in the road by the springhouse. Turned out in tailored suits and muttonchop whiskers, he would stand there, "quiet, just gazing at the house and then after a while move away and be gone."

His name was George Rhoads. He had prospered in a family leather business in Wilmington. Rhoads was a neighbor of the Walter Pyles on Delaware Avenue. He had built the house at Westbrae in 1910 for himself and his wife, Frances. It was to be their dream house. He planted the grounds, filled the cellars with coal and wine. But, as it turned out, Frances Rhoads loathed the quiet of the country. Reluctantly, George agreed to give the place up. In fact, the Rhoadses and the Pyles simply made an exchange. The Rhoadses bought out the Pyles' property at 2504 Delaware Avenue and combined it with their own, next door at No. 2500. In the exchange, the Pyles took over Westbrae Farm.

But George Rhoads never lost his love of the place. Into the 1920s he reappeared from time to time on the fringes of the property, lingering in sight of the house. As a child Caroline dreaded his appearances. The man was like a ghost of her father. He angered her. She resented the way he just stood there, gazing at their house. She saw him as "an intruder with no claim to even look."

Later, as she came to see that in some ways her father and Rhoads had shared a similar fate—"destined," as she put it, "not to remain at Westbrae"—Caroline would think of Rhoads with compassion. For in 1936,

when Caroline's mother died and the Pyles had to sell Westbrae Farm, George Rhoads at last got what he had longed for. He bought back his dream house. He moved back in, reloading the cellars with coal and wine. He replanted the garden and did everything possible to resume the life he had left in 1918. Not long afterward a fire broke out in the library. Desperate to save the house, Rhoads tried to smother the flames but died of a heart attack.

In 1943 N.C. was sixty-one, Caroline twenty-nine. As the war took hold of their lives, she began to see that in many ways he resembled both men from her childhood at Westbrae, Walter Pyle, the rocklike and tender father, and George Rhoads, the ghost of a father, uprooted and gazing nostalgically at a lost dream. With Pa Wyeth, though, there was a crucial difference. He was here now. Caroline could know him as he really was.

"Yes, we have come to know each other," he answered on May 19. "Perhaps, as you say, distance has enriched and hastened this mutual understanding. Nevertheless, I feel very depressed whenever I dwell upon it that I cannot enjoy more frequent contacts with you, and especially that circumstances have deprived me of the deep satisfaction of watching your boy grow and develop."

N.C. wrote with increasing candor, endearingly flustered about what to call himself and her. Sometimes he addressed her as "my dear Caroline." Sometimes he slipped and wrote her name "Carolyn." Sometimes he signed off as "Pa," sometimes as "C."

He wrote to her constantly. Even in letters to both Nat and Caroline, he added postscripts for Caroline alone. These were pep talks, in which, excluding Nat, he reassured Caroline, as mentor to protégée, of his faith in her "potentiality." He reminded her that her soul searching would be rewarded by spiritual and artistic growth. He linked the future fulfillment of literary yearnings with her "transcendent instincts as a mother."

Sometimes letters were not enough. One day in the middle of writing to Caroline, the "irresistible desire to call you came upon me, and I obeyed the impulse."

His son Nat's prolonged absences from Cedar Road had much the same effect as his father's from South Street. N.C. became Caroline's partner and worried about Newell. Sometimes he telephoned two or three times a day, asking about Newell's asthma, Newell's inoculations. His tone was once again Teutonic. A report of a cold "dismayed, though it did not surprise me. I had thought often of the slight symptoms that appeared while we were there, and wondered about them. In a child, an approaching cold is so

stealthy, one is always suspicious. I hope however that the turn for the better was true as you hinted on the telephone."

He was entranced by "the beautiful and powerful little figure" of his grandson, and by Newell's sensitivity to music and painting and the out-doors. He was astonished by the boy's personality, and by "his blond face and figure," its "sharp preciseness and ultimate delicacy."

"I see so much 'Wyeth' in him now," N.C. replied after Caroline sent some recent color snapshots. "This naturally tickles me to death! The close-ups of his head and certain expressions of his eyes and mouth are *haunting* in their warm and alive charm."

As the war expanded in the Pacific, the pressure to produce ammu-nition kept Nat at the plant day and night. In seven months—November 1942 to May 1943—he had taken one Sunday off. His responsibilities as supervisor added hours of overtime. Du Pont had discovered that even the most conscientious wartime workers continually made mistakes—mistakes that a high-explosives plant could not afford. Between deaths caused by industrial accidents, which would number some 30,000 by the end of the war, and the constant threat of industrial espionage, a "third front" had opened in America's munitions plants. With supervisors in short supply, Nat filled in wherever and whenever he was needed, sometimes pulling guard duty on the night shift, frisking workers as they entered the plant.

The war explained Nat's long absences from home, turned them into sacrifices. The picture the Wyeths had of Caroline in this period—of a "young woman abandoned by her husband"—typified the disaffection of millions of young women in 1943. Married couples everywhere had been disrupted. Only later would Caroline say that even before the war she and Nat had cooled toward each other. And yet, in July 1943 Caroline was pregnant.

A month later N.C. dreamed that Caroline had had a baby girl. All day the feeling of the dream stayed with him—"the utter surprise" followed by a "fanatical hunt for a car and some gasoline to get up to see you all."

Gas rationing had severely limited the number of trips that Caroline could take back home to the valley. N.C. made it his mission to come to her rescue. Trading sugar ration stamps for gas stamps, he would pack Carol into the Ford and drive up to New Jersey for a two- or three-day visit. He invariably returned home despondent.

Images of Caroline with her swelling belly and Newell alone in the house merged "even into the veiled fabric of my dreams at night . . . and what haunting and fantastic dreams they have been!"

He identified so much with Caroline's isolation in the little house on Cedar Road he began to see it as indistinguishable from his own in Chadds Ford in 1910. He reminded Caroline that he himself had brought a "Delaware Avenue girl out into a strange country" and insisted that his and Carol's earlier experience had been "along very similar lines to your own."

He chose Nat and Caroline as the couple of the next generation who would succeed himself and Carol in the Homestead. "My dream," he wrote Nat in a postscript to an undated 1943 letter, "is that this place can be yours sometime."

With each visit to Cedar Road, he more and more relished "little traits so characteristic of her." He liked that Caroline was mischievous, a superb mimic. On the telephone she would sometimes trick her sisters' husbands into thinking they were talking with Katie or Ellen. N.C. had no use for old-fashioned Pyle airs, but he approved of her sharp-spoken superiority, the way she was not afraid to say that someone was "common" and would not hesitate to hold people to their stated opinions.

As Caroline's pregnancy advanced into the winter of 1944, N.C. made a point of her virtues as a mother. He admired her caution, her frugality, her "impassioned care and watchfulness of little Newell," even her appetite. Whereas skinny Betsy had refused the bread pudding N.C. pressed on her at the Homestead, Caroline ate it up, earning N.C.'s high praise as a "good feeder." Above all, she adored her son. N.C. compared her to the idealized mother in Giovanni Segantini's *Child of Love*. He wrote to her about his own mother, remembering Hattie's "superior intuitions," insisting that "so much of what she said and did was true and right."

In his eyes Caroline outshone all the mothers in the Wyeth circle. "You top the list," he told her in 1944, and by then Nicholas Wyeth had been born to Betsy on September 21, 1943; Maude Robbins McCoy had brought to three the number of Ann's children; Peter Wyeth Hurd was now fourteen, and Ann Carol Hurd, nine. Proud of them all, N.C. could still not say enough about Caroline's expert "methods."

By all accounts, she was a devoted mother, sensitive, merry, bright. The fact was, she could also be overcautious, high-strung, dark. "She was volatile," one son recalled later. "She was a very tense person," said another son. In the Wyeth circle she was known for being brittle, fiery, tightfisted. Fear often got the better of her. She was afraid to take long car rides, to be out on water in a small boat, to be alone. She had a pleasant speaking voice, but, as her children later recalled, it "had an edge to it." Without warning Caroline's normal voice "could break into a scream."

So much like Mama: edgy, adoring, overcontrolling, extreme. Way up, way down. "You are an unusually intense and sensitive person," N.C. told

Caroline, "and your feelings are bound to swing the pendulum of emotional experience in both directions—from ecstatic and grateful moments to those of despair and frustration. That is the penalty of being so richly constituted."

Her mood swings freed him, as his mother's had, to move closer to her, to tell her whatever was on his mind. "Am I getting too sentimental?" he asked.

Well, I *am* sentimental and not at all ashamed of it! . . .

I wish at times that I could shut myself away from the terrible agitations, but it seems impossible to resist the morning paper or to listen to the radio broadcasts and so expose oneself to the glut of stupefying facts and frightful portents. And so it is, I suppose that one surrenders to all the romantic and nostalgic faculties one is capable of, for relief and release!

This spring has been desperately intense. . . . The past is irreturnable, I know that. And yet, blessed, or cursed, as I am with abundant nervous energy and teeming desires, I really refuse to accept this truth and constantly dream of renewed youth and to face again its glorious complications and its fascinating problems.

In February 1943, Andy marched off to Baltimore for his army physical. He was offered the rank of sergeant among forty-five artists in the army war art unit. Andy was gung ho to ship out for the Solomon Islands. N.C. bitterly rejected all arguments that going to war could be an enriching experience for an artist. But his protests were unnecessary. Andy flunked the physical. Classified 4F on account of Otto's pelvic syndrome, a congenital condition which gave his legs their distinctive outward twist, he was declared unfit for overseas duty. Relieved, N.C. was even more grateful when, after failing a second chance at an army physical, Andy turned down a third offer and stayed in Chadds Ford. "This pleases everybody," Bill Phelps noted in his diary.

Admitting to Caroline that he felt lucky to have Andy and Ann living close by (no mention of Betsy or John), N.C. concluded: "Andy offers me great encouragement and stimulation. But I need the rest of you so much!"

ON APRIL 22, 1944, Caroline gave birth to a second son, Howard Pyle Wyeth. The names of the two most significant American illustrators of the nineteenth and twentieth centuries were now joined.

Back on Cedar Road with the new baby and Newell, Caroline felt more out of place than ever. She was afraid to be alone at night. When Nat did

come home from the plant, it was often just for a change of clothes. The stench of chemicals on his shoes was sometimes so acrid she worried for the safety of the children and asked him to leave his work clothes outside.

N.C. wrote her in the midst of cleansing rain showers. The dimmed light would stop his work at the easel. Putting down his brushes, lingering over the "smell of new-wet vegetation and earth," he would start a letter to Caroline.

"The old valley," he wrote her one July afternoon, "is steaming like a hot house."

By the summer of 1944, N.C.'s letters to Caroline had become as ardent as any he had ever written; in effect, a suitor's diary. "Never before," he wrote on July 4,

> have I felt the craving so intensively to either talk with you, or by letters, to communicate some of the many sharp delineations of feelings that rise and fall these days with such excruciating force. Doubtless you have at times reflected upon the character of some of the letters I have written you and have subtly wondered at some of the personal sentiments expressed in them. Also, those endless and ponderous dissertations on so many topics must give you doubtful pause. Well, it is hardly necessary to remind you that you hold a growing and unique place in my heart and mind. In spirit and person, you have become a shining mark which draws my fire—a very beautiful, resilient, live target.

Finishing the letter, he lifted his head at the sound of a train whistle. "On this significantly silent 'Fourth' it is an especially eerie and poignant voice," he wrote, "—a call from great distances, in space *and* time. It also speaks of the future; it punctuates the moment between the two eternities."

Thinking ahead, he hoped that one day soon, when Newell and Howard were a little older, they would all spend their summers together in Maine. "We plan to make a small apartment in the garage. It's a fine building and offers a splendid opportunity—a couple of ample rooms, toilet, and porch. This would offer just the seclusion to retreat into and relieve the tension which young parents, and old, feel, when forced into close quarters over a sustained period of time."

By summer 1944, Nat shared Caroline's discontent in New Jersey—he had always wanted to move home to Chadds Ford—but unless Du Pont would transfer him to its Wilmington plant, he was powerless to alter the situation. Later that summer, when Du Pont agreed to consider moving Nat to Wilmington, N.C. was joyful.

Road to McVey's House, c. 1917.

In the fall, however, the company balked, and Caroline was crushed. N.C. sympathized in her continued banishment. "My hopes too were lifted very high, and I dreamed with you." On October 22 he celebrated his birthday by driving with Carol up to Cedar Road to be with Caroline.

At Christmas, Du Pont reversed its decision. Nat and Caroline would be coming home to the valley after all. In January 1945 they bought the McVey farmhouse, which stood next to Andy and Betsy's schoolhouse at the foot of the Wyeth property. Located where the road from Wilmington made its final turn into Chadds Ford, both farmhouse and schoolhouse looked down Brandywine Creek Road to the village.

An Open Secret

THE MOVE PUT Caroline and Newell and Howard five hundred feet from the Homestead's front gate. Nat's situation had not changed, however. Several days each week that spring, Du Pont called him away to the plant in New Jersey. His absences, regretted, commented on ("He drives himself unmercifully," N.C. reported to Henriette), no longer marred family happiness. The long-wished-for reunion was at hand.

Dropping in on Caroline two or three times each day, N.C. became the man in her house, as he had been for Carol and the fatherless "Bockiae" in Wilmington forty years earlier. In Nat's absence he was a substitute father for Newell and Howard. Even when Nat *was* home, even when a child's temperature was only slightly above normal, it was Pa who consulted with the doctor.

First thing each morning, he stopped in at the farmhouse and picked up Newell, loading the boy into the big plum-colored station wagon, a boxy 1940 Ford with varnished teak side panels and bright chrome trim. Then, as N.C. ran his morning errands, Newell accompanied his grandfather around Chadds Ford. The two N. C. Wyeths became a familiar sight in the village. the boy, three and a half, curious, talkative, with a cheerful, uncomplaining disposition and golden hair so fine and curly each filament seemed to gleam individually in the sun; the gray-haired grandfather, pensive, often ashen-faced, brightening as Newell chirped up with one of his characteristically astute observations.

N.C. frequently warned Caroline about the roads in Chadds Ford. Exactly thirty years earlier, in June 1915, while living in the house that Nat and Caroline now occupied, the Wyeths' friends John and Hannah McVey had lost their adopted son when an automobile ran the boy over after a Saturday ball game in the village. The death of the McVeys' boy, "an unusually bright, cheery little fellow," had made a deep impression on the thirty-three-year-old N.C.

At the intersection where the Wyeths' driveway joined Brandywine Creek
Road (Rt. 100), outside the farmhouse and the schoolhouse. Scene from a home
movie, shot in October 1945, shows NCW on his morning rounds, stopping
in the station wagon to pick up Newell, who is off camera. Caroline pushes
Howard Pyle Wyeth, eighteen months old, in the stroller. In the next shot,
the camera follows Newell to the passenger-side door.

Now, in 1945, with bright, cheery Newell and his little brother Howard
living at the McVey house, N.C. warned Caroline, "You must be awfully
careful in the automobile with that little boy." Nat later remembered it as a
constant refrain, "over and over again telling us to be careful."

On June 8 Nat took his first vacation since the start of the war. After a
week at home he returned to work, and N.C. resumed daily rounds at the
farmhouse. "All seems to be going well at Caroline's," N.C. reported to
Carol, while to Henriette he professed that "Ma enjoys her so much, and so
does Ann and Carolyn."

The truth was, the Wyeth women did not like Caroline. Henriette
found her cold and calculating. "I never liked that girl," Henriette would
admit in later years. Carolyn did not trust her either. *Newsweek* had once
reported that "Caroline is often confused with her sister-in-law Carolyn,"
and in Carolyn's eyes, Caroline Pyle Wyeth had been an interloper from the
start. She despised Caroline's snobbish airs and resented the cold shoulder
Caroline had given Francesco Delle Donne.

"The rest of the family didn't like her at all," recalled Ann, who at first opened her door to Caroline but then found her sister-in-law prickly. Ann was upset by Caroline's sudden, shrill attacks on Nat. At family gatherings Ann resented Caroline keeping Newell and Howard from Ann's children, as if Denys and Anna B. were a bad influence. N.C. added to the strain by agreeing with Caroline that Ann's children were "difficult to manage."

Carol acquiesced, as always. In the first place, she had made a deliberate effort to be fair and friendly as both her daughters-in-law had become her Chadds Ford neighbors. She loaned Betsy and then Caroline pieces of family furniture and made sure that between them they swapped a desk or a table so that both could enjoy it.

With Caroline remaining in Chadds Ford for the summer, Carol knew she had a rival close to home, but, as Henriette later ventured, "She was rather relieved, I think." Grateful to her daughter-in-law for sharing the burden of her husband's depressions, Carol resigned herself to N.C.'s attachment to Caroline. "She averted her eyes," said Henriette's daughter, Ann Carol. "She had a curious serenity about the whole thing."

ON JUNE 23, 1945, Carol decamped for Maine with the McCoys, leaving N.C. in the house with Carolyn.

"It's impossible for me to go for the short time," he claimed. That winter wartime gas rationing had prevented him from getting heating oil for the larger end of his studio, where he hung vast swathes of canvas for mural painting. To complete work on an enormous commission for the Metropolitan Life Insurance Building in New York City, he had to make use of the warm summer months. Besides, if he was not going to paint the Maine coast, it was useless to go at all.

At some point that spring, N.C. had moved out of the master bedroom into the adjoining room at the Homestead. He and Carol maintained separate bedrooms and bedtimes. In Carol's absence, Carolyn was supposed to act as her mother's replacement. She kept house, making her father's bed every morning.

Down at the farmhouse Caroline took up where Carolyn left off. Every couple of nights she cooked supper for N.C. and Carolyn. Years later Carolyn would remember that before every meal at Caroline's house, her father would shyly present himself for inspection, like a high school boy dressing up for a big date. He would ask Carolyn's advice about his clothes: Was he wearing the right shirt? Did this necktie go with that jacket?

If Caroline was too tired to cook, N.C. treated everyone to dinner at the Chadds Ford Hotel. One evening they went into Wilmington for the early

movie—*The Corn Is Green*, with Bette Davis. When Nat had to be away through Saturday, N.C. reported to Ann in Maine that he had "been down to Caroline's for four different meals, and [would] go down [again] at four this afternoon." N.C. and Caroline's house-playing came to include a ritual sign-off. Newell would pipe up, "Well, I'll be seein' you soon!" To which N.C. would reply, "You *betcha!*"

Through the first month of Carol's absence in Maine, N.C. kept her up to date on details from home. By the end of July, however, he contrived a blackout on the usual day-to-day accounting of his feelings.

"Well," he concluded on July 27, "there is really little else to tell you."

"Well," he closed again the next day, "I must get this into the mail." Then on second thought he declared, "And Carol, I'm *not* going to write things that might reveal my inside feelings because you are up there for so short a time and we both must accustom ourselves to this temporary change and each profit from it in the best way possible."

It was nearly the same Prussian outburst with which he had warded off his mother's meddling when he had fallen in love with Carol.

For of course a great deal was happening. In June N.C. suggested to Caroline that she "express her sharp moods in writing." He encouraged her to write poetry, and by the middle of July she had produced a dozen poems. He admired the purity and simplicity of her lines.

To Newell

Tiny Son God
Bold in grace,
Of bright, piquant and
Golden face.
Toss your sun-lit curls
In play
And strut upon your
Brown-skinned way.
I shall follow,
Straight with pride,
Thinking, fool am I!
Who tried
For poetry more pure
Than lies
In your enchanted
Amber eyes.

Newell, Pines Lake, New Jersey, summer 1943.
NCW was gratified by "the beautiful and powerful
little figure" of his grandson, and by Newell's
"quick and attentive spirit." He praised Caroline
for her "impassioned care and watchfulness
of little Newell."

In her first attempts he felt "something really alive." She, in turn, thrilled to his interest and enthusiasm. Caroline felt, she later wrote, "privileged to be on intimate terms with him," and she thanked God she was one of the lucky ones for whom N. C. Wyeth had "opened the doors to the wonders of nature, literature, history, music, philosophy, and art."

N.C. kept a collection of Caroline's poems, distributing the latest verse to the family circle. He promoted Caroline as if it were his mission in life. He did not trust Carol to take the same trouble with Caroline's poems that he did. Mailing one batch to Port Clyde, he instructed her to return "C's poems" without creases or folds.

Carol's reactions to Caroline's poems are not recorded. We do know that she was depressed that summer. Her weight depressed her. During the first year of the war, the Wyeths had lost their usual household help to war jobs, and Carol had taken up the housework, with the result that she brought her weight down to 166 pounds. "Losing weight has boosted her morale enormously," N.C. reported to Henriette in October 1942, later adding: "It is a blessing that our help evaporated as it did. . . . Ma goes around with that self-satisfied Mona Lisa smile because she's lost more weight." Now, in the summer of 1945, she had put the weight back on, and "it depressed her," Ann said.

Carol's low spirits became a subject of concern in the family's letters that summer. But though everyone acknowledged that Carol was "home-sick," no one was bold enough to look into the trouble. Taking a back channel, N.C. wrote to Andy: "I most often think about the *real* status of Ma. . . . Nobody tells me much one way or another . . . least of all Ma whose letters, except for saying she's homesick at times, are full of cheer. I miss her more than it is possible to say, but I too am playing the game and saying nothing about it."

At the Homestead both N.C. and Carolyn contrived to make Carol feel loved and missed. N.C. made excuses for Carolyn's bed-making and Carolyn "disparages and apologizes and announces, with that air of finality that 'No one could possibly make a bed up as well as Ma.' "

To Ann, N.C. announced that "Caroline's verse writing is continuing apace and she now has about forty poems which, in my humble estimate, really sing." He had decided, he told Ann, to send a "sheaf of them to Max Perkins of Scribners for his estimate of them."

Four days later, N.C. formally introduced Caroline as his protégée to the great Scribners editor. "The creation of these poems has been an extraordinary experience for me," he told Perkins, "as it all started from my urgent appeal to Caroline to express her sharp moods in writing—and these have gushed forth in a steady stream, all in six weeks time."

WORD OF PA'S shepherding of Caroline reached Port Clyde on the first of August, strongly affecting the family circle. Maxwell Perkins was a vivid figure in the Wyeth household. The editor of Fitzgerald, Hemingway, Wolfe, and Rawlings had recently suggested to Wyeth that he write an autobiography; N.C. had declined, but the offer made clear how much artistic capital N.C. had built up over the years with Charles Scribner's Sons. For the family it was difficult to see why Pa would now trade on his name and

reputation to bring Caroline into the fold. When N.C. had helped a student like Peter Hurd get started at Scribners in the 1920s, it had been in the natural order of things. Commissions from the art department were the family stock-in-trade; submitting verse for Maxwell Perkins's "estimate" was something else again. What made the lines Caroline had dashed off since June worthy of Ernest Hemingway's editor?

"There was a certain amount of jealousy," Betsy Wyeth remembered. "Too much attention was being paid to Caroline, and all the children were jealous. Andy was jealous. Ann was jealous."

In June, before leaving for Maine, Ann had written a piano piece, *Portrait of N. C. Wyeth*. She'd played it for her father in the emotional days before the family disbanded for its annual departure. Pa had been pleased and, as always, she later noted, "a little bit embarrassed."

Between father and daughter there remained an irreplaceable bond. Sometimes by design, but often unconsciously, Ann had patterned many of her compositions after the structure of her father's paintings, letters, and critiques. All invariably started in a solemn tone, under restraint, building to a passionate climax and an often stormy crescendo before resolving in a smooth, illuminated finish.

Marriage and motherhood had changed the direction of Ann's work, as N.C. had warned her it would. John McCoy was less supportive of Ann's music than her father had been. "You've got to let Ann go on with her music," N.C. had urged John, but with John working full-time and three young children to raise, Ann's music had yielded. She could no longer devote herself to symphonies for the Philadelphia Orchestra but had to satisfy her ambition with piano pieces—themes, marches, lullabies, fragmentary fanfares composed for family occasions.

John's health made the summer of 1945 particularly harrowing for the McCoys. Working in strictest secrecy at Du Pont, he had been responsible for keeping track of the stainless steel used by the Manhattan Project. The detonation of the first atomic bomb on July 16 at the White Sands Missile Range in Alamogordo, New Mexico, occurred only seventy-five miles from Henriette and Peter Hurd's ranch. The tension of secrecy and the threat of failure finally went to McCoy's back, which seized up so badly that for a while in early August he was immobilized. He resigned his job and went to Maine, joining Ann and the children. Within a week the back pain vanished.

Ann missed the force of her father's interest. Pa had charged her ear, opened the world to her, given her the feeling that in music she could dream for both of them, and bring the dream to life. Now he did the same for Caroline.

. . .

ON AUGUST 8, Maxwell Perkins replied that he had read Caroline Pyle's poems with pleasure and turned them over to the poetry editor at Scribners, the poet John Hall Wheelock. "Undoubtedly the author has a poetic gift," said Perkins, "but as in any other art, it must be disciplined and developed."

Wheelock decided against the manuscript but judged one of Caroline's poems, "A Child Is Born," to have "real power and beauty."

N.C. felt vindicated. "All this means a lot to me for it proves that I wasn't barking up the wrong tree," he wrote to Andy and Betsy, emphasizing that the editors' "technical criticism was very searching and severe, and they warned [Caroline] of the years of maturing in execution which are necessary before she reaches a quality worthy of her motifs." He added that Perkins and Wheelock "both are struck by Caroline's freshness of expression and intensity and feel very definitely that she has the stuff. . . . It is encouraging too to see how healthily Caroline takes the criticism and how thrilled she is over it all."

To Perkins he proudly reported that Caroline was "tremendously stimulated by the frank, strong, and wise criticisms and suggestions and is already planning a long campaign of study and incessant work."

WHAT WAS NAT to think of his father writing to his wife, "You have become a shining mark which draws my fire—a very beautiful, resilient, live target"?

Until that summer Nat had behaved with characteristic unconcern about the intimacy between his father and Caroline. As in his college years at home, he allowed Pa to intrude in his life. If he felt uneasy this time, he did not complain.

Henriette remembered Nat's ability to withhold his feelings: "If he's unhappy about someone, he's very polite and quiet, with certain tentative remarks or questions." In 1945, certainly, he did not force his father to answer for the ardent letters to his wife. Confrontation was not Nat's style. "Nat was a real kidder; it was hard to get Nat to be serious about anything," Caroline's niece Alice Pyle Lawrence Abrash recalled. "He had a sensitive side, which he covered up because he lived in a family in which people didn't know how sensitive he was because he wasn't an artist."

With Pa, Nat was still a young man, devoted, obliging, always eager to prove his worth in the family of artists, always ready to help out with technical problems around the house and studio. As often as his schedule permitted, Nat assisted with the big metal slide projector N.C. used for his murals.

It was a heavy piece of equipment, and the operation of projecting sketches onto canvas was best done at night. While N.C. with charcoal in hand stood up close to the canvas, calling for increasingly fine adjustments of focus, Nat manned the lantern at the far end of the studio.

Forty years later Nat would recall walking into the studio one night late that summer and finding his father alone, his face smeared with bright red lipstick. Nat recognized the shade: it was Caroline's. He said, "Pa, you've got lipstick on your face. How can you do this, Pa?"

N.C. answered by talking about the unseasonable weather in the valley. Even when Nat said, "Look, Pa, this has got to stop," N.C. maintained a pose of total denial, returning forcibly to the subject of the weather.

Caroline's lipstick on Pa's face settled the matter for Nat. He decided then and there that his father and his wife were engaged in a physical relationship.

N.C.'s CHILDREN and grandchildren, alongside Caroline's extended family, would debate the extent of "the thing with Aunt Caroline" for years to come. Some members of the Wyeth family believed that N.C. did not trespass into his son's marriage. Betsy Wyeth dismissed the idea that Caroline and N.C. were sexually intimate: "It was nothing more than an obsession. Morals were morals." Betsy maintained that, although "a lot of women were attracted to my father-in-law, including my mother," N.C. had primarily "wanted someone who would listen to him." Caroline was N.C.'s listener, not his lover.

Others saw it differently. Andy remembered a strong physical attraction between his father and Caroline. "I'm not saying they went to bed, I'm not saying they didn't, but I wouldn't rule it out. I wouldn't be naïve about it. My father was not a prude, and Caroline was a passionate woman." In Andy's eyes, Caroline in 1945 was the seductress she had been that summer of 1934 at the Haskells' wedding pavilion. Caroline, he asserted, was a "master vamp" and "any man who could stand up to that and not fall for that would be a pretty strongwilled man."

"Caroline had a real feeling for my father," said Ann. "My mother, at that time, sort of sat back and didn't do enough; she was heavy; she wasn't interested in anything. And I think my father found that Caroline was interested in his work, and writing poetry, doing something in the arts, and very attractive, of course—a very sexy girl, actually. But I don't think it ever went any further than a passion in what she was and how she looked and what she was doing and her interest in him—this great adoration."

There was unanimous agreement on one point. The affair hurt Nat, no

matter how far it went sexually. At the same time, Nat so successfully distanced himself that the affair did not alter his view of his father.

"He had no rancor, no ill will toward his father, in what to me seems a grievous wrong," said Nat's second wife, Jean Krum Wyeth. "It would seem one of the ultimate betrayals. This father, whom you'd idealized, having any kind of relationship with a son's wife." Jean Wyeth believed that N.C. and Caroline had a "romance and a love affair," the effect of which, whether consummated or not, made life "very painful for all of them, when you stop to think that this was a father they all idolized."

Betsy Wyeth pointed out, however, that it was the children themselves—Carolyn, Andy, Ann; jealous of Caroline, stirred by rivalry, relishing family drama—who had started the talk of an affair.

In the village, helped on by the war, it became an open secret. People in the valley had always taken pride in knowing each other's secrets. During the war the valley became still more clannish. An influx of munitions workers, attracted by thousands of war jobs, but without housing or food or transportation, hardened the older community against the newcomers, setting native families like the Pyles and the Wyeths and their neighbors even farther into their own world. Kept to itself, the old order became vulnerable to rumor and exaggeration.

ON AUGUST 14 the village siren shrieked for twenty minutes straight. Japan had surrendered, the war was over. In thirty-five years of living in Chadds Ford, N.C. had never seen so many people making so much noise all at the same time. The highway was blocked by cars. People cheered, honked their horns, shouted. The bell at the Chadds Ford Hotel rang all afternoon.

In the evening N.C. and Nat decided to take Caroline and Carolyn to the hotel for lobsters and champagne. N.C. reported to Carol that he was "feeling very well indeed." That morning he had finished a composition drawing for a painting that he titled *George Washington, Farmer*. He was confident that he had caught the feel of Washington's farm on the Potomac. He had taken pains with the drawing, and he hoped the publisher would accept it so that he could complete the work.

In another two days he found himself in a "dead period between two pictures." During such times he never wanted to touch a brush again. With the magnitude of what had happened that summer, both inside the family and in the world at large, there was a new feeling, too. "I know this," he wrote. "The experience of the past weeks since that catastrophic event, has effected a change within me which will never disappear. It is now so much

more difficult to stand before an easel and try to record those hallowed things of an era which was shattered the day the first atomic bomb was dropped."

In the record of N.C.'s devaluation of himself that summer, Caroline stands as the one woman he believed could restore his whole self. In every letter to Carol and Ann, he complained about how little he heard from Andy at Broad Cove Farm.

He had also written to Henriette twice, urging "a postal, or *anything,*" but had had no word by August 29, when he wrote to Ann complaining about the silence from San Patricio.

He divulged the extent of his relations with Caroline to no one. We know that Caroline later suffered a sense of guilt. Years afterward she would tell one of her sons: "Andy, I've done some terrible things in my life."

"I don't know if she was talking about the affair," said Andrew Nathaniel Wyeth, "but she said that with a shudder."

ON AUGUST 21 the Curtis Publishing Company approved Wyeth's interpretation of George Washington. Before going back to it, however, he began work on *Cornfield,* another panel in the Metropolitan Life murals. *Cornfield* depicts a Pilgrim man and boy in a field at harvesttime. Kneeling, the man is showing the boy the braiding technique of cornhusking. The boy has bright blond hair.

Friday, August 31, leaving brushes, paints, and the apparatus of his murals behind, he arrived in Maine for two weeks' rest.

He had been at Eight Bells, the family's house in Port Clyde, less than twelve hours when he assembled everyone for a poetry reading. He was the reader; Andy and Betsy, together with Ann and John, Carol's sister Ruth, and Carol herself, were the audience. The poems were Caroline's.

Rain beat on the windows. Inside, open fires warmed the house. The chimney moaning behind him, N.C. opened the reading with "A Child Is Born." Then, to awed silence, he read "To Newell." And then:

> *The mind cannot accept a wound*
> *too deep upon the heart.*
> *When tragedy with cutting knife*
> *descends, the two must part.*
> *The heart to stagger on alone,*
> *unsuccored and unseen,*
> *'Till time at last comes to her side*
> *her painful wound to clean.*

Early summer 1945. Newell, beside the table with the two milk bottles;
Carol, seated; Caroline.

Late summer 1945. NCW alongside Newell; Caroline behind the two
milk bottles; Carolyn stretched out on the grass. Carol had left for Maine.

By the time he finished "First Born," with its evocation of the loss of a child, all the women were in tears, and he waited several minutes before resuming.

"Andy was most deeply impressed and made comments I know you would have been delighted to hear," he wrote Caroline afterward. "Betsy could hardly believe her ears and after my reading of the majority of the verses was over, disappeared into another room with all the copies to go over them alone."

On Monday, N.C. went to Broad Cove to see Andy's new work and his grandson Nicholas, who was now almost two. In Andy's latest watercolors he noted a "spirit of penetrating sadness." He predicted that if controlled, this quality would have "enormous potentiality."

THE LAST NIGHT before N.C. returned to Chadds Ford, Andy sat up with him until two o'clock in the morning. Andy's few letters to N.C. that summer had been, in N.C.'s words, "brief, nervous, and squirmy." Andy had kept his father at arm's length, but now he opened up.

"I told him that he didn't realize what he had done: He'd reached a pinnacle in illustration that would live forever. And I hoped that he would not look down on it. I got off my chest all the things that I felt about his work, the kind of things you never get a chance to say to people. He was very moved, but he tried to fluff it off. I got mad. I said: 'Do you realize what you've painted? The pictures you've painted are going to live way beyond all these modern artists that you look up to.'"

N.C. did not—could not—agree. "He didn't think what he had done in illustration was worth a damn," recalled Andy. To be a farmer was still the most dignified thing N.C. could imagine, being a painter only slightly more noble. He still saw both occupations as distinct and separate from his life as an illustrator. He did not believe that he had done anything more than insert some pictures in some books.

Back in Chadds Ford a week later, N.C. wrote Andy, "I have returned so much stronger for having seen [your work], plus the strong and honest things you said in the course of our conversations."

On October 1 the first bright smack of autumn turned his thoughts to business. He was planning on October 29 to attend the opening of Andy's show at Macbeth's. Fussing in Andy and Betsy's absence over details of framing, he asked Andy if it would be all right if he, N.C., touched up one of Andy's pictures. "I think I can do it properly."

On October 8 and again on October 15, he supervised Andy and Betsy's housekeeping, hiring a local woman, Evelyn Smith, to clean out the schoolhouse after the humid summer. N.C. congratulated Andy on an *Art Digest*

article which spoke of Andrew Wyeth's 1944 drybrush *Huppers Point* as a "major watercolor by a major watercolorist." N.C. broke his long neglect of Betsy to admire her writing. Through Andy he sent his love to her.

He seemed to be cleaning house. On October 15, as Ann would later recall, N.C. made a point of thanking Carol for the freedom she had given him to paint and to live his life as he had wished. He maintained that he had much more to accomplish as a painter, but he was grateful to Carol for having let him do as he had wanted over the years.

That day he also asked Carolyn to come into the studio to check the proportions of Washington and his horse in *First Farmer of the Land.* He had been criticized for making his men too big and his horses too small; according to Carolyn, this man and this horse were in proportion.

First Farmer is a window through which to re-view the unspoiled world of the new American Republic. In the foreground, under the shade of an overhanging branch, a mounted George Washington makes notes as he oversees the harvest on his estate. Having devoted himself to the good of his "children," the father of his country has returned home to plant his own garden. Washington's surveyor's eye carries the viewer over a wheat field, beyond the woods and meadows, far away to the wide horizon. *First Farmer* is a mirror, a portrait of a founder who has at last let go.

On October 18, at the end of the day, the picture stood incomplete. N.C. shrouded the canvas under a worn cloth for the night, hung up his smock. At his desk beside the big Palladian window, he finished a draft of a letter. He told the publisher of *First Farmer* how pleased he was that the preliminary sketch had been approved. "I shall try," he wrote, "to make it outstanding."

NEXT MORNING he was up with the light. He saw the sun disperse mist from the cornfields. After breakfast he set off on his errands. It was Evelyn Smith's last day of sweeping out the schoolhouse before Andy and Betsy returned from Maine. On his way to pick up the housekeeper, N.C. stopped as usual at the farmhouse for Newell.

The night before he had eaten supper at the Homestead with Carol and Carolyn and Ann and her children, then sent everyone to the movies in Wilmington so he could finish reading the next book he was to illustrate, *The Robe,* the best-selling historical novel by the Reverend Lloyd C. Douglas. Its hero, Marcellus, a young Roman tribune in the reign of the Emperor Tiberius, is banished to Palestine, where, under the rule of Pontius Pilate, procurator of Judea, he unwillingly takes on the job that will change his life: supervising the execution of Jesus of Nazareth.

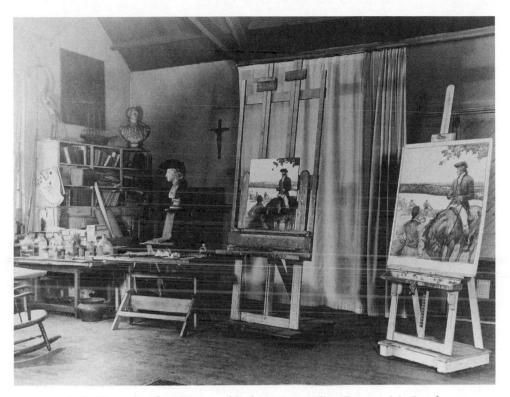

NCW's studio, October 1945. His last canvas, *First Farmer of the Land.*
The preliminary study stands on easel at right. Bust of George
Washington with tricorn hat at left.

N.C. had begun drawing arrows in the margins of scenes for possible
pictures. He may have gone to see Caroline at the farmhouse. Within the
family it was understood that their affair, however far it had gone that sum-
mer, remained unresolved as of October. N.C. had never come clean with
his son, and he had never responded to Nat's plea that the affair stop.

Later Caroline would remember that when she put Newell in N.C.'s
station wagon that morning, her son said to her, "Good-bye, darling." He
had never called her that before.

THE DAY WAS FAIR, the temperature over sixty degrees at nine o'clock.
Evelyn Smith lived beside Mother Archie's Church, up Ring Road past
Karl Kuerner's farm. Turning off Route 1, N.C. followed Ring Road east.

In the old mill pasture by the road, he spotted a German farmer and his
wife, shocking cornstalks by hand. N.C. pulled over and got out. He took
Newell by the hand. The German woman heard N.C. telling the boy,

"Newell, look at this. This is something you must remember because this is something that is passing. You won't see this again. Remember this."

Saying good-bye to the Germans, N.C. and Newell returned to the car. As they went up Ring Road into the morning sunshine, they waved to the woman in the field. It was about nine-fifteen.

THE OCTORARO BRANCH of the Pennsylvania Railroad intersected Ring Road at a grade crossing one mile from the village of Chadds Ford, less than a mile from the Wyeth Homestead. A small oval crossing sign, rusted but bearing the old warning, STOP, LOOK AND LISTEN, stood as the safety signal alongside the tracks.

The rural road approached the rail crossing at an odd, forty-degree angle. Just before reaching the railroad embankment, the road also made two rises, mounting one last incline before crossing the tracks. On the side from which N.C. was approaching, trees grew thick and close along the embankment. The only way to have a clear view down the tracks was to hurl the station wagon onto them and then lean forward over the wheel.

Breasting the crossing that morning, N.C.'s car came suddenly to a halt. A train was approaching from the the city. Reports later differed over whether it was a freight, milk, mail, or passenger train. The locomotive, in any case, was a steam engine, and it was running hard.

As soon as the engineer saw the station wagon on the tracks, he slammed on the air brakes. He sounded his whistle and bell, but the car did not move, and no one got out of it. In the braked but still hurtling locomotive, the engineer knew that it was too late to stop. Railroad maintenance workers, who happened that morning to be working on the tracks about a hundred yards from the crossing, later told reporters that the train's engineer had "practically tied his whistle down."

The collision occurred at seventeen minutes past nine. The train crushed the driver's side of the station wagon, then dragged the car 143 feet down the rails, scraping and squealing, steel on steel, before tossing the heap against a signal control and derailing itself. Miraculously, none of the train crew was injured. For the Wyeths, the calamity was total. Both N. C. Wyeths—grandfather and grandson—were killed.

Newell was a month shy of his fourth birthday. N.C. would have been sixty-three on Monday. The date was Friday, October 19.

NEWS OF THE COLLISION spread through the valley. A neighbor informed Caroline that there had been an accident. She fled to her car, got

in behind the wheel, but was immobilized. The neighbor drove her to the crossing. By the time they arrived, a doctor, summoned by a passing motorist, had pronounced N.C. and Newell dead.

N.C.'s body, severely crushed by the impact of collision, had to be cut from the station wagon. Newell was thrown from the car. His body landed alongside the tracks.

A large crowd had gathered. The locomotive, disconnected from the cars, was down the tracks, puffing steam. Debris lay strewn all over the embankment. A deputy coroner had sealed the crossing, and N.C.'s wallet had been found. It contained two items, a single dollar bill and a photograph of Howard Pyle: a studio portrait of Pyle as a young illustrator, which Caroline had given to N.C. that summer. Two acorns were found in Newell's trouser pocket.

The bodies and the wreckage remained around the tracks until the coroner had finished a preliminary investigation. A neighbor of the Wyeths, a young man named Allan Lynch, posted himself by the bodies to keep dogs from the blood.

Caroline identified Newell but could not look at N.C. She then drove to the Homestead to break the news to her mother-in-law.

NAT WAS AT WORK when he learned that he had lost his father and his son. He drove himself home. Henriette and Peter Hurd were in New Mexico, sitting in their garden when the telephone rang. Carolyn was buying something at DeHaven's, a West Chester drugstore, when the druggist handed her the telephone. Ann was with her children at Osborne Hill Farm, John McCoy's parents' place, some nine miles from Chadds Ford. Andy and Betsy were in Cushing, Maine, at Broad Cove Farm.

One by one they made their way home, gathering around Carol in the small brick house on the hill. Henriette, in the sixth month of a difficult pregnancy, had to abandon her first impulse to fly home. John McCoy immediately took charge of notifying the authorities and making the necessary arrangements. But John, in shock, became incoherent, and many of the people he telephoned with news of the accident thought that the collision had killed the entire Nat Wyeth family, including the baby, Howard.

Nat and Caroline faced each other at the Homestead. "Nat came in and the first thing he did, he looked at my mother and she looked at him," David C. Wyeth later recounted. "Everything passed between them right then, in that one look—all the emotion, and the whole question: *Is this punishment?*"

. . . .

TELEGRAMS FLOODED THE HOMESTEAD. "Unreal"—"shock"—
"double tragedy" were repeated again and again. *Time* and *Newsweek* ran
obituaries. In Washington, D.C., the *Evening Star* declared that nowhere
would Wyeth be more deeply mourned than in the capital.

> He had many friends here, and his sudden and tragic death with his
> little grandson in a crossing accident near his home at Chadds Ford,
> Pennsylvania, yesterday, also brought sorrow to a larger public
> which knew him only through his work. . . . Thousands of people
> admired his achievements without comprehending why they were
> good. On the other hand, he was a painter's painter, an illustrator's
> illustrator.

In Wilmington his death cast "a pall of gloom over this city and state
from which we will be long recovering," said the *Sunday Morning Star.*

In Chadds Ford two coffins, one massive, one child size, lay open at
Birmingham Friends Meetinghouse. On Sunday afternoon, October 21, the
family gathered at three o'clock for the funeral service. It was a spectacular
day in the valley, brilliant with light and color. The pews were jammed. Sur-
vived by all his brothers, all his children, by Carol and all the "Bockiae," by
his old colleagues in illustration at the Howard Pyle School—Ashley, Ayl-
ward, Chase, Dunn, Peck, Schoonover—N.C. seemed to have died much
too soon. With Newell alongside him, and the valley all around, he was
buried in the graveyard behind the meetinghouse.

After N. C.

EWELL DIED WITH HIM, but for a long time little else would. Fathers who die violent deaths inhabit shallow graves. In the valley more than fifty years later, the chain of events leading to N. C. Wyeth's death would still be discussed as if it had happened hours ago.

The first explanation of the collision had appeared in the Wilmington press on the evening of October 19, 1945: TROOPERS BELIEVE FAMOUS PAINTER WAS BLINDED BY SUN AS HE DROVE UP INCLINE TOWARD TRACKS. That N.C. had failed to see the train coming was a reasonable theory, since he was driving into the morning sun, but it explained neither why he had not *heard* the train nor why his station wagon had stalled on the tracks.

N.C.'s overcautious driving may have been partly to blame. He typically drove about fifteen miles per hour, often hogging the middle of the road. His brother Nat, the automobile test driver, continually reminded Convers that if he drove that way, the engine would never get hot enough to burn off its impurities and would remain susceptible to stalling.

Among N.C.'s children, three not quite consistent versions would take hold. The first was that N.C. had neither seen nor heard the train, that he had blundered onto the tracks at exactly the wrong moment and therefore had had no time to save Newell or himself.

The second was that the sound of the whistle had stopped his heart. Both Nat and Andy believed that once the car had stalled, their father's heart failed at the shriek of the locomotive. But over the years, as Nat later told it, he and Caroline "tried not to think that that happened because it sort of left the boy in an unheard-of position: there in the car with a driver bent over the wheel."

Thus, the third version, a variation, inconsistent with official accounts of the crash scene, as well as with a heart attack: that at the last moment N.C. had acted heroically to protect Newell. His arm outstretched against the train, Pa had moved to shield the boy from the oncoming blow.

The Pennsylvania Railroad encouraged the theory that the collision had been accidental, afterward claiming that the train's arrival at the crossing was random and "could not be timed accurately." Officials contended that the train made a single run every day but never on a set schedule. Moreover, the train had the right of way. By law any motor vehicle approaching a grade crossing must yield to the train.

On the Bockius side of the family, suicide seemed plausible. Carol's nephew Larry Bockius would argue that driving onto the railroad crossing and stalling the car was the act of a severely depressed man. "He was in pain, and he couldn't bear it. He killed himself to stop the pain. I'm convinced that N.C. put that car there [at the crossing]. But I think that at the last minute, like Grandfather, he changed his mind, and he put his arm up to ward off the train."

Among the Wyeths, no one believed that N.C. would have committed suicide and taken Newell with him. Indeed it would have been out of character. And yet his mother's attempt to take her own life in 1925 reinforces the idea. Hattie Zirngiebel Wyeth's depression and emotional extremes had left their mark on Convers and his brothers. Nathaniel Wyeth's life would end in suicide. To the end Nat struggled with depression and with guilt. According to his daughter Gretchen, Nat never forgave himself his homosexuality; he never lost his sense of shame, never stopped accusing himself of having committed a crime. "Being gay was a torment for my father, and it just pushed him up the wall." On October 27, 1954, having made several unsuccessful suicide attempts in previous years, Nat drove an experimental model of a new Ford car into a repair zone on a highway construction site in St. Clair County, Michigan. He ignored warning lights and signs, and crashed head-on into a road-paving roller. The operator of the roller was thrown clear and suffered bruises. Nat died instantly.

In the Brandywine Valley a folk version arose which gave N.C. a motive for doing away with himself and Newell. Whenever people discussed N.C. Wyeth's wartime love affair with his daughter-in-law Caroline, the story would invariably make Newell into N.C.'s son. This was consistent with the valley's Gothic embroidering of Wyeth lore, but the date of Newell's birth makes it improbable. However far N.C. and Caroline had gone as lovers, they did so three and a half years after Newell was born. All the same, it remained a popular myth, told often enough over the next thirty years that Newell's younger brother Howard, conceived during Nat's wartime absences in the summer of 1943, would later in life strongly suspect that he was N. C. Wyeth's "love child."

After N.C.'s death, Bill Phelps—"Uncle Willie"—was encouraged by the family to write Wyeth's biography. But by the time he began work on a

sample chapter for Doubleday in late 1946, Phelps had come to believe that Newell was indeed N.C.'s son. So sure was Phelps of this version of the story that he abandoned the project altogether, afraid that if he signed a publisher's contract he would be obliged to do more than hint at the whole truth. In correspondence with one of several editors interested in a Wyeth biography, Phelps suggested that the tragedy of N.C.'s death was "deeper than appeared on the surface." Phelps's letters, diaries, and papers show no other evidence, however, that N.C.'s death was more than an accident or that Newell had been anything but his grandson.

On October 26, 1945, a week after the collision, Deputy Coroner Margaret H. Ward found that Newell Convers Wyeth had died of a fractured skull and shock. His death was officially ruled an accident.

In the year following N.C.'s death, Caroline and Nat and baby Howard went on living in the farmhouse, two pastures back of the railroad tracks. The vibrations of each passing train rattled the windows. The locomotives' steam whistle penetrated every room in the house.

Caroline never stopped feeling responsible for the calamity. In the winter of 1946, she felt suicidal. "She went into absolute despair," her niece Alice recalled. "She paced back and forth—she couldn't sit still. She was a very desperate person." During that period Caroline told Ann McCoy something that Ann would never forget. Caroline said that N.C. Wyeth was the only man she had ever really loved.

Yet Nat and Caroline would go on with their marriage, and on October 13, 1946, Caroline gave birth to another boy. They named him Newell Convers Wyeth, and his birth, not quite a year after the collision, seemed to the Wyeths and their friends "a miracle." The family called this N.C.—the third Newell Convers Wyeth—Convers.

Four more children followed, three boys: Andrew Nathaniel in 1948; John Bound in 1950; David Christopher in 1953; and a girl, Caroline Melinda in 1956. Known as Melinda, she was born mentally retarded and died in 1962. She was buried in Birmingham Meeting cemetery, beside her grandfather, her brother Newell, and Katharine, the sister who had died in 1938.

When Newell was discussed, he was remembered as a child who had appreciated Rachmaninoff concertos at age three. Caroline adored her sons and connected with each of them. Still, five brothers—Howard, a musician; Convers, a physicist; Andy, a painter; John, a playwright; and David, an arts administrator and actor—would grow up in the shadow of a precocious, golden-haired boy, the apple of his parents' and grandfather's eyes.

The Nat Wyeths moved for ten years to Hockessin, Delaware, but eventually settled back in the valley, living in an old brick house less than five miles from Chadds Ford. For the rest of her life, Caroline would keep on her bureau a photograph of N.C. as he had appeared in June 1945: smiling, with light in his eyes. That was how she liked to think of him. She herself would never change the bright red lipstick she had worn in the 1940s.

In 1973 Caroline formed a close friendship with a young woman named Karen Murphy—a friend and schoolmate of her son Andrew and a former girlfriend of her son Howard. Outside of her family it was the only close friendship Caroline had ever had. Karen was something of a rebel; Caroline was in a rebellious period of her life. She and Karen became inseparable, spending evenings alone, talking. One of their constant subjects was Caroline's love life.

Caroline had begun an extramarital affair that spring but was having doubts about how far to pursue it. One evening, Caroline suggested that Karen bring over a Ouija board. The board gave vague, unhelpful replies to Caroline's questions about love, but on another subject the answer was direct. Caroline asked, "Will I be alive next Christmas?" and the board answered "No."

September 18, 1973, was a rainy Tuesday in the valley. Caroline had taken her son David's poodle, Napoleon, to the veterinarian in Centerville for shots. Returning with the dog on the Kennett Pike, she came around a corner which curved and went uphill at the same time. The state had tried to alter the curve—the Wilmington & Kennett Pike, formerly known as the P. S. du Pont Road, was a treacherous thoroughfare; fourteen people had been killed in car accidents on the pike in the previous ten years—but the du Ponts, who still owned the surrounding piece of land, did not want their grounds changed.

Caroline was driving a Volkswagen Karmann Ghia convertible. In the opposite lane, a station wagon rounded the curve and plowed head-on into Caroline's small car. The driver survived, as did two passengers and the driver of a third car that collided with the station wagon. Even the Wyeths' dog lived. Caroline was the sole fatality in a three-car collision involving five women. She was fifty-nine.

NAT FORGAVE CAROLINE. He had forgiven his father, too, although for a long time he kept his true feelings concealed. "For Nat, nothing seems to exist except his work, in which he is completely absorbed," Bill Phelps noted in 1947. Nat worked at Du Pont to the age of sixty-five. He became the inventor of—among two dozen other patents—the manufacturing process

that produces the plastic bottle used all over the world for soft drinks and mineral waters. Recognition came late to Nat. Viewed as a product first of the university and then of the corporate world—he would become the first person to hold the Du Pont Corporation's highest technical position of senior engineering fellow—Nat Wyeth was routinely left out of accounts of "America's First Family in Art." Eventually he would be fit in as "The Wyeth Who Doesn't Paint."

No matter what life threw at Nat—the passion of his father for his wife; the killing of his firstborn son in his father's car; the deaths in infancy and early childhood of his daughters; the tragic fate of Caroline at a bad curve in the road; the revelation that his wife's heart had belonged to N.C.; to say nothing of several extramarital affairs Caroline had recorded in her diary throughout their marriage—Nat always maintained, as Henriette put it, "an utterly forgiving sweetness, a true tolerance."

Everyone in the family agreed that Nat had "always been that way." But Henriette contended that none of them really knew Nat: He had a dark side that no one ever saw. "If he hadn't had that other side," she said, "he couldn't have survived."

Eleven years after Caroline's death, in 1984, Nat remarried, the only one of N.C.'s children to marry twice. Eleven months later he suffered a stroke. It had a curious effect. The man who had bottled his emotions all those years began suddenly to talk about the past. Nat had never revealed his feelings about Newell's death. He had never spoken to anyone about his father and Caroline. But in 1985 Nat began to talk to his wife, Jean, and to his sons. "It was all understandable," he said, speaking of the love affair between his father and his wife. "I think Pa lost control." Four years later, on the evening of July 4, 1990, Nat died of heart failure after the finale of a fireworks display in Maine. He was seventy-eight.

THE DAY AFTER Henriette heard the news of her father's death, she went to her easel as usual. "I felt Pa tell me: Henriette, you get to work."

The Hurds would go on living and painting on their ranch in the Hondo Valley. They made a glamorous couple. Surrounded by peacocks and splashing fountains and Mexican stone angels, they entertained a wide array of friends, international celebrities, fellow artists, and portrait sitters. Struggling with grown children who would become artists, Henriette doubted that as a mother she had ever shown her children the consistency and patience that N.C. had given her as a teacher and adviser.

In their separate studios the Hurds critiqued each other's work, and though Peter became the more appreciated artist during his lifetime, he

always knew that Henriette would eventually be seen as the better painter. In 1965, at the height of his career, Hurd was commissioned to paint the official White House portrait of the president of the United States. Lyndon Baines Johnson of Texas loved Peter Hurd's temperas of the Southwest; *Rancheria*, on loan from New York's Metropolitan Museum of Art, hung opposite the Johnsons' bed in the White House. But during the sole sitting the president would allow his portrait painter, LBJ fell asleep, forcing Hurd to work from photographs. When the painting was finished Johnson rejected it harshly, and Hurd was humiliated. Hurd had admired Johnson, wanted his approval, and in an act of self-destruction, the artist told the press what Johnson had said when shown the finished portrait: "That's the ugliest thing I ever saw."

As it confirmed Johnson's image as a graceless buffoon, the remark became national news. Scores of editorial cartoonists lampooned the uncultured yokel in the White House; and since every presidential fracas must produce a winner and a loser, Hurd became the winner. "Right now he is as well-known as Norman Rockwell and the telephone at the ranch rings constantly," John McCoy noted in January 1967. But the tables turned on Hurd. For years he and Henriette had been deducting the upkeep of Sentinel Ranch in San Patricio against their income as painters. The Internal Revenue Service came after Hurd for thousands in back taxes. He took his case to court, but unbeknown to his attorneys, who were depending on his testimony, Hurd had by then developed Alzheimer's disease. On the witness stand in Federal Court, the artist proved unable even to draw a diagram of his own living room. Hurd lost two tax trials, one before a jury, one before a judge. He lived the last years of his life in a nursing home, not recognizing his wife, children, or grandchildren. Peter Hurd died on July 9, 1984.

Henriette lived on into old age at Sentinel Ranch. She would be the only one of N.C.'s children to make a life beyond the Brandywine Valley. But as she lived out her days in the arid land to which Peter had brought her as a young bride, Henriette more often sounded as if she were the widow of N. C. Wyeth. He was the one to whom she had first devoted herself, and he would stay with her for good. "He is always there, looking over her shoulder," said her daughter, Ann Carol Hurd. In 1997 Henriette died of complications from pneumonia at the age of eighty-nine.

CAROLYN GOT BACK TOGETHER with Frank Delle Donne after her father's death. For a time the couple lived at the Homestead with the widowed Mrs. Wyeth. "We all sort of needed one another," said Frank. "But, believe me, Wyeth was around us all the time. Spiritually, there was some-

thing there. I really felt him all around me. When I'd walk up to the studio, I could feel him clomping on those slabs of stone."

The Delle Donnes divorced in 1952. Carolyn had no children. She taught painting in her father's studio, training a third generation in N.C.'s methods. One of Carolyn's pupils was James Browning Wyeth, Andrew and Betsy's second son, born July 6, 1946. Known as Jamie, he would leave school after the sixth grade and commit himself to a life of painting, achieving an early mastery and brilliance in oil portraits and watercolor landscape that would deepen as time went on.

In 1979 Carolyn exhibited her life's work at the Brandywine River Museum in Chadds Ford. Powerful images from the hills and woods and rooms of the Homestead filled the galleries. Critics were respectful, but the shock of public exposure was too much for Carolyn. She never touched a paintbrush again.

"She's a character, no mistake," N.C. had said of her when she was seven. More and more a "character" every year, Carolyn suffered from alcoholism. Surrounding herself with unruly dogs, she turned the Homestead into a two-story kennel. She used the telephone at all hours, calling family and friends in the middle of the night.

To the end of her life, Carolyn walked with a limp and lived in the past, as imprisoned by her resistance to change as her grandmother Zirngiebel had been. After a series of debilitating strokes, she died in 1994 at the age of eighty-four. At her funeral on Rocky Hill, Carolyn's ashes were placed cupful by cupful into a makeshift cannonball, laced with five ounces of black gunpowder, and blasted into a clear spring sky over the Homestead.

ANN HAD COMPOSED a piece of music for her father's sixty-third birthday. She would have played it for Pa on the piano in the Big Room on October 22, 1945. Instead, she retitled the composition *In Memoriam*.

For years afterward Ann would struggle with her music. She never lost her love of composing, but without N.C.'s encouragement something went out of her life that she never replaced. "It was worth it," Ann would say, "to work for him. I loved doing it for him—and for myself—but I loved doing it for him."

She outlived her husband. In 1989, suffering from Alzheimer's disease, John Willard McCoy died of pneumonia at the age of seventy-nine. Ann lived alone in Chadds Ford and in Maine, planting her Pennsylvania woods with trees from Needham, decorating the house for grandchildren at Christmas, huddled at the piano as she played *My Grandfather's Sleigh*. She loved and revered her husband and with him raised three children to whom

she was devoted. But of the *27 Musical Portraits* that would sum up Ann's intimate feelings about her family and friends in the years after 1945, her father—and her composition evoking her father, *Portrait of N. C. Wyeth*—would take first place.

ANDY RETURNED again and again to the railroad crossing in the winter of 1946. The site of his father's death was surrounded by people and places he had known all his life and yet, until that winter, had never seen. Transformed by shock, Andy glimpsed the familiar world of the crossing with new eyes. The rock-jawed German farmer Karl Kuerner brought his father back to life. The big, rounded hill across Ring Road from Kuerner's farm embodied qualities of N.C.'s physical presence. The pine trees that fenced Kuerner's cattle run suggested the spruces of South Street and Switzerland. One day that winter Andy caught a glimpse of a neighbor's son running, nearly out of control, down the massive slope of Kuerner's Hill. It was Allan Lynch, the boy who had stood by his father's body to keep dogs away. Andy painted Allan as his surrogate, traumatized, disoriented, lost on the hill.

The pivotal point in Andrew Wyeth's life and art, *Winter 1946*, was a projection, as a map is a projection, of the world of his future work. From that tempera on, in portrait and landscape, including *Karl* (1948), *Trodden Weed* (1951), *Snow Flurries* (1953), *Brown Swiss* (1957), *Far from Needham* (1966), *Spring* (1978), *Night Shadow* (1979), *The Big Room* (1988), Andy painted things as they were, now, seen through the lens of N.C.'s absence. "His death was the thing that really brought me to life," said Andy, later adding, "It gave me a reason to paint, an emotional reason. I think it made me."

From 1971 Andrew Wyeth painted and drew a collection of work that recorded, among other things, the painter's involvement with his model, Helga Testorf, a homesick, German-born nurse who lived with her husband and children near the crossing where N.C. was killed. For the next fifteen years Andy withheld from Betsy not only the fact of his relationship with Helga but, even more important in a marriage dedicated to truth in art, the work itself—240 portraits, figure studies, and landscapes, including some of the best painting Andrew Wyeth would ever accomplish. Surpassing his father in the art of subterfuge, Andy went to great lengths—lying, cheating, even disguising Helga in plain sight of Betsy—to deceive the woman who had been his wife and business partner, as well as the one he had placed in N.C.'s dominant role.

Andy and Betsy's marriage survived. They continued to winter in Chadds Ford and summer in Maine. N. C. Wyeth remained a daily pres-

Portrait by Arnold Newman, 1948. Photographed in NCW's studio: John, Ann, Carolyn, Betsy, Carol, Andrew, Caroline, Nat. Henriette and Peter appear, respectively, in a painting and a photograph on top of the bookshelf. On the rear wall, NCW's *Self Portrait in Top Hat and Cape* (1927) is flanked by his portraits of Hattie and Newell.

ence, a ruling passion in their life together. Returning home from a day of painting at Karl Kuerner's farm, Andy would announce—and Henriette Zirngiebel and Hattie Wyeth would have wept to hear it—"I spent the day in Switzerland."

Year after year, as the list of Andrew Wyeth's honors and prizes lengthened, as the sale of his temperas brought in millions, Andy became increasingly driven to preserve the legacy of the artist who had made it possible for him to paint. N.C.'s unselfishness as a father, his chronic self-devaluation as a painter, haunted Andy for the rest of his life.

BETSY JAMES WYETH became the authority on N. C. Wyeth. As the editor of his correspondence, she single-handedly established the foundation on which all future examination of the artist's life and work was built.

Betsy had known N.C. only six years. In the decade immediately following his death, as she came to understand the breadth of N. C. Wyeth's

talent, her youthful resistance to her father-in-law broke down. After collecting his paintings and editing his letters, after studying his work and documenting on film his influence on Andrew Wyeth, Betsy would come to love N.C. without criticism. She would recognize that all along she herself had wanted his love and acceptance.

CAROL BOCKIUS WYETH often said that she wished her life had ended with her husband's. In some ways, it did. She never learned to drive. She remained in her house with her linens and drying corsages and a growing collection of blond curls taken from the unshorn heads of Wyeth grandchildren. Yet "unlike other grandmothers, her grandchildren never entirely engrossed her," Henriette wrote. "Mummy's life and excitements were all in and around Pa." At the urging of her children, Carol left everything in the Homestead and the studio as it was. Everything became a relic. Unlived in, the present was at last defeated.

Life itself would go on. Twenty-five years passed. Carol aged, becoming a stooped old woman with snow white hair. Yet the Homestead and the studio remained exactly as they had been on October 19, 1945. Scarcely visited by outsiders, overgrown, Rocky Hill became N. C. Wyeth's shrine. Even N.C.'s place in *The Robe,* the book he was reading the night before the collision, stayed marked at page 176. Carol died of a heart attack on March 15, 1973, a week before her eighty-seventh birthday.

As time went on, as three generations of Wyeth painters succeeded N.C., the Wyeths would remain in the public eye as a group—a federal family like the Peales, the Roosevelts, the Kennedys, the Barrymores, their collective identity forged by a strong-armed father and dominated by the celebrity of one brother. Treated in the national press as a ruling family, the Wyeths were always approachable in their villages; open, engaging, modest—"ordinary people" listed in the telephone directory. In reality, they were in a class by themselves.

Of home there was no letting go. N. C. Wyeth's survivors, like his Swiss ancestors, would give up homestead and village and valley only in death. One by one they would come to be buried beside Pa under the grave marker he had designed. As in Needham, a single stone marked the lives and deaths of the Wyeths, their individual birth years, initials, and terminal dates carved one below the next, the family reunited under one rock.

GENEALOGY OF THE
WYETHS

ACKNOWLEDGMENTS

NOTES

BIBLIOGRAPHY

ILLUSTRATION CREDITS

INDEX

Jean Denys Zirngiebel
1829–1905
m.
Henriette Zeller
1830–1903

Jean Denys Zirngiebel
1854–1929
m.
Oretta Adelaide Freeman

Augustus Zirngiebel
1861–1924
m.
Mary Frances Richardson

Rudolph Zirngiebel
1865–1866

Henriette Zirngiebel
1858–1925
m.
Andrew Newell Wyeth
1853–1929

NEWELL CONVERS WYETH
1882–1945
m.
Carolyn Brenneman Bockius
1886–1973

Carolyn
1906

Henriette
1907–1997
m.
Peter Hurd
1903–1984

Carolyn
1909–1994
m.
Francesco
Joseph
Delle Donne
1919–

Nathaniel Convers
1911–1990
m.
Caroline
Ashton Pyle (1st)
1914–1973

(2d) Jean Krum
1922–

Ann
1915–
m.
John
Willard
McCoy
1910–1989

Andrew Newell
1917–
m.
Betsy Merle
James
1921–

Peter Wyeth Hurd
1930–
|
Ann Carol Hurd
1935–
|
Michael Hurd
1946–

Katharine Pyle Wyeth
1938
|
Newell Convers Wyeth
1941–1945
|
Howard Pyle Wyeth
1944–1996
|
Newell Convers Wyeth
1946–
|
Andrew Nathaniel Wyeth
1948–
|
John Bound Wyeth
1950–
|
David Christopher Wyeth
1953–
|
Caroline Melinda Wyeth
1956–1962

John Denys
McCoy
1938–
|
Ann Brelsford
1940–
|
Maude Robbins
1944–

Nicholas Wyeth
1943–
|
James Browning Wyeth
1946–

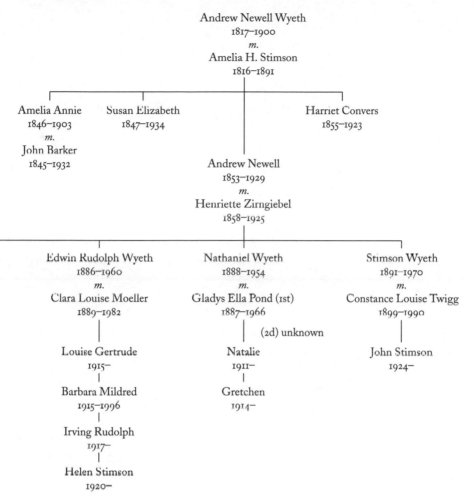

Andrew Newell Wyeth
1817–1900
m.
Amelia H. Stimson
1816–1891

Amelia Annie
1846–1903
m.
John Barker
1845–1932

Susan Elizabeth
1847–1934

Harriet Convers
1855–1923

Andrew Newell
1853–1929
m.
Henriette Zirngiebel
1858–1925

Edwin Rudolph Wyeth
1886–1960
m.
Clara Louise Moeller
1889–1982

Louise Gertrude
1915–

Barbara Mildred
1915–1996

Irving Rudolph
1917–

Helen Stimson
1920–

Nathaniel Wyeth
1888–1954
m.
Gladys Ella Pond (1st)
1887–1966

(2d) unknown

Natalie
1911–

Gretchen
1914–

Stimson Wyeth
1891–1970
m.
Constance Louise Twigg
1899–1990

John Stimson
1924–

GENEALOGY OF THE WYETHS AND THE ZIRNGIEBELS

ACKNOWLEDGMENTS

THE WYETH FAMILY archive in Chadds Ford, Pennsylvania, contains a vast written record of five generations. More than ten thousand items are preserved in buildings that once were valued institutions of American life: a waterwheel gristmill, a granary, a millhouse, a one-room schoolhouse, even an "Oval Office." The archive is both a biographer's dream and his peril.

Within the family records N. C. Wyeth's letters form a mountainous document, as idiosyncratic, historically valuable, and hypnotic as their surroundings. Yet for all their detail, consistency, and openhearted probing, Wyeth's letters do not by themselves form the basis of a reliable account of his life. The twice-weekly letters he exchanged with his mother—a voluminous correspondence, uninterrupted over twenty-three years—tend to lead one into error. N.C.'s side of the exchange appears to tell the whole story of his life, from the age of twenty, when he left home, until his mother's death in 1925. In fact, Wyeth made a habit of withholding significant information from his mother. He did the same with his wife, children, and friends, keeping from one what he would then tell another.

Therein, the peril. Intimate and self-revelatory as Wyeth's writing appears, his correspondence must be seen in its entirety. His omissions, denials, rages, repetitions, grand gestures, mood swings, and raptures tell only half the story. The questions they raise are literally unanswerable without the corresponding records. Indeed, without reading Henriette Zirngiebel Wyeth's part of the correspondence—her share alone consists of some three thousand letters, never before consulted by anyone outside the family—a biographer could not hope to understand the central and most complicated relationship, the template, of Wyeth's emotional life.

Additional collections of correspondence in the Wyeth Family Archive are no less vital to a full account of N. C. Wyeth's life and work. Without careful study of the letters of Andrew Newell Wyeth II, Nathaniel Wyeth, Edwin Rudolph Wyeth, Stimson Wyeth, and Carolyn Bockius Wyeth, a biographer could do little more than scratch the surface. I have obligations, therefore, to the authors of those papers, and to their keepers and conservators. But my greatest debt is to Mr. and Mrs. Andrew Wyeth for granting me unrestricted access to the family archive and for permitting me an unusual degree of freedom to work independently therein.

In 1992, when I set out to write the life of N. C. Wyeth, no one studying the artist's life or work had ever had access to the full range of Wyeth family papers. I had no reason to think that I would. In truth, I suspected the opposite. The answers to my first inquiries showed only that in Chadds Ford the woods of Wyeth scholarship were tightly posted. I owe an enormous debt of gratitude to those who helped an outsider find his way into the heart of N. C. Wyeth's Chadds Ford.

In my first year of work, Paul Horgan was the unexpected godfather to this book. As a young man in the 1930s, Horgan had loved Henriette Wyeth Hurd and her family. As a dis-

tinguished man of letters in the early 1990s, he loved them still, and he transmitted that love to me in the years before his death. Through his private correspondence with Henriette and Peter Hurd, and his essays, portraits, appreciations, and novels—in particular, *The Richard Trilogy*—I came to know the family and the valley that had first enraptured the young novelist. In May 1993, Paul Horgan took my case directly to the Wyeths. He was devoted to biography as a narrative art, and he honored me with his confidence. This work would have taken a different and lesser form had it not been for Paul Horgan's uncommon generosity and great example.

There were three other advocates without whose early, behind-the-scenes efforts the book would have veered off course: Jane Amsterdam, Robert F. Kennedy, Jr., and Mabel H. Cabot. I thank each of them for coming to my support when I most needed their strength. Alexandra Styron and Ashley Gates also lent themselves to my cause at that crucial moment, as did Jonathan Z. Larsen, John M. Seabrook, Jr., and George A. Weymouth.

In Chadds Ford, Jamie Wyeth turned out to be my champion. He was the one who brought me into the valley, and I will always be grateful to him, and to Phyllis Mills Wyeth. Following Jamie Wyeth over Pyles Twin Bridge and into Chadds Ford, I came to meet Mrs. Andrew Wyeth.

My debt to Mrs. Wyeth was already great. From the moment I first thought of writing N. C. Wyeth's life, I had turned to *The Wyeths: The Letters of N. C. Wyeth, 1901–1945*, edited by Betsy James Wyeth. This collection of 666 letters provided an essential road map to the life, work, and genealogy of my subject; it was always at my elbow and has remained so to this day.

But it was that first morning with Betsy Wyeth that forever altered the scope of this work. She took me to the family archive. She showed me to N. C. Wyeth's mother's letters, gave me a basket and a desk, offered a bunch of keys, and turned me loose.

In addition to thousands of letters, there were diaries, scrapbooks, and family papers reaching back to the 1850s; medical, financial, and household records, incoming and outgoing mail, deeds, blueprints; and scores of photographs, as well as sketches, drawings, and materials from N. C. Wyeth's lifetime as an artist. The Wyeths had saved every scrap. I was luckier still: Betsy James Wyeth had preserved it.

Everything was in order. N.C.'s letters, starting in 1891, were safely tucked into thirty-six ring binders and interpolated with photographs from each phase of his life. His mother's and father's, brothers', and aunts' and uncles' papers had been arranged chronologically in deep, shallow drawers that were clotted with letters, bundles and bundles of letters, paper-banded like money in the bank.

I was to return as often as I needed. The only restriction placed on me was that I had to study the material there at the Mill.

At the Mill and Granary, thanks are due to Karen Heebner and George Heebner and Betty Hammond; at the Ark and Long House, to Peter Ray and Mary Seton Corboy. Betsy and Andrew Wyeth's hardworking curatorial staff, including Deborah S. Sneddon, Dolly Bruni Parker, and Diane Packer, deserve high praise. My particular appreciation and gratitude to the talented and indefatigable Mary Adam Landa for innumerable special favors and wisdom in all things Wyeth.

After the death of Carolyn Wyeth in 1994, Betsy and Andrew opened the Wyeth Homestead and N.C.'s studio, once again allowing me to explore at my own pace. No request was too great or too small; together and separately they answered dozens of questions, often spending the better part of an afternoon or evening discussing the figures who loomed largest in N. C. Wyeth's life and work. Betsy Wyeth's film, *Self-Portrait: Snow Hill*, then in production, was a second awakening to my subject.

My deepest gratitude is insufficient tribute to the dual honor Betsy and Andrew Wyeth did me: namely, in sharing a man they loved and then leaving me free to my conclusions. For permission to quote without restriction from the letters and papers of N. C. Wyeth; his wife, Carolyn Bockius Wyeth; and his parents, Henriette Zirngiebel Wyeth and Andrew Newell Wyeth II, I am in their debt. This book has also benefited from the Wyeths' generosity with photographs and paintings, and I thank them for their trust.

In every postmortem account of "Pa" Wyeth's life, the theme of bigheartedness emerges—his urge to give of himself to others. In Chadds Ford, Ann Wyeth McCoy showed the same spirit; for her unswervingly frank recollections of her parents, and her recital of *My Grandfather's Sleigh*, my heartfelt thanks. I must also thank Jean Krum Wyeth, Nat Wyeth's widow, for nothing less than complete candor. Francesco Delle Donne, ex-husband of Carolyn Wyeth, and Jamie Wyeth, Carolyn's pupil, both helped me to remember something that is easily forgotten about Carolyn Wyeth: she was a painter. Gretchen Wyeth Underwood helped me to understand, as no one else had, the complex relationship of her parents, Nathaniel and Gladys Ella Pond Wyeth; I deeply appreciate her honesty, compassion, and exactitude.

The sons of Nat Wyeth and Caroline Pyle Wyeth have a unique knowledge of the Wyeths and the Pyles, as well as an unusually clear-eyed view of their parents. I owe them a tremendous debt for passing both on in many forms; even John Bound Wyeth, whom I never met, provided needed dates. From the day David C. Wyeth opened his door to me, his generosity never let up. David's feeling for Nat and Caroline and his deep interest in his Wyeth and Pyle grandparents revealed the real people and the real relationships behind family mythology. I am greatly indebted to David for making available his mother's letters and poems and, especially, early drafts of some of his own published writing about his family.

Andrew Nathaniel Wyeth, a natural historian, made a significant contribution to this work: first, in a series of highly developed narrative letters in which Andy performed the literary equivalent of opening the one locked trunk in the attic for which there is no longer a key; second, in making available rare footage from home movies and later producing them as still photographs for study and publication. I thank Andy for his openhanded kindness, which sustained me right to the end of this book.

In yet another river valley, I found the spirit of N. C. Wyeth alive. The Hondo Valley of New Mexico enhanced my understanding of the Brandywine Valley and of N.C.'s oldest daughter, Henriette, and her husband, Peter Hurd. I was fortunate to meet Henriette on her eighty-seventh birthday and to speak with her at Sentinel Ranch over several days. Ann Carol Hurd Rogers filled in gaps left by her mother's memory, supplying me with an early diary of Henriette as well as her own recollections of her parents and grandparents. Ann Carol and her husband, Peter Rogers, were good as gold; I thank them for their kindness. At the same time I have Michael Hurd to thank for an unvarnished portrait of his parents, and for the unqualified support he gave my project. My thanks, too, to Linda Miller, whose memories of Henriette as a teacher sharpened the picture of N.C.'s lifelong influence on each of his daughters.

The Bockiuses, without whom Convers Wyeth could not have become N. C. Wyeth, were first revealed to me by Nancy Bockius Scott. At ninety-two, Mrs. Scott reached across time and brought back to life the Convers and Carolyn whom she had observed during their earliest days together. I regret that she did not live to see the effect her perceptions had on this work.

Carol and N.C.'s nephew William Lawrence Bockius had studied his family with a

Shakespearean eye; he generously opened his research, sharing leads that took me to England and eventually helped me uncover the suicide of N.C.'s father-in-law.

For permission to quote from unpublished letters and papers, I thank Convers Wyeth and Jean Wyeth; David Wyeth, on behalf of his brothers; Gretchen Wyeth Underwood; John Stimson Wyeth; Rosalie Soons; Ann Wyeth McCoy; Michael Hurd; the Archives of American Art on behalf of Robert Macbeth, Robert McIntyre, and Clifford W. Ashley; the Pierpont Morgan Library on behalf of Howard Pyle; the Houghton Library on behalf of Julia A. Starkey, R. L. Scaife, and Lovell Thompson; Peter A. Gilbert on behalf of the Estate of Robert Frost. For permission to quote from videotaped interviews, I thank Peter de la Fuente. I am especially grateful to Sophie Consagra and Dr. Caroline C. Murray for making available and granting permission to quote from the previously unconsulted letters and diaries of their late uncle, William Eliott Phelps.

Special mention goes to the three most important manuscript collections for N. C. Wyeth scholarship outside of Chadds Ford: the Scribner Archive in the Manuscripts Division of the Department of Rare Books and Special Collections, Princeton University Library, Margaret Meyer Sherry, reference librarian and archivist; the Houghton Mifflin Papers at the Houghton Library, Harvard University, Leslie Morris, curator of manuscripts; and a host of collections (especially the Peter Hurd and Henriette Wyeth Papers, and the records of the Massachusetts Normal Art School and the Macbeth Gallery) at the Archives of American Art (Smithsonian Institution) in Washington, D.C. The archives' director, Judith E. Throm, welcomed my earliest searches for archival material, and I will be forever grateful to Judy and her staff for taking me in, giving me a start.

I also thank the following repositories of manuscripts and their curators, who gave invaluable assistance in the order listed here: Boston Public Library, Rare Books and Manuscripts Department; the Botany Libraries (Harvard University), Jean Cargill, reference librarian; the Pierpont Morgan Library, Charles E. Pierce, Jr., director; the Library of Congress, Jeffrey M. Flannery, manuscript reference librarian; the National Archives and Records Administration (Washington, D.C.), Mitchell A. Yockelson, reference archivist.

I profited from the courtesy of Walt Reed and Roger Reed, directors, Illustration House (New York City); Terrence Brown, director, the Society of Illustrators (New York City); Kenneth Schlesinger, reference archivist, Time/Life Archives, Time-Warner Incorporated; City of Cambridge Historical Commission; Wilmington Library, Delaware Collection; Harriet B. Memeger, librarian, the Delaware Art Museum Library; Constance J. Cooper, manuscript librarian, Historical Society of Delaware; Marjorie G. McNinch, reference archivist, Hagley Museum and Library (Wilmington); Angela M. Wootton, Department of Printed Books, the Imperial War Museum (London); Marisa Keller, archivist, Corcoran Gallery of Art (Washington, D.C.); Eddie Parker, manager, the Hurd–La Rinconada Gallery (San Patricio, N.M.); Denver Public Library, Western History and Genealogy Department; Ruth Bassett, librarian, Brandywine River Museum (Chadds Ford); Walter Hurst, Medical Examiner's Office, Delaware County, Pa.; Howard Mandelbaum, Photofest film-stills archive; David Joyall, Northeast Document Conservation Center; Don Allyn, administrative assistant, New York Public Library; Ana Cerro, editor, Atheneum Books for Young Readers; Karen Baumgartner, assistant registrar, Brandywine River Museum.

I owe a notable debt to Douglas Allen and Douglas Allen, Jr.'s *N. C. Wyeth: The Collected Paintings, Illustrations, and Murals.* If Betsy Wyeth surveyed the life and genealogy, the Allens mapped the paintings, and Douglas Allen, Jr., compiled *the* indispensable bibliography of Wyeth's work. Taken together with *The Wyeths*, this work saved me the labor of many years.

Walt Reed and Roger Reed have produced valuable treasuries of information in a field not always hospitable to independent scholarship. In my earliest research I relied upon their work, and also upon the work of the Wyeth scholars James H. Duff and Géné E. Harris. I am grateful to Ronald R. Randall, another independent, for original bibliographic work; and to Christine B. Podmaniczky, associate curator for N. C. Wyeth Collections at the Brandy-wine River Museum, whose detailed and wide-ranging knowledge of Wyeth's work was helpful during my prepublication search for illustrations. Richard Meryman's interviews with N. C. Wyeth's children were valuable, particularly those with Nat Wyeth and Carolyn Wyeth, both of whom I arrived too late to know. Jill Johnson's interviews with Nat Wyeth helped me understand N.C.'s complicated relationship with his older son.

All Wyeth scholarship has benefited from the photography of Peter Ralston; I thank him for helping me see with new eyes the paintings in the Scribner Illustrated Classics. I thank the filmmaker David Grubin for making available for study and quotation the full, unedited transcripts of the interviews that contributed to his affecting documentary about N. C. Wyeth's influence on his children, *The Wyeths: A Father and His Family.* I owe a special debt to David McCullough, whose work on that film advanced the family story and formed a broad foreground to my own interviews, which began at Wyeth's birthplace beside the Charles River.

In Needham, John Stimson Wyeth, N.C.'s nephew, who with his wife, Betty, still lived across South Street, welcomed my questions. Ned and Jane and Liz Brewer opened the door to 284 South Street. Liz and Robert Hunter were equally gracious about showing me around the Zirngiebel Homestead. Henry Hicks, a dedicated historian and benevolent curator at the Needham Historical Society, filled in gaps in the town records. The Needham Free Public Library was a gold mine, and I thank Ann C. MacFate, director, and Arian Schuster, archivist, for their help. Irene Guiney, registrar at the high school, was kind enough to let me look through bundles of century-old report cards until I found the Wyeth boys' grades. My greatest thanks go to those in the town clerk's office who provided crucial information on the life and death of Rudolph Zirngiebel.

In Wilmington and Chadds Ford, I thank those who helped me find my way around when I started knocking on doors: Carol Irving and her family, George H. Straley. John R. Schoonover welcomed me at the Bancroft Studios on Rodney Street. Norma Day of the Studio Group opened the Howard Pyle Studios on Franklin Street. My thanks, also, to Paul Preston Davis, for permission to study his comprehensive collection of Howard Pyle's magazine work; and to Mr. and Mrs. Howard Pyle Brokaw for their courtesy.

For specific acts of kindness or technical advice that directly benefited this work, I thank Patricia Blake, Walter Isaacson, Elliot Ravetz, Deb Futter, Jill Bossert, Sally Fisher Carpenter, Nell Broley, Elise Solomon, Peter Ryerson Fisher, Nicholas Fox Weber, Christopher Benfey, and James Kaplan. Melissa Hardin assisted me at the Library of Congress during the middle stages of the book. My father, Michael Michaelis, gave technical support as he became in my household both computer consultant and grandfather. Particular thanks to Matthew Arnold, comrade in the search.

No man is a failure who has a "Clarence" like Peter W. Kaplan. Years ago Peter dropped a book into my life at a moment of crisis. The date was Christmas 1981. The book, just reissued by Scribners, was *Treasure Island,* illustrated by N. C. Wyeth. I seized on it. My mother had died nine days earlier. Night after sleepless night I took refuge in N. C. Wyeth's pictures. Exactly ten years would have to go by before I understood what I had in my hands—and Kaplan would have to rescue me, in one icy plunge after another—but with the ringing of this bell, let Peter earn his wings.

For reading the manuscript, I thank Laura Leedy Gansler and Tandy Levine; their astute comments and suggestions sharpened the text and rallied me in the last months of work.

I owe a large debt to Laurie Schneider Adams for giving crucial advice at the very earliest thought of an artist's biography and a thorough marking of the manuscript when I most needed it. This book and its author have been improved in a hundred ways by Laurie Adams's guidance and clear thinking.

Melanie Jackson, my literary agent, was the best thing that could have happened to a thirty-four-year-old writer living on a dead-end street a hundred miles from midtown. After hearing three sentences, Melanie knew that N. C. Wyeth was my subject, and her understanding revived me. If I made strides, I have Melanie to thank for setting me off in the right direction.

In one important way this book has been different from others I have attempted: the time given me to think. Victoria Wilson of Alfred A. Knopf foresaw that it was going to take longer than I knew; but, unlike any editor I have known, she encouraged me to take my time. This alone gave value to the final result. Vicky also greatly simplified and improved an overlong manuscript. Her ear and eye were as exacting as ever, but her work on this book, and her sensitivity to its subject, surpassed the intellectual brilliance and editorial rigor for which she is rightly known, qualifying in this case as an act of true empathy.

At Knopf, I owe thanks as well to Lee A. Buttala, whose patience and dedication consistently inspired confidence; and to Susan M. S. Brown, whose meticulous copyediting saved book and author from innumerable errors.

Biography takes luck. No one should try it, as E. B. White once wrote about living in New York, unless he is willing to be lucky. With Clara Bingham at my side, I was willing. In the course of this project, as Clara and I married and wrote books and became parents of Jamie and Henry, Clara's full embrace of life made possible the sustained study of a life. She gave me time. She taught me trust. For although I had made a lifelong habit of examining family papers and piecing lives together in narrative form, I never thought that this was my line of work. More than anyone, Clara brought out the biographer in me. She also put her own shoulder to the wheel, casting a dispassionate eye on each new shred of evidence and making corrections and improvements as I read aloud the manuscript. In a real sense, Clara Bingham gave this book love. I give it back to her with joy in my heart.

David Michaelis
Washington, D.C.
October 3, 1997

NOTES

Abbreviations

JDZ Jean Denys Zirngiebel
 (grandfather)

HZZ Henriette Zeller Zirngiebel
 (grandmother)

JDZII Jean Denys Zirngiebel, Jr.
 (Uncle Denys)

ANWI Andrew Newell Wyeth I
 (grandfather)

ANWII Andrew Newell Wyeth II
 (father: Newell)

HZW Henriette Zirngiebel Wyeth
 (mother: Hattie)

NCW Newell Convers Wyeth
 (Convers; N.C.)

ERW Edwin Rudolph Wyeth
 (brother: Ed)

NW Nathaniel Wyeth (brother: Nat)

SW Stimson Wyeth (brother: Babe)

HCW Harriet Convers Wyeth
 (aunt: Hat)

HP Howard Pyle

CWA Clifford Warren Ashley

SMC Sidney Marsh Chase

HJP Henry Jarvis Peck

FES Frank Earle Schoonover

ATT Allen Tupper True

JHC Joseph Hawley Chapin

CBB Carolyn Brenneman Bockius
 (fiancée)

CBW Carolyn Bockius Wyeth
 (wife: Carol)

GB George Bockius III
 (father-in-law)

ABB Annie Brenneman Bockius
 (mother-in-law)

NBS Nancy Bockius Scott
 (sister-in-law)

WLB William Lawrence Bockius
 (nephew: Larry)

HW Henriette Wyeth
 (daughter: Henriette)

HWH Henriette Wyeth Hurd
 (Mrs. Peter Hurd)

PH Peter Hurd (son-in-law)

CW Carolyn Wyeth
 (daughter: Carolyn)

FDD Francesco Delle Donne
 (son-in-law: Frank)

N Nathaniel Convers Wyeth
 (son: Nat)

CPW Caroline Pyle Wyeth
 (daughter-in-law)

JKW Jean Krum Wyeth
 (Nat's second wife)

AWMcC Ann Wyeth McCoy
 (daughter: Ann)

JWMcC John Willard McCoy II
 (son-in-law)

AW Andrew Newell Wyeth III
 (son: Andy; Andrew Wyeth)

BJW Betsy James Wyeth
 (daughter-in-law)

GPW Gladys Pond Wyeth
 (sister-in-law: Nat's wife)

GWU Gretchen Wyeth Underwood
 (niece: Nat's daughter)

JSW John Stimson Wyeth
 (nephew: Stimson's son)

EBTP Ellen Bernard Thompson
 Pyle

HPB Howard Pyle Brokaw

APLA	Alice Pyle Lawrence Abrash	AAA	Archives of American Art,
P	Paul Horgan		Smithsonian Institution
RM	Robert Macbeth	BRM	Brandywine River Museum
WEP	William Eliott Phelps	DAM	Delaware Art Museum
		DTM	David Tead Michaelis
ACHR	Ann Carol Hurd Rogers	HMA	Harpers Magazine Archive,
	(granddaughter: Ann Carol)		Pierpont Morgan Library
MH	Michael Hurd (grandson)	HMP	Houghton Mifflin Papers,
NCWIII	Newell Convers Wyeth III		Harvard University
	(grandson: Convers)	HPSA	Howard Pyle School of Art
ANW	Andrew Nathaniel Wyeth	HUA	Harvard University Archives
	(grandson: Andy)	NARA	National Archives and Records
DCW	David Christopher Wyeth		Administration
	(grandson: David)	NFPLA	Needham Free Public Library
JDMcC	John Denys McCoy		Archives
	(grandson: Denys)	SA	Scribner Archive, Princeton
ABMcC	Anna Brelsford McCoy		University
	(granddaughter: Anna B.)	SWT	Smithsonian World Transcripts
JBW	James Browning Wyeth	WFA	Wyeth Family Archive,
	(grandson: Jamie)		Chadds Ford

NOTE: Quotations from published letters of N. C. Wyeth can be found in *The Wyeths: The Letters of N. C. Wyeth, 1901–1945,* edited by Betsy James Wyeth. Material from NCW's letters not previously published is indicated by the abbreviation "n.p." Unless otherwise noted, all quotations from Zirngiebel, Wyeth, and Bockius family letters are from unpublished collections in the Wyeth Family Archive in Chadds Ford. Dates in text and notes are taken from original source material; when only the day of the week was known in a given week, month, and year, I dated according to the Perpetual Calendar, 1775–2076, in *The New York Public Library Desk Reference.* My interviews are dated in numerical style (e.g., 9/25/96), because it was easier, in differentiating between past and present, to keep track of them that way. Undated correspondence is noted "n.d."

PART ONE : *Needham, 1866–1903*

Black and White

page 3 "some sleepy": *Boston Globe,* Nov. 1874.

JDZ apprenticeship: *Horticulture,* Nov. 18, 1905; marriage, birth of JDZII: Zirngiebel scrapbook, WFA.

4 railroad took land: Ibid.

JDZ itinerary and letters of introduction: Zirngiebel scrapbook, WFA.

gardener's quarters in Asa Gray house: Rettig, E44.

"never heard from"; Zeller family history; Thun customs: See Lena Bleidorn, "Runge Genealogy," 1924. Zirngiebel scrapbook, WFA.

"healthy": See HZZ passport, Zirngiebel scrapbook, WFA.

HZZ's homesickness: see HZW to CBW, Nov. 1, 1907.

"key-machine": Mumford, *Technics and Civilization,* 14.

"We don't": Ford quoted in Chicago *Tribune*, May 25, 1916.

5 "retiring disposition": Needham *Chronicle*, Nov. 14, 1903.

"The mind in Nostalgia": Hofer, 387.

"Swiss malady": Zwingmann, 20.

"frequent contemplations": Hofer, 384.

natives of Bern: Ibid., 383. See also *Oxford English Dictionary:* "homesickness" cites 1756 translation of *Keysler's Travels,* in which eighteenth-century travelers noted the "homesickness with which those of Bern are especially afflicted."

6 Wyeth landowners: City of Cambridge, vol. 1, 119. See also Gilman, 29–34; Pope, 517. Five Wyeths fought on April 19, 1775: Ebenezer; Jonas, Sr.; Jonas, Jr.; Noah; Joseph: See Grousset, 9–10; for war records of Jonas, Noah, and Ebenezer, see Commonwealth of Massachusetts, 972–74.

JDZ arrival: *The Cambridge Directory and Almanac for 1857* lists "Zirgiebel [*sic*] Dennis, gardener." This coincides with HZZ's travel dates found in Zirngiebel scrapbook, WFA.

boys sledded, skated: See JDZII to ANWII, n.d. 1865.

Americanized version of Denys: *Cambridge Directory and Almanac,* 1857, 1858, 1859.

"as that is": HZW to NCW and CBW, Oct. 26, 1907. See also NCW to HZW, Oct. 24, 1907.

7 "Zirngerbeit": Summary of the History of the Botanic Garden; "Notes from Prof. R. Wetmore," c. 1960, Gray Herbarium Archives, Harvard University.

"old cronies": Needham *Chronicle*, Jan. 27, 1923.

"garden of girls": Brooks, 446.

"many, many times": NCW in K. W. Watson, 262–63.

Longfellow Papers, Houghton Library, Harvard University. Into his forties NCW would tell reporters that "Louis Agassiz and Henry Wadsworth Longfellow used to visit my grandparents [in Needham]." *Boston Sunday Herald,* Nov. 12, 1922. See also NCW to HZW, June 7, 1907, no. 208.

JDZ as "director": NCW in Watson, 262–63. See also Needham *Suburban,* [undated] 1905, in which JDZ "at once took charge of the Harvard Botanical Gardens."

Charles Sprague Sargent: Dupree, 348.

"prominent Swiss Horticulturist": NCW, "Thoreau, His Critics and the Public," 231; "for years at Harvard": NCW in K. W. Watson, 262–63.

JDZ's university career: Zirngiebel scrapbook, WFA.

8 "our great hero": HZW to CBW, Oct. 1907.

Agassiz' teaching: NCW, "For Better Illustration," 638–42. See also NCW to HZW, Oct. 5, 1919.

No records of JDZ assisting Agassiz: HUA. See also Harvard University *Annual Reports, 1852–66,* with complete listings of faculty and staff at Lawrence Scientific School.

"florist": Bailey, vol. 3, 1203–4.

"staid and sober": "A Promising Suburb," Boston *Globe,* Nov. 28, 1874. See also *Needham High School Advocate, 1895.*

"home-loving": Sam Wragg, "Needham Native," 1932, NFPLA.

Needham's commercial history: Bowers, 12.

9 Dimensions of Zirngiebel property on South Street: *Auditor's Report, Town of Needham, 1882,* NFPLA.

9 "clayish": See JDZ's description of ideal growing conditions, Bailey, 1204.
 Augustus Zirngiebel was born in Cambridge, Mass., in 1861: Birth records, Office of
 the City Clerk.
 "as a signe": JDZII to ANWII, n.d. 1865.
 "a paint box": JDZII to ANWII, n.d. 1866.
 "a womankind"; "a girl": HZW to CBW, Dec. 18, 1906.
 "We have got": JDZII to ANWII, n.d. 1866. Record of Rudolph Zirngiebel's birth:
 Needham Town Clerk.

Rudolph

10 Rudolph Zirngiebel's death, on August 25, 1866, is recorded in Needham Town Hall,
 Town Clerk's Office, register no. 4, 33. His death was kept out of sequence for four
 months and then put into the official record in December 1866.
 Plaque for Rudolph Zirngiebel's coffin (incorrectly bearing the legend "Age 9 mos 22
 dys") can be found in Zirngiebel scrapbook, WFA.
 Moody's elegy, "On the death of our babe." Zirngiebel scrapbook, WFA.
11 "Dropsy in the brain": As registered in Town Clerk's Office. On February 1, 1867,
 when Flagg submitted *Town Clerk's Report for 1866*, 26–27, Rudolph's death appeared
 in proper sequence; cause of death given as "Dropsy on the brain."
 avoiding quarantine: Kaplan, *Mr. Clemens and Mark Twain*, 19.
 "Sickness": HZW to NCW, Oct. 26, 1906.
 "so carefree": HZW to NCW, Jan. 29, 1907.
 started to reveal: HZW to NCW, Dec. 25, 1906.
12 "intent on teaching": HZW to NCW, Jan. 29, 1907.
 ANWI biographical information: Obituary, Cambridge *Tribune*, Apr. 15, 1900.
 ANWII family and business: WFA. See also Boston City Directory, 1881.
 "common tumbler": Needham *Chronicle* clipping, n.d. 1905.
 "plant for the million[s]": JDZ, "Pansy," Bailey, 1204.
 customers in every state and territory: A. B. Dresser, *Hampshire Gazette*, Dec. 1, 1888.
 National reputation as "Pansy King": Needham Historical Society.
14 "permanently sad woman": HWH, SWT, 14.
 "doing what was expected": HZW to NCW, Mar. 23, 1906. HZW-ANWII wed-
 ding: WFA. Thirty Austin Street still stands.
15 "homesickness at the thought"; "a feeling": HZW to CBB, Apr. 3, 1906.
 "cheaper in the end": HZW to NCW, Feb. 16, 1906.
 "how hard it is": ANW to NCW, Nov. 7, 1907.
 "He sacrificed": HZW to CBB, Apr. 3, 1906.
 "She had her way": NW to NCW, Nov. 6, 1907.
 "little home": HZW to CBB, Apr. 3, 1906.

Two Bloods

16 Germanic Cottage: McAlester, 360.
 Date of moving in: ANWII to NCW, Aug. 22, 1925.
 "four generations"; "too much of a crowd": ANWII to NCW, Dec. 31, 1905.
 "eagle eye": NCW to ANWII and HZW, Feb. 5, 1917.
17 stuffy cars: NCW to SW, Nov. 5, 1913.

ten-to-six train: NCW to HZW, Jan. 26, 1918.

"What would I do": HZW to ANWII, Sept. 5, 1893.

the upper hand: HZW to NCW, May 1909; ANWII to NCW, Nov. 7, 1907.

"hardheaded": SW, "My Brother—N. C. Wyeth," 32.

18 "felt sorry for": ANW to DTM, 5/26/94.

"George Eliot of a woman": NBS to DTM, 11/29/93.

"meek, mild man": AWMcC to DTM, 12/15/93.

"You could feel it"; HZW's skirts: AWMcC to DTM, 5/15/93.

"a certain weakness": HZW to CBW, Sept. 30, 1907.

"letting folks kiss": HZW to CBW, Dec. 18, 1906.

"little feller": NCW to CPW, Mar. 4, 1942.

Not to their taste: HZW to NCW and CBW, Oct. 26, 1907.

Andrew Newell (1751–1798) and Lydia Convers Francis (1778–1850): Grousset, 23, 82.

"plain to see": HZW to NCW and CBW, Oct. 26, 1907.

NCW baptism. Parish records, First Parish Church, Needham.

"her virile way": NCW to SW, Dec. 30, 1910.

19 Iceman fantasy: ANW to DTM, letter, 12/26/94.

"fat body": NCW to SW, May 25, 1927, n.p.

"strange thing": Quoted by *Boston Post*, Nov. 27, 1921.

"try and control"; "people will think": HZW to ANWII, Sept. 5, 1893.

"tired and vexed"; "seek the haven": NCW to SMC, May 24, 1918, n.p.

perfect tranquillity: Ibid.

"why I inherited"; "born under": HZW to CBW, Nov. 1, 1907.

"never could account": Ibid.

20 "I hope": HZW to NCW, Jan. 12, 1906.

"great hope"; "just so anxious"; "when folks": HZW to CBW, Sept. 30, 1907.

Nathaniel Wyeth: The Wyeth family gravestone in Needham Cemetery gives his birth year as 1888. Previous genealogies have incorrectly published it as 1889.

"I'm satisfied": ANW quoted by HZW to CBW, Dec. 18, 1906.

Regretted only sons: HZW to CBW, Nov. 1, 1907.

"missed a daughter": HZW to NCW, Nov. 9, 1906.

21 "only had skirts": HZW to NCW, Aug. 7, 1906.

"afraid he'll be spoiled": HZW to ANWII, Sept. 5, 1893.

"calm enough": HZW to NCW, Mar. 23, 1906. President William H. Baldwin of the Boston Young Men's Christian Union advised HZW to have faith in herself.

"knew Convers would"; "gets that from me": HZW to ANWII, Sept. 5, 1893.

"To be homesick": HZW to NCW, Feb. n.d., 1908.

"constant home conversation": HZW to NCW, Dec. 15, 1905.

"parlor clock!!" etc.: NCW to NCWII, Nov. 11, 1944, n.p.

22 "the one" etc.: NCW to ANWII, Nov. 10, 1907.

To understand NCW's insistence on HZW's unlimited perfection, I am indebted to Christopher Lasch for his discussion of "perfect" mothering: Lasch, 171.

begged for: NCW to SMC, May 24, 1918.

"even my father": NCW to HWH, Apr. 19, 1943.

actual associations: *Boston Globe*, Apr. 20, 1875; *Boston Post*, Apr. 19, 1875.

"more persons died": ANWII to NCW, Apr. 20, 1925.

"raw, March-like air": *Boston Globe*, Apr. 20, 1875.

23 "we all look": HZW to NCW, May 1909.

23 "Edwin is so earnest": HZW to NCW, Apr. 6, 1906.
 "open Ed up": HZW to NCW, n.d. 1905.
 "civil but disinterested": NCW to his brothers, May 1, 1906.
 "wheels in his head": HZW to NCW, Mar. 12, 1906.
 "legs protruding": NCW to his brothers, May 1, 1906.
 NW's grades: Student records, Needham High School.
 "boost": HZW to NCW, Jan. 5, 1906.
 "old plodder": HZW to NCW, Feb. 16, 1906.
 "whatever Convers said": GWU to DTM, letter, 3/2/95.
 "our living example": NCW to SW, Nov. 5, 1913.
 "It was": HZW to NCW, Feb. 5, 1909.
 "they are *shallow*": NCW to HZW, Nov. 29, 1903, n.p.

24 *wholesome*: NCW to HZW and ANWII, Mar. 5, 1920; see also SW, "My Brother," 32.
 bread crusts: BJW to DTM, 12/15/93.
 taught a lesson: AW to DTM, 12/15/93.
 "For all my": HZW to NCW, Feb. 26, 1906.
 Dates for NCW's schooldays: WFA, courtesy of BJW.
 Harris School budget: *Annual Report for 1893*, NFPLA.
 seasons in schoolroom: NCW to SW, Sept. 1, 1909; for wood and water, see *Annual Report for 1893*, NFPLA.
 "school days": NCW to HZW and ANWII, Sept. 1, 1913.
 Never missed a day: *Annual Report for 1893*, NFPLA.

25 Date for entrance: Student records, Needham High School.
 "I'm not": NCW to HZW, Jan. 26, 1903.
 "They represent": NCW to SMC, Aug. 3, 1922.

26 "full of true affection": Wyss, Howells introduction, xii.
 "honest-hearted, home-loving boy[s]": Ibid., xiii.

27 "that dreary family": Stevenson, *Essays*, 230.
 "being all Swiss": HZW to NCW, Feb. 28, 1906.
 Sunday serenades: NCW to SW, Feb. 5, 1909.
 "Swiss yodels": NCW to HZW, Dec. 26, 1918; taught his nephews: GWU to DTM, letter, 3/2/95.
 "talk of Switzerland": HZW to NCW, June 8, 1906.
 Precisely measured amounts: JDZ's instructions for cultivation of pansies, Bailey, 1204.

28 Neighbors working long rows: Olive Sutton Collishaw to AW, Sept. 2, 1975, WFA.
 "Eh, *là-bas*": SW, "My Brother," 31.
 "foreign *tang*": NCW to HZW and ANWII, Nov. 25, 1917.
 "with that shrug": NCW, "Thoreau, His Critics and the Public," 231.
 "squeezed it to death": ANW to DTM, letter, 1/19/95.
 "sudden yearning": NCW to CPW, July 4, 1944.
 TR quoted by NCW to HZW and ANWII, Sept. 1, 1913.
 "two bloods": NCW to HZW and ANWII, Nov. 26, 1907, n.p.

29 liked to think: See NCW, "Thoreau, His Critics and the Public," 231.
 "I don't really see": HZW to ANWII, Sept. 5, 1893.
 "made up to me": HZW to CBW, Dec. 18, 1906.
 "my old weakness": HZW to NCW, Aug. 7, 1906.

30 "When you're sick": NW quoted by HZW to NCW, Mar. 6, 1906.

"weakness of the womb": HZW to NCW, Aug. 7, 1906.

"living this life": HZW to NCW, Mar. 23, 1906.

Adams Nervine Asylum: Strouse, 222.

"felt strange": HZW to NCW, Apr. 6, 1906.

"pure, health-giving": *Needham High School Advocate*, 1895.

"She it was": NCW to Elizabeth James (Mrs. Merle), Sept. 26, 1943, n.p. See also "When my brothers' or my birthday came around we celebrated my mother."

"always seemed": Ibid.

31 "pest": Mitchell, 218.

"nerve-worn woman" and the "big physician": Boston news clip, "WORK CURE FOR NERVES," HZW Album, 1896–1917, WFA.

"I've tried": HZW to NCW, Aug. 7, 1906.

"My trouble": HZW to CBW, July 31, 1906.

"not keep brooding"; "get over that": ANWII to NCW, Aug. 29, 1906.

32 "My father": NCW to HWH, June 26, 1937.

"not worth 'shucks' ": NCW to HZW, Mar. 30, 1903, n.p.

"constant urge to draw": SW, "My Brother," 32.

"Grandmama's old home longing": HZW to NCW, Feb. 16, 1906.

"someone unkempt": SW, "My Brother," 32.

expensive hobby: Kamp, 4.

NCW's work with Cora Jean Livingston: WFA.

absurd for husky young man: GWU to DTM, letter, 3/2/95.

"the divided opinion" etc.: SW, "My Brother," 32.

33 "this artist nonsense": Ibid.

Recommended by Cora Livingston: I am drawing the inference that Livingston, who knew the Mass. Normal Art School faculty, would have been the one to make the recommendations.

"shiftless": JSW to DTM, 4/22/93.

Practical Pictures

34 Du Bois. Quoted in Brooks, *John Sloan*, 72.

"Western picture man": Ballinger, 47.

"A picture": NCW, "On Illustrations."

35 average worker's earnings: F. L. Allen, 55.

Edwin Austin Abbey's fee: Walt Reed to DTM, 1/11/93.

Remington's rate: Ballinger, 89.

Gibson's contract with *Collier's:* Reed and Reed, 33.

"Do you know": Van Gogh, vol. 1, 453.

Medievalism and Howard Pyle: See Lears, 163–67.

Twain quoted by Jane Allen Gregory, "Howard Pyle, 1853–1911." HP Papers, DAM.

36 "run down to Washington": HP to Woodrow Wilson, Dec. 18, 1895; see also HP to Woodrow Wilson, Jan. 11, 1896, Library of Congress, Collections of the Manuscript Division.

"as soon as the face": HP quoted by Brown and Rush, "Notes from Howard Pyle's Monday Night Lectures." HP Papers, DAM.

"besieged by work": Walt Reed to DTM, 1/13/93.

"painters of pictures": HP to Edward Penfield, Mar. 17, 1900; quoted by Abbott, 215.

37 "hopeless mysteries": "Reminiscences of a Pupil Who Entered M.N.A.S. in February 1897, by A.M.H." Mass. College of Art Records, 1873–1972, AAA.

"an air": NCW, "For Better Illustration," 639.

"Paris of America": Minutes of annual Mass. Normal Art School Assoc. meeting, 1894; *Fiftieth Anniversary Record, 1888–1938*, Mass. School of Art Alumni Assoc., AAA.

"no steadying": NCW, "For Better Illustration," 639.

All information on Richard Andrew from *The Centre of Vision*, 1903–1921; *The Artgum*, 1922–1927; publications of Mass. Normal Art School, AAA.

38 "and right there": Quoted by Kamp, 4.

George L. Noyes (1864–1954) and NCW: Keny, 129.

Charles Harold Davis (1856–1933): See Greenwich Gallery, *American Art Review*, Apr.–May 1995.

"the shallowest art": NCW to ERW, May 25, 1903.

"I have been doing": HZW to NCW, May 15, 1909.

"demoralized": HZW to NCW, June 30, 1909.

39 "queer admixture": NCW to HZW, Mar. 5, 1920.

"bum" training: NCW to ERW, May 25, 1903.

"symbolic": NCW to ANW, Nov. 14, 1919, n.p.

"as practical": NCW to ANW, Sept. 15, 1903.

"Art is a thing": NCW to ANWII, Feb. 27, 1903.

41 "the twelve": News clippings, n.d. 1902, Denver *News*, Washington *Post*, "Art Topics," ATT Papers, AAA.

"as widely coveted": Denver *News*, June 7, 1902.

HIGH HONOR: Ibid.

"future is assured": Washington *Post*, "Art Topics" column quoted in Denver *News*, June 7, 1902.

"Mr. Pyle appeared": HJP to HZW, Nov. 3, 1902, WFA.

"winning": P to DTM, 4/23/93.

an impression of force: BJW to DTM, 2/1/94.

HZW who lost her head: NCW to N, Oct. 23, 1941.

Among several examples of NCW's fixing of the date, see NCW to HZW, Oct. 20, 1907; see also NCW to HZW, Oct. 8, 1921.

October 19

42 Contrary to all accepted accounts, NCW did not arrive in Wilmington on October 19. The written record shows that Clifford W. Ashley wrote to NCW in Needham on October 21, discussing arrangements and sending directions. Ashley dated his letter from Wilmington "Tues night/Nov 21, 1902," though context indicates that he certainly meant October 21, a Tuesday, and that, in any case, NCW was not yet in Wilmington on October 21. Moreover, when NCW did arrive, he wrote a postcard to HZW: "Reached 907 Adams St. safe and sound at 7.45 last night. Ashley was not home but let me have his room until this morning. Was given a very cordial welcome by the family of the house. Wilmington is very pretty. Your loving son, Convers." He dated the card "Sat. morn/6.45." The postmark on the card clearly shows the date: "Oct. 25/930AM/1902." This would make Friday evening, October 24, the likeliest date for his arrival in Wilmington.

NCW's arrangements in Wilmington: CWA to NCW, "Tuesday night/[Oct.] 21, 1902, WFA.

"plenty of factories": NCW to HZW, Oct. 25, 1902, n.p.

Wilmington population: 1900 census; see Hoffecker, III.

43 "It makes me": NCW to SW, May 20, 1912, n.p.

lean, fast-moving people: BJW to DTM, 2/4/94.

Three generations in leather trade: Started by HP's grandfather, Isaac Pyle (1774–1855); Isaac's sons, William (1820–1872, HP's father), Cyrus, and Joseph all went into business together; HP and his brothers followed.

postcard: NCW to HZW, Oct. 25, 1902.

"very pretty": NCW to HZW, Oct. 25, 1902.

"within a few hours": NCW to HZW, Oct. 8, 1921.

44 "has the idea": NW to SW, Aug. 27, 1907, WFA. HZW spoke of Convers "not coming home at all": HZW quoted by NCW to HZW, Jan. 26, 1903.

"into another sphere": HZW to NCW, Mar. 12, 1906.

"I can understand": HCW to HZW, Jan. 1909, WFA.

"lost to myself": HZW to NCW, Dec. 15, 1905.

"still be hers": ERW to NCW, Feb. 9, 1908, WFA.

"I see you both": HZW to NCW, n.d. c. Feb. 1908.

"How can I bear": HZW to NCW, Oct. 14, 1909.

broke down again: HZW to NCW, Oct. 27, 1909.

"some sad story": NCW to HZW, Nov. 5, 1902.

"You say": NCW to HZW, Oct. 29, 1902, n.p.

"all the fellows": NCW to HZW, Nov. 3, 1902.

45 "I never want": NCW to HZW, Oct. 20, 1907.

"board by board": NCW to HZW and ANW, Oct. 22, 1918.

46 "phantom impression": Ibid.

"visions": NCW to HZW, Oct. 26, 1910.

"whirls of dreams": NCW to HZW, Oct. 28, 1916.

"the life": NCW to HZW and ANW, Oct. 24, 1906.

"just quietly": N, SWT. Also, HWH to DTM, 10/24/94: "Pa would almost cry—almost weep when he opened them."

"by Mama's hands"; "to sleep": NCW to HZW, Oct. 24, 1907.

"It tasted": AWMcC to DTM, 12/15/93.

"Just think": NCW to HZW, Oct. 26, 1902.

47 Description of HP: Ibid. See also NCW, "A Recollection," in Howard Pyle, *Merry Adventures of Robin Hood . . .*, ii.

"beyond the actual man": Ibid.

"practical": NCW to HZW, Oct. 26, 1902.

"into whose minds"; "pliable age": Aylward, iii.

"a sheltered place": Pitz, *Howard Pyle*, 175.

"very bright": HP, "When I Was a Little Boy: An Autobiographical Sketch," quoted from a typescript in Delaware Room, Wilmington Library.

"the quaintest"; "a sad time": Ibid.

48 "straitened pecuniary circumstances": Abbott, 10.

Failure of William Pyle's business and family moves: Margaret Churchman Painter Pyle, "A Little Country Girl"; *Wilmington City Directory*, 1859–60 through 1882–83.

"the best mother": HP, "When I Was a Little Boy . . ."

48 "perfect in her"; "perfect sympathy": Abbott, 15, 3.
"Nothing would matter": Ibid., 15.
HP was seven: HPB to DTM, 12/7/94.

49 "pay off my debts": HP quoted in Abbott, 48–49.
"My boy": HP quoted in NCW, "Howard Pyle As I Knew Him," 15.
"the spirit of": Ibid.
"a deep affection"; "I knew": Ibid.

Missing Sons

50 "faint prospects": NCW to HZW, Oct. 26, 1902.
"the big": NCW to HZW, Oct. 26, 1902, n.p.
"Of course": HP quoted by NCW to HZW, Oct. 26, 1902, n.p.
"I don't know": NCW to HZW, Oct. 26, 1902.
"won't cost much": Ibid.
less than ten dollars: NCW to HZW, Nov. 5, 1902, n.p.
next bank draft: NCW to HZW, Oct. 29, 1902, n.p.
sweated every nickel: NCW to HZW, Nov. 30, 1902, n.p.
"abrupt change": NCW to HZW, Oct. 29, 1902.
"own hook": Ibid.

51 "turning point": HP quoted in Exman, 116.
"Don't make it": HP quoted by Harvey Dunn in Taylor, "Evening in the Classroom,"
31. See also Lykes, "Howard Pyle: Teacher of Illustration," 42.
"I think": NCW to HZW, Oct. 26, 1902.
"We're near": NCW to HZW, Nov. 9, 1902, n.p.
"The name of"; "painting pictures": NCW in *Joseph Hawley Chapin, 1869–1939* . . .
"the Big Three": Ibid.

52 "wrong foot": NCW to SMC, May 24, 1918.
"I wish": NCW to HZW, Dec. 10, 1902.
"almost mountains": NCW to HZW, Nov. 3, 1902.
"purely agricultural district": *Wilmington & Reading Railroad Guide,* c. 1870.
"all magic": NCW to NW, Oct. 23, 1941.

53 "my dear boys": HP to ATT et al., July 11, 1902, ATT Papers, AAA.
"He cannot do": Ibid.

54 "very slim": Gertrude Brincklé, Oral History Program, AAA.
"fit of enthusiasm": NCW to HZW, June 22, 1903, n.p.
"his face": NCW to HZW, Nov. 2, 1902.
"never been away": Ibid.

55 sense of foreboding: ANW to DTM, 5/26/94, citing recollection of Ellen Pyle
Lawrence.
dates for arrival of cable and Pyles' sailing: Wilmington *Evening Journal,* Feb. 27,
1889.

56 Cause of Sellers's death: Registered in 1889 as death no. 37598. State of Delaware,
Division of Historical and Cultural Affairs, Bureau of Archives and Records Man-
agement, Hall of Records, Dover, Del.
"as bad": HZW to NCW, Feb. 5, 1909.
"the little boy": Pyle, *Garden Behind the Moon,* xi.
"Question": Howells, *Stops of Various Quills.*

"in the shadow": HP to F. B. Schell, Aug. 15, 1891, HMA, with permission of the Pierpont Morgan Library, New York. MA 1950.

"If you publish": Ibid.

"I have tried": HP to Henry Mills Alden, Aug. 28, 1891, HMA, with permission of the Pierpont Morgan Library, New York. MA 1950.

57 "I was glad": Pyle, *Garden Behind the Moon,* xi.

58 "At last": Eleanor Pyle Crichton to HPB, Feb. n.d., 1978, June 2, 1983, courtesy of HPB. Also, HPB to DTM, 12/7/94, emphasized the intensity of Eleanor Pyle's memories of her family's dinner table conversations.

"prayer meeting fashion": Gurney, 241.

"I like this": Pitz, *Brandywine Tradition,* 93.

"Stick to your first": HP quoted by ATT in notebooks, HP Papers, DAM.

"He seems to": NCW to HZW, Nov. 2, 1902.

59 "humdrum, mossy": HP quoted in Eisenstat and Sperry, 88.

"Quaker foot": Gertrude Brinckle, Oral History Program, AAA.

"one real artist": Canby, *Age of Confidence,* 234.

"any other respectable": HP, "When I Was a Little Boy."

the Misses Hebbs School: HPB to DTM, 12/9/94.

"the great Pyle": Burlingame, 227.

his associates: NCW, "Howard Pyle As I Knew Him," 15.

61 "as clean": HP quoted by NCW to HZW, Oct. 26, 1902, n.p.

"I *couldn't*": NCW to HZW, Oct. 26, 1902.

"He tried": FES, Oral History Program, AAA, transcript, 12.

"mental projection": Ibid., 6.

"project your mind": HP quoted in ATT, Notebooks, HP Papers, DAM.

"fought, sang": Koerner, 479.

"Live in your picture": HP quoted in Brown and Ruoh, "Notes from Howard Pyle's Monday Night Lectures, June–November, 1904," HP Papers, DAM.

"Dig deep": Stanley M. Arthurs to Richard Wayne Lykes, Dec. 27, 1946, HP Papers, DAM.

"You are thinking," "I'd like you": HP quoted by SMC in NCW and SMC, "Pupils of Pyle Tell of His Teaching."

62 "new language": Ibid.

"likes better": NCW to HZW, Nov. 9, 1902.

"race horses": *Joseph Hawley Chapin, 1869–1939 . . .*

"afford to wait": NCW to HZW, Nov. 23, 1902.

a million readers: Mott, 685.

"I really need": NCW to HZW, Nov. 19, 1902, n.p.

63 "good enough": HP quoted by NCW to HZW, Nov. 23, 1902, n.p.

"I'm going": Ibid.

"when a fellow": NCW to ANWII, Nov. 5, 1903.

"do so much": NCW to ANWII, Feb. 27, 1903, n.p.

"power of self-command": *Harvard University Catalogue, 1902–03,* HUA.

Wyeth's annual expenses: Eight months of the year, Pyle's students boarded in Wilmington rooming houses at $5.50 per week and paid $4.90 per month to use the HPSA studios. From the school art supply closet, a year's worth of supplies cost $50.00. Models posed at $0.20 an hour.

"every fellow": HP quoted by NCW to HZW, Dec. 14, 1902, n.p.

63 "monotonous": NCW to HZW, Dec. 7, 1902, n.p.
 "now appreciate": Ibid.
 "read a book": NCW to HZW, Dec. 10, 1902.
 "Mr. Pyle is trying": NCW to HZW, Dec. 14, 1902.
64 "I've held off": Ibid.
 "most inartistic": HP quoted in Pitz, *Howard Pyle*, 179.
 "something to do": NCW to HZW, Jan. 2, 1903, n.p.
65 "terrible depth": NCW to HZW, Jan. 2, 1903.
66 "wild over": NCW to HZW, Jan. 6, 1903.
 "From now on": NCW to HZW, Jan. 4, 1903.

Likeness

67 "They had": NCW to HZW, Feb. 23, 1903, n.p.
 "to have people": HP, "When I Was a Little Boy."
 "my little success": NCW to HZW, Jan. 6, 1903.
 "your mother": William W. Peck to NCW, Jan. 14, 1903, WFA.
 "Just as soon": NCW to HZW, Apr. 3, 1903, n.p.
69 Pyle formally accepted: NCW to ANWII, Feb. 27, 1903.
 "I suppose Papa": NCW to HZW, Mar. 9, 1903, n.p.
 "Finances": NCW to SW, Oct. 3, 1917, n.p.
 "I never counted": NCW to SMC, May 24, 1918.
 made forty-five dollars: Albert H. Eucke to NCW, Jan. 31, 1903, WFA.
 "put it": NCW to ANWII, Nov. 14, 1919.
 "give help": NCW to HZW, May 8, 1903, n.p.
 "Does he": Ibid.
 "I wished mine": NCW to ANWII, Sept. 15, 1903.
70 "I often envied": William Aylward to NCW, Apr. 11, 1907, WFA.
 "only us fellows": NCW to HZW, Mar. 5, 1903.
 "a marked point": NCW to HZW, Mar. 9, 1903.
 "Pyle man": Aylward, "The Giant at the Crossroads," introduction to HP, *The Story of King Arthur and His Knights*.
 "baby of the class": NCW to HZW, Mar. 9, 1903.
 HPSA pecking order: Oakley, *Report of the Private View . . .* , 28. See also HJP to Richard Wayne Lykes, Nov. 5, 1946, HP Papers, DAM.
71 "men were more": HP quoted by Frances Rogers to Richard W. Lykes, Feb. 14, 1947; HP Papers, DAM.
 "a future": HP quoted by NCW to HZW, Mar. 5, 1903; Pyle graduated Wyeth on the same basis: "[Pyle] thinks I have got the roots and fundamental ideas of his, which he claims will be the foundation of any successful artist." NCW to HZW, Sept. 11, 1904.
 "worthy, principled": Lykes, "Howard Pyle: Teacher of Illustration," 59.
 "tricks": HP, "Small School of Art," 710–11.
 Dismissal of McCouch: HP quoted by ANW to DTM, letter, 2/22/95, based on recollections of the episode passed on from NCW to N, and from Ellen Bernard Thompson Pyle and CPW: "Both my grandparents believed that Pyle was simply enraged at having been tricked by one of his own students, in front of the class."
72 sounds of Pyle's approach; "And then": NCW, "Howard Pyle As I Knew Him," 15.
73 idolized Pyle: See FES, Oral History Program, AAA, transcript, 13.

"Colonial life": HP, "Notes from Monday Night Lectures, June–November 1904," HP Papers, DAM.

spoke of his doubts: FES, Oral History Program, AAA, transcript, 12. See also NCW, "Howard Pyle As I Knew Him," 15; Exman, 116.

"many shortcomings": HP to F. B. Schell, June 7, 1890, HMA, with permission of the Pierpont Morgan Library, New York, MA 1950.

"stiff and halting": HP to F. B. Schell, July 18, 1890, HMA, Ibid.

"extremely slow": HP to F. B. Schell, Mar. 1, 1890, HMA, Ibid.

"put himself": Jessie Willcox Smith, "Address," in Oakley, *Report of the Private View . . .* , 19–20.

"one of [them]": Ibid.

"aspirations": NCW, "Howard Pyle As I Knew Him," 15.

"National Art Spirit": Lykes, "Howard Pyle: Teacher of Illustration," 35.

"magnificent gift": NCW to ANWII, Nov. 5, 1903, n.p.

"Everybody": Ibid.

74 "If there was". HP quoted by NCW to HZW, Jan. 2, 1903.

"I think"; "Tell them": Ibid.

"Mr. Pyle went wild": NCW to HZW, Jan. 22, 1903, n.p.

"slapped": Ibid.

"certainly got": Ashley quoted by NCW: Ibid.

"cost him $80"; "It fit": NCW to HZW, Nov. 9, 1903.

toenail operation: NCW to HZW, Sept. 11, 1904.

"a thing"; "Mr. Pyle": NCW to HZW, July n.d., 1904, n.p.

75 "Lord": ANW to DTM, 6/8/98.

Promoted: NCW to HZW, Jan. 8, 1904.

ranked with Aylward: NCW to HZW, July n.d., 1904, n.p.

"had more confidence": NCW to HZW, Sept. 11, 1904.

"physically vigorous": NCW to HZW, Sept. 11, 1904.

"Gee whiz": NCW to HZW, June 22, 1903.

"blow ups": Ibid.

"it makes me feel": NCW to HZW, June 22, 1903, n.p.

"the biggest one": NCW to HZW, July 24, 1903.

76 a genius: HP quoted by NCW to HZW, Apr. 3, 1903, n.p.

"all fine": Ibid.

"what [his] heart": HP quoted by ATT, Notebooks, HP Papers, DAM.

"So you are having": Monte Cross to NCW, July 4, 1908, WFA: "the ever solicitous and tender 'So you are having your troubles again, my poor boy?' and all that other old con talk we bolted like fishes."

"no one realizes": NCW to HZW, May 13, 1903, n.p.

"sat upons": NCW to HZW, Sept. 7, 1903.

"How Pyle did": NCW to HZW and ANWII, Oct. 27, 1918.

"Oh!": NCW to HZW, May 13, 1903.

78 "we are left": NCW to HZW, Nov. 29, 1903.

"Either personally": CWA to HZW, Nov. 30, 1902, WFA.

"As to my not": NCW to HZW, Nov. 5, 1902, n.p.

"just for": NCW to HZW, Oct. 26, 1902.

"$5,000 worth": NCW to HZW, Nov. 2, 1902.

79 "the least excuse": NCW to HZW, June 15, 1903, n.p.

79 "HOME": NCW to HZW, July 24, 1903, and passim.
"could experience": NCW to HZW, Sept. 11, 1903, n.p.
"United States of Lyncherdom": Kaplan, *Mr. Clemens and Mark Twain*, 364. See also William James, "How Can Lynching Be Stopped?" *Literary Digest*, Aug. 8, 1903.
Accounts of Helen Bishop murder and George White execution: Wilmington *Every Evening Journal*, June 22–23, 1903, 1–2.
Wyeth recognized: NCW to HZW, June 25, 1903, n.p.
"saw it all": NCW to HZW, June 29, 1903.

80 "Nobody knows": Ibid. Sketch of lynching is among Wyeth Papers, Boston Public Library.
Description of Fourth of July: NCW to HZW, July 5, 1903.

81 "just like Papa": NCW to HZW, July 3, 1903.
ANWII's drumming skills: ANW to DTM, letter, 2/22/95.
"almost took": NCW to HZW, July 5, 1903.
"became so carried away": NCW to ERW, July 14, 1903.
"My God!" William Merritt Chase quoted by Harold Rosenberg, *The De-definition of Art* (New York: Horizon Press, 1973), 26.
"no enthusiasm"; "I've fully": NCW to HZW, June 19, 1903.

82 "that we should": Ibid.
"Too independent": NCW to HZW, July 24, 1903, n.p.
"I knew it": NCW to ANWII, Sept. 15, 1903.
"gave me": NCW to HZW, Aug. 31, 1903, n.p.
"by *hypnotizing*": NCW to HZW, July 24, 1903, n.p.
"so well": NCW to ANWII, Sept. 15, 1903, n.p.
"one of"; "happiest man"; "putting his arms": NCW to HZW, Oct. 19, 1903.

83 "Mr. Pyle laughed": NCW to HZW, Oct. 3, 1903.
"You wait": NCW to HZW, June 15, 1903, n.p.

PART TWO : *Wilmington, 1904–1910*
The Ideal

87 prettiest girl: See NBS, memoir, 18.
"black hair": NCW to CBW, Dec. 26, 1905, n.p.
"my model girl": NCW to HZW, May 23, 1906.
"impossible": NCW to CBB, Feb. 10, 1904, n.p.
frequently compared to Gibson Girl: NBS to DTM, 11/29/93.
CBB did not like being looked at by Pyle, and for years afterward she held it against him. BJW to DTM, 2/4/94; AWMcC to DTM, 12/8/94.
"shy, beautiful": NBS, memoir, 20.
best sitter: Caroline Peart quoted by CBB to NCW, Oct. 9, 1904.
Bockius genealogy, courtesy of WLB. For career of Christopher Bockius, see NBS, memoir, 7; and Morocco Manufacturers' National Association pamphlet, "The Early Morocco Manufacturers," n.d., collection of WLB.

89 Sybilla Lutz features: NBS, memoir, 7.
Carolyn: NBS to DTM, 11/29/93.
Closely chaperoned: NBS to DTM, 11/29/97.
"half-afraid": NBS, memoir, 14.
liked him immediately: NBS to DTM, 11/29/93.

Friends School education: DCW to DTM, 12/16/94; CBB attended the Wilmington
Friends School in the Meetinghouse at Fourth and West Streets.

CBB's voice: NBS to DTM, 11/29/93.

"dangerously fascinating": NCW to CBB, Feb. 10, 1904, n.p.

"Until I met": NCW to CBB, Apr. 11, 1904, n.p.

"I met": NCW to HZW, Jan. 17, 1904.

90 brush of skirts: NCW to CBB, Aug. 2 1905, n.p.

"all Bockius": WLB to DTM, 5/25/94.

Crazy Bockiae: NBS to DTM, 11/29/93.

"besplotched": NBS, memoir, 33.

"We weren't accurate": NBS to DTM, 11/29/93. See also NBS to DTM, letter,
12/11/93.

eight addresses: See *Wilmington City Directory*, 1882—1904.

Snooty Wilmington: See Canby, *Age of Confidence*, 17, 20.

91 "We weren't in": NBS to DTM, 11/29/93.

"We're not poor": Ibid.

Carolyn learned to laugh: See CBB to NCW, Oct. 15, 1904.

twelve "adventures": See *Wilmington City Directory*, 1883–1911.

single bathroom: NBS, memoir, 34.

"Do you think": NBS to DTM, 11/29/93.

ran it into the ground: NBS to DTM, 11/29/93.

"He took it over": Ruth Pratt Bockius quoted by WLB to DTM, 1/14/95.

"cushioned him": NBS, memoir, 16.

mistresses: WLB to DTM, 5/25/94. I am grateful also to Ann Files Snyder, daughter
of Ruth Bockius, for her documentation of her grandfather's affairs, based on the rec-
ollections of her great-aunts, Bessie and Fannie; Ann Files Snyder to WLB, Jan. 3,
1990.

drank excessively; disappeared: NBS to DTM, 11/29/93.

92 "suave": Ibid.

"clark": See GB listing, *Wilmington City Directory*, 1898.

flowers, songbirds: See ABB letters, 1922–1946, WFA.

"little sacks": NBS, memoir, 18.

"a wonderful life": NBS to DTM, 11/29/93.

white dresses: NBS, memoir, 27.

dangerously poor; went to bed hungry: AWMcC to DTM, 12/15/93.

"With us": NBS to DTM, 11/29/93.

"carried himself": NBS, memoir, 13.

"turned out": Ibid.

dressing up alcoholic behavior: See Meryman, *Secret Life*, 73.

"Carol's young artist": NBS, memoir, 35.

93 "To tell": NCW to HZW, Jan. 22, 1904, n.p.

"My dear Margaret": See NCW to CBB, Feb. 6 and Feb. 12, 1904, n.p.

"entirely overcome": NCW to CBB, Feb. 12, 1904, n.p.

"You must think": NCW to CBB, Apr. 11, 1904, n.p.

94 most impressed: NCW to HZW, Feb. 10, 1904.

"half-civilized": NCW to HZW, Feb. 21, 1904.

revised four times: NCW to HZW, Mar. 14, 1904, n.p.

"debate in my mind": NCW to HZW, Mar. 14, 1904.

94 "the source": NCW to CBB, Apr. 11, 1904, n.p.
 "beautiful, heavenly": NCW to CBB, Feb. n.d., 1904, n.p.
 "I sacrifice": NCW to CBB, Mar. 13, 1904, n.p.
 fetched doctor: See NCW to HZW, Feb. 21, 1904.
 brought books, made drawings, household repairs: NBS to DTM, 11/29/93.
 foible-finding humor: See NBS, memoir, 8.
 opera glasses: See NBS to DTM, letter, 12/11/93.
 "invitations": NCW to HZW, Feb. n.d., 1904, n.p.

95 "Some would": HZW to NCW, Nov. 9, 1906.
 "We thought": NBS to DTM, 11/29/93.
 "he hadn't read": NBS to DTM, 11/29/93. See also AW, "N. C. Wyeth," *American Vision*, 78.
 asthma attack: NBS to DTM, 11/29/93.
 description of evening at Bockiuses': NCW to HZW, Feb. 21, 1904.

96 "love and practical art": HP quoted in "Why Art and Marriage Won't Mix—By Howard Pyle."
 "dead in love": NCW to HZW, June 4, 1903, n.p.
 HP's "art ideal": See editorial notes, *Scribner's*, Mar. 1906, 38.
 HP's Russo-Japanese War offer: NCW to HZW, Feb. 16, 1904.

97 Davis salary: Lubow, 233; Remington signed up: Mott, 458.
 "I did": NCW to CBB, Feb. 12, 1904, n.p.
 "I haven't lived": NCW to HZW, Feb. 16, 1904.

98 cousin from Lancaster: NCW to CBB, Feb.–Mar. n.d., 1904, n.p.
 "not deserving": NCW to CBB, Mar. n.d., 1904, n.p.
 "treasure": NCW to CBB, Mar. n.d., 1904, n.p.
 "Please": NCW to CBB, Mar. n.d., 1904, n.p.
 "social pleasures": NCW to CBB, Feb.–Mar. n.d., 1904, n.p.
 "at the bottom": NCW to HZW, Apr. 11, 1904.
 "The Banquet!": NCW to HZW, Mar. 7, 1904.
 "both physically": NCW to HZW, Mar. 25, 1904, n.p.
 "gained knowledge": NCW to FES, Jan. 15, 1904, n.p.
 edge of the wilderness: See Brandywine River Museum, frontispiece, *Frank E. Schoonover, Illustrator*.
 "strung up": NCW to HZW, Apr. 11, 1904.
 "made a man": NCW to HZW, Mar. 31, 1904.

99 "which pleased": Ibid.
 "costumed"; "he actually": NCW to HZW, Mar. 7, 1904.
 "a continual": NCW to HZW, Oct. 29, 1905.
 "couldn't help it": FES, Oral History Program, AAA, transcript, 22.
 "all our work": Ibid.

100 "He failed": Exman, 117.
 "I'm dangerously": NCW to CBB, Mar. 13, 1904, n.p.
 "I have been": Ibid.
 "foremost art editor": NCW to HZW, Mar. 25, 1904.
 "dangerous game": NCW to CBB, Mar. 13, 1904, n.p.
 "majestic presence"; "with fear"; "benevolent"; "crowned"; "He made me": NCW in *Joseph Hawley Chapin, 1869–1939* . . .
 "beau idéal": Janello and Jones, 169.

"could tackle": *Century Association Year-Book 1940*, 27.

"nice chuckling": Wallace Morgan in *Joseph Hawley Chapin, 1869–1939* . . .

"Wherever he went": Burlingame, 234–37.

101 felt understood by him: Wallace Morgan in *Joseph Hawley Chapin, 1869–1939* . . .

JHC biographical information: see obituary, *New York Times*, Sept. 23, 1939.

"I had": JHC quoted by George H. Wright in *Joseph Hawley Chapin, 1869–1939* . . .

"always a guarantee": Editorial notes, *Scribner's*, Mar. 1906, 38.

102 "for my own": NCW to HZW, Mar. 25, 1904.

Chapin impressed: Ibid.

Bibliographers have for years presented Arthur Stanwood Pier's *Boys of St. Timothy's* (New York: Charles Scribner's Sons, 1904) as NCW's debut as a book illustrator, which, strictly speaking, it was. Pier's novel was published in September. Wyeth's illustrated volume in the Turgenev set appeared in November (Library of Congress copyright entry, Nov. 29, 1904). The Turgenev was, however, NCW's first commission as a book illustrator, and I am indebted to Ronald R. Randall for directing me to the 16-volume set *The Novels and Stories of Iván Turgénieff*, trans. by Isabel F. Hapgood. Vol. 14, *The Brigadier and Other Stories*, contains NCW's frontispiece.

"clear, broad": Burlingame, 235.

"clairvoyant friend": *Century Association Year-Book 1940*, 27.

103 Writing to Carol: NCW to CBB, Apr. 10, 1904, n.p.

"dear old": NCW to HZW and ANWII, Apr. 4, 1904, n.p.

104 "in the spirit": NCW to HZW, Apr. 16, 1904; see also NCW in *Joseph Hawley Chapin, 1869–1939* . . .

"We'll be glad": NCW, in *Joseph Hawley Chapin, 1869–1939* . . .

105 "two days"; "deep mystery": NCW to CBB, Apr. 27, 1904, n.p.

106 "I can tell": Ibid.

"an extremely valuable": NCW to HZW, June 12, 1904, n.p.

"with Miss Boulden": NCW to HZW, June 5, 1904.

"go again": NCW to CBB, Oct. 20, 1904, n.p.

"that day": CBB to NCW, Oct. 31, 1904.

"the record": NCW to HZW, July 8, 1904, n.p.

Boys of St. Timothy's, by Arthur Stanwood Pier: "It's not much of a book, and the rest of the illustrations are much worse than mine." NCW to HZW, Oct. 29, 1904, n.p.

108 "I've made": NCW to HZW, July 19, 1904, n.p.

"fallen back": NCW to CBB, July 22, 1904, n.p.

"possible for us": NCW to HZW, Aug. 28, 1904.

"growing pains": NCW to HZW, July 29, 1904, n.p.

An Old Weakness

109 Every evening: HZW to NCW, Oct. 26, 1904.

"fearing": HZW to NCW, Mar. 23, 1906.

"sorely troubled": HZW to NCW, Dec. 2, 1905.

"awful game": HZW to NCW, Oct. 18, 1904.

110 "feared"; "never": HZW to NCW, Mar. 23, 1906.

ERW during sieges: HZW to NCW, Jan. 12, 1906.

"If a young man": ERW to NCW, Feb. 9, 1908, WFA.

"a fine nurse": HZW to NCW, Jan. 12, 1906.

110 "never the closeness": GWU to DTM, letter, 3/2/95.

"magnetically connected": HZW to NCW, Jan. 12, 1906.

"I do not feel": Ibid.

In James B. Connolly's "Chavero" (*Scribner's*, Aug. 1916), a twelve-year-old boy reads aloud to his invalided mother. Her doctors say that "any severe shock might take her off." Confined to his mother's sickroom on a sunny day, the boy is outfitted "in the native costume which his mother so liked to see him in."

sinking feeling in her chest: NW to NCW, Nov. 6, 1907, WFA.

HZW's sleep anxieties: See HZW to NCW, Oct. 18, 1904, Dec. 13, 1907.

"baby nightmares": ANWII quoted by NW to HZW, Dec. 30, 1907.

"continuous strain": NW to NCW, Nov. 6, 1907, WFA.

112 "too much thinking": Dr. Pease quoted by NW to NCW, Nov. 6, 1907, WFA.

"My only pleasure": HZW to NCW, Oct. 18, 1904.

"felt bad"; "been out": HZW to NCW, Jan. 12, 1906.

"how it preys"; "I hardly": HZW to NCW, Feb. 4, 1911.

"night air": HZW to NCW, Feb. 24, 1911.

"peace to myself": HZW to NCW, Oct. 18, 1904.

"Mama burned up": NCW to ANWII, Mar. 25, 1927.

"day of joy": NCW to HZW, Aug. 12, 1904.

"You have grasped": Arthurs quoted by NCW to HZW, Aug. 14, 1904, n.p.

"launch forward": NCW to HZW, Aug. 12, 1904.

"right track": NCW to HZW, Aug. 14, 1904, n.p.

113 "go right home"; "identify myself": NCW to HZW, Aug. 14, 1904.

"mental conditions": NCW to HZW, Aug. 14, 1904, n.p.

"satisfying influence": CBB to NCW, Sept. 2, 1904.

"Mr. Pyle": NCW to HZW, Aug. 14, 1904.

"total lack"; "very successful": NCW to HZW, Sept. 9, 1904, n.p.

NCW's pictures at *Scribner's:* Three illustrations in black and white for "Tommy," by Charles Belmont Davis.

"place for me": NCW to HZW, Nov. 29, 1903. NCW was objecting to the documentary approach made popular by "Western" illustrators like Remington, but he left out nineteenth-century American painting in the American West, especially Albert Bierstadt's panoramic canvases of the 1860s.

114 "girl I love": NCW to CBB, Aug. 21, 1904, n.p.

"She spoke lightly"; "closed her up": NCW to CBB, Sept. 14, 1904, n.p.

"My Own Dear Carolyn": Ibid.

"Dearest!": CBB to NCW, Sept. 15, 1904.

115 "green paradise": HZW quoted by NCW to HZW, Sept. 11, 1904, n.p.

"probably the last": NCW to HZW, Sept. 11, 1904, n.p.

"I can seem": HZW to NCW, Dec. 15, 1905.

"moods": NCW to HZW, Aug. 28, 1904.

"until the last minute": NCW to CBB, Sept. 17, 1904, n.p.

116 "Do you think": HZW to NCW, Oct. 7, 1904.

Shoot-Out

117 "My dear Carolyn": NCW to CBB, Oct. 5, 1904, n.p.

"Dear Mama": NCW to HZW, Oct. 5, 1904.

"Things look": NCW to HZW, Sept. 23, 1904.
"Things seem": NCW to CBB, Sept. 29, 1904, n.p.
"Just as I start": NCW to CBB, Sept. 25, 1904, n.p.
"As I start": NCW to HZW, Sept. 25, 1904.

118 "At last": NCW to CBB, Sept. 29, 1904, n.p.
"Here I am": NCW to HZW, Sept. 29, 1904.
"my nerve": NCW to HZW, Oct. 19, 1904.
"trackless wilds": NCW to NW, Jan. 22, 1905.
Accounts of send-off party: See NCW to CBB, Sept. 26, 1904, n.p.; NCW to HZW, Sept. 26, 1904, n.p.; NCW to CBB, Oct. 20, 1904, n.p.; CBB to NCW, Oct. 8, 1904.

119 Etta Boulden was the daughter of a Mrs. Boulden, who had replaced Eva Simpers as the Pyle students' cook on Feb. 8, 1904. Five days later NCW accompanied Etta Boulden and Blanche Swayne to the theater.

120 "hunt": NCW, "Day with the Round-Up," 286.
"first bad spill": NCW, Diary, Oct. 13, 1904, WFA.
"go into anything": NCW to HZW, Oct. 22, 1904, n.p.

121 "I was never": NCW to CBB, Oct. 6, 1904, n.p.
"I feel perfectly": NCW to HZW, Sept. 29, 1904.
"foul and filthy": NCW to CBB, Oct. 5, 1904, n.p.
grown tired of "Dutch Lou": Ibid.

122 "almighty lonesome": Ibid.
"Please": CBB to NCW, Nov. 28, 1904.
"Indian smallpox"; "the characters"; "It's hard": HZW to NCW, Oct. 18, 1904.
NCW claimed to have killed fifty-two rattlesnakes: NCW to HZW, Oct. 19, 1904. Ten years later, writing to SW (Nov. 19, 1914), he admitted: "Two rabbits and a few rats, some chickens and a 'beef' on the round-up is all the killing I ever did. All else I admitted was a fabrication. To kill does not turn my stomach; it sours my sensibilities."
"thanks to": NCW to HZW, Oct. 27, 1904.
"When I spoke": NCW to CBB, Nov. 4, 1904.

123 "the wildest": NCW to HZW, Oct. 19, 1904.
"one hour ago": NCW to CBB, Oct. 20, 1904, n.p.
"afraid": NCW to HZW, Oct. 22, 1904.
"day in": NCW to CBB, Oct. 24, 1904, n.p.
"I *don't* know": Ibid.

126 "I have made": NCW to ANWII, Nov. 3, 1904.
set-piece format: See Remington's illustrations for Theodore Roosevelt's "The Round-Up," including *The Rope Corral, Cutting Out a Steer, In a Stampede, The Herd at Night.*
"This sort": NCW to CBB, Nov. 4, 1904, n.p.
"I do hope": CBB to NCW, Nov. 14, 1904.
"We will know": Ibid.
The offices of the Denver *Times* occupied the same building as NCW's studio, but the *Times,* the Denver *Post,* and the *Republican* all failed to carry any account or photograph of young NCW or his pictures between Oct. 30 and Nov. 16, 1904.
"Oh, I'll tell": NCW to CBB, Nov. 4, 1904, n.p.
"hundreds of Indians": NCW to HZW, Nov. 7, 1904.

127 ate horsemeat: NCW, Diary, Nov. 12, 1904.

127 "these damned": Ibid., Dec. 1, 1904.
His pay: Ibid., Nov. 17, 1904.
"long dim trail": NCW to HZW, Dec. 14, 1904.
"Hard ride": NCW, Diary, Nov. 24, 1904.
"Back to Ft. Defiance": Ibid., Nov. 25, 1904.
"Back to Two": Ibid., Nov. 26, 1904.
"Again to": Ibid., Nov. 27, 1904.
"Remember my": NCW to CBB, Dec. 20, 1904, n.p.
"Anxious to find": Thornton S. Hardy to NCW, Nov. 22, 1904, WFA.

128 "I cannot": NCW to CBB, Dec. 24, 1904, n.p.
lack of "home interest": NCW to HZW, Jan. 15, 1905, n.p.
"knuckle right down": NCW to HZW, Jan. 9, 1905.
"I'll show you": NCW to HZW, Jan. 9, 1905, n.p.
"downright guilty": NCW to NW, Jan. 22, 1905.
"as you are": CBB to NCW, Dec. 27, 1904.
"looking into": NCW to CBB, Dec. 20, 1904, n.p.
"too much Remington": HP quoted by NCW to HZW, Dec. 29, 1904.
"the artist spent": *Scribner's,* Mar. 1906, editorial notes, 38.

129 "A Day with the Round-Up" echoes Theodore Roosevelt's "The Round-Up," illustrated by Frederic Remington, *Century,* vol. 35, no. 6, Apr. 1888.
"delicious and scathing": NCW to HZW, Dec. 29, 1904.
New Year at the Bockiuses': NCW to HZW, Jan. 1, 1905.
"an attraction": FES to HZW, Jan. 15, 1905, WFA.
"a young lady": NCW to HZW, Jan. 20, 1905.
Settled on March as wedding month: NCW to CBB, Dec. 23, 1905, n.p.
"But oh!": NCW to CBB, Dec. 26, 1905, n.p.
"certain figure": Ibid.

130 Work in demand: One N. C. Wyeth western painting, *Roping in the Corral,* became so popular that it was pirated. See NCW to HZW, Aug. 3, 1906.
Change in rapport with HP: See NCW to HZW, Jan. 9, 1905, n.p.
"I thought of": NCW to CBB, May 11, 1905, n.p.

131 "In fact": NCW to HZW, Jan. 6, 1906, n.p.
Bockiuses had no objections: NBS to DTM, 11/29/93.
"and it *has*": NCW to ANWII, Jan. 20, 1905.
"an individual": HZW to NCW, Jan. 12, 1906.

Siege

132 "What do you hear": JDZ quoted by HZW to NCW, Aug. 12, 1907.
"I feel": HZW to NCW, Mar. 22, 1906.
"grated": Ibid.
"It upsets"; "How I miss": HZW to NCW, Jan. 12, 1906.
"There has been": HZW to NCW, Dec. 15, 1905.
"all turned around": HZW to NCW, Dec. 2, 1905.
railroad timetable, see HZW scrapbook, "Album," WFA.

133 "clinging": HZW to NCW, Mar. 22, 1906.
"The fact is": Ibid.
"If I don't deserve": Ibid.

"felt bad": HZW to NCW, Jan. 12, 1906.

"tell things": ANWII to NCW, Dec. 31, 1905.

"to speak it": NCW to HZW, Jan. 6, 1906, n.p.

"taint"; "sort of melt"; "I don't want": NCW to HZW, Mar. 1, 1906.

"Delaware Avenue girl": NCW to CPW, Oct. 12, 1944.

"*I know* her"; "*never* appraise"; "stimulated"; "close": NCW to HZW, Jan. 6, 1906, n.p.

"To come to": Ibid.

134 "resort to": HZW to NCW, Jan. 12, 1906.

"Your large baby picture": Ibid.

"marriage siege": NCW to HZW, ANWII et al., Oct. 24, 1907.

reply to his engagement: HZW to NCW, Jan. 12, 1906.

135 "I can see": NCW to ANWII and HZW, Mar. 1, 1906.

"Your being away": HZW to NCW, Mar. 12, 1906.

"I came down": NCW to HZW, Jan. 6, 1906, n.p.

"It sounds nice": HZW to NCW, Jan. 12, 1906.

"She has taken": NCW to HZW, Jan. 20, 1905.

"Remember, Convers": HZW to NCW, Jan. 12, 1906.

"I want you to feel": CBB to HZW, April 6, 1906.

"look for"; "after long waiting": HZW to NCW, Mar. 22, 1906.

136 arranged everything: NCW to HZW, Jan. 15, 1906, n.p.

"used good tact": ANWII to NCW, Jan. 16, 1906.

two or three a week: NCW to ANWII, Mar. 16, 1906.

"New York editors": NCW to HZW, Mar. 5, 1906.

"leading artists": A group that included Frederic Remington, A. B. Frost, Arthur Heming, and Charles Livingston Bull; see Mott, 637.

"The more I hear": HZW to NCW, Mar. 23, 1906.

"Do good work": ANWII to NCW, Mar. 14, 1906.

"Swiss chateau style": NCW to HZW, May 26, 1905.

found himself: NCW to HZW, Mar. 23, 1906.

137 "I hear good": NCW to HZW, Feb. 26, 1906, n.p.

"a canoe": HZW to NCW, Feb. 28, 1906.

"They certainly": HZW to NCW, Mar. 22, 1906.

"It really": HZW to NCW, Feb. 28, 1906.

"After April 16th": NCW to ANWII and HZW, Mar. 1, 1906.

"sacredness"; "the big"; "the kind of": Gustav Stickley quoted in Lynes, 186–88.

138 "ostracized from": NCW to HZW, Mar. 22, 1906.

"Why don't you": Ibid.

"expressed"; "far into": NCW to HZW, Oct. 16, 1905.

eight of sixty-three: See *Howard Pyle: The Artist and His Legacy*, 16.

HP income and expenses: Ibid., 17.

"They lack"; "I feel": HP quoted in Pitz, *Howard Pyle*, 187.

"the biggest picture" any: HP quoted by NCW to CBB, Aug. 6, 1905, n.p.

"the biggest picture" ever: NCW to HZW, Mar. 22, 1906.

grain of salt: NCW to CBB, Aug. 6, 1905, n.p.

"wild with delight": NCW to HZW, Jan. 15, 1906, n.p.

"Not that I": NCW to HZW, Jan. 20, 1905, n.p.

"put his foot"; "paint it"; "as he thinks"; "He said": NCW to HZW, Mar. 25, 1906.

139 not sure what to say: ANWII to NCW, Jan. 16, 1906.
"quiet"; "cannot be": HCW to NCW, Mar. 9, 1906.
"It makes me": NCW to ANWII, Mar. 22, 1906, n.p.
"It may seem": ANWII to NCW, Mar. 14, 1906.

140 "My golly": NCW to ANWII, Mar. 15, 1906, n.p.
"I rapped": ANWII to NCW, Dec. 31, 1905.
she dwelled: HZW to NCW, Jan. 12, 1906: "I seem to cling to bygones in these days that I am alone so much."
She noted: HZW to NCW, Jan. 6, 1906.
"mighty good": HZW to NCW, Mar. 12, 1906.
"In him": HZW to NCW, Mar. 2, 1906.
received art editor's letter: See NCW to HZW, Mar. 22, 1906.
"the big desk": see Orson Byron Lowell in *Joseph Hawley Chapin, 1869–1939* . . .

141 Pyle's salary: Pitz, in *Howard Pyle* (178–79), is guessing, and doing inferential arithmetic, when he states that "the facts seemed to be that [Pyle] had been offered the unheard of salary of $36,000 a year to act as full-time art director of *McClure's* magazine." We know from McClure's papers that he offered $18,000 (Lyon, 284) to Pyle to become art director on a proposed new publication, *McClure's Journal;* when Pyle instead became art editor for *McClure's Magazine,* we know that Pyle went to work three days a week and took a salary of $350 a week, or about $18,000 a year (see JHC to Charles Scribner II, May 20, 1906, SA). Just because Pyle worked "half time" doesn't mean that $18,000 was a "half salary." To the contrary, it was uniquely generous, and typical of S. S. McClure.
one big hotel: Canby, *Age of Confidence,* 8.
champagne in Wilmington: Ibid., 19.
"a snug"; "had a weakness": Pitz, *Howard Pyle,* 142.
Auction of *Kim:* See Bynner, 164.
spared no expense; encouraged to spend years: See Tarbell, 258.
"right people": McClure quoted in Janello and Jones, 60.
Oliver Wendell Holmes: Quoted in Kaplan, *Lincoln Steffens,* 90: "I will neither be lured nor McClured."
$8,000 a year: See JHC to Charles Scribner II, May 20, 1906, SA.
McClure's way of punishing: See Lyon, 283–86.
negligent: See Tarbell, 256–58.
"fancy fee": Lyon, 287.
HP anxious about future: See Pitz, *Howard Pyle,* 179.

142 Pyle's arrangement at *McClure's:* See JHC to Charles Scribner II, May 20, 1906, SA: "Mr. Pyle . . . is drawing three-hundred and fifty dollars a week (three days only in the office)."
"fully half": HP to Frederick A. Duneka, Dec. 29, 1905, HMA, with permission of the Pierpont Morgan Library, New York, MA 1950.
"of direct and practical": Ibid.
"very important": NCW to HZW, Jan. 9, 1906, n.p.
"stick out": NCW to HZW, Mar. 23, 1906.
"the good tack": ANWII to NCW, Apr. 2, 1906.
"We see"; "we are"; "she is": HZW to NCW, Mar. 22, 1906.
"If she only": NCW to ANWII, Mar. 22, 1906, n.p.

"I think": NCW to HZW, Mar. 22, 1906.

"I did try": HZW to NCW, Mar. 23, 1906.

143 "Just because": NCW to HZW, Mar. 22, 1906.

"I don't drop": HZW to NCW, Mar. 23, 1906.

"We both want": NCW to HZW, Mar. 23, 1906.

"How can you": HZW to NCW, Mar. 23, 1906.

"to a T": NCW to HZW, Mar. 22, 1906, n.p.

"enjoying all": Ibid.

"any little token": HZW to NCW, Mar. 23, 1906.

"I also feel": Ibid.

144 "abundance of true sympathy": NCW to SW, Sept. n.d., 1911.

first perceived: See NCW to HZW, Mar. 1, 1918, n.p.

"being swept": Ibid.

"understand it"; "made me think": NCW to HZW, Mar. 24, 1906, n.p.

"We both": HZW to NCW, Mar. 23, 1906.

"Please let me": NCW to HZW, Mar. 25, 1906, n.p.

Unhorsing the Master

145 "very logical": NCW to HZW, Apr. 7, 1906.

prior commitment to Whitney: See NCW to HZW, Apr. 7, 1906, n.p.: "This is the one argument of all that carried my point"

"the only man": HP and McClure quoted by NCW to HZW, Apr. 7, 1906.

"That sounds": NCW to HZW, Apr. 7, 1906.

"felt mean"; "I'm not": HZW to CBB, Apr. 3, 1906.

"not got"; "strange"; dosed herself: HZW to NCW, Apr. 6, 1906.

"no intimation": HZW to NCW, Mar. 23, 1906.

"I have": HZW to CBB, Apr. 12, 1906.

146 "No one knows": HZW to CBB, Apr. 3, 1906.

"It's hard": HZW to NCW, Apr. 6, 1906.

"Some [people]": HZW to NCW, Mar. 23, 1906.

"she is not": ANWII to NCW, Apr. 2, 1906.

"and that's": NCW to HZW and ANWII, Apr. 10, 1906.

"try and feel": HZW to CBB, Apr. 12, 1906.

"I think"; "most strenuous"; "for illustration"; "a big"; "Gee!": NCW to HZW and ANWII, Apr. 10, 1906.

"right in the midst": NCW to HZW and ANWII, Apr. 10, 1906, n.p.

"I painted": NCW to HZW et al., Oct. 24, 1907.

"When Convers": HZW to CBB, Apr. 12, 1904.

147 He admitted: NCW to HZW, Apr. 13, 1906.

NCW-CBB wedding details from CBW's family record book, WFA, and from NBS to DTM, 11/29/93.

"a frail": NCW to CPW, Apr. 4, 1943.

"When she saw": NBS to DTM, 11/29/93.

afraid of the old woman: NBS, memoir, 35.

"Mr. Pyle expects": NCW to HZW, June 22, 1906.

148 "Convers's success": NBS to DTM, 11/29/93.

148 "just the two": Ibid.

how happy: See also CBW to HZW, May 13, 1906.

two or three nights: CBW to HZW, Apr. 26, 1906.

"clean off his trolley": NCW to ERW, NW, and SW, May 1, 1906.

mutiny at *McClure's:* See Lyon, 279–94; Bynner, 164.

"most brilliant staff": Ellery Sedgwick quoted in Lyon, 295.

"of direct": HP to Frederick A. Duneka, Dec. 29, 1905, HMA.

"like a whirlwind": NCW to HZW, May 23, 1906.

"like a shadow": NCW to HZW, Aug. 10, 1906.

"quite a few": NCW to HZW, May 7, 1906. For complete guest list of Third Annual Dinner of the Periodical Publishers' Association of America, May 4, 1906, see CWA Papers, AAA.

149 "If only someday": NCW to HZW, Oct. 6, 1906.

Pyle's offer: See NCW to HZW, June 11, 1906.

"How many times": NCW to HZW, July 19, 1907.

"It troubled": CBW to HZW, Aug. 17, 1906.

September cover story: "The Story of Montana" by C. P. Connolly, *McClure's*, Aug.–Dec. 1906. See also NCW to HZW, May 23, 1906.

"time to paint": NCW to HZW, June 11, 1906.

150 "to satisfy": NCW to HZW, July 2, 1906.

"poured": Ibid.

Sloan at *McClure's:* See Brooks, *John Sloan*, 46–49; see also Loughery, 84: "[Sloan] particularly hated approaching Howard Pyle at *McClure's*."

"good in character"; "sourish or kindly": Ibid, 49.

Sloan's vision of city: See Loughery, 93–94.

"poor little": Sloan quoted in Brooks, *John Sloan*, 47.

"yearning for": A. B. Frost quoted in Pitz, *Howard Pyle*, 180.

"benefit to": HP quoted in Abbott, 219.

"shocks": See Pitz, *Howard Pyle*, 180.

McClure luring Chapin: See JHC to Charles Scribner II, May 20, 1906, SA. "Mr. Pyle . . . intends to stay on for a period but with the idea that I will succeed him." See also, Burlingame, 238.

151 "You are the man": HP to ATT, June 4, 1906, ATT Papers, AAA.

"He got True": NCW to HZW, Aug. 10, 1906.

"The trouble": CBW to HZW, Aug. 17, 1906.

CBW's memory of Pyle's refusal: AWMcC to DTM, 12/8/94.

"And *oh!*"; "To tell"; "blinded": NCW to HZW, Aug. 10, 1906.

"notoriously selfish": Quoted by NCW to HZW, Aug. 17, 1906.

152 "That's damn bad": NCW to HZW, Aug. 10, 1906.

"The whole thing": NCW to HZW, Aug. 17, 1906.

birth of first child: See CBW, Family Record Book, WFA.

"doing splendidly": NCW to HZW and ANWII, Dec. 19, 1906.

"from a young": NCW to HZW, Nov. 16, 1906.

"the next two": NCW to HZW and ANWII, Dec. 19, 1906.

death of Carolyn Wyeth: See CBW, Family Record Book, WFA.

Christmas carols: NBS to DTM, 11/29/93.

"one of the greatest": NCW to HZW, Jan. 4, 1907.

"But how it": NCW to HZW and ANWII, Dec. 23, 1906.
"Why is it": HZW to NCW, Dec. 25, 1906.

Secret of the Grave

154 "Most unhappy": CBW, Family Record Book, WFA.
"We must": HZW to CBW, Dec. 25, 1906.
"I'm glad"; "hard to"; "poor Carol"; "No particulars": HZW to NCW, Dec. 25, 1906.
155 "a chaos": NCW to HZW, Jan. 4, 1907.
"no equal": *Scribner's*, Literary Notes, Oct. 1907.
"poetry": Quoted by NCW to HZW, June 7, 1907.
"one of our greatest": *Outing*, 1907, subscription promotion advertising "A Wyeth Portfolio."
"from the far back": Mrs. Elizabeth B. Custer to NCW, July 2, 1907, WFA.
"very little": NCW to HZW, Dec. 14, 1906.
"These pictures": NCW to HZW, Jan. 25, 1907.
156 "terrible rut": Ibid.; see also NCW to HZW, June 7, 1907.
"to be *able*": NCW to HZW, Jan. 25, 1907.
"every piece": NCW to HZW, Aug. 9, 1907, n.p.
"very severe"; "a year"; "striking for": NCW to HZW, Jan. 25, 1907.
"Remember"; "you hardly"; "All this": HZW to NCW, Jan. 29, 1907.
"in an atmosphere": NCW to HZW, July 19, 1907.
157 "deep green": Bianchi, "Back to the Farm," *Scribner's*, Aug. 1908, 164–71.
"I believe": NCW to HZW, July 3, 1907.
"the first *big*": Ibid.
"But I want": NCW to HZW, Aug. 2, 1907, n.p.
decision to cast aside: NCW to HZW, July 27, 1907, n.p.
158 "predominated": NCW to HZW, Aug. 2, 1907, n.p.
"continually mentioned": Ibid.
"brick confines": NCW to HZW, July 19, 1907
"I am not": NCW to HZW, Aug. 2, 1907, n.p.
"I have worked"; "get back"; "I shall go": NCW to HZW, Aug. 9, 1907, n.p.
159 "The fellows": NCW to HZW, Oct. 7, 1907.
"the man's": NCW to NW, Oct. 18, 1907.
"the grand": NCW to HZW and ANWII, Nov. 14, 1911.
"anxious and nervous": CBW to HZW, Aug. 29, 1906.
"My mind": NCW to HZW, Aug. 9, 1907, n.p.
"that eternal": Ibid.
HZW's mental health seemed improved: See NCW to HZW, May 10, 1907, n.p. See also NCW to ANWII, Nov. 10, 1907.
visit to HZW's family's grave: HZW to NCW, May 27, 1907.
160 "stirred me": NCW to HZW, June 7, 1907, n.p.
"have a conversation": HZW to NCW, Nov. 9, 1906.
"don't feel right": HZW to NCW, Oct. 26, 1906.
"Saturday morning": NCW to SW, Nov. 27, 1911, n.p.
"ravenous"; "Don't ever": NCW to HZW, Feb. 5, 1904.
"I seem to": HZW to NCW, July n.d., 1908.

160 "There is such": CBW to HZW, Sept. 12, 1911.
"You can't imagine": CBW to HZW, Aug. 29, 1907.

161 "think of no": NCW to HZW, Apr. 16, 1917, n.p.
"rich and full": NCW to HZW, Nov. 10, 1907.
"Oh! Mama": NCW to HZW, Oct. 2, 1907, n.p.
"Carol is": NCW to HZW, Mar. 18, 1909, n.p.
"Her regard": NCW to SW, May 22, 1911, n.p.
"O! how hungry": NCW to HZW, Mar. 29, 1912, n.p.
"When it comes"; "all at once": CBW to HZW, Sept. 12, 1911.
"I feel as though": CBW quoted by NCW to HZW, Feb. 23, 1907.
"That just took": Ibid.
"to show him": NCW to HZW, Sept. 27, 1907, n.p.

162 Birth of Ann Henriette Wyeth: See CBW, Family Record Book, WFA.
"Poor Carol"; "all the above": NCW to HZW, Nov. 1, 1907, n.p.
"Each year": ANWII to NCW, Oct. 13, 1907.
long, effusive: Four pages, HZW to NCW and CBW, Oct. 26, 1907.
"Perhaps I was": NCW to HZW, Nov. 6, 1907, n.p.
"My mind": NCW to HZW, ANWII et al., Oct. 24, 1907.

163 "That last letter": NW to NCW, Nov. 6, 1907, WFA.
her chances: HZW to NCW and CBW, Oct. 26, 1907.
"too much thinking": Dr. Pease quoted by NW to NCW, Nov. 6, 1907, WFA.
overtaxed her: ANWII to NCW, Nov. 8, 1907: "she has got it into her mind that so much letter writing has been overtaxing her mental strength and by advice from Dr. Pease she is going to give up all writing for the present."
doctor agreed: see NW to NCW, Nov. 6, 1907: "She went to the doctor and asked him if the continuous strain on her mind, which she says is due to thinking up subjects and things to write, had any thing to do with making her nights restless and causing certain depressed feelings about her chest. She was inclined to think it was her age, but the doctor told her that it was not that, it was due to too much thinking, etc."
"I suppose": HZW to CBW and NCW, Nov. 1, 1907.

164 one of the brightest: Ibid.
"Any change": ANWII to NCW, Nov. 8, 1907.
Newell believed: See NW to NCW, Nov. 6, 1907.
"I sometimes think": ANWII to NCW, Nov. 8, 1907.
"Don't change": ANWII to NCW, Nov. 14, 1907.
doctor's warning: See NCW to ANWII, Nov. 10, 1907.
sided with Newell: See NCW to ANWII, Nov. 10, 1907, n.p.: "I agree with you."
"I shall try": NCW to ANWII, Nov. 10, 1907.
"By the way": NCW to HZW, Nov. 10, 1907.

165 "Although": NCW to HZW and ANWII, Dec. 3, 1907, n.p.
"Tomorrow I look": NCW to HZW, Nov. 14, 1907, n.p.
"Tomorrow I expect": NCW to HZW, Dec. 6, 1907, n.p.
"My hopes": NCW to HZW, Dec. 14, 1907, n.p.
"tried mental science"; "[gone] out": HZW to NCW, Dec. 13, 1907.
"following you"; "I cannot": Ibid.

166 convoluted prose: See HZW to NCW, Dec. 25, 1906.
"*greatest* regrets"; "Only Ed's": HZW to CBW, Oct. n.d., 1907.
"old flame": Recollection of GPW as told by GWU to DTM, letter, 3/21/95.

family story: Recollection of NCW as told by BJW to DTM, 5/14/93, AWMcC to DTM, 5/15/93 and 12/8/94, AW to DTM, 2/1/94; HWH recollection to JBW to DTM, 12/19/95.

"I'm getting along": HZW to NCW, Dec. 13, 1907.

167 No record at Cambridge city clerk: When the binding for the original volume containing birth records for 1857–59 was replaced, the pages higher than 100 were omitted, thereby eliminating all records in those years for anyone whose name begins with "Z." (Office of City Clerk, Cambridge, Mass., to DTM, 2/19/98.)

December 25, 1958: ANWII was the "informant" for the date of birth on HZW's certificate of death, issued by the Needham Town Clerk on Aug. 12, 1925 (on microfilm, NFPLA); obituary for HZW, Needham *Chronicle,* Aug. 17, 1925; gravestone, Needham Cemetery: In the absence of surviving primary-source material in Cambridge or in the Wyeth Family Archive, I take these as the most reliable sources available with which to date HZW's birth.

"later"; "Unless I get": HZW to NCW, Dec. 13, 1907.

full-fare ticket and stateroom: See NCW to HZW, Dec. 8, 1907.

doctor approved: Ibid. Quoted by NCW: "I don't see why not."

refused to risk: Ibid.

"I can't depend": Ibid.

168 "My heart": NCW to HZW, Dec. 15, 1907, n.p.

"To compromise": Ibid.

"I want this promise": Ibid.

"The change": NCW to HZW, Dec. 15, 1907, n.p.

"I have never": NCW to CBW, Dec. 25, 1907, n.p.

"so elated": HZW to NCW, Dec. 17, 1907.

169 "No one missed": HZW to ANWII, Dec. 28, 1907.

"a doily": HZW to CBW, Dec. 25, 1907.

"small": HZW to CBW, Jan. 9, 1908.

"good care": HZW to ANWII, Dec. 28, 1907.

"baby nightmares": ANWII quoted by NW to HZW, Dec. 30, 1907; see also ANWII to HZW, Dec. 29, 1907.

"a different woman": HJP reply to letter from HZW; Mar. 29, 1908.

Moods

170 "colorized"; "vivid red": Wilmington *Star,* Jan. 23, 1910.

"more ashamed": NCW to HZW, Apr. 10, 1910, n.p.

"whipped"; "We were taught": NCW to HZW, July 16, 1911.

"hardly believe": NCW to HZW, June 20, 1908.

"None of us": NCW to ATT, Jan. 6, 1909, ATT Papers, AAA.

171 "paint only for": NCW to SMC, Mar. 16, 1908.

finishing touches: *The Locating Engineer,* painted Mar. 1908, published in *Scribner's,* Sept. 1908, is another self-dramatizing image. In the manner of *Two Surveyors* (1903), it portrays an isolated craftsman, poised on a precipice, risking his life to find the route between two worlds.

"this move": NCW to HZW, Mar. 9, 1908.

"old Outside Inn": NCW to ATT, June n.d., 1910, HP Papers, DAM.

"allow ten": NCW to SMC, Mar. 16, 1908.

171 "Painting and illustration": Ibid.
"God damn": NCW to HZW, Feb. 13, 1908, n.p.
purgatory: See NCW to HZW, Jan. 18, 1909, n.p.
"the peak": Quoted in Brooks, *John Sloan,* 96.
"to leave out": NCW to HZW, Feb. 13, 1908, n.p.

172 "contaminated": NCW to HZW, Jan. 17, 1910, n.p.
"sublime state": NCW to SMC, Apr. 15, 1908, n.p.
"healthy state": NCW to HZW, Jan. 17, 1910, n.p.
early Chadds Ford: See Zack Haig to Thomas R. Thompson, Apr. 9, 1974, WFA. See
also recollections of N as told by ANW to DTM, letter, 2/22/95.
"do a little": CBW to HZW, May 25, 1908.
"I brought": NCW to CPW, Oct. 12, 1944.
saw herself as city girl: CBW quoted in *New York Times,* June 1, 1972, 52.
"I don't look": CBW to HZW, May 25, 1908.
took pride: See CBW to HZW, June 15, 1908.
"She is": NCW to HZW, May 29, 1908.
"scared"; "too much": CBW to HZW, June 15, 1908.
marvelous spring: NCW to ERW, Apr. 9, 1908.

173 "I *worship* it": NCW to HZW, Feb. 13, 1908, n.p.
pushing himself: See CBW to HZW, May 25, 1908.
studies in open: See NCW to HZW, May 29, 1908.
Scribner's and *Post:* See CBW to HZW, May 15, 1908.
"Convers spends": CBW to HZW, May 25, 1908.
"never worked": NCW to HZW, June 20, 1908.
"*study,*": NCW to HZW, June 30, 1908.
"paint": NCW to ATT, Dec. 24, 1910, n.p., HP Papers, DAM.
"great mysterious night": NCW to HZW, May 17, 1909.
series of rumblings: See recollection of N as told by ANW to DTM, letter, 12/28/94.
all details of confrontation with automobile: See NCW to HZW, May 17, 1909.

175 "comes nearer": NCW to HZW, Nov. 16, 1906, n.p.
"Orders still": NCW to HZW, May 20, 1909, n.p.
"Can a poet": NCW to SMC, April 20, 1909.
"the uselessness": NCW to HZW, June 7, 1907.
"faked": NCW to NW, Oct. 19, 1908.
"killed them": NCW to SMC, Apr. 20, 1909.
"a higher": NCW to ATT, Jan. 6, 1909, ATT Papers, AAA.
high-low split: Anne Hollander has pointed out that for the successful crossover
painter Winslow Homer, the graphic skills developed in nineteenth-century com-
mercial art actually enriched not just early or transitional works but important paint-
ings *throughout* his career; see *Moving Pictures,* 360–61.

176 market for Wyeth originals: On May 25, 1908, JHC took NCW to lunch with a Mr.
Davis, who had already bought several Wyeth originals. In May a collector from
Flushing, N.Y., who had bought some of his western pictures, wrote to ask if she
could buy his "drunk" picture in the May issue of *McClure's.* In October, Mrs. Phelps
Stokes bought *On the October Trail,* as seen in that month's *Scribner's,* and three col-
lectors all wanted the canoe picture that NCW had painted in May.
"I am *not*": NCW to HZW, June 20, 1908.

"merely sketches": NCW quoted in Philadelphia newspaper, Nov. 20, 1912, unidentified clipping, WFA.

"But this does not": NCW to ATT, Dec. 24, 1910, n.p., HP Papers, DAM.

"The cry is": NCW to HZW and ANWII, Nov. 17, 1910, n.p.

"The pictures": NCW to SMC, Nov. 9, 1910.

rejected Marshall Field offer: Ibid.

"found how earnest": NCW to HZW and ANWII, Nov. 14, 1911, n.p.

177 Sketch Club exhibition: Philadelphia *Press,* Nov. 10, 1912.

"break away": See review, dated Nov. 20, 1912, of NCW landscapes at Sketch Club of Philadelphia, WFA, Oval Office scrapbooks.

Dunn's best man: See HJP to HZW, Mar. 29, 1908, WFA: "I suppose you have heard all about the Dunn-Krebs wedding, at which your son was the best man."

"glassy stares"; "considering"; "everyone": NCW to HZW, Mar. 9, 1908, n.p.

"New England narcissus": See Edel, 165.

less "wild": NCW to ATT, June n.d., 1910, HP Papers, DAM.

178 "Start in": NCW to ATT, Jan. 6, 1909, ATT Papers, AAA.

"Clarify": Ibid.

"It is utterly": NCW to Gayle Hoskins, n.d. 1908, NCW Papers, DAM.

"My impulsiveness": NCW to HZW, June 20, 1908.

"blood tingling": NCW to HZW, Oct. n.d., 1907.

"Yes, Convers": CBW quoted by HWH to DTM, 10/22/94.

179 "We all have": NCW to HZW, May 29, 1908, n.p.

Carol had to remind: See NCW to HZW, June 20, 1908.

"The fact was": NCW to SMC, Mar. 4, 1909, n.p.

"had planned": CWA to NCW, Jan. 23, 1909, CWA Papers, AAA.

"he needs soothing"; "Convers gets": CBW to HZW, Apr. 19, 1910.

"the *hardest* thing": NCW to HZW, Aug. 9, 1907, n.p.

NCW's limerick in NCW to ANWII and HZW, Dec. 22, 1908, n.p.

"so indignant": NCW to HZW, July 16, 1909, n.p.

"How often": NCW to ANWII and HZW, Aug. 13, 1915.

180 "compatriot": NCW to HZW, Aug. 28, 1914, n p

both taken painting as high calling: Walt Reed to DTM, 1/13/93.

"enthusiastic autoist": Wilmington *Star,* Oct. 31, 1909.

"take away his edge": AW to DTM, 2/3/94.

"Convers wasn't the sort": NBS to DTM, 11/29/93.

"He wanted to do": CBW to HZW, June 15, 1908.

"Wyeth sent word": Recollection of George Harding as told by ATT to Richard Wayne Lykes, July 14, 1947, Lykes File, HP Papers, DAM.

181 "My, Convers gets": CBW to HZW, June 15, 1908.

Dunns lost a child: I am inferring from evidence in Harvey Dunn to NCW, Apr. 12, 1909, WFA.

"one of those": NCW to NW, Oct. 19, 1908.

"my Needham and Concord": NCW to HZW, Oct. 29, 1914, n.p. This describes in general terms the same condition as on Oct. 19, 1908.

"fly to Concord": NCW to HZW and ANWII, Oct. 27, 1911.

"suddenly transplanted": NCW to SW, Sept. 1, 1909.

"Oh! sometimes": NCW to SW, Feb. 11, 1909, n.p.

181 *"Never"*: NCW to HZW, Oct. 22, 1909.
"the river": NCW to SW, Feb. 11, 1909.
"I must stop": NCW to HZW, Oct. 22, 1909.

182 "I can't fathom": NCW to SW, June 11, 1909, n.p.
nightly custom; "not be long": NCW to HZW, May 6, 1915.
"mental projection": NCW to HZW, Oct. 5, 1919.
"only to stand": NCW to HZW and ANWII, Sept. 12, 1913, n.p.
"God damn it": NCW to SW, Feb. 11, 1909.
"go too long": NCW to SW, Sept. 1, 1909.
"real mark": NCW to HWH and PH, Aug. 27, 1939.
"If I could": NCW to HZW and ANWII, July 4, 1910.

183 "the true realms"; "the eternal": NCW to HZW, July 16, 1911.
anything he had learned: See NCW to HZW, Aug. 7, 1909: "There is no swapping
back again if I should have to die for it."
"There are no": NCW to NW, Oct. 19, 1908.

184 "bully": CWA to NCW, Jan. n.d., 1909, CWA Papers, AAA. Chapin quoted by
NCW to HZW, Nov. 13, 1908.
"perhaps the pictures": Ibid.

185 "meddled": NCW to SMC, Apr. 15, 1914.
"I want to avoid": NCW to CBW, July 22, 1910, n.p. For a contemporary reading
of Mary Johnston's two Civil War novels, I am indebted to George Garrett. See
Garrett's foreword to *The Long Roll* (Baltimore: Johns Hopkins University Press,
1996).
"breath of life": Johnston, *The Long Roll,* viii, "To the Reader."
"luminous": W. S. Scudder quoted by NCW to HZW, Oct. 19, 1910. For HM Co.
advertising campaign see also NCW to HZW and ANWII, June 2, 1911, n.p.
"will show me": NCW to HZW, Nov. 2, 1910.
"a sensation": W. S. Scudder quoted by NCW to HZW, Oct. 19, 1910.
"*You* know": NCW to HZW and ANWII, June 2, 1911, n.p.
"hideous caricature": Mary Anna Jackson, "Mrs. 'Stonewall' Jackson Denounces 'The
Long Roll,' " *New York Times Magazine,* Oct. 29, 1911. See also Cella, 68–69.
"I get the heave": NCW to HZW and ANWII, June 2, 1911, n.p.
common complaint: Walt Reed to DTM, 1/11/93: "Almost every illustrator had the
same complaint. It wasn't possible to reproduce the original perfectly."

186 "I would work": ATT quoted in Denver *Times,* Nov. 26, 1915.
"All that I have done": NCW to ANWII, Feb. 20, 1909.
a plan: Ibid.
"prevent my ever": NCW to ANWII, Feb. 20, 1909, n.p.
"You seem to put": ANWII to NCW, Mar. 4, 1909.
"the one to give": Ibid.
"*practical* ideals": NCW to ANWII, July 30, 1906.
"I have *always*": NCW to ANWII, Feb. 20, 1909.

187 "There's just this": NCW to HZW, Feb. 28, 1909, n.p.
"the first": NCW to HZW, May 20, 1909, n.p.
regained: see NCW to HZW, June 4, 1909, n.p.
"Strange": NCW to ATT, June n.d., 1910, n.p., HP Papers, DAM.
"he alone": Doyle, "Coming of the Huns," 552.

188 "If ever I": NCW to HZW, Aug. 7, 1909.

189 "It was impossible": HZW to NCW, Sept. 7, 1909: HZW omitted the dollar sign and zeroes, calling the gift "15." I infer $15, rather than the unlikely $1,500.

"practical, but not": NCW to ANWII, Sept. 6, 1909.

birth of Carolyn Wyeth: See CBW, Family Record Book, WFA.

lonelier: NCW to SMC, Mar. 4, 1909, n.p.

strain became severe: NCW to CBW, c/o George Bockius, Esq., 1513 Delaware Ave., Wilmington, Del., Apr. 4, 1910, n.p.: "Two minds, whose sympathies are so closely united and tuned so delicately, so sensitively, are bound to reach a tension that becomes a severe strain . . . and so I feel it is the case with us."

"call on": NCW to HZW, Apr. 5, 1910, n.p.

"Monday night/Dear Carolyn": NCW to CBW, Apr. 4, 1910, n.p.

separation lasted until Friday: See NCW to CBW, Apr. 6, 1910, n.p.; see also NCW to HZW, Apr. 10, 1910, n.p.

190 "not three feet": NCW to HZW, July 11, 1910.

"the shudders": NCW to HZW, July 11, 1910, cont. July 14, 1910.

"manage it well": NCW to ANWII, Oct. 13, 1910.

"recovering slowly": NCW to SMC, Nov. 9, 1910, n.p.

"My attachment": NCW to SMC, Feb. 7, 1911.

"My feelings": NCW to CBW, July 21, 1910, n.p.

191 "a peculiar": NCW to SW, Aug. 16, 1908.

"because H.P."; "It is"; "my color": NCW to HZW, Sept. 25, 1908.

PART THREE : *Chadds Ford/Needham, 1911–1929*

Treasure

195 Purchase of land: See NCW ledger, WFA: "Paid Charles Davis on account for Rocky Hill property $1000.00." Mortgage records in the Office for Recording Deeds in and for Delaware County, Pa., mortgage book no. 12, page 190.

"most glorious": NCW to HZW and ANWII, Mar. 7, 1911.

"It's a happy": NCW to ANWII, Jan. 31, 1904, n.p.

"I'm totally satisfied": NCW to HZW and ANWII, Mar. 7, 1911.

rainy afternoon; began with a map: Stevenson, "My First Book: 'Treasure Island,'" *Selected Essays*, 122.

196 "If things had gone": James, "Robert Louis Stevenson."

"repeat itself": Stevenson, *Essays*, 220.

"succession": Stevenson, *Selected Essays*, 120.

"pedestrian": Stevenson, *Essays*, 229.

"The map was": Stevenson, *Selected Essays*, 127.

"*boiling over*": NCW to HZW, Mar. 30, 1911.

"first mark": Notation on canvas, preliminary study, initialed "NCW," collection of JBW. This would become the leading pirate figure in the *Treasure Island* endpapers.

construction contracts: WFA.

"The gods": NCW to SMC, Mar. 6, 1911.

"My conceptions": NCW to HZW, June 16, 1911.

198 deadline for dummy: See NCW to HZW and ANWII, Apr. 17, 1911.

nine hours: see NCW to ERW, June 12, 1911.

198 "culminating": Stevenson, *Essays,* 225.

"This is the highest": Ibid.

"arrest the eye": James, "Robert Louis Stevenson," 869.

"should narrate": Carpenter, 323. Stevenson's four-page essay on the first illustrated edition of *Treasure Island* (Cassell & Co., 1885) by the French illustrator and painter George Roux remained in ms. until 1982.

"Hawkins leaves": From the flyleaf of NCW's working copy of *Treasure Island,* with original illustrations by Walter Paget (New York: Charles Scribner's Sons, 1909), WFA.

"goodbye to mother"; "attack of tears": Stevenson, *Treasure Island,* 57.

199 "very little company": Stevenson, *Treasure Island,* 4.

"supreme moment": HP quoted in "Notes from Howard Pyle's Monday Night Lectures, June–November 1904," HP Papers, DAM: "In painting we can only picture the supreme moment, leaving to the imagination what precedes and follows."

"To put figures": HP commenting on NCW's *Pony Race and Indians,* quoted in "Notes from Howard Pyle's Monday Night Lectures, June–November 1904," HP Papers, DAM.

"One more step": Stevenson, *Treasure Island,* 204.

201 "sight seen": NCW to ANWII, Dec. 31, 1927, n.p.

"sees, hears": Ibid.

"the curtains": NCW to HZW, Jan. 17, 1910, n.p.

"it is easy": NCW to HZW and ANWII, Dec. 22, 1923.

202 his "shrine": NCW to SW, Oct. 17, 1913.

"I'd have given": NCW to HZW, Oct. 23, 1908, n.p.

"treasure-words": NCW to ANWII, Feb. 21, 1909, n.p.: "Mama's letter Saturday brought those 'treasure-words.' "

"hidden treasures": NCW to HZW, Oct. 23, 1908.

"treasurable incidents": NCW to SW, Oct. 31, 1911, n.p.

"that treasure in you": NCW to HZW, Mar. 25, 1909, n.p.

"*treasure house*": NCW to HZW, Mar. 15, 1918, n.p.

"cruel, and cold": Stevenson, *Treasure Island,* 24.

"nearly smothered"; "dared not"; "mystery": NCW to ERW, Sept. 13, 1911.

204 Based on Stevenson's broken friendship: See Alexander, 25.

no longer felt free: See NCW to HZW, June 6, 1911, n.p. *Ben Gunn,* the portrait of the islanded hermit, is an equally natural picture for an artist whose ambivalence about owning property convinced him that he had "lost that sense of merely existing in a beautiful country, floating about like a wild animal, making my home wherever I find soft ground to dig a hole."

"They treat me": Ibid.

"blond face": Stevenson, *Treasure Island,* 106.

"no common man": Ibid., 76.

"smart as paint": Ibid.

"beaming"; "deadly look": Ibid., 233, 257.

"changed man": Ibid., 238.

"the picter": Ibid., 216.

205 "playing double": Ibid., 236–37.

"You're young"; "addressing another": Ibid., 81.

PICTURES GREAT: JHC telegram quoted by CBW to SW, June 17, 1911.

206 "almost as big": NCW to HZW, July 26, 1911.

"miserable smudges"; "corkers": NCW to HZW and ANWII, June 2, 1911.

"sometimes": JHC to NCW, Aug. 9, 1911, WFA.

$7,750: See NCW's loan indentures, dated July 14, 1911, and May 18, 1912, WFA.

Ground broken: See NCW to HZW, May 12, 1911, n.p.

flipped a coin: Recollection of N as told by ANW to DTM, letter, 2/22/95. See also NCW to HZW, May 26, 1911.

"men": CBW quoted by NCW to HZW, Dec. 8, 1911, n.p.

"I am writing": NCW to HZW and ANWII, June 23, 1911.

"actually look": NCW to HZW, July 16, 1911.

207 layout of Homestead: See NCW drawing, WFA.

"positively ideal": NCW to HZW and ANWII, Oct. 27, 1911.

"I feel myself": NCW to SW, June 1, 1911, n.p.

Carol remarked: See NCW to ERW, June 12, 1911, n.p.

"Work": NCW to HZW and ANWII, June 2, 1911, n.p.

"Glorious machine"; "dragged me"; "the week": NCW to HZW and ANWII, June 23, 1911.

"four huge pictures": NCW to HZW et al., Apr. 17, 1911.

"a rather unusual": NCW to HZW, July 7, 1911.

208 "Treasure Island completed": NCW to HZW, July 26, 1911.

could make CBW blush: BJW to DTM, 2/4/94.

"Really". CBW to HZW, Sept. 12, 1911.

"I am feeling"; "and quietly sobbing"; "for not being able": NCW to SW, Sept. n.d., 1911.

"deficiencies": See NCW to ANWII, Feb. 24, 1911, n.p.

209 "the subtle things": NCW to HZW, July 12, 1907, n.p.

hated school, viewed her mother: See CBW quoted in *New York Times*, June 1, 1972, 52. Confirmed by NBS to DTM, 11/29/93.

a compliant fiancée: See CBW letters, Sept.–Oct. 1904.

"the Gilbert and Sullivan": Recollection of N as told by ANW to DTM, letter, 2/22/95. See also NCW to HZW and ANWII, Mar. 25, 1910; NCW to HZW, Sept. 17, 1910.

"Her mind": NCW to HZW and ANWII, June 8, 1913, n.p.

"She established": NBS to DTM, 11/29/93.

"spiritual aid": NCW to SW, Sept. n.d., 1911.

"emerged feeling": Ibid.

"lack of": NCW to HZW, Mar. 1, 1912, n.p.

"all so beyond": NCW to SW, Feb. 11, 1909, n.p.

"I have my": NCW to HZW, Mar. 13, 1912.

210 "a very attractive": *New York Times,* Oct. 22, 1911, 647.

"More genuinely": Boston *Transcript,* Nov. n.d., 1939; review of NCW retrospective at the School of Fine Arts and Crafts, WFA, Oval Office scrapbooks.

211 *Treasure Island* first printing: 10,050 copies. For rate of sale, see Charles Scribner's Sons Manufacturing Records, 1902–1955, SA. See also NCW to HZW and ANWII, Nov. 14, 1911: "It has sold phenomenally."

landmark: see Silvey, 696.

211 cottage industry; outsold Pyle, etc.: See Scribner's Manufacturing Records, 1902–1955, SA.

212 "Most of the books": Maxwell Perkins to Marjorie Kinnan Rawlings, Aug. 22, 1940, SA, Manuscripts Division, Dept. of Rare Books & Special Collections, Princeton University Library, Published with permission of the Princeton University Library.
birth of N: See CBW, Family Record Book, WFA.
exchange of telegrams: See NCW to HZW and ANWII, Oct. 27, 1911.

Alan Breck

213 newspaperman: See NCW to HZW and ANWII, Nov. 14, 1911.
Appalled: NCW to SMC, May 31, 1912.
"Nothing ever": Ibid.
"whether it was": Stevenson, *Kidnapped,* 107.

214 Sousa-like elegy: See text of statement in NCW to SMC, May 31, 1912.
"has risen": NCW to HZW and ANWII, Nov. 14, 1911.
"only temporary": Ibid.
unworthy: See NCW to a Mrs. Abbott of the Contemporary Club, Jan. 23, 1912, n.p.
"my main theme": NCW to HZW, Feb. 14, 1912, n.p.
size 20 collars: Wilmington *Star,* Jan. 6, 1946.
"a table for": Wilmington *Evening Journal,* Oct. 12, 1968, 21.
if he were lighter: NCW to SW, Oct. 1, 1911, n.p.: "I feel so often that I could think better, and accomplish more, were I less heavy."
"But I do eat": NCW to HZW, May 15, 1914.
blacksmith: See Stephen Etnier interview, transcript, p. 15, Feb. 22, 1973, Oral History Program, Stephen Morgan Etnier Papers, 1915–, AAA.
"shrink around": *Boston Sunday Post,* Nov. 27, 1921, F1.
"more like": Ibid.
place of honor; "epic": Quoted by NCW to HZW, Nov. 15, 1912, n.p.

215 "simply splendid": *New York Times Book Review,* Dec. 1, 1912, 704.
"I know so": NCW to HZW, Mar. 13, 1912, n.p.
"as though": NCW to SMC, May 31, 1912.
appointed himself: See NCW to SMC, May 31, 1912, n.p.
"lash": NCW to SW, Sept. 25, 1912, n.p.
"choked": NCW to HZW, Mar. 13, 1912.
"It is hopeless": NCW to SW, Sept. 25, 1912, n.p.
"people": Ibid.
"under false": Ibid.

216 "It took days": NCW to SW, Jan. 8, 1914, n.p.
"an air of novelty": NCW to SMC, Sept. 22, 1915, n.p.
attracted invitations: Ibid.
"No illustration": NCW to HZW, June 27, 1914, n.p. The prospective buyer was a Mr. Bolles of Harvard, perhaps related to Frank Bolles (1856–1894), secretary of Harvard University under President Charles W. Eliot. NCW had once overheard Eliot's harsh judgments about art (see NCW to HZW, Jan. 18, 1909), and Eliot's presence as a powerful, forbidding figure in NCW's father's childhood in Cambridge (ANWII sat Sundays in a church pew that quarter-faced President Eliot's pew, though, as NCW once noted, even after all those years, "they reached only a nodding acquain-

tance") might offer clues to NCW's sense of shame and fraudulence about selling his illustration "as if it were a painting."

landscape would make him: NCW to SMC, May 31, 1912, n.p.: "Landscape still holds my most serious attention."

"nothing to stand": NCW to SW, Sept. 25, 1912, n.p.

"I deeply": NCW to SW, May 20, 1912, n.p.

proudly listed: See NCW to HZW, Mar. 13, 1912.

"knock": Ibid.

"Unless I outclass": NCW to JHC, n.d. 1913, SA.

"almost too adequate": NCW to HZW, Nov. 15, 1912, n.p.

"When I walk": NCW to HZW, Mar. 4, 1910.

217 "I have thoroughly": NCW to JHC, July 19, 1920, SA.

"Now that": NCW to SW, Aug. n.d., 1920, n.p.

"sick of it all": NCW to SW, Sept. 25, 1912, n.p.

"There has been": NCW to HZW, Oct. 15, 1912.

"I want to start": NCW to SW, Sept. 25, 1912, n.p.

"her powers": NCW to HZW, Mar. 13, 1912.

"forms indelible": NCW to HZW, Oct. 28, 1915.

"big noise": NCW to HZW, Sept. 19, 1913.

"pounds through"; "as broad": NCW to HZW and ANWII, Apr. 12, 1913.

until her clothes shredded: CBW to HZW, Oct. 1, 1915.

218 "Napoleonic frown": NCW to HZW and ANWII, Apr. 12, 1913.

"astonishingly alert": NCW to HZW, Sept. 19, 1913.

than he had been: NCW to HZW, Mar. 13, 1912.

his salvation: See NCW to SW, Sept. 25, 1912, n.p.

"all broke up": CW quoted by HZW to NCW, Mar. 28, 1913.

"merged into": NCW to HZW, Apr. 7, 1913, n.p.

"fell back": HZW to NCW, Mar. 28, 1913.

"It is reported": Clipping, June n.d., 1909, NFPLA.

"literary career": Needham High School *Advocate*, 1910.

Stimson's letters: See NCW to SW, Oct. 24, 1914.

"Not a day": NCW to SW, June 28, 1914.

"by the river": NCW to SW, Oct. 24, 1914.

"intimate": NCW to SMC, Oct. 30, 1912, n.p.

219 One night: See NCW to HZW, May 15, 1914.

SW entrance examinations: HUA.

"My baby": HZW to NCW, Oct. 27, 1909.

220 "magnetically connected": HZW to NCW, Jan. 12, 1906.

no mind of his own: See Lasch, 173.

"just tide"; "It's matter": HZW to NCW, Oct. 27, 1909.

SW college academic record: HUA.

no literary mark: HUA show no evidence of SW as either author or staffer in the *Harvard Advocate*, vol. 88, no. 1, Oct. 5, 1909–vol. 105, no. 10, June 19, 1913. No record of SW joining the college literary society, the Signet.

221 "His life": NCW to HZW and ANWII, Oct. 18, 1918.

"meant": NCW to HZW and ANWII, Apr. 10, 1906, n.p.

"Congratulations!": ERW to NCW, Apr. 8, 1906, WFA.

"I read more": NCW to NW, Dec. 14, 1903.

221 "I have always": NCW to HZW, Apr. 8, 1907.
 "The automobile's": NCW to HZW, Dec. 1, 1908, n.p.
 "on the highest": NCW to HZW, July 23, 1905.
 "all closed up": NCW to HZW, Jan. 11, 1918, n.p.
 "the flow": NCW to HZW, July 5, 1918, n.p.
222 "exasperating": NCW to HZW, Jan. 11, 1918, n.p. Bitterly, NCW would conclude that SW was either lazy or unable to concentrate. See also NCW to SW, June 22, 1915.
 "read between": NCW to SW, Jan. 18, 1915.
 "important occasion": NCW to HZW, Apr. 7, 1913, n.p.
 "get over": ANWII to NCW, Aug. 29, 1906.
 "Do you ever": NCW to HZW, Apr. 7, 1913.
 high hopes: See NCW to JHC, n.d. 1913, SA.
223 "the rude disorder": Stevenson, *Memories and Portraits,* 129.
 "man of duty": Bell, 180.
 "There has been": NCW to SW, May 26, 1913.
224 "wanted to be": BJW to DTM, 12/15/93.
 "a great taste": Stevenson, *Kidnapped,* 107.
 "somewhat more"; "never": Ibid., 189.
 "chief spring": Ibid., 283.
 HPSA buttons: See NCW to HZW, Nov. 6, 1902; NCW to HZW, Mar. 9, 1903.
 "the friends": Stevenson, *Kidnapped,* 92.
 "big-hearted": NCW to SW, May 26, 1913.
 twelve inches taller: *Kidnapped,* 231. See also 236: "They were neither of them big men."
 "ordinary": NCW to HZW, Mar. 4, 1910.
225 "Those folds": NCW quoted by CW in Meryman, "A Wyeth Comes out of Hiding," 20.
 "Everyone seems": NCW to HZW, Mar. 13, 1912, n.p.
 "How I would": NCW to HZW and ANWII, June 8, 1913.
 "in whom": NCW to SW, Dec. 8, 1913.
 "sympathizer": NCW to SW, Oct. 1, 1911.
 "appealed": NCW to HZW, Oct. 14, 1907, n.p.
 "inspiring"; "besliming": See NCW to SW, Oct. 3, 1917.
 "How seldom": NCW to SW, Jan. 24, 1919, n.p.
226 "the search": NCW to HZW, Jan. 11, 1918, n.p.
 "*Chapin*": NCW to JHC, n.d. 1913, SA, Manuscripts Division, Dept. of Rare Books & Special Collections, Princeton University Library. Published with permission of the Princeton University Library.
 "never hiding": Burlingame, 241.
 "a sort of communion": NCW to SW, Nov. 19, 1914, n.p.
 "I'm not crazy": NCW to SW, Sept. 25, 1912, n.p.
 "my springhead": NCW to HZW, Dec. 10, 1914.
227 "the present": NCW to SW, Oct. 17, 1913.
 "feel his approval": NCW to SW, Sept. 25, 1912, n.p.
 "a big sane": NCW to SW, Mar. 26, 1912, n.p.
 "I am no more": NCW to SW, Sept. 25, 1912, n.p.
 "It is very": Rev. J. Adams Puffer quoted by NCW to SW, May 11, 1912, n.p.

"You and I": NCW to SW, Mar. 26, 1912, n.p.

"a sympathetic": NCW to HZW, Mar. 13, 1912.

"some man": NCW to SW, Sept. n.d., 1911.

details of TR meeting: See NCW to HZW and ANWII, Sept. 1, 1913.

228 "broad, virile": NCW to HZW, June n.d., 1916, n.p.

"the nude-": NCW to SMC, Apr. 19, 1916.

229 "tide over": NCW to HZW, July 25, 1913, n.p.

"Everything": SW to NCW, Sept. 21, 1913.

"very distasteful": See SW in Harvard College, *Class of 1913, Secretary's Third Report,* HUA.

"I would wonder": HZW to NCW, Sept. 26, 1913.

"Of course": ANWII to NCW, Sept. 26, 1913.

Stimson concluded: SW to NCW, Sept. 21, 1913.

"I am glad": NCW to SW, Dec. 8, 1913.

"breathe": SW to NCW, Sept. 21, 1913.

"a leave": NCW to HZW and ANWII, Dec. 20, 1913, n.p.

"Where would you": Augustus Zirngiebel to NCW, Feb. 27, 1908. Uncle Gig predicted that if the Wyeth boys remained on South Street, they "never would get anywhere around Boston" because Boston was a "damn slow place."

The Skies of Chadds Ford

230 Three publishers: Hearst, Doubleday Page, Century. See NCW to HZW, Sept. 20, 1914.

"our third dog": NCW to HZW and ANWII, Sept. 12, 1913, n.p.

the real story: NCW to HZW, Nov. 15, 1912, n.p.

"I want to retrench": NCW to HZW, Apr. 25, 1914.

231 "When I think": Ibid.

Hearst offered: See NCW to HZW, Sept. 20, 1914; NCW to HZW, Sept. 28, 1914, n.p.; NCW to SMC, Oct. 1, 1914.

"no particular direction". See NCW to HZW, Apr. 21 and Apr. 24, 1914, n.p.

"repertoire": NCW to SW, Sept. 30, 1914.

"Flying cavalry": NCW to SMC, Oct. 1, 1914.

"My responsibilities": NCW to HZW, Sept. 20, 1914, n.p.

232 Hearst would double: NCW to HZW, Sept. 20, 1914, n.p.: "The sum offered, they claim, will cover my present earning capacity twice if necessary."

"a jump": NCW to HZW, Mar. 31, 1915.

"dispel": NCW to HZW, Sept. 20, 1914, n.p.

"bigger tax": NCW to SW, Sept. 30, 1914.

"dear little kids": NCW to HZW, Sept. 28, 1914, n.p.

"I can't": NCW to SMC, Apr. 15, 1914.

"yet emerged": NCW to SW, Oct. 3, 1917.

"commonplace": NCW to SW, Feb. n.d., 1913, n.p.: "My efforts were called *commonplace*—a truly terrible verdict!"

233 Indiana-born James Baldwin: See Randall, 2.

Christian Brinton was married for a short time to CBW's cousin the artist Caroline Peart. See Brinton Papers, AAA.

"I don't want": NCW to HZW, Sept. 13, 1915.

233 "skied": NCW to SW, May 30, 1913.
"how fortunate": Ibid.
"conspicuously *skied*": NCW to ANWII, Mar. 18, 1916, n.p.
banquet scene: *"However, after six days o' restin' up, with salubrious fruits an' wines an'
the most melojus concerts, my capt'm broaches the cause of why we're callin' on the Don
Hidalgo Rodreego Cazamma"* illustrated James B. Connolly's "Medicine Ship," 657.

234 "a serious worker": NCW to ANWII, Mar. 18, 1916, n.p.
"With all": NCW to HZW, Apr. 21 and Apr. 24, 1914, n.p.
"gray, thundering": NCW to HZW, Aug. 11, 1916.
HWH quoted on *The Wyeths: A Father and His Family* (Smithsonian World). See
also HWH to DTM, 10/24/94; ACHR to DTM, 10/23/94.
Birth of Ann: See CBW, Family Record Book, WFA: Anne Wyeth [with an *e*], born
Monday, 2.25 a.m., March 15, 1915.
Ann's appearance as newborn: See CBW to HZW, Oct. 1, 1915.
the most attractive: NCW to HZW, Aug. 18, 1916.
most interesting: NCW to SW, June 22, 1915.
carried Carol: See NCW to HZW, Mar. 31, 1915.
"carried everyone": NBS to DTM, 11/29/93.
"patriarch and matriarch": ACHR to DTM, 10/23/94.

235 GB wrote from London: See GB to CBW and Esther Bockius, Jan. 31, 1915, WFA.
"little house": NBS, memoir, 27.
Evidence of NCW's disgust with the Bockiuses is found both in his unpublished let-
ters and in unpublished passages of his letters to his mother. See NCW to HZW,
Mar. 25, 1909; Mar. 1, Mar. 13, and Mar. 29, 1912; July 14 and July 25, 1913; Aug. 27, 1913;
Sept. 26, 1913; May 30, 1918.
"I can't see": NCW to SW, Dec. 8, 1913.
"healthier, stronger": NCW to HZW, May 19, 1917.
N.C. thought: See NCW to HZW, May 3, 1917.
stand in for Lincoln: See Wilmington *Evening Journal*, Oct. 12, 1968.
"beautiful as stars": Creswick, 117.
"seemed like a star": ABB to CBW, Mar. 24, 1919, WFA.
"terrific conditions": NCW to HZW, May 24, 1917.
"My family": NCW to CBW, May 24, 1916, n.p.
"enjoy so many more": NCW to HZW, Aug. 7, 1913, n.p.
"no one realizes": NCW to HZW, Sept. 19, 1913, n.p.

236 For the account of NCW's teaching of Clark Fay, Pitt Fitzgerald, Dwight Howland,
Leo Mack, and, later, Owen Stephens, I have relied, in part, on an eyewitness, Nancy
Bockius Scott, who was then living at the Wyeth Homestead. See NBS to DTM,
11/29/93.
For biographical, personal, and descriptive information about Pitt L. Fitzgerald, see
Fitzgerald's letter of enlistment to the War Department, Office of the Chief of Engi-
neers, Washington, D.C., July 30, 1917. NARA, Records of the Office of the Chief of
Engineers; General Correspondence, 1894–1923, box 2637, no. 113024, part 1.
"an incorporate part"; "their hands": NCW to ANWII and HZW, Sept. 25, 1916.
"the Transmitter": NCW to HZW, Apr. 14, 1912, n.p.
"enthusiast, anarchist": NCW to HZW, Sept. 19, 1913.
"this absolutely cherubic": HWH, SWT, 42.

First evidence of the name Nat for NCW Jr. appears in an unpublished letter, NCW to HZW, Aug. 13, 1917: "Andrew and *Nat* doing finely."

"such an astonishing": NCW to HZW, Aug. 21, 1917, n.p.

"my unquestionable": NCW to HZW and ANWII, Aug. 13, 1915.

237 "She interests me": NCW to HZW, Apr. 21, 1916.

Bloodroot episode: See NCW to HZW, Apr. 14, 1912, n.p.

238 "Memories": NCW to HZW, Oct. 9, 1916.

wrapping paper: See Meryman, *Andrew Wyeth: First Impressions,* 25. See also Hoving, *Andrew Wyeth: Autobiography,* 133.

astounded at draftsmanship: See NCW to HZW, Mar. 13, 1912.

239 "a collection": NCW to HZW, Dec. 5, 1919, n.p.

"night art school": NCW to HZW, Oct. 11, 1920.

"the source": NCW to HZW and ANWII, Dec. 21, 1918.

"the beautiful illusion": NCW to SMC, Dec. 17, 1914.

rigged up a dummy: Recollection of N as told by ANW to DTM, letter, 2/22/95.

240 skies over Chadds Ford: I am indebted to Andrew Wyeth for this observation; AW to DTM, 2/1/94. See also AW, "N.C. Wyeth," in *American Vision,* 82.

"adequate distances": Dorothy Canfield quoted by NCW to HZW, Mar. 13, 1912.

"If she only knew": Ibid.

"If it wasn't": NCW to HZW, July 15, 1921.

every Saturday: See John Clymer, part-time student of NCW, in Nelson, *Masters of Western Art.*

"just to prove that I can": NCW quoted by Straley, *County Lines,* typescript, p. 4.

241 "strong bent": Robert Frost to NCW, Mar. 18, 1917, WFA. Used by permission of the Estate of Robert Frost.

"dead-mule barricades": See Col. William F. Cody, "The Great West That Was," *Hearst's,* Sept. 30, 1916, 197: "Behind Simpson's dead-mule barricades we made ready for attack from the circling redskins."

243 acoustics of memory: Cowbells, see NCW to HWH, June 26, 1937; South Street trees, see NCW to ERW, Sept. 13, 1911; slam of screen door, chain on front gate, Uncle Denys's footsteps, see NCW to HZW, Dec. 28, 1915.

"a Switzerland": Verne, *Mysterious Island,* 48.

244 "in the light and air": NCW to FES, n.d. c. Jan. 1918, Schoonover Papers, folder 19, box 15, DAM.

"Whatever isn't contemporary": Ibid.

N.C. on Fitzgerald's behalf: See NCW to Chief of Engineers, War Department, Nov. 27, 1917, NARA, Records of the Office of the Chief of Engineers, General Correspondence, 1894–1923, box 2642, no. 113024, pt. 30. For records of the camouflage company organized in August 1917 by the Corps of Engineers, see boxes 2637–44, pts. 1–50.

"disturbed me": NCW to HZW, Sept. 21, 1917.

"Mothers": HZW to NCW, Apr. 27, 1917.

"a depressed spring": Ibid.

"the terrible conditions": May Zirngiebel to HZW, postcard, Apr. 1917, WFA.

246 "You speak of": NCW to HZW, Apr. 16, 1917, n.p.

"things remote": NCW to SMC, Dec. 3, 1907.

"passive state": NCW to HZW, May 3, 1917.

246 "I'll be glad": Ibid.
NCW boyhood drawings: WFA.
dollar a day: See Galbraith, 25.
"I see no reason": NCW to SW, July 13, 1917, n.p.
247 "Told them": NCW to SMC, Aug. 21, 1917.
Birth of Andrew Newell Wyeth III: See CBW, Family Record Book, with BJW
annotations, WFA.
248 "gentle sweet": ABB to CBW, Aug. 11, 1922: "I always think of [AW] as a little for-
get-me-not. His gentle sweet nature looking out at the big world through his sky
blue eyes—truly cerulean of the sweetest quality."
"like Papa": NCW to HZW, July n.d., 1917, n.p.
"Few babies": NCW to HZW and ANWII, Sept. 1, 1913.

Teutonic

249 The artists called by the War Department were NCW, Harvey Dunn, George Hand
Wright, J. Andre Smith. See NARA, Records of the Office of the Chief of Engi-
neers, General Correspondence, 1894–1923; box 2662, no. 113949: Capt. Ayman
Embury memo to Gen. Black, Dec. 11, 1917, proposes to send NCW, with the rank of
captain, for historical sketching abroad. See also General Black's memo to army chief
of staff, Dec. 12, 1917.
NCW received communication from W. M. Black, Major General, Chief of Engi-
neers, War Department, Washington, D.C., by Jan. 28, 1918. See NCW to ANWII,
Jan. 31, 1918, n.p.
"this glorious valley": NCW to ANWII and HZW, Feb. 8, 1918, n.p.: "I sent in my
definite refusal to serve as a captain this week, with provisions appended, however,
which gives them a way to send me."
seemed foolish: See NCW to ANWII, Jan. 31, 1918, n.p.
"a way to send me": Ibid.
"They ask": Ibid.
"real torture": NCW to ANWII and HZW, Feb. 8, 1918, n.p.
"immensity of things": NCW to SMC, Apr. 22, 1918.
250 tremendous relief: See NCW to ANWII and HZW, Feb. 8, 1918, n.p.
"provisions": Ibid.
pencil sketch of 1896: Collection of Paul Davis, West Chester, Pa.; see also Allen and
Allen, 22. The cap would reappear in a headpiece illustration, *Portrait of a Lumber-
jack,* for Stewart Edward White's "The Brace-Game," *Saturday Evening Post,* Dec.
14, 1907, 10.
"power to see": NCW to HZW, Feb. 22, 1918.
251 "the shock and loss": Harvey Dunn quoted by Tepper, 2.
public speaking: See NCW to HZW, Jan. 12, 1921.
"once he started": AWMcC to DTM, 12/15/93.
"slightest"; "cursed": NCW to HZW, May 22, 1918, n.p.
Fairbanks and Chaplin at third Liberty Bond rally: See Brownlow, *Hollywood,* 84–85.
Photograph on page 85 shows NCW standing on platform behind Chaplin.
252 "reeling": NCW to HZW, Apr. 11, 1918, n.p. See also *New York Times,* Apr. 7, 1918, 1.
"most terrifying": NCW to SMC, Apr. 22, 1918.
"blue streaks": NCW to ATT, n.d., c. June 1910, n.p., HP Papers, DAM.

"very piers": NCW to ANWII and HZW, Sept. 25, 1916.

leave the house: See NCW to HZW and ANWII, Dec. 21, 1918.

" 'Oh, heavens' ": HWH to DTM, 10/24/94.

exploded: NCW to HZW, Feb. 5 1917, n.p.: A Needham neighbor, Paul Franklin, remarked that when it came to the health of their children, NCW and CBW "made mountains out of ant heaps." NCW dealt Franklin a severe tongue-lashing, which he afterward regretted: "I wish I could restrain myself in such cases. But his lack of comprehension of the subtler feelings that exist in family life exasperates me beyond control."

"ugly drunken": NCW to HZW, Sept. 13, 1915.

"never hurt"; "Going under": NBS to DTM, 11/29/93.

253 "being very naturally": NCW to HZW and ANWII, May 30, 1918.

"Carol led": NBS to DTM, 11/29/93. See also CBW to HZW, June 14, 1918: "When you were down last fall I am afraid I was pretty tense at times, I have to get control of myself, when one has a family there are so many things to think of and do."

blamed herself for children's illnesses: See NCW to CBW, May 24, 1916, n.p.

"No wonder": NCW to HZW and ANWII, Feb. 8, 1918.

"In all her": NCW to HZW, Feb. 22, 1918.

"I've given Carol": NCW to ANWII, Nov. 14, 1919

loved to open and count: recollection of N as told by JKW to DTM, 3/29/94.

"Nothing could be wrong": JDMcC to DTM, 10/31/94.

in six years: See NCW to JHC, Apr. n.d., 1919, SA.

"Our home": NCW to HZW, Oct. 10, 1917.

254 "If I would": HWH, Diary, May 31, 1918.

"those nearest": NCW to HZW, Jan. 11, 1918, n.p.

"contained so much": NCW to HZW, May 22, 1918, n.p.

"No one in the world": Ibid.

"did not want them": NCW to HZW, Mar. 15, 1918, n.p.

"Even now": Ibid.

bombing of London during WWI: See Capt. Joseph Morris, *The German Air Raids on Great Britain, 1914–1918* (London: Sampson Low, Marston, 1925). Morris's sources include official air-raid reports drawn up during the war by the War Office.

255 night air raid of March 7: See Christopher Cole and E. F. Cheesman, *The Air Defence of Britain, 1914–1918* (London: Bodley Head, Putnam, 1984), 404–7.

casualty reports: See John Hook, *They Come! They Come!: The Air Raids on London During the 1914–1918 War* (London: Imperial War Museum Library, 1987), 178–80.

No. 1 Kings Cross Road clear of bombs: See collection of sketch maps, *Plans Showing Position and Nature of Bombs,* which show the fall of bombs dropped by German airships and aircraft within the Metropolitan Police District, London, 1915–1918, Museum Map Collection, Imperial War Museum, London.

"our failing": HZW to ANWII, Dec. 28, 1907.

"Don't be as stupid": HZW to NCW, June 27, 1907.

"this Germany": NCW to HZW, May 3, 1917.

256 "Sometime or other": NCW to HZW and ANWII, Nov. 25, 1917.

"infused": NCW to HZW, Oct. 1, 1915.

"drowse[s] in peace": From text entitled *No. 44, The Mysterious Stranger,* in Gibson, 221.

"a paradise": Ibid., 222.

256 "several possible careers": Kaplan, *Great Short Works of Mark Twain*, 341.

"fleshed duplicates": From text entitled *No. 44, The Mysterious Stranger*, in Gibson, 343.

Holzers: See NCW to HZW, Feb. 17, 1916: "Much of the spirit of the scene I have built upon the spirit of, and memories of, my boyhood in the Holzer family."

257 misgivings about depicting the supernatural: See NCW to ANWII, Mar. 18, 1916, n.p.

"a constant": Giovanni Segantini quoted in exhibition material at Segantini Museum, San Moritz.

"little eaten": HZW to NCW, Mar. 14, 1918.

dreaded to think: See NCW to HZW, Dec. 7, 1917.

On July 2: NCW to "TAG," July 2, 1918, n.p., NARA, Records of the Military Intelligence Division, no. 9960-4702.

army reversed decision: See SW, in Harvard College, *Class of 1913, Secretary's Third Report*.

"Babe will not": NCW to HZW, Dec. 21, 1917, n.p.

258 "may lead me": SW in Harvard College, *Class of 1913, Secretary's Second Report*.

felt "browbeaten": See NCW to SW, Feb. 19, 1914.

"Germanic": NCW to SW, Mar. 19, 1917, n.p.

"dribblings": NCW to SW, June 28, 1914.

"insistent German ways": NCW to HZW, Oct. 28, 1916.

SW in England: See SW in Harvard College *Class of 1913, Secretary's Third Report*.

259 "certainly in for": NCW to HZW, Feb. 22, 1918, n.p.

"I have a boy": HZW to NCW, Mar. 12, 1918.

JDZII's eye injury: See HZW to NCW, Mar. 14, 1918; confirmed by ANW to DTM, 7/11/95; ANW offered N's recollection that a miniature steam engine had blown up in JDZII's face.

"I'm not the strong-minded": HZW to NCW, Mar. 14, 1918.

"most virile thoughts": NCW to HZW, Mar. 15, 1918, n.p.

"filled Grandpapa's place": HZW to NCW, Mar. 18, 1918.

260 "so that one"; "lovable habit": Kinross, 852–61.

SW's overseas card: WFA; see NCW to HZW, Aug. 14, 1918.

Death by Misadventure

261 Both agreed; Carol insisted: See NCW to HZW, Sept. 26, 1918, n.p.

"to meet the demands": NCW to HZW, Sept. 20, 1918.

"eagerness"; "lurched"; "forsaken"; "My art": NCW to ANWII and HZW, Sept. 25, 1916.

262 "had to figure out": WLB to DTM, 5/25/94.

These facts: See NBS, memoir, 17: "These two facts about our grandfather stood us all in good stead in our darkest hours. Anything seemed possible in the face of them." NBS accepts George Bockius II's appointment as fact, as did the other Bockiuses (WLB to DTM, 5/25/94), but George Bockius II's name does not appear in the state papers of James Buchanan: *The Works of James Buchanan*, collected and ed. by John Bassett Moore, vol. 10, *1856–1860* (Philadelphia: J. B. Lippincott Co., 1910).

"He wanted to be": WLB to DTM, 3/27/94.

settling first: Postcards from GB to CBW begin in Warrington, n.d. 1911, WFA.

"to pieces": NCW to SMC, Mar. 25, 1918; see also NCW to HZW, Mar. 15, 1918, n.p.

"Carbon monoxide poisoning from inhalation": See certified copy of an entry of death, given to DTM at the General Register Office, London, June 28, 1994. Note: At St. Catherine's House, Office of Population Censuses and Surveys, records of GB's death are misregistered (vol. 1-b, 62, Mar. 1–Mar. 11, 1918) under the name George Bockins. Between the handwritten death certificate and the typewritten registry entry, the *u* in Bockius was accidentally inverted, becoming the *n* in Bockins.

264 "I dream incessantly": NCW to HZW and ANWII, Apr. 12, 1913.

He assumed: See NCW to HZW, May 8, 1903, n.p.: "I think I can not only support myself but give help at home, then Papa will be able to run a farm and live his ideal life."

"still leaves home": HZW to NCW, Feb. 4, 1911.

"I hope soon": NCW to ANWII, June 26, 1904.

"I wish I could send": NCW to ANWII, Oct. 3, 1912.

"one drawback": NCW to ANWII, Jan. 31, 1904, n.p.

"*enjoy[ed]*": NCW to SW, Nov. 5, 1913.

"shatter the actuality": NCW to ANWII and HZW, Sept. 25, 1916.

"The true artist": NCW quoted in *Boston Sunday Globe Magazine*, Mar. 23, 1923.

265 "outside of Schwartz's": From fragment of JHC's unpublished memoir, SA, Manuscripts Division, Dept. of Rare Books & Special Collections, Princeton University Library. Published with permission of the Princeton University Library.

"absolutely choked": P to DTM, 4/22/93.

Newell refused: See NW to NCW, Mar. 23, 1925; from 920 Santa Anita Ave., Glendale, Calif., WFA.

taxes and loan: See ANWII to NCW, Sept. 29, 1925: In an enclosed note marked "Personal," ANWII asked NCW to help him pay his property tax bill ($193.60). See also Oct. 1, 1925: "Borrowed and Received from Newell Convers Wyeth Thirty-Six Hundred dollars ($3600—) which I promise to pay on demand. Andrew N. Wyeth."

stayed out all night: See NCW to HZW, Sept. 26, 1918, n.p.

"youngers": AWMcC to DTM, 12/15/93.

"My life": NCW to HZW, Apr. 25, 1914.

"decision came": NCW to HZW, Sept. 26, 1918, n.p.: "I stayed out almost all night on Sugar Loaf wrapped in a blanket, trying to come to a decision. . . . As I returned and the house loomed through the morning mist the decision came and in half an hour I had written my answer to N.Y."

"not the Red Cross's fault": NCW to JHC, Sept. 26, 1918, n.p., SA.

"In the last analysis": NCW to HZW, Sept. 26, 1918, n.p.

267 Saint-Gaudens as proof: See NCW to HZW, Jan. 19, 1921.

"We kids": AW to DTM, 12/16/93.

"I tell him": CBW to HZW, Apr. 19, 1910.

"I'm afraid": NCW to CBW, Oct. 15, 1906, n.p.

"it was worth": NCW to HZW and ANWII, June 2, 1911, n.p.

"not as ecstatically happy": NCW to HZW, Nov. 12, 1918, n.p.

Nat Wyeth's service in WWI: GWU to DTM, letter, 3/2/95. NARA has no corresponding records.

268 "I lost": NCW to HZW, Nov. 27, 1918, n.p.

forcing Houghton Mifflin: NCW to SW, Jan. 24, 1919, n.p.

"a calamity": NCW to HZW, Oct. 5, 1919.

268 "The last rags": Dos Passos quoted in Daniel Aaron, "*U.S.A.*," *American Heritage*, July–Aug. 1996, 66.

"America helped": HWH, Diary, Mar. 1919.

"Series of War Paintings": See *Pictorial Review*, Mar. 1919, 20: *Kamerad!*; and *Pictorial Review*, Apr. 1919, 12.

"slowly mending": NCW to SMC, Oct. 25, 1919, n.p.

"the qualifications"; "aggravated": NCW to HZW, Oct. 12, 1919, n.p.

"as upon"; "broken [his] whole faith": Ibid.

269 "I do wonder": NCW to HZW, Dec. 5, 1919, n.p.

SW's rank in July 1918: See NARA, Records of the Military Intelligence Division, no. 9960-4702.

"extraordinary": NCW to SMC, Oct. 25, 1919, n.p.

"in the peculiar state of mind": SW in Harvard College *Class of 1913, Decennial Report.*

"*terrible failures*": NCW to HZW, Sept. 14, 1919.

"very slight": NCW to SMC, Oct. 25, 1919.

cooking his supper: See NCW to JHC, Mar. 7, 1919, n.p., SA.

270 "the appearance": NCW to SMC, Oct. 25, 1919, n.p.

NCW warned book dealers: See NCW to ANWII, Nov. 14, 1919, n.p.

Scribners coasting: See NCW to HZW, Oct. 5, 1919, n.p.: "What worries me as much as the bad results is the calm way Scribner's take it, for they remarked with utmost ease that the book would sell well on the representation of the others—a point of view which hurts to hear from *Charles Scribner's Sons.*"

271 Disposition of NCW's original canvases: See Charles Scribner's Sons art department card file, BRM Library.

highest payment: See NCW to JHC, Apr. 16, 1919, n.p., SA.

"If I worry": NCW to HZW, June 7, 1907, n.p.

"shallowing process": NCW to HZW, Feb. 28, 1918.

"to find all gods dead": Fitzgerald, *This Side of Paradise* (New York: Charles Scribner's Sons, 1920), 304.

"deeper purpose": NCW to JHC, Aug. 19, 1929, SA, Manuscripts Division, Dept. of Rare Books & Special Collections, Princeton University Library. Published with permission of the Princeton University Library.

first had to "find": NCW quoted in E. Watson, 17.

NCW's reaction to *Gulliver's Travels:* See NCW to Maxwell Perkins, June 25, 1929, n.p., SA.

272 "getting the very best": NCW to SW, Nov. 3, 1919.

"*Contracts*": NCW to HZW, Feb. 17, 1916.

"Mr. Wyeth's omission": Julia A. Starkey to R. L. Scaife, Inter-Departmental Memorandum, Art Dept., Riverside Press, Dec. 18, 1918, HMP, shelf mark, bMS Am 1925 (1962). By permission of the Houghton Library, Harvard University.

"a club": NCW to HZW, Dec. 13, 1918, n.p.

felt guilty: See NCW to SW, Nov. 3, 1919, n.p.: "the constant feeling of guilt stealing over me that I might be doing Scribner's a wrong (and yet there is absolutely nothing wrong about it, except that I have crossed their exclusive and selfish use of me)."

"the Cooper plates"; "In no sense"; three concessions: See NCW to JHC, Nov. 11, 1919, n.p., SA, Manuscripts Division, Dept. of Rare Books & Special Collections,

Princeton University Library. Published with permission of the Princeton University Library.

unless guaranteed better results: See NCW to HZW, Oct. 29, 1920, n.p.

273 Scribners' reaction: See NCW to ANWII, Nov. 14, 1919, n.p. See also Charles Scribner's Sons art department card file, BRM Library: With *Westward Ho!* the following notation for the first time appears on the cards for NCW's illustrations: "Painting is the property of the artist."

"take advantage": NCW to HZW, Dec. 5, 1919, n.p. See also Scribners art department card file: $3,500 for *Westward Ho!*, same fee as for *Last of the Mohicans*, and as for *Scottish Chiefs*.

Lillian Gish at the Homestead, Sunday, Jan. 23, 1921: See HW to HZW, Jan. 24, 1921, WFA; NCW to HZW, Jan. 24, 1921, n.p.; AWMcC to DTM, 12/15/93.

"large evening": NCW to ANWII, Jan. 23, 1928, n.p.

"a washing": Recollection of John Biggs, as told by BJW to DTM, 12/15/93; also P to DTM, 4/23/93.

fumes of Limburger: Recollection of N, as told by ANW to DTM, letter, 2/22/95. See also N to Jill Johnson, interview 1, 14.

AW singing "Marseillaise": NCW to HZW and ANWII, Mar. 17, 1919.

274 lesson in modesty: See NCW to ANWII, June 7, 1927. NCW admired Lindbergh's "power to resist commercialization."

"trying to do": NCW to HZW, Feb. 28, 1918.

Hollywood still in debt: See Clarence Brown in Brownlow, *Parade's Gone By . . .* , 161: "Whenever we saw a painting with an interesting lighting effect, we'd copy it. We had a library of pictures. 'Rembrandt couldn't be wrong,' we'd say, and we'd set up the shot and light it like Rembrandt."

"very obviously followed": NCW to HZW and ANWII, Dec. 22, 1920.

bolted the room: See NCW to ANWII, Mar. 24, 1926.

"Verily," "mayhap": See NCW, foreword to *Great Stories of the Sea and Ships*, 5.

276 NCW's racist views: See NCW to HZW, July 19, 1907, n.p.; NCW to CBW, Apr. 5, 1910, n.p.; NCW to CBW, July 21, 1910, n.p.

"profound scientific knowledge": NCW to HZW, Oct. 5, 1919, n.p.: "*The Passing of the Great Race* by Morrison Grant [sic] . . . is to me a startlingly new but convincing argument based upon profound scientific knowledge." See also Fitzgerald, *Great Gatsby* (New York: Charles Scribner's Sons, 1925), 16, for Tom Buchanan's arguments in favor of the fictional counterpart, *The Rise of the Colored Empires.*

exhibition juries: See NCW to ANWII, Mar. 24, 1926.

Horace Pippin: *American Folk Painters of Three Centuries* credits NCW and Brinton with discovering Pippin; see also Bearden.

"with that startled look": NCW to CBW, Feb. 27, 1919, n.p.

"Canned life": NCW to ANWII, Feb. 26, 1926.

fighting Chadds Ford's fires: See NCW to HZW and ANWII, May 1, 1915; spike through foot: See NCW to HZW, May 6, 1915, n.p.

lifting car out of ditch: See "Stouthearted Heroes of a Beloved Painter."

"I don't think he knew": Charles E. Staats to CBW, Oct. 26, 1945, WFA.

"du Pont millionaires": NCW to SMC, Aug. 21, 1917.

277 "Babylonian brothels": NCW to HZW and ANWII, May 30, 1918.

"The invasion of wealth": NCW to HZW, May 10, 1918, n.p.

277 "Some fashionable people": HWH, Diary, May 26, 1918.
"huge prices": NCW to HZW, May 2, 1918.
"too well": NCW to HZW, Oct. 10, 1917.
base annual income: See NCW to JHC, n.d. 1920, n.p., SA: "Unless I can keep busy throughout the year and do at least three books or its equivalent I am not doing what I should in a financial way."
Missouri State Capitol murals: *Battle of Westport, 1864* and *Battle of Wilson's Creek,* for which he earned $7,000. See NCW to ANWII and HZW, Feb. 4, 1920, n.p.: "For once, I made a decent business deal." The murals appeared in *Ladies' Home Journal,* Mar. 1921, for an additional $500 each.
prompted him not to sell: See NCW to SMC, June 30, 1921.
begged him to name: See NCW to HZW and ANWII, Feb. 26, 1920.
"I am beginning": NCW to SMC, May 24, 1918.
"better minds": Ibid.
278 "Both Carol and myself": NCW to SMC, Aug. 21, 1917.
"pictures, pictures, pictures": P to DTM, 4/22/93.
"*Drawing!*": NCW to HZW, Oct. 11, 1920.
"We thought": HWH, SWT, 51.
"reclaim a lost life": NCW to ANWII and HZW, Sept. 25, 1916.
"the greatest question": NCW to SMC, Aug. 21, 1917.
"prohibitive": NCW to HZW, Oct. 10, 1917; see also NCW to SMC, May 24, 1918.
"phenomenal results": NCW to HZW, Oct. 5, 1919.
279 "hell of an upheaval": N, SWT, 30.
"homesick for Needham": AWMcC to DTM, 12/15/93.
280 "destroy the appearance": NCW to HZW, Aug. 29, 1918, n.p.
Boston architect: Richard Clipston Sturgis. See NCW to SMC, June 30, 1921.
"dollar-hungry": NCW to SMC, Apr. 22, 1918.
"some rich man": JDZII and Oretta Freeman Zirngiebel quoted by F. Ernest Thorpe, Needham Real Estate and Insurance Co., to NCW, Apr. 12, 1918, WFA.
"if that dear old": NCW to SMC, Apr. 22, 1918.
date of HZW's operation: See NCW to SMC, Dec. 22, 1920, n.p.: "We went through a very depressing period in November on account of my mother who passed through a very critical operation, but thank heaven she pulled through successfully."
generalizing phrases: See NCW to SMC, Dec. 22, 1920, n.p.
"no sign whatever": Dr. Pease quoted by NCW to HZW, Dec. 3, 1920, n.p.
"mark the turning point": NCW to HZW, Mar. 9, 1921.
older Socratic figure: See NCW to HZW, Jan. 1, 1921: "If I could only find a *man* to whom I could write, or to whom I could talk and discuss. One who is in perfect sympathy with *Nature,* who looks upon her from a vastly higher standpoint than I do."
281 untreated bouts: NCW to JHC, n.d. 1921, n.p., SA: "I have passed through two months of the worst depression I ever remember."
For further details about negotiations of purchase and move back to the Old Homestead, see NCW to JHC, June n.d., 1921, n.p., SA; NCW to R. L. Scaife, July 26, 1921, n.p., HMP.
282 "dawn of a new"; "The village": NCW to ANWII, July 28, 1921.
Homestead caretaker: See NCW to Walter S. Brown, Sept. 20, 1922, BRM.
"found" powder horn: See Kamp; see also Caswall.
"when no eye": Irving, 39.

memories of old Mr. Onion: See NCW to ANWII, July 28, 1921.

"would help tie over": Ibid. "Tie over" is NCW's phrase, not a typo for "tide over."

"Perhaps even more": See "Greatest Illustrator."

283 "The whole event": NCW to HZW, Oct. 8, 1921.

Rip

284 broken niches: See NCW to ANWII and HZW, Sept. 25, 1916.

roll of the henhouse door: NCW to his brothers, May 1, 1906.

bread smell: See NCW to HZW, Dec. 28, 1915.

grape juice: See NCW to HZW, Oct. 23, 1905.

hoping to find: See Dinneen.

Birds Hill Station: See NCW to HZW and ANWII, Mar. 5, 1920.

"another living symbol": NCW to SW, Aug. 3–4, 1927, n.p.

No fewer than three: *Boston Sunday Post*, Nov. 27, 1921; *Boston Sunday Herald*, Nov. 12, 1922; *Boston Sunday Globe Magazine*, Mar. 23, 1923. See also *Needham Chronicle*, Feb. 3, 1923.

"WORST SLEET STORM": *Needham Chronicle*, Dec. 3, 1921, 1.

"of the stately": Ibid, 4.

285 "grim irony": NCW to SMC, Nov. 30, 1921.

"Well, I'm glad": Recollection of N, as told by ANW to DTM, 5/26/94.

as if a giant: See *Needham Chronicle*, Dec. 3, 1921, 1.

bank holiday posters: See Allen and Allen, 142.

"How the so-called": NCW to SW, Aug. 3–4, 1927, n.p.

dramatically aged: See NCW to SMC, Dec. 22, 1920, n.p.: "The shock [of her first operation] however aged her very much, and on my several flying trips to see her I have been made to feel the intensity of the ordeal."

Thorgunna: See NCW to HZW, Sept. 8, 1914, n.p.: NCW finished the painting a day after he had dreamed of his mother and Needham. The dream intensified his portrayal of Thorgunna; the residual feelings gave him an uncanny feeling of knowing the woman in the picture. He was euphoric when he finished: "How I have enjoyed it! I've thrust my romantic relations with every one I know into that picture."

"Aunt Ma"; "scary": AWMcC to DTM, 5/15/93.

"She had something": NBS to DTM, 11/29/93.

"my foolish habit": HZW to CBW, Aug. 30, 1924.

begged Newell: See NCW to ANWII, Nov. 14, 1919, n.p.

286 "giving yourself in sympathy": NCW to HZW, Nov. n.d., 1920, n.p.

NCW at Child-Walker School: See Agatha Rowland to BJW, Apr. 29, 1985, WFA.

sledded, caroled, yodeled: See GWU to DTM, letter, 3/2/95.

"how intensely"; "six live points": NCW to SMC, Nov. 30, 1921.

287 Carolyn's homesickness: AWMcC to DTM, 12/15/93; see also Meryman, "A Wyeth Comes out of Hiding."

"I don't wonder": ABB to CBW, Jan. 11, 1922, WFA.

sight of NCW as Father Christmas: AWMcC to DTM, 12/15/93; see also GWU to DTM, letter, 3/2/95.

never felt more convinced: Recollection of N, as told by ANW to DTM, letter, 2/22/95; see also N to Jill Johnson, interview 1, 19–20.

impatience: See NCW to SMC, Aug. 3, 1922.

287 "surroundings": NCW to CBW, Sept. 20, 1922, n.p. Earliest evidence of NCW's and
 CBW's dissatisfaction with Needham. From Port Clyde, Maine, in the midst of a
 stint of outdoor painting with SMC and SW, NCW wrote CBW: "The telephone
 talk with you has made me very uncomfortable and homesick. It was almost unbear-
 able to hear you talking and to vividly see you in my mind in those familiar surround-
 ings, surroundings with which we are dissatisfied but which at this distance became
 dear to me, because *you* are there."

 "show something": NCW to CBW, Sept. 25, 1922, n.p. Newly available correspon-
 dence of NCW with Walter S. Brown, Brown & Whiteside, Architects, Wilming-
 ton, Del., shows that as early as Sept. 4, 1922, NCW planned to move the family back
 to Chadds Ford by July 1923.

 family accounts disagree: AWMcC to DTM, 2/4/97: Her mother had a hysterec-
 tomy. BJW to DTM, 2/4/97: CBW told BJW that her fallopian tubes had been
 tied.

 "Many things": NCW to R. L. Scaife, n.d. c. July 22–24, 1923, n.p., HMP, shelf mark,
 bMS Am 1925 (1962). By permission of Houghton Library, Harvard University.

288 serious relapse: See NCW to R. L. Scaife, telegram, Aug. 1, 1923, n.p., HMP. See also
 NCW to Walter S. Brown, n.d. (early Aug. 1923 by context), n.p., BRM.

 "We seem to be": NCW to R. L. Scaife, Aug. 8, 1923, n.p., HMP, shelf mark, bMS
 Am 1925 (1962). By permission of Houghton Library, Harvard University.

 still concerned: See NCW to CBW, Aug. 12, 1923, n.p.

 "our journey together": Ibid.

 "When *will*": Ibid.

 "hit it off": JSW to DTM, 4/22/93.

289 "ready to go back": NBS to DTM, 11/29/93.

 Hattie's favorite: AWMcC to DTM, 5/15/93.

 HZW's medical record: See Medical Certificate of Death, Aug. 11, 1925, NFPLA,
 which records the duration of her cancer as two years exactly, placing it in the first
 week of August 1923. This conflicts with NCW to SMC, July 26, 1925: "It is just a
 year to the week that the knowledge of her affliction . . . a fatal cancer . . . has been
 known to us," which dates it July 1924. However, in HW to NCW, July 27, 1924,
 WFA, Henriette in Needham reports that "Aunt Mama had a recurrence of her old
 trouble yesterday—a slight flowing of blood [in her bowels]. We had Dr. Pease down
 and immediately he advised her to have an examination made by Dr. Brewster. She'll
 probably have it tomorrow." Taken together, the archival medical record and Henri-
 ette's statement that the July 1924 episode was a "recurrence of her old trouble" leads
 one to believe that the Wyeths knew about HZW's cancer earlier than NCW
 suggests.

 "a recurrence": HW to NCW, July 27, 1924, WFA.

 "to keep Mama": ANWII to NCW, July 30, 1924.

 could not go on: See NCW to HZW and ANWII, Dec. 22, 1923.

 admitted to business colleague: NCW to R. L. Scaife, n.d., c. Sept. 1, 1924, n.p.,
 HMP: "I cannot resign myself to the prospects." Shelf mark, bMS Am 1925 (1962).
 By permission of Houghton Library, Harvard University.

 "I am marking"; "Meet husband": NCW to CBW, Aug. 14, 1923, n.p.

290 "She ruled": AWMcC to DTM, 12/15/93.

 "autocratic": NCW to HZW, Jan. 2, 1920.

"fascinating": JSW to DTM, 4/22/93.

"our farmer": NCW to HZW, Dec. 13, 1918, n.p.

"She always liked": HWH, SWT, 43. CW's animals, see Meryman, "A Wyeth Comes out of Hiding," 20.

291 "I am getting": NCW to HZW, Aug. 5, 1918, n.p.

"so astonishing": NCW to SMC, Oct. 25, 1919. See also NCW to SMC, June 30, 1921: "nothing short of phenomenal."

"inevitable disease": NCW to HZW, Oct. 11, 1920.

"This young man": HWH to DTM, 10/22/94.

Lord Jehovah: Recollection of PH, as told by HWH to DTM, 10/24/94.

PH's version of the first and second meetings with NCW can be found in his unpublished autobiography, which forms the basis of Metzger's account in *My Land Is the Southwest*, 37–40.

292 seven feet long: HWH to DTM, 10/24/94.

it was dreadful: HWH to DTM, 10/24/94.

"masterly act": PH, unpublished autobiography, quoted in Metzger, 38.

293 other disappointments: See NCW to HZW, Nov. 19, 1918, n.p.

"poor Engle"; "broken down"; "I am not": Ibid.

Hurd's charm: See also P to DTM, 4/23/93: "Peter charmed him the minute they met. Peter was cavalier, but also deferential, and Wyeth responded immediately to his charm."

"annex": HWH, SWT, 5.

"lovely body": HWH on "Peter Hurd," video recording, KENW-TV, courtesy La Rinconada Gallery, San Patricio, N.M.

Texas Pete: HW to NCW, June 24, 1924, quoted in Metzger, 40.

"But if you": Recollection of PH, as told by HWH to DTM, 10/24/94.

"work began": PH, "Southwestern Heritage."

"to settle": NCW to HZW, Apr. 21, 1916.

take control of Hurd's brush: See PH, "Southwestern Heritage."

294 "caveman": ANW to DTM, 1/24/96.

"3HRS": *Dusty Bottle*, 1924. Collection of BRM.

"If you look": AW on *The Wyeths: A Father and His Family*, video recording, Smithsonian World.

"When you saw": Recollection of N, as told by ANW to DTM, letter, 12/26/94.

"contagious stimulant": NCW to ANWII and HZW, Dec. 23, 1919, n.p.

"that beetling brow": AWMcC to DTM, 12/15/93.

desperately short: See NCW to PH, Mar. 11, 1941, n.p.

"fundamentally unhappy": NCW to HWH, Aug. 21, 1941, n.p.

"another day right away": NCW quoted by CBW in Wilmington *Evening Journal*, Oct. 12, 1968.

"He hated to leave": Ibid.

build a fire: See NCW to R. L. Scaife, Oct. 2, 1919, HMP.

296 covered with paint: See NCW to N, Nov. 7, 1940, n.p.

his mother's letters: See NCW to HZW, Mar. 15, 1918, n.p.: "I have often picked out at random a letter or a group of letters."

"keenest regret": Ibid.

Episode with John McVey: See NCW to HZW, July 28, 1910, n.p.

296 "emotional state of mind": NCW to HZW, Mar. 15, 1918, n.p.

understood her better: See NCW to HZW, Jan. 1, 1909, n.p.: "I pride myself on being able, not only to catch the word meanings of your letters, but to read between the lines besides."

"the only woman": HWH, SWT, 24.

three to twelve months: See NCW to R. L. Scaife, n.d., c. Sept. 1, 1924, n.p., HMP. "The best doctors in Boston have given up my mother; she may be with us a year, possibly not 3 months." Shelf mark, bMS Am 1925 (1962). By permission of the Houghton Library, Harvard University.

kept the truth from her: Ibid.: "For her sake the truth of her condition is known only to me in the family, so mention nothing of it to friends who might come in contact with my mother."

297 "The letters all have": NW to NCW, Aug. 9, 1924, WFA.

standard diagnostic criteria: See Jamison, 261–62, app. A.

HZW's symptoms: See ANWII to NCW, Aug. 27, 1924; see also ANWII to NCW, Sept. 4, 1924: "Wants someone with her at all times."

"better than pills": ANWII to NCW, Aug. 27, 1924.

"We must": Anton Kamp to NCW, Aug. 29, 1924, WFA.

doctors joined the sham: See ANWII to NCW, Sept. 30, 1924.

demanded to know: See Anton Kamp to NCW, Aug. 29, 1924, WFA.

Believing herself contagious: See ANWII to NCW, Oct. 16, 1924: "Mama seems about the same. Worries badly all the time. She is now fretting for fear that folks will take the disease from her. Even afraid to go over to Stimson for fear of contagion. I tell her that her trouble is not in that nature at all."

One night that October: See SW to NCW, Nov. 13, 1924, WFA.

298 became violent: See SW to NCW, Nov. 2, 1924; see also ANWII to NCW, Nov. 4, 1924.

Reports from the sanitorium: ANWII to NCW, Nov. 4, 1924.

"so self-centered": SW to NCW, Nov. 13, 1924.

"bad": ANWII to NCW, Nov. 30, 1924.

might try suicide: See SW to NCW, Nov. 13, 1924.

HZW attempted to persuade: See HZW to Anton Kamp, Feb. 16, 1925, WFA.

Ann's appendix ruptured; critical condition: See NCW to R. L. Scaife, Sept. 27, 1924, HM Papers. See also NCW to SMC, July 26, 1925.

George Herbert Palmer [Mar. 19, 1842–May 7, 1933]: See R. L. Scaife to NCW, Sept. 24, 1923, HMP, shelf mark bMS Am 1925 (1962). By permission of Houghton Library, Harvard University.

Wyeth's one chance: See R. L. Scaife to NCW, Oct. 1, 1924, HMP, Ibid.

"been busy": NCW to R. L. Scaife, c. Sept. 3, 1924, n.p., HMP, Ibid.

"Look out": R. L. Scaife to NCW, Sept. 3, 1924, HMP, Ibid.

299 NCW's weight: See NCW to CBW, Aug. 14, 1923, n.p.; NCW to R. L. Scaife, c. Sept. 3, 1924, n.p., HMP, Ibid.

carried the Wyeths: See NW to NCW, Mar. 23, 1925, WFA.

"Herculean burden": ABB to CBW, Jan. 22, 1925, WFA.

improperly claimed: Ibid.: To qualify for the allowance, Robert Bockius had to be his mother's only son, and she had to be "old, decrepit, and destitute."

N.C. had told her: NCW quoted by ABB to CBW, Jan. 3, 1925, WFA.

helped SW buy car: See SW to NCW, June 8, 1925.

"rational periods": SW to NCW, Dec. 31, 1924; see also SW to NCW, Apr. 10, 1925.

"and seems happy": ANWII to NCW, Apr. 30, 1925.

"hausfrau": SW to NCW, Apr. 10, 1925.

"Even though": Ibid.

"little spells": SW to NCW, July n.d., 1925.

300 Plans to visit HZW: See NCW to HZW, July 3, 1925, n.p.: On his way to Maine, NCW planned to stop in Needham on Tuesday, July 14. He started the trip on July 13, but in all his discussions of his mother's condition after he reached Maine, he did not once mention stopping in Needham. See also NCW to SMC, July 26, 1925, in which NCW again announced a plan to visit HZW with two of his children.

"Another day": ANWII to NCW, Aug. 11, 1925; no postmark on envelope of second letter: never mailed.

9:15 P.M.; final hemorrhage from the bladder: See HZW medical death certificate, issued Aug. 12, 1925; on microfilm, NFPLA.

Description of NCW's vigil: See NCW to ANWII, Aug. 27, 1925.

"the true facts": ANWII to NCW, Aug. 16, 1925.

took up Hattie's post: See ANWII to NCW, Sept. 24, 1925.

"how little I have expressed": NCW to ANWII, Mar. 4, 1927.

301 "the beginning": NCW to R. L. Scaife, Apr. 21, 1927, n.p., HMP, shelf mark, bMS Am 1925 (1962). By permission of Houghton Library, Harvard University.

"a canvas of my own": NCW to ANWII, Mar. 4, 1927.

complicated atmospherics: NCW's letters reveal a link between his deepest feelings of loss and "the miracle of a great sky of towering clouds." See NCW to SW, Mar. 11.d., 1930.

"tendency": NCW to HWH, June 26, 1937. See also NCW to AW, May 18, 1938: "Intense nostalgia is the truest barometer in the world of . . . spiritual and emotional potentialities."

turned him cold: NCW himself would eventually come to wonder whether a constant state of sentimental longing was really "conducive to enduring artistic expression." See NCW to HWH, June 26, 1937.

his "highest": NCW quoted in " 'Walden Pond Revisited' Deserves Close Study," *Daily Local News*, Oct. 16, 1935. See also NCW to Lovell Thompson, Aug. 21, 1939, n.p., HMP: NCW based the painting "upon my own emotional reactions after spending several nights near the [Thoreau] cairn [at Walden Pond]." Shelf mark, bMS Am 1925 (1962). By permission of Houghton Library, Harvard University.

302 "I just couldn't": NCW to ANWII, Oct. 30, 1925.

"go into masque": BJW to DTM, 2/1/94.

"saved the evening": NCW to ANWII, Oct. 30, 1925.

303 "special": AWMcC to DTM, 12/15/93.

came to associate: AWMcC to DTM, 12/15/93; recollection of N, as told by ANW to DTM, 3/25/94; AW on *Self-Portrait: Snow Hill.*

"It always starts": ANWII to NCW, Nov. 12, 1925.

Shoemaker's Children

304 stood guard over Andy: BJW to DTM, 2/4/94.

Andy unable to sleep: See NCW to ANWII, Sept. 13, 1925.

"Andy is showing": NCW to ANWII, Mar. 25, 1927.

304 "a case of": NCW to ANWII, Feb. 14, 1928, n.p.

"I'm afraid": NCW to R. L. Scaife, July 6, 1920, n.p., HMP, shelf mark bMS Am 1925 (1962). By permission of Houghton Library, Harvard University.

305 overlooked: See Hoving, *Two Worlds of Andrew Wyeth*, 9.

"I don't give a damn": NCW quoted by AW in Plimpton and Stewart, 99.

"I want you to learn": NCW quoted by AW in Richardson, 68.

"Work": Horgan, *Peter Hurd*, 29.

literal and romantic: See NCW to RM, Feb. 19, 1939, re: AW's training in studio.

"Never paint": NCW quoted by Horgan in BRM, *Henriette Wyeth*, 14.

"for its own sake": NCW, "For Better Illustration," 641.

"The stain": NCW to HZW, Dec. 5, 1913.

"My affections": NCW to SW, Aug. 3–4, 1927, n.p.

"It was ideal": N to Jill Johnson, interview 2, 47.

"He wanted people": AWMcC to DTM, 12/15/93.

306 "at dawn": NCW to HZW, Oct. 11, 1920.

Beethoven: NCW to SMC, Dec. 29, 1917.

"always expected more": AWMcC to DTM, 12/15/93.

"some 5000 strong": NCW to WEP, Jan. 21, 1935, n.p., WEP Letters and Diaries.

brothers in audience and parents looking on; thunderous ovation: NCW to WEP, Jan. 21, 1935, n.p., WEP Letters and Diaries.

"The reception was deafening": Ibid. See also Oliver Daniel, *Stokowski* (New York: Dodd, Mead, 1982), 332.

"Nat's benchwork": NCW to HZW, Dec. 12, 1923.

307 "That's where": NCW quoted in Meryman "Wyeth Family: American Visions," 93.

"mentor": BRM, *Henriette Wyeth*, 12.

"A thing done right": NCW to SMC, Apr. 1, 1915.

severe: See AW in Plimpton and Stewart, 99.

308 N.C. suspected: HWH to DTM, 10/24/94.

flashing eyes: HWH to Peter de la Fuente, videotaped interview, 1984: "He'd take several heads off with one stroke. And those gray eyes would flash!"

"dull as the devil": Recollection of N, as told by ANW to DTM, 5/26/94.

satisfied *him:* See BRM, *Carolyn Wyeth, Artist,* 13.

"You get to work": Ibid.

especially hard on Carolyn: HWH to DTM, 10/24/94.

"Maybe I was": BRM, *Carolyn Wyeth, Artist,* 16.

"I have *always*": NCW to ANWII, Feb. 20, 1909. "Think clearly": NCW quoted by CW in BRM, *Carolyn Wyeth, Artist,* 14.

309 "cut like a sword": HWH to Peter de la Fuente, videotaped interview, 1984.

tears: See HWH, SWT, 35.

Another time: CW, SWT.

"outskirts": AW quoted in Hoving, *Two Worlds of Andrew Wyeth*, 6.

Alone among the children: AW to DTM, 12/16/93: AW felt that he had a different relationship with his father because of the intensity of his interest in NCW's canvases: "I studied his work. My brother and sisters didn't really know what he was painting. I got a very complete knowledge because I was interested in his work. His art was always what interested me."

AW was tutored by a Mrs. Rigby, Mrs. William Seal, Lydia Betts, Mrs. William Betts, and Chris Sanderson.

First grenadiers, then crusaders: See PH to P, Mar. n.d., 1930, Hurd-Wyeth Papers, AAA.

"vibrant enthusiasm": AW to King Vidor, Jan. 6, 1975, King Vidor Papers, AAA.

310 N.C. envied: See NCW to ANWII, Nov. 14, 1919.

"lifting me clear": NCW to JHC, June 20, 1929, SA, Manuscripts Division, Dept. of Rare Books & Special Collections, Princeton University Library. Published with permission of the Princeton University Library.

"an old story": NCW to ANWII, Jan. 18, 1927.

"enchanting": Horgan, *Peter Hurd,* 31.

supper dances: See NCW to ANWII, Feb. 17, 1928, n.p.

"filled with relatives": Horgan, *Everything to Live For,* 2.

"member of that court": P to DTM, 4/23/93.

Limousines: Recollection of HWH, as told by ACHR to DTM, 10/23/94.

Bonwit Teller bills; "someone in this family": Recollection of N, as told by ANW to DTM, 5/26/94.

"He must have wondered": HWH to DTM, 10/24/94.

"begged for criticism": Ibid.

fifty-dollar bills: Recollection of HWH, as told by MH to DTM, 10/23/94.

"As soon as a limousine": ACHR to DTM, 10/23/94.

311 "I was so relieved": HWH to DTM, 10/24/94

Hurd socked Phelps in jaw: JSW to DTM, 4/22/93; breaking eyeglasses: Recollection of N, as told by ANW to DTM, 1/24/96.

"blinding glamour": NCW to ANWII, Jan. 18, 1927.

"The first flush": PH to NCW, n.d., c. June 29–July 1, 1927, WFA.

312 Peter's father and mother: MH to DTM, 10/23/94.

"A great deal": PH to NCW, n.d., c. June 29–July 1, 1927, WFA.

HWH unmaternal: See ACHR to DTM, 10/23/94.

CBW embraced PH: P to DTM, 4/23/93.

"Christmas at Chadds Ford": PH to P, Jan. 1935, Hurd-Wyeth Papers, AAA.

"I know how": PH to NCW, n.d., c. June 29–July 1, 1927, WFA.

Career of Harl McDonald (1899–1955): Neil Butterworth, *A Dictionary of American Composers* (New York and London: Garland, 1984), 304–5; *The New Grove Dictionary of Music and Musicians,* vol. 11 (New York: Macmillan, 1980), 416–17; liner notes of "Koussevitzky Conducts American Music," Pavilion Records, England, n.d.

313 sought N.C.'s advice; let it be known: AWMcC to DTM, 12/8/94.

N.C. argued; "bored my father": AWMcC to DTM, 12/8/94.

"one day": PH to NCW, c. June 29–July 1, 1927, WFA.

"successfully suppressed": NCW to JHC, June 20, 1929, n.p., SA, Manuscripts Division, Dept. of Rare Books & Special Collections, Princeton University Library. Published with permission of the Princeton University Library.

"doing nothing but washing": Ibid.

315 "a high": P to DTM, 4/23/93.

Andy got drunk: Ibid.

"When he'd finish": NBS to DTM, 11/29/93. See also recollection of N, as told by ANW to DTM, 5/26/94.

"worthy": NCW to Harrison S. Morris, Aug. 13, 1931, Harrison Smith Morris Papers, Manuscripts Division, Dept. of Rare Books & Special Collections, Princeton University Library. Published with permission of the Princeton University Library.

315 Declining a watercolor exhibition in Newport: "I do not consider the best I have
done as worthy to send to such an exhibition."
He might send: See NCW to P, Mar. 2, 1930, n.p., WFA.
"Professionally": NCW to Walter S. Brown, Mar. 22, 1926, n.p., BRM.
"In each case": NCW to R. L. Scaife, Apr. 21, 1927, n.p., HMP, shelf mark, bMS Am
1925 (1962). By permission of the Houghton Library, Harvard University.
"had I not": NCW to SMC, Apr. 15, 1914.
A group of art students: See NCW to PH, Oct. 16, 1929.

316 three false starts, destroying entire set: See NCW to R. L. Scaife, Apr. 21, 1927, n.p.,
HMP.
"Aunt Pa": AWMcC to DTM, 12/15/93.
"probably end up": NCW quoted by Walter Nield and Arthur L. Nash to BJW, Nov.
16, 1987, WFA.
five past five: See ANWII medical death certificate, issued July 30, 1929; on micro-
film, NFPLA.
"Abide with Me": See Andrew Newell Wyeth II, 1853–1929, obituary, Needham
Chronicle, Aug. 3, 1929.

317 JDZII died of chronic valvular heart disease, Aug. 31, 1929, age 75 years, 6 months;
death certificate on microfilm, NFPLA.
reserved, reliable: Arian Schuster, archivist, NFPLA, SW's neighbor and fellow
parishioner, to DTM, 4/21/93.
"connected": SW in Harvard College *Class of 1913, Twenty-fifth Anniversary Report,*
1938.
"Whatever I have": SW to NCW, July 12, 1926.

PART FOUR : *Pa, 1930–1945*
Colony

321 "beyond seeing": Horgan, foreword to Allen and Allen, 13.
"Papa is most horribly": HWH to P, Nov. 29, 1932, Hurd-Wyeth Papers, AAA.
play a symphony on the windup Victrola: ACHR to DTM, 10/23/94: "Sometimes he
would come down from the studio with a darkened brow and go into the Big Room
and listen to Sibelius with his head in his hands." See also N to Jill Johnson, inter-
view 1, 23.
"to risk": NCW to AW, Aug. 15, 1942, n.p.
"for crazy people": ANW to DTM, 5/26/94.
movie fan magazine to bed: Recollection of CPW, as told by ANW to DTM, letter,
2/22/95. "He was manic-depressive. He suffered from depression most of his adult
life. My mother said that when he got depressed he would go to bed with a Holly-
wood fan magazine and just read that—as ultralight as he could get."
"Naturally": N on *The Wyeths: A Father and His Family.*
"You could see": NBS to DTM, 11/29/93.
$12,000: St. Andrew's School mural, 1936–1938, commissioned by Mrs. Irénée du
Pont; contract in WFA.
$5,000: See JHC to NCW, Dec. 27, 1938, WFA: Confirms that payment for *The
Yearling* (as it had been for *Drums* and *The Little Shepherd of Kingdom Come*) will be
$5,000, for 17 drawings, including 14 illustrations, cover lining, jacket, title page, with
the originals to return to NCW.

NCW's earnings: By 1939 he could report a comfortable net income of $9,542.23. See NCW Income Tax Records 1939, WFA.

322 tennis court: See NCW to SW, May 25, 1927, n.p.

"very swell": HW to P, Apr. 18, 1930, Hurd-Wyeth Papers, AAA.

Wyeth cars: See NCW to SW, May 25, 1927, n.p.

"They didn't live ostentatiously": P to DTM, 4/22/93.

"He wove": Ibid.

"barely-cooked": Recollection of N, as told by ANW to DTM, letter, 2/22/95.

"He always made sure": CBW quoted in Wilmington *Evening Journal,* Oct. 12, 1968, 21.

"Everyone felt close": P to DTM, 4/23/93.

"The main thing": HWH to Peter de la Fuente, videotaped interview, 1984.

"came down from the studio": N, SWT, 30.

"tightly bottled": P to DTM, 4/22/93.

"Pa is so austere": HWH to WEP, n.d. 1941, WEP Letters and Diaries.

324 "petticoats": AW to DTM, 3/29/94.

pass around and discuss: PH to P, Jan. 17, 1930; PH to P, Sept. n.d, 1930; PH to P, May n.d., 1933; Hurd-Wyeth Papers, AAA.

"had a deep effect": PH to P, Aug. 3, 1934, Hurd-Wyeth Papers, AAA.

Carol after supper: AWMcC to DTM, 12/15/93.

"Mothers": CBB to NCW, Oct. 31, 1904.

"totally useless": CBW quoted by P to DTM, 4/22/93.

"Look at them": BRM, *Henriette Wyeth,* 11.

Bockiuses at Bedford Springs: NBS, memoir, 17.

"She was all": HWH to Peter de la Fuente, videotaped interview, 1984.

325 "great addition"; "great subtraction": DCW to DTM, 10/12/96.

"We moved": NBS to DTM, letter, 12/11/93.

"on the wing": ABB to CBW, Feb. 28, 1938, WFA.

"I do my best": NCW to HZW, Mar. 1, 1912, n.p.

"He treated her": HWH quoted in Meryman, *Secret Life,* 35.

Old Sweet: CBW to NCW, Aug. 5, 1945.

"The intention": NCW to HWH, Dec. 30, 1940, n.p.

326 bathroom door: AWMcC to DTM, 4/9/94.

tales of old Cathay: AWMcC to DTM, 12/15/93.

"streaked with mud": Recollection of N, as told by ANW to DTM, letter, 2/22/95.

"a backward lot": NCW to Christian Brinton, Mar. 2, 1931, n.p., Christian Brinton Papers, AAA.

"Pa was awfully good": AWMcC to DTM, 12/15/93.

undervalued local painters: See N.C.'s championing of the painter Jack Lewis, *Humanities,* vol. 17, no. 4 (Sept.–Oct. 1996), 23.

327 "feeling a little": NCW to CBW, June 14, 1937, n.p.

Thoroughly attended: See NCW to CBW, June 9, 1937, n.p.

"lush opulence": PH to P, Dec. n.d., 1929, Hurd-Wyeth Papers, AAA. See also PH to P, Nov. 13, 1930.

"tadpole": PH to P, Jan. 17, 1930, Hurd-Wyeth Papers, AAA.

"overcrowded": PH to P, Jan. 15, 1940, Hurd-Wyeth Papers, AAA.

328 "right in every detail": PH to P, Feb. 20, 1927, Hurd-Wyeth Papers, AAA.

"This is not": Ibid.

328 PH's philandering: See MH to DTM, 10/23/94; ACHR to DTM, 10/23/94.
"clan loyalty": PH to P, n.d. 1930s, Hurd-Wyeth Papers, AAA.
"tremendous solidarity": PH to P, Oct. n.d., 1933, Hurd-Wyeth Papers, AAA.
lunch every day: See NCW to CBW, June 9, 1937, n.p.
"like a member": BRM, *John W. McCoy: A Retrospective View,* 10.
"competition": AW to DTM, 12/15/93.
"outside blood": CW quoted by P to DTM, 4/22/93.

329 "She didn't like it": HWH, SWT, 43.
prototypical self-made man: Paul Dottin, in *Daniel Defoe et ses romans* (Paris, 1924),
called *Robinson Crusoe* "la Bible du self-made man." See Green, 29.

330 Account of dream: See NCW, "Washington Dream Picture Description," WFA. See
also NCW to SW, Feb. 19, 1931, n.p.
Sets of father-son figures: A fifth set, the portrait painters Charles Willson Peale and
Rembrandt Peale, can be inferred. In 1795, while Rembrandt, age seventeen, painted
George Washington's portrait alongside his father, the elder Peale kept up a steady
stream of sociable conversation, leaving the son free to focus his attention on paint-
ing. (See Rembrandt Peale, "Washington and His Portraits," p. 16, Charles Roberts
Autograph Collection, Haverford College, Haverford, Pa.)

331 "inevitable battle picture": NCW to SW, Feb. 19, 1931, n.p.

332 "If you're not better": NCW quoted by AW in Plimpton and Stewart, 100.
left the portfolio: See AW to RM, Jan. 5, 1937, Macbeth Gallery Records, AAA.
"something quite new": RM to AW, Jan. 18, 1937, Macbeth Gallery Records, AAA.
"The boy": NCW to RM, Sept. 20, 1937, Macbeth Gallery Records, AAA.
"I have been": NCW to RM, Feb. 19, 1939.

333 trying to neaten: See AW in *Autobiography,* 68.
sketch on Andy's paper: AW to DTM, 2/1/94. See example in Pitz, "N. C. Wyeth," 55.
date of AW's first academic study: WFA, Oval Office.
"This is": RM to AW, Oct. 7, 1937, Macbeth Gallery Records, AAA.
no steady girlfriends: AW to DTM, 2/1/94.
"Andy eats": NCW to RM, Feb. 19, 1939.
AW's equipment: See *American Artist,* Sept. 1942, 18–27.
"It is with envy": NCW to WEP, Sept. 1, 1937, n.p., WEP Letters and Diaries.
forty-eight: See NCW's "List of titles for Andrew Wyeth's watercolors," Macbeth
Gallery Records, AAA; see also AW to RM, Sept. 8, 1937.

334 "Every mark": NCW to Mr. and Mrs. Merle D. James, Dec. 11–12, 1939, n.p.
"talking to himself": Ibid.
"They represent": NCW to AW, Sept. 26, 1937.

335 NCW's list of titles; handwritten ms. of foreword; guest list: See Macbeth Gallery
Records, AAA.
"Sign them": NCW to AW, Sept. 26, 1937.

Oil and Water

336 "The serious practice": NCW, "Catalogue Introduction," Macbeth Gallery Records,
AAA.
"one of four": Associated Press, Dec. 13, 1934.
Silver Foil: See NCW to WEP, Sept. 6, [1932], WEP Letters and Diaries. The
launching took place in Port Clyde, Maine.

337 freeze water: See N on *The Wyeths: A Father and His Family.*
"didn't seem": NBS to DTM, 11/29/93.
"two talented daughters": *Philadelphia Enquirer,* Sunday, May 15, 1932; see also *Daily Local News,* Oct. 27, 1938.
"talented member": *Daily Local News,* June 3, 1935.
ART SHOW: *Evening Bulletin,* June 1, 1940.
"son of a famous": *Art Digest,* Nov. 1, 1937, 15.
"only non-artistic": "Pyles and Wyeths," 57.
"the one": NCW quoted by Nat to Jill Johnson, interview 1, 4.
Nat felt homesick: ANW to DTM, 5/26/94.
"He clings": NCW to HZW, Oct. 11, 1920.
"Nat would hate to leave": ANW to DTM, 5/26/94.
"Father persuaded": N to Jill Johnson, interview 1, 2. See *Who's Who in the East,* 1977–78: N's fraternity was Pi Tau Sigma.

338 "just so that": N to Jill Johnson, interview 1, 2.
"Nat, have you": NCW quoted by N to Jill Johnson, interview 2, 52. See also DCW to DTM, 3/18/94.
Marx Brothers movies: Recollection of N, as told by ANW to DTM, letter, 2/22/95.
"He always understood": HWH, SWT, 45.

339 "There's so much more": HWH to Peter de la Fuente, videotaped interview, 1984.
too good a time at home: Recollection of N, as told by JKW to DTM, 3/29/94.
CBW all but invisible: Ibid.
"listening intently": N, audiorecording for the dedication of the N. C. Wyeth Room, NFPLA.
"He had this": HWH, SWT, 53.
"How he'll manage": NCW to JWMcC, July 1935.
dating two men at a time: ANW to DTM, letter, 9/20/95.

340 a figure: AW to DTM, 2/1/94.
"I think": ANW to DTM, 5/26/94.
basketball game: DCW to DTM, 3/18/94; ANW to DTM, letter, 2/22/95; see also N to Jill Johnson, interview 2, 37.
first date: ANW to DTM, letter, 9/20/95.

341 N.C. raged: Recollection of N, as told by ANW to DTM, letter, 9/20/95.
"I'd lie there": AW to DTM, 3/29/94.
Ellen Bernard Thompson: See Mary Johnston, *To Have and to Hold* (Boston and New York: Houghton Mifflin, 1900), with illustrations by Howard Pyle, E. B. Thompson, A. W. Betts, and Emlen McConnell. See also Riis's "Children of the People" in *Century Magazine.*
soda-sipping: see *Saturday Evening Post,* cover, Sept. 21, 1935: Katie, Caroline, and Ellen at an ice-cream parlor table.
"Nearly everyone": Ellen B. T. Pyle, *Saturday Evening Post,* Apr. 7, 1928, 48.
"in our lives": AWMcC to DTM, 12/15/93.

342 "He was easy-going": ANW to DTM, 5/26/94.
"When a dog": Recollection of N, as told by ANW to DTM, 5/26/94.
"lightweight"; "He was right": Recollection of CPW, as told by ANW to DTM, 5/26/94.
"Boy, you sure": ANW to DTM, letter, 9/20/95.

343 Caroline was appalled: Recollection of CPW, as told by ANW to DTM, letter, 2/22/95.
CPW and AW, episode in summer 1934: AW to DTM, 3/29/94.
"And I realized": Ibid.
"a boy and girl romance": CPW to N, Mar. 28, 1936, private collection.
"I am so": Ibid.
June 6, date of engagement: See CPW photograph albums, courtesy of ANW.
"You know, darling": CPW to N, Mar. 30, 1936, private collection.

344 "I felt so": CPW to N, June 22, 1936, private collection.
"wasn't the easiest": N to Jill Johnson, interview 2, 35.
"half alive without you": CPW to N, July 7, 1936, private collection.
sandwiches made by Pa: ANW to DTM, 7/11/95.
"I was over there": N to NCW, Aug. 7, 1936.

345 "Caroline is clinging": NCW to HWH, Aug. 9, 1936, n.p.
"Pa, why": Recollection of N, as told by ANW to DTM, letter, 9/20/95.
"I don't blame you"; "made my mouth water": N to NCW, c. Aug. 1936.
"Say, Papa": Ibid.
"On that basis": N to Jill Johnson, interview 2, 35–36.

346 "a depressing day": AW to DTM, 3/29/94.
"Don't tell": NCW to HWH and PH, Oct. 22, 1937.
Mrs. Cornelius Vanderbilt Whitney: AW to DTM, 2/1/94.

347 record for the gallery, sales figures: See Macbeth Gallery Records, AAA; AW Ledger, WFA.
"This in itself": Robert McIntyre to AW, May 28, 1941, Macbeth Gallery Records, AAA.
N.C. speechless: AW to DTM, 2/1/94.

Egg Tempera

348 might faint: Recollection of NCW as told by AWMcC to DTM, 12/15/93. See also BJW to DTM, 2/4/94.
"Give no thought": NCW to AW, May 18, 1938.
Descriptions of Broad Cove Farm from BJW, 12/16/93, and Meryman, *Andrew Wyeth*, 119.
Andy decided: BJW to DTM, 12/16/93.

349 "Are you the wood man?": BJW to DTM, 12/16/93.

350 "Olson's" and Christina: See BJW, *Christina's World:* Anna Christina Olson, born May 3, 1893.
All quotations for July 11–13, 1939: BJW to DTM, 12/16/93.

351 The tempera portrait was AW's *Young Swede* (1938).
"too free": AW in *Two Worlds of Andrew Wyeth*, 13. See also Corn, 130: "my real nature, messiness."
"swish and swash": AW quoted in Pitz, "N. C. Wyeth," 55.

352 "After seeing Andy's": NCW to HWH and PH, Oct. 22, 1937, n.p.
"You won't sell": NCW quoted in Meryman, *First Impressions,* 75.
"real paintings": NCW quoted in Duff et al., *American Vision,* 86.
more color: see Richardson, "Andrew Wyeth," 64.
gun and a dog: see Meryman, *First Impressions,* 78.

"bogged down": BJW, *The Wyeths,* 4.

"truly remarkable temperas": NCW to HWH, May 21, 1941.

"Andy's summer work": NCW to HWH, Sept. 19, 1938, n.p.

"just turned out": NCW to WEP, Sept. 16, 1939, n.p., WEP Letters and Diaries.

See also NCW to PH, Mar. 11, 1941: Description of "a very sensitive and very magical tempera" that Andy had just completed.

AW's output, summer 1938: See AW Ledger and "Complete List of Pictures Painted by Andrew Wyeth," pictures 75–135, 9, 11, WFA, Oval Office.

"The bulwark"; "hard to hold back": NCW to HWH, Aug. 17, 1938.

353 AW's lucky month: See RM to NCW, Sept. 25, 1939, WFA: "What would you think of December, which was the time I originally talked about for Andy until he said he felt October was his lucky month?"

"handsome show": RM to NCW, Sept. 19, 1939, Macbeth Gallery Records, AAA.

the critics: See *World Telegram,* Oct. 14, 1939; *Art News,* Oct. 14, 1939 ("Andrew Wyeth Repeats Success in New Show . . . broke records again this year when, on the opening day of the show, red stars were pasted upon 18 out of a total of 24 paintings in the show."); *Herald Tribune,* Oct. 15, 1939.

"dull picture market": NCW to Marjorie Kinnan Rawlings, Nov. 6, 1939, Marjorie Kinnan Rawlings Collection, University of Florida Libraries.

"one of the white hopes": *Newsweek,* Apr. 24, 1939.

"the daddy": *Newsweek,* Dec. 18, 1939, 40.

"Of course I am"; "my answer"; "*have got something*"; "clear vision": NCW to HWH and PH, Aug. 27, 1939.

354 "my first appearance": NCW to P, Dec. 12, 1939, n.p.

"Clan Wyeth": "Clan Wyeth Presents Its Famed Patriarch," 8.

" 'Pa'—the jovial patriarch": *Newsweek,* Dec. 18, 1939, 40.

engagement ring: AW and BJW to DTM, 1/5/97.

Robert Macbeth's disappointment: See RM to NCW, Dec. 17, 1939, WFA.

NCW's reception: See HWH to WEP, Dec. n.d., 1939, WEP Letters and Diaries; see also NCW to P, Dec. 12, 1939, n.p.

"that an illustrator": NCW to Marjorie Kinnan Rawlings, Jan. 13, 1939, Marjorie Kinnan Rawlings Collection, University of Florida Libraries.

"If I were": NCW to Marjorie Kinnan Rawlings, Nov. 6, 1939, Marjorie Kinnan Rawlings Collection, University of Florida Libraries.

"huge and violent": HWH to WEP, Dec. n.d., 1939, WEP Letters and Diaries.

355 characteristic: See AWMcC to DTM, 12/15/93: "He wasn't comfortable with praise. He'd accept it and be nice about it, but he'd rather be the one to do it."

Macbeth summarized: RM to NCW, Dec. 17, 1939, WFA.

opportunity to sell himself short: See RM to NCW, Dec. 5 and Dec. 9, 1939, Macbeth Gallery Records, AAA.

Accounting of exhibition: See RM to NCW, Jan. 5 and Jan. 12, 1940, Macbeth Gallery Records, AAA; see also NCW 1939 and 1940 Income Tax Records, WFA.

"inevitable reaction": NCW to P, Dec. 12, 1939, n.p.

"*ought* to be": NCW to PH, Dec. 11, 1939, n.p.

"father of": NCW to HWH, Dec. 1 1937.

"dean of": See Buffalo *Courier-Express,* May 16, 1940.

356 "fantastically silly": NCW to AWMcC, Aug. 17, 1938.

356 Johns Hopkins diagnosis: See NCW to Lovell Thompson, n.d., c. Apr. 1939, n.p., HMP.

refused: NCW to Lovell Thompson, June 25, 1939, n.p., HMP.

"The doctor": CBW to AWMcC, Aug. 19, 1938.

"After all these": NCW to RM, Feb. 25, 1939.

how much salt: See recollections of Alice Moore Triller to CBW, Oct. 24, 1945, WFA.

AW's jaundice: See HWH to Witter Bynner, n.d., c. Aug.–Sept. 1940, Witter Bynner Papers, Houghton Library, Harvard University: "The poor lamb, with jaundice. Andy had it fearfully badly a year ago, so I know what it can be." (Shelf mark, bMS Am 1891.28 [246]; by permission of the Houghton Library, Harvard University.)

allowed N.C. to worry: See NCW to AW, Sept. 26, 1937: "It is my prayer that you control . . . your health."

"Watch": NCW to AW, May 18, 1938.

"so utterly unmindful": NCW to HWH, Apr. 4, 1943.

"Unless he takes": HWH to P, Jan. 4, 1940, Hurd-Wyeth Papers, AAA.

"Don't worry": NCW quoted in unsigned handwritten recollection attributed to a "Mr. Stone," Nov. 4, 1951, Christian Brinton Papers, AAA.

Left Out

357 "made him sick": N to Jill Johnson, interview 1, 44.

death of JHC: See Gweneth Beam of Charles Scribner's Sons to NCW, Sept. 21, 1939, WFA.

"I wish": NCW in *Joseph Hawley Chapin, 1869–1939* . . .

"one of constant": NCW to CBW, June 15, 1938, n.p.

Robert Macbeth, obituary, *New York Times*, Aug. 2, 1940.

"What an invaluable": NCW to AW, July 5, 1941, n.p.

"I have never": HWH to P, n.d. 1939, Hurd-Wyeth Papers, AAA.

358 "I am hideously": HWH to Witter Bynner, Nov. n.d., 1939, Witter Bynner Papers, shelf mark, bMS Am 1891.28 (246); by permission of the Houghton Library, Harvard University.

"great reward": HWH, SWT, 33.

"He hated": ACHR to DTM, 10/23/94.

359 "The remarkable thing": BJW quoted in Richardson, "Andrew Wyeth," 68.

"He lives": *American Artist*, Sept. 1942, 18.

"This has been": AW in studio logbook, Dec. 1939, WFA.

"I had two": BJW to DTM, 12/16/93.

Unbeknown: AW and BJW to DTM, 1/5/97.

"He was quite broken up": NCW to HWH, Dec. 24, 1939.

360 "fortunate choice": NCW to Mr. and Mrs. Merle D. James, Dec. 11–12, 1939.

"my precious Betsy": AW to BJW, Mar. 9, 1940, quoted on *Self-Portrait: Snow Hill*. See also AW to BJW, Feb. 26, 1940: "Dearest, my dearest."

"floating": HWH to WEP, Dec. n.d., 1939, WEP Letters and Diaries.

"steady enough income": NCW to Mr. and Mrs. Merle D. James, Dec. 11–12, 1939.

"Everyone else": AW to DTM, 3/29/94.

a deal: BJW to DTM, 12/16/93: Andy refused the offer but kept it to himself for years. BJW: "Andy didn't tell me that for a while."

"I think he felt": BJW to DTM, 12/15/93.

"I don't think he wanted": AWMcC to DTM, 12/15/93.

Details of wedding ceremony: See Buffalo *Courier-Express,* May 16, 1940.

361 "sea of faces": BJW to DTM, 12/16/93.

tearful hug: BJW to DTM, 12/16/93. Afterward, no one discussed it, and it was never mentioned again.

"How many times": NCW to AW and BJW, June 10, 1940.

"I seem to see him": NCW to JWMcC, July 8, 1940.

"keen intuitions": NCW to Mr. and Mrs. Merle D. James, Dec. 11–12, 1939.

"energy": NCW to HWH, Nov. 18, 1940.

"academic": NCW to JWMcC, July 8, 1940.

362 BJW silent: HWH to Peter de la Fuente, videotaped interview, 1984.

"I was tough": BJW to DTM, 12/16/93.

"Why does he talk": Ibid.

"someday": NCW quoted by BJW to DTM, 12/15/93.

NCW felt Betsy recoil: See NCW to HWH, Aug. 16, 1940.

NCW's impressions of Nat and Caroline's house: See NCW to N and CPW, July 21, 1940, n.p.

"contentment and bliss": Ibid.

363 "A man": N quoted by ANW to DTM, 5/26/94.

"Mr. Wyeth"; "You really": CPW and NCW quoted by ANW to DTM, 5/26/94.

felt a burden lift: See NCW to HWH, July 27, 1940.

solidly against them: BJW to DTM, 5/14/93. In the beginning it was BJW who "resented him more than he resented me."

"worried us": NCW to HWH, Aug. 16, 1940.

365 "All this": BJW to DTM, 12/7/94.

"It is difficult": CPW in "Stouthearted Heroes of a Beloved Painter," courtesy of DCW.

convention of tall tales: See Osborne.

13 pounds birth weight: AWMcC to DTM, 5/15/93; 18 pounds at birth: AW to DTM, 5/15/93; 300 pounds: AW, quoted on video recording, *The Real World of Andrew Wyeth,* 1980.

"strict school": BJW to DTM, 12/16/93.

366 delivered *New York Times:* AW to DTM, 12/15/93.

"as if life": BJW, *The Wyeths,* 4.

so that she could "go": BJW to DTM, 12/16/93.

any intrusion: BJW to DTM, 3/29/94.

"*really* pleasing Pa": BJW to DTM, letter, 11/29/93.

"Ever so gradually": BJW, *The Wyeths,* 4.

"The chasm": NCW to HWH, Nov. 18, 1940.

368 "needless moment of terror": Usdin, 69–70, 237. For clinical information about therapeutic convulsions, Metrazol, camphor treatments, and electroconvulsive therapy (ECT), see Beck, 305–10.

eight: See NCW to HWH, Dec. 7, 1940, n.p.: "[Nat] has had eight treatments (metrazol) and will start in on more soon." See also NCW to GPW, Oct. 29, 1940, n.p.

"Like my father": See NCW to HWH, Aug. 16, 1940.

"fear complex": NCW to HWH and PH, Sept. 26, 1940, n.p.

368 Nat was gay: GWU to DTM, 6/13/97.

"My brother": NCW to N and CPW, June 12, 1941, n.p.

"invalidism": NCW to HWH and PH, Sept. 26, 1940, n.p.

"my mother's asthma": GWU to DTM, 6/13/97.

"unpleasant": See NCW to N, Nov. 7, 1940, n.p.: "These metrazol treatments are unpleasant things to talk of in detail so I won't go into the matter further."

369 Known around the valley: See "The Wyeth Heritage and the Rebel Carolyn," Philadelphia Sunday *Bulletin*, Jan. 10, 1979. Carolyn is called "the wildest of the Wyeths."

"I do what I damn want": CW quoted in Richard, B13. Carolyn's lifelong motto.

370 "incredibly imaginative sins": HWH in SWT, 43.

"to Andy with yarns": PH to NCW, n.d. 1944, WFA.

"perplexing problem": NCW to JHC, Mar. 1930, n.p., SA.

"extraordinarily upset": HWH to P, n.d., c. Jan. 6, 1932, Hurd-Wyeth Papers, AAA.

unresolved feelings about her father: BJW to DTM, 3/29/94. Margaret Handy, the family doctor who replaced Dr. Betts, later saw a copy of the report prepared by Carolyn's well-known psychiatrist, Esther Richards at Johns Hopkins, who believed that Carolyn Wyeth's trouble originated from feelings about her father.

"holdovers": NCW to N and CPW, June 12, 1942, n.p.

"fundamentally": NCW to AW, July 24, 1942, n.p.

"the delayed": NCW to HWH, Feb. 12, 1940, n.p.

April 30: FDD, 5/12/94, verified all dates against his 1941 datebook.

371 "Mrs. Francesco Delle Donne": See NCW to AW, June 23, 1941, n.p.

FDD's mother, Emilia [1882–1945], came from Rome, sewed lacework. His father, Francesco Sr. [1879–1953], was born in Naples.

"at cost": NCW to AW, July 24, 1942, n.p.

"Mister Big"; and all quotes re: courtship and marriage of FDD and CW: FDD to DTM, 5/12/94.

372 "especially becoming": NCW to AW, July 5, 1941, n.p.

"Carolyn's first entry": Ibid.

"Francisco": NCW to AW, Sept. 7, 1941, n.p.

"poor frugal husband": HWH to Jere Knight, n.d. 1941, Hurd-Wyeth Papers, AAA.

"Italian husband": HWH to Mary Phelps, Sept. n.d., 1941, WEP Letters and Diaries.

"pope's nose": FDD to DTM, 5/12/94.

373 "I found": Ibid.

"put food on the table": Ibid.

"Everything went": NCW to AW, July 5, 1941, n.p.

CW and FDD's living arrangements: See NCW to HWH, July 14, 1941, n.p.; HWH to Mary Phelps, Sept. n.d., 1941; see also FDD to DTM, 5/12/94.

"be [themselves]"; "did everything": FDD to DTM, 5/12/94.

"Do it": CW on *The Wyeths: A Father and His Family.*

five-dollar-a-week salary: See NCW to AW, July 24, 1942, n.p.

"In my family": FDD to DTM, 5/12/94.

374 wedding present: HWH to Mary Phelps, Sept. n.d., 1941.

"I pointed": FDD to DTM, 5/12/94.

FDD working on portrait: See NCW to AW, Sept. 7, 1941, n.p. "Francisco is working in the lower studio on a portrait study of little Peter, upon which he's been working for several weekends. I haven't seen it yet."

house on the Brandywine: See HWH to Mary Phelps, n.d., 1941.

struck by the change: See NCW to AWMcC and JWMcC, Aug. 3, 1941, n.p.; NCW to AW, Sept. 7, 1941, n.p.

begun painting again: See HWH to Mary Phelps, Sept. n.d., 1941.

"perfect condition": CW to NCW and CBW, Aug. 25, 1941: "Fran and myself are well. Dr. Flinn told me last week I am in perfect condition."

hot, humid: FDD to DTM, 5/12/94: CW's hospital bills begin on Nov. 22, WFA. Wilmington *Every Evening Journal:* Nov. 20, 1941, had seen a high temperature of 73 degrees; Nov. 21, high of 67 degrees; Nov. 22, high of 67 degrees, low of 30.

Wyeths had warned: FDD to DTM, 5/12/94: "Mrs. Wyeth had told me that Carolyn had been known to do a lot of sleepwalking."

fourteen feet: See HWH to Jere Knight, n.d., early 1942, Hurd-Wyeth Papers, AAA: "a fall of 14 feet."

CW's condition on arrival: Ibid.

cost of Carolyn's convalescence: Including private room and nurses, a total of $645. CW's hospital bills, WFA.

"A big tremor": FDD to DTM, 5/12/94.

375 Carolyn relieved: HWH to Jere Knight, n.d. early 1942, Hurd-Wyeth Papers, AAA. According to HWH, FDD acknowledged that he "couldn't afford marriage."

deliberately jumped: JBW to DTM, 5/14/93.

pushed her: FDD to DTM, 5/94: "People said I pushed her out the window."

"defenestrated": P to DTM, 4/23/93.

on CW's wedding night: Recollection of N, as told by DCW to DTM, 3/18/94.

"bombshells": HWH to Jere Knight, n.d., early 1942, Hurd-Wyeth Papers, AAA.

AW planned to wait: See AW to WEP, Sept. 22, 1942, WEP Papers, AAA.

"carrying": NCW to HWH, Jan. 21, 1943.

$200,000: See NCW to Lovell Thompson, Mar. 16, 1943, n.p., HMP.

$1 million: NCW to AW, June 14, 1944, n.p.

376 "principal battleground": MacLeish quoted in Bredhoff, iii.

"In common": NCW to HWH, July 24, 1942.

"The war": HWH to Jere Knight, n.d. 1942, Hurd-Wyeth Papers, AAA.

"What creative power": NCW to SW, May 29, 1943, n.p.

"suffocating": NCW to HWH, July 24, 1942.

"rush": NCW to HWH, Jan. 21, 1943.

"ugly": NCW to CPW, July 4, 1944.

Two-Headed

377 vote of 126 to 4: See RM to NCW, Apr. 11, 1940, WFA.

"To me": NCW to Gayle Hoskins, n.d., n.p., NCW Papers, DAM.

"These times": NCW to HWH, July 24, 1942.

"All sense": NCW to HWH, May 21, 1941.

378 Strained: See NCW to HWH, Oct. 19, 1942, n.p.: "I've got to hedge and scheme to meet the terrific tax burden of next year, besides insurances and other basic expenditures."

Coca-Cola ads: At $500 per painting. See Forbes Lithograph Mfg. Co. correspondence with NCW, Jan. 14, 1943–July 12, 1943, WFA.

"At my age": NCW to AW and BJW, Aug. 15, 1942, n.p.

378 "curtailed": NCW to SW, May 29, 1943, n.p.

"I am forced": NCW to F. F. Stevens, Oct. 1943; draft of letter, WFA.

hated to let it go: See NCW to HWH, June 8, 1945, n.p. *Walt in the Dory* hung in a small exhibition at Bowdoin College when NCW received an honorary degree in June 1945. The buyer, a Mr. McCain of Greenport, L.I., was an alumnus.

"escape": NCW to HWH, July 24, 1942.

379 "A birthday to me": NCW to CPW, Mar. 4, 1942.

"No. 1 danger point": Special instructions from Washington quoted by NCW to AW, July 5, 1941, n.p.

"It gives one": Ibid.

"What ability": NCW to HWH, Aug. 30, 1942, n.p.

380 nightmare: See Ibid.

"intense and wearing": NCW to SW, May 29, 1943, n.p.

"The 'old days' ": BJW, *The Wyeths*, 4.

"Last night": NCW to HWH, Sept. 9, 1936.

instructions: See NCW to AW, Sept. n.d., 1942, n.p.

"Again": NCW to AW, Sept. 20, 1942, n.p.

The Big Parade seemed to have been made for Andy. He had grown up to resemble the movie's hero, starry-eyed, lean Jim Apperson, played by John Gilbert. Like Jim, Andy had a brother working double shifts in a factory. He, too, was the apple of his mother's eye. And as war broke out, he, like Jim, was secretly in conflict with an autocratic father whom he overtly wished to please. In the Apperson mansion, when newspaper headlines blare the news from Europe—"WAR DECLARED . . . Tremendous rush for enlistment"—Jim's doting, gray-haired mother wrings her hands over her favorite son's fate. But as Jim waits before enlisting, he explains, "I have enough war on my hands . . . with Dad."

"This film": AW in *Metaphor: King Vidor Meets with Andrew Wyeth,* King Vidor Papers, AAA.

four or five times a year: Ibid. "I've seen that film about one-hundred-and-eighty times—no exaggeration."

images in his art: Compare scenes from King Vidor's *The Big Parade* (1925) with AW's *Winter, 1946* (1946), *The Patriot* (1964), and *Afternoon Flight* (1970).

381 "You realize": NCW to AW, Sept. 20, 1942, n.p.

his best yet: AW quoted by NCW to HWH, Oct. 1, 1942, n.p.

He was touched: See NCW to AW, Sept. 20, 1942, n.p.

Nat's wartime experience: See N to Jill Johnson, interview 1, 38–42. See also NCW to HWH, July 24, 1942.

tried to conceive: See N on *The Wyeths: A Father and His Family.*

resolved to adopt: ANW to DTM, 7/11/95.

"out of the blue": See N on *The Wyeths: A Father and His Family.*

description of Cedar Road: ANW to DTM, 7/11/95.

"immersed": CPW to NCW and CBW, July 24, 1941, courtesy of ANW.

black-market heating oil: See N to Jill Johnson, interview 1, 42–43.

CPW's fears: ANW to DTM, 5/26/94.

"surrounded with noisy": CPW to NCW and CBW, July 24, 1941, courtesy of ANW.

382 "They all three": APLA to DTM, 7/18/97.

no intimate friendships: See ANW to DTM, letter, 9/20/95; confirmed by APLA, 7/18/97: None of the Pyle sisters made close friends outside the family.

Nat's gregariousness: DCW to DTM, 3/18/94.

383 "Jake Summers!": Ibid.

model and pennant: ANW to DTM, 5/29/94. See also CPW's photograph album, 1938.

"Oh hell!": CPW to NCW and CBW, July 24, 1941, courtesy of ANW.

"nostalgic regrets": NCW to CPW, June 16, 1943, n.p.

clockwork: ANW to DTM, 5/26/94.

CPW clothing and pregnancy: BJW to DTM, 12/15/93.

CPW scrapbooks: Courtesy of ANW.

"on her high horse": Ellen Pyle Lawrence quoted by APLA to DTM, 7/18/97.

"prevailing hum": NCW to N and CPW, Sept. 28, 1942, n.p.

384 "pangs": NCW to CPW, May 19, 1943.

Thomas Hardy: See NCW to N and CPW, June 12, 1942, n.p.

"intellectual": BJW to DTM, 12/15/93.

CPW had had exactly one year of formal education—ninth grade at Wilmington Friends School. Her sister Ellen had tutored her. See ANW to DTM, 7/11/95.

"not even the newspaper": NBS to DTM, 11/29/93.

honored and moved: NCW to HWH, Nov. 18, 1940, n.p.

"She argued with him": DCW to DTM, 3/15/98.

"has been done": Lovell Thompson to NCW, Jan. 17, 1940, HMP, shelf mark, bMS Am 1925 (1962), by permission of Houghton Library, Harvard University.

"do something": NCW to Lovell Thompson, Jan. 22, 1940, n.p., HMP, Ibid.

"My mother": NCW to Lovell Thompson, Jan. 6, 1940, HMP, Ibid.

385 relented: See Lovell Thompson to NCW, Feb. 27, 1940, HMP, Ibid.

calls our attention to voice: Johanna Spyri, *Heidi*, illustrated by Jessie Willcox Smith, 52.

"Yes": NCW to WEP, Sept. 1, 1937, WEP Letters and Diaries.

386 "I decided": CBW quoted by BJW to DTM, 12/15/93.

CW's convalescence: See ABB to CBW, Mar. 25, 1942, WFA.

Andy's word as final: See NCW to HWH, June 8, 1944.

"How I shall": NCW to HWH, July 24, 1942.

"slowly pushing": NCW to AW, Aug. 12, 1942, n.p.

"How I could": NCW to AW and BJW, Aug. 15, 1942.

painful period: AW to DTM, 12/16/93.

greater talent in drawing: AW to DTM, 12/19/93: "His drawings must be empha sized." AW revered N.C.'s "quality of being able to draw any animal or human being in any position. It would just come out on the page. I don't know of any artist in the whole history of the world who could do this." See also AW to DTM, 2/1/94: "Winslow Homer, N. C. Wyeth, Thomas Eakins, Albert Ryder, and Edward Hopper. I think he belongs in that group."

"a shit": AW to DTM, 2/1/94.

387 "I dream again": NCW to AW, Sept. 20, 1942, n.p.

"might prove": NCW to HWH, Oct. 1, 1942.

Wounded, confided: See NCW to AW, Sept. 23, 1942, n.p.; NCW to N and CPW, Sept. 28, 1942, n.p.

"It is highly": NCW to CPW, Apr. 4, 1943.

The anthology was one of the few books in his career that NCW allowed himself to take pleasure in. The seventeen paintings survived the process of reproduction and

retained for NCW their original feeling. He was thrilled by Houghton Mifflin's first edition. See NCW to Lovell Thompson, Oct. 17, 1940, n.p., HMP, shelf mark bMS Am 1925 (1962), by permission of the Houghton Library, Harvard University.

387 "private and secret": Johnson and Scott, 102.

388 painted *Jack the Giant-Killer:* See NCW to Lovell Thompson, June 25, 1939, n.p., HMP.

characteristics and expressions of Nat and Caroline: I am indebted to David C. Wyeth for this observation, which he first made known in his essay "My Family's Picture," *Art & Antiques,* Feb. 1994.

"a sure sign": Ibid., 30.

"insisted": NCW to AWMcC, Sept. 12, 1944, n.p.

"They both look": NCW to HWH, Oct. 19, 1942, n.p.

390 AW & NCW collaborations: See Mortenson. See also BJW notation in first Oval Office scrapbook: "Pa helped him with The Nub illustration." *The Nub,* by Robb White III, with illustrations by Andrew Wyeth (Boston: Little, Brown, 1935). The dust jacket incorrectly identified "the first book illustrations done by Andrew Wyeth, who is the son of the famous artist."

$200, AW, $100, NCW: NCW to CBW, June 26, 1938, n.p.

intrude: See AW to Lovell Thompson, telegram, Apr. 24, 1939; AW to Lovell Thompson, May 31, 1939; AW to Lovell Thompson, Apr. 17, 1943, HMP.

"not normal times": Robert McIntyre to AW, May 28, 1941, Macbeth Gallery Records, AAA.

Forest and the Fort tempera and episode: See AW to DTM, 12/16/93; BJW to DTM, 12/16/93; AW and BJW to DTM, 2/1/94.

391 AW unrealistic about money: See NCW to HWH, Jan. 11, 1941, n.p.: "He has an alarming habit of ignoring or destroying bills—out of sight, out of mind, out of existence!"

"You are the only": AW to NCW quoted in Meryman, *Secret Life,* 114.

"full charge of business": BJW to Hazel Lewis, Oct. 22, 1942, Macbeth Gallery Records, AAA.

392 "All of us": Ibid.

Macbeth's acknowledged: See Hazel Lewis to BJW, Oct. 28, 1942, Macbeth Gallery Records, AAA.

avoided asking: See NCW to AW, Sept. 15, 1942, n.p.

"fresh mind": See NCW to CPW, Apr. 4, 1943.

Delaware Avenue Girl

393 CPW's commentary and details about Ellen Bernard Thompson, Walter Pyle, and Anna Jackson Pyle can be found in CPW, "Scenes of My Childhood."

a good dime novel: EBTP quoted in CPW, "Scenes of My Childhood."

one wish: see EBTP, vertical file, Delaware Room, the Wilmington Library; EBTP quoted in clipping from unnamed local newspaper, Nov. 11, 1934: "My one wish at this time was to make painting my life work, but while I was studying at the Howard Pyle summer school at Chadds Ford I met his younger brother Walter."

Walter Pyle and Anna Jackson were married Oct. 12, 1885. (Anna Jackson, born May 2, 1852, in Philadelphia.) Their son, Gerald Jackson Pyle, was born in Wilmington on

Apr. 2, 1893. Walter Pyle and Ellen Thompson were married Jan. 23, 1904. Dates courtesy of John Bound Wyeth.

postpartum depression: DCW to DTM, 3/21/96. CPW's memoir does not identify the cause of Anna Jackson Pyle's postpartum "insanity." I'm grateful to David C. Wyeth for leading me to the information about psychotic postpartum depression.

"He was wonderful": Katherine Ashton Thompson quoted in CPW, "Scenes of My Childhood."

394 rugged and kindhearted: Ibid.

395 hanged herself: Ibid. See also Brandywine Cemetery records, which confirm that Anna Jackson Pyle's death was a suicide: APLA to DTM, 7/18/97.

"Mother barely retained": CPW, "Scenes of My Childhood." See also APLA to DTM, 7/18/97: After Walter's death Ellen Pyle went into a depression.

Gerald Jackson Pyle, born in Wilmington, Apr. 2, 1893. Graduate of Wilmington Friends School; Princeton, 1914; Columbia, 1916. Second lieutenant, USMC, 1917; served in Haiti; discharged 1919 as captain. Lecturer in philosophy, Columbia U., 1919–20. "In business" in Greenville, 1920. Courtesy of John Bound Wyeth.

Gerald scandalized: Recollection of Ellen Pyle Lawrence, as told by DCW to DTM, letter, 4/7/96. Confirmed by APLA to DTM, 7/18/97.

"untouched for fifteen years": CPW, "Scenes of My Childhood," 10.

"broadly painted": Norman Rockwell to Ellen Pyle, 1927, quoted in Elzea and Hawkes, 196.

396 "not a subject": APLA to DTM, 7/18/97.

Ellen did not know: DCW to DTM, 12/16/94; APLA to DTM, 7/18/97. Ellen Pyle Lawrence was born in 1907; Walter died before her birthday in 1919.

"The terrible thing": Ellen Pyle quoted in CPW, "Scenes of My Childhood."

"faintly": Recollection of CPW, as told by ANW to DTM, 5/26/94.

"I have always": CPW, "Scenes of My Childhood."

CPW's impressions of George Rhoads: "Scenes of My Childhood."

loathed the quiet: See Frances Rhoads letters, collection of ANW.

CPW dreaded appearances: "Scenes of My Childhood." See also APLA to DTM, 7/18/97: "They all dreaded it."

397 "Yes, we have": NCW to CPW, May 19, 1943.

"Carolyn": See NCW to HWH, July 24, 1942.

"Pa": NCW to CPW, Feb. 13, 1944.

"C.": NCW to CPW, Apr. 4, 1943.

"transcendent instincts": NCW to CPW, Feb. 13, 1944.

"irresistible": NCW to N and CPW, Oct. 15, 1943.

worried about Newell: See NCW to AWMcC, Sept. 12, 1944, n.p.: "He's quite aggressive and inclined to be selfish, according to Caroline, and she's quite concerned how to handle these traits."

"dismayed": NCW to N and CPW, Oct. 15, 1943, n.p.

398 "the beautiful": NCW to N and CPW, Oct. 19, 1943.

"so much 'Wyeth' ": NCW to N and CPW, Nov. 10, 1942.

one Sunday off since November: See NCW to SW, May 29, 1943, n.p.

"third front": See Jeansonne, 20.

guard duty: N to Jill Johnson, interview, 1, 38–42.

"young woman abandoned": ANW to DTM, 5/26/94.

398 cooled: Recollection of CPW, as told by ANW to DTM, 7/11/95.
"utter surprise": NCW to CPW, Aug. 17, 1943.
"even into": NCW to N and CPW, Oct. 15, 1943.

399 "Delaware Avenue girl": NCW to CPW, Oct. 12, 1944.
"My dream": NCW to N, n.d. 1943, n.p.
"little traits": NCW to HWH, Dec. 30, 1940, n.p.: "She boasts, you know, that a watch is one thing she would never wear in her life."
mischievous: ANW to DTM, 5/26/94.
"common": DCW to DTM, 3/18/94.
hold people: BJW to DTM, 12/15/93.
"impassioned care": NCW to CPW, June 16, 1943, n.p.
"good feeder": ANW to DTM, 5/26/94.
idealized mother: See NCW to HWH, July 24, 1942.
"superior intuitions": NCW to CPW, July 4, 1944.
"top the list": NCW to CPW, Oct. 12, 1944, n.p.
sensitive, merry: APLA to DTM, 7/18/97, et al.
"volatile": DCW to DTM, 3/18/94.
"very tense": ANW to DTM, 7/11/95.
fiery: BJW to DTM, 12/15/93.
afraid: ANW to DTM, 5/26/94.
"an edge": ANW to DTM, 7/11/95.
"could break": ANW to DTM, 5/26/94.

400 "richly constituted": NCW to CPW, Oct. 12, 1944.
"Am I getting": NCW to CPW, May 19, 1943.
army war art unit: See Sidney Simon, Capt., Army Corps of Engineers, in charge of organizing war artists, to DTM, 9/27/93.
Otto's pelvic syndrome: See NCW to HWH, Feb. 4, 1943; NCW to ERW, Dec. 5, 1943; see also BJW to DTM, 12/16/93.
second chance: See NCW to HWH, Feb. 4, 1943, n.p.
Third offer, to join an ice-breaking naval ship in Alaska: AW to DTM, 2/1/94. As NCW had done in 1918, Andy took himself to the top of a favorite rock on Rocky Hill and sat looking out over the valley, thinking it over. Unlike N.C., however, Andy took only an hour to return with a decision.
"This pleases": WEP, Diary, Mar. 14, 1943, WEP Letters and Diaries.
"Andy offers": NCW to CPW, May 19, 1943.

401 chemicals on his shoes: ANW to DTM, 5/26/94.
"The old valley": NCW to CPW, July 23, 1943.
"Never before": NCW to CPW, July 4, 1944, including n.p.

402 "My hopes": NCW to CPW, Oct. 12, 1944.
to Cedar Road: NCW to HWH, Oct. 24, 1944, n.p.

An Open Secret

403 Nat's absences: See NCW to CBW, July 24, 1945, n.p.; July 27, 1945, n.p.
commented on: WEP, Diary, Mar. 24, 1945: "Saw Caroline + interior of old man John McVey's house—great charm—Nat not home—v. attractive children."
"He drives himself": NCW to HWH, June 8, 1945, n.p.
moderate temperature: NCW to CBW, July 28, 1945, n.p.

astute observations: See CPW, Scrapbook: "Newell talks a great deal and one night at dinner said, 'Neighbors are what knock on the door and say, "Hello, can I come in." ' Pretty good description for two-and-a-half years."

"an unusually bright": See NCW to SW, June 22, 1915, n.p.: "I shall miss his enthusiastic 'Mornin' Mr. Wythe' and his occasional errand running. It was good to know him. John McVey is badly broken up over the loss."

404 "You must be"; "over and over": N on *The Wyeths: A Father and His Family*.

"All seems": NCW to CBW, July 27, 1945, n.p.

"Ma enjoys her": NCW to HWH, June 8, 1945, n.p.

"I never liked": HWH quoted by ANW to DTM, 7/11/95: "They never got along well. After [Caroline's] death, Henriette said, 'I never liked that girl.' " See also BJW to DTM, 12/15/93.

Carolyn did not trust: BJW to DTM, 12/16/93.

"Caroline is often confused": "Pa Wyeth and His Clan," 40.

CW resented: FDD to DTM, 5/12/94.

405 "The rest": AWMcC to DTM, 12/15/93.

kept Newell and Howard apart: AWMcC to DTM, 12/15/93; BJW to DTM, 12/15/93.

"difficult to manage": NCW to HWH, June 8, 1945, n.p.

"rather relieved": HWH to DTM, 10/24/94.

"She averted": ACHR to DTM, 10/24/94.

"It's impossible": NCW to HWH, June 8, 1945, n.p.

separate bedrooms: AW and BJW to DTM, at the Homestead, 3/29/94; see also BRM, *Carolyn Wyeth, Artist*, 9.

CW kept house: See NCW to CBW, July 28, 1945, n.p.: "Carolyn continues consistently in Ma's good work and her making of my bed is just about perfect."

present himself to CW: See Meryman, *Secret Life*, 218–19.

406 "been down to": NCW to AWMcC, Aug. 1, 1945, n.p.

"You *betcha*": NCW to CBW, Aug. 22, 1945, n.p.

"express her": NCW to Maxwell Perkins, Aug. 5, 1945, n.p., SA, Manuscripts Division, Dept. of Rare Books and Special Collections, Princeton University Library. Published with permission of the Princeton University Library.

"To Newell": CPW, collected poems, private collection, New York City.

407 "really alive": NCW to Maxwell Perkins, Aug. 15, 1945, n.p., SA.

"privileged to be": CPW in "Stouthearted Heroes of a Beloved Painter," courtesy of DCW.

"C's poems": NCW to CBW, Aug. 9, 1945, n.p.

408 weight depressed her: AWMcC to DTM, 12/15/93.

166 pounds: See NCW to HWH, Oct. 19, 1942, n.p.

subject of concern: See Forrest Wall to NCW, Aug. 5, 1945, WFA.

"the *real* status": NCW to AW, July 30, 1945, n.p.

"disparages": NCW to CBW, July 28, 1945, n.p.

"Caroline's verse": NCW to AWMcC, Aug. 1, 1945, n.p.

"The creation": NCW to Maxwell Perkins, Aug. 5, 1945, n.p., SA, Manuscripts Division, Dept. of Rare Books and Special Collections, Princeton University Library. Published with permission of the Princeton University Library.

autobiography: See Maxwell Perkins to NCW, Oct. 17, 1939, SA, Ibid. Perkins believed that Wyeth's letters to JHC proved he could write; he proposed a book of some 40,000 words, an artist's autobiography, beginning in boyhood: "The aim

would be to explain simply the elements of how an artist worked, and what his life was like." Houghton Mifflin had approached NCW with a similar project. But with what NCW still hoped to accomplish in painting, he doubted he would ever write a word. See NCW to Ferris Greenslet, Nov. 12, 1940, n.p., HMP.

409 "jealousy": BJW to DTM, 12/15/93.

"embarrassed": *27 Musical Portraits by Ann Wyeth,* liner notes.

patterned her compositions: JDMcC to DTM, 10/31/94: "All her compositions followed this pattern. They were portraits of her father. He was her Medici. She composed for him and about him."

"You've got": NCW quoted by AWMcC to DTM, 12/15/93.

piano pieces: See *27 Musical Portraits by Ann Wyeth,* BRM; see also "Ann Wyeth McCoy Plays Some Original Compositions," Coatesville *Record,* n.d. 1940.

JWMcC's health and work: See NCW to AWMcC, Aug. 1, 1945, n.p.; see also BRM, *John W. McCoy: A Retrospective View,* 16.

410 "Undoubtedly the author": Maxwell Perkins to NCW, Aug. 8, 1945, SA, Manuscripts Division, Dept. of Rare Books and Special Collections, Princeton University Library. Published with permission of the Princeton University Library.

"real power": Wheelock quoted by NCW to CBW, Aug. 15, 1945, n.p.

"All this means": NCW to AW and BJW, Aug. 11, 1945, n.p.

"tremendously stimulated": NCW to Maxwell Perkins, Aug. 15, 1945, SA, Manuscripts Division, Dept. of Rare Books and Special Collections, Princeton University Library. Published with permission of the Princeton University Library.

"live target": NCW to CPW, July 4, 1944.

"If he's unhappy": HWH to Peter de la Fuente, videotaped interview, 1984.

"real kidder": APLA to DTM, 7/18/97.

411 scene in studio: Recollection of N in 1985, as told by DCW to DTM, 5/24/94. See also ANW to DTM, 5/26/94.

"the thing": JDMcC to DTM, 10/31/94.

"It was nothing": BJW to DTM, 12/15/93, 2/1/94.

"I'm not saying": AW to DTM, 2/1/94.

"master vamp": AW to DTM, 3/29/94.

"Caroline had": AWMcC to DTM, 12/15/93.

412 "no rancor": JKW to DTM, 3/29/94.

started the talk: BJW to DTM, 2/1/94.

"feeling very well": NCW to CBW, Aug. 15, 1945, n.p.

"dead period": NCW to AW, Aug. 16, 1945, n.p.

"I know this": NCW to CBW, Aug. 22, 1945, n.p.

413 "a postal": NCW to HWH, June 8, 1945, n.p.

"Andy, I've done": Recollection of CPW, as told by ANW to DTM, 5/26/94.

poetry reading: See NCW to N and CPW, Sept. 2, 1945, n.p.

415 "Andy was most": Ibid.

"enormous potentiality": NCW to HWH, Sept. n.d., 1945.

"squirmy": NCW to HWH, June 8, 1945, n.p.

"I told him": AW to DTM, 12/15/93.

insert some pictures: See Moser, 310.

"I have returned": NCW to AW, Sept. 10, 1945, n.p.

"properly": NCW to AW, Oct. 1, 1945, n.p.

416 *Art Digest:* Quoted by NCW to AW, Oct. 15, 1945, n.p.

sent his love: Ibid.

thanking Carol: AWMcC to DTM, 12/15/93.

"I shall try": NCW to a Mr. Funk, n.d., annotated, WFA: "Found on N. C. Wyeth's desk at the time of his death."

The night before: AWMcC to DTM: 12/15/93.

NCW copy of *The Robe*, WFA. CBW noted on the flyleaf: "This book Convers was reading at the time of his death, he was to illustrate it the coming year of 1947 [*sic*]. The marker he put in the book." The marker remained at page 176.

417 "Good-bye, darling": ANW to DTM, 5/26/94.

sixty degrees at nine: Wilmington *Morning News*, Oct. 20, 1945: measurement taken Oct. 19 at 8:00 A.M.

418 "Newell, look": BJW, *The Wyeths*, 844.

Reports: *Wilmington Journal–Every Evening:* a steam engine and two passenger coaches. *New York Times:* westbound freight train. *Philadelphia Evening Bulletin:* a Pennsylvania mail train. Karl Kuerner, Jr. (eyewitness): the milk train.

too late to stop: Norman R. Strickland, engineer, to state police: "Too late to come to a complete stop." Quoted in *Philadelphia Evening Bulletin*, Oct. 22, 1945, 1.

"practically tied": *Wilmington Journal–Every Evening*, Oct. 19, 1945, 1.

time of collision: Ibid.

143 feet: Ibid.

tossed against a signal control: *Wilmington Morning News*, Oct. 20, 1945, 1.

419 a doctor: Dr. Duer Reynolds of Kennett Square.

N.C.'s body crushed, Newell thrown free: *Philadelphia Evening Bulletin*, Oct. 22, 1945, 1. Meanwhile, *Wilmington Journal–Every Evening*, Oct. 19, 1945, 1, had reported that Newell had been thrown into the backseat; NCW remained where he was. The *Evening Bulletin* account seems the more reliable because of its timing and because it makes more sense.

large crowd: *Wilmington Journal–Every Evening*, Oct. 19, 1945, 1.

contents of pockets: "This is the photograph of Howard Pyle that was found in N. C. Wyeth's wallet after he was killed on Oct. 19, 1945," WFA. Dollar bill: AWMcC to DTM, 12/15/93. Acorns: JKW to DTM, 3/29/94.

Allan Lynch: AW to DTM, 12/15/93. He would become the subject of AW's *Winter, 1946* (1946).

could not look at N.C.: ANW to DTM, 5/26/94.

difficult pregnancy: PH to CBW, Nov. 2, 1945, WFA.

JWMcC incoherent: ANW to DTM, letter, 9/20/95.

Nat and Caroline: Recollection of Nat in 1985, as told by DCW to DTM, 5/24/94.

420 "He had many": *Washington Evening Star*, Oct. 20, 1945, editorial page.

After N.C.

421 TROOPERS BELIEVE: *Wilmington Journal–Every Evening*, Oct. 19, 1945, 1.

overcautious driving: ANW to DTM, 5/26/94.

first version: See BJW, *The Wyeths*, 844.

second version: AW to DTM, 5/15/93; N on *The Wyeths: A Father and His Family*.

"tried not to think": N on *The Wyeths: A Father and His Family*.

third version: BJW to DTM, 12/15/93; AW to DTM, 12/15/93.

422 "could not be timed": *Philadelphia Evening Bulletin*, Oct. 22, 1945, 1.

422 Bockius version: WLB to DTM, 5/25/94.

Among the Wyeths: ANW to DTM, 5/26/94. See also Jean Wyeth, DCW et al. NW's death, Oct. 27, 1954; suicide attempts in previous years; shame at homosexuality: GWU to DTM, 6/13/97. Details of crash in highway repair zone, attributed to eyewitnesses: *Detroit News,* Oct. 28, 1954.

Howard would strongly suspect: DCW to DTM, 3/21/96.

encouraged by the family; preparing sample chapter for Doubleday: See WEP to David [Anthony], n.d., late 1946, WEP Letters and Diaries. Elma M. Simpson, compiler of an early NCW bibliography, stated in her research notes, "The biography of N. C. Wyeth is now being written by his friend Mr. William E. Phelps, of Guyencourt, Delaware." NCW Papers, DAM.

423 "deeper than appeared": WEP to his editor at the Atlantic Monthly Press, June 6, 1963, WEP Papers, AAA.

accident: See NCW's Certificate of Death; file no. 84880, registered no. 116, Pennsylvania Division of Vital Records: Under "other conditions" in the medical certification column, the number 169 is listed. Of three possible choices—homicide, suicide, accident—the coding of the manner of NCW's death is consistent, according to research done at my request by Walter Hurst of the Medical Examiner's Office, Delaware County, Pa., with the findings of the coroner, Margaret H. Ward. Walter Hurst to DTM, 3/13/97: "One-sixty-nine means it was an accidental death."

CPW suicidal: ANW to DTM, 5/26/94.

"desperate person": APLA to DTM, 7/19/97.

the only man CPW ever really loved: CPW quoted by AWMcC to DTM, 12/15/93.

"a miracle": NCWIII to DTM, 2/8/97. See telegram dated 10/14/46 in NCWIII's baby book.

Rachmaninoff concertos: DCW to DTM, 3/18/94. See also DCW, "My Family's Picture," 30; and N to Jill Johnson, interview 2, 45.

in the shadow: See ANW to DTM, 5/26/94: After studying home movies of family life before and after the accident, ANW remarked that while Newell really was a happy child, "none of us look quite so bursting with happiness."

424 On CPW's bureau, photograph of NCW at Bowdoin College receiving his honorary degree: ANW to DTM, 5/26/94.

a rebellious period: DCW to DTM, 10/13/96.

"Will I be alive": I am indebted to ANW for this account of CPW's friendship with Karen Murphy. ANW to DTM, letter, 9/20/95.

fourteen killed: See *Wilmington Journal–Every Evening,* Sept. 19, 1973.

account of CPW's death: See *Wilmington Journal–Every Evening,* Sept. 19, 1973. See also DCW to DTM, 3/18/94.

"For Nat": WEP to HWH, Sept. 28, 1947, WEP Letters and Diaries.

425 "America's First Family in Art": *Today* show, NBC 12/7/95; see also the "famously artistic family," in Carolyn Wyeth, obituary, *New York Times,* Mar. 4, 1994.

"The Wyeth Who Doesn't Paint": See Martin.

"a true tolerance": HWH to Peter de la Fuente, videotaped interview, 1984.

"lost control": N quoted in Meryman, *Secret Life,* 219.

Nat's death: JKW to DTM, 3/29/94.

"I felt Pa": HWH quoted by ACHR to DTM, 10/23/94.

doubted: HWH to Witter Bynner, n.d., Witter Bynner Papers, Shelf mark, bMS Am 1891.28 (246), by permission of the Houghton Library, Harvard University.

426 "Right now": JWMcC to Ronald Thomason, Jan. 16, 1967, Ronald Thomason Papers, AAA.

Peter Hurd's tax trials: John W. Bassett, Esq., to DTM, 2/26/97.

"He is always there": ACHR to DTM, 10/23/94.

"We all": FDD to DTM, 5/12/94.

427 never touched a paintbrush again: JBW to DTM, 3/26/93.

"character": NCW to HZW, Aug. 2, 1917.

CW's funeral: See DTM, Journal, April 1994.

"It was worth it": AWMcC to DTM, 12/15/93.

428 "His death": AW to DTM, 12/16/93.

"It gave me a reason": AW on *Self-Portrait: Snow Hill.*

429 "in Switzerland": AW quoted in Meryman, *Andrew Wyeth,* 53.

unselfishness: AW to DTM, 12/16/93: "We got a lot from him, and I still don't think it was worth it. I wish it had gone into his painting. But he couldn't help himself. I felt we were very selfish. Kids *are* selfish. And he gave. I don't know what we gave back. I really don't. And I feel I have to do something to justify what this great man gave us."

430 never learned to drive: See WEP to HWH, Sept. 28, 1947.

"unlike other grandmothers". HWH to WEP, Nov. 29, 1945, WEP Letters and Diaries.

See Carolyn Bockius Wyeth, obituary, *New York Times,* Mar. 16, 1973.

BIBLIOGRAPHY

Unpublished Sources

Manuscript Collections and Private Papers

Ashley, Clifford W. Papers, 1903–1964. Archives of American Art. Smithsonian Institution. Correspondence with NCW, 1908–9.

Brandywine River Museum, Chadds Ford, Pa. Library holdings include complete card-file records from Charles Scribner's Sons art department, which provide important information about NCW's work for *Scribner's Magazine* and the Scribners Illustrated Classics.

Bynner, Witter. Papers. Houghton Library. Harvard University. Forty-six letters from Henriette Wyeth Hurd to Bynner revealing HWH's feelings about her life and family in Chadds Ford and San Patricio, N.M., 1936–1942, 1948–1964.

Gray Herbarium Archives. Botany Libraries. Harvard University. Records and official history of the Harvard Botanic Garden showing actual standing of NCW's maternal grandfather in the years 1855–1864.

Harpers Magazine Archive. Pierpont Morgan Library. New York City. Includes sixty-six letters from Howard Pyle to his editors, 1890–1895, 1907, commenting on work, methods, students, and his takeover of the art editorship at *McClure's Magazine*, 1906.

Harvard University Archives. Pusey Library. Harvard University. Records of the Faculty and Administrative Board of the Lawrence Scientific School, notable for the absence of Denys Zirngiebel. Academic record of Stimson Wyeth, Class of 1913.

Houghton Mifflin Papers. Houghton Library. Harvard University. Previously unconsulted collection of some 162 letters from NCW to his editors, 1918–1944; invaluable for the light they shed on NCW's attitude toward himself as a professional illustrator. Also 254 letters to NCW from his editors, as well as in-house memoranda about NCW. In addition, small collection of letters to and from Andrew Wyeth and the editors concerning illustration jobs between 1938 and 1943; and 26 letters from Howard Pyle to the editors, 1891–1900.

Howells Papers. Houghton Library. Harvard University. Twenty-one letters from Howard Pyle to William Dean Howells, 1890–1895.

Hurd, Peter, and Henriette Wyeth. Papers, 1917–1989. Archives of American Art. Smithsonian Institution. Extensive collection of useful material, including intimate correspondence between Henriette Wyeth Hurd and Paul Horgan, 1926–1988; and Peter Hurd and Paul Horgan, 1927–1979.

Imperial War Museum. London, England. Map collection contains detailed plans showing position and nature of bombs dropped by German airships and aircraft within the Metropolitan Police District of London, 1915–1918. Along with death certificate obtained through the Office of Population Censuses and Surveys, St. Catherines House, Lon-

don, the Imperial War Museum map collection provides the only extant information to
determine the true cause of death of George Bockius, Mar. 10, 1918.

Johnston, Mary. Papers, 1898–1936. University of Virginia Library. Brief correspondence
between illustrator and author reveals that both were equally committed to pushing the
limits of illustration as an art form in *The Long Roll* (1911) and *Cease Firing* (1912).

Macbeth Gallery Papers. Archives of American Art. Smithsonian Institution. Complete,
detailed correspondence between Andrew Wyeth and Robert Macbeth, Jan. 5,
1937–Nov. 8, 1939; between NCW and Robert Macbeth, Sept. 29, 1937–Apr. 11, 1940; and
between AW and Betsy Wyeth and the gallery, May 28, 1941–1953. Including thorough
business and sales records, exhibition catalogs, guest lists, photographs.

National Archives and Records Administration, Washington, D.C., Records of the Office of
the Chief of Engineers contain heretofore unconsulted material showing the War
Department's high regard for NCW's services and NCW's reticence to serve as an artist
with the rank of captain in World War I. Also, NCW's recommendation for Pitt
Fitzgerald and the new camouflage unit. Records of the Military Intelligence Division,
although incomplete, show NCW's efforts to have SW transferred to military intelli-
gence branch in July 1918.

Needham Free Public Library, Needham, Mass. Archives in the Genealogical Room include
town reports, directories, personal memoirs on Needham history and on Zirngiebels,
Wyeths, and other local Swiss-American families. N. C. Wyeth Collection in N. C.
Wyeth Room includes reference files, original works, and complete collection of books
illustrated by NCW.

Oval Office Collection, Chadds Ford, Pa. The complete, unedited collection of NCW's let-
ters, 1891–1945, are the bedrock of this book. The published version of NCW's letters,
The Wyeths, although authoritative, is now unavoidably incomplete. Even in 1970 Betsy
James Wyeth was restricted by an incomplete record; working from a total of some 1,500
letters then available, BJW selected and edited letters numbered 1–666, omitting con-
siderable material from a massive record. Since then four significant unpublished col-
lections have become available for study: the love letters of NCW and Carolyn
Brenneman Bockius (1904–1906); family correspondence of Carolyn Bockius Wyeth
(1904–1970); business correspondence of NCW, including 24 letters from NCW to
Walter S. Brown, Brown & Whiteside, Architects, Wilmington, Del.; and an invaluable
collection of NCW's personal letters, 1906–1944, purchased at auction by Andrew and
Betsy Wyeth, Nov. 1989.

Also in the Oval Office at the time of my research: indispensable collection of CBW's letters,
1904–1915, 1917–1970; NCW's western diaries, 1904; NCW's working copy of *Treasure
Island* (with illustrations by Walter Paget, New York: Charles Scribner's Sons, 1909);
AW's Ledger, winter 1938–winter 1947, and Scrapbook, 1936–1941; and exhibition cata-
logs for the Wyeth family of artists, 1937 to the present.

Phelps, William E. Papers. Archives of American Art. Smithsonian Institution. A primer to
any study of the Wyeths of Chadds Ford. Intimate correspondence with Andrew
Wyeth and Betsy James Wyeth, 1939–1969; of value especially for AW's feelings toward
the draft in World War II and BJW's observations about life in a multigenerational
family of painters.

Phelps, William E. Letters, 1930–1965; and Diaries, 1940–1956. Private collection, New York
City. Includes six previously unconsulted letters of NCW, 1935–1939; twenty-four letters
of Henriette Wyeth Hurd, 1930–1955; eight letters of Andrew Wyeth, 1938–1965; four
letters of Betsy James Wyeth, 1950–1960; and Phelps's intimate observations of the

Wyeth family in daily diaries, invaluable for the light they shed on family life across two generations at midcentury.

Pyle, Howard. Papers. Helen Farr Sloan Library, Delaware Art Museum, Wilmington, Del. Correspondence, lectures, scrapbooks. Including the very important Richard Wayne Lykes collection of personal correspondence to and from Pyle students, providing detailed accounts of life at the Howard Pyle School of Art, 1901–1905. Also, Allen Tupper True's notebooks, Oct. 1903–Jan. 1906, compiled immediately following Howard Pyle's lectures; and correspondence between True and NCW. Ethel Pennewill Brown's and Olive Rush's notes from Howard Pyle's Monday night composition lectures, June–Nov. 1904.

Pyle Collection. Paul Preston Davis, West Chester, Pa. A sizable private archive devoted to the works, life, and genealogy of Howard Pyle, helpful for the *McClure's* period and for time lines and charts showing development of the C & W Pyle Company, Wilmington, Del.

Schoonover, Frank Earle. Papers. Delaware Art Museum, Wilmington, Del. Correspondence to and from NCW, 1918. Scrapbooks depicting life at the HPSA, 1901–1906.

Scribner Archive. Manuscripts Division, Department of Rare Books and Special Collections. Princeton University Library. Princeton University. NCW's invaluable correspondence with Joseph Hawley Chapin during the creation of the Scribners Illustrated Classics, 1911–1939. Also of value are JHC's periodic, unpublished recollections as Scribners' art director; NCW's correspondence with Arthur Scribner and Maxwell Perkins; and the Charles Scribner's Sons Manufacturing Records, 1902–1955, showing the firm's business decisions and accounting for each Wyeth edition.

True, Allen Tupper. Papers. Archives of American Art. Smithsonian Institution. Correspondence to and from Howard Pyle, 1902, and NCW, 1909. Scrapbooks and photographs depicting life at the Howard Pyle School of Art, 1901–1906.

Wilson, Woodrow. Papers. Manuscript Division. Library of Congress. Correspondence with Howard Pyle about illustration methods, sixteen letters, Oct. 1, 1895–Mar. 6, 1901.

Wyeth Family Archive, Chadds Ford, Pa. The primary source of Zirngiebel-Wyeth material: invaluable collection of private papers and genealogies for the Zirngiebel, Zeller, Runge, Wyeth, and Bockius families; including the previously unconsulted letters and papers of Henriette Zirngiebel Wyeth and Andrew Newell Wyeth, some 3,500 documents in all. Also, HZW's scrapbooks, NCW's early drawings, family photographs, mementos; Carolyn Bockius Wyeth's household records and papers, including some 250 Bockius letters; letters from Frank Schoonover and Allen True to HZW, 1905–1907; Wyeth family social invitations, 1929–1945; and condolence letters and cables, 1945–46.

Wyeth, Caroline Pyle. Letters. Private collection, New York City. Nine letters from Caroline Wyeth to Nat Wyeth, Mar.–July 1936.

Wyeth, N. C., and family. Papers. Boston Public Library, Boston, Mass. Some eighty letters, 1880–1929, to and from NCW and his parents and brothers in Needham.

Oral History Transcripts and Interviews

Brincklé, Gertrude. Interviewed by Richard K. Doud. Wilmington, Del., Apr. 7, 1966. Oral History Program. Archives of American Art. Smithsonian Institution.

Crichton, Eleanor Pyle. Notes from conversations with Howard Pyle Brokaw, Feb. 1978; June 2, 1983. Courtesy of Howard Pyle Brokaw.

Hurd, Henriette Wyeth; Ann Wyeth McCoy; Andrew Wyeth; Carolyn Wyeth; Nat Wyeth; Jamie Wyeth; Anna Brelsford McCoy. Interviewed by David McCullough. Complete, unedited transcripts of interviews that contributed to the making of David Grubin's *The Wyeths: A Father and His Family*, on *Smithsonian World*, a co-production of WETA-TV and the Smithsonian Institution, November 19, 1986.

Hurd, Peter. Interviewed by Sylvia Loomis. San Patricio, N.M., Mar. 28, 1964. Oral History Program. Archives of American Art. Smithsonian Institution.

Schoonover, Frank E. Interviewed by Richard K. Doud. Wilmington, Del., Apr. 6, 1966. Oral History Program. Archives of American Art. Smithsonian Institution.

Wyeth, Nat. "Reminiscences of Nathaniel Convers Wyeth." Interviewed by Jill Johnson. Mendenhall, Pa., April 1978. Columbia University Oral History Office Collection.

Dissertations, Memoirs, Scrapbooks, and Other Unpublished Works

Hurd, Henriette Wyeth. Diary, May 1918–Mar. 1919. Private Collection, Ann Carol Hurd Rogers, San Patricio, N.M.

Kirstein, Lincoln. Manuscript. "Newell Convers Wyeth, 1882–1945: Illuminator and Educator." Wyeth Family Archive.

Lykes, Richard Wayne. "Howard Pyle: Teacher of Illustration." Master's thesis, University of Pennsylvania, Graduate School of Arts and Sciences, 1947. Includes author interviews with and personal correspondence from numerous Pyle students.

Oakley, Thornton. "Howard Pyle: His Art and Personality." Address given at the Free Library of Philadelphia, Nov. 8, 1951. Free Library of Philadelphia Archives.

Pyle, Margaret Churchman Painter (1828–1885). Memoir. "A Little Country Girl." Written 1885, at the request of her niece Frances Eyre Morgan. Private collection, Wilmington, Del.

Scott, Nancy Bockius. Memoir. "Poking About Among the Clutter of Facts, Fancies, Hearsays, and Imaginings Hanging on the Brenneman-Bockius Family Tree: As Seen, Heard, and Embroidered by the Last of Its Ten Fruits." Private collection, Amherst, Mass.

Taylor, Miss ———. "An Evening in the Classroom, Being Notes Taken by Miss Taylor in One of The Classes of Painting Conducted by Harvey Dunn." Privately printed pamphlet, 1934.

Wyeth, Caroline Pyle. Collected poems. Private collection, New York City.

———. "The Scenes of My Childhood." Memoir. Written c. 1960s. Private collection, New York City.

Wyeth, Carolyn B. Family Record Book. Wyeth Family Archive.

Wyeth, Henriette Zirngiebel. Scrapbook. "Album," Jan. 1896–1917. Wyeth Family Archive.

Zirngiebel, Jean Denys. Scrapbook. "Letters, etc. Zirngiebel/1829–1905." Wyeth Family Archive.

Zwingmann, Charles A. A. " 'Heimweh' or 'Nostalgic Reaction': A Conceptual Analysis and Interpretation of a Medico-Psychological Phenomenon." Ph.D. diss., Stanford University, 1959.

Author's Interviews

Alice Pyle Lawrence Abrash, Washington, D.C.; John W. Bassett, Roswell, N.M.; William Lawrence Bockius, Pound Ridge, N.Y.; Ned Brewer, Needham, Mass.; Mr. and Mrs.

Howard Pyle Brokaw, Greenville, Del.; Sophie Consagra, New York City; Paul Preston Davis, West Chester, Pa.; Francesco J. Delle Donne, Wilmington, Del.; James H. Duff, Chadds Ford, Pa.; Frank E. Fowler, Chadds Ford, Pa.; Henry Hicks, Needham, Mass.; Paul Horgan, Middletown, Conn.; Mr. and Mrs. Robert Hunter, Needham, Mass.; Henriette Wyeth Hurd, San Patricio, N.M.; Michael Hurd, San Patricio, N.M.; Walter Hurst, Delaware County, Pa.; Ann Wyeth McCoy, Chadds Ford, Pa.; John Denys McCoy, San Patricio, N.M.; John Meigs, San Patricio, N.M.; Linda Miller, San Patricio, N.M.; Dr. Caroline Chandler Murray, Nantucket, Mass.; Peter Ralston, Rockland, Me.; Ronald R. Randall, Santa Barbara, Calif.; Roger Reed, New York City; Walt Reed, New York City; David Richardson, Washington, D.C.; Ann Carol Hurd Rogers, San Patricio, N.M.; Peter W. Rogers, San Patricio, N.M.; John R. Schoonover, Wilmington, Del.; Nancy Bockius Scott, Amherst, Mass.; Helen Stimson Wyeth Scoville, Brunswick, Ga.; Sidney Simon, New York City; Gretchen Wyeth Underwood, Vero Beach, Fla.; George A. Weymouth, Chadds Ford, Pa.; Andrew Wyeth, Chadds Ford, Pa.; Andrew Nathaniel Wyeth, Willimantic, Conn.; Betsy James Wyeth, Chadds Ford, Pa.; David Christopher Wyeth, New York City; Irving Rudolph Wyeth, Port Huron, Mich.; James Browning Wyeth, Wilmington, Del.; Jean Krum Wyeth, Chadds Ford, Pa.; Mr. and Mrs. John Stimson Wyeth, Needham, Mass.; Newell Convers Wyeth III, Oakton, Va.; Phyllis Mills Wyeth, Wilmington, Del.

Published Sources
Letters

Agassiz, Elizabeth Cary. *Louis Agassiz: His Life and Correspondence.* 2 vols. Boston, 1885.

Booth, Bradford A., and Ernest Mehew, eds. *The Letters of Robert Louis Stevenson.* Vol. 3 (Aug. 1879–Sept. 1882)–Vol. 5 (July 1884–Aug. 1887). New Haven: Yale University Press, 1994, 1995.

Gogh, Vincent van. *The Complete Letters of Vincent van Gogh.* 3 vols. Boston: Little, Brown, New York Graphic Society, 1958.

Gray, Jane Loring, ed. *Letters of Asa Gray.* 2 vols. Boston, 1893.

Metzger, Robert, ed. *My Land Is the Southwest: Peter Hurd Letters and Journals.* College Station, Tex.: Texas A&M University Press, 1983.

Wagenknecht, Edward, ed. *Mrs. Longfellow: Selected Letters and Journals of Fanny Appleton Longfellow (1817–1861).* New York: Longmans, Green, 1956.

Wyeth, Betsy James, ed. *The Wyeths: The Letters of N. C. Wyeth, 1901–1945.* Boston: Gambit, 1971.

Monographs and Published Primary Sources

Allen, Douglas, and Douglas Allen, Jr. *N. C. Wyeth: The Collected Paintings, Illustrations, and Murals.* Foreword by Paul Horgan, introduction by Richard Layton. New York: Crown, 1972.

American Guide Series. *Pennsylvania: A Guide to the Keystone State.* New York: Oxford University Press, 1940.

Ayres, Harry V. *Hotel du Pont Story: Wilmington, Delaware, 1911–1981.* Wilmington: Serendipity Press, 1981.

Ayres, William. *Picturing History: American Painting, 1770–1930.* Fraunces Tavern Museum. New York: Rizzoli, 1993.

Baist, G. W. *Baist's Property Atlas of the City of Wilmington, Delaware.* Philadelphia: G. W. Baist, 1901.

Ballinger, James K. *Frederic Remington.* New York: Harry N. Abrams, 1989.

Bearden, Romare. *Horace Pippin.* Washington, D.C.: Phillips Collection, 1977.

Bosworth, Raymond F. *Needham, With Interest.* Needham, Mass.: Needham Free Public Library, 1989.

Bowers, Edgar H. *View of Needham In 1854.* Needham, Mass.: Chronicle Press, 1914.

Brandywine River Museum. *The Brandywine Heritage: Howard Pyle, N. C. Wyeth, Andrew Wyeth, James Wyeth.* Chadds Ford, Pa.: Brandywine Conservancy, 1971.

———. *Carolyn Wyeth, Artist.* Interview with Carolyn Wyeth by Richard Meryman. Chadds Ford, Pa.: Brandywine Conservancy, 1979.

———. *Catalogue of the Collection, 1969–1989.* Chadds Ford, Pa.: Brandywine Conservancy, 1991.

———. *Frank E. Schoonover, Illustrator.* Essay by Ann Barton Brown. Chadds Ford, Pa: Brandywine Conservancy, 1979.

———. *Henriette Wyeth.* Essay by Paul Horgan. Chadds Ford, Pa.: Brandywine Conservancy, 1980.

———. *Howard Pyle, A Teacher: The Formal Years, 1894–1905.* Essay by Ann Barton Brown. Chadds Ford, Pa.: Brandywine Conservancy, 1980.

———. *John W. McCoy: A Retrospective View.* With "Reflections of John W. McCoy." Chadds Ford, Pa: Brandywine Conservancy, 1982.

———. *N. C. Wyeth.* Chadds Ford, Pa.: Brandywine Conservancy, 1972.

———. *N. C. Wyeth's Wild West.* Essay by Géné E. Harris. Chadds Ford, Pa.: Brandywine Conservancy, 1990.

———. *Not for Publication: Landscapes, Still Lifes, and Portraits by N. C. Wyeth.* Essay by James H. Duff. Chadds Ford, Pa.: Brandywine Conservancy, 1982.

———. *Thornton Oakley (1881–1953).* Chadds Ford, Pa.: Brandywine Conservancy, 1983.

Bredhoff, Stacey. *Powers of Persuasion: Poster Art from World War II.* Washington, D.C.: National Archives, 1994.

Brokaw, Howard Pyle. *Howard Pyle and the Golden Age of Illustration.* Billings, Mont.: Yellowstone Art Center, 1984.

———. *The Howard Pyle Studio: A History.* Wilmington, Del.: Studio Group, 1983.

Bryan, C. D. B. *The National Geographic Society: 100 Years of Adventure and Discovery.* Washington, D.C.: National Geographic Society, 1987.

Cambridge, City of. *Proprietors' Records.* Cambridge, Mass. Register of lands and houses in the "New Towne," 1634–1829.

———. *Vital Records To the Year 1850.* Vol. 2, *Marriages and Deaths.* Boston, 1915.

Century Association. *The Century Association Year-Book 1940.* New York, 1940.

Cikovsky, Nicolai, Jr., and Franklin Kelly. *Winslow Homer.* Washington, D.C.: National Gallery of Art; New Haven: Yale University Press, 1995.

Cohen, Stan. *V for Victory: America's Home Front During World War II.* Missoula, Mont.: Pictorial Histories, 1991.

Corn, Wanda M. *The Art of Andrew Wyeth.* With contributions by Brian O'Doherty, Richard Meryman, and E. P. Richardson. San Francisco: Fine Arts Museum of San Francisco; Greenwich, Conn.: New York Graphic Society, 1973.

Davidson, Marshall B. *Treasures of the New York Public Library.* New York: Harry N. Abrams, 1988.

Delaware Art Museum. *The American Illustration Collection.* Wilmington, Del., 1991.

————. *Howard Pyle: Diversity in Depth.* Wilmington, Del., 1973.

Denver, City of. *Denver Business Directory.* Denver, Colo., 1904.

Duff, James H., Andrew Wyeth, Thomas Hoving, and Lincoln Kirstein. *An American Vision: Three Generations of Wyeth Art.* Chadds Ford, Pa.: Brandywine River Museum; Boston: Little, Brown, 1987.

Elzea, Rowland, and Elizabeth H. Hawkes, eds. *A Small School of Art: The Students of Howard Pyle.* Wilmington: Delaware Art Museum, 1980.

Falk, Peter Hastings, ed. *Annual Exhibition Record of the Pennsylvania Academy of the Fine Arts, 1876–1913.* Madison, Conn.: Sound View Press, 1989.

Flagg, Solomon. *Town Clerk's Report for 1866.* Needham, Mass., 1867.

Giovanni Segantini, 1858–1899. Zurich: Kuntshaus, 1990.

Harvard *Advocate.* Vol. 88, no. 1, Oct. 5, 1909, through vol. 105, no. 10, June 19, 1913.

Harvard College. *Class of 1913, Secretary's Second Report.* Cambridge, Mass., 1917.

————. *Class of 1913, Secretary's Third Report.* 1920.

————. *Class of 1913, Decennial Report.* 1923.

————. *Class of 1913, Fifteenth Anniversary Report.* 1928.

————. *Class of 1913, Twentieth Anniversary Report.* 1933.

————. *Class of 1913, Twenty-fifth Anniversary Report.* 1938.

————. *Class of 1913, Fortieth Anniversary Report.* 1953.

————. *Class of 1913, Fiftieth Anniversary Report.* 1963.

Harvard University *Annual Reports, 1852–66.* Cambridge, Mass., 1853–1867.

The Harvard University Catalogue, 1902–03. Cambridge, Mass., 1902.

Hearn, Michael Patrick. *Myth, Magic, and Mystery: One Hundred Years of American Children's Book Illustration.* Norfolk, Va.: Chrysler Museum of Art; Boulder, Colo.: Robert Rinehart Publishers, 1996.

Horgan, Paul. *Andrew Wyeth: Impressions for a Portrait.* Tucson: University of Arizona Art Gallery, 1963.

————. *N. C. Wyeth, N.A., 1882–1945, Memorial Exhibition.* Wilmington: Wilmington Society of Fine Arts, 1946.

————. *Peter Hurd: A Portrait Sketch from Life.* Austin and Fort Worth: Amon Carter Museum of Western Art, University of Texas Press, 1964.

Hoving, Thomas. *Andrew Wyeth: Autobiography.* With commentaries by Andrew Wyeth as told to Thomas Hoving. Kansas City: Nelson-Atkins Museum of Art; Boston: Little, Brown, 1995.

————. *Two Worlds of Andrew Wyeth: Kuerners and Olsons.* New York: Metropolitan Museum of Art, 1976.

Howard Pyle: The Artist and His Legacy. Wilmington: Delaware Art Museum; Chadds Ford, Pa.: Brandywine River Museum, 1987.

Hurd, Peter. *Peter Hurd: Sketchbook.* Chicago: Swallow Press, 1971.

Hyams, Edward. *Great Botanical Gardens of the World.* New York: Macmillan, 1969.

Hyland, Douglas, and Howard Pyle Brokaw. *Howard Pyle and the Wyeths: Four Generations of American Imagination.* Memphis, Tenn.: Memphis Brooks Museum of Art, 1983.

Janello, Amy, and Brennon Jones. *The American Magazine.* New York: Harry N. Abrams, 1991.

Jennings, Kate F. *N. C. Wyeth.* New York: Crescent Books, 1992.

Joseph Hawley Chapin, 1869–1939, Artist, Director, Friend. With reminiscences by N. C. Wyeth et al. New York: William C. Weber, 1939.

Jones, Frederic A. *Old Houses in Needham, Massachusetts.* Needham, Mass.: Hampshire Press, 1979.

Kloss, William, Doreen Bolger, David Park Curry, John Wilmerding, and Betty C. Monkman. *Art in the White House: A Nation's Pride.* Washington, D.C.: White House Historical Association, 1992.

Lipman, Jean, and Tom Armstrong. *American Folk Painters of Three Centuries.* New York: Whitney Museum of American Art, Hudson Hills Press, 1980.

Macbeth Gallery. *In the Georges Islands, Maine: Paintings by N. C. Wyeth.* Introduction by Peter Hurd, Dec. 5–30, 1939.

McAlester, Virginia, and Lee McAlester. *A Field Guide to American Houses.* New York: Alfred A. Knopf, 1993.

Manguel, Alberto, and Gianni Guadalupi. *The Dictionary of Imaginary Places.* New York: Macmillan, 1980

Massachusetts, Commonwealth of. *Massachusetts Soldiers and Sailors of The Revolutionary War.* Boston: Wright & Potter, 1908.

Massachusetts Normal Art School. *The Artgum of the Massachusetts Normal Art School.* Boston, 1922–1927.

———. *Catalogue for the Twenty-sixth Year, 1899–1900.* Boston, 1900. Massachusetts College of Art Records, 1873–1972. Archives of American Art. Smithsonian Institution.

———. *Fiftieth Anniversary Record, 1888–1938.* Boston: Massachusetts School of Art Alumni Association, 1939.

———. *History of the Massachusetts Normal Art School, 1873–4 to 1923–4.* Boston, 1924.

———. *The Vignette.* Yearbook of the Massachusetts Normal Art School. 1901–1926.

Meigs, John, ed. *Peter Hurd: The Lithographs.* Lubbock, Tex.: Baker Gallery Press, 1968.

Meryman, Richard. *Andrew Wyeth.* Boston: Houghton Mifflin, 1968.

Mitnick, Barbara J. *The Changing Image of George Washington.* New York: Fraunces Tavern Museum, 1989.

Monaghan, Jay. *The Book of the American West.* New York: Julian Messner, 1963.

Mongan, Agnes. *Andrew Wyeth: Dry Brush and Pencil Drawings.* Cambridge, Mass.: Harvard University, Fogg Art Museum, 1963.

Morse, Willard S., and Gertrude Brinckle. *Howard Pyle: A Record of His Illustrations and Writings.* Wilmington: Wilmington Society of the Fine Arts, 1921.

Mortenson, C. Walter. *The Illustrations of Andrew Wyeth: A Check List.* West Chester, Pa.: Aralia Press, 1977.

Needham High School. *Advocate, 1910.* Needham, Mass., 1910.

Needham, Town of. *Annual Report, 1893.* Needham, Mass., Chronicle Press, 1894.

———. *History and Directory for 1888–89.* Needham, Mass.: A. E. Foss, 1888.

Oakley, Thornton, ed. *Report of the Private View of the Exhibition of Works by Howard Pyle At the Art Alliance.* Philadelphia, Pa.: privately printed, 1923.

Parrish Art Museum. *Loan Exhibition of Paintings by the Wyeth Family.* Foreword by Nicholas Wyeth. Southampton, N.Y., 1966.

Pennsylvania Historical and Museum Commission. *N. C. Wyeth and the Brandywine Tradition.* Harrisburg, Pa.: William Penn Memorial Museum, 1965.

Pitz, Henry C. *Howard Pyle: Writer, Illustrator, Founder of the Brandywine School.* New York: Bramhall House, 1975.

Podmaniczky, Christine B. *N. C. Wyeth: Experiment and Invention, 1925–1935.* Chadds Ford, Pa.: Brandywine River Museum, 1995.

Randall, Ronald R. *The World of N. C. Wyeth.* Randall House catalogue no. 24. Santa Barbara, Calif., 1992.

Reed, Sue Welsh, and Carol Troyen. *Awash in Color: Homer, Sargent, and the Great American Watercolor.* Boston: Museum of Fine Arts; Little, Brown, Bulfinch Press, 1993.

Reed, Walt, ed. *The Illustrator in America, 1900–1960's.* New York: Reinhold, 1966.

Reed, Walt, and Roger Reed. *The Illustrator in America, 1880–1980: A Century of Illustration.* New York: Society of Illustrators, 1984.

Reed, Walter. *50 Great American Illustrators.* New York: Crown, 1979.

Rettig, Robert Bell. *Guide to Cambridge Architecture: Ten Walking Tours.* Cambridge, Mass.: Cambridge, Cambridge Historical Commission, 1969.

Robertson, Bruce. *Reckoning with Winslow Homer: His Late Paintings and Their Influence.* Cleveland: Cleveland Museum of Art, 1990.

Sargent, Charles Sprague, ed. *Scientific Papers of Asa Gray.* 2 vols. Boston and New York: Houghton Mifflin, 1889.

Samuels, Peggy, Harold Samuels, Joan Samuels, and Daniel Fabian. *Techniques of the Artists of the American West.* Secaucus, N.J.: Wellfleet Press, 1990.

Schoonover, Cortlandt. *Frank Schoonover: Illustrator of the North American Frontier.* New York: Watson-Guptill, 1976.

Sweet, Frederic A. *Andrew Wyeth.* Boston: Museum of Fine Arts, 1970.

Switzerland: A Phaidon Cultural Guide. Englewood Cliffs, N.J.: Prentice-Hall, 1985.

Tepper, Saul. *Harvey Dunn: The Man, the Legend, the School of Painting.* New York: Museum of American Illustration, Society of Illustrators, 1983.

Truettner, William H., ed. *The West as America: Reinterpreting Images of the Frontier, 1820–1920.* Washington, D.C.: Smithsonian Institution Press for the National Museum of American Art, 1991.

U.S. Bureau of the Census. *Ninth Census of the United States . . . 1870.* Washington, D.C., 1872.

Walmsley, James S. *The Brandywine Valley: An Introduction to Its Cultural Treasures.* New York: Harry N. Abrams, 1992.

Wilmerding, John. *Andrew Wyeth: The Helga Pictures.* Washington, D.C.: National Gallery of Art; New York: Harry N. Abrams, 1987.

Wilmington City Directory. Wilmington, Del., 1859, 1860, 1882–1918.

Winslow Homer Illustrations. New York: Dover, 1983.

Wyeth, Betsy James. *Christina's World: Paintings and Pre-studies of Andrew Wyeth.* Boston: Houghton Mifflin, 1982.

———. *Wyeth at Kuerners.* Boston: Houghton Mifflin, 1976.

Wyeth, Carolyn. *Carolyn Wyeth: A Retrospective Exhibition.* Introduction by Susan E. Meyer. Shreveport, La.: R. W. Norton Art Gallery, 1976.

Wyeth, Henriette, and Paul Horgan. *The Artifice of Blue Light.* Santa Fe: Museum of New Mexico Press, 1994.

Wyeth, James. *James Wyeth: Paintings.* Foreword by Lincoln Kirstein. New York: M. Knoedler, 1966.

———. *Jamie Wyeth.* Boston: Houghton Mifflin, 1980.

The Wyeths: N. C. Wyeth, Andrew Wyeth, James Wyeth. New York: Hammer Galleries, 1995.

Wyman, Thomas Bellows. *The Genealogies and Estates of Charlestown, 1629–1818.* Boston: David Clapp and Son, 1879.

Zurrier, Rebecca, Robert W. Snyder, and Virginia M. Mecklenburg. *Metropolitan Lives: The Ashcan Artists and Their New York.* Washington, D.C.: National Museum of American Art; New York: W. W. Norton, 1995.

Books

Abbott, Charles D. *Howard Pyle: A Chronicle.* Foreword by N. C. Wyeth. New York: Harper & Brothers, 1925.

Adams, Laurie Schneider. *Art and Psychoanalysis.* New York: HarperCollins, 1993.

———. *The Methodologies of Art: An Introduction.* New York: HarperCollins, 1996.

Alexander, Doris. *Creating Literature out of Life: The Making of Four Masterpieces: Death in Venice, Treasure Island, The Rubaiyat of Omar Khayyam, War and Peace.* University Park, Pa.: Penn State University Press, 1996.

Allen, Frederick Lewis. *The Big Change.* New York: Harper & Brothers, 1952.

Allen, Hervey. *The Forest and the Fort, Bedford Village, Toward the Morning.* 3 vols. New York: Rinehart, 1943, 1944, 1948.

Arthurs, Stanley. *The American Historical Scene: As Depicted by Stanley Arthurs.* With contributions by N. C. Wyeth et al. New York: Carlton House, 1937.

Bailey, L. H. *Cyclopedia of American Horticulture.* 4 vols. New York: Macmillan, 1900.

Beard, George M. *American Nervousness.* New York: Putnam's, 1881.

———. *A Practical Treatise on Nervous Exhaustion (Neurasthenia), Its Symptoms, Nature, Sequences, Treatment.* New York: William Wood, 1880.

Beck, Aaron T. *Depression: Clinical, Experimental, and Theoretical Aspects.* New York: Harper & Row, 1967.

Bell, Ian. *Dreams of Exile: Robert Louis Stevenson: A Biography.* New York: Henry Holt, 1992.

Berger, John. *Ways of Seeing.* London: British Broadcasting Corporation; Penguin Books, 1972.

Blewett, David. *The Illustration of Robinson Crusoe, 1719–1920.* Gerrards Cross, England: Colin Smythe, 1995.

Bolton, Theodore. *American Book Illustrators: Bibliographic Check Lists of 123 Artists.* New York: R. R. Bowker, 1938.

Bradley, James T. *Wrecks, Accidents, and Collisions.* Irving, Tex.: Bradley Enterprises, 1991.

Brookhiser, Richard. *Founding Father: Rediscovering George Washington.* New York: Free Press, 1996.

Brooks, Van Wyck. *The Flowering of New England, 1815–1865.* New York: E. P. Dutton, 1936.

———. *John Sloan: A Painter's Life.* New York: E. P. Dutton, 1955.

Brown, Kenneth A. *Inventors at Work: Interviews with Sixteen Notable American Inventors.* Interview with Nat Wyeth. Redmond, Wash.: Microsoft Press, Tempus Books, 1988.

Brownlow, Kevin. *Hollywood: The Pioneers.* New York: Alfred A. Knopf, 1979.

———. *The Parade's Gone By . . .* New York: Alfred A. Knopf, 1969.

Burlingame, Roger. *Of Making Many Books: A Hundred Years of Reading, Writing, Publishing.* New York: Charles Scribner's Sons, 1946.

Bynner, Witter. *The Works of Witter Bynner: Prose Pieces.* New York: Farrar, Straus & Giroux, 1979.

Canby, Henry Seidel. *The Age of Confidence: Life in the Nineties.* New York: Farrar & Rinehart, 1934.

———. *The Brandywine.* Illustrated by Andrew Wyeth. New York: Farrar & Rinehart, 1941.

Cella, C. Ronald. *Mary Johnston.* Boston: Twayne Publishers, 1981.

Chasseguet-Smirgel, Janine. *The Ego Ideal: A Psychoanalytic Essay on the Malady of the Ideal.* Translated by Paul Barrows. Introduction by Christopher Lasch. New York: W. W. Norton, 1987.

Clark, Eliot. *History of the National Academy of Design, 1825–1953.* New York: Oxford University Press, 1954.

Clarke, George Kuhn. *History of Needham, Massachusetts, 1711–1911.* Cambridge: Cambridge University Press, 1912.

Cooper, Lane. *Louis Agassiz as a Teacher.* Ithaca, N.Y.: Comstock, 1945.

Davis, Fred. *Yearning for Yesterday: A Sociology of Nostalgia.* New York: Free Press, 1979.

Doerner, Max. *The Materials of the Artist,* rev. ed. New York: Harcourt Brace, Harvest, 1984.

Drinka, George Frederick. *The Birth of Neurosis: Myth, Malady, and the Victorians.* New York: Simon & Schuster, 1984.

Dupree, A. Hunter. *Asa Gray, 1810–1888.* Cambridge: Harvard University Press, 1959.

Dykes, Jeff. *Fifty Great Western Illustrators: A Bibliographic Checklist.* Flagstaff, Ariz.: Northland Press, 1975.

Edel, Leon. *Writing Lives.* New York: W. W. Norton, 1984.

Exman, Eugene. *The House of Harper.* New York: Harper & Row, 1967.

Galbraith, John Kenneth. *A Journey Through Economic Time.* Boston: Houghton Mifflin, 1994.

Gay, Peter. *The Cultivation of Hatred.* Vol. 3, *The Bourgeois Experience: Victoria to Freud.* New York: W. W. Norton, 1993.

Gibson, William M., ed. *No. 44, The Mysterious Stranger by Mark Twain.* Berkeley and Los Angeles: University of California Press, 1969.

Goodwin, Doris Kearns. *No Ordinary Time: Franklin and Eleanor Roosevelt: The Home Front in World War II.* New York: Simon & Schuster, 1994.

Green, Martin. *The Robinson Crusoe Story.* University Park: Pennsylvania State University Press, 1990.

Grousset, Agnes M. *Horns A'Plenty: Newells, Tiemanns, Wyeths.* Baltimore: Gateway Press, 1980.

Hall, Max. *The Charles: The People's River.* Boston: David R. Godine, 1986.

Hamilton, N. Gregory. *Self and Others: Object Relations Theory in Practice.* Northvale, N.J.: Jason Aronson, 1988.

Hassrick, Peter H. *The Way West: Art of Frontier America.* New York: Harry N. Abrams, 1977.

Hoffecker, Carol E. *Wilmington, Delaware: Portrait of an Industrial City, 1830–1910.* Charlottesville: University Press of Virginia, 1974.

Holder, Charles Frederick. *Louis Agassiz: His Life and Work.* New York: G. P. Putnam's Sons, 1893.

Hollander, Anne. *Moving Pictures.* Cambridge, Mass.: Harvard University Press, 1991.

———. *Seeing Through Clothes.* New York: Viking Press, 1978.

Horgan, Paul. *A Certain Climate: Essays in History, Arts, and Letters.* Middletown, Conn.: Wesleyan University Press, 1988.

———. *The Richard Trilogy.* Hanover, N.H.: Wesleyan University Press in association with University Press of New England, 1990.

———. *Tracings: A Book of Partial Portraits.* New York: Farrar, Straus & Giroux, 1993.

Howells, W. D. *Stops of Various Quills.* New York: Harper & Brothers, 1895.

Hunt, Peter. *Children's Literature: An Illustrated History.* New York: Oxford University Press, 1995.

Jamison, Kay Redfield. *Touched with Fire: Manic-Depressive Illness and the Artistic Temperament.* New York: Free Press, 1993.

Jeffries, John W. *Wartime America: The World War II Home Front.* American Ways Series. Chicago: Ivan R. Dee, 1996.

Kaplan, Justin. *Lincoln Steffens: A Biography.* New York: Simon & Schuster, 1974.

———, ed. *Great Short Works of Mark Twain.* New York: Harper and Row, 1967.

————. *Mr. Clemens and Mark Twain: A Biography.* New York: Simon & Schuster, 1966.

Kohut, Heinz. *The Analysis of the Self: A Systematic Approach to the Psychoanalytic Treatment of Narcissistic Personality Disorders.* Psychoanalytic Study of the Child, monograph no. 4. New York: International Universities Press, 1977.

Larsen, Robin, ed. *Emanuel Swedenborg, A Continuing Vision: A Pictorial Biography and Anthology of Essays and Poetry.* New York: Swedenborg Foundation.

Lasch, Christopher. *The Culture of Narcissism: American Life in an Age of Diminishing Expectations.* New York: W. W. Norton, 1978.

Lears, T. J. Jackson. *No Place of Grace: Antimodernism and the Transformation of American Culture, 1880–1920.* New York: Pantheon, 1981.

Logsdon, Gene. *Wyeth People: A Portrait of Andrew Wyeth As Seen by His Friends and Neighbors.* New York: Doubleday, 1971.

Loughery, John. *John Sloan: Painter and Rebel.* New York: Henry Holt, 1995.

Lubow, Arthur. *The Reporter Who Would Be King: A Biography of Richard Harding Davis.* New York: Charles Scribner's Sons, 1992.

Lurie, Edward. *Louis Agassiz: A Life in Science.* Baltimore: Johns Hopkins University Press, 1988.

Lutz, Tom. *American Nervousness, 1903: An Anecdotal History.* Ithaca, N.Y.: Cornell University Press, 1991.

Lynes, Russell. *The Tastemakers.* New York: Harper & Brothers, 1954.

Lyon, Peter. *Success Story: The Life and Times of S. S. McClure.* New York: Charles Scribner's Sons, 1963.

Masterson, James F. *The Search for the Real Self: Unmasking the Personality Disorders of Our Age.* New York: Free Press, 1988.

McCullough, David. *Brave Companions: Portraits in History.* New York: Prentice Hall Press, 1992.

————. *Mornings on Horseback.* New York: Simon & Schuster, 1981.

Meryman, Richard. *Andrew Wyeth: A Secret Life.* New York: HarperCollins, 1996.

————. *Andrew Wyeth: First Impressions.* New York: Harry N. Abrams, 1991.

Meyer, Susan E. *America's Great Illustrators.* New York: Harry N. Abrams, 1978.

————. *A Treasury of the Great Children's Book Illustrators.* New York: Harry N. Abrams, 1983.

Mitchell, Silas Weir. *Lectures on Diseases of the Nervous System, Especially in Women.* Philadelphia: Henry L. Lea, 1881.

Miller, Alice. *The Drama of the Gifted Child: The Search for the True Self.* New York: Basic Books, 1981.

Morris, Edmund. *The Rise of Theodore Roosevelt.* New York: Coward, McCann & Geoghegan, 1979.

Mott, Frank Luther. *A History of American Magazines, 1885–1905.* Cambridge, Mass.: Harvard University Press, 1957.

Mumford, Lewis. *The Myth of the Machine: Technics and Human Development.* New York: Harcourt, Brace & World, 1967.

————. *Technics and Civilization.* New York: Harcourt, Brace, 1934.

Nelson, Mary Carroll. *Masters of Western Art.* New York: Watson-Guptill, 1982.

Nevins, Allan. *Ford: The Times, the Man, the Company.* New York: Charles Scribner's Sons, 1954.

Osborne, Mary Pope. *American Tall Tales.* New York: Alfred A. Knopf, 1991.

Panofsky, Erwin. *Meaning in the Visual Arts.* Chicago: University of Chicago Press, 1955.

Petroski, Henry. *The Evolution of Useful Things.* New York: Alfred A. Knopf, 1992.

Pitz, Henry C. *The Brandywine Tradition.* New York: Weathervane Books, 1968.

———. *Illustrating Children's Books: History, Technique, Production.* New York: Watson-Guptill, 1963.

———. *Two Hundred Years of American Illustration.* New York: Random House, 1977.

Pope, Charles Henry. *The Pioneers of Massachusetts.* Boston, 1900.

Pyle, Howard. *The Champions of the Round Table.* Introduction by Frank E. Schoonover. New York: Charles Scribner's Sons, 1933.

———. *The Garden Behind the Moon.* New York: Charles Scribner's Sons, 1895.

———. *The Grail and The Passing of Arthur.* Introduction by Stanley M. Arthurs. New York: Charles Scribner's Sons, 1933.

———. *The Merry Adventures of Robin Hood of Great Renown, in Nottinghamshire.* Introduction by N. C. Wyeth. New York: Charles Scribner's Sons, 1933.

———. *Sir Launcelot and His Companions.* Introduction by Harvey Dunn. New York: Charles Scribner's Sons, 1933.

———. *The Story of King Arthur and His Knights.* Introduction by W. J. Aylward. New York: Charles Scribner's Sons, 1933.

Rogers, Peter. *A Painter's Quest: Art As a Way of Revelation.* Santa Fe, N.M.: Bear & Company, 1987.

Rothstein, Arnold. *The Narcissistic Pursuit of Perfection.* New York: International Universities Press, c. 1980.

Schivelbusch, Wolfgang. *The Railway Journey: The Industrialization of Time and Space in the Nineteenth Century.* Berkeley and Los Angeles: University of California Press, 1977.

Silvey, Anita, ed. *Children's Books and Their Creators.* Boston: Houghton Mifflin, 1995.

Steinberg, Jonathan. *Why Switzerland?* Cambridge: Cambridge University Press, 1976.

Stevenson, Robert Louis. *Memories and Portraits.* New York: Charles Scribner's Sons, 1887.

———. *Essays by Robert Louis Stevenson.* New York: Charles Scribner's Sons, 1918.

———. *Selected Essays of Robert Louis Stevenson.* London: Oxford University Press, 1929.

Stilgoe, John R. *Metropolitan Corridor: Railroads and the American Scene.* New Haven: Yale University Press, 1983.

Strouse, Jean. *Alice James.* Boston: Houghton Mifflin, 1980.

Tarbell, Ida M. *All in the Day's Work: An Autobiography.* New York: Macmillan, 1939.

Thompson, Thomas R. *Chris: A Biography of Christian C. Sanderson.* Philadelphia: Dorrance, 1973.

Toll, Seymour I. *A Judge Uncommon: A Life of John Biggs, Jr.* Philadelphia: Legal Communications, 1993.

Tourtellot, Arthur Bernon. *The Charles.* Rivers of America Series. New York: Farrar & Rinehart, 1941.

Updike, John. *Just Looking: Essays on Art.* New York: Alfred A. Knopf, 1989.

Usdin, Gene. *Depression: Clinical, Biological, and Psychological Perspectives.* New York: Brunner/Mazel, 1977.

Wagman, Richard J. *The Medical and Health Encyclopedia.* Chicago: J. G. Ferguson Publishing, 1992.

Warner, Sam B. *Streetcar Suburbs: The Process of Growth in Boston, 1870–1900.* Cambridge, Mass.: Harvard University Press, 1962.

Watson, Ernest. *Forty Illustrators and How They Work.* New York: Watson-Guptill, 1946.

Watson, Katharine Williams. *Once upon a Time: Children's Stories Retold for Broadcasting.* New York: H. W. Wilson, 1942.

Wills, Garry. *Certain Trumpets: The Call of Leaders.* New York: Simon & Schuster, 1994.

Winsor, Mary P. *Reading the Shape of Nature*. Chicago: University of Chicago Press, 1991.
Wyeth, Betsy James. *The Stray*. With drawings by Jamie Wyeth. New York: Farrar, Straus & Giroux, 1979.
Wyeth, N. C., ed. *Great Stories of the Sea and Ships*. Philadelphia: David McKay, 1940.
———. *Marauders of the Sea*. New York: G. P. Putnam's Sons, 1935.
Wyss, David. *The Swiss Family Robinson*. Introduction by W. D. Howells, with illustrations by Louis Rhead and Frank E. Schoonover. New York: Blue Ribbon Books, 1909.

Articles

Aaron, Daniel. "U.S.A." *American Heritage*, July–Aug. 1996.
"A.M.H." "Reminiscences of a Pupil Who Entered M.N.A.S. in February 1897." *Centre of Vision*. Student publication, Massachusetts Normal Art School, Boston, Mass. 1905.
"Andrew Wyeth: One of America's Youngest and Most Talented Painters." *American Artist*, Sept. 1942.
"Andrew Wyeth's Maine Water Colors." *Scribner's Magazine*, Mar. 1938.
"Andy's World." *Time*, Dec. 27, 1963.
Angyal, Andras. "Evasion of Growth." *American Journal of Psychiatry*, vol. 110, no. 5 (Nov. 1953).
"The Artist, His Family, and Examples of His Work." Needham *Chronicle*, Feb. 3, 1923.
Aylward, W. J. "The Giant at the Crossroads." Introduction to Howard Pyle, *The Story of King Arthur and His Knights*. New York: Charles Scribner's Sons, 1933.
Bogart, Michele H. "Artistic Ideals and Commercial Practices: The Problem of Status for American Illustrators." *Prospects: An Annual of American Cultural Studies*, vol. 15 (1990).
"Book Notes: N. C. Wyeth's Choice." *Scribner's Magazine*, Dec. 1918.
Brower, Brock. "Notes on an Illustrated Childhood." *Esquire*, Mar. 1974.
Carpenter, Kevin. "R. L. Stevenson on the *Treasure Island* Illustrations." *Notes and Queries*, n.s., vol. 29, no. 4 (Aug. 1982).
Caswall, Muriel. "King of the Pirates . . ." Boston *Post*, Nov. 27, 1921.
"The Charles Building." *Western Architect and Building News*, vol. 1, no. 7 (Sept. 1889).
"The Clan Wyeth Presents Its Famed Patriarch." *Art Digest*, Dec. 15, 1939.
Dinneen, Joseph F. "Wyeth, Noted Illustrator, Back in Needham Home." Boston *Globe Sunday Magazine*, Mar. 25, 1923.
Eisenstat, Benjamin, and Jane Sperry. "Illustration in America, 1880–1890: The Beginning of 'the Golden Age.' " *Graphis 268*, July–Aug. 1990.
"Four to Carry On." *Time*, Jan. 28, 1946.
Gilman, Roger. "The Wyeth Background." Cambridge, Mass.: Cambridge Historical Society Publications, vol. 28 (1942).
"The Greatest Illustrator." *Time*, Nov. 18, 1957.
"Greatest Painter of Costumed Romance Once Cowboy." Boston *Herald*, Nov. 12, 1922.
Gurney, Elizabeth. "An Evening with Howard Pyle." *Delaware Magazine*, Nov. 1919.
Hitchings, Catherine, and Sinclair Hitchings. "Wyeth, Newell Convers." *Dictionary of American Biography*, supp. 3, 1941–1945. New York: Charles Scribner's Sons, 1973.
Hofer, Johannes. "Medical Dissertation on Nostalgia or Homesickness" (1688). Translated by Carolyn Kiser Anspach. *Bulletin of the Institute of the History of Medicine*, vol. 2. Baltimore: Johns Hopkins University Press, 1934.
Horgan, Paul. "Peter Hurd, Artist." *Roswell Daily Record*, Dec. 14, 1929.
———. "The Style of Peter Hurd." *New Mexico Quarterly 22*, no. 4 (Winter 1950–51).

Hurd, Peter. "A Southwestern Heritage." *Arizona Highways,* Nov. 1953.

James, Henry. "Robert Louis Stevenson." *Century Magazine,* vol. 35, no. 6 (Apr. 1888).

Jeansonne, Glen. "America's Home Front." *History Today,* vol. 45, no. 5, May 1995.

Kamp, Anton. "N. C. Wyeth, Painter and Illustrator." *The Artgum of the Massachusetts Normal Art School,* vol. 4, no. 4, junior no. (1926).

Keny, James. "The Legacy of Cape Ann." *American Art Review,* vol. 7, no. 5 (1995).

Kinross, Albert. "Torpedoed!" *Atlantic Monthly,* Dec. 1917.

Kirstein, Lincoln. "Artist and/or Illustrator." *Nation,* Jan. 24, 1972.

Koerner, W. H. D. "Howard Pyle: An Appreciation from One of His Students." *New Amstel Magazine,* 1911.

"A Little About a Great Artist: N. C. Wyeth." Dearborn *Independent,* Jan. 20, 1923.

Lunt, Dudley. "The Howard Pyle School of Art." *Delaware History,* vol. 5, no. 3 (Mar. 1953).

———. "N. C. Wyeth, 1882–1945." *Horn Book,* vol. 22, no. 5 (Sept.–Oct. 1946).

Lykes, Richard Wayne. "Howard Pyle: Teacher of Illustration." *Pennsylvania Magazine of History and Biography,* July 1956.

Martin, Pete. "The Wyeth Who Doesn't Paint." Philadelphia *Bulletin Sunday Magazine,* July 3, 1966.

Meryman, Richard. "Andrew Wyeth: An Interview." *Life,* vol. 58, no. 19 (May 14, 1965).

——— . "A Wyeth Comes Out of Hiding." *New York Times Magazine,* Jan. 7, 1979.

———. "The Wyeth Family: American Visions." *National Geographic,* vol. 180, no. 1 (July 1991).

———. "The Wyeths' Kind of Christmas Magic." *Life,* vol. 71, no. 25 (Dec. 17, 1971).

Meyer, Susan. "Three Generations of the Wyeth Family." (8 articles in special issue.) *American Artist,* vol. 39 (Feb. 1975).

Miller, Janet M. "An Intimate Glimpse of N. C. Wyeth." *Garnet and White* [West Chester Public High School, West Chester, Pa.], vol. 28, no. 1 (Nov. 1935).

Moser, Barry. "God, Posterity, and Well-Made Objects." *Princeton University Library Chronicle,* vol. 57, no. 2 (Winter 1996).

Nawas, M. Mike, and Jerome J. Platt. "A Future-Oriented Theory of Nostalgia." *Journal of Individual Psychology,* vol. 21, no. 1 (May 1965).

"N. C. Wyeth." *Life,* vol. 20, no. 24 (June 17, 1946).

Nemerov, Alex. "Doing the 'Old America.' In *The West as America.* Edited by William H. Truettner. Washington, D.C.: Smithsonian Institution Press, 1991.

Oakley, Thornton. "Remarks on Illustration and Pennsylvania's Contributors to Its Golden Age." *Pennsylvania Magazine of History and Biography,* vol. 71, no. 1 (Jan. 1947).

"Pa Wyeth and His Clan." *Newsweek,* Dec. 18, 1939.

Pitz, Henry C. "N. C. Wyeth." *American Heritage,* vol. 16, no. 6 (Oct. 1965).

Plimpton, George, and Donald Stewart. "An Interview with Andrew Wyeth." *Horizon,* vol. 4, no. 1 (Sept. 1961).

Pyle, Ellen B. T. "Who—And Why: Facts About the Great and the Near Great." *Saturday Evening Post,* Apr. 7, 1928.

Pyle, Howard. "A Small School of Art." *Harper's Weekly,* July 17, 1897.

———. "When I Was a Little Boy." *Woman's Home Companion,* vol. 39 (Apr. 1912).

———. "Why Art and Marriage Won't Mix." *North American,* June 19, 1904.

"Pyle Display at Macbeth's." *American Art News,* Nov. 14, 1908.

"Pyles and Wyeths." *Time,* Nov. 15, 1937.

Richard, Paul. "The Rebel in the First Family of Art." *Washington Post,* Jan. 18, 1979, B1.

Richardson, E. P. "Andrew Wyeth." *Atlantic Monthly,* vol. 213, no. 6 (June 1964).

Seelye, John. "Wyeth and Hopper." *New Republic,* Mar. 11, 1972.

Scribner, Charles, III. "The First Hundred and Fifty." *Scribner Magazine,* Fall 1996.

"The Stouthearted Heroes of a Beloved Painter." *Life,* vol. 43, no. 24 (Dec. 9, 1957).

Straley, George H. "A Wyeth Afternoon." *County Lines,* Sept. 1987.

Watson, Ernest W. "N. C. Wyeth: Giant on a Hilltop." *American Artist,* vol. 9, no. 1 (Jan. 1945).

"Wilmington's Colony of Artists: A Series of Interesting and Timely Articles About the Many Popular Illustrators and Painters in This City and Vicinity." Wilmington *Star,* Oct. 31, 1909 (no. 1, Harvey T. Dunn); Nov. 7, 1909 (no. 2, Stanley M. Arthurs); Dec. 19, 1909 (no. 7, Gayle Porter Hoskins); Jan. 23, 1910 (no. 12, N. C. Wyeth); Jan. 30, 1910 (no. 13, Henry J. Peck).

Wyeth, Caroline Pyle. "We pile our treasures high . . ." (poem). *Saturday Review of Literature,* vol. 29, no. 2 (Jan. 12, 1946).

Wyeth, David C. "My Family's Picture." *Art & Antiques* (Feb. 1994).

Wyeth, N. C. "For Better Illustration." *Scribner's Magazine,* Nov. 1919.

———. "Howard Pyle As I Knew Him." *Mentor,* June 1927.

———. "Illustration in Museum Galleries." New York *Herald,* Dec. 8, 1907.

———. "The Illustrator and His Development." *American Art Student,* vol. 1, nos. 3 and 4 (Nov.–Dec. 1916).

———. "On Illustrations: A Suggestion and a Comment on Illustrating Fiction." *New York Times,* Oct. 13, 1912.

———. "Thoreau, His Critics and the Public." *Thoreau Society Bulletin,* no. 37 (Oct. 1951).

Wyeth, N. C., and Sidney M. Chase. "Pupils of Pyle Tell of His Teaching." *Christian Science Monitor,* Nov. 13, 1912.

Wyeth, Stimson. "My Brother—N. C. Wyeth." *Horn Book,* Feb. 1969.

"Wyeths by Wyeths." *Town & Country,* Nov. 1946.

Zirngiebel, Denys. "Pansy." *Cyclopedia of American Horticulture,* vol. 3. 1900.

Selected Books and Periodicals Illustrated by N. C. Wyeth

The following list includes works considered for or given attention to in the text.

Allen, Hervey. *Anthony Adverse.* 2 vols. New York: Farrar and Rinehart, 1934.

Anonymous. "A Modern Opium Eater: A Newspaperman's Story of His Own Experience with the Drug," by No. 6606. *American Magazine,* vol. 77, no. 6 (June 1914).

Baldwin, James. *The Sampo: Hero Adventures from the Finnish Kalevala.* New York: Charles Scribner's Sons, 1912.

Bianchi, Martha Gilbert Dickinson. "Back to the Farm." *Scribner's Magazine,* Aug. 1908.

Boyd, James. *Drums.* New York: Charles Scribner's Sons, 1928; Atheneum, 1995.

Bulfinch, Thomas. *Legends of Charlemagne.* New York: Cosmopolitan, 1924.

Cadman, S. Parks. *The Parables of Jesus.* Philadelphia: David McKay, 1931.

Cheney, Warren. *The Challenge.* Indianapolis: Bobbs-Merrill, 1906.

Cody, William F. *The Great West That Was: Buffalo Bill's Life Story.* New York: Star Company, 1916.

Connolly, James B. "Chavero." *Scribner's Magazine,* Aug. 1916.

———. "The Medicine Ship." *Scribner's Magazine,* Dec. 1915.

———. "The Rakish Brigantine." *Scribner's Magazine,* Aug. 1914.

Cooper, James Fenimore. *The Deerslayer or, The First War-Path.* New York: Charles Scribner's Son, 1925; 1990.

———. *The Last of the Mohicans: A Narrative of 1757.* New York: Charles Scribner's Sons, 1919; 1986.

Creswick, Paul. *Robin Hood.* Philadelphia: David McKay, 1917; New York: Charles Scribner's Sons, 1984.

Defoe, Daniel. *Robinson Crusoe.* New York: Cosmopolitan, 1920; Charles Scribner's Sons, 1983.

Doyle, Arthur Conan. "The Coming of the Huns." *Scribner's Magazine,* Nov. 1910.

———. "The First Cargo." *Scribner's Magazine,* Dec. 1910.

———. "The Red Star." *Scribner's Magazine,* Jan. 1911.

———. *The White Company.* New York: Cosmopolitan, 1922; New York: William Morrow, Books of Wonder, 1988.

Dreiser, Theodore. "Rural America in War-time." *Scribner's Magazine,* Dec. 1918.

Forester, C. S. *Captain Horatio Hornblower.* Boston: Little, Brown, 1939.

Fox, John, Jr. *The Little Shepherd of Kingdom Come.* New York: Charles Scribner's Sons, 1931.

Hay, John. *The Pike County Ballads.* Boston: Houghton Mifflin, 1912.

Hough, Emerson. "The Law at Heart's Desire, A Tale of the West." *Saturday Evening Post,* Feb. 21, 1903.

Irving, Washington. *Rip Van Winkle.* Philadelphia: David McKay, 1921; New York: William Morrow, Books of Wonder, 1987.

Jackson, Helen Hunt. *Ramona.* Boston: Little, Brown, 1939.

Johnson, Edna, and Carrie E. Scott, eds. *Anthology of Children's Literature.* Boston: Houghton Mifflin, 1940.

Johnston, Mary. *Cease Firing.* Boston: Houghton Mifflin, 1912.

———. *The Long Roll.* Boston: Houghton Mifflin, 1911.

Kingsley, Charles. *Westward Ho! or, The Voyages and Adventures of Sir Amyas Leigh, Knight, of Burrough, in the County of Devon—In the Reign of Her Most Glorious Majesty Queen Elizabeth.* New York: Charles Scribner's Sons, 1920; 1991.

Kipling, Rudyard. *The Years Between and Poems from History.* Vol. 27, *The Works of Rudyard Kipling.* New York: Charles Scribner's Sons, 1919.

Lanier, Sidney, ed. *The Boy's King Arthur: Sir Thomas Malory's History of King Arthur and His Knights of the Round Table.* New York: Charles Scribner's Sons, 1917; 1989.

Longfellow, Henry Wadsworth. *The Courtship of Miles Standish.* Boston: Houghton Mifflin, 1920.

Markham, Edwin. "The Romance of the 'C.P.' " *Success,* vol. 6, no. 106 (Mar. 1903).

Marsh, George T. "The Moods." *Scribner's Magazine,* Dec. 1909.

———. "The Quest of Narcisse Lablanche." *Scribner's Magazine,* May 1916.

Matthews, Brander, ed. *Poems of American Patriotism.* New York: Charles Scribner's Sons, 1922.

Merwin, Samuel. *Silk: A Legend As Narrated in the Journals and Correspondence of Jan Po.* Boston: Houghton Mifflin, 1923.

Moffat, Edward S. "The Misadventures of Cassidy." *McClure's Magazine,* May 1908.

Morris, Gouverneur. "Growing Up." *Harper's Monthly Magazine,* Nov. 1911.

Nordhoff, Charles, and James Norman Hall. *The Bounty Trilogy.* Boston: Little, Brown, 1940.

Palmer, George Herbert, trans. *The Odyssey of Homer.* Boston: Houghton Mifflin, 1929.

Parkman, Francis. *The Oregon Trail: Sketches of Prairie and Rocky-Mountain Life.* Boston: Little, Brown, 1925.

Peattie, Donald Culross. "The First Farmer of the Land." *Country Gentleman,* Feb. 1946.

Phillips, David Graham. "The Great Baltimore Fire." *Collier's Weekly,* Feb. 1904.

Pier, Arthur Stanwood. *Boys of St. Timothy's*. New York: Charles Scribner's Sons, 1904.

Porter, Jane. *The Scottish Chiefs*. Edited by Kate Douglas Wiggin and Nora A. Smith. New York: Charles Scribner's Sons, 1921; 1991.

Raine, W. M., and W. H. Eader. "How They Opened the Snow Road." *Outing Magazine*, vol. 49, no. 4 (Jan. 1907).

Rawlings, Marjorie Kinnan. *The Yearling*. New York: Charles Scribner's Sons, 1939; 1985.

Roberts, Kenneth. *Trending into Maine*. Boston: Little, Brown, 1938.

Rollins, Philip Ashton. *Jinglebob*. New York: Charles Scribner's Sons, 1930.

San Souci, Robert. *N. C. Wyeth's Pilgrims*. San Francisco: Chronicle Books, 1991.

Spearman, Frank H. *Nan of Music Mountain*. New York: Charles Scribner's Sons, 1916.

———. *Whispering Smith*. New York: Charles Scribner's Sons, 1906.

Stevenson, Robert Louis. *The Black Arrow: A Tale of the Two Roses*. New York: Charles Scribner's Sons, 1916; 1987.

———. *David Balfour: Being Memoirs of the Further Adventures of David Balfour at Home and Abroad*. New York: Charles Scribner's Sons, 1924; 1993.

———. *Kidnapped: The Adventures of David Balfour*. New York: Charles Scribner's Sons, 1913; 1982.

———. "The Waif Woman." *Scribner's Magazine*, Dec. 1914.

———. *Treasure Island*. New York: Charles Scribner's Sons, 1911; 1981.

Stewart, Elinore Pruitt. *Letters of a Woman Homesteader*. Boston: Houghton Mifflin, 1914.

Thoreau, Henry David. *Men of Concord and Some Others As Portrayed in the Journal of Henry David Thoreau*. Edited by Francis H. Allen. Boston: Houghton Mifflin, 1936.

Turgenev, Ivan. *The Novels and Stories of Iván Turgénieff*. Vol. 14, *The Brigadier and Other Stories*. New York: Charles Scribner's Sons, 1903–4.

Twain, Mark. *The Mysterious Stranger: A Romance*. New York: Harper & Brothers, 1916.

Verne, Jules. *Michael Strogoff: A Courier of the Czar*. New York: Charles Scribner's Sons, 1927; Atheneum Books for Young Readers, 1997.

———. *The Mysterious Island*. New York: Charles Scribner's Sons, 1918; 1988.

White, Stewart Edward. *Arizona Nights*. New York: Grosset & Dunlap, 1907.

Wiggin, Kate Douglas. *Susanna and Sue*. Boston: Houghton Mifflin, 1909.

Wyeth, N. C. "A Day with the Round-Up: An Impression." *Scribner's Magazine*, Mar. 1906.

———. "The Indian in His Solitude." *Outing Magazine*, vol. 50, no. 3 (June 1907).

———. "A Sheep-Herder of the South-West." *Scribner's Magazine*, Jan. 1909.

Magazines and Journals

The American Boy; American Legion Magazine; The Bookman; The Century Magazine; Collier's Weekly; The Country Gentleman; Delaware Life; The Delineator; Everybody's Magazine; Frank Leslie's Popular Monthly; Good Housekeeping; Harper's Monthly Magazine; Harper's Weekly; The Harvard Advocate; Hearst's; Horticulture; Ladies' Home Journal; McClure's Magazine; Metropolitan Weekly; National Geographic; The Outing Magazine; Redbook Magazine; The Red Cross Magazine; St. Nicholas; The Saturday Evening Post; Scribner's Magazine; Success; Woman's Day; Woman's Home Companion.

Newspapers

Albuquerque (N.M.) *Journal;* Boston (Mass.) *Evening Transcript,* Boston *Globe,* Boston *Herald,* Boston *Journal,* Boston *Post, Christian Science Monitor;* Buffalo (N.Y.) *Courier-*

Express; Cambridge (Mass.) *Tribune;* Dearborn (Mich.) *Independent;* Dedham (Mass.) *Gazette;* Delaware County (Pa.) *Times;* Denver (Colo.) *News,* Denver *Post,* Denver *Republican,* Denver *Times;* Lancaster (Pa.) *New Era;* Los Angeles (Calif.) *Herald Examiner;* Needham (Mass.) *Chronicle,* Needham *Suburban,* Needham *Times;* New York (N.Y.) *Herald,* New York *Sun,* New York *Times;* Philadelphia (Pa.) *Bulletin,* Philadelphia *Inquirer,* Philadelphia *North American,* Philadelphia *Press,* Philadelphia *Public Ledger,* Philadelphia *Record;* Rockland (Maine) *Courier-Gazette;* Roswell (N.M.) *Daily Record;* Washington (D.C.) *Post,* Washington *Star;* West Chester (Pa.) *Daily Local News;* Wilmington (Del.) *Journal Every Evening,* Wilmington *Morning News,* Wilmington *Star.*

Video and Recordings

Hurd, Henriette Wyeth. Filmed and interviewed by Peter de la Fuente. Private production. Sentinel Ranch, San Patricio, N.M., 1984.

Vidor, King. *Metaphor: King Vidor Meets with Andrew Wyeth.* Incomplete documentary film about the influence of King Vidor's *Big Parade* on the art of Andrew Wyeth. Directed by King Vidor. 1975. Motion picture film outtakes on VHS video format are among the King W. Vidor Papers, 1894–1982. Archives of American Art. Smithsonian Institution.

Wyeth, Andrew. *The Real World of Andrew Wyeth.* Directed by Andrew Snell. London Weekend Television/RM Productions, 1980.

———. *Self-Portrait: Snow Hill.* Produced by Betsy James Wyeth. Directed by Bo Bartlett. Chip Taylor Communications, 1995.

Wyeth, N. C. *The Wyeths: A Father and His Family.* Executive Producer, Adrian Malone. Written by David McCullough and David Grubin. Music by Ann Wyeth McCoy. David Grubin Productions, 1986. *Smithsonian World,* a co-production of WETA-TV and the Smithsonian Institution, Nov. 19, 1986.

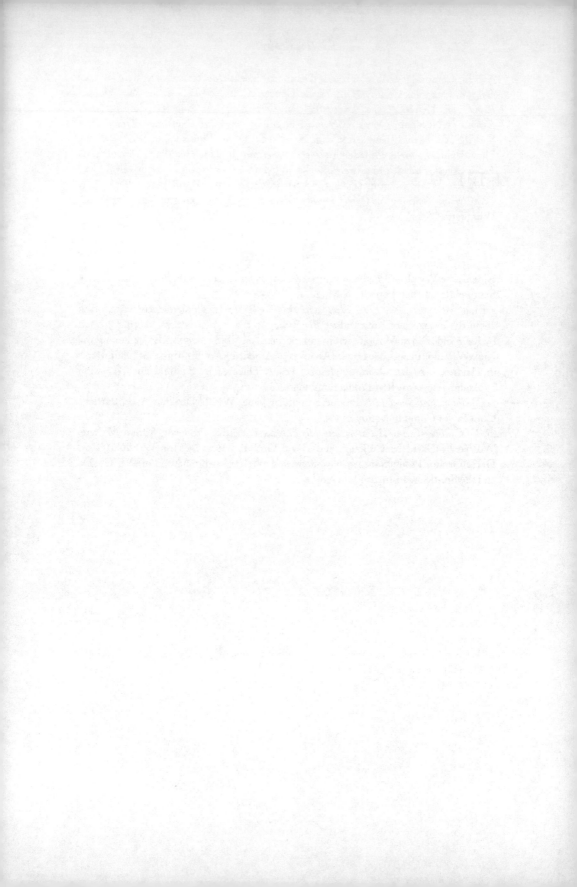

ILLUSTRATION CREDITS

All paintings and drawings are by N. C. Wyeth except where noted.

OPPOSITE CONTENTS PAGE

The Wreck of the "Covenant," 1913. Collection of the Brandywine River Museum. Bequest of Mrs. Russell G. Colt. Photography by Peter Ralston.

PART ONE

Color Illustrations Between Pages 20 and 21

Joe Pointer. Reprinted with the permission of Atheneum Books for Young Readers, an imprint of Simon & Schuster Children's Publishing Division from *Treasure Island* by Robert Louis Stevenson, illustrated by N. C. Wyeth. Copyright 1911 Charles Scribner's Sons; copyright renewed 1939 N. C. Wyeth.

Treasure Island, endpaper illustration, 1911. Collection of the Brandywine River Museum. Purchased in memory of Hope Montgomery Scott. Reprinted with the permission of Atheneum Books for Young Readers, an imprint of Simon & Schuster Children's Publishing Division from *Treasure Island* by Robert Louis Stevenson, illustrated by N. C. Wyeth. Copyright 1911 Charles Scribner's Sons; copyright renewed 1939 N. C. Wyeth.

Long John Silver and Hawkins, 1911. Collection of Mr. and Mrs. Andrew Wyeth. Photograph courtesy of the Brandywine River Museum. Photography by Peter Ralston. Reprinted with the permission of Atheneum Books for Young Readers, an imprint of Simon & Schuster Children's Publishing Division from *Treasure Island* by Robert Louis Stevenson, illustrated by N. C. Wyeth. Copyright 1911 Charles Scribner's Sons; copyright renewed 1939 N. C. Wyeth.

The Hostage, 1911. Collection of the Brandywine River Museum. Bequest of Mrs. Gertrude Haskell Britton. Reprinted with the permission of Atheneum Books for Young Readers, an imprint of Simon & Schuster Children's Publishing Division from *Treasure Island* by Robert Louis Stevenson, illustrated by N. C. Wyeth. Copyright 1911 Charles Scribner's Sons; copyright renewed 1939 N. C. Wyeth.

121 NCW on horseback, Gill Ranch, Limon, Colorado, 1904. Photograph courtesy of the Wyeth Family Archive.

124 *Above the Sea of Round, Shiny Backs the Thin Loops Swirled and Shot into Volumes of Dust,* 1904. Buffalo Bill Historical Center, Cody, Wyoming / Gift of John M. Schiff.

125 *Cutting Out,* 1904. Buffalo Bill Historical Center, Cody, Wyoming / Gift of John M. Schiff.

A Night Herder, 1904. Collection of Mr. and Mrs. Andrew Wyeth. Photograph courtesy of the Brandywine River Museum. Photography by Peter Ralston.

Color Illustrations Between Pages 148 and 149

Kidnapped, cover label, illustration, 1913. Collection of the Brandywine River Museum. Purchased through the generosity of Mrs. J. Maxwell Moran and Anson M. Beard. Reprinted with the permission of Atheneum Books for Young Readers, an imprint of Simon & Schuster Children's Publishing Division from *Kidnapped* by Robert Louis Stevenson, illustrated by N. C. Wyeth. Copyright 1913 Charles Scribner's Sons; copyright renewed 1941 N. C. Wyeth.

The Wreck of the "Covenant," 1913. Collection of the Brandywine River Museum. Bequest of Mrs. Russell G. Colt. Photography by Peter Ralston. Reprinted with the permission of Atheneum Books for Young Readers, an imprint of Simon & Schuster Children's Publishing Division from *Kidnapped* by Robert Louis Stevenson, illustrated by N. C. Wyeth. Copyright 1913 Charles Scribner's Sons; copyright renewed 1941 N. C. Wyeth.

At Queen's Ferry, 1913. Collection of the New York Public Library, Central Children's Room, Donnell Library Center, New York, N.Y. Photography by Schecter Lee. Reprinted with the permission of Atheneum Books for Young Readers, an imprint of Simon & Schuster Children's Publishing Division from *Kidnapped* by Robert Louis

Stevenson, illustrated by N. C. Wyeth. Copyright 1913 Charles Scribner's Sons; copyright renewed 1941 N. C. Wyeth.

174 NCW painting outdoors, Chadds Ford, c. 1908. Photograph courtesy of Gretchen Wyeth Underwood, used by permission of Mr. and Mrs. Andrew Wyeth.

Color Illustrations Between Pages 180 and 181

Mrs. N. C. Wyeth in a Rocking Chair, c. 1910. Collection of Mr. and Mrs. Andrew Wyeth. Photography courtesy of the Brandywine River Museum.
Robin Meets Maid Marian, 1917. Collection of the New York Public Library, Central Children's Room, Donnell Library Center, New York, N.Y. Photograph courtesy of the Brandywine River Museum. Photography by Peter Ralston.
King Mark Slew the Noble Knight Sir Tristram as He Sat Harping Before His Lady La Belle Isolde, 1917. Private Collection. Photography by Peter Ralston. Reprinted with the permission of Atheneum Books for Young Readers, an imprint of Simon & Schuster Children's Publishing Division from *The Boy's King Arthur* by Sidney Lanier, illustrated by N. C. Wyeth. Copyright 1917 Charles Scribner's Sons; copyright renewed 1945 N. C. Wyeth.
Why Don't You Speak for Yourself, John?, 1920. Courtesy of Houghton Mifflin & Company. Photography by Gregory R. Staley.

183 *Haystacks Under Rum-Cherry Tree,* pencil drawing, 1908. Courtesy of the Wyeth Family Archive. Photography by Rick Echelmeyer.
188 *The Water-Hole,* 1925. Courtesy of Wells Fargo.

PART THREE

197 *Map of Treasure Island,* based on Robert Louis Stevenson's original drawing, 1881. Photography by Gregory R. Staley. Reprinted with the permission of Atheneum Books for Young Readers, an imprint of Simon & Schuster Children's Publishing Division from *Treasure Island* by Robert Louis Stevenson, illustrated by N. C. Wyeth. Copyright 1911 Charles Scribner's Sons; copyright renewed 1939 N. C. Wyeth.
NCW and Carol with Carolyn and Henriette, 1910. Photograph courtesy of the Wyeth Family Archive.
200 Walter Paget, *The Coxswain Loosed His Grasp upon the Shrouds, and Plunged Head First into the Water,* 1899. Children's Special Collections, the Free Library of Philadelphia. Photography by Will Brown.
Israel Hands, 1911. Collection of the New Britain Museum of American Art, Harriet Russell Stanley Fund. Photograph courtesy of the Brandywine River Museum. Photography by Peter Ralston. Reprinted with the permission of Atheneum Books for Young Readers, an imprint of Simon & Schuster Children's Publishing Division from *Treasure Island* by Robert Louis Stevenson, illustrated by N. C. Wyeth. Copyright 1911 Charles Scribner's Sons; copyright renewed 1939 N. C. Wyeth.
203 284 South Street, from the lower pasture. Photograph courtesy of the Wyeth Family Archive.
Old Pew, 1911. Collection of Mr. and Mrs. Andrew Wyeth. Photograph courtesy of the Brandywine River Museum. Photography by Peter Ralston. Reprinted with the permission of Atheneum Books for Young Readers, an imprint of Simon & Schuster Children's

Publishing Division from *Treasure Island* by Robert Louis Stevenson, illustrated by N. C. Wyeth. Copyright 1911 Charles Scribner's Sons; copyright renewed 1939 N. C. Wyeth.

211 *The Studio*, c. 1911. Mr. and Mrs. Frank E. Fowler.

219 *Portrait of Stimson*, 1909. John and Betty Wyeth. Photography by Greg Heins.

237 Wyeth children, photographed by N. C. Wyeth, 1918. Courtesy of the Wyeth Family Archive.

242 *Cows in Moonlight* [*Newborn Calf*], 1917. Collection of Mr. and Mrs. Andrew Wyeth. Photograph courtesy of the Brandywine River Museum. Photography by Peter Ralston. *A Fight on the Plains*, 1916. Collection of Mr. and Mrs. Andrew Wyeth. Photograph courtesy of the Brandywine River Museum. Photography by Peter Ralston.

Color Illustrations Between Pages 244 and 245

They Fought with Him on Foot More Than Three Hours, Both Before Him and Behind Him, 1917. Private collection. Photograph courtesy of the Brandywine River Museum. Photography by Peter Ralston. Reprinted with the permission of Atheneum Books for Young Readers, an imprint of Simon & Schuster Children's Publishing Division from *The Boy's King Arthur* by Sidney Lanier, illustrated by N. C. Wyeth. Copyright 1917 Charles Scribner's Sons; copyright renewed 1945 N. C. Wyeth.

The Fence Builders, 1915. Private collection. Photograph courtesy of the Brandywine River Museum.

In the Fork, Like a Mastheaded Seaman, There Stood a Man in a Green Tabard, Spying Far and Wide, 1916. Collection of Mr. and Mrs. Andrew Wyeth. Photograph courtesy of the Brandywine River Museum. Photography by Peter Ralston. Reprinted with the permission of Atheneum Books for Young Readers, an imprint of Simon & Schuster Children's Publishing Division from *The Black Arrow* by Robert Louis Stevenson, illustrated by N. C. Wyeth. Copyright 1916 Charles Scribner's Sons; copyright renewed 1944 N. C. Wyeth.

Robin Hood and His Companions Lend Aid to Will o' th' Green from Ambush [*Their Arrows Flew Together, Marvelous Shots, Each Finding Its Prey*], 1917. Collection of the New York Public Library, Central Children's Room, Donnell Library Center, New York, N.Y. Photograph courtesy of the Brandywine River Museum. Photography by Peter Ralston.

The Battle at Glens Falls, 1919. Collection of the Brandywine River Museum. Bequest of Mrs. Russell G. Colt. Photography by Peter Ralston. Reprinted with the permission of Atheneum Books for Young Readers, an imprint of Simon & Schuster Children's Publishing Division from *The Last of the Mohicans* by James Fenimore Cooper, illustrated by N. C. Wyeth. Copyright 1919 Charles Scribner's Sons; copyright renewed 1947 Carolyn B. Wyeth.

The Duel, 1924. Private collection. Photography courtesy of the Brandywine River Museum. Reprinted with the permission of Atheneum Books for Young Readers, an imprint of Simon & Schuster Children's Publishing Division from *David Balfour* by Robert Louis Stevenson, illustrated by N. C. Wyeth. Copyright 1922 Charles Scribner's Sons; copyright renewed 1950 Charles Scribner's Sons and Carolyn B. Wyeth.

The Duel on the Beach, 1920. Private collection. Photography by Peter Ralston. Reprinted with the permission of Atheneum Books for Young Readers, an imprint of Simon & Schuster Children's Publishing Division from *Westward Ho!* by Charles Kingsley, illustrated by N. C. Wyeth. Copyright 1920 Charles Scribner's Sons; copyright renewed 1948 Charles Scribner's Sons and Carolyn B. Wyeth.

245 *The Passing of Robin Hood,* 1917. Collection of the New York Public Library, Central Children's Room, Donnell Library Center, New York, N.Y. Photograph courtesy of the Brandywine River Museum. Photography by Peter Ralston.

247 NCW, 1916. Photograph by Sanborn. Courtesy of the Wyeth Family Archive.

251 *Self-Portrait* [*In Skating Cap*], 1918. Private collection. Photography courtesy of the Brandywine River Museum.

263 Bockiuses and Wyeths, July 4, 1918. Photograph courtesy of William Lawrence Bockius. George Bockius, London, 1917. Photograph courtesy of the Wyeth Family Archive.

266 Andy Wyeth, 1923. Photograph courtesy of the Wyeth Family Archive.
Ann Wyeth, c. 1917. Photograph courtesy of the Wyeth Family Archive.

Color Illustrations Between Pages 276 and 277

Endpapers for *The Last of the Mohicans,* first Wyeth edition, 1919. Photography by Gregory R. Staley. Reprinted with the permission of Atheneum Books for Young Readers, an imprint of Simon & Schuster Children's Publishing Division from *The Last of the Mohicans* by James Fenimore Cooper, illustrated by N. C. Wyeth. Copyright 1919 Charles Scribner's Sons; copyright renewed 1947 Carolyn B. Wyeth.

The Last of the Mohicans, endpaper illustration, 1919. Collection of the Brandywine River Museum. Given in memory of Raymond Platt Sorland by his children. Reprinted with the permission of Atheneum Books for Young Readers, an imprint of Simon & Schuster Children's Publishing Division from *The Last of the Mohicans* by James Fenimore Cooper, illustrated by N. C. Wyeth. Copyright 1919 Charles Scribner's Sons; copyright renewed 1947 Carolyn B. Wyeth.

The Captives, 1919. Private collection. Photography by John L. Manning. Reprinted with the permission of Atheneum Books for Young Readers, an imprint of Simon & Schuster Children's Publishing Division from *The Last of the Mohicans* by James Fenimore Cooper, illustrated by N. C. Wyeth. Copyright 1919 Charles Scribner's Sons; copyright renewed 1947 Carolyn B. Wyeth.

275 *Penny Tells the Story of the Bear Fight,* 1939. Private collection. Photography by David H. Ramsey. Reprinted with the permission of Atheneum Books for Young Readers, an imprint of Simon & Schuster Children's Publishing Division from *The Yearling* by Marjorie Kinnan Rawlings, illustrated by N. C. Wyeth. Illustrations copyright 1939 Charles Scribner's Sons; copyright renewed 1967 Charles Scribner's Sons.
Movie still from Clarence Brown's *The Yearling,* M-G-M, 1946. Courtesy of Photofest Film Stills Archive.

279 Wyeth family, photographed by NCW, 1922. Courtesy of the Wyeth Family Archive.

281 *My Grandfather's House,* c. 1929. Collection of Jamie Wyeth.

292 Peter Hurd, Chadds Ford, 1920s. Photograph courtesy of the Wyeth Family Archive.

295 NCW painting murals, Chadds Ford, 1924. Photograph courtesy of the Wyeth Family Archive.

307 Ann at the piano, early 1930s. Photograph by William E. Phelps, courtesy of Ann Wyeth McCoy.

308 Nat, 1923. Photograph courtesy of the Wyeth Family Archive.

Color Illustrations Between Pages 308 and 309

It Was with Some Difficulty That He Found His Way to His Own House, 1921. Millport Conservancy, Lititz, Pennsylvania.

The Giant, 1923. Collection of the Westtown School, Westtown, Pennsylvania, 19395.

My Mother, 1929. Collection of the Brandywine River Museum. Bequest of Carolyn Wyeth.

Still Life with Iris and Oranges, c. 1924. Delaware Art Museum / Gift of Mary R. Phelps.

Harvey's Run, c. 1912. Photograph courtesy of the Hurd La Rinconada Gallery. Collection of Michael Hurd.

314 Harl McDonald. Photograph courtesy of Ann Wyeth McCoy.

Henriette in her studio in Wilmington, 1928. Photograph by Sanborn, courtesy of the Wyeth Family Archive.

PART FOUR

323 NCW with his brother Nat and the Wyeths' new 1929 Cadillac, photographed by Carolyn Wyeth. Photograph courtesy of Gretchen Wyeth Underwood, used by permission of Mr. and Mrs. Andrew Wyeth.

Wyeth dining room, Chadds Ford, 1930s. Photograph courtesy of the Wyeth Family Archive.

329 John W. McCoy, Rehoboth Beach, Delaware, 1935. Photograph courtesy of the Wyeth Family Archive.

331 *In a Dream I Meet General Washington,* 1930–31. Collection of the Brandywine River Museum. Purchased with funds given in the memory of George T. Weymouth.

334 NCW with Andrew Wyeth on Cannibal Shore, Maine, 1936. Photograph courtesy of the Wyeth Family Archive.

338 Nat Wyeth relaunching the *Silver Foil,* 1938. Photograph courtesy of the Wyeth Family Archive.

340 Caroline Pyle, c. 1930, with an unidentified young man. Photograph courtesy of Andrew Nathaniel Wyeth.

Color Illustrations Between Pages 340 and 341

Andrew Wyeth, *The Lobsterman,* 1937. Hunter Museum of American Art, Chattanooga, Tennessee, Gift of the Benwood Foundation.

Andrew Wyeth, *Pennsylvania Landscape,* 1942. Collection of the Brandywine River Museum. Bequest of Miss Remsen Yerkes.

Heidi, 1940. Children's Special Collections, the Free Library of Philadelphia. Photography by Will Brown.

Andrew Wyeth, *The Forest and the Fort,* 1942. Private Collection.

The Doryman, 1938. Private Collection.

349 Betsy James, 1939. Photograph by William E. Phelps, courtesy of the Wyeth Family Archive.

358 Peter and Henriette Wyeth Hurd, New Mexico, 1944. Photograph courtesy of Andrew Nathaniel Wyeth.

361 Betsy and Andrew Wyeth's wedding day, May 15, 1940. Photograph courtesy of the Wyeth Family Archive.

363 Caroline Pyle Wyeth, Pompton Lakes, New Jersey, July 1940. Photograph courtesy of Andrew Nathaniel Wyeth.

364 Caroline and Nat, Port Clyde, 1940. Photographed by Carolyn Wyeth, courtesy of
 Andrew Nathaniel Wyeth.
 NCW and Carol on the Wyeths' dock, Port Clyde, Maine. Photograph by William E.
 Phelps. William E. Phelps Papers, Archives of American Art, Smithsonian Institution.
367 Nat Wyeth with his daughters, Gretchen and Natalie, Big Bear, California, c. 1924.
 Photograph courtesy of Gretchen Wyeth Underwood.
 Nathaniel Wyeth and Gladys Ella Pond Wyeth, Palm Springs, California, c. 1941.
 Photograph courtesy of Gretchen Wyeth Underwood.
369 Carolyn Wyeth, Maine, August 1938. Photograph courtesy of Andrew Nathaniel
 Wyeth.

Color Illustrations Between Pages 372 and 373

Bright and Fair—Eight Bells, 1936. Farnsworth Art Museum, Museum Purchase, 1989.
Photography by Melville D. McLean.
Cowboy Watering His Horse, c. 1937. Museum of Texas Tech University.
Island Funeral, 1939. The Hotel du Pont Collection of American Art.
The War Letter, 1941. Collection of the Brandywine River Museum. Purchased in memory of Deo du Pont Weymouth and Tyler Weymouth.

382 NCW with Newell Convers Wyeth II. Still from a 1942 home movie. Courtesy of
 Andrew Nathaniel Wyeth. Photographic reproduction, David Joyall, Northeast Document Conservation Center.
389 *Jack the Giant Killer,* 1939. Collection of David C. Wyeth. Photograph courtesy of the
 Archives of the American Illustrators Gallery, New York City.
394 Walter Pyle and Ellen Bernard Thompson Pyle, 1904. Photograph courtesy of Alice
 Pyle Lawrence Abrash.
402 *Road to McVey's House,* c. 1917. Collection of H. Richard Dietrich, Jr., Philadelphia,
 Pennsylvania.
404 At the intersection of the Wyeths' driveway and Brandywine Creek Road. Still from a
 home movie, October 1945. Courtesy of Andrew Nathaniel Wyeth. Photographic
 reproduction, David Joyall, Northeast Document Conservation Center.
407 Newell Wyeth, Pines Lake, New Jersey, 1943. Photograph courtesy of Andrew
 Nathaniel Wyeth.
414 Picnic, early summer 1945. Photograph courtesy of Andrew Nathaniel Wyeth.
 Picnic, late summer 1945. Photograph courtesy of David C. Wyeth.
417 NCW's studio, October 1945, with his last canvas, *First Farmer of the Land,* on easel.
 Courtesy of the Wyeth Family Archive.

AFTER N.C.

429 Portrait by Arnold Newman, 1948. Copyright © by Arnold Newman.

ENDPAPERS

(front) *The Fence Builders,* 1915. Private collection. Photography courtesy of Brandywine
 River Museum.
(back) *April Rain,* 1935. Private collection. Photography courtesy of Brandywine River
 Museum.

INDEX

Note: Works by N. C. Wyeth are identified NCW; works by Andrew Wyeth are identified AW.

A NOTE ON THE TYPE

This book was set in Caslon, a typeface named after William Caslon (1692–1766). The first of a famous English family of type designers and founders, he was originally an apprentice to an engraver of gun-locks and gun barrels in London. In 1716 he opened his own shop, for silver chasing and making bookbinders' stamps. The printers John Watts and William Bowyer, admirers of his skill in cutting orna-ments and letters, advanced him money to equip himself for type-founding, which he began in 1720. The fonts he cut in 1722 for Bowyer's sumptuous folio edition of John Selden, published in 1726, excited great interest. A specimen sheet of typefaces, issued in 1734, established Caslon's superiority to all other letter cutters of the time, English or Dutch, and soon his types, or types modeled on his style, were being used by most English printers, supplanting the Dutch types that had formerly prevailed. In style, Caslon was a reversion to earlier type styles. Its characteristics are remarkable regularity and symmetry, and beauty in the shape and proportion of the letters; its general effect is clear and open but not weak and delicate. For uniformity, clearness, and readability it has perhaps never been sur-passed. After Caslon's death his eldest son, also named William (1720–1778), carried on the business successfully. A period of neglect followed which lasted almost fifty years. In 1843 Caslon type was revived by the firm Caslon for William Pickering and has since been one of the most widely used of all type designs in English and Amer-ican printing.

Composed by North Market Street Graphics,
Lancaster, Pennsylvania
Printed and bound by Quebecor Printing,
Martinsburg, West Virginia
Designed by Virginia Tan